Post-Impressionism

COVER ILLUSTRATIONS
FRONT Gauguin *Contes Barbares* (no. 93)
Folkwang Museum, Essen
BACK Seurat *Le Crotoy, Looking Upstream* (no. 202)
(detail) Stavros S. Niarchos Collection

This exhibition has been generously supported by
IBM UNITED KINGDOM LIMITED

Post-Impressionism

Cross-Currents in European Painting

ROYAL ACADEMY OF ARTS LONDON 1979–80

Catalogue published in association with

WEIDENFELD AND NICOLSON LONDON

General Information

DATES OF EXHIBITION
17 November 1979–16 March 1980

HOURS OF OPENING
Daily 10 am–6 pm, Wednesdays 10 am–8 pm

PRICE OF ADMISSION
£2.00
Half price for students, pensioners and children, and until 1.45 pm on Sundays
Pre-booked school parties 75p
Pre-booked evenings for a minimum of 400 people at £3.50 a head
Admission at the officially reduced rate of £1 for
Students, for Teachers accompanying parties, for Members of Staff
Associations, Working Men's or Girls' Clubs or similar
organizations, and for Pensioners, can be obtained at the entrance
of the Exhibition on production of the appropriate card.

BUFFET RESTAURANT WITH LICENSED BAR
Open daily.
Access to the Restaurant is from the Ground Floor, Entrance Hall.

Invalids may use their own wheeled chairs or obtain the use of
one without charge by previous arrangement. Application should
be made to the Registry for the necessary authority.

Visitors are required to deposit all miscellaneous items other
than ladies' handbags with the attendants at the Cloakroom in
the Entrance Hall. The other attendants are strictly forbidden
to take charge of anything.

House Editor Esther Jagger
House Art Editor Tim Higgins
Designed by Trevor Vincent for
George Weidenfeld and Nicolson Ltd
91 Clapham High Street, London SW4

ISBN 0 297 77713 0

Set in Monophoto *Photina* and printed by
BAS Printers Limited, Over Wallop, Hampshire

Colour separations by Newsele Litho Ltd, Italy

Contents

List of Lenders

BELGIUM
Antwerp, Koninklijk Museum voor Schone Kunsten
Brussels, Musées Royaux des Beaux-Arts de Belgique
Ghent, Museum voor Schone Kunsten
Ixelles, Musée d'Ixelles
Liège, Musée des Beaux-Arts
Mabille, Marcel

CANADA
Godfrey, Mrs Samuel
Ottawa, National Gallery of Canada
Toronto, Art Gallery of Ontario

DENMARK
Copenhagen, Ny Carlsberg Glyptothek

FRANCE
Albi, Musée Toulouse-Lautrec
Bellier, Jean Claude
Besançon, Musée des Beaux-Arts
Boutaric, Mlle Henriette
Chausson, Famille Ernest
Denis, Jean François
Dijon, Musée des Beaux-Arts
Douai, Musée de la Chartreuse
Durand-Ruel
Grenoble, Musée de Peinture et de Sculpture
Le Puy, Musée Crozatier
Lille, Musée des Beaux-Arts
Manoukian, N.
Moulins, Musée de
Nancy, Musée des Beaux-Arts
Nantes, Musée des Beaux-Arts
Nice, Musée des Beaux-Arts Jules Chéret
Nice, Musée Matisse
Orléans, Musée des Beaux-Arts
Paris, Musée des Arts Décoratifs
Paris, Musée du Louvre
Paris, Musée Gustave Moreau
Paris, Musée National d'Art Moderne, Centre Georges
 Pompidou
Paris, Musée d'Orsay
Paris, Musée du Petit Palais
Paris, Musée Rodin
Perinet, Michel
Quimper, Musée des Beaux-Arts
Reims, Musée Saint-Denis
Rennes, Musée des Beaux-Arts
Rouen, Musée des Beaux-Arts
Saint Etienne, Musée d'Art et d'Industrie
Saint Germain-en-Laye, Musée du Prieuré
Saint Tropez, Musée de l'Annonciade
Senlis, Musée du Haubergier
Signac, Mme Ginette
Strasbourg, Musée d'Art Moderne
Toulouse, Musée des Augustins
Walker Collection
Walker, Mme Robert

GERMANY
Berlin, Brücke Museum
Berlin, Nationalgalerie
Bremen, Kunsthalle
Bremen, Sammlung Böttcherstrasse
Cologne, Ludwig Museum
Cologne, Wallraf-Richartz Museum
Essen, Folkwang Museum
Essen, Gesellschaft Kruppsche Gemäldesammlung
Hamburg, Kunsthalle
Hanover, Niedersächsisches Landesmuseum
Kaufmann, Herr Bernhard
Mannheim, Städtische Kunsthalle

Munich, Bayerische Staatsgemäldesammlungen
Seebüll, Stiftung Ada und Emil Nolde
Wuppertal, Von der Heydt Museum

GREAT BRITAIN AND NORTHERN IRELAND
Aberdeen, Art Gallery and Museum
Bacon, A. W.
Bamford, Mrs Anthony
Baty, Mrs E. H.
Belfast, Ulster Museum
Bevan, Mrs R. A.
Birmingham, Barber Institute of Fine Arts
Bradford Museums and Art Galleries
Bristol Art Gallery
Butler, The Lord, of Saffron Walden, KG, PC, CH
Cambridge, Fitzwilliam Museum
Cardiff, National Museum of Wales
Clore, the Executors of the late Sir Charles
Cluff, J. G.
Department of the Environment
Diamand, Mrs
D'Offay, Anthony
Edinburgh, National Gallery of Scotland
Edinburgh, Scottish National Gallery of Modern Art
Fitzmaurice, Mr and Mrs Robert
Glasgow Art Gallery and Museum
Glasgow University Collections
Green, Richard, Galleries
Grogan, A. H.
Guadalmina, Marquesa de
Hull University Art Collection
Ipswich Museum
Irvine, Mr and Mrs Alexander
Iwaszkiewicz-Dowmunt, Julian
Kessler, Mrs Anne
King, Mr and Mrs Richard
Kirkcaldy Museum and Art Gallery
Kirkman, James
Leeds City Art Gallery
Liverpool, Walker Art Gallery
London, Courtauld Institute Galleries
London, Guildhall Art Gallery
London, National Gallery
London, National Portrait Gallery
London, Tate Gallery
London, Victoria and Albert Museum
Lyons, Sir Jack, CBE
Manchester City Art Gallery
Marlborough Fine Art (London) Ltd
McIntosh Patrick, Andrew
MacNicol, Mrs Ian
Montagu, The Hon. John
Newcastle-upon-Tyne, Laing Art Gallery, Tyne and Wear
 Museums Service
Northampton, Central Museum and Art Gallery
Norfolk Museums Service
Oxford, Ashmolean Museum
Peraticos, M. C.
Piccadilly Gallery
Plymouth City Museum and Art Gallery
Rochdale Art Gallery
Rothenstein, Sir John, CBE
Roussel, Guy
Sands, The Collection of the late Morton H.
Sheffield, Graves Art Gallery
Shine, The Collection of the late Mrs Barnett
Skipwith, Mr and Mrs Peyton
Southampton Art Gallery
Wolfson, Sir Isaac

GREECE
Niarchos, Stavros S.

NETHERLANDS
Amsterdam, Rijksmuseum Vincent Van Gogh
Amsterdam, Stedelijk Museum
The Hague, Gemeentemuseum
Otterlo, Rijksmuseum Kröller-Müller
Rotterdam, Boymans-Van Beuningen Museum

REPUBLIC OF IRELAND
Dublin, National Gallery of Ireland
Dublin, Hugh Lane Municipal Gallery of Modern Art

ITALY
Banca Commerciale Italiana
Milan, Civica Galleria d'Arte Moderna
Milan, Museo Nazionale della Scienza e della Tecnica
Morbelli, O.
Piceni-Testi Collection
Rome, Galleria Nazionale d'Arte Moderna
Trento, G.
Treviso, Museo Civico
Turin, Museo Civico
Venice, Museo d'Arte Moderna
Vercelli, Museo Civico Borgogna

NORWAY
Bergen, Rasmus Meyers Samlinger
Oslo, Munch Museet
Oslo, Nasjonalgalleriet

PORTUGAL
Lisbon, Calouste Gulbenkian Foundation

SWITZERLAND
Basle, Kunstmuseum
Berne, Kunstmuseum
Berne, Gottfried Keller Stiftung
Feilchenfeldt, M.
Franck, Louis
Geneva, Petit Palais
Josefowitz, Samuel
Koerfer, Dr Jacques
Staechelin Foundation
Thyssen-Bornemisza Collection
Winterthur, Kunstmuseum
Zürich, Kunsthaus

UNITED STATES OF AMERICA
Aberbach, Julian J.
Altschul, Arthur G.
Boston, Museum of Fine Arts
Chicago, Art Institute of
Crowell, Joan
De Lange, Mr and Mrs Jeff
Detroit Institute of Arts
Flint Institute of Art
Gould, Mrs Florence
Hammer, Dr Armand
Hartford, Wadsworth Atheneum
Hirschl and Adler Galleries, Inc.
Lewyt, Mr and Mrs Alexander
New York, Metropolitan Museum of Art
New York, Museum of Modern Art
Pearlman, Henry and Rose, Foundation
Perls Galleries, New York
Philadelphia, Museum of Art
Philadelphia, Pennsylvania Academy of the Fine Arts
Rhode Island School of Design, Museum of Art
Rochester, University of, Memorial Art Gallery
San Francisco, Fine Arts Museums
Smith, Mrs Bertram
Thaw, E. V., and Co. Inc.
Washington, National Gallery of Art
Washington, Phillips Collection
Wildenstein and Co. Inc.
Williamstown, Sterling and Francine Clark Institute

Also the many owners who prefer to remain anonymous.

6

Foreword

Hugh Casson President of the Royal Academy

In 1974 the Royal Academy mounted in its Diploma Galleries an exhibition to commemorate the centenary of the first Impressionist exhibition in Paris. It was a great public success. Ever since then it has been our firm intention to present a major Post-Impressionist display. The form that this should take was the subject of considerable debate and was still evolving when we finally committed ourselves to the project just over 18 months ago. The 1974 exhibition was a relatively modest display, although it contained, as well as painting by the great French Impressionist masters, works by some of their precursors in France and England. Also included were a group of paintings which indicated the extent of the influence of the French Impressionists on English painters up to 1910, the year of Roger Fry's first Post-Impressionist exhibition. That was the moment – it will be remembered – when the term 'Post-Impressionist' was coined. It has since been universally adopted, even by the French, to indicate that explosion of artistic possibilities triggered off by the innovations of the original French Impressionists in their classic phase in the late 1860s and 1870s.

In planning this exhibition we had two aims in view. First, the almost infinite number of painterly possibilities that were opened up, especially in France, meant that the exhibition would have to be large, generously filling all our main galleries. Second, while an extra dimension in the 1974 exhibition came from the inclusion of English paintings, the implications of Impressionism had great consequences for painting throughout Europe. To show this we believed would be an exciting and revealing task which, as far as we know, has never been systematically attempted in any other exhibition.

The end of the nineteenth century saw great changes in the whole concept of the public art exhibition, particularly outside the Salon and the Academy. Contemporary art was moved with greater and greater ease from country to country, by dealers, collectors and artists themselves, while artists became increasingly aware of what was happening in centres other than their own. Rooms in the exhibition are therefore devoted to Britain, Germany, Italy and the Low Countries. Lack of space has prevented us from including work produced in Central Europe, Scandinavia, Spain or indeed the United States, which were the sources of fascinating aspects of Post-Impressionism.

To the team of scholars (listed on p. 2), assembled under the Chairmanship of Professor Alan Bowness, and co-ordinated and directed by John House and MaryAnne Stevens (themselves responsible for choosing and cataloguing the French core of the exhibition), we are most grateful, as we are to Frederick Gore RA, who represented the Academy at the selection meetings. The exhibition has been organized entirely within the Royal Academy, and in particular by its exhibition office, headed by the Royal Academy's Exhibitions Secretary, Norman Rosenthal. He has been most ably assisted by Jane Hepburne-Scott in ensuring the efficient co-ordination of the complex arrangements connected with an exhibition such as this. We are particularly happy to record IBM United Kingdom's generous support of the exhibition, and must thank too Lord Donaldson, Minister for the Arts in the last government, for making the British Government Indemnity available to the Royal Academy for the first time, and thus relieving us of the almost prohibitive cost of insurance. The catalogue has been produced in collaboration with Weidenfeld and Nicolson. The partnership has been a very happy one. We believe that this catalogue will be not only a fitting record of this exhibition but a significant addition to the literature of the art of this period.

We believe that we have brought together an exhibition unrivalled in quality, scope and size, and encompassing one of the most exciting periods in the history of painting. It begins with later works by artists such as Monet and Degas, and concludes with major early works by Picasso and Matisse. The core of the exhibition is represented by a unique gathering of masterpieces by Van Gogh, Cézanne, Seurat and Gauguin. But there is much more by other artists who are perhaps less well known to the general public, but who have all made a vital contribution to arguments about what was possible in painting at the time. That all this is possible is due entirely to the overwhelming generosity of private collectors and museums all over the world. They are listed opposite. It is almost impossible for us to express adequately our gratitude to them all.

Notes to Users

Within each geographical section of the catalogue, artists appear in alphabetical order. A few artists appear not under their country of birth, but where their importance for the exhibition lies – for instance, Van Gogh and Meyer de Haan are catalogued under France. However, the Americans Whistler, Sargent and Harrison all appear under Great Britain and Ireland, and Vallotton under Germany, Norway and Switzerland. An alphabetical index of all the artists whose work features in the exhibition will be found on p. 302.

Within the catalogue entries on each artist, the paintings are listed in chronological order, after a brief biography.

Where possible, pictures are given the title by which they were originally exhibited, and otherwise that by which they are best known.

A simple date, after the title, indicates that the picture was definitely executed, or, if painted over a span of years, completed during this year. A date preceded by '*c.*' indicates that the picture was executed at around this date, thus: *c.* 1892. Two dates separated by an oblique stroke indicate that the picture was definitely executed at some point during this span of years, thus: 1890/4.

Inscriptions on the picture are transcribed in full, where possible, with their nature and placing indicated by the following abbreviations:

s – signed
ns – not signed
d – dated
b – bottom
t – top
l – left
c – centre
r – right
insc – inscribed
rev – reverse

All works are oil on canvas, unless otherwise stated.
Sizes are given to the nearest 0.5 cm., and to the nearest $\frac{1}{4}$ inch; height precedes width.

Under EXHIBITIONS, only showings from before 1914 are noted. The number of the picture in an exhibition, where known, appears in brackets, thus: (286). The picture's appearance at later exhibitions is only noted when the catalogue of this exhibition makes a significant contribution to the literature on the painting; in these cases the catalogue is listed under REFERENCES, again with the picture's number in brackets.

Under REFERENCES are listed only significant discussions of the picture in question, and also references to colour reproductions of it (where it is not reproduced in colour in the present catalogue), and to other reproductions which have particular historical interest. If an entry refers to the catalogue of a permanent collection, the picture's number in it is preceded by 'no.', thus: no. 628.

Documentary references are given within the text of a catalogue entry when the quotation or information cited does not refer directly to the picture in question.

Figure references within the text refer to the illustrations accompanying the essays which introduce each section, thus: fig. 28. Number references within the text refer to pictures which appear in the present exhibition, thus: no. 186.

Abbreviations are only used, in REFERENCES, when a particular source is frequently used in the entries for a particular artist. The key to such abbreviations will be found following that artist's biography. The same abbreviations are also used in the texts of catalogue entries, together with abbreviated forms of other references which are given in full in the REFERENCES to that picture. Generally, references are given in a full enough form to allow them to be readily located.

Where references to the standard catalogue raisonné of one artist appear in the entries of another artist, these are indicated simply by the name of the catalogue's author followed by the catalogue number.

Certain exhibiting institutions are given abbreviated titles:
RA – Royal Academy of Arts
NEAC – New English Art Club
AAA – Allied Artists Association
RBA – Royal Society of British Artists
RHA – Royal Hibernian Academy
RSA – Royal Scottish Academy
Société Nationale refers to the annual exhibition of the Société Nationale des Beaux-Arts in Paris, founded in 1890, and often known as the Salon du Champ de Mars, or the New Salon. Salon des Artistes Français refers to the continuing exhibitions, after the foundation of the Société Nationale, of the original Salon, reorganized in 1881 as the Salon de la Société des Artistes Français, and often known as the Salon des Champs-Elysées, or the Old Salon.

The authors of the catalogue entries are noted by the following initials:
S.B. – Sandra Berresford
A.G. – Anna Gruetzner
J.H. – John House
G.P. – Gillian Perry
MA.S. – MaryAnne Stevens

Introduction

Alan Bowness

It is a curious fact that the word 'Post-Impressionism' would not have been recognized by any of the major artists to whom it is now generally applied. When the art critic Roger Fry invented what he called this 'somewhat negative label'[1] in 1910, Cézanne, Gauguin, Van Gogh and Seurat were all long since dead, and the younger artists who showed with them in the two Post-Impressionist exhibitions of 1910 and 1912 had already accepted such other labels as 'Fauve' and 'Cubist', albeit reluctantly and not of their own invention. Almost 60 years later we have agreed that 'Post-Impressionism' can now be meaningfully applied to the later work of other great Impressionists – notably Degas, Monet, Renoir and Pissarro – who were specifically excluded by Fry; and more widely still to painting in France and western Europe which reflects an awareness of Impressionism and seeks to move away from and beyond it. Admittedly the Post-Impressionist net has been spread rather wider than before in the present exhibition, but the need to broaden the context in which we look at the paintings of the great Post-Impressionist masters has been felt by all associated with the exhibition and with its catalogue.

It is important to know how a neologism occurs when it describes a new tendency in art or letters. 'Post-Impressionism' is unusual, not only because it was invented 25 years after the art it describes, but because it was the suggestion of an English critic arranging an exhibition of modern French art. That exhibition was put together in a hurry to fill a gap in the Grafton Galleries programme, and its public success astonished all those concerned with it, not least the very young and inexperienced secretary of the exhibition, Desmond MacCarthy.

In a broadcast talk given in 1945 about *The Artquake of 1910*,[2] MacCarthy most engagingly admitted that he had 'never seen the work of any of the artists exhibited'. 'By the way', he continued, '[Fry] himself had seen very few of their pictures. But he was a man of exploring sensibility, and those that he had seen had impressed him.' MacCarthy described how the show was put together by Fry visiting a handful of leading Parisian dealers, including Cézanne's former agent, Vollard, whom he already knew. Then MacCarthy went on his own to Munich, and to Amsterdam, to see Van Gogh's sister-in-law, with whom he made a selection of Vincent's work. 'When we came to price them,' he said, 'she was asking a hundred and twenty pounds or less for some admirable examples of his art.' MacCarthy went on to explain how the name was invented:

What was the exhibition to be called? That was the next question. Roger and I and a young journalist who was to help with publicity, met to consider this; and it was at that meeting that a word which is now safely embedded in the English language – 'post-impressionism' – was invented. Roger first suggested various terms like

'expressionism', which aimed at distinguishing these artists from the impressionists; but the journalist wouldn't have that or any other of his alternatives. At last Roger, losing patience, said: 'Oh, let's just call them post-impressionists; at any rate, they came after the impressionists'. Later he handed over to me, with a few notes, the ticklish job of writing the preface to the catalogue – the unsigned preface.

So the exhibition that opened on 8 November 1910 was called *Manet and the Post-Impressionists.* In a way it was an explicitly anti-Impressionist manifesto. Fry took Manet as the starting-point (nine works, including *A Bar at the Folies-Bergère*, later to be bought by Samuel Courtauld, and now in the Courtauld Institute Galleries). Then there was massive representation of Gauguin (46 works), Van Gogh (25) and Cézanne (21). Seurat had only two pictures, Sérusier and Denis five works each, Vallotton four and Redon three. Twentieth-century art was represented by some Fauve paintings – Marquet (five), Manguin (four), Rouault (six) – and a substantial group of the closest followers of Cézanne, Vlaminck (eight) and Derain (three). As painters, Matisse and Picasso were modestly shown, with two and three oils respectively, though their drawings and, in Matisse's case, sculptures, were numerous.

Fry's own view of modern art at this stage was relatively immature – he had after all made his reputation as someone who knew about the old masters, and had already five years before been offered (and had refused) the Directorship of the National Gallery. He had never displayed much interest in Impressionism, and his own painting was still very conservative in character. His conversion to the cause of modern art – and a conversion it certainly was – came only at the age of 40, when in 1906 he saw two paintings by Cézanne in a London exhibition.[3] Reviewing the show, Fry seems suddenly to have appreciated that Cézanne was not what he later described as the 'hidden oracle of ultra-impressionism' but a modern old master in the succession of Manet: 'We confess to having been hitherto sceptical about Cézanne's genius, but these two pieces reveal a power which is entirely distinct and personal, and though the artist's appeal is limited, and touches none of the finer issues of imaginative life, it is none the less complete.'[4]

Fry's view of modern art was to be confirmed and augmented by the great German art critic, Julius Meier-Graefe, whose book *Modern Art* appeared in English translation in 1908.[5] Fry acquired much of his information and many of his value judgments from Meier-Graefe, most notably the belittling of Monet, and the connection established between Manet and the triumvirate of Cézanne, Gauguin and Van Gogh. The German critic calls the latter artists 'expressionists', and of course this is why Fry wanted to follow suit – had not that young publicist intervened, the

exhibition would probably have been called *Manet and the Expressionists* (and let us not contemplate the terminological confusions that would have ensued).

In the unsigned Fry/MacCarthy preface to the 1910 exhibition another possible appellation was considered and dismissed. The preface is boldly entitled 'The Post-Impressionists', and begins:

The pictures collected together in the present Exhibition are the work of a group of artists who cannot be defined by any single term. The term 'Synthesists', which has been applied to them by learned criticism, does indeed express a quality underlying their diversity; and it is the principal business of this introduction to expand the meaning of that word, which sounds too much like the hiss of an angry gander to be a happy appellation.

The preface continues by claiming that:

In no school does individual temperament count for more. In fact, it is the boast of those who believe in this school, that its methods enable the individuality of the artist to find completer self-expression in his work than is possible to those who have committed themselves to representing objects more literally . . . the Post-Impressionists consider the Impressionists too naturalistic.

Thus Post-Impressionism is born out of the reaction against (or crisis within) Impressionism that occurred in the 1880s. It is at this stage still defined by Fry as being separate and in opposition to that alternative development represented by Seurat, Cross and Signac which takes the Impressionists' 'scientific interest in the representation of colour' a step further – a development that Fry allowed into the 1910 exhibition, but only in a very modest way. The emphasis was firmly on Cézanne, Gauguin and Van Gogh, artists who were 'interested in the discoveries of the Impressionists only so far as these discoveries helped them to express emotions which the objects themselves evoked'. The Impressionists' dependence on nature, on the objective recording of visual experience, gives way to a search for the 'emotional significance that lies in things'. And this is to be achieved by a simplification of design that is immediately disconcerting.

Of the three great Post-Impressionists, Cézanne, the heir to Manet, shows most clearly the way out of the cul-de-sac of naturalism. He 'aimed first at a design which should produce the coherent, architectural effect of the masterpieces of primitive [i.e. early Italian] art', passing from 'the complexity of the appearance of things to the geometrical simplicity which design demands'. Van Gogh is seen as a morbid visionary, expressing his strongest emotions in paint; and Gauguin as a theorist, concerned with 'the fundamental laws of abstract form', and with 'the power which abstract form and colour can exercise over the imagination of the spectator'. He deliberately chose, therefore, to 'become a decorative painter, believing that this was the most direct way of impressing upon the imagination the emotion he wished to perpetuate'.

Matisse is the only follower of the three Post-Impressionists who is mentioned by name. In his work 'this search for an abstract harmony of line, for rhythm, has been carried to lengths which often deprive the figure of all appearance of nature'. It is again 'a return to primitive, even . . . to barbaric art', and primitive art is justified because it is conceptual rather than perceptual, and more expressive than work which displays greater skill.

The final paragraph of the preface contains a comment that the new movement is now widely spread: '. . . the school has ceased to be specifically a French one. It has found disciples in Germany, Belgium, Russia, Holland, Sweden. There are Americans, Englishmen and Scotchmen in Paris who are working and experimenting along the same lines.'[6]

Two years later, Roger Fry provided a follow-up with what was called the 2nd Post-Impressionist Exhibition, opening at the Grafton Galleries on 5 October 1912. This was a much more carefully planned and polemical exhibition, showing the 'contemporary development' of the 'new movement' in England and Russia as well as in France, but, as Fry says, 'It would have been possible to extend the geographical area immensely. Post-Impressionist schools are flourishing, one might almost say raging in Switzerland, Austro-Hungary and most of all in Germany.' But he is rather dismissive of their achievement, as he is of the Futurists of Italy, who have developed 'a whole system of aesthetics out of a misapprehension of some of Picasso's recondite and difficult works'.

Fry also wrote the five-page introduction to 'The French Group', which might well have been called (like the exhibition itself) *Cézanne and the Moderns*. He personally chose the French work, and of the three Post-Impressionists only Cézanne survived. Matisse was the best represented artist, with 19 oils, 13 drawings and eight bronzes; then came Picasso with 13 oils and three drawings, most of them executed since 1908 and thus showing the development of Cubism. Fry made a point of exhibiting the work of Douanier Rousseau for the first time in England; paintings by Braque (four), Vlaminck (eight), Derain (six), Herbin (11), Marchand (four), Lhote (eight), and other lesser-known names completed the French group. The smaller English group was chosen and introduced by Clive Bell; it included work by Duncan Grant, Vanessa Bell, Spencer Gore, Henry Lamb, Wyndham Lewis, Stanley Spencer and Fry himself. In the Russian section were paintings by Roerich, Ciurlionis, Goncharova and Larionov; here the stress was on an exotic and richly decorative style.

Not much is said about Post-Impressionism in the 1912 catalogue, and one imagines that by this time Fry appreciated that the artists represented in the exhibition had moved on to other things. The term however had quickly gained acceptance, and, faute de mieux, it remains a useful description of that phase in French painting from, say, 1885 to 1905, and of its immediate impact on the art of other countries. Fry himself later softened the anti-Impressionism of his first pronouncements, and extended the term to include the Neo-Impressionism (or Divisionism, or Pointillism) of Seurat, whom he came to recognize as of equal importance to the three great Post-Impressionists.[7]

Yet it is difficult to define Post-Impressionism too explicitly, and one ends up by sharing Fry's unease with the 'somewhat negative label', 'the vaguest and most-committal' name of which he could think. It is a notable fact that no serious comprehensive history of Post-Impressionism has been

written, and perhaps none can be written because the unity of an artistic movement is quite simply lacking. That great historian of modern art, John Rewald, to whom we are all so indebted, decided many years ago to follow his definitive history of Impressionism with a study of Post-Impressionism, but the first volume emerged as a parallel treatment of three outstanding artists, Seurat, Gauguin and Van Gogh, and nothing more has appeared.[8] That warning made in the 1910 preface to the effect that the Post-Impressionists were above all individualists could hardly have been better exemplified.

Our thinking about the 1979 Royal Academy exhibition began several years ago with a desire to show the crisis of Impressionism in the 1880s in the fuller context of French painting of the time. It was my conviction, shared by the Directors of the exhibition, MaryAnne Stevens and John House, that it was the right moment to investigate that crucial change of direction in the later 1880s when experience rather than appearance became the reason for art. The personal achievement of the four great painters who pioneered that change – Cézanne, Gauguin, Van Gogh and Seurat – is by now familiar to everyone, but exactly how it came about and what were its immediate repercussions have never been altogether clear.

There is also a danger that in a period when painting of very real originality and high quality is being produced, the lesser figures are neglected. Artists of an older generation find themselves unjustly eclipsed by the young. And we should remember that what looks plain to us now was far from obvious at the time. Until the Caillebotte bequest went on show in 1897[9] Impressionist pictures were not readily to be seen, and the central importance of Impressionism in art, let alone of Post-Impressionism, was not widely recognized. This is confirmed by the remarkable fact that someone as sensitive and intelligent as Matisse, when an art student in Paris from 1892 onwards, either knew nothing of Impressionism, or showed no interest in it. Instead he looked to such artists as Cottet and Dagnan-Bouveret, and began to spend his summers in Brittany like so many young painters of his generation. If we then assume that he was at once aware of Gauguin and the School of Pont-Aven, we should probably again be quite wrong, for Pont-Aven was only one of a number of artists' colonies in Brittany, and far from being universally accepted as the most significant.

In the hospitable galleries of the Royal Academy, and in the pages of this catalogue, something of the rich diversity of French painting of this period is presented. The revolutions bred immediate reactions, new theories and new arguments abounded, but Post-Impressionism kept its position as the most challenging form of modern art from its heyday in the late 1880s and very early 1890s until c. 1905. Of the four major protagonists, Van Gogh and Seurat had died young, in 1890 and 1891 respectively; and although Gauguin lived until 1903 and Cézanne until 1906, their later work was done in relative seclusion. All four had their followers, but the absent avant-garde left behind a vacuum (as MaryAnne Stevens points out in her essay). Nobody in France was able to go forward into radically new kinds of art until 1905 when

Matisse and Derain painted the first Fauve pictures, and Picasso and Braque began their evolution towards Cubism. It is at this point in time that the French contribution to the exhibition comes to a natural close.

That the exhibition has a full-scale European dimension rather than being confined to French art is largely due to the advocacy of the Royal Academy's Exhibitions Secretary, Norman Rosenthal. Again we have found it important to provide a broader context for the notion of Post-Impressionism, and if some paintings in the exhibition look like Victorian (and Edwardian) painting this is because Post-Impressionism *is* Victorian painting, both being products of the same cultural situations. Of course there are differences, but the divide is not unbridgeable, and the questioning of widely held artistic presumptions will surely further our understanding and appreciation of both Victorian and Post-Impressionist art.

Outside France, we have concentrated on those neighbouring countries where the impact of Post-Impressionism was most clearly felt. Retaining the same starting-point in the 1880s, the definition has been stretched backwards in time to permit the inclusion of artists omitted by Fry from his exhibitions. Their work is perhaps not so much Post-Impressionist as after-Impressionist – in other words, the painting shows some awareness of Impressionism without necessarily adopting its style or subjects. In certain cases, in Britain and Germany in particular, the younger artists preferred more conservative models – witness the tremendous enthusiasm for Bastien-Lepage, born in 1848 and thus younger than the Impressionists, and dead at the height of his popularity in 1884. But the doubts about Impressionism felt by some of the most gifted younger non-French artists of the 1880s and 1890s are often the same doubts expressed by the Post-Impressionists proper – notably the absence of spiritual quality in a naturalistic art committed primarily to the objective representation of visual experience.

In each country studied the pattern is revealingly different, conditioned as it often is by geographic, economic and social factors. Chance personal contacts can transform an artistic situation; Toorop's return to Holland in 1890 is a case in point. Political convictions can explain artistic decisions; Neo-Impressionism, or Divisionism, for example, had a clearcut socialist/anarchist association, and this perhaps accounts for its particular importance in Italy, where other varieties of Post-Impressionism are less in evidence, and also for its relative absence in the more apolitical climate of Britain, where the painting of Gauguin and then of Cézanne were more likely to attract admirers. In all the countries outside France the artistic time-lag has justified our inclusion of work produced up to c. 1910, the date of the first Post-Impressionist exhibition, and the contents of that exhibition and of its successor two years later have been borne in mind.

Generations of painters have wanted to make an art that is entirely new: only a few succeed. The development of art is not progressive; there are always losses as well as gains. Simplification can result in a loss of subtlety, and a move in one direction implies withdrawal from another. But great artists do stimulate the efforts of all their contemporaries, and

raise the general level of attainment.

Looking back after almost a hundred years it is hard not to regard the art of Cézanne, Gauguin, Van Gogh and Seurat as an apogee in the history of art, a moment when a high point was reached with a conjunction of stars of a magnitude and illumination unlikely to be seen together again for a very long time.

Norman Rosenthal and Gillian Perry have selected and catalogued the German section of our exhibition which includes those Scandinavian and Swiss artists whose indispensable contribution to the art of the time was made primarily in the German cultural context. The Italian and British work has been chosen by two scholars, Sandra Berresford and Anna Gruetzner; the Belgian and Dutch paintings were selected by MaryAnne Stevens. We would all like to acknowledge the help received from Frederick Gore, whose advice has been coloured by both artistry and ancestry. John Milner has tried very hard to provide a Russian contribution, but like the Russian section of the 2nd Post-Impressionist Exhibition it has been hampered by 'delays in transport' and may not be forthcoming. The French section was in the hands of the Directors of the Exhibition, John House and MaryAnne Stevens.

NOTES

1. Introduction to the catalogue of the 2nd Post-Impressionist Exhibition, Grafton Galleries, 5 October–31 December 1912, pp. 7–8. In the auto-biographical *Retrospect* to *Vision and Design* (1920) Fry also wrote, rather self-deprecatingly: 'For purposes of convenience it was necessary to give these artists a name, and I chose, as being the vaguest and most non-committal, the name of Post-Impressionist.' I prefer Desmond MacCarthy's more colourful account of this event, which follows in the main text.
2. Published in *The Listener*, 1 February 1945.
3. The *Nature morte* (199) and the *Paysage* (205) at the 1906 International Society's exhibition were probably Venturi 70 and Venturi 164.
4. Fry's review of the exhibition appeared in the *Athenaeum* for 13 January 1906; his remark about Cézanne is in the *Retrospect* chapter of *Vision and Design* (1920).
5. This was first pointed out by Douglas Cooper in his introduction to the catalogue of the Courtauld collection (1954).
6. All these quotations come from the preface to the catalogue *Manet and the Post-Impressionists*, Grafton Galleries, 8 November 1910–15 January 1911, pp. 7–13. The figures for works shown are taken from the printed catalogue, with some alterations made where it is known that extra pictures were exhibited.
7. As he wrote in 1920 in the *Retrospect* chapter, '. . . my most serious lapse was the failure to discover the genius of Seurat'.
8. John Rewald presents these painters with their associates against a rich cultural background, and the continuing importance of his book, first published in 1956, is unquestionable.
9. Strictly speaking, only a part of the Caillebotte bequest, for many important works were refused by the authorities, presumably on grounds of quality and duplication. The bequest was made in 1894; the works were first shown in the spring of 1897, in the Musée du Luxembourg.

France

The Legacy of Impressionism in France

John House

In the heroic years of the 1870s, the Impressionist painters had tried to bridge the gap between the eye and the mind – to transmit their visual experiences directly and without artifice. This aim involved certain sacrifices: to capture the immediacy of their sensations they had to paint quickly and on a comparatively small scale, and they were unwilling to resort to the studio to elaborate or enlarge their initial notations.[1] For many generations, artists had painted in oils with a similar speed and directness, but only when making studies from nature or compositional sketches; in the 1870s, the Impressionist landscapists presented as finished pictures their outdoor canvases – often bold in brushwork and bright in colour, and without the tidy, ordered surface traditionally expected from a finished painting.

After frequent rejections at the exhibitions of the official Salon, they had tried from 1874 onwards to establish them-selves by a series of independently organized exhibitions, but these had brought them notoriety without success. By 1880, they seemed to have reached an impasse. Critics continued to censure them for what they neglected – finish, composition, and serious content – and the painters, now that they had mastered the mechanics of working quickly from nature, began to wonder whether this, in itself, was an adequate goal, whether it could make a complete and serious form of art. This search, to restore something to their art which they felt had been lost, took the Impressionists in various directions.

At the same time, the challenge which their art had set – with its direct expression and boldness of handling and colour – began to affect many painters outside the Impressionists' immediate circle, and, by the later 1880s, Impressionism had become a force which no artist born after 1840 could ignore. On a superficial level, this impact transformed the characteristic colour-schemes seen in the Salon exhibitions from the dominant tonal contrasts of dark and light values which were the legacy of Courbet and the Realist generation, to the light-toned, high-key colour which drove Zola to despair in his final review of the Salon in 1896: 'Was it for this I fought? Was it for this bright painting, for these patches of colour, these reflections, this decomposition of light? Was I mad?'[2]

But Impressionism posed certain more fundamental questions which remained central to artistic debates well beyond 1900. These were summarized in a questionnaire organized by Charles Morice and published in the *Mercure de France* in 1905; 56 painters answered a set of questions about modern tendencies in painting, and questions and answers alike provide a rich survey of attitudes. The artists were asked whether they felt that art was heading in new directions; whether Impressionism had a future; what they felt about three recently dead artists – Whistler, Gauguin and Fantin-Latour, and about one still alive – Cézanne; and whether art should depend on nature, or simply seek from nature the raw material for realizing the artist's inner thoughts and ideas (*pensée*).[3]

Both questions and answers show that, in 1905, Impressionism was still seen as the yardstick against which the artist had to measure his own attitudes. In the answers, it was generally considered to be alive in one sense, but to belong to the past in another – alive because the freedom which the Impressionists had won in the 1870s had a permanent and positive value, and dead because the artists felt that something more was now needed, to be built on the foundations which the Impressionists had laid. Replies to the other questions focused on what this 'something more' should be. Among the four artists mentioned, Gauguin and Cézanne elicited the strongest responses; their art was felt to contain the most important general lessons, principally in their use of colour – the richness and decorative quality of Gauguin's colour and the way in which Cézanne used colour relationships to create pictorial structure. These two elements of decoration and structure should, it was felt, be reintroduced into the work of art. In answer to the final question, many artists insisted that nature was not enough, and that the artist had to impose his own personality on to the material which he treated.

The issues raised in Morice's questionnaire grow out of the problems which the Impressionists themselves had faced in the 1880s in trying to extend their art: problems about the mechanics of their art, and about its meaning. They did not have simple or single answers; artists responded to them in many ways between 1880 and 1905. But they formed the central focuses of artistic debate during the period, and it is by them that Post-Impressionism can best be defined, as the responses to the questions raised by Impressionism. In a sense, the history of Post-Impressionism is the story of the way in which these responses evolved.

In 1880, in his review of the Salon exhibition, Zola laid

down a challenge to the Impressionist artists. He accused them, and Monet in particular, of concentrating on an easy sketchiness and informality, of failing to finish their paintings adequately, and urged them to devote their energies to making ambitious, single paintings which would express their personality fully.[4] His comments echoed many of the criticisms made against the Impressionists in the 1870s, and the painters had already begun to respond to some of them before 1880; but Zola presented his argument in a way which must have given them pause for thought, since he had previously championed their art and shared their underlying belief that art should be based on direct personal experience. Unlike the more reactionary critics, Zola criticized them not for their aims, but for what he felt was their failure to realize them.

For the Impressionists, the idea of 'finish' had several facets. They rejected out of hand the meticulously finished surfaces of the paintings of the Neo-Classical tradition, in favour of visible, emphatic brushwork whose animation expressed direct contact with nature. One one level, this bypassed the question of finish altogether, since any sketch, however freely handled, could be a complete statement if it conveyed the desired effect; Monet, for one, always valued these spontaneous notations (cf. no. 138). However, they were only a notional ideal; natural effects often changed too fast for the artist to capture them, and few quick sketches finally satisfied their authors. The Impressionists' notoriety of the 1870s was based on sketches such as Monet's *Impression, Sunrise* of 1872 (Musée Marmottan, Paris) and Renoir's *Nude in Sunlight* of 1875 (Jeu de Paume, Paris), but even in this decade, when their outdoor work was at its height, they exhibited few canvases so summarily treated; when they did, it was alongside other, more fully resolved paintings, and the sketches were generally subtitled *esquisse*, *étude* or *impression* to distinguish them from the finished paintings.

During the 1880s, they tried to live down this notoriety by proving that there was more to their art than quick sketches. This was in part a reaction to the demands of dealers such as Durand-Ruel, who offered them the prospect of a market for their more highly finished canvases;[5] but criticisms like Zola's must have played a part in encouraging them to seek something more. This quest took a variety of forms, and led to changes in their painting methods and in the qualities which they sought in their finished canvases. They came to depend less on painting out of doors, and tried by various means to give their canvases a tauter structure – by their compositional arrangements, and by the patterns of colour and brushwork in them.

The practical problems of completing a painting out of doors were only one reason why the Impressionists became dissatisfied with open-air work; during the 1880s Monet, Pissarro and Renoir all came to feel that there was some positive ingredient which could only be added to a painting in the studio. Renoir in these years turned most radically against the open-air aesthetic, insisting on the primacy of drawing and composition, and painting his major pictures in the studio, with the help of small outdoor studies. But Monet and Pissarro too found that the studio offered them

something essential; it was there, Pissarro wrote, that he could 'look over his studies with more indulgence, and see better what needed to be done to them'; Monet always needed 'a moment of rest before putting the final touches to my canvases'.[6]

Rarely can one tell precisely what was added in the studio to a particular painting, but the changing appearance of their finished paintings of the 1880s shows the qualities that they were seeking as they completed their canvases. In their brushwork, Pissarro and Cézanne had from the late 1870s been working over their paintings with successions of short, often parallel strokes which lend tautness and homogeneity to the surface (cf. nos 152 and 40), while Monet began to recreate the patterns of nature by a sort of painterly calligraphy (cf. nos 136 and 138). Colour, like brushwork, began to be used more as a means of unifying the whole canvas, as an English interviewer pointed out in describing Monet's working methods in 1888:

One of his great points is to use the same colours on every part of the canvas. Thus the sky would be slashed with strokes of blue, lake, green and yellow, with a preponderance of blue; a green field would be worked with the same colours with a preponderance of green, while a piece of rock would be treated in the same way, with a preponderance of red. By working in this way, the same colour appearing all over the canvas, the subtle harmony of nature . . . is successfully obtained without the loss of colour. . . .[7]

Subtleties such as these could only emerge if the painting was worked up at the artist's leisure. Monet told a friend in 1892 that he was no longer satisfied by quick sketches, but only by 'a long continued effort', and that he hoped that this would give his canvases 'more serious qualities',[8] while Pissarro, at the same date, was 'more than ever in favour of the impression via the memory – things become less material – vulgarity disappears, and lets float there only the truth as it is perceived and felt';[9] he found that 'the unity which the human spirit gives to vision can only be found in the studio. it is there that our impressions – previously scattered – are co-ordinated, and give each other their reciprocal value, in order to create the true poem of the countryside.'[10]

It was by this search for 'unity' and 'more serious qualities' that Monet and Pissarro tried to transcend the Impressionists' reputation as sketchers of ephemeral nature. They shared these preoccupations with younger painters who themselves had found the Impressionists' original objectives too limited. The Impressionists' assault on conventions of colour, brushwork and composition gave younger painters the freedom to explore more fully the implications of what they had done, and to develop them in many directions. Various starting-points offered themselves: the discipline of Pissarro's and Cézanne's brushwork of the earlier 1880s, or the expressiveness of Monet's; the pursuit of integrated, almost woven harmonies of colour, or of the intense colour of the Mediterranean; and their richly conceived compositional patterns – either Monet's deliberately asymmetrical arrangements, inspired by the Japanese (cf. no. 136), or Cézanne's more monumental build-up of forms (cf. no. 40).

The rigorous analysis of natural light and colour in separate 'points' of paint in the canvases of Seurat and the

other Neo-Impressionists of *c.* 1886–9 owed much to Pissarro's handling of *c.* 1880, and to the observation of natural colour seen especially in Monet's work, while Van Gogh's accentuated handling echoed the more improvisatory quality of Monet's brushwork. Gauguin, too, learned from the tautness of treatment of Pissarro and Cézanne, but transformed their modes of recording the nuances of natural effects into a more schematic and anti-naturalistic style. His rich patterns and arabesques are indebted, like many of Monet's more dramatic compositions, to the compositional schemata of Japanese colour prints (cf. nos 86–7). Decorative patterns, too, became of central importance in the work of Seurat and Signac, and in the style of the Nabi group, by 1890 (cf. nos 204, 211, 28–9, 67). The increasingly bold colour of Monet and Cézanne was a response to the impossibility of imitating in paint the effects of full sunlight, and led them to realize, in Cézanne's words, that 'sunlight . . . must be represented by something else, by colour'.[11] This lesson was the startingpoint in the development of colour as an independent means of recreating light, culminating in the anti-naturalism of the colour of Matisse and the Fauves (cf. nos 131, 73, 35).

Technical experiments are an essential part of the history of the art of the period, but they were essentially a means of expression, rather than an end in themselves. The crucial change in direction in the later 1880s was a change away from the idea that painting was a means of exploring the artist's relationship to the world around him, towards a fuller dialogue with the spectator. Pissarro's and Monet's search for deeper qualities was part of a more general quest to reintroduce fuller meaning into art, to make it express basic truths about human experience rather than confining itself to the surface appearances of everyday life. The deeper levels of meaning took painters in a number of directions – towards considering the fuller significance of landscape, in relation to the spectator, and to the people who lived and worked in it; to questions about the significance of modern urban life; to a reintroduction of mythological or religious meaning into paintings; and to an insistence on the primacy of the painter's inner experience. But in all these possible approaches the spectator is actively implicated. No longer is he merely a mute witness to the painter's dialogue with nature; the relationship between forms and images in the picture invites him to participate actively in the painter's experience.

Landscape remained a prime theme, and each type of landscape demanded a different treatment to extract its full character. Monet in the 1880s pursued nature in its most extreme forms – stormy seas, dazzling light – and accentuated his pictorial forms to convey these extremes, using dramatic patterns of brushwork to express the forces of the sea, and luminous colour harmonies to recreate atmospheric effects (cf. nos 138, 136, 139). Van Gogh explored these directions in his paintings of Arles and Saint Rémy, where brushstrokes become a metaphor for nature's animation and colour contrasts for the power of the sun. By *c.* 1890 both Monet and Cézanne were restricting the range of effects they sought, focusing, respectively, on the atmosphere and the structure of the scene, with less and less reference to

specifically human values. In Monet's series of the 1890s, observed atmospheric variations on single motifs became the basis for rich colour harmonies which recreate the everchanging nuances of coloured light in closely integrated sequences of paintings. As originally exhibited in series, these canvases transformed the ephemeral into a unified pictorial experience which the spectator could explore at leisure (cf. no. 141). For Cézanne, this unity emerged from the sequences of coloured planes by which he realized pictorially the complexities of his vision of nature, of the patterns and structures of trees and rocks, and the sense of space between them (cf. no. 47); the order within the painting had to express the underlying relationships which he saw between the diverse elements in the scenes before him.

Landscape could also mirror the experiences of the people who lived in it. Pissarro's 'true poem of the countryside' was a fusion of peasant and nature, each being needed to give meaning to the other (cf. no. 155), and Van Gogh similarly emphasized the human content of many of his landscapes. Both artists inherited a tradition of peasant painting going back to Millet; for Van Gogh, in particular, these references were part of larger patterns which he, like Millet, saw as underlying the meaning of the countryside – the evercontinuing cycles of night and day, the seasons, and life itself (cf. no. 104). This type of expressive landscape, of scenes which reflect the fullness of human experience, was one important element in the appeal of Brittany for painters in the late nineteenth century. Gauguin wanted his Breton scenes to reflect the muted yet powerful note which he found in the landscape (cf. no. 82), and Brittany's barren, intractable coasts echoed the hardship and danger facing its inhabitants. This facet of the place was explored most fully by Cottet, Simon and their associates in the 1890s; Cottet for many years in succession exhibited Breton scenes (including no. 53) under the collective heading *Au Pays de la mer*, and in 1894 Maxime Maufra (1861–1918) added an extra dimension to the visual imagery of the region by showing a Breton scene at the Société Nationale, with, in the catalogue, an appended quotation from *Pêcheur d'Islande*, Pierre Loti's classic novel of 1886 about the lives and deaths of Breton fishermen.

Maufra's literary reference was meant to heighten the pathos of the scene for an audience which would have known Loti's book well, using the quotation to add an associational value in a way more common in English than in French exhibition catalogues at the time. However, a landscape could carry literary or spiritual references of other sorts as well, quite alien to the descriptive attitude taken towards nature by the Impressionists in the 1870s. Corot's late *Souvenirs* and subject pictures set in landscapes, such as *Macbeth and the Witches* (1859, Wallace Collection, London), were prime examples of this type of suggestive landscape, which was given a religious dimension by Puvis de Chavannes and Cazin *c.* 1880 in paintings such as Puvis' *Poor Fisherman* (fig. 11) and Cazin's *Tobias and the Angel* (no. 39), where the mood of the landscape complements and augments the meaning of the subject. Specifically literary references are rare in the outdoor scenes of the period, but Matisse in *Luxe,*

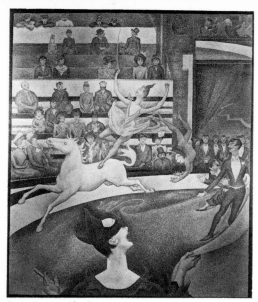

fig. 1 Seurat *The Circus*
Palais de Tokyo, Paris

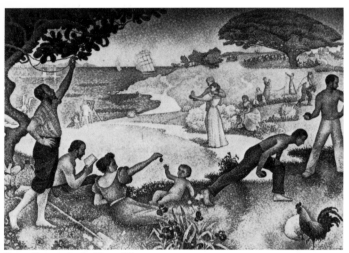

fig. 2 Signac *In the Time of Harmony*
Mairie de Montreuil

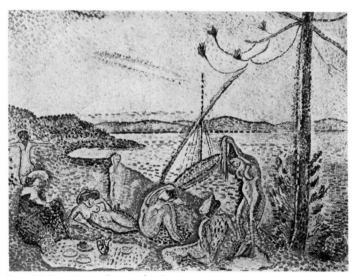

fig. 3 Matisse *Luxe, calme et volupté*
Private Collection

calme et volupté (fig. 3) used the quotation in the title, from Baudelaire's *L'Invitation au voyage*, to give the keynote for the mood of the picture. Van Gogh also found literary associations in the landscapes which he painted – sometimes generalized, as in his identification of the landscape around Arles with Daudet's Tartarin, sometimes more specific, as in *The Tarascon Diligence* (de la Faille 478a, Private Collection), inspired by one of Daudet's descriptions,[12] and in the *Poet's Garden* paintings (cf. no. 100), which acquired part of their meaning from an article which Van Gogh had read about the poets of the Renaissance.

Modern urban life had been a key theme in the paintings of the Impressionists in the 1860s and 1870s, and it was taken up again in the 1880s, but with a rather different focus. Whereas the Impressionists had generally painted the more fashionable areas of the city and had treated them with a studied *dégagement* (echoing the milieu and the mood celebrated in Baudelaire's essay *Le Peintre de la vie moderne*[13]), artists in the 1880s turned to the suburbs and working-class areas – already common themes in the novels of writers such as the Goncourt brothers and Zola. Raffaëlli, a close associate of the Naturalist novelists, was the first painter to specialize in these subjects (cf. no. 162), but they were given a different slant in the work of the Neo-Impressionists, many of whom were active supporters of the Anarchist movement. The old opposition of city versus country[14] was a central issue for the Anarchists, and for the painters who espoused their cause: was the city a principal cause of the current ills, and thus by definition evil, or could its forces be harnessed to good ends? Pissarro's Anarchist beliefs were firmly based on a return to the soil (cf. no. 155), and the archetypal Anarchist pictorial manifesto, Signac's *In the Time of Harmony* (1895, fig. 2), is an Arcadian scene of an idyllic, self-sufficient existence in the country; however, Luce, though aware of the city's evils, took a far more positive view of its potential (cf. nos 117 and 119). The city–country dilemma is most marked in Seurat, whose precise political stance remains obscure: his images of urban entertainments, such as *The Circus* (fig. 1), do not read as polemics about the ignominies of modern life, as his more politically committed friends maintained after his death;[15] but his major paintings suggest that he had a strong sense of the ironies and artificiality of city life – in particular the sequence of *Une Baignade, Asnières, A Sunday Afternoon on the Ile de la Grande Jatte*, and *Les Poseuses* (figs 4–6; cf. nos 197–8).

Deeper levels of meaning, of a different sort, were given to scenes of modern urban life by the Nabis, in particular in the domestic interiors of Vuillard. These infuse a type of subject matter common in Impressionism with a sense of psychological presence comparable to the dramas of Ibsen (cf. nos 235–7), augmenting their effect by unexpected compositional arrangements. However, as with Seurat, there is often an added element of ironic humour (cf. no. 204) which leaves the viewer free to interpret the scene from many different points of view.

These suggestive yet inexplicit levels of meaning have close parallels with the poetic theory of Stéphane Mallarmé (1842–98), whose ideas are central to the understanding of

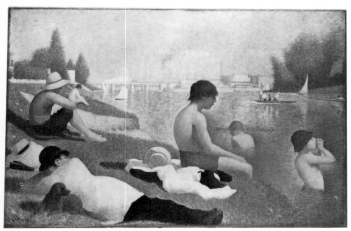

fig. 4 Seurat *Une Baignade, Asnières*
National Gallery, London

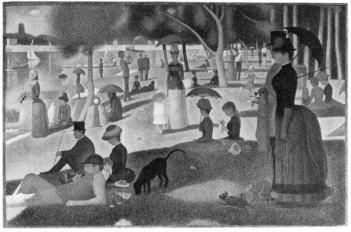

fig. 5 Seurat *A Sunday Afternoon on the Ile de la Grande Jatte*
Courtesy of the Art Institute of Chicago,
Helen Birch Bartlett Memorial Collection

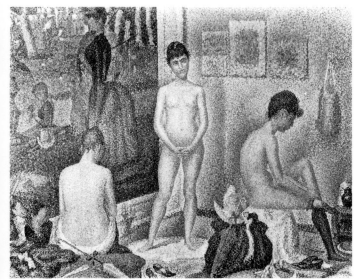

fig. 6 Seurat *Les Poseuses* (small version)
Private Collection (on loan to the Jeu de Paume, Paris)

the painting of the period. He explained his aesthetic in an interview in 1891:

I think . . . that there should be only allusion. The contemplation of objects, the image emanating from the dreams which the objects excite, this is poetry. The Parnassian poets take a thing whole and fully reveal it; by this they lack mystery; they deny the human spirit the delicious joy of believing that it is creating. To *name* an object is to suppress three-quarters of the enjoyment of the poem, which is created by the gradual pleasure of apprehending it. To suggest it, that is the dream. . . .[16]

Mallarmé's 'Symbolism', based on the suggestive qualities of objects and images, is a far cry from the esoteric and religious themes advocated by theorists such as Sâr Péladan (1858–1918), and the relationship between Symbolism and the legacy of Impressionism has been clouded by a failure to make this distinction clear. Mallarmé was a close friend of many of the Impressionist generation – initially of Manet, and later of Monet and Whistler – and his ideas about suggestiveness share much with the aims of the painters. Moreover, the Impressionists' strongest supporters in the early 1890s, writers such as Octave Mirbeau, Gustave Geffroy and Georges Lecomte, began to discuss their paintings in a critical language which has the closest affinities with Mallarmé's.

Lecomte stated the distinction between the different types of 'Symbolism' in the closing pages of his book *L'Art impressionniste* of 1892, describing Durand-Ruel's collection of paintings, and the first separate volume devoted to the Impressionists, in a section entitled 'The Art of Tomorrow'. He acknowledged modern tendencies towards 'an art exclusively mystical, symbolic and decorative', based on a philosophical aesthetic deliberately seeking Thought (*la Pensée*) and the Dream (*le Rêve*). However, for Lecomte, this art was limited by its concentration on the Idea. The Impressionists, by contrast, reached *la Pensée* by their 'splendid evocations of nature', which transcended mundane reality by their synthetic approach and with their warm harmonies. They rendered 'the great mystery of nature' without sacrificing 'the vibration of light or the harmony of colours'.[17] Pissarro voiced his opposition to the mystical stream of Symbolist art in a letter about Gauguin in 1891:

The uneasy bourgeoisie, surprised by the great clamour of the disinherited masses, by the vast claims of the people, feels the need to lead people back to superstitious beliefs. Hence the hullabaloo about religious symbolists, about religious socialism, about an art based on ideas, about Occultism, Buddhism, etc. . . . The Impressionists are on the right path, that is a healthy art based on *sensations* [sensory experiences], and it is honest.[18]

The affinities between the Impressionists and Mallarméan suggestiveness around 1890 are not just an invention of the critics. Pissarro's search for an 'intellectual unity' to express the 'true poem of the countryside' testifies to this, as does Monet's insistence, in these years, that the quality which he was seeking in his paintings was 'mystery' – the key element in Mallarmé's theory. Monet's paintings, particularly when exhibited in series, transcended the mere sketch and gained their 'more serious qualities'[19] from the suggestiveness and mystery introduced by their atmospheric effects and their rich

patterns and harmonies.

Gauguin's position in relation to these two strands of Symbolism was equivocal. In his late writings, he defined his aims in Mallarméan terms, quoting Mallarmé's phrase 'a musical poem which dispenses with a libretto' to explain his rejection of literal allegory in favour of suggestive form and colour. He used the metaphor of the Dream to define the experience which he was trying to recreate, but this Dream, as he described it, had complex ingredients – both the colours, perfumes and figures around him in Tahiti, and evocations of religious rites and primitive fears and joys, which together created an unresolvable enigma.[20] His South Seas paintings reveal these many levels of meaning, in their fusion of direct experience with references to visual and iconographic traditions, to create a suggestiveness not based (as Monet's was) on *sensation* alone; the richness of Gauguin's art derives from this synthesis (cf. nos 88, 93).

However, before his departure for the South Seas, Gauguin had used far more overtly mystical and religous imagery, which led Pissarro in 1891 to label his former pupil firmly as a mystical artist.[21] It was in his canvases painted from the imagination in the late 1880s that Gauguin most completely rejected the Impressionist vision (cf. no. 86). Alongside his religious and overtly symbolic themes, he adopted a technique which itself stood for his repudiation of Impressionism and its dependence on nature, painting thinly in flat, outlined colour-planes which emphasized the pictorial surface at the expense of any vestige of illusionism.

Religious and symbolic subjects were, for Gauguin, the product of the painter's inner vision, while for Van Gogh deeper and more universal meanings emerged from his study of reality, by a process of association (cf. no. 100). In his colour and brushwork, he harnessed the effects which he found in his subjects to expressive ends, using certain colour relationships and patterns of natural forms as metaphors for emotional and religious experience, as in the *Night Café* (de la Faille 463), whose red–green contrasts were meant to express the 'terrible passions of humanity',[22] and in his canvases of the asylum garden and olive orchards of Saint Rémy (cf. no. 104).

Impressionist landscape gave rise to many possibilities – the potential autonomy of colour and the brushstroke, a fresh approach to compositional conventions, and an insistence on the individuality of the painter's vision; from these roots developed many elements in the pictorial language of the younger generation. After 1880, both the Impressionists themselves and the younger artists accentuated these purely pictorial qualities while at the same time infusing their paintings with richer levels of meaning – sometimes extending the primarily naturalistic inspiration of the Impressionism of the 1870s, sometimes repudiating it. Technical experiments and thematic concerns cannot be discussed separately: technique and pictorial style expressed the artist's meaning. The period after 1880 was one in which this relationship between treatment and content was most fully explored; by bringing the two together, the painters of the Post-Impressionist period were able to realize Cézanne's declared aim to make of Impressionism 'something solid and durable like the art of the museums'.[23]

NOTES

1. In this essay, the term 'Impressionist' is used to refer to the paintings of Monet, Renoir, Pissarro and Sisley from the 1870s, when they most fully shared an aesthetic of outdoor naturalism; the art of Manet and Degas, though often grouped with theirs, differed from it in many ways (cf. nos 60–1, 124, 126).

2. 'Peinture', *Le Figaro*, 2 May 1896, in Zola, *Mon Salon, Manet, Ecrits sur l'art*, 1970, p. 377.

3. 'Enquête sur les tendances actuelles des arts plastiques', *Mercure de France*, 1 and 15 August, and 1 September, 1905; Morice's choice of painters for his questionnaire must have been affected by his own tastes and contacts – he was an associate and supporter of the Symbolists, and had been a close friend of Gauguin; among the painters to reply were: Besnard, Blanche, Camoin, Carrière, Delville, Denis, Van Dongen, Dufy, La Touche, Le Sidaner, Maufra, Puy, Rouault, Schuffenecker, Sérusier and Signac.

4. Zola, 'Le Naturalisme au Salon', *Le Voltaire*, 18–22 June 1880, in Zola, *Mon Salon, Manet, Ecrits sur l'art*, 1970, pp. 331 ff.

5. cf. Monet, letter to Durand-Ruel, 3 November 1884, in D. Wildenstein, *Monet*, II, p. 256, letter 527.

6. Pissarro, letter to Lucien, 1 December 1883, in C. Pissarro, *Lettres à son fils Lucien*, 1950, p. 70; Monet, letter to Durand-Ruel, 9 November 1886, in D. Wildenstein, *Monet*, II, p. 287, letter 741.

7. E. M. Rashdall, 'Claude Monet', *The Artist*, 2 July 1888, p. 196 (I owe this reference to Anna Gruetzner).

8. Theodore Robinson, Diary for 3 June 1892, extract published in Chicago, Art Institute, *Paintings by Monet*, 1975, p. 35.

9. Pissarro, letter to Lucien, 26 April 1892, in *Lettres à son fils Lucien*, p. 278.

10. P. Gsell, 'L'Impressionnisme', *Revue bleue*, 26 March 1892, p. 404.

11. M. Denis, 'Cézanne', *L'Occident*, September 1907, in *Théories*, 1912. and in P. M. Doran (ed.), *Conversations avec Cézanne*, 1978, p. 173.

12. Van Gogh, letter 552, 13 October 1888.

13. Baudelaire, 'Le Peintre de la vie moderne', written 1859–60, first published *Le Figaro*, 26 and 28 November 1863; this essay, devoted to the art of Constantin Guys, is a crucial statement of an approach to the aesthetic possibilities of modern urban life.

14. cf. R. L. Herbert, 'City versus Country, the Rural Image in French Painting from Millet to Gauguin', *Artforum*, February 1970.

15. cf. no. 204, and Signac's comment quoted there, and also G. Kahn, 'Seurat', *L'Art moderne*, 5 April 1891, in N. Broude (ed.), *Seurat in Perspective*, 1978, pp. 24–5.

16. J. Huret, *Enquête sur l'évolution littéraire*, 1891, p. 60.

17. G. Lecomte, *L'Art impressionniste*, 1892, pp. 259–63; the prime focus of Lecomte's attacks against mysticism is presumably Péladan, who had published his *Salon de la Rose + Crois, règle et monitoire* in 1891.

18. Pissarro, letter to Lucien, 13 May 1891, in *Lettres à son fils Lucien*, pp. 247–8.

19. cf. n. 10 and n. 8; Monet's 'mystery' references in unpublished portions of Robinson's Diary, 19 June and 29 July 1892, Frick Art Reference Library, New York.

20. Gauguin, letter to André Fontainas, March 1899, in *Lettres de Gauguin à sa femme et à ses amis*, 1946, letter 170, pp. 286–90 (this letter is Gauguin's most important late statement of his aims).

21. cf. n. 18.

22. Van Gogh, letter 533, 8 September 1888.

23. M. Denis, 'Cézanne', *L'Occident*, September 1907, in *Théories*, 1912, and in P. M. Doran (ed.), *Conversations avec Cézanne*, 1978, p. 170.

Innovation and Consolidation in French Painting

MaryAnne Stevens

In 1895, Téodor de Wyzéwa, the art critic and Wagnerian enthusiast, looked back over the previous 15 years of French art and concluded that a clear distinction could be drawn between the anarchy and impetuous innovation of the 1880s and the consolidation and relative order of the succeeding five years.[1] De Wyzéwa's analysis of the distinctive characteristics of art before and after 1890 proves a useful starting point for a review of painting in France during the period 1880 to 1905.

Art in Paris in the 1880s defied simple definition. No one aesthetic theory and no single style was dominant either within or outside the circle of the annual Salon exhibition. So confused was the situation that, when Bernard joined Cormon's atelier in 1884, he not only applied himself diligently to acquiring the rudiments of an academic training but also, following the example of his fellow students, Anquetin and Toulouse-Lautrec, spent his time copying old masters in the Louvre and studying the latest products of Impressionism in the galleries of the rue Laffitte. The result was the somewhat contradictory ambition 'to paint with the palette of the Impressionists and draw like the Old Masters'.[2] Bernard's response to the lack of coherence in the artistic scene was typical; neither the official art world of the Salon and the Ecole des Beaux-Arts, nor the Impressionists, satisfied the demands of the young artists in this decade for a coherent aesthetic theory.

Within the Salon, the situation was less than encouraging. In 1880 the Marquis de Chennevières was alarmed by the organization and content of the Salon.[3] He suggested reforming its structure so that the artists could become their own governing body. This was put into practice in 1881 when the Salon was renamed the Société des Artistes Français, a change formalized in 1884. Yet this reform did not at once improve the quality of art exhibited. De Chennevières had cried out in 1880: 'What a chaotic collection of useless artists! What a graveyard of mediocrities! What a muddle of insignificant painters! They have been hung everywhere, inside, outside, on the landings, in the hallways, on the stairs, here, there and everywhere! *What* does one have to have done in order to merit exclusion from such an exhibition?'[4] In 1886 Alfred de Lostalot mournfully summarized that year's Salon as 'timid, discreet, and terribly polite'.[5]

It was partly the inadequacies of the Salon which provoked the flood of alternative exhibiting bodies in Paris in the 1880s. Following such precursors as the Impressionists' group exhibitions established in 1874 and the transformation of dealers from being mere picture handlers into exhibition organizers, this proliferation of exhibitions developed in three directions. There was a dramatic increase in the number of independent exhibiting bodies such as the Société des Aquarellistes Français, the Cercle Artistique et Littéraire Volney, the Cercle Boissy d'Anglas and, in 1884, the Salon des Indépendants. Second, commerical galleries increased their exhibition activities. For example, in 1882 the dealer Georges Petit established a series of international exhibitions which would be held annually in his spacious, richly hung galleries. These exhibitions were large and cosmopolitan, including at different times French artists such as Gérôme, Besnard, Raffaëlli, Monet and Renoir, and foreign painters such as Whistler, Watts, Millais, Menzel, Liebermann and Boldini. Finally, exhibition space was provided by the rising number of small literary periodicals which showed a growing interest in the visual arts. Redon had his first two important exhibitions of lithographs at the offices of *La Vie moderne* (1881) and *Le Gaulois* (1882). Similarly, Edouard Dujardin was induced by his friends Anquetin and Toulouse-Lautrec to make available the offices of *La Revue indépendante*, and the first exhibition was held in 1887. This practice was continued in the 1890s by such periodicals as *La Revue blanche* and *La Plume*, the latter's offices housing the Salon des Cent. In 1881 Arthur Baignières had viewed the growth of the Société des Aquarellistes Français as the beginning of the flood which could well topple the monopoly of the official Salon.[6] Jacques-Emile Blanche later felt that it was this very 'flood' which had, by the late 1880s, produced such 'subdivisions within painting styles' as 'Exoticism, Pre-Raphaelitism, Japonism, Whistlerism, and this "Wildism" or the cult of art which carries within its very being its own end – all mixed in with Impressionism'.[7]

Blanche's reference to Impressionism as one of the many styles within painting in the 1880s is indicative of its lack of a separate identity which could be developed by a younger generation of artists. The dissolution of the Impressionist group was already evident by 1880, when Monet and Renoir exhibited in the Salon rather than in the fifth Impressionist exhibition. Zola delivered three broadsides at Impressionism in *Le Voltaire*,[8] accusing the Impressionists of unfinished, hasty execution and of failing to find a formula for producing the great Masterpiece of Impressionism: 'The struggle of the Impressionists has not yet reached its goal; they remain inferior to what they undertake, they stammer without being able to find the right words.' Monet and Renoir responded to challenges such as Zola's; both re-emphasized in different ways the importance of form in their paintings. The crisis which all Impressionists went through in this decade was aptly summarized by Félix Fénéon in a comment made about Renoir:

Renoir began to have scruples. As a reaction against the exotic drunkenness with colour and against the subordination of figures to atmosphere, he outlined the human form with a forceful contour and, deciding that the aim of the artist consisted expressly in

decorating a rigid, rectangular surface, he tried to avoid allowing the atmosphere and its accidents to exercise their former ravages on the composition.[9]

One solution to the crisis within Impressionism lay in the evolution of Neo-Impressionism. Making its appearance in an embryonic form at the 1884 Salon des Indépendants in Seurat's *Une Baignade, Asnières* (fig. 4), this new form of naturalism, with its emphasis upon scientific theories of colour, appeared more soundly based than Impressionism. Yet, symptomatic of the confused artistic climate in Paris in this decade, this new style of painting could simultaneously be interpreted as the ultimate naturalist form of painting, as the visual expression of Anarchism and as the pictorial equivalent of the overtly anti-scientific literary movement, Symbolism.

An alternative solution to the pictorial crisis lay in the more nihilistic gesture, exemplified by Anquetin and Bernard's rejection late in 1886 of academic painting, Impressionism and Neo-Impressionism. Following a visit to Signac's studio in the autumn to 'obtain the latest word on the chromatic researches of the theoreticians of optics', Bernard concluded that 'while the method was good for the vibrant reproduction of light, it spoiled the colour, and I instantly adopted an opposite theory'.[10] This theory was a desire to 'abandon the Impressionists in order to allow Ideas to dominate the technique of painting'.[11]

The implications of Bernard's and Anquetin's decision were to be momentous for the evolution of a new form of painting in the late 1880s – Pictorial Symbolism. The character of their decision is equally significant. It reflects both the anarchic social and political situation in France during this decade and recent developments within literary circles.

Within the context of political and social events in France, the 1880s was a decade of extremes. Shaped by rapid industrialization and economic growth, though subject to crises such as the depression of the mid-1880s, French society had also had to come to terms psychologically with its defeat by the Prussians in 1870. Industrialization brought with it a capitalist society with materialism as its hallmark. The Franco-Prussian War brought with it both intense pessimism and an upsurge of French nationalism. At one end of the political spectrum were the chauvinistic followers of General Boulanger whose germanophobia led them, on 3 May 1887, to hound off the stage of the Eden-Théâtre the first Paris performance of Wagner's *Lohengrin*; in their view, genius did not exonerate Wagner from being a member of the hated German race. At the other extreme, an organized socialist party had emerged under Guesdes, and in 1884 the trades unions had been legalized. Kropotkin and the Anarchists were also active. Encouraged by the transference of Kropotkin's review, *Le Révolté*, from Geneva to Paris in 1885, the Anarchists' expression of disgust with the materialism and exploitation of contemporary France took many guises: the bomb-throwing activities subscribed to by writers such as Claudel and Fénéon; the retreat into a hermetically sealed world of artificiality as propagated by J. K. Huysmans in his novel *A Rebours*, published in 1884;

the attempt to outrage the art-loving public through revolutionary painting techniques such as Seurat's Neo-Impressionism; and the desire to abolish all past forms of literature and art as proposed by Jean Moréas and by Bernard and Anquetin, in order to create art which was totally new.

French literature in the 1880s, too, lacked a sense of coherence. As early as 1881, Paul Bourget, in his *Essais sur la psychologie française*, argued that there was a crisis in contemporary French decadent literature as epitomized, to him, by Zola and the de Goncourt brothers. Dismissing these authors' dependence upon the recording of the sordid details of contemporary life, Bourget advocated the creation of a new literature based upon the Imagination and Feeling. In this Bourget was in part responding to a disgust with the Positivist philosophy which had dominated French thought since Auguste Comte and Hippolyte Taine, replacing it with concepts central to the philosophers of the German School, notably Schopenhauer and Hegel. The ensuing debate in French literary circles about the reform of literature took place against a background of growing interest in the belief that Truth, or the Idea, resides only in the Mind, that proof of this Truth can only be intimated through objects which stand as equivalents or symbols of that Truth, and that the human being who is endowed with genius is alone able to interpret this particular set of equivalents. The struggle for reform reached its apogee in 1885. On 6 August, Paul Bourde issued a swingeing attack on all decadent poets, accusing them of being no more than the representatives of 'the final death throes of a period of literary infatuation'.[12] Moréas picked up this challenge five days later. Attacking Bourde and, by implication, Zola, he declared that decadence, rather than being the end of the road, was the beginning of the new: 'The decadent writers are neither sick nor perverted, but are rather the innovators to whom the future will render justice.'[13]

To confirm his faith in the innovative face of this literature, Moréas issued one year later his manifesto for a new school of literature, Symbolism. Published in *Le Figaro littéraire* on 18 September 1886, this 'Manifeste du symbolisme' announced the decay of all earlier schools of literature and the need to establish a totally new school whose aim was 'to clothe the *Idea* in sensual form' through the evolution of an 'archetypal and complex style'. This manifesto in its turn unleashed a storm of debate, within which Gustave Kahn issued his own manifesto for Symbolism ten days later. Entitled 'La Réponse des symbolistes', and published in the newspaper *L'Evénement*, Kahn's article gives the most coherent expression of the aims of this new school. On the question of subject matter, Kahn declared that:

We are tired of the everyday, the near-at-hand and the contemporaneous; we wish to be able to place the development of the symbol in any period, even in dreams (dreams being indistinguishable from life). We want to substitute for the battle of individuals the battle of feelings and Ideas . . . The essential aim of our art is to objectify the subjective [the externalization of the Idea] in place of subjectifying the objective [Nature seen through the temperament].

Kahn concluded by stating that this new subject matter, the Idea, demanded new literary forms:

We will give back to the novel the right to use free verse, to accentuate the power of declamation; the tendency is towards a poem in prose, which is very flexible, its line set in differing rhythms according to the pace, the fluctuation, the turnings and simplicity of the Idea.

It was this resolution of the decadent problem in literature through the introduction of the Idea as subject matter which was also referred to by Anquetin and Bernard when they dismissed Impressionism and wanted to allow 'Ideas to dominate the technique of painting'. This is not mere coincidence. During winter and early spring 1885–6, Anquetin had been preparing a vast painting called *Interior at Aristide Bruant's*. Destroyed shortly afterwards, this painting apparently showed a view of Aristide Bruant's popular café-cabaret on Montmartre, Le Mirliton, with portraits of such habitués as Bernard, Toulouse-Lautrec and Dujardin. However, there was one incongruous figure in the picture, a large nude figure described as a *'figure symbolique'*, whose presence was due to Dujardin. Anquetin and Dujardin had been friends since their schooldays in Rouen. They both came to Paris *c.* 1880, where Dujardin quickly became involved with the proto-Symbolist literary circles of Mallarmé and Villiers de l'Isle Adam. In 1885 he launched the *Revue wagnérienne* and in 1886 he became editor of the *Revue indépendante*, and met such central literary figures as Moréas and Kahn. While Dujardin's contacts with Symbolist writers could have made the Symbolist manifestos available to Anquetin, Bernard was also well aware of innovations in the literature of the day. During his walking tour of Normandy and Brittany in 1886, he recited the poetry of Mallarmé, Verlaine and Moréas, as well as composing his own poems, later described as *'moderniste, décadent, symboliste'*.[14]

Armed with the Symbolist programme set out by Moréas and Kahn, and encouraged by a small group of articles such as de Wyzéwa's 'Notes sur la peinture wagnérienne et le Salon de 1886'[15] and Kahn's 'De l'Esthétique du verre polychrome'[16], which called for reconsideration of the balance between form and content in painting, Bernard and Anquetin evolved in winter 1886–7 a style of painting which could adequately express the new subject matter of art, the Idea. They attacked the problem from two sides: subject and technique. For the former, they turned to overtly non-naturalistic or artificial themes such as circuses and café-cabaret scenes. That these subjects were considered to be contradictions of naturalism is proved by developments in the 1880s. In the theatre there was a revival of interest in pierrots and mime. This was illustrated by the establishment in 1880 of Paul Marguérite's mime theatre, the Théâtre des Valvins; by the number of pierrot plays written by such Symbolist writers as Huysmans and Albert Aurier, and in Mallarmé's belief that a relationship existed between the element of surprise, the evocation of dreams, Ideas and mime. The importance of this association between pierrots, mime, Symbolism and non-naturalism is underlined by the fact that when, on 23 March 1888, Antoine, the director of the Théâtre Libre, decided to make a break with the naturalism which had dominated his theatre, he chose to stage Marguérite's *Pierrot assassin de sa femme*. It was also during

fig. 7 Cézanne *Portrait of Achille Emperaire* Jeu de Paume, Paris

the 1880s that Pierrot made his migration from the world of mime to that of the circus, where he became the Clown.

For a new technique of painting, Bernard and Anquetin turned to examples of crudely handled, almost gauche painting which they found in Cézanne's *Portrait of Achille Emperaire* (fig. 7), and in Van Gogh's *Potato Eaters* (de la Faille 82). This style was also influenced by the bold outlines and flat colour areas of Japanese prints and medieval stained glass windows, and Cézanne's spatially disparate still-lives of the early 1880s (e.g. no. 41).

By late spring 1887, Bernard and Anquetin had fused these pictorial and technical sources into a style of painting which they christened 'Cloisonnism'. Characterized by rigorous outlines surrounding areas of flat colour, and by the absence of logical spatial recession, the new style, as displayed in Anquetin's *Street – Five O'Clock in the Evening* (no. 7) and Bernard's *Iron Bridges* (no. 12), was the evocation of the essence of the subject portrayed rather than the accurate record of its physical appearance.

Bearing this new form of painting, Bernard arrived at Pont-Aven in Brittany in mid-August 1888. Here he renewed contact with Gauguin. The result was the execution of two Symbolist paintings, Bernard's *Breton Women at a Pardon* (no. 15), followed by Gauguin's *Vision After the Sermon* (fig. 8, National Gallery of Scotland). For Gauguin, Bernard's painting provided the solution to problems which he had initially confronted at least three years earlier. In January 1885, Gauguin had expressed the view that feelings rather than intellect create great works of art, that both line and colour possess symbolic properties, that a painting need have no specific literary connotations and that great emotions are best translated into their simplest form through dreaming rather than through direct observation of the external

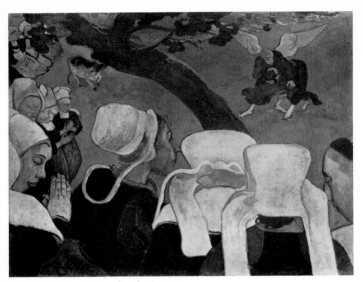

fig. 8 Gauguin *Vision After the Sermon*
National Gallery of Scotland, Edinburgh

ment of artists' colonies at Pont-Aven, Douarnenez, Cancale, Concarneau and, slightly later, at Camaret. By 1880 improvements in communications ensured a rapid increase in tourism and the growth of bathing resorts at Dinan, St Malo and the recently established, purpose-built La Baule. The demands of this new public led to a rash of guide-books such as Blackburn's *Breton Folk – An Artistic Tour of Brittany* (1880), to the establishment of the souvenir pottery industry, and to a vogue for pictures recording local beauty spots and characteristic Breton events such as wrestling matches, the bonfires on St John's Day and the Pardons.

Brittany had other advantages to offer the artist. The cost of living was low, as Gauguin mentioned in a letter to his wife in August 1885: 'It is still in Brittany that one lives the cheapest.'[19] Moreover, models were apparently readily available and accommodating. In 1880 Blackburn reported that the peasants, especially the women, were only too willing to sit as models for a small fee.

While a cheap life, obliging models and picturesque subjects explain the flood of French artists who regularly arrived in Brittany, one of the distinctive features of the artists' colonies was their international character, with artists from America, Sweden, Norway, England and Holland. This was largely the result of the arrival at the end of the 1860s of a Dutch artist, Hermann Van de Anker, and an American, Robert Wylie, who both settled at Pont-Aven. Wylie had trained at Gérôme's atelier, which the majority of American artists in Paris attended, and through him other students of Gérôme's went to paint in Brittany. The opening of the Académie Julian in the late 1870s, where students from Gérôme's and other ateliers could receive extra tuition, expanded this network of contacts and ensured a constant stream of students of many nationalities in Brittany.

There was a further aspect of Brittany which appealed to some artists. Springing from its geographic remoteness from Paris, its harsh climate and poor soil, and its social and economic backwardness, Brittany was also a region marked by extreme poverty, intense piety, residual paganism and a fatalism brought on by the bitter struggle for survival. Some of these harsher qualities emerge in the work of Salon artists such as Dagnan-Bouveret and Guillou (cf. nos 58, 108), but it was in the work of Redon, Cottet, Gauguin, Bernard and the group of Gauguin's followers labelled the School of Pont-Aven that these characteristics were most overtly displayed. When Redon visited the region in 1876, the dour, grey, mist-wrapped landscape led him to conclude that Brittany was a 'sorrowful land, weighed down by sombre colours . . . one without daydreams'.[20] Gauguin's response to its primitivism and piety was more positive. He sought to capture 'the dull, muted, powerful note'[21] of his clogs ringing out on the granite soil, as well as the 'rustic superstitious piety'[22] of the Breton peasant which he expressed in *Vision After the Sermon* and the two Calvary paintings of 1889, *The Yellow Christ* (Wildenstein 327) and *Breton Calvary* (fig. 9). For Bernard, too, there was an intimate relationship between the primitivism and piety of Brittany and his own rejection of contemporary French industrial society. On his return from Brittany in 1886, he admitted that:

world.[17] During the intervening three years Gauguin had indeed experimented with such departures from objective naturalism as split compositions, as in *The Breton Shepherdess* (no. 81), in the simplification of outline and colour in the decorations applied to ceramic pots in winter 1886–7, and in the decorative colour-planes in *Martinique Landscape* (no. 83) of 1887. However, it was a release from the last vestiges of Impressionism which Bernard offered to Gauguin in summer 1888 and which the older artist realized in *Vision After the Sermon*. In this picture, Gauguin arrived at a radical form of painting in which dream and memory superseded the objective observation of the external world and in which line, colour and composition directed the spectator's attention away from the recognition of individual objects within the painting to an appreciation of a more general meaning – the creative power of the artist – for which these objects stood merely as symbols. Gauguin and Bernard, in summer 1888, gave pictorial form to the literary manifestos of 1886; the Idea in the work of art had been clothed in sensuous form, the objects portrayed were the mere vehicles for the externalization of that Idea, not the means through which the artist's personal response to the visible world was to be conveyed.

The simplification of the image achieved by Gauguin and Bernard was assisted, it was suggested in 1903 by Armand Séguin,[18] by the sharply coloured field patterns of the Breton landscape. Brittany had attracted artists and writers for several decades because of its varied landscape, distinctive costumes, and the traditional pattern of life and religion which could be classified as 'picturesque'. Noted as early as 1795 by Jacques Cambry, this interpretation of Brittany was first captured by writers such as Châteaubriand and Balzac. However, from *c.* 1840, painters also began to visit Brittany. Led by Adolphe Leleux, whose first Breton subject paintings were exhibited at the Salon of 1838, and followed by artists such as Dureau, Luminais and Penguilly l'Haridon, enthusiasm for the region led in the 1860s to the establish-

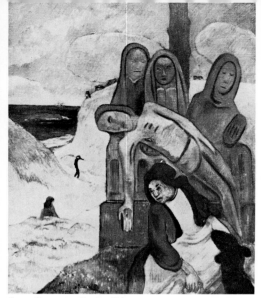

fig. 9 Gauguin *Breton Calvary*
Musées Royaux des Beaux-Arts, Brussels

I returned a devout believer; . . . Brittany has made a Catholic of me again, capable of fighting for the Church. I was intoxicated by the incense, the organs, the prayers, the ancient stained glass windows, the hieratic tapestries and I travelled back across the centuries, isolating myself increasingly from my contemporaries whose preoccupations with the modern industrial world inspired in me nothing but disgust. Bit by bit, I became a man of the Middle Ages, I had no love for anything save Brittany.[23]

When Sérusier arrived at Pont-Aven in 1888 he was a student at the Académie Julian and the artist of a successful Salon painting, *The Breton Weaver* (no. 186), a picturesque interpretation of the region. When he departed from Pont-Aven in early October 1888 he had received a lesson in the principles of Pictorial Symbolism from Gauguin, and had become a convert to the harsher, primitivizing interpretation of the region subscribed to by Gauguin and Bernard. Armed with the product of his lesson, a radically simplified account of the landscape outside Pont-Aven, which became known as *The Talisman* (no. 187), Sérusier returned to the Académie Julian. Here, *The Talisman* inspired a group of young artists to throw off their academic training and their tentative experiments with Impressionism and to adopt a style of painting conforming to the canons of Gauguin's Pictorial Symbolism. With Sérusier as their leader, the group christened itself the 'Nabis', or 'Prophets', and by spring 1889 its members included Bonnard, Denis, Ranson, Ibels, Vuillard and Ker-Xavier Roussel. Together these artists were to dominate one aspect of painting in Paris in the 1890s.

Although the Nabis' conversion to the cause of Gauguin links the 1880s and 1890s, there are features in the latter decade which distinguish it clearly from the revolutionary, experimental years of the 1880s. Perhaps the most significant events of the 1890s were the deaths or absences from Paris of the leaders of the avant-garde in the 1880s – Vincent Van Gogh committed suicide in July 1890. Seurat died in March 1891, and Gauguin departed on his first voyage to Tahiti in the following month. A vacuum had been created which had to be filled.

One solution to the loss of leadership lay in a realignment between art and literature. Maurice Denis recalled that 'Gauguin having gone to Tahiti . . . what now dominated the preoccupations of the painters . . . was primarily literary symbolism'.[24] The impact of this shift can be seen in the character of the Nabis' work during the 1890s. Although each member guarded his own individual style, almost all the Nabis designed stage sets, costumes and programmes for the two Symbolist theatres founded in this decade, Paul Fort's Théâtre d'Art and Lugné-Poë's Théâtre de l'Oeuvre. Book illustration also attracted them; Denis, for example, executed designs for Verlaine's *Sagesse* in 1889–90, and for Gide's *Voyage d'Urien*, published in 1893. Literature and art met again in the patronage given to the Nabis by avant-garde literary reviews such as the *Revue blanche* in the form of original prints to be inserted into monthly editions.

During this vacuum in Paris the Brussels Les XX group came to play an influential role in the Parisian avant-garde. From its inception in 1883, Les XX had made it a policy to invite avant-garde artists from abroad to show at its annual exhibitions, and had established itself as the foremost international exhibiting body of avant-garde art by the end of the 1880s. Moreover, located at the cross-roads between the Arts and Crafts Movement in England and the non-naturalist decorative tradition of France, it became the cradle of Art Nouveau and a leading forum for the decorative arts. Les XX's advocacy of the decorative arts had an immediate effect on Paris. From its second exhibition in 1891, the more liberal Salon, the Société Nationale, devoted an increasing proportion of its exhibition space to the decorative arts, a move which was complemented in the same year by the *Revue encyclopédique*'s decision to publish extensive articles on this growth area in the arts. Artists, too, responded to the rise of the applied arts. While Besnard, Aman-Jean and Henri Martin pursued extensive programmes of mural decorations, the Nabis turned their attention to furniture, screens and fabrics. Indeed, the suitability of their style to the decorative arts was fully appreciated by Louis Tiffany when in 1894 he commissioned a group of stained glass panels from these artists. The completed works were given pride of place at the inaugural exhibition of Samuel Bing's Maison de l'Art Nouveau in Paris in December 1895.

While the Nabis were able to find in literature and in Les XX alternatives to Gauguin's leadership which could maintain the innovations of Pictorial Symbolism throughout much of the 1890s, other artists, as well as writers, found the demands of innovation established in the previous decade too great to sustain. The importance of innovation in the art of the 1880s can be seen in the programme of Symbolism. It had rejected all past traditions in art and literature to create a new, non-descriptive art form, which, by definition, could not be judged by any objective standards. Excellence resided solely in the artist's conviction that he had given an adequate plastic interpretation to the Idea, and so became synonymous with individuality and originality. For many artists, this demand for constant innovation was too onerous and they sought a return to more traditional, recognizable standards. Téodor de Wyzéwa summarized the crisis: 'We had come

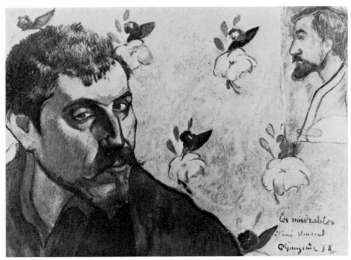

fig. 10 Gauguin *Self-Portrait, Called 'Les Misérables'*
Rijksmuseum Vincent Van Gogh, Amsterdam

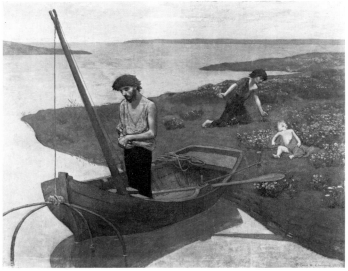

fig. 11 Puvis de Chavannes *The Poor Fisherman*
Musée du Louvre, Paris

quite seriously to believe that the one necessity of an artist was to be original: that is to say, to supply the public with a work of art which is totally different in every way from that which has gone before . . . The remedy is to return to the traditions of the past, and notably, to the most important of these traditions, the "imitation" of a valued model.'[25]

One aspect of de Wyzéwa's recommendations was relevant to Symbolists and Naturalists alike, and came in the form of 'spiritual naturalism'. Given a clear exposition in J. K. Huysmans' first 'pilgrimage' novel, *Là-Bas*, published in 1891, this retreat involved applying Naturalism's precision of detail and language to the investigation of spiritual movements and the physical human experience. This allowed the Ideal and the Supernatural to be married to descriptions of mundane experience. This form of Naturalism endowed with an Ideal was given pictorial expression in paintings shown at both the Salons in the 1890s. Edouard Rod, for example, pointed out in 1891 that, as in contemporary literature, naturalism had disappeared from the walls of the Salons. A

new school, headed by Cazin, Carrière and Besnard, had been established in its place, which applied naturalist techniques to express the full range of human emotions and aspirations. Maignan attempted to achieve this in *Carpeaux* of 1891 and *The Passage of Fortune* of *c.* 1895 (no. 120), and Besnard believed that he had accomplished it in his 'environmental' portraits such as *Portrait of Mme la Comtesse Mégrot de Cadignan* (no. 23). Furthermore, it was the blend of specific realism, topicality and philosophical message which won praise from the critics for paintings at the 1899 Salon, such as Chabas' *Happy Frolics* (no. 50) and Martin's *Serenity* (no. 127).

An alternative remedy proposed by de Wyzéwa to the pressures of innovation was a return to the classical ideal. This solution had been pioneered by one of the leaders of the Symbolist literary movement, Moréas. In autumn 1891 he announced the establishment of a new school of literature based on classical and seventeenth-century French models; he called it the 'Ecole Romane'. This solution was also adopted by the Salon de la Rose + Croix. Established in 1891 by the eccentric, arch-Roman Catholic, decadent author and critic, Joséphin (Sâr) Péladan, this exhibiting body held the first of its six annual exhibitions in the smart galleries of Durand-Ruel in March 1892. The aims of the Salon were enshrined in a set of rules issued by Péladan in which history and military painting, landscapes and portraits, domestic scenes and oriental exoticisms were irrevocably barred from exhibition. Instead the favoured subject matter was to be 'first the Catholic Ideal and Mysticism, then Legend, Myth, Allegory, the Dream, the Paraphrase of great poetry . . . The Order prefers work which has a mural-like character.'[26] Péladan was in no doubt as to the importance of transforming the Idea into a concrete Ideal, as he showed in an earlier Salon criticism, when he remarked that 'The Ideal is not any Idea; the Ideal is all Ideas made sublime, carried to the furthest point of harmony, of intensity, of sublimity.'[27] Alphonse Germain endorsed these sentiments in his comments on the entries to the first Salon de la Rose + Croix of artists such as Vallotton, Toorop, Khnopff and Aman-Jean:

To idealize aesthetically means to see with the eyes of the spirit and to create works which move towards a synthesis, a unity, to annihilate all detail harmful to the ensemble and useless to the movement of the figure: to correct all ugliness, suppress all triviality, all vulgarity: above all else, to choose beautiful lines and beautiful forms according to the laws of nature . . . never to copy, always to interpret.[28]

Péladan's reference to 'the Catholic Ideal' as a recommended subject for artists of the Salon de la Rose + Croix points to his association with a third remedy proposed for the crisis of the 1880s, namely a return to religion in general and to Roman Catholicism in particular. The suitability of such a remedy had already been outlined in two books published in 1889, Charles Morice's *La Littérature de toute à l'heure* and Georges Vanor's *L'Art symboliste*. Morice made the equation between the Idea and God when he declared that 'Souls which are the externalization of God, seek to return, through a book, Art, a musical phrase, a pure thought, to the metaphysical realm of Ideas, to God. Truth resides in the harmonious laws of Beauty.'[29] Vanor pursued

this equation further. There was a specific and logical link to be made between Ideas, God, Symbols and Christian Symbolism, and, since France was Roman Catholic, it was to Catholic art that all Art should return.[30] The impact of this programme during the 1890s was extensive and profound. Books were published on religious topics, plays about religious subjects proliferated in the theatres of Paris, fringe religions such as Theosophy, Occultism and Satanism were highly popular, conversions of prominent writers and artists to Roman Catholicism multiplied and the walls of the Salons and the avant-garde exhibitions blossomed with religious paintings. While most critics gave unstinting praise to the religious paintings of Olivier Merson, Dagnan-Bouveret and La Touche, other religious Salon painters were less fortunate. Edouard Rod deplored the increase in modern religious subjects epitomized in Béraud's *Mary Magdalene in the House of the Pharisee* (no. 11), exhibited in 1891, and Huysmans bemoaned the shameful effect of the new-found fervour of the literary set on J.-E. Blanche's *The Host* (Musée des Beaux-Arts, Rouen) when it was exhibited in 1892.[31]

The avant-garde was also caught up by the rising tide of religiosity in the 1890s. Denis had embarked upon his career as a painter with the intention of becoming a second Fra Angelico; Bernard passed through mysticism to embrace a rigorous form of Roman Catholicism by 1894; and Sérusier,

under the influence of the recently converted Jan Verkade, adopted a system of mystical numbers devised by the Abbé Lenz to create an Ideal, sacred form of painting.

Despite the consolidation of the 1890s, the decade should not be seen as a negative one, hovering in the shadow of the seemingly more brilliant, innovative 1880s. Rather, it was a period in which the achievements of the previous decade were modified and sustained to provide an inheritance for the twentieth century. The interest in colour pursued by Moreau, Besnard, La Touche and the Nabis, as well as by the Neo-Impressionists, together with the Nabis' persistent investigations of the distortion of external nature, laid the foundations for Matisse and Derain. The continued veneration and reinterpretation of Cézanne guaranteed the accessibility of his work to Picasso and Braque. It was Maurice Denis who was most conscious of this apparent ambiguity between innovation and consolidation during the period 1880–1905. Using Bernard as a paradigm, he looked back at the generation of the 1880s shortly before his death and concluded: '[We] undertook a reaction against impressionism. No sensations, no windows open on to Nature. Our generation had been responsible for the creation of the Idea [*La Notion*] of a painting, something which others have pushed all the way to abstraction and [we] all the way back to the museums.'[32]

NOTES

1. T. de Wyzéwa, *Nos Maîtres*, 1895, pp. 11, 266.
2. E. Bernard, 'Louis Anquetin, peintre-artiste', *Mercure de France*, November 1932, p. 591.
3. Marquis de Chennevières, 'Le Salon de 1880 – 2e article', *Gazette des Beaux-Arts*, June 1880, pp. 402–3.
4. Marquis de Chennevières, 'Le Salon de 1880 – 3e article', *Gazette des Beaux-Arts*, July 1880, p. 499.
5. A. de Lostalot, 'Le Salon de 1886', *Gazette des Beaux-Arts*, June 1886, p. 454.
6. A. Bagnières, 'Deuxième exposition des aquarellistes français', *Gazette des Beaux-Arts*, April 1881, p. 370.
7. J.-E. Blanche, *Les Arts plastiques*, 1931, p. 113.
8. E. Zola, 'Le Naturalisme au Salon', *Le Voltaire*, 18, 19, 22 June 1880, in Zola, *Mon Salon, Manet, Ecrits sur l'art*, 1970, pp. 331 ff.
9. F. Fénéon, 'Renoir', in *Oeuvres plus que complètes*, I, 1970, p. 310.
10. E. Bernard, 'Aventure de ma vie', Ms., p. 67.
11. E. Bernard, 'Louis Anquetin, peintre-artiste', *Mercure de France*, November 1932, p. 594.
12. P. Bourde, 'Les poètes décadents', *Le Temps*, 6 August 1885.
13. J. Moréas, 'Les Décadents', *Le XIX siecle*, 11 August 1885.
14. A. Auriant, 'Souvenirs sur Emile Bernard'. *Maintenant*, no. 7, 1947, p. 129.
15. T. de Wyzéwa, 'Notes sur la peinture wagnérienne et le Salon de 1886', *Revue wagnérienne*, May 1886, pp. 100–13.
16. G. Kahn, 'De l'Esthétique du verre polychrome', *La Vogue*, 18 April 1886, pp. 54–65.
17. P. Gauguin, letter to Schuffenecker, 14 January 1885, in P. Malingue, *Lettres de Paul Gauguin à sa femme et à ses amis*, 1946, pp. 44–7.
18. A. Séguin, 'Paul Gauguin', *L'Occident*, March 1903, p. 166.
19. P. Gauguin, letter to Mette, 19 August 1885, in Malingue, *op. cit.*, p. 66.
20. O. Redon, *A Soi-même*, 1961, p. 49.
21. P. Gauguin, letter to Schuffenecker, February 1888, in Malingue, *op. cit.*, p. 232.
22. P. Gauguin, letter to Vincent Van Gogh, mid-September 1888, in J. Rewald, *Post-Impressionism*, 1978, pp. 181–2.
23. E. Bernard, 'Récits d'un passager voyageant au bord de la vie', *Lettres de Paul Gauguin à Emile Bernard, 1888–1891*, 1954, p. 30.
24. M. Denis, 'Paul Sérusier', *L'Occident*, December 1908, in *Théories*, 1964 edn, p. 55.
25. T. de Wyzéwa, *op. cit.*, p. 266.
26. J. Péladan, *Salon de la Rose + Croix: régle et monitoire*, 1891, rule VII.
27. J. Péladan, *L'Art chlorotique: Salons de 1882 et 1883*, 1888, pp. 156–7.
28. A. Germain, 'L'Idéale et l'idéalisme: Salon de la Rose + Croix', *L'Art et l'Idée*, January–June 1892.
29. C. Morice, *La Littérature de toute à l'heure*, 1889, p. 30.
30. G. Vanor, *L'Art symboliste*, 1889, pp. 38–40.
31. J. K. Huysmans, preface to R. de Gourmont, *Le Latin mystique*, 1892, p. VII.
32. M. Denis, *Journal*, III, 1959, p. 241.

Adler, Jules 1865–1952

Adler was trained at the Ecole des Beaux-Arts under Bouguereau, Robert-Fleury and Dagnan-Bouveret. He made his Salon début in 1889, and his career as a professional artist shows a continued commitment to the official art institutions of Paris. During the First World War he was an official war artist. The majority of his subject matter was drawn from the lower end of urban life. It was handled in a realistic style which, at first, would seem to contradict Adler's established position within the official circles of French art. However, as in Zola's novels, with which Adler's paintings were often compared, the artist maintained the Naturalists' impartiality to subject matter, which evaded social comment.

1 *Young Flower Girl* 1899

Jeune fille marchande de fleurs
sbl. Jules Adler 81 × 66 cm/32 × 26 ins
Lent by the Petit Palais, Geneva

The desire to dignify manual work and the labouring classes by bringing these subjects into the Salon had been expressed in the 1880s by artists such as Bastien-Lepage (cf. no. 10), Roll (cf. no. 178), Dagnan-Bouveret (cf. no. 58), and Raffaëlli (cf. no. 162), and it was given official blessing by the Minister of Public Education and Fine Arts in his address preceding the distribution of prizes at the official Salon in 1891. Adler, like Cottet (cf. no. 51), continued with this subject matter during the 1890s. He achieved an art which Aman-Jean considered ('Le Salon des Champs-Elysées', *Revue encyclopédique*, 1897, p. 368) to be 'devoid of symbols, less concerned with finish than with simplicity of technique, yet somehow fuller of emotion . . . it is the intensity of the life which he sees around him in the *quartier* where he lives that gives birth to his art. It is life well observed.' Aman-Jean further suggests parallels between Adler's work and Zola's Naturalist novel *L'Assommoir*. Although less monumental than his 1897 Salon entry *The Weary Ones* and *The Strike*, exhibited in 1900, this painting well illustrates Adler's mastery over one of the typical themes of the Salons in the 1890s. MA.S.

1 2

Allais, Alphonse 1855–1905

A journalist who made a name for himself as a wit and humorist, Allais was born in Honfleur. His appearance in the Exposition des Arts Incohérents of 1883 and 1884 is the only evidence to date of his activity as an artist.

2 *First Communion of Anaemic Young Girls in the Snow* 1883

Première communion de jeunes filles chlorotiques par un temps de neige
ns. Bristol paper with four drawing pins (modern replica)
26.5 × 35 cm/10½ × 13¾ ins
Lent by the Musée des Arts Decoratifs, Paris

Allais exhibited a sheet of white paper with this title at the 1883 exhibition of the Arts Incohérents, followed in 1884 by a group of similarly burlesque pieces, including *Apoplectic Cardinals Harvesting Tomatoes on the Shore of the Red Sea (Study of the Aurora Borealis)* and the *Great Sorrows Are Silent (Incoherent Funeral March)*. The former was certainly a red version of the pristine sheet of Bristol which represented the *First Communion of Anaemic Young Girls* in 1883; the format of *Great Sorrows* is unknown.

The Exposition des Arts Incohérents was founded by Jules Lévy in 1882, and lasted into the 1890s. The surviving catalogues and reviews of the exhibitions show that it attracted artists such as Angrand (cf. nos 4–6) as well as literary wits such as Allais. The works shown seem to have been in the same vein as Allais' contributions. Fénéon, in his review of the 1883 exhibition, noted the 'suave title' of Allais' 'sheet of absolutely white Bristol paper', and drew attention to other works which were part-painted, part in three dimensions, such as the *Rabbit*, a painting of a man and woman chatting and drinking, with a live rabbit, eating carrots in a cage, attached by a cord to the mouth of the man in the painting. The work was meant to illustrate allegorically the phrase 'to hoax someone' ('*poser un lapin*').

Lévy's Expositions des Arts Incohérents were a parody of the whole apparatus surrounding the Salon exhibitions of the period, complete with illustrated catalogue, modelled on the *Salon illustré* volumes. Many of the listed 'artists' were thinly disguised notables of the day, and their 'works' referred to current topics and scandals. On one level, the whole phenomenon is an example of the essentially individualistic nature of the Anarchist ideas current in France in the 1880s, which contrast with the more organized expression of disgust at contemporary society which characterized the Anarchism of the 1890s. By the time of the bomb outrages of 1892–3, Lévy's spoofs had become anachronistic. MA.S.

EXHIBITION
1883, Paris, Galerie Vivienne, Exposition des Arts Incohérents
REFERENCES
F. Fénéon, 'Les Arts incohérents', *La Libre Revue*, 1 November 1883, in *Oeuvres plus que complètes*, 1, 1970, pp. 12–13
Paris, Musée des Arts Decoratifs, *Equivoques*, 1973 (Allais)

Aman-Jean, Edmond 1860–1936

In 1880 Aman-Jean entered Lehmann's atelier where he met Seurat, with whom he shared a studio for several years. He also studied under Puvis de Chavannes and assisted him in the painting of *The Sacred Grove* (1884, Musée des Beaux-Arts, Lyon). Aman-Jean exhibited regularly at the Salon and then at the Société Nationale. He became involved in Mallarmé's circle and was invited to show at Péladan's Salon de la Rose + Croix, 1892–3. After *c.* 1912 his work increasingly came under the influence of Bonnard.

3 *Portrait de Mlle Thadée C. Jacquet* 1892

Portrait de Mlle Thadée C. Jacquet
sbl. Aman-Jean 112.5 × 89.5 cm/44¼ × 35¼ ins
Lent by the Musée d'Orsay, Paris

3

4

This portrait is of the woman whom Aman-Jean was to marry on 6 October 1892. It shows the artist's search for a solution to the problem of the balance between the real and the ideal in portraiture, which was to preoccupy him throughout the 1890s. Although he has set the figure in an apparently domestic interior, Aman-Jean concentrates upon the decorative aspect of the painting through the use of a narrow picture plane, gently curving lines and subtly harmonious colour. The result is the evocation of a mood rather than the literal transcription of the sitter. This successful compromise between the real and the ideal won Aman-Jean consistent praise from the critics throughout the 1890s. His work was compared to 'the elegiac mood of the Pre-Raphaelites' (Claude Phillips, 'Le Salon du Champ de Mars', *Magazine of Art*, 1895, p. 425) and to the poetry of Baudelaire and Maeterlinck (Roger Marx, 'Les Salons de 1895–11', *Gazette des Beaux-Arts*, June 1895, p. 446). His concern with the expression of the Ideal illustrated in this painting led him to exhibit at the Salons de la Rose + Croix, and his stress on the decorative qualities of painting not only reflects his early years as an assistant to Puvis de Chavannes, but also looks forward to his work as a painter of large-scale mural panels (e.g. *Confidence* and *Waiting*, 1898, Musée des Arts Décoratifs, Paris). M.A.S.

EXHIBITIONS
1892, Paris, Société Nationale (8)
1911, Buffalo, Albright Art Gallery, *Works by Members of the Société des Peintres et Sculpteurs* (4)
REFERENCES
Anon, 'Beaux-Arts expositions à Paris: Société Nationale des Beaux-Arts', *Revue encyclopédique*, 1892, p. 1253
A Fontaine, *Les Salons de 1908. Questions d'art contemporain*, Paris, 1908, p. 18
L. Bénédite, *Le Musée du Luxembourg*, 1912, no. 5, pl. 83
Paris, Grand Palais, *Autour de Lévy-Dhurmer*, 1973 (2)

Angrand, Charles 1854–1926

Angrand came from Normandy, and was educated in Rouen. After treating modern themes in a style reminiscent of Bastien-Lepage in the early 1880s, he moved through Impressionism into a pointillist style in 1886–7, when he was in close contact with Seurat and Signac, and with Van Gogh. He exhibited with the Indépendants from 1884, and with the Artistes Incohérents in the 1880s, but virtually gave up painting in favour of pastel and drawing after 1891. In 1896 he left Paris for Normandy and a life of seclusion.

ABBREVIATION
Welsh-Ovcharov, *Angrand* – B. Welsh-Ovcharov, *The Early Work of Charles Angrand and His Contact with Vincent Van Gogh*, Utrecht and The Hague, 1971

4 *In the Garden* 1884

Dans le jardin
sdbl. Ch. Angrand 1884 73 × 91.5 cm/28¾ × 36 ins
Lent by a Private Collector

In 1883–5, Angrand painted a sequence of peasant scenes from his native Normandy, of which *In the Garden* is one of the largest and most ambitious. They show his gradual assimilation of Impressionist techniques into the tradition of peasant painting ultimately derived from Millet, which Bastien-Lepage and Camille Pissarro were both exploring in the early 1880s (cf. nos 10 and 152). The crisp, descriptive handling of plants in *In the Garden* owes something to Bastien, but the brushwork is broader; considerable areas of the white canvas-priming are seen around the brushstrokes, which gives the canvas luminosity. There is a little light blue modelling in the cabbages, and many red touches across the canvas, but the dominant greens are quite muted and far less varied in nuance than in Pissarro's contemporary work. For a different synthesis of Bastien and Impressionism at this date, compare no. 195. J.H.

EXHIBITION
1884, December, Paris, Société des Indépendants (2)
REFERENCE

Welsh-Ovcharov, *Angrand*, pp. 18–24

5 *The Western Railway at its Exit from Paris (View from the Fortifications)* 1886

La Ligne de l'ouest à sa sortie de Paris (vue prise des fortifications)
sdbr and insc. Paris – 86 Ch. Angrand
size on canvas 73 × 92 cm/28¾ × 36¼ ins
Lent by a Private Collector

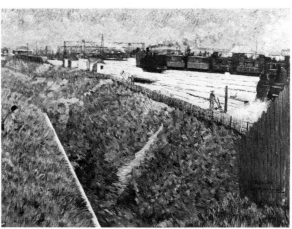

Angrand did not immediately follow Seurat into the Neo-Impressionist technique in 1886 (cf. nos 198 and 206), although he knew him well; at the Indépendants in August he showed a group of paintings, including *The Western Railway*, in a style principally indebted to Impressionism. The handling in *The Western Railway* varies from area to area, from the flatness of the wagons to the crisp strokes which introduce rich colour variations into the foreground grass. Besides general reminiscences of Monet and Pissarro, there may be an echo of Seurat's *Baignade* (fig. 4) in the figure of the boy in profile and in the treatment of this grass (cf. no. 195).

The picture shows the point at which the main western railway line from the Gare Saint-Lazare cut through the city's fortifications near Clichy, creating a wasteland of ridges and ditches beside the new tracks. Luce and Signac were working on particularly closely related themes around this time (cf. nos 117 and 206).

The painting reveals Angrand's interest in experimental media (shared, among the Neo-Impressionists, particularly by Hayet), since it is executed in *peinture à la colle*, using size (a sort of animal glue) rather than oil as the medium for mixing the pigments (cf. Welsh-Ovcharov, *Angrand*, pp. 35–6). J.H.

EXHIBITION
1886, Paris, Indépendants (16)
REFERENCES
Welsh-Ovcharov, *Angrand*, pp. 23–36, 57
J. Sutter, *The Neo-Impressionists*, 1970, pp. 77, 81

6

6 *The Harvest* c. 1887

La Moisson
sbl. Ch. Angrand 38 × 46 cm/15 × 18 ins
Lent by the Petit Palais, Geneva

Angrand adopted the 'point' as his unit of execution during 1887, perhaps as a result of seeing Seurat's and Signac's more highly systematized Neo-Impressionist canvases shown at the Indépendants in spring 1887 (cf. nos 198 and 207). The present canvas seems to be the earlier of two versions of the Harvest theme – the second, though dated '88', was, it seems, exhibited in December 1887, (cf. Guggenheim, *Neo-Impressionism* and Welsh-Ovcharov, *Angrand*). The present version is less schematic in forms and colours, and more tied to local colour, introducing light blues only sporadically to express shadow, while the version dated 1888 uses luminous blues, with crimson, throughout the shadows. J.H.

REFERENCES
Geneva, Petit Palais, *L'Aube du XXe siècle*, 1. 1968, no. 83
cf. too:
Welsh-Ovcharov, *Angrand*, pp. 57–9
New York, Guggenheim Museum, *Neo-Impressionism*, 1968 (3)

Anquetin, Louis 1861–1932

Born in Normandy, Anquetin moved to Paris c. 1882, studying first under Bonnat and then at the Atelier Cormon, where he met Toulouse-Lautrec, Bernard and Van Gogh. He established a reputation as a brilliant, innovatory artist and the leader of a café-cabaret circle centred on Aristide Bruant's Le Mirliton in Montmartre. Anquetin consulted Monet about Impressionism in 1886, before rejecting all naturalist styles to produce Cloisonnism by summer 1887. His subject matter included townscapes, café-cabaret scenes, nudes, the racecourse and fashionable women; he absorbed and discarded with equal speed styles derived from Lautrec and Renoir. By c. 1896 Anquetin eventually settled on a Baroque style of monumental painting, indebted primarily to Rubens. He exhibited in both Paris and Brussels.

7 *Street – Five O'Clock in the Evening* 1887

Rue – cinq heures du soir
[repr. in colour on p. 107]
sdbl. L. Anquetin 1887 69 × 53.5 cm/27¼ × 21 ins
Lent by the Wadsworth Atheneum, Hartford, Connecticut.
Ella Gallup Sumner and Mary Catlin Sumner Collection

Although the critic Edouard Dujardin (1888) considered this to be an unfinished painting, it was exhibited at both Les XX and the Salon des Indépendants exhibitions of 1888, together with two companion pictures. At both showings, the critics hailed this group of pictures as representative of a new style of painting, Cloisonnism, the pictorial equivalent of the recently established school of Symbolist literature.

In his unpublished autobiography, Emile Bernard recalls that during 1886 'Anquetin was changing his style very quickly. He had gone to Vétheuil [*sic*] to see Claude Monet and Michelangelo was now replaced by impressionism' (p. 66). In October or November of that year, Bernard, perhaps accompanied by Anquetin, was invited to visit Signac's studio; while there, Bernard relates, 'I looked carefully at some large, very luminous but not very lively landscapes [cf. no. 207]; some interior scenes [cf. no. 208] in which all the figures seemed to me to be made of wood. I concluded that although the technique [Pointillism] might have been good for the reproduction of vibrant light, it ruined the colour, and I immediately adopted an alternative system,' (*Autobiography* Mss. p. 67). The theory which Bernard and Anquetin adopted was later described by Bernard as 'painting in which Ideas dominate the technique' (*Mercure de France*, 1932, p. 594). Through studying Japanese prints, the early work of Van Gogh and stained glass windows, Bernard and Anquetin had evolved by early summer 1887 the new style which is demonstrated in this painting and in its companion pictures *Reaper – Noon* (Private Collection, Paris) and *Boat – Sunset* (untraced).

For Bernard Cloisonnism was no more than a mere technical preliminary to the Pictorial Symbolism of his *Breton Women at a Pardon* painted the following year (no. 15) ('Louis Anquetin', *L'Art et les artistes*, January 1933, p. 116). Dujardin disagreed. In his manifesto on Cloisonnism, *Aux XX et aux Indépendants – le Cloisonnisme* (1888), Dujardin emphasized that the style rejected the representation of the external world. Through line and colour it captured the truth which lay behind the objects portrayed. 'The painter will set out to retain with the smallest possible number of characteristic lines and colours, the intimate reality, the essence of the object which he selects What practical lesson can be derived from this? First of all a rigorous differentiation between line and colour. To confuse line and colour . . . means to have misunderstood what

each specific medium is: line expresses what is permanent, colour what is momentary; line, an almost abstract symbol, gives the character of the object; the unity of colour establishes the general atmosphere, retains the sensation . . .' (p. 490). Thus, whereas the dominant tone of *Reaper – Noon* was yellow to evoke 'the sensation of full sunlight at mid-day', and that of *Boat – Sunset* was red-purple to denote the setting sun, the orange-blue contrast in *Street – Five O'Clock in the Evening* evoked the gathering dusk and the glow of the gas lamps on the avenue de Clichy.

In *Street – Five O'Clock in the Evening* Anquetin captures an exact moment in the day, which corresponds to Van Gogh's subsequent interest in depicting both the phases of the day and the seasons of the year (cf. no. 104). On a more general level, the stylistic innovations of this painting provided the basis for Bernard's and Gauguin's work during the summer of 1888. Dujardin's article also sets a precedent for later 'manifestos' of Symbolist painting, notably Denis' 'Définition du néo-traditionnisme' (1890) and Aurier's 'Le Symbolisme en peinture – Paul Gauguin' (1891). M A.S.

EXHIBITIONS
1888, Brussels, Les XX (Anquetin 5)
1888, Paris, Indépendants (25)
1889, Paris, Café Volpini (2; *Effet du soir*)

REFERENCES
E. Dujardin, 'Aux XX et aux Indépendants – le Cloisonnisme', *Revue indépendante*, March 1888, pp. 487–92
E. Verhaeren, 'Chronique bruxelloise: l'Exposition des XX à Bruxelles', *Revue indépendante*, March 1888, p. 456
G. Kahn, 'Peinture: exposition des indépendants', *Revue encyclopédique*, April 1888, pp. 163–4
M. O. Maus, *Trente années de lutte pour l'art (1884–1914)*, 1926, p. 68
E. Bernard, 'Louis Anquetin, artiste-peintre', *Mercure de France*, November 1932, p. 595
E. Bernard, 'Louis Anquetin', *Gazette des Beaux-Arts*, 1934, I, pp. 113–14
J. Rewald, *Post-Impressionism*, 1978, p. 32

8

8 *Gust of Wind: Bridge Over the Seine* 1889

Le Coup de vent
sdbr. Anquetin 89 119.5 × 126 cm/43 × 49½ ins
Lent by the Kunsthalle, Bremen

Emile Bernard noted that, once Anquetin had evolved the cloisonnist style of painting (cf. no. 7), 'he took on the task of becoming *the* painter of his period through depicting purely modern Parisian subjects' (*Louis Anquetin, L'Art et les artistes*, January 1933 pp. 116–17). This painting illustrates Bernard's point. Anquetin's continuing success as an innovator had already been demonstrated by his evolution of Cloisonnism during 1887 and his treatment of

café-cabaret scenes in 1885–6. This picture, while capturing the mood of modernity in its subject matter, uses rigorous outlines and flat zones of colour to create a decorative composition which shows a debt to Japanese prints. Few works from Anquetin's 'modern-subject' phase have survived and, according to J. E. S. Jeanès (*D'après nature: souvenirs et portraits*, 1946, p. 19), they represent only a passing interest, discarded by 1890. M A.S.

REFERENCE
Bremen, Kunsthalle, *Katalog der Gemälde*, pp. 20 ff.

9

9 *Girl Reading a Newspaper* 1890

Jeune femme lisant un journal
sdbl. Anquetin 90 pastel on paper mounted on mill board
54 × 43.5 cm/21¼ × 17¼ ins
Lent by the Trustees of The Tate Gallery, London

This pastel is another example of Anquetin's constant search for the new. Jacques-Emile Blanche (*Les Arts plastiques*, 1931, p. 126) mentions that in 1890 Anquetin was involved in a series of studies of 'women in hats full of flowers' and that 'all this was very novel at the time'. Rothenstein (*Men and Memories*, I, 1931, p. 64), in his recollections of early student days in Paris, confirms this point and identifies the source for the women: 'Meanwhile, like Lautrec, he had a searching eye for character, and chose for his models women who frequented places like the Moulin Rouge and the Moulin de la Galette.'

From the technical side Anquetin's originality was also noted. Although his link with Degas (possibly with his pastels) was noticed by Signac (*Journal*, in *Gazette des Beaux-Arts*, April 1952, pp. 299–300), he modified his pastel technique during the winter of 1885–6 in studies for his large painting *At Aristide Bruant's* (destroyed), some of which were exhibited at Les XX in 1888. *Girl Reading a Newspaper* shows how, by 1890, the pastel medium had been further modified by Anquetin's Cloisonnism, winning him praise from both Maurice Denis in 1890 ('Définition du néo-traditionnisme', in *Théories*, 1964 edn, p. 43) and from the anonymous writer in the *Revue encyclopédique* (p. 549) who reviewed the pastels by Anquetin exhibited at the Indépendants in 1891. M A.S.

EXHIBITIONS
1906, London, International Society, 6th Exhibition (2nd section) (87)
1917, London Grosvenor Gallery, Modern Loan Exhibition
 (138: as *Mont Martre* [sic] *Type*)
REFERENCE
London, Tate Gallery, *The Foreign Paintings*, 1959, p. 3

Bastien-Lepage, Jules 1848–84

Bastien-Lepage was born in Damvillers in north-eastern France, and worked there for most of his career. He studied under Cabanel at the Ecole des Beaux-Arts in Paris from 1867, and won 2nd prize in the Prix de Rome competition in 1875. He made his reputation by a sequence of peasant subjects, beginning with *The Harvest* at the 1878 Salon, and by his portraits. He visited London in 1879, 1880, 1881 and 1882, and made contacts with British artists including Burne-Jones and Clausen; he travelled to Venice in 1881, to Concarneau in Brittany in 1883, and to Algiers in spring 1884 shortly before his death from cancer.

10 *Poor Fauvette* 1881

Pauvre Fauvette
[repr. in colour on p. 164]
sdbl. and insc. J. Bastien-Lepage Damvillers 1881
162.5 × 125.5 cm/64 × 49½ ins
Lent by Glasgow Art Gallery and Museum

Poor Fauvette was one of Bastien-Lepage's few major canvases not to be shown at the Paris Salon, but, as the result of its exhibition in Britain, it became 'probably better known in Britain than any other Bastien-Lepage painted' (*Art Journal*, 1896, p. 200), and thus plays a central part in the story of Bastien's influence in Britain. Like all of Bastien's mature paintings, it treats an expressive figure subject with a detailed but selective realism, in muted colours. The girl's name presumably means 'little wild girl'.

Bastien insisted that painters should base their art on their own home surroundings, whether painting religious or peasant themes (cf. Cazin, no. 39), and he set his peasant subjects in the flat, open countryside of north-eastern France – often, as in *Poor Fauvette*, against stark, open horizons. Peasants, Bastien felt, should be carefully studied, since 'the peasant has his own fashion of being sad or joyous, of feeling and of thinking . . .; it matters little if your personages have irregular features, clumsy manners and coarse hands. They cannot fail to be beautiful because they will be living and thinking beings' (quoted J. Cartwright, *Bastien-Lepage*, 1894, p. 27).

The young Russian painter Marie Bashkirtseff, who was to become Bastien's close friend in the last years of his life, saw *Poor Fauvette* on her first visit to his studio, and was struck by its 'penetrating poetry; the eyes of the little girl have an expression of childlike and rustic reverie which I cannot describe' (*Journal*, 21 January 1882, II, p. 347). On a later occasion, she heard Bastien describe how he found 'so much poetry in nature' (*Journal*, 30 April 1883, II, p. 455), and he composed his subjects to maximize their expressive force. Ragged Fauvette, dwarfed by a tall thistle and a barren tree, stands in a shallow space which has little relationship to the distance beyond, pushing the figure towards the viewer. Bastien's colour is consistently subdued, without any trace of Impressionist influence, and crisp, distinct brushwork is used to pick out certain details of the weeds and plants; the silhouetted tree suggests the influence of Japanese prints, which Bastien admired (cf. letter to Theuriet, 1877, quoted J. Cartwright, *Bastien-Lepage*, p. 56).

Bastien's work shows a clear debt to Millet's peasant paintings, but Bastien signposted particular details far more sharply than Millet had, and placed more emphasis on the pathos of his figures. This psychological involvement made his canvases accessible, despite their stark themes, to viewers who were unable to understand the *dégagement* of Manet's modern life themes. J.H.

EXHIBITION
1882, London, United Arts Gallery
REFERENCES
'Art Notes', in *Magazine of Art*, 1882, p. XXX
W. C. Brownell, 'Bastien-Lepage', in *Magazine of Art*, 1883, pp. 268–71
Art Journal, 1896, p. 200
Marie Bashkirtseff, *Journal* (French edn), II, p. 347
W. Feldman, *The Life and Work of Jules Bastien-Lepage*, PhD thesis, New York University, 1973, pp. 171–5
K. McConkey, 'Bastien-Lepage and British Art', *Art History*, September 1978, p. 377

Béraud, Jean 1849–1936

Born in Russia, Béraud enrolled as a pupil of Bonnat and exhibited for the first time at the 1873 Salon. He was a founder member of the Société Nationale, with which he exhibited regularly 1890–1929. Although a portraitist, he established his artistic reputation as the meticulous recorder of contemporary social *mores* in paintings such as *Sunday, Near St Philippe du Roule* (1877) and *The Gaming Room, Monte Carlo* (1890). However, in response to the general trend he turned in 1890 to religious subjects, which he treated in so realistic and 'modern' a manner that, when exhibited at the Salon, they provoked both a barrage of criticism and a flood of praise.

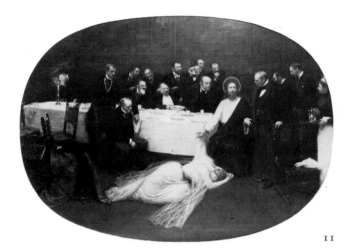

11

11 *Mary Magdalene in the House of the Pharisee* 1891

La Madeleine chez le Pharisien
sdbr. Jean Béraud 1891 126.5 × 157 cm/50 × 61¾ ins
Lent by the Walker Collection, Paris

When exhibited at the Société Nationale in 1891, this painting provoked wild acclaim from the public and almost unanimous abuse from the critics. Although religious subjects in contemporary settings had been exhibited during the 1880s, by artists such as Munkaczy and Von Uhde, Béraud had the effrontery not only to set his figures in a conventional Parisian genre interior but also to cast several eminent personalities in the leading roles: the poet the Duc de Quercy was Christ, the writer Ernest Renan Simon the Pharisee, the beautiful courtesan Liane de Pougy the Magdalene; Alexandre Dumas *fils* was on Christ's left and the greying, bespectacled, recently deceased centenarian Chevreul, exponent of the theory of complementary colours and inventor of margarine, to Renan's right.

Leaving aside scandal and potential libel, even its critics acknowledged the painting's significance as an example of the contemporary religious revival affecting all the arts. Developing as a response to the inadequacies of the Symbolist and Naturalist programmes of the 1880s, this revival took various forms, including the conversion to Catholicism of prominent writers, critics and artists including Claudel, Huysmans and Bernard, and a rapid increase in the number of religious plays and books published, and of fringe religions such as occultism and Theosophy (cf. Ranson, no. 163). Béraud, in keeping with other artists such as Blanche, Dagnan-Bouveret and Carrière, continued to exhibit religious paintings during the 1890s (e.g. *Descent from the Cross*, 1892; *The Way of the Cross*, 1894). M A. S.

EXHIBITIONS
1891, Paris, Société Nationale (57)
1900, Paris, Exposition Universelle, *Exposition Décennale* (124)
REFERENCES
E. Rod, 'Les Salons de 1891 – 2e partie', *Gazette des Beaux-Arts*, July 1891, pp. 18–20
L Bourdeau, 'Beaux-Arts: Société Nationale des Beaux-Arts', *Revue encyclopédique*, 1891, p. 751
W. Armstrong, 'The Two Salons', *Magazine of Art*, 1891, pp. 361–2
E. Potter, 'Les Salons de 1892 – 1', *Gazette des Beaux-Arts*, June 1892, p. 465
B. Hamilton, 'French Feeling in Parisian Pictures, Impressions of the Salon', *Magazine of Art*, 1892, pp. 422–3
A. Celebonovic, *The Heyday of Salon Painting*, 1974, pp. 55–7, repr. in colour

Bernard, Emile 1868–1941

Bernard attended classes at the Ecole des Arts Décoratifs and in 1884 entered Cormon's atelier where he met Anquetin, Toulouse-Lautrec and Van Gogh. Expelled for insubordinate behaviour, he went to Normandy and Brittany and met Gauguin at Pont-Aven. His style moved rapidly from Impressionism to Pointillism and Cloisonnism, and by summer 1888 he had evolved the form of Pictorial Symbolism which led Gauguin to create his *Vision After the Sermon*. Bernard and Gauguin worked closely together 1888–91, both exhibiting at the Café Volpini in 1889. After Gauguin left for Tahiti in 1891 Bernard attached himself briefly to the Nabis, exhibiting with them at Le Barc de Boutteville in 1892 and 1893; he also showed at Sâr Péladan's 1st Salon de la Rose + Croix (1892).

ABBREVIATIONS
MSS – E. Bernard, *L'Aventure de ma vie*, unpublished manuscript in Collection M. A. Bernard-Fort, Paris

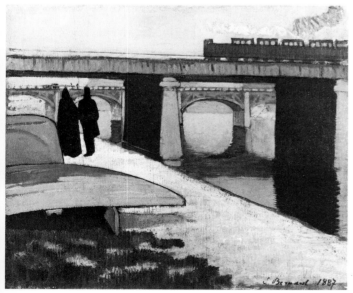

12

12 *The Iron Bridges* 1887

Les Ponts de Fer
sdbr. E. Bernard 1887 46 × 54 cm/18 × 21¾ ins
Lent by the Museum of Modern Art, New York,
Grace Rainey Rogers Fund, 1962

Several features of Bernard's personal life and artistic career are summarized in this painting. The location is the bank of the river Seine at Asnières, a suburb to the north-west of Paris, where Bernard's parents had moved in 1884.

The bold outline, the conscious patterning of flat colour zones and the evidence of compositional changes, especially in the position of the foreground bridge, suggest that this painting was produced from memory rather than in front of the scene. The painting is an example of Cloisonnism, the style evolved by Bernard and Anquetin over the winter of 1886–7 and which Anquetin employed in his *Street – Five O'Clock* (no. 7). Like Anquetin, Bernard had executed his early work in an Impressionist style. However, in Brittany in 1886 he had met Schuffenecker, who introduced him to Neo-Impressionism (cf. no. 184). It was a group of paintings in this new technique which Bernard exhibited at Asnières in autumn 1886, causing Signac to invite the younger artist to visit his studio. On the strength of this visit, Bernard resolved to find a new style of painting in which 'Ideas dominate the technique'. Bernard fulfilled this search during the following six months by experimenting with self-consciously anti-naturalistic subjects and techniques. For subject matter, he chose the artificial world of circuses and café-cabarets, which contemporary artists and writers saw as emblems of the negation of the natural world (cf. nos 218 and 219). For technique Bernard absorbed the heavily loaded and crudely outlined styles of Van Gogh's *Potato Eaters* (1885, de la Faille 82) and of Cézanne's *Achille Emperaire* (fig. 7), owned by Père Tanguy, which he combined with the flat colour zones and the clear outlines of Japanese prints and stained glass windows. Finally, the vertical brushstrokes of the foreground point to the influence of Degas' 'non-naturalistic' use of pastel in the mid-1880s (cf. no. 62).

The view in this picture was also painted by Van Gogh. Although executed in an Impressionist technique similar to *Fishing in Spring* (cf. no. 96), Van Gogh's *Bridges at Asnières* (early summer 1887, de la Faille 301), with its identical subject matter, points to the relationship between Bernard and the Dutch artist. In his autobiography (MSS pp. 63–4), Bernard records having met Van Gogh when calling on Anquetin, Toulouse-Lautrec and Tampier at the Atelier Cormon in autumn 1886. The friendship between Bernard and Vincent developed rapidly and was mutually supportive. At that time Van Gogh showed Bernard examples of his early paintings and drawings as well as Japanese prints (MSS p. 65). He also organized two or possibly three exhibitions during 1887 and 1888 in which Bernard participated; persuaded his brother, Théo, to buy works by Bernard; and pressed Bernard into renewing contact with Gauguin in 1888. Bernard, in his turn, invited Van Gogh to paint with him at Asnières in late spring 1887; provided material for Albert Aurier's important article on Van Gogh, published in January 1890 ('Les Isolés – Vincent van Gogh', *Mercure de France*), and, following Vincent's death in 1890, he paid tribute to him with articles (e.g. 'Vincent Van Gogh', *Les Hommes d'aujourd'hui*, no. 390, 1890) and a memorial exhibition containing 16 of his works at Le Barc de Boutteville in April 1892. Throughout their friendship they also corresponded regularly, giving each other encouragement and advice, as well as discussing more general artistic questions. M A. S.

REFERENCES
M. Roskill, *Van Gogh, Gauguin and the Impressionist Circle*, 1970, p. 108
J. Rewald, *Post-Impressionism*, 1978, repr. p. 59

13 *Portrait of Père Tanguy* 1887

Portrait du Père Tanguy
sdtl. Emile Bernard 1887; insc tr. à mon ami Tanguy
36 × 31 cm/14¼ × 12¼ ins
Lent by the Kunstmuseum, Basle

Julien Tanguy was born in 1825 and, until he moved to Paris in 1860, he lived in the Côtes du Nord. In Paris he started to grind and sell his own colours. After the vicissitudes of the Franco-Prussian War and the Commune, he built up an extensive clientele which included Cézanne, most of the Impressionists, Anquetin, Gauguin and Signac. His shop at 10 rue Clauzel was both the unofficial lycée of the new movements in painting and also the repository of works by one of the artists most revered by the younger generation, Cézanne. He died in 1894.

When Bernard came to execute this portrait in 1887, he had already benefited from Père Tanguy's legendary kindness. The colour dealer had lent him money for his 1886 walking tour of Normandy and Brittany and, the following autumn, he had revealed to Bernard his stock of early Cézannes (MSS p. 46). Tanguy supported Bernard by purchasing his work and Bernard continued to hold Père Tanguy in affectionate regard. He expressed his concern for Tanguy's failing health in a letter to Schuffenecker dated 21 April 1891 (Mss., Bibliothèque Nationale, n.a. fr. 14277 ff. 18–19); dedicated his first volume of poems, *Voyage de l'être* (1898), to Tanguy; and paid posthumous homage to his benefactor in an extensive article published in the *Mercure de France* ('Julien Tanguy, dit le "Père Tanguy"', 16 December 1908, pp. 600–16).

Unlike Van Gogh's portrait of Père Tanguy (no. 98), Bernard's picture emphasizes the shrewdness and quiet distinction of his sitter's personality. Set against a decorative backdrop which possibly reflects Bernard's early training at the Ecole des Arts Décoratifs, the image is etched out of the surface with the cloisonnist bounding line found also in *The Iron Bridges* (no. 12). The handling of the face, too, reflects the decorative intention of Cloisonnism. Despite the presence of darker tones to give the face some three-dimensionality, the bold streaks of colour, which wilfully cross these areas of shadow, negate the implied naturalism. The patterns of colour and the textures of the paint surface become the focus of attention. The use of this technique to create a less naturalistic image is similar to Degas' procedures in his pastels of the mid-1880s. The violent foreshortening, artificial colour and emphasis upon the intrinsic qualities of the pastel medium in the group of pastels shown at the 8th Impressionist exhibition in May–June 1886 (cf. no. 62), caused critics like Félix Fénéon (reprinted *Oeuvres plus que complètes*, I, pp. 30–1) to see them as explicitly non-naturalistic statements. Although Bernard was away from Paris at the time of this exhibition, he could have known of Degas' pastels at least through Anquetin (cf. no. 9).

Père Tanguy is executed in the same style as Bernard's *The Artist's Grandmother* (1887, Rijksmuseum Vincent Van Gogh, Amsterdam), the painting which Van Gogh praised for having 'something deliberate, sensible, something solid and self-assured' about it: 'Have you ever done anything better? Yet have you ever been more yourself or more of a person? I doubt it. A profound study of the first thing that came to hand, or the first person who came along, sufficed to produce a real creation!' (letter B14). M.A.S.

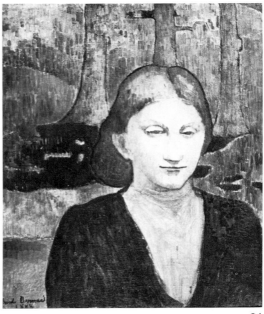

14

14 *Portrait of My Sister, Madeleine* 1888

Portrait de ma soeur Madeleine
sdbl. Emile Bernard 1888 61 × 50 cm/24 × 19¼ ins
Lent by the Musée Toulouse-Lautrec, Albi

Born in 1871, and three years younger than her brother Emile, Madeleine Bernard suffered from ill-health and was famed for her beauty, gentleness and saintliness. A friend and admirer of Gauguin, she remained utterly loyal to her brother after the break-up of the artists' relationship in 1891. Following her engagement to Charles Laval, probably in 1890, she followed him out to Cairo in 1894 where she died of tuberculosis the following year.

Bernard executed several portraits of his sister; this one and the monumental *Madeleine at the Bois d'Amour* (Palais de Tokyo, Paris) both date from 1888. In both portraits Madeleine is shown against the trees of the Bois d'Amour, outside Pont-Aven. However, unlike the large painting, the present picture, small and hieratic, does not make any overt reference to Madeleine's position within the circle of Bernard's friends at Pont-Aven.

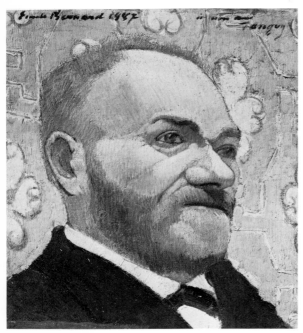

13

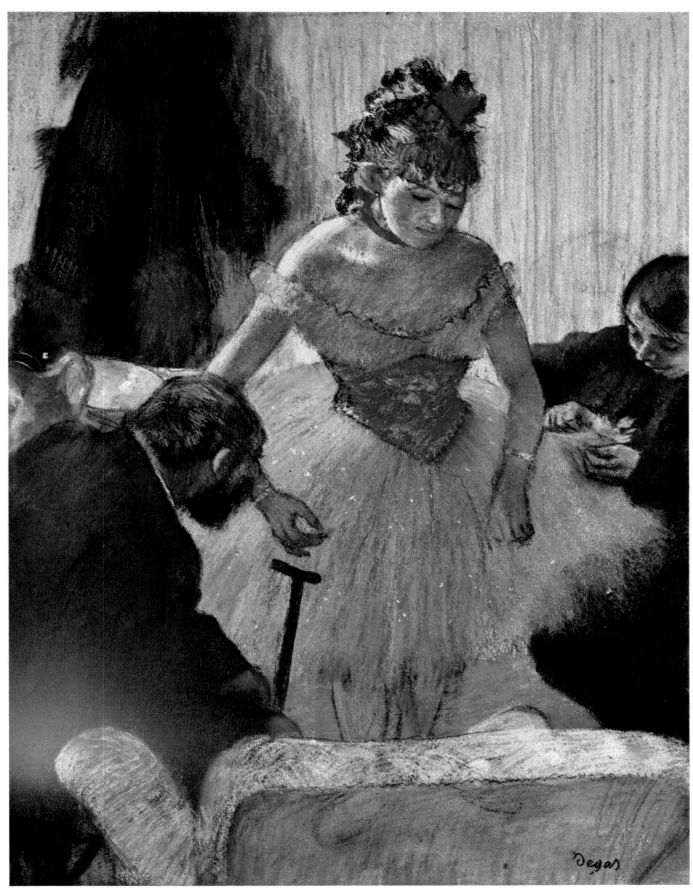

60 Degas *Dancer in Her Dressing-room*

136 Monet *Varengeville Church*

172 Renoir *La Roche-Guyon*

45 Cézanne *Undergrowth*

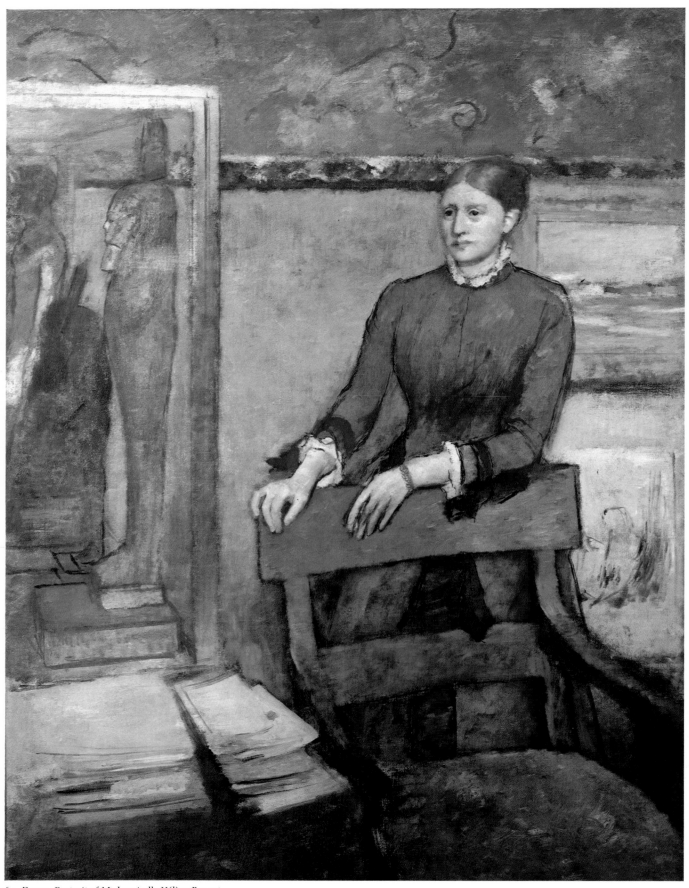

63 Degas *Portrait of Mademoiselle Hélène Rouart*

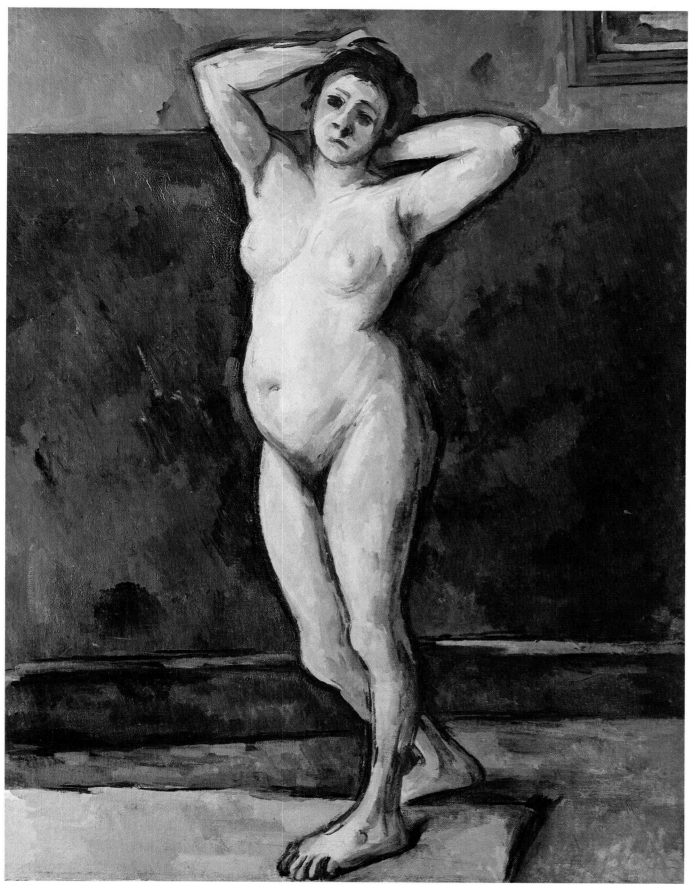

46 Cézanne *Standing Nude*

80 Gauguin *Still-Life with a Horse's Head*

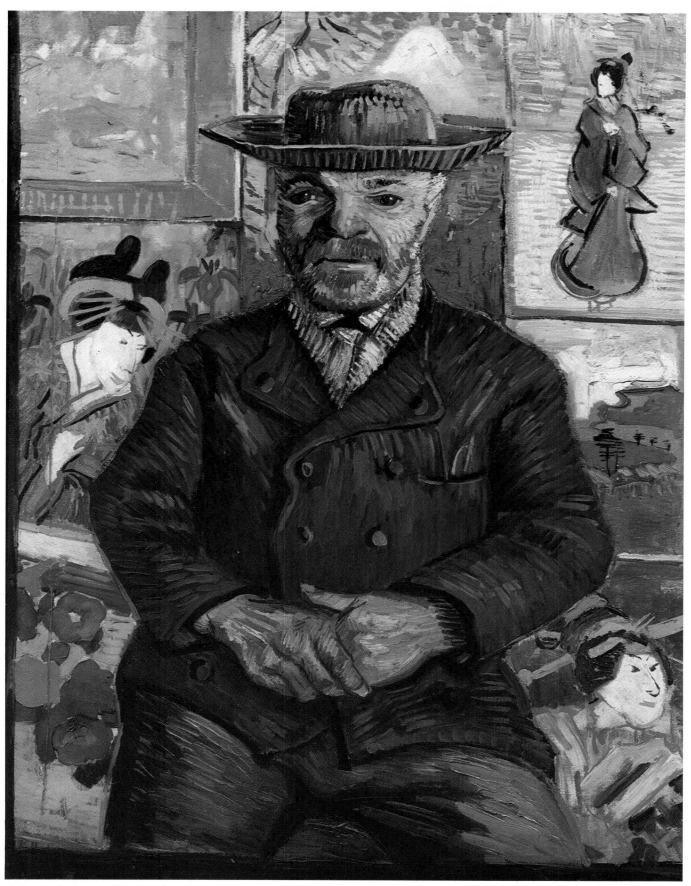

98 Van Gogh *Portrait of Père Tanguy*

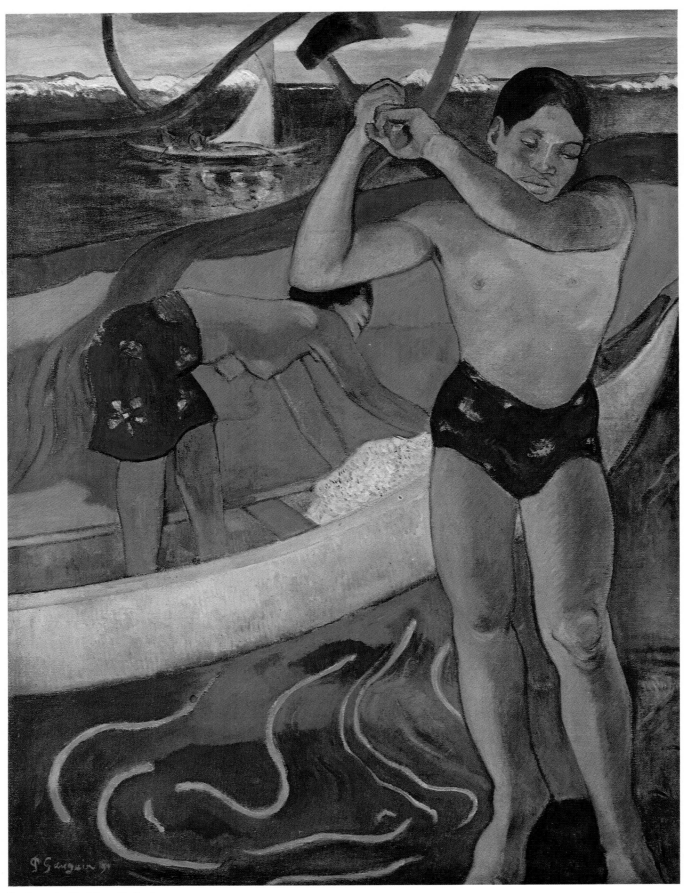

89 Gauguin *The Man with the Axe*

She arrived in Pont-Aven with her mother in August 1888. Gauguin was immediately struck by her beauty and painted her portrait in which he presented her as a lively and slightly coquettish personality (*Portrait of Madeleine Bernard*, Musée de Peinture et de Sculpture, Grenoble; Wildenstein 240). However, by the time she returned to Paris in September, Gauguin's attitude towards her had changed (cf. no. 85). In a letter of October 1888 to Madeleine Gauguin wrote that: 'First you must consider yourself as an androgyne, sexless; what I mean by that is that the soul, the heart, in fact everything which is divine, must not be shackled to matter, that is, to the body. The virtues of a woman are exactly similar to those of a man and these are Christian virtues.' Gauguin implies that Madeleine might be the St Joan of painters, when he concludes: 'We artists, we also need your defence, your help . . .' (*Lettres de Paul Gauguin à sa femme*, 1946, no. 69).

Bernard made an overt reference to Madeleine as St Joan in *Madeleine at the Bois d'Amour*, which shows her lying on the ground, her hand cupped to her ear as if to hear the heavenly voices. In the present version, the down-cast eyes, the sombre dress and the conscious rejection of realistic representation suggest that here, too, Bernard was concerned to create this saintly role for his sister.

Bernard and Gauguin were not alone in their belief in the androgyne as the saviour of mankind and artists. The social theorist Auguste Comte had propagated this theory in the 1840s, and the subject was adopted again in the 1880s by writers such as Sâr Péladan. Indeed Gauguin himself admired Balzac's novel on androgynism, *Seraphita Seraphitas* (1833), as well as expressing continuing respect for his liberated grandmother, Flora Tristan. M A.S.

REFERENCES
London, Tate Gallery, *Gauguin and the Pont-Aven Group*, 1966 (79)
Rewald, *Post-Impressionism*, 1978, p. 182, repr. p. 183

15 *Breton Women at a Pardon* 1888

Bretonnes au pardon
sdbl. E. Bernard 1888 74 × 92 cm/29 × 36¼ ins
Lent by a Private Collector, Paris

This painting has always held a central and controversial position in the history of Pictorial Symbolism. Executed just before Gauguin's *Vision After the Sermon* (fig. 8), it has raised both the specific question of whether it was the decisive factor in forging Gauguin's Symbolist style and the more general question of the relationship between the two artists.

Breton Women at a Pardon was almost certainly painted within the first few weeks of Bernard's arrival at Pont-Aven in mid-August 1888. He had spent the first part of that summer at St Briac – possibly meeting the critic Albert Aurier for the first time (MSS pp. 69–70). However, under pressure from Vincent Van Gogh he crossed Brittany with a number of recently completed paintings to renew, somewhat reluctantly, his contact with Gauguin. Gauguin was impressed by the younger artist's work and they started to paint together; Gauguin borrowed colours from Bernard and, following the execution of *Breton Women at a Pardon*, applied the innovatory techniques of this painting to *Vision After the Sermon*.

Both the techniques and the subject matter of Bernard's painting would seem to have given Gauguin the final push into non-naturalistic painting towards which he had been moving since at least early 1885 (cf. nos 81–4). In its technique, *Breton Women at a Pardon* is a synthesis of Bernard's non-naturalistic stylistic sources. The dominant green-yellow ground, the schematic, flatly

15

handled figures, the blue outlines and the irrational space come from Bernard's Cloisonnism of the previous year (cf. no. 12). The two little dogs, indebted to Hokusai, are a specific reference to the importance of Japanese prints. The seated figures with their abrupt, wooden silhouettes seem to reflect the latent 'Symbolist' aspect of Seurat's *Grande Jatte* (fig. 5), which Paul Adam had noted in 1886: 'The hieratic pose of the figures, synthesized according to their individual demands, the ambitious perspectival exaggeration, the perfect tonal harmonies . . .' ('Les Artistes indépendants', *La Vogue*, 8–13 September 1886). Lastly, and somewhat ironically, the monumentality of the painting's figures may have been taken from Gauguin's Martinique painting, *Aux Mangoes* (1887, Wildenstein 224), which Bernard could have seen at Théo Van Gogh's gallery and which he later praised for its 'heavy colour, its noble style' (MSS p. 75).

The subject of the painting summarizes Bernard's attitude to Brittany. From an inscription in Bernard's hand on the verso of the canvas, it had from the beginning a religious association through its reference to a Pardon (cf. no. 108). For Bernard, Brittany was a land of primitivism, poverty and religion: 'Atheist that I was, it [Brittany] made of me a saint . . . it was this gothic Brittany which initiated me in art and God' (unpublished MSS).

The crude, primitive technique and the religious subject matter of *Breton Women at a Pardon* capture the essence, or the Idea, which Bernard felt to be the truthful representation of Brittany. It was this fusion of style and subject matter to express an abstract emotion which Gauguin saw in this painting and then sought to express in his *Vision After the Sermon* (fig. 8). Gauguin explained this painting to Van Gogh: 'I believe that I have achieved a great rustic, superstitious simplicity in these figures. Everything is very severe. The cow under the tree is very small relative to reality, and . . . for me, in this painting, the landscape and the struggle exist only within the imagination of the praying people, the product of the sermon. This is why there is a contrast between the "real" people and the struggle in its landscape devoid of naturalism and out of proportion' (letter to Van Gogh, mid-September 1888, in J. Rewald, *Post-Impressionism*, 1978, pp. 181–2).

The execution of these two paintings cemented Bernard's and Gauguin's relationship; it lasted until their split in 1891, though psychologically it lingered on until Bernard's death in 1941. The two artists were involved in joint activities such as the Café Volpini exhibition of 1889, and their successive plans of 1890 to set up an atelier in Le Pouldu, to travel together to Madagascar, and to go to Tahiti. However, contrary to Bernard's later protestations, the relationship was not one of equals. As shown in Bernard's rather self-effacing, deferential attitude to Gauguin in his *Self-Portrait with Paul Gauguin* (no. 16), Gauguin rapidly became the 'teacher' of the

pair; this is also demonstrated in their 1888–91 correspondence, in which, for example, it was Gauguin who provided advice on technical and artistic matters. The breakdown of the relationship in February 1891 had three main causes: the powerful visual impact of Gauguin's paintings when exhibited at the fund-raising sale held on 22 February; Aurier's manifesto for Pictorial Symbolism, in which he hailed Gauguin, not Bernard, as the leader of the new school of painting ('Le Symbolisme en peinture – Paul Gauguin', *Mercure de France*, February 1891); and Bernard's own religious crisis in the winter of 1890–1. From 1891 until his death Bernard repeatedly, and often acrimoniously, testified to his innovatory role in the field of Pictorial Symbolism, citing *Breton Women at a Pardon* as proof.

The painting was taken by Gauguin to Arles in November 1888. It was copied in a watercolour by Van Gogh (de la Faille 1422; Museo d'Arte Moderna, Milan). Although he had failed to appreciate its religious connotations, Van Gogh did appreciate its originality (letter w16). MA.S.

EXHIBITION
Paris, Indépendants, 1892 (98)
REFERENCES
E. Bernard, *Souvenirs*, 1939
Lettres de Paul Gauguin à Emile Bernard, 1954, p. 30
Van Gogh, letter w16
S. Løvgren, *The Genesis of Modernism*, 1959, p. 103
H. Perruchot, *La Vie de Gauguin*, 1961, p. 162
London, Tate Gallery, *Gauguin and the Pont-Aven Group*, 1966 (83)
M. Roskill, *Van Gogh, Gauguin and the Impressionist Circle*, 1970, pp. 88, 103–4, 105–6, 127, 128, 136
W. Jaworska, *Gauguin et l'Ecole de Pont-Aven*, 1971, pp. 19, 20, 22, p. 19 repr. in colour

16 *Self-Portrait, for his Friend Vincent* 1888

Autoportrait, à son copaing Vincent
sd and insc tr. Emile Bernard 1888 à son copaing Vincent
46 × 55 cm/18 × 21¾ ins
Lent by the Rijksmuseum Vincent Van Gogh, Amsterdam

In a letter to Bernard written in early October 1888 (B19), Van Gogh reports delightedly that he has just received a package containing self-portraits by Gauguin and Bernard: 'It warmed my heart greatly to see these two faces again. As for your portrait, you know, I like it very much. . . .' The two self-portraits referred to in Van Gogh's letter are this one and its pendant, *Self-Portrait, Called 'Les Misérables'* by Gauguin (fig. 10). During much of the summer of 1888 Van Gogh had been encouraging Bernard and Gauguin to execute portraits of each other to send to him in Arles. The attempt came to nothing (cf. Van Gogh, letter B16). Instead both artists resorted to self-portraiture which, it has been suggested (*Gauguin and*

16

the *Pont-Aven Group*, 1966), extended to the small, inset portraits of each other in the two paintings. Thus Gauguin's hand may have been responsible for the portrait of himself hanging in this painting on the wall behind Bernard.

Comparison between the self-portraits reveals important differences between the two artists at this date. In contrast to Gauguin's tough, architectural, yet relatively naturalistic version of himself, Bernard's more vacuous self-image is essentially an abstraction rather than a representation. Thin, flat paint-work, the thick, schematic outline, the unidentified, decorative feature on the lower right-hand side and the plain backdrop sit uneasily beside the more straightforward 'self'-portrait of Gauguin hanging on the wall. The literary reference to Jean Valjean, hero of Hugo's novel, in Gauguin's *Self-Portrait Called 'Les Misérables'* makes it an associational portrait; whereas the negation of naturalism in Bernard's *Self-Portrait* makes it, as Van Gogh suggested, a painting about the essence of the artist's personality: 'The Gauguin at first is remarkable, but personally I very much like Bernard's picture. It is nothing but the idea of the artist, a few summarily chosen tones, a few blackish lines, but it is as "chic" as a real Manet' (letter 545). If it is accepted that Bernard was also responsible for painting the image of himself in profile into Gauguin's *Self-Portrait Called 'Les Misérables'*, then the highly schematic red and blue outlines which trace the image over a flat ground of green and white are also an expression of this abstract idea.

These pendant self-portraits had great significance for Van Gogh. On the one hand, they represented part of an exchange system of paintings which had interested him during summer 1888. He had already received a drawing of a brothel by Bernard (letters B9, B11), from which Van Gogh painted his *Brothel Scene* (October 1888, de la Faille 478) to give to Bernard, and also intended to execute a copy of his *Night Café* (September 1888, de la Faille 463) for Bernard (letter B18). On the other hand, the receipt by Van Gogh of self-portraits by two of his closest artist friends represented for him the spiritual cementing of that community of artists which Van Gogh was determined to establish as a physical reality in the south of France. MA.S.

REFERENCES
Van Gogh, letter B19
London, Tate Gallery, *Gauguin and the Pont-Aven Group*, 1966 (84)
M. Roskill, *Van Gogh, Gauguin and the Impressionist Circle*, 1970, pp. 101–3
J. Rewald, *Post-Impressionism*, 1978, p. 186, repr. p. 168

17 *The Buckwheat Harvest* 1888

Le Blé noir
sdbrc. Emile Bernard 1888 72 × 92 cm/28¼ × 35½ ins
Lent by the Josefowitz Collection, Switzerland

This painting is striking for its dominant red tonality, the extreme schematization of the figures and the curiously abrupt spatial organization, especially on the left-hand side of the composition. Yet careful study of the paint surface reveals that the original dominant colour was yellow-green rather than red, and that the lower part of the figures of the three stooping harvesters in the background has been painted over. This painting must therefore have been reworked at some time during 1888. Given the rigorous simplification of image and the similarity between the red buckwheat and the red grass in Gauguin's *Vision After the Sermon* (fig. 8), *The Buckwheat Harvest* may have been brought by Bernard to Pont-Aven in mid-August 1888 (MSS p. 75), but reworked after Gauguin had executed *Vision After the Sermon* in order to create a more uncompromising expression of the new Pictorial Symbolism.

The radical nature of a painting such as *The Buckwheat Harvest* was recognized by critics in 1889 when Bernard showed paintings of subjects drawn from Brittany at Père Tanguy's shop and at the Café Volpini exhibition. While Albert Aurier praised them for their 'synthesis of drawing, of composition and colour' and linked them to the work of fifteenth-century primitive painters ('En quête des choses d'art – chez Tanguy', *Le Moderniste illustré*, 13 April 1889, p. 14), Félix Fénéon stressed both their affinity to stained glass windows and their barbaric aspects: 'M. Emile Bernard is exhibiting some landscapes and some scenes of Brittany. . . . The thick lines with which M. Bernard circles the accidents of landscapes and figures are like the leading lines of a stained glass window. By intense simplification, these figures could possibly remind one of traditional poses if it were not for the fact that some barbaric twist immediately destroys this recollection' ('Autre groupe impressionniste', *La Cravache*, 6 July 1889, in *Oeuvres plus que complètes*, I, p. 158).

The presence of the crudely represented, slightly slit-eyed woman on the left-hand side of this painting clearly justifies the critics' references to primitive art and barbaric techniques. Here, Bernard has captured two aspects of Brittany which had been referred to by other artists and writers. Jules Breton, for example, draws a parallel between the Breton peasants and the paintings of Holbein and Memling in his poem 'Le Pardon', published in *Les Champs et la mer* (1875). The same writer, in *La Vie d'un artiste* (1890), also made the comparison between Breton peasants, especially those in the Douarnenez region, the people of 'the dolmens of the Celtic forests' and the 'harems of the orient' (p. 301). Balzac had taken the reference to the barbaric even further when in *Les Chouans* (1822) he compared the Bretons to the barbarians of Europe and the savages of Africa and America. M A.S.

17

EXHIBITIONS
1889. Paris, Café Volpini (19, as *Moisson, Bretagne*)
1892, Paris, Indépendants (99, as *Moissonneurs de blé noir, Pont-Aven*)
REFERENCES
G. Geffroy, 'Chronique artistique – Les Indépendants', *La Justice*, 29 May 1892
London, Tate Gallery, *Gauguin and the Pont-Aven Group*, 1966 (82)
W. Jaworska, *Gauguin et l'Ecole de Pont-Aven*, 1971, p. 37 repr. in colour

18 *Bathers* 1890

Baigneuses
sdbr. Emile Bernard 90 32 × 41.5 cm/12¾ × 16¼ ins
Lent by a Private Collector, London

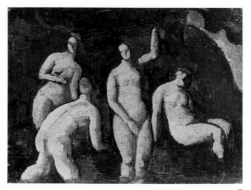

18

Despite the flattened decorative background and the blue bounding line in this painting, the strong directional brushstrokes and the cubic quality of these bathers underline Bernard's artistic debt to Cézanne. The degree to which the younger artist had absorbed Cézanne's technique was noted by Maurice Denis when he recalled that 'Bernard's atelier at his parent's house at Asnières revealed the influence of Cézanne to me before I had discovered Cézanne's paintings at Père Tanguy's shop' ('L'Epoque du Symbolisme', *Gazette des Beaux-Arts*, March 1934, in M. Denis, *Du Symbolisme au Classicisme, théories*, 1964, p. 61). Denis was probably referring to Bernard's large mural decorations of Cézannesque nudes to which *Bathers* is related. Although now destroyed, a section of these murals can be seen in the background of his *Self-Portrait* (repr. W. Jaworska, *Gauguin et l'Ecole de Pont-Aven*, 1971, p. 35).

Bathers was painted in the same year that Bernard published his first article on Cézanne (*Les Hommes d'aujourd'hui*, no. 387, 1890). In this youthful but perceptive account, Bernard makes three points. Like Sérusier (cf. no. 190), he praises Cézanne for being a painter above all: 'Style – Tone – Painter before anything else, although also a thinker; serious too, he opens to art that astonishing door: painting for painting's sake.' Second, he emphasizes the hieratic and primitive qualities in Cézanne's work. Third, he analyses the stages of Cézanne's stylistic development. While the so-called 'crude' stage had been operative in evolving Bernard's cloisonnist style (cf. no. 12), the latest stage, to which *Bathers* is so indebted, was described in these words: '[with their] solid impasto in slow touches from right to left, the works of the last manner confirm the researches into a new art, strange and unknown. Weighty light glides mysteriously amongst objects both transparent and solid; an architectural gravity emanates from the ordered lines; some areas of heavy impasto prompt references to sculpture.' The year after he wrote this article Bernard reiterated his respect for Cézanne when he claimed, in an interview given to Jacques Daurelle for the *Echo de Paris*, that Cézanne and Redon were the only two Great Masters of today ('Chez les jeunes peintres', 28 December 1891).

Apart from sketches after the nude model executed at the Atelier Cormon, Bernard's first recorded paintings of nudes date from 1887. However, it was only in 1890 that he started to refer to his nudes as 'decorative sketches' (*Inventaire des toiles vendues à M. Vollard, le 22 mai, 1905*, no. 5, unpublished Mss.). Since 1890 was the year in which *Bathers* was executed, the 'decorative' status accorded to paintings of this type might help to explain the severely two-dimensional background to this painting. Following his stylistic and religious crises during the second half of the 1890s, Bernard's nudes became increasingly Titianesque (e.g. *After the Bath*, 1906, untraced) and his praise for Cézanne more qualified (e.g. F. Lepeseur [pseudonym for E. Bernard] 'De Michel Ange à Paul Cézanne', *La Rénovation esthétique*, March 1906, pp. 250 ff). M A.S.

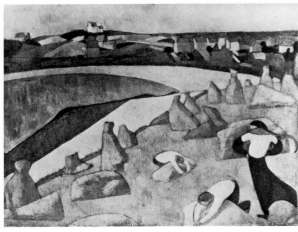

19

19 *Harvest by the Sea* 1891

Moisson au bord de la mer
sbr. E. Bernard; dbc. 1891 54 × 73 cm/21¼ × 28¾ ins
Lent by Mme Robert Walker

The inventory of the paintings which Bernard had sold to Vollard in May 1905 contains a precise description of this picture. The town of St Briac lies to the right, with the village of La Chapelle in the centre (*Inventaire des toiles vendues à M. Vollard, le 22 mai, 1905*, no. 71, unpublished Mss.). Bernard had first visited St Briac in 1886, and from then until his departure for Egypt in 1893 he spent the major part of each summer there. The town's attraction, from the evidence of Madeleine Bernard's letters, lay in its landscape and wide bay, less wild than at Pont-Aven, and the opportunity it offered to observe surviving customs and traditional costume as well as its relative freedom from tourists. This last feature, according to Madeleine Bernard, transformed Bernard's personality: 'You [Mme Bernard] would not recognize him now that he is here. He is very relaxed' (letter from Madeleine Bernard to her mother, St Briac, 1891, unpublished Mss.).

Bernard had already painted several pictures recording the variety of harvests in Brittany (cf. no. 17). To this extent he reflected the widespread enthusiasm amongst painters and writers to depict activities typical of the region (cf. no. 59). Bernard observes with accuracy the agricultural progress in Brittany which by this date had led to men as well as women labouring in the fields, but he predictably rejects the picturesque treatment of the subject. Instead, by creating a rhythmic pattern of forms across the surface of the painting, he has forced a pictorial integration between harvesters and landscape which symbolizes the symbiotic relationship between the two. It was this quality which was noted by Gustave Geffroy when he reviewed *Harvest by the Sea* alongside three other paintings by Bernard at the Indépendants of 1892. M A.S.

EXHIBITION
1892, Paris, Indépendants (106)
REFERENCES
G. Geffroy, 'Chronique artistique – Les Indépendants', *La Justice*, 29 May 1892
London, Tate Gallery, *Gauguin and the Pont-Aven Group*, 1966 (90)
W. Jaworska, *Gauguin et l'Ecole de Pont-Aven*, 1971, repr. p. 36

20 *Breton Women on a Wall* 1892

Bretonnes sur un mur
sdbl. Emile Bernard 1892 83 × 115 cm/32½ × 45 ins
Lent by the Josefowitz Collection, Switzerland

In this painting, Bernard makes use of irrational scale, extremely simplified forms, intense colours and repeated vertical brushstrokes to capture the decorative quality of Brittany, considered by several writers (e.g. A. Séguin, 'Paul Gauguin', *L'Occident*, March 1903, p. 166) to be its most striking characteristics. Indeed, one anonymous critic was quick to point out in 1895 that it had been Bernard, not Gauguin or the other members of the School of Pont-Aven, who had been the first to uncover this aspect of the region: 'Bernard, gifted first and foremost with one of the most inventive personalities, capable of suffering extreme hardship, took the initiative of identifying himself with the soul of the land of the Celts, of painting Brittany in its noble, decorative guises, and of merging the figures and the landscape into a single mystical harmony' ('L'Exposition de M. Armand Séguin – La Galerie du Barc de Boutteville', *Le Coeur*, June 1895).

It is possible that this painting was included in an exhibition of recent Brittany paintings by Bernard held at Père Tanguy's shop in May 1893. These paintings were greeted with rapturous praise by Tiphereth, the critic of *Le Coeur* ('L'Art', *Le Coeur*, May 1893). MA.S.

EXHIBITION
1893, Paris, Père Tanguy
REFERENCES
C. Chassé, *Les Nabis et leur temps*, 1960, pl. 37
London, Tate Gallery, *Gauguin and the Pont-Aven Group*, 1966 (99)
W. Jaworska, *Gauguin et l'Ecole de Pont-Aven*, 1971, p. 39 repr. in colour

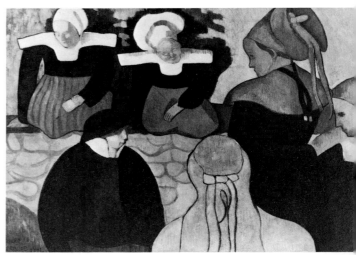

20

Besnard, Paul Albert 1849–1934

Besnard was born and always lived in Paris. Trained under Cabanel at the Ecole des Beaux-Arts, he won the Grand Prix de Rome in 1874, and gained a great reputation as a portraitist and as a painter of large decorative schemes. He was in England c. 1880–2, and in the 1880s his handling and colour became influenced by Impressionism. He exhibited first at the Salon in 1868, and with the Société Nationale from 1890. In later years he visited Algeria and India.

21 *Portrait of Mme Roger Jourdain* 1886

Portrait de Mme Roger Jourdain
sbl. A. Besnard 200 × 155 cm/78¾ × 61 ins
Lent by the Musée des Beaux-Arts Jules Chéret, Nice

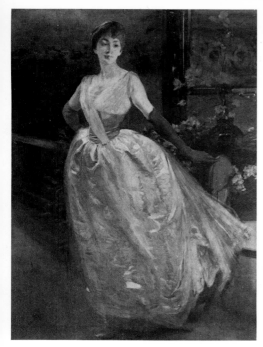

21

This portrait caused a sensation at the Salon of 1886. Its colour and brushwork suggested that Besnard – a former Prix de Rome winner – had gone over to the Impressionist camp, but the Impressionists repudiated him, feeling that he had usurped the superficial elements of their style. 'Besnard is flying with our wings', said Degas; 'he is a man who tries to dance with leaden soles', (quoted G. Moore, 'Degas', *Impressions and Opinions*, 1891, p. 226 of 1913 edn).

In an interview in 1892, Besnard explained his motives in creating this type of environmental portrait: 'I always try to place my characters in their most natural setting; by lighting them with the reflections of everything which surrounds them, I express the relationship which they have with the world in which they live. I suggest the role of a thing by the way in which it concentrates in itself the light which comes from the objects around it. In this way, flesh looks different from dress material, through the more intimate fusion of the rays of light' (Gsell 1892).

What caused most comment in the *Portrait of Mme Roger Jourdain* was the stark juxtaposition of two different lightings – blue and yellow, natural and artificial. The painting was a turning-point in making the richness of the Impressionists' atmospheric colour acceptable in the context of a major Salon painting; critics were reassured to find that, beneath its colour, it retained the lessons of Besnard's *Ecole* draughtsmanship.

Its use of colour to evoke mood won it the applause of Téodor de Wyzéwa, reviewing the Salon in the *Revue wagnérienne*, an influential journal in Symbolist circles, devoted to discussion of the Wagnerian fusion of the arts: 'Today under the pretext of a portrait he presents a symphony of blues and whites. The idea which he wants to express appears clearly, from the start. He has dreamed of a voluptuous emotion, specifically feminine, and translated by contrapuntal variations of two lascivious themes. The atmosphere on the left is of a purplish blue, on the right the strong notes of a luminous yellow; and in the middle it is the body of a woman, on which the two themes are united in elegantly varied chords; the face, of a yellowish pallor, elongated, accentuates the feminine character of the emotion; below it, a dazzling dress in which the symphony of the two colours pours out in a virtuoso display of nuances.' J.H.

EXHIBITIONS
1886, Paris, Salon (208)
1889, Paris, Exposition Universelle, French section (111)
1900, Paris, Exposition Universelle, *Exposition Centennale* (34)
REFERENCES
T. de Wyzéwa, 'Notes sur la peinture wagnérienne et le salon de 1886',
 Revue wagnérienne, 8 May 1886, pp. 110–11
A. de Lostalot, in *Gazette des Beaux-Arts*, June 1886, pp. 462–4
G. Olmer, *Salon de 1886*, pp. 78–9
J. Noulens, *Artistes au Salon de 1886*, pp. 36–7
P. Gsell, 'La Tradition artistique française, I, L'Impressionnisme', *Revue bleue*,
 26 March 1892, p. 405
C. Mauclair, *Albert Besnard*, 1914, pp. 14–15, 120–3
G. Lecomte, *A. Besnard*, 1925, pp. 71–2
J. E. Blanche, *Les Arts plastiques*, 1931, p. 175

22 Summer Morning 1886

Matinée d'été
sdbl. A. Besnard 1886 oil on panel 37×45 cm/$14\frac{1}{2} \times 17\frac{3}{4}$ ins
Lent by the Musée St-Denis, Reims

In this little panel Besnard used rich contrasts and nuances of colours – luminous yellows in the landscape and orange in the girl's hair against soft blues and mauves – to depict a young girl in the light of a summer morning. His palette, and the execution by bold patches (*taches*) of paint, show a debt to Impressionism, but Besnard's evocative use of colour to suggest a mood is very different from the Impressionists' more descriptive aims (cf. no. 136).

Though small, *Summer Morning* is certainly a finished picture. Possibly identifiable with *Summer Day*, exhibited at Petit's Exposition Internationale in 1887, it is a good example of the domestic-scaled paintings which were an important part of the stock-in-trade of most artists, even of those who, like Besnard, won their public fame by decorative schemes and monumental exhibition pictures. J.H.

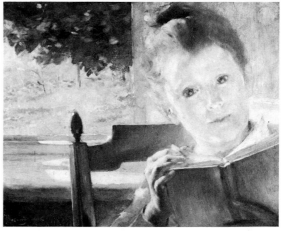

22

23 Portrait of Mme la Comtesse Mégrot de Cadignan c. 1895

Portrait de Mme la Comtesse Mégrot de Cadignan
sdtl. Besnard Paris, 18[rest illegible] 210×141 cm/$82\frac{3}{4} \times 55\frac{1}{2}$ ins
Lent by the Musée des Beaux-Arts Jules Chéret, Nice

This portrait must have entered directly into the ownership of the sitter since no Salon exhibition is recorded for it. The virtuosity of brushwork, the richness of colour and texture, and the suggestion of the sitter's personality and social position in this portrait reflect those qualities which had first established Besnard's reputation as a portraitist at the 1886 Salon. In the technically brilliant *Portrait of*

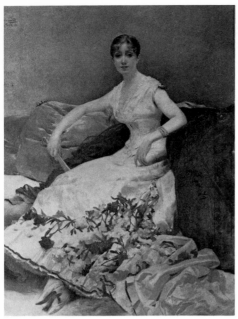

23

Mme Roger Jourdain (no. 21) he had introduced at that Salon a new painting type, the environmental portrait, as a means of solving the problem of the balance between the real and the ideal in portraiture. In a review of the 1897 Société Nationale (*Gazette des Beaux-Arts*, July 1897, pp. 29–30), Besnard justifies this new portrait type. He deplores the contemporary vogue in portraiture for the idealization of women, which makes all the sitters look alike. However, rather than arguing for a return to the particularization achieved by the photographic representation of the sitter, he suggests that the portraitist may retain the ideal yet at the same time capture individuality through the evocation of that environment unique to each sitter. It was this compromise which created portraits such as *Mme la Comtesse Mégrot de Cadignan*, in which he, more than any other artist of his day, has translated 'the nervous, sparkling, artificial, voluptuous and mad charm of the contemporary Parisienne, so graceful, so dainty, under the chandeliers, light reflecting light' (Georges Lecomte, *Albert Besnard*, 1921, p. 72). M A.S.

Blanche, Jacques Emile 1861–1942

Son of a noted pathologist, Blanche was born in Paris and lived there all his life, regularly visiting Dieppe where his family had a house until 1895. A pupil of Gervex and Humbert, and much influenced by Manet, he gained great success as a portraitist of fashionable society, and won a gold medal at the Exposition Universelle of 1900. His contacts in Britain and his hospitality at Dieppe made him a focus for Anglo-French artistic relations, described in his volumes of autobiography. He showed at the Salon in 1882–9, and thereafter with the Société Nationale, and also exhibited much in London.

24 *Head of a Young Girl* 1885

Tête de jeune fille
sbdr and insc. J. E. Blanche 1885 To my friend Sickert
55 × 45 cm/21½ × 17¾ ins
Lent by a Private Collector, Wales

Dieppe was an important summer cultural centre in the late nineteenth century, visited by French and English artists and writers. Many who visited the town were friends and associates of Blanche. Sickert, who was to live in Dieppe for many years, first visited it in 1885, when Whistler, Degas, Helleu and George Moore were also there (cf. Blanche, *Portraits of a Lifetime*, 1937, pp. 45–50, and W. Baron, *Sickert*, 1973, pp. 15–17). Blanche had met Sickert on a recent visit to London, and presented him in Dieppe with this little study, *Head of a Young Girl*, painted in a free, sketch-like manner which recalls Gervex, Blanche's teacher, and Manet, whose work he greatly admired. Many years later, in 1927, Blanche dedicated to Sickert his book on Dieppe. J.H.

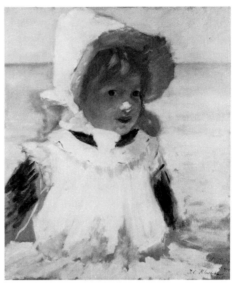

24

25 *Portrait of Aubrey Beardsley* 1895

Portrait d'Aubrey Beardsley
[repr. in colour on p. 237]
sdbr and insc. J. E. Blanche Dieppe 95 90 × 72 cm/35½ × 28¾ ins
Lent by the National Portrait Gallery, London

After 1885 (cf. no. 24), 1895 was the next and last *annus mirabilis* in the artistic life around Blanche in Dieppe. In that year he welcomed Beardsley and Conder, the poet and critic Arthur Symons, the poet Dowson, and Leonard Smithers, publisher of *The Savoy*, for whom Beardsley was working at the time. Smithers published Symons' evocation of that summer's stay at Dieppe in *The Savoy* (1, pp. 84–102), with illustrations by Beardsley, and Blanche also painted Symons' portrait during the summer (Tate Gallery, London, on loan to the National Portrait Gallery).

Both Beardsley and Blanche were at this time absorbed in the art of the eighteenth century. In 1895, an English critic described Blanche's work as being in the tradition of the English eighteenth-century portrait (Claude Phillips, in *Magazine of Art*, 1895, pp. 425–6), and Gainsborough's influence is certainly felt in the free, fluid brushwork and subdued colour of the *Portrait of Aubrey Beardsley*. Beardsley is posed, like many of Gainsborough's sitters, against a hint of landscape, in the finery of his daytime dress which Blanche described (*Propos de peintre*, pp. 117–18). This grey and silvery tonality led to Blanche being included in the so-called 'Bande noire', christened by critics in 1895 as a counter-movement to the Impressionists (cf., too, Cottet and Simon, nos 52 and 217). Beardsley had now abandoned the mediaevalizing and Japanese

tendencies of, respectively, his *Morte d'Arthur* and *Salomé* illustrations, adopting a delicate style of lines and stipples which owed much to eighteenth-century engravings, seen in particular in his drawings for Pope's *Rape of the Lock* (published 1896). J.H.

EXHIBITIONS
1896, Paris, Société Nationale (146)
1907, Paris, Petit, *Exposition de peintres et de sculpteurs* (22)
1907–8, Paris, Bernheim Jeune, *Portraits d'hommes* (5)
REFERENCES
J. E. Blanche, *La Pêche aux souvenirs*, 1949, pp. 236–8
H. Maas, etc. (eds), *The Letters of Aubrey Beardsley*, 1971, p. 100 (letter to William Rothenstein, September 1895)
cf., too:
J. E. Blanche, 'Aubrey Beardsley', in *Propos de peintre*, I, 1919, pp. 116–19
J. E. Blanche, *Portraits of a Lifetime*, 1937, pp. 91–7

Bonnard, Pierre 1867–1947

Son of an official in the War Ministry, Bonnard was destined for the law, but when he passed his examinations in 1888 he was already attending the Ecole des Beaux-Arts and the Académie Julian, where he met Sérusier, Denis, Ranson and Ibels. By 1890 he was evolving his own individual style through close study of Sérusier's *The Talisman*, Gauguin's work at the Café Volpini (1889) and Japanese art. A member of the Nabis, Bonnard shared the group's commitment to the applied arts, executing designs for decorative panels, stained glass, and furniture, together with book illustrations and prints. He had his first one-man exhibition at Durand-Ruel's in 1896, exhibited in Belgium in 1893 and 1897 and in London in 1898. After 1900 he adopted a modified form of Impressionism.

ABBREVIATION
D– J. and H. Dauberville, *Pierre Bonnard, catalogue raisonné de l'oeuvre peint*, 3 vols and supplement, Paris, 1965–75

26

26 *House with a Turret (Château de Vizien)* 1888

Maison à la tourelle (Château de Vizien)
sbl. Pierre Bonnard 19 × 29 cm/7½ × 11½ ins
Lent by a Private Collector

Executed during the summer of 1888, according to Dauberville, while Bonnard was on holiday at Grand-Lemps, this painting predates the arrival of Sérusier's *The Talisman* (no. 187) at the Académie Julian, which Bonnard had been attending since 1887. Therefore, it is not surprising that this landscape displays the careful naturalism which he would have learnt from the Beaux-Arts and from his teachers at Julian's such as Bouguereau and Lefebvre – the same naturalism as that found in Sérusier's *The Breton Weaver* (no. 186) and the early works of Vuillard. M A.S.

REFERENCE
DI

27

27 *Bouquet of Wild Flowers* c. 1888

Bouquet des champs
sbl. P. Bonnard 38 × 33 cm/15¾ × 13 ins
Lent by a Private Collector

Less finished than two flower-pieces to which it is related (D5 and D6), this delicate study of flowers is closer to the later flower-pieces of Manet (cf. no. 125) than to the more polished ones of Fantin-Latour.

During the 1880s similar flower-pieces had been painted as exercises in colour relationships by several artists, notably Renoir, Monet and Van Gogh (cf. no. 95). In the following decade, Redon was also to use them for the same purpose, though he placed more emphasis on the colour balance between the bouquet of flowers and the patterns of the vase (cf. nos 165, 167–8). M A.S.

REFERENCE
D4

28 *Women with a Dog* 1891

Femmes au chien
sdbr. P. Bonnard 1891 40 × 32 cm/16 × 12¾ ins
Lent by the Sterling and Francine Clark
Art Institute, Williamstown

Although Bonnard had already used concentrated areas of patterned material to emphasize the purely decorative non-naturalistic aspects of a painting in works such as *Grandmother with Chickens* (1890, DII), the change from the restrained flower pattern of the grandmother's dress to the strident checks of the lady in the foreground of *Women with a Dog* makes the emphasis upon two-dimensionality all the more forceful. The insistence upon the decorative quality of this painting is reinforced by Bonnard's reference to Japanese motifs such as the dog on the right (cf. no. 29) and the isolated blooms on the left, which recall his *Snowballs* of about the same date (D30). However, the dresses are still recognizably Parisian fashions of the early 1890s, and the small figures in the background do make some concessions to conventional spatial recession. This fusion between Japanese and Western art was recognized by Charles Saunier as a common starting-point for all the Nabis, although he went on to add that Bonnard, together with Vuillard, Ibels, Lautrec and Anquetin had used it to create a new decorative style in which the 'silhouette alone is retained, albeit drawn with great care, and emerges from a

background either very simply rendered or very complex in patterning' ('Les Peintres symbolistes', *Revue indépendante*, December 1892). Bonnard used the check dress as a forceful decorative motif in several paintings, e.g. *Woman in a Check Dress* (no. 30), *The Check Bodice* (1892, D36) and *The Croquet Game* (1892, D38). M A.S.

REFERENCE
D20

28

29 Two Dogs Playing 1891

Deux chiens jouant
sdcl. P. Bonnard 1891 37 × 39.7 cm/14½ × 15½ ins
Lent by Southampton Art Gallery

The virtual abolition of three-dimensional space in this picture, which forces the dogs and the background into an overall surface pattern of silhouette and arabesque, together with the subject matter itself, illustrate Bonnard's profound debt to Japanese prints. Interest in Japanese art had been developing rapidly during the 1880s in Paris; scholarly studies by Théodore Duret and Louis Gonse were published in 1882 and 1883 respectively; general information and lavish reproductions were made available when in May 1888 Bing founded the monthly *Le Japon artistique*; and major exhibitions of Japanese art were held at the Galerie Georges Petit in 1883, at the Exposition Universelle of 1889 and, more importantly for the Nabis, at the Ecole des Beaux-Arts in 1890. Furthermore, the Nabis could also have seen the radical results of an integration of Japanese artistic principles into the works of Gauguin, Bernard, Van Gogh

and, after 1889, in the revolutionary woodcuts of Auguste Lepère and Henri Rivière.

Almost all the members of the Nabis were influenced to some extent by Japanese art (cf. Sérusier, no. 193, and Vuillard, no. 233), although Bonnard's particular debt earned him the nickname *'le Nabi très japonard'*. While the critic Aurier (*Revue encyclopédique*, April 1892, in *Oeuvres posthumes*, 1893, p. 308) described the relationship between Bonnard's Japanese sources and his decorative expertise, Charles Saunier ('Le Salon des Indépendants', *Revue indépendante*, April–June 1892) proclaimed that, beyond all doubt, Bonnard was 'the most Japanese of all French painters'.

Other paintings which express a similar overt debt to Japanese art include *Snowballs* (c. 1891, D30) and, in parts, *Women with a Dog* (no. 28). M A.S.

REFERENCE
D27

30 Woman in a Check Dress c. 1891

Femme à la robe quadrillée
stl. PB oil on paper glued on canvas 160 × 48 cm/63 × 19 ins
Lent by Mrs Florence Gould, USA

30

29

31 *Woman in a Cape* c.1891

Femme à la pèlerine
stl. PB oil on paper glued to canvas 160 × 48 cm/63 × 19 ins
Lent by Mrs Florence Gould, USA

These two panels are from a set of four (D 0175a–d) which was exhibited at the Indépendants in 1891. By this date Bonnard had already been involved in large-scale decorative work. In 1889 he had received the commission for a poster for *France champagne* (published 1891) and it was almost certainly in the following year that he executed the decorative panel *The Gown – Woman Seen from the Back* (D14). Bonnard was the first of the Nabis to become involved with decorative works; Denis and Vuillard received their first commissions from Lerolle and Paul Desmarais respectively in 1892 (cf. no. 69).

While certainly reflecting the Nabis' admiration for Puvis de Chavannes' large-scale public mural decorations (cf. no. 161), the private, explicitly decorative character of Bonnard's panels also suggests that he owed something to the ideas of literary Symbolism. Disgusted by the contemporary world, Symbolist writers such as Huysmans and Gustave Kahn had called for the creation of an artificial world in which Art reigned supreme. One of the most

satisfactory ways of achieving this, as Alphonse Germain suggested, was to cover the walls with decorative panels: 'Oh frescoes on the walls, harmonious patterns of colour bounded by the knowledgeable lines of the masters! Oh to forget the ugliness of the street when we look at the idealized landscapes, the lyrical messengers of the Infinite' (*L'Ermitage*, 1892). Bonnard's particular facility in this genre was noted by Aurier in 1892 ('Les Peintres symbolistes', *Revue encyclopédique*, April 1892, in *Oeuvres posthumes*, 1893, p. 308), when he declared that Bonnard was 'a delicious ornamentalist . . . capable of decking out all the ugly things in our life with the ingenious and iridescent floral patterns of his fantasy'.

Along with his fellow Nabis, Bonnard continued this association with the decorative arts throughout the 1890s. For example, he executed another decorative panel in 1894 (*Nude with a Background of Foliage*, D73), worked for Bing's Maison de l'Art Nouveau in 1895, and designed a number of free-standing screens. M A.S.

EXHIBITIONS
(For no. 30) 1891, Paris, Indépendants (127)
(For no. 31) 1891, Paris, Indépendants (128)
REFERENCES
(For no 30) DO1715c
(For no 31) DO1715d

31

32

32 *The Barrel Organ Grinder* 1895

Le Joueur d'organe
sdbc. 95 P. Bonnard oil on panel 41 × 26 cm/16 × 10¼ ins
Lent by E. V. Thaw and Co., Inc.

From *The Street* (D8) onwards, Bonnard had displayed intense interest in the variety of subject matter and compositional devices which could be found in street scenes. This picture's high viewpoint, tight organization of space into flat horizontal bands, which rise up the picture-surface, and the meticulously judged rhythm of the dark organ grinder, curved archway and rectangular, open window are also found in other paintings of similar date, such as *Street at Eragny-sur-Oise* (D63). Bonnard continued to explore these effects throughout the later 1890s and in his first volume of colour lithographs commissioned by Vollard and published in 1899. Bearing the general title of *Some Aspects of Paris Life*, two plates, *Street Corner*

Seen from Above and *House in a Courtyard*, are closely related to *The Barrel Organ Grinder*. As with *Two Dogs Playing* (no. 29), both this painting and the lithographs express Bonnard's debt to Japanese prints, especially the townscapes in Hiroshige's *One Hundred Views of Famous Places in Edo*.

Bonnard's apparent concern to capture a small moment from contemporary life would suggest that he shared interests with the Impressionists. Camille Pissarro thought otherwise. When referring to Bonnard's one-man show held at Durand-Ruel's in January 1896, he burst out: 'Yet another symbolist has perpetrated a fiasco! . . . all the painters who have respect for themselves, Puvis, Degas, Renoir, Monet and your humble servant, are unanimous in finding hideous the exhibition which has taken place at Durand's. This symbolist is called Bonnard! What's left to say? It is a complete fiasco!' (*Letters to his son Lucien*, 1943, pp. 281–2). Pissarro implies that Bonnard's paintings should be interpreted in the same light as Vuillard's domestic interiors (cf. no. 237); '*intimisme*' is not the mere record of the small-scale events of everyday existence but the means of expressing truths which lie beneath their surface. M A . S .

REFERENCE
D91

33

33 *Place Pigalle* 1900

sdbl. Bonnard 1900 32 × 58 cm/12½ × 23 ins
Lent by Sir Isaac Wolfson

While reflecting Bonnard's interest in street scenes (cf. no. 32), this picture also shows his debt to Japanese prints. The organization of people and buildings into long, horizontal planes in this picture suggests that he was looking here to the prints of Kiyonaga rather than to Hiroshige. Bonnard had used this frieze-like organization of compositional elements in several of his street scenes: in paintings such as *Le Fiacre* (D92 *bis*); in the lithographs *Boulevard* and *Street, Evening, Rain*, both published as part of the 1899 Vollard volume, *Some Aspects of Paris Life*; and in his screens, for example, the four-panel colour lithographic screens published in 1899 (Museum of Modern Art, New York).

As with many of Vuillard's intimist paintings (e.g. *The Outspoken Dinner Party*, no. 235), the interest in the bustle of street life shown by Bonnard in paintings such as this seems to set them apart from the expression of the Idea which formed the basis of the Nabis' artistic programme. However, the rigorous simplification of subject matter and the emphasis on harmonious colour pattern indicate that Bonnard, as Gustave Geffroy recognized (*Le Journal*, 8 January 1896), wished to express his personal response to the Idea of contemporary life, rather than to capture its ephemeral, detailed appearance. This he achieved by distillation of the scene observed through memory and reflection. M A . S .

REFERENCE
D241

34 *The Red Garters* c. 1904

Les Jarretières rouges
sbl. Bonnard 61 × 50 cm/24 × 19½ ins
Lent by a Private Collector, Switzerland

Bonnard's interest in nudes emerges towards the end of the 1890s (e.g. *The Indolent Woman*, 1899, Palais de Tokyo, Paris, D219), which coincides with the stylistic disintegration within the Nabis. Both in technique and subject matter this painting aptly summarizes Bonnard's approach to his newly adopted genre. The loose, rapidly executed technique seems to caress the form of the nude figure, while the prominence given to the red garters transforms the painting into a softly spoken, erotic statement.

Bonnard's work after 1900 incorporates two stylistic developments shared with his Nabi friends. Faced with the difficulty of giving pictorial form to the Idea as the subject matter of painting in the 1890s, Denis and Roussel had returned to classicism (cf. nos 71 and 183) and Vuillard to naturalism (cf. no. 239). Bonnard found his solution to the problem in a blend of these two. Thus, as Thadée Natanson pointed out in June 1912, Bonnard succeeded in combining in a single picture aspects of Greek sculpture and the art of Raphael, which he had come to admire, perfectly fusing these with an everyday event such as 'the girl who has just undressed in his studio; he does not even give her time to finish taking off her stockings, he does not even allow her to take up a pose. . . . [he paints her as she is] surrounded by the ripple of discarded dress and underwear . . .' (T. Natanson, *Peints à leur tour*, 1948, p. 336.) M A . S .

REFERENCE
D300

34

Braque, Georges 1882–1963

Brought up in Le Havre where he met Dufy, Braque was based in Paris from 1902, where he studied under Bonnat, painting first in a sub-Impressionist style, then, from 1905–6, under the influence of the Fauves. He visited the south regularly during 1906–12, working most often at L'Estaque. Increasingly influenced by Cézanne from 1907, he met Picasso in the same year, and the Cubist style evolved in 1907–10 from their association. Braque exhibited with the Indépendants in 1906–9, with the Salon d'Automne in 1907, and after that date mainly with dealers.

35 *The Port* 1906

Le Port
sdbl. G. Braque 06 46 × 55 cm/18 × 21½ ins
Lent by a Private Collector

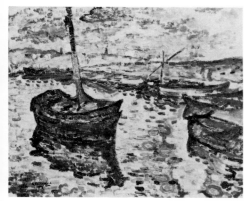

35

Braque's earliest surviving Fauve paintings date from a stay in Antwerp in summer 1906. That autumn, after the Salon d'Automne, he went to the Mediterranean coast to paint at L'Estaque, west of Marseille, where Derain had spent the summer. His handling became bolder and his colour stronger in his L'Estaque paintings such as *The Port*, and he adopted a varied touch reminiscent of Derain's 1905 Collioure canvases (cf. no. 73), juxtaposing emphatic dabs, residually inspired by Neo-Impressionism (cf. no. 216), with flatter colour-planes, often outlined in cursive ribbons of colour. This 'mixed' style is a synthesis of the recent Fauve work of Derain and Vlaminck with the lessons of the major Gauguin retrospective at the 1906 Salon d'Automne. The use of linear arabesques, very prominent in some of the L'Estaque paintings, may owe something, too, to Matisse's *Le Bonheur de vivre* (Barnes Foundation, Merion, Pa.), shown at the Indépendants that spring.

On a return visit to the south, to La Ciotat, in summer 1907, Braque began to introduce a tauter planar structure to his work, initially alongside his luminous Fauve colour, but later in the year with more sombre colours and more angular forms. At this point in his development, Cézanne became of central importance to Braque's art, and set him on the path which led to the genesis of Cubism (cf. W. Rubin, 'Cézannisme and the Beginnings of Cubism', in Rubin [ed.], *Cézanne, The Late Work*, 1977). J.H.

Camoin, Charles 1879–1965

Camoin was born in Marseille, and studied art there from 1895 until he left to join Moreau's studio at the Ecole des Beaux-Arts in Paris in 1896, where he met Marquet, Matisse, and the rest of the Fauves-to-be; he met Cézanne at Aix-en-Provence in 1901. He began to show regularly with the Indépendants in 1903, and at the Salon d'Automne in 1904. From 1904 onwards he travelled widely, particularly around the Mediterranean; he painted mainly landscapes and figure-pieces.

36 *Madame Matisse Doing Tapestry Work* 1905

Madame Matisse faisant de la tapisserie
sbr. Camoin 65 × 81 cm/25½ × 32 ins
Lent by the Musée d'Art Moderne, Strasbourg

Camoin provides one of the crucial historical links in the evolution of Fauvism. He was the only close associate of Matisse and Derain who knew Cézanne personally – he had visited him in Aix on several occasions, and had received letters from him; in 1905, Camoin published a series of Cézanne's sayings on art, in Charles Morice's 'Enquête sur les tendances actuelles des arts plastiques' (*Mercure de France*, 1 August 1905, pp. 353–4). Camoin himself never painted with the freedom and improvization of Matisse or Derain, working often with heightened colour, but in a more naturalistic vein than the other two artists.

Madame Matisse Doing Tapestry Work belongs to one of the closest moments of collaboration among the Fauve group (cf. Elderfield 1976). Derain had painted Matisse's wife in a Japanese gown, and she exhibited a tapestry made after Derain's painting at the Indépendants in 1905; while she was making it, both Marquet and Camoin painted her. In Camoin's painting the colour and brushwork are simple and basically descriptive; its complexity comes from its space and pattern, from the interplay between furniture, figure and pictures, with varied diagonals set off against rounded shapes. Matisse explored similar effects in his interiors, as did Vuillard (cf. nos 130 and 239), and there is perhaps a trace in Camoin's painting of the complex arrangements of Cézanne's later still-lives (cf. no. 43). J.H.

REFERENCE
J. Elderfield, *Fauvism and its Affinities*, 1976, pp. 41–3

36

Carrière, Eugène 1849–1906

Brought up in Strasbourg and apprenticed to a lithographer, Carrière decided in 1869 to become a painter. He went to Paris to study under Cabanel at the Ecole des Beaux-Arts, supporting himself with lithographic work in Jules Chéret's studio, among others. He visited London in 1876–7 where he admired Turner's work. Towards the end of the 1880s his style changed from naturalism to one of monochrome mists which enveloped vaguely transcribed forms, creating a sense of mystery that greatly appealed to the younger generation of artists. He exchanged paintings with Gauguin, executed portraits of Verlaine and Edmond de Goncourt, and in 1904 a banquet was given in his honour, arranged by Rodin.

37 *Motherhood* c. 1890

Maternité
sbl. Eugène Carrière 53.5 × 71 cm/21 × 28 ins
Lent by the National Museum of Wales, Cardiff

37

At the 1879 Salon Carrière exhibited a picture entitled *Maternité*, whose subdued naturalism emphasized the sentimental narrative of the subject. In this later treatment of the same theme, while Carrière still makes use of his family and immediate environment for his models, he so masks the specificity of these references by casting a mist over the painting that it ceases to be either a narrative or a portrait and becomes a statement about a general emotional state. The interplay between the real and the ideal in Carrière's work, which emerged with the introduction of his *sfumato* technique at the end of the 1880s, won him praise from writers and critics alike. Edmond Rod, in 1891, believed that Carrière's excellence lay not just in his 'perfect workmanship, his mastery of his tools' but also in the fact that he 'was a poet, a soul possessed of an interior life which is made immanent in his work' ('Les Salons de 1891', *Gazette des Beaux-Arts*, June 1891, p. 450).

Two years earlier, Paul Mantz had praised Carrière for his independence of expression, and claimed that his manipulation of light actually revealed states of mind, or ideals: 'In order to express the world of thoughts and new feelings, Eugène Carrière has created an ambiance of the ideal, derived from the real, in which Nature transforms herself into a new set of logical relationships. The delicate, unsettling atmosphere in which his figures live is observed within Parisian interiors at the hour when the filtered light suffuses all to create a world of nuance, gently dying as it touches each object. And this is also the milieu of his dream, the choice of his spirit, this veiled harmony in which nothing totally disappears, in which everything is purified, this sorrowful asylum where, far removed from all contact with a brutal world, in the centre of all he knows best, his beloved vision lives' ('Le Salon de 1889 – la peinture', *Gazette des Beaux-Arts*, June 1889, p. 444).

Despite Carrière's essentially naturalistic depiction of *Motherhood*, the symbolic use of light within a domestic, contemporary setting to reveal dreams and the ideal invites comparisons with the role of light as interpreted by Maeterlinck and Ibsen, and by artists such as Vuillard (cf. no. 235) and Bonnard. M A.S.

REFERENCES
Cardiff, National Gallery of Wales, *Catalogue of Oil Paintings*, 1955, no. 749
J. Ingamells, *The Davies Collection of French Art*, 1967, p. 96

Cassatt, Mary 1844–1926

Born near Pittsburgh, Mary Cassatt studied art in Philadelphia during 1861–5 before leaving the United States to travel widely in Europe. She first exhibited at the Paris Salon in 1872, and settled there in 1874, evolving her art through her contact with Manet, and particularly with Degas who became a lifelong friend. She exhibited with the Impressionists 1877–81, and at Durand-Ruel's gallery in the 1890s, principally painting women and children in interiors, and after 1890 making many prints.

38 *Women Reading* c. 1900

sbl. Mary Cassatt 38 × 49 cm/15 × 19¼ins
Lent by Hirschl and Adler Galleries, Inc., New York

Mary Cassatt adopted a freely brushed, soft-edged delineation of forms in the later 1870s, after her initial contact with Degas, but during the 1880s her drawing became tauter and more crisply silhouetted. Japanese prints certainly played a part in this development; she and Degas both greatly admired the exhibition of them at the Ecole des Beaux-Arts in 1890, but this can only have been a confirmation, since the finest Japanese prints were widely available in their circle during the 1880s. Connected with her change of style was her work as a printmaker, in which she explicitly used Japanese prints as her models. In 1891, the centrepiece of her exhibition at Durand-Ruel's gallery was a sequence of experimental colour prints treated in simple planes of colour with crisp contours.

Women Reading is characteristic of her later paintings; the outlines are clear, if less taut than they had been c. 1890. Cassatt's central preoccupation, as Degas wrote c. 1890, was the study of 'reflections and shadows on skin and costumes for which she has the greatest feeling and understanding, but without committing herself to using nothing but green and red to achieve her effects' (*Lettres de Degas*, ed. M. Guérin, p. 150, letter to Lepic; the gibe about red and green is presumably directed against the Neo-Impressionists). J.H.

REFERENCE
A. D. Breeskin, *Mary Cassatt, A Catalogue Raisonné of the Oils, Pastels, Watercolors and Drawings*, Washington, 1970, no. 346

38

Cazin, Jean Charles 1841–1901

Born at Samer in the Pas-de-Calais, Cazin studied in Paris under Lecoq de Boisbaudran, who encouraged the cultivation of the pictorial memory. On Legros' suggestion Cazin was based in London in 1871–4, making pottery. He lived in France from 1874. He showed at the Salon from 1876, winning a 1st-class medal in 1880, and with the Société Nationale from 1890. Until the 1880s he concentrated on figure paintings, often biblical, and thereafter on evocative landscapes in subdued colours.

39 *Tobias and the Angel* 1880

Tobie et l'ange
sdbr. J. Cazin 80 186 × 142 cm/73¼ × 56 ins
Lent by the Musée des Beaux-Arts, Lille

At the 1880 Salon Cazin exhibited two religious subjects, *Tobias and the Angel* and *Hagar and Ishmael* (Musée des Beaux-Arts, Tours); in the same Salon, Bastien-Lepage too showed a religious theme, *Joan of Arc* (Metropolitan Museum of Art, New York). Cazin recreated the story from the Apocrypha in the context of his own native

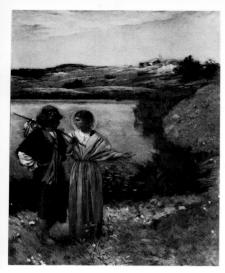

39

landscape, setting Tobias against a background characteristic of the open spaces of the Channel coast of the Pas-de-Calais around Boulogne.

Cazin shared with Bastien the belief that religious subjects were not incompatible with a Realist credo, challenging Courbet's famous dictum that one could not paint an angel if one had never seen one. Bastien justified this attitude in an interview, instructing the painter to go back to work in his home area: 'There you would quietly draw the portrait of your own province, and when, one morning, by chance, after reading some book, you were seized with the wish to paint the Prodigal Son, or Priam at the feet of Achilles, or anything else of the same kind, you would imagine the scene after your own fancy . . . , set in a frame of your own country with the best models you could find at hand, as if the old story were a thing of yesterday' (quoted J. Cartwright, *Bastien-Lepage*, 1894, p. 18).

Tobias is simply and thinly painted, muted in colour but quite luminous in tone, with soft blues to evoke atmosphere. The barren evening landscape, spreading out ahead of the figures, complements the mood of the story, of the angel encouraging Tobias to continue his toilsome journey. The mood and tonality of the landscape have similarities with Corot's late work and with Puvis de Chavannes' paintings. Puvis used similarly simple poses and modelling in the figures of his contemporary canvases such as *The Prodigal Son* (shown at the 1879 Salon; Bührle Foundation, Zürich; cf. too no. 161) – another religious painting in an everyday setting, and an important inspiration for Cazin's 1880 pictures. Cazin's handling contrasts with Bastien-Lepage's more ostentatiously realistic treatment of detail (cf. no. 10).

Tobias and the Angel and *Hagar and Ishmael* won great admiration, and a 1st-class medal, for Cazin in 1880, but critics from the Realist camp had mixed feelings about his and Bastien's religious subjects. Zola praised Cazin's feeling for nature, but disapproved of the 'mystic naturalism' of his subjects, and had similar reservations about Bastien's image of Joan of Arc's vision. Huysmans, however, found in Cazin a truly modern spirit, touching and evocative, while Bastien's *Joan*, for him, represented a spurious and false attempt to make naturalism palatable. J.H.

EXHIBITIONS
1880, Paris, Salon (661)
1889, Paris, Exposition Universelle, French section (273)
REFERENCES
P. de Chennevières, in *Gazette des Beaux-Arts*, June 1880, pp. 503–4
Huysmans, in *L'Art moderne*, 1883, pp. 139–40
Zola, 'Le Naturalisme au Salon', 1880, in *Ecrits sur l'art*, 1970 edn, p. 345
L. Bénédite, *J. C. Cazin*, 1901, p. 23
F. Benoit, *La Peinture au Musée de Lille*, III, 1909, no. 188

Cézanne, Paul 1839–1906

Son of a banker in Aix-en-Provence, Cézanne first visited Paris in 1861 to see his boyhood friend Emile Zola. There he met Camille Pissarro, who later introduced him to landscape and worked with him on occasions for many years, particularly in the 1870s. Throughout his life Cézanne worked partly around Paris and partly in Provence, exhibiting his work rarely; he showed with the Impressionists in 1874 and 1877, and then exhibited little until 1895, when the young dealer Vollard took up his work. In the 1880s, his paintings were only available through colour-merchants such as Père Tanguy. Alongside his landscape and still-life painting from nature, Cézanne continued to paint imaginary subjects – the romantic figure scenes of his earlier years giving way to monumental compositions of bathers.

ABBREVIATIONS
V – L. Venturi, *Cézanne, son art, son oeuvre*, Paris, 1936
Paris 1978 – Pairs, Grand Palais, *Cézanne, les dernières années*, catalogue by J. Rewald, 1978
Conversations – *Conversations avec Cézanne*, ed. P. M. Doran, Paris, 1978

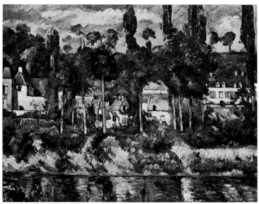

40

40 *The Castle of Médan* c. 1880

Le Château de Médan
sbl. P. Cézanne 59×72.5 cm/$23\frac{1}{4} \times 28\frac{1}{2}$ ins
Lent by the Burrell Collection, Glasgow Art Gallery and Museum

The Castle of Médan was painted while Cézanne was staying with Emile Zola at Médan, on the Seine north-west of Paris, probably in summer 1880. It shows the ordered brushwork which, by this date, he was imposing on to the natural scene; the foliage, in particular, is rendered in a systematic diagonal brushstroke, varied in colour but repetitive in direction, which gives a taut structure to the central band of the canvas.

This so-called 'constructive stroke' has given rise to much discussion: did it evolve first in Cézanne's imaginative compositions (as suggested by Reff, 1962), or simultaneously in his landscapes too? And should it be seen as a rejection of Impressionism, or as an extension of ideas which he had evolved while working with Camille Pissarro in the 1870s? There is virtually no documentary evidence for dating Cézanne's paintings of the later 1870s, and this stroke can first be securely located in *The Bridge of Maincy* of 1879 (V396, Jeu de Paume, Paris). However, in landscapes and imaginary figure compositions alike, a plausible sequence can be made which suggests that, in both genres of painting, Cézanne began to use occasional fairly heavy parallel diagonal strokes c. 1877, and gradually refined this procedure in the following two years.

Pissarro's work at the time supports this idea. In 1876–7 he adopted a tighter, more ordered handling, using small, evenly sized strokes placed in sequences which often run in a single direction (cf. no. 152). Only rarely, and then probably under Cézanne's influence, did Pissarro approach the extreme systematization seen in Cézanne's *The Castle of Médan*; but the tendencies in Pissarro's landscapes of 1877 (a year in which Cézanne was working with him at Pontoise) show that Cézanne had a stimulus at this point towards a more ordered handling, and that such a procedure could be introduced into landscape without repudiating the careful study of nature which Pissarro had taught him.

There are also similarities between the working methods of the two artists. Both, at this date, painted the initial layers of a canvas quite thinly and broadly (as in the more lightly worked sky of *The Castle of Médan*), and only introduced more systematic brushwork in the more highly worked parts of their pictures; thus Cézanne's 'constructive stroke' was not an alternative to sketching from nature, but a means of imposing greater pictorial order on to sketchier beginnings.

The Castle of Médan is one of Cézanne's most densely worked canvases of this period. The houses are built up very thickly, without the 'constructive stroke', and the colour accents and nuances on them complement the colour variations in the foliage. The forms of the houses are played off against the trees, a structural device favoured too by Pissarro (cf. *The Côte des Boeufs at the Hermitage, Pontoise*, 1877, National Gallery, London), and repeatedly echoed by Cézanne in later years (cf. no. 45). Cézanne's care in working out the compositional details of this canvas is shown by the existence of an outline drawing establishing the detailed relationships between trunks and buildings just left of centre in the picture (VI 588, cf. Ratcliffe 1973).

Paul Gauguin was the first owner of *The Castle of Médan*; though he left the canvas behind him in Denmark in 1884, he remembered it well enough to describe it in detail in his late autobiographical notes *Avant et après* (cf. Bodelsen 1970), and its taut brushwork had a great influence on the systematization which Gauguin introduced into his own paintings in the later 1880s (cf. no. 83). J.H.

EXHIBITION
1889, Copenhagen, Kunstforeningen, *Scandinavian and French Impressionists*
REFERENCES
V325
Gauguin, *Avant et après*, 1903 (English edn 1930, p. 200)
M. Bodelsen, 'Gauguin's Cézannes', *Burlington Magazine*, May 1962, p. 208
M. Bodelsen, 'Gauguin, the Collector', *Burlington Magazine*, September 1970, p. 606
London, Arts Council, *Watercolour and Pencil Drawings by Cézanne*, catalogue by R. W. Ratcliffe, 1973, pp. 157–8, sv. nos 37–8
T. Reff, 'Cézanne's Constructive Stroke', *Art Quarterly*, autumn 1962, pp. 220, 226 n. 21

41 *Still-Life with Plate and Fruit-Bowl* c. 1880

Nature morte, assiette et compotier
ns. 43.5 × 54 cm/17 × 21¼ ins
Lent by the Ny Carlsberg Glyptotek, Copenhagen

In some ways, still-life painting was an ideal outlet for Cézanne. He could arrange his subject as he chose before painting it, instead of depending on the arrangements of nature, and he could then work from an ensemble in front of his eyes, instead of depending on his imagination as he did in his Bather compositions. He began painting still-life in earnest c. 1870, perhaps under the stimulus of the great collection of still-lives by Chardin which had entered the Louvre in 1869 in the La Caze bequest. In his still-lives of the 1870s and early 1880s, Cézanne worked very much within the Chardin tradition, presenting objects frontally and generally separate from each other, in static, monumental groupings. In *Still-Life with Plate and Fruit-*

41

Bowl, probably painted during a stay around Paris c. 1880, this monumentality is complemented by the painting's technique. Many of its forms are densely built up within their contours, in ordered sequences of parallel brushstrokes – the so-called 'constructive stroke' which dominated his more highly worked canvases of this period (cf. no. 40).

The shapes in the painting are carefully inter-related – the angular modelling of the napkin set off against the curves of fruit and bowls, making contrasts which are echoed in the floral wallpaper of the background. In its smaller-scale relationships, the canvas shows Cézanne's willingness to subordinate literal description of objects to the demands of pictorial coherence: the light and shade patterns of the napkin dissolve into those of the stem of the fruit-bowl, and, on the right edge of the table top, the plate's shadow is displaced downwards to emphasize the lit edge of the plate itself, while, above this, the table top becomes abnormally light beside the red side of the apple and the dark back edge of the plate.

Gauguin owned a Cézanne still-life (V341, Private Collection) very similar to the present painting; he used it in the background of his *Portrait of Marie Derrien* of 1890 (Wildenstein 387, Art Institute, Chicago), and, in turn, Denis used it as the focus of his 1900 *Homage to Cézanne* (Palais de Tokyo, Paris). It was the solid paint surfaces and crisply demarcated fruit of still-lives such as these which made Cézanne such an important influence on Bernard, in particular, as he turned against Impressionism during 1887 (cf. no. 13). The static forms of Cézanne's still-lives of c. 1880 can be contrasted with the more freely flowing rhythms of Monet's contemporary fruit-pieces (cf. no. 135). J.H.

REFERENCES
V342
F. Novotny, *Cézanne*, 1971 edn, pl. 20, repr. in colour

42 *The Sea at L'Estaque* c. 1885

La Mer à L'Estaque
ns. 71 × 58 cm/28 × 22¾ ins
Lent by Lord Butler of Saffron Walden, KG, PC, CH

The experience of painting in the south showed Cézanne the full potential of colour. In the early 1870s Camille Pissarro had taught him to 'replace tonal modelling by the study of colours', and had justified this on naturalistic grounds, but the implications of this became clearer to Cézanne only when, in 1876 at L'Estaque on the coast west of Marseille, he began to paint a motif of red roofs against the blue sea: 'The sunlight here is so intense that it seems to me that objects are silhouetted not only in black and white, but also in blue, red, brown and violet. I may be mistaken, but this seems to me to be the opposite of modelling' (letter to Pissarro, 2 July 1876; cf. letter of

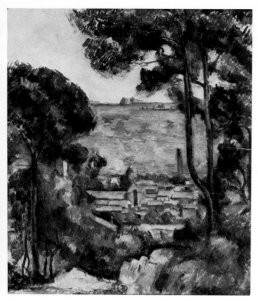

42

24 June 1874; *Correspondance de Paul Cézanne*, 1978, pp. 152, 147). The painting mentioned here (v168) was the first of a long sequence, including *The Sea at L'Estaque*, in which Cézanne looked down from the hills above L'Estaque across the roofs of the village to the Bay of Marseille, using the contrasts between the red-orange roofs and the blue sea as the pivot of his compositions.

Late in his life Cézanne told Maurice Denis that one of his greatest discoveries had been that 'sunlight cannot be *reproduced*, but that it must be *represented* by something else – by colour' (Denis, in *L'Occident*, September 1907, quoted *Conversations*, p. 173). His paintings show the results of this lesson in two ways – in the shifting colour nuances, or modulations, which he used to suggest relationships of small-scale forms and textures, and in his use of dominant colour-contrasts, like the oranges and blues in *The Sea at L'Estaque*. These devices appeared particularly in his paintings of southern scenes, as they did in Monet's Mediterranean canvases of the 1880s (cf. no. 139); both artists found that the light of the south brought home to them the impossibility of imitating nature directly, and forced them to think of coloured paint as an independent means of conveying light.

The composition of *The Sea at L'Estaque* complements the organization of its colour, with darker trees acting as *repoussoirs* framing the central coloured vista, and the edges of the tree at the top centre framing the distant island. These correspondences of form and colour, space and pattern, were Cézanne's means of 'revivifying Poussin in front of nature', which, he told Camoin, was his aim in his landscapes (this remark was first published by Camoin during Cézanne's lifetime, in *Mercure de France*, 1 August 1905, p. 353; cf. Camoin, no. 36), Past art, for Cézanne, was not a historical straitjacket. Throughout his career he studied and copied from works of art in the Louvre, and used these experiences as a means of revitalizing his own perceptions of form and colour. He could at the same time 'realise his sensations' in front of nature, and 'make of Impressionism something solid and durable like the art of the museums' (conversations with Bernard and Denis, *Conversations*, pp. 36, 170). J.H.

EXHIBITION
1913, Brussels, Libre Esthétique, *Interprétations du Midi* (50)
REFERENCES
v406
D. Cooper, *The Courtauld Collection*, 1954, no. 9, p. 86

43 *Still-Life with Pots and Fruit* 1890/4

Nature morte, pots et fruits
ns. 65.5 × 81.5 cm/25¾ × 32 ins
Lent by a Private Collector

Only in the later 1880s did Cézanne find a way of going beyond the Chardin tradition in his still-lives (cf. no. 41); he began to abandon the frontality of his earlier compositions, in favour of elaborate counterpoints between shapes and textures, colours and patterns. In *Still-Life with Pots and Fruit*, tablecloth and drapery, fruit on and off the bowl, and bottle and jars are drawn together into a lavish network of contrasting shapes, against a soft but austere grid suggested in the background and by the bottle.

The young painter Louis le Bail watched Cézanne, probably in the late 1890s, setting up a still-life motif of a napkin, a glass containing red wine, and peaches: 'The cloth was very slightly draped upon the table, with innate taste. Then Cézanne arranged the fruits, contrasting the tones one against the other, making the complementaries vibrate, the greens against the reds, the yellows against the blues, tipping, turning, balancing the fruits as he wanted them to be, using coins of one or two *sous* for the purpose. He brought to this task the greatest care and many precautions; one guessed that it was a feast for the eye to him' (quoted J. Rewald, *Paul Cézanne*, 1950, p. 174).

Many of Cézanne's still-lives contain minor inconsistencies of perspective, like the left-hand jar in *Still-Life with Pots and Fruit*, of whose top we see too much. These can be explained, not as a deliberate assault on traditional perspective, but as a reflection of the painter's physical proximity to his subject; his every move would have modified the relationships within it, and, as he concentrated on the jar-top, he may well have leaned forward, thus altering his view of its perspective. Small inconsistencies never bothered him, since he was seeking not a precise illusionism, but a harmony of coloured relationships on the canvas; when friends pointed out oddities in his canvases, he used to laugh them off; 'I am a primitive, I've got a lazy eye,' he told Rivière and Schnerb in 1905, 'I presented myself twice to the Ecole [des Beaux-Arts], but I could never get the proportions right: a head interests me, and I make it too big' (quoted *Conversations*, p. 87). J.H.

EXHIBITION
1912, Cologne, Sonderbund (129)
REFERENCES
v598
J. Elderfield, *European Master Paintings from Swiss Collections*, New York, 1976, pp. 30–1

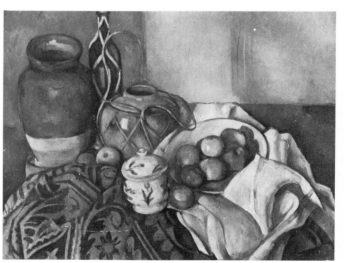

43

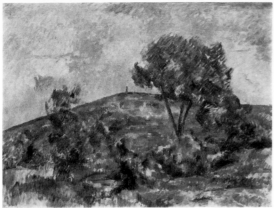

44

44 Landscape near Aix with the Tour de César c. 1895

Paysage près d'Aix avec la Tour de César
ns. 73 × 92 cm/28¾ × 36¼ ins
Lent by a Private Collector, the Netherlands

This landscape shows, on the far hilltop, the Tour de César, a late medieval watch tower about three miles north-east of Aix-en-Provence, seen from the hills north of the Château Noir, where Cézanne had a studio at the time (cf. map in W. Rubin [ed.], *Cézanne, the Late Work*, 1978, pp. 96–7). Like his views of the Montagne Sainte-Victoire, but unlike his late scenes of trees and rocks (cf. nos 45 and 97), it shows a panoramic sweep of the Provençal countryside, which is emphasized by the bold line of the hilltop, cutting across the whole picture.

All areas of the canvas are painted, but none are heavily reworked. In some zones, the parallel brushstrokes, used to suggest the textures of foliage, show the legacy of Cézanne's 'constructive stroke' of c. 1880 (cf. no. 40); however, the strokes here are applied loosely, without the regimentation or the dense impasto of the earlier paintings. The white priming, showing through semi-translucent paint layers, gives the image a luminosity comparable to the effect of watercolour. Indeed, Cézanne's developing use of watercolour from the later 1880s onwards may have contributed to this simplification in his handling of the oil medium at this period, though in many of his last oils (cf. nos 46 and 49) the medium regains its density and opacity.

To convey the southern sunlight, Cézanne has used a high-key colour range in *Landscape with the Tour de César*, setting off greens and blues against a range of oranges and reds. These warm colours are picked up by the small zones of stronger red in the tree trunks, which provide a hot spot near the centre of the picture as a pivot around which the rest of the colour scheme revolves. Cézanne often gave his colour compositions small exaggerated colour accents such as these, to give them a focal point. He was probably referring to such devices in 1904 when he described to Bernard his means of giving a picture its 'effect': 'The effect creates the picture, it unifies it and concentrates it; one must base it on the existence of a dominant colour-patch (*tache*)' (quoted *Conversations*, p. 37, cf. n. 20, pp. 192–3). J.H.

REFERENCES
v300 (as 1878–83)
Aix-en-Provence, Pavillon de Vendôme, *Paul Cézanne*, 1961 (14, as 1894/6)

45 Undergrowth c. 1897

Sous-bois
[repr. in colour on p. 35]
ns. 54.5 × 46 cm/21½ × 18 ins
Lent by Marlborough Fine Art (London) Ltd

Ever since the 1870s, Cézanne had returned continually to subjects dominated by trees, using them to give pictorial structure against which he could play off the other elements in the scene (cf. no. 40). After c. 1895, he pared down to a minimum the extraneous elements, and concentrated on the relationships between the lines of tree-trunks and the texture of foliage, often set off against the solid mass of rocks. Cézanne found his subjects for these paintings in the Fontainebleau forest (where *Undergrowth* may have been painted) on his visits to the north in the later 1890s, and in particular on the rocky hillsides above the Château Noir outside Aix (cf. no. 47), and in the nearby Bibémus quarry. In contrast with the deep space of his late paintings of the Montagne Sainte-Victoire, these tree canvases – mainly in a vertical format – present enclosed views, with only glimpses of sky and distance, and the subject becomes a sort of screen in front of the eyes, which Cézanne recreated in networks of coloured planes.

These subjects best allowed him to fulfil the tenets which he explained to Emile Bernard in 1904: 'To read nature is to see it, as if through a veil, in terms of the interpretation in patches of colour which follow each other according to a law of harmony. . . . Modelling results from the exact relationship of colours. When they are harmoniously juxtaposed and complete, the picture develops modelling of its own accord' (quoted *Conversations*, p. 36). In *Undergrowth*, the principal relationships are between the blues and greens, and the contrasting accents of orange which animate the surface. J.H.

REFERENCE
v382 (as 1882–5)

46 Standing Nude 1898/9

Femme nue debout
[repr. in colour on p. 37]
ns. 92.5 × 71 cm/36½ × 28 ins
Lent by a Private Collector, USA

The nude played a central role in Cézanne's art throughout his career, in the imaginary paintings which culminated in his compositions of Bathers (cf. no. 48). But, paradoxically for an artist who evolved in close contact with the Impressionists, direct study from the nude model played very little part in these compositions. Cézanne's personal shyness and the prejudices of provincial society in Aix-en-Provence stood in his way, and his study of past art, with a few of his own student nude studies, supplied him with what material he needed, with the one major exception of the present painting and the closely related watercolour (v1091; Paris 1978, no. 98). These were painted, according to Vollard, in Paris in 1898/9, from an ageing model, identified by Rivière as a certain Marie-Louise, who may also have been the model for two clothed figure-pieces at much the same time (v703, 705; cf. Paris 1978; on Cézanne's attitude to women, cf. Rivière, *Le Maître Paul Cézanne*, 1923, pp. 143 ff.). It has been suggested that he chose a middle-aged model because she would disturb him less, although he told Larguier that 'the body of a woman reaches fullness at around fifty' (L. Larguier, *Cézanne*, 1947, p. 77).

The model is presented in an obviously unnatural posture, with echoes of past art, and of poses from some of Cézanne's own previous compositions. It may well have been the starting-point for a figure in a four-bather composition of c. 1900 (v726, Ny Carlsberg Glyptotek, Copenhagen), but it should not be seen simply as a preparatory study for this one picture; it was, essentially, an addition to the repertory of images and poses upon which Cézanne could call in constructing his compositions, and a similar pose occurs in one of the *Grandes baigneuses* canvases (v720, Barnes Foundation, Merion, Pa.).

In the present oil version, the body is fully modelled in varied nuances of colour, with the soft flesh textures quite explicitly suggested around the belly, while in the related watercolour it is left largely unpainted. In the oil the whole pose, especially the head, is turned a little more towards the spectator. These factors suggest that both works were executed directly from the model, rather than, as has been suggested, the oil being a reworking based on the watercolour. The different media, too, give the two paintings a very different effect – the richest colour in the watercolour is mainly in the lower band of the background wall, while in the oil this band, though treated in various deep colours, is kept subsidiary to the modulations in the figure and the oranges in the floor and upper wall. This reversal of formal structure between the two works shows how responsive Cézanne was to the differences between the two media; the development of his late oil technique is not as closely related to his work in watercolour as has sometimes been suggested, and the most fully realized oils from his last years build up a density of colour utterly unlike the natural translucency of watercolour (cf. no. 49). J.H.

REFERENCES
V710
G. Rivière, *Le Maître Paul Cézanne*, 1923, p. 222
A. Vollard, *Cézanne*, 1914, quoted *En Écoutant Cézanne, Degas, Renoir*, 1938, p. 59
Paris 1978 (97), and cf. (98)

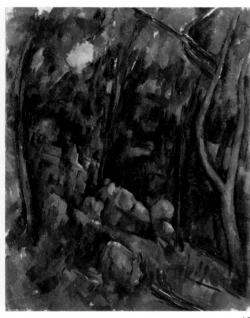

47

47 *In the Park of the Château Noir* c. 1902

Dans le parc du Château Noir
ns. 90.5 × 71.5 cm/35¾ × 28¼ ins
Lent by the Trustees of the National Gallery, London

The rocky hillsides above the Château Noir, to the east of Aix, gave Cézanne a mass of taut structures which he could integrate into his favoured motif of trees and foliage (cf. no. 45). In this late example the colour is generally more subdued than in his landscapes of the 1890s, with a few sharp orange-reds and luminous points in the central rocks acting as the pivots around which the rest of the composition revolves, with rapports of greens, yellows, light blues and softer oranges knitting the whole together. In his last figure-pieces, too, his colour was often comparatively muted (cf. nos 48 and 49).

In the Park of the Château Noir, and very many of his other later landscapes (cf. no. 45), seem to belie his often repeated insistence that, in nature, 'there is no such thing as line' (cf. e.g. *Conversations*, p. 36, as recorded by Bernard); their surfaces show recurrent linear strokes, often in deep blue, which give objects fragmentary contours. However, these lines, as Rivière and Schnerb learned from Cézanne in 1905, 'were not a separate element meant to be added to colour, but simply a means of more easily redefining by a contour the shape of a form before modelling it with colour' (quoted *Conversations*, p. 87). In 1906 Cézanne explained to another visitor, Karl Osthaus (founder of the Folkwang Museum at Hagen), the problems which he had in expressing modelling and depth by colour alone, and showed him one of his canvases of trees and rocks: "Colour has to express all the breaks in space".... And, saying this, his fingers followed the boundaries of the various planes on his pictures. He showed exactly how far he had succeeded in suggesting depth, and where the solution had yet to be found; here the colours remained colour without becoming the expression of space' (quoted *Conversations*, p. 97). So the lines in Cézanne's canvases must be seen, in a sense, as provisional, like the areas of unpainted canvas (cf. no. 48); both lines and gaps might have been covered over if he had continued work on the canvas. But, at the point at which work was left off on each canvas, these lines and gaps played an integral part in its effect; indeed, small linear gestures were among the last touches which Cézanne put to many of his canvases, presumably at the points where the full expression of distance by colour had eluded him. J.H.

REFERENCES
V787
London, National Gallery, *French School, 19th century*, catalogue by
 M. Davies and C. Gould, 1970, p. 21

48 *Women Bathing* 1902/6

Baigneuses
ns. 73.5 × 92.5 cm/29 × 36½ ins
Lent by M. Feilchenfeldt, Zürich

Alongside landscapes and still-lives, Cézanne painted imaginary compositions of Bathers in outdoor settings throughout his career. These culminated in three monumental canvases, executed in the last decade of his life, and in a number of smaller ones, including the present version, probably executed in his very last years, in which he began to explore increasingly fluid relationships between figures and setting.

By the late 1870s Cézanne had abandoned the overtly erotic content of his previous imaginary subject pictures in favour of groups of Bathers, generally inactive and without obvious narrative content; rarely did he present figures of both sexes in a single picture. These compositions were painted in the studio, and largely

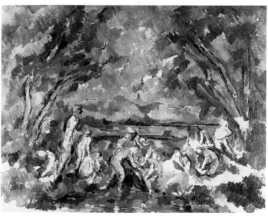

48

57

built up from Cézanne's experience of past art, very rarely from direct study of the model (cf. no. 46). The present painting, and the others from his last years, relate most closely to the last of the three large Bather compositions (v710, Philadelphia Museum of Art; on the dating of these, cf. Paris 1978 [96]), in showing a distant background beyond the figures, seen through the arched framework of trees. Both the Philadelphia painting and the present canvas are quite thinly painted, with many elements suggested by unpainted white-primed canvas. However, even though their surfaces are incompletely covered, neither should be seen as unresolved (cf. Paris 1978 [104]). 'Finish', in the conventional sense, had no meaning for Cézanne. His aim was to 'realize' each painting as fully as possible, in terms of relationships between coloured planes, and in some paintings, like the present one, the effect could be resolved without the canvas being completely worked, though Cézanne was aware that these gaps posed a problem. He wrote to Bernard in 1905: 'The coloured sensations which create the light produce abstractions which do not allow me to cover my canvas, nor to pursue the delimitation of objects where their points of contact are fine and delicate; hence my image or picture is incomplete' (*Correspondance*, 1978, p. 315, letter of 23 October 1905; cf. nos 44 and 47).

In the present picture, the figure groupings are quite unlike those in Cézanne's other Bather oils; they are more animated, and focused on some central incident or ritual around which four figures are bending. Similar focuses of interest appear in some of the smaller Bather pictures of the 1880s. It has been suggested that, in these groupings, there is an echo of a biblical or mythological subject. Certainly no explicit narrative can be read into the present scene, nor would Cézanne have wished this; but the effect of the figure-groups, complemented by the movement of the trees which frame them, is to fuse figures and setting together, as if all were part of some over-riding pattern. In this way, perhaps, at the end of his life, Cézanne found a way to reconcile his love for nature with his insistence on the continuing need for order and classical values in art. J.H.

REFERENCES
v725
T. Reff, in *Cézanne, the Late Work*, ed. W. Rubin, 1977, p. 40
Paris 1978 (104)

49 *The Gardener Vallier* 1905/6

Le Jardinier Vallier
ns. 107.5 × 74.5 cm/42¼ × 29¼ ins
Lent by the National Gallery of Art, Washington,
Gift of Eugene and Agnes Meyer, 1959

At the end of his life, Cézanne painted a number of canvases of the gardener Vallier seated on the terrace outside his studio. Three of these are large and ambitious paintings – one (v717) seeing him frontally, the other two (v716 and the present version) in semi-profile. The present picture and v717 are in parts particularly heavily reworked, especially around some of the main contours, indicating that Cézanne again and again revised the relationships of colours at these salient points (cf. no. 47). In their palette, these canvases are almost sombre. Some of Cézanne's last works retain the overall brightness of colour of his paintings of the later 1890s, but many, even those which are less heavily worked than *The Gardener Vallier*, are more subdued (cf. nos 47 and 48). In these late paintings he did not abandon the use of bold accents of light tone and strong colour, but he seems to have found that he could give them their fullest value by fitting them into a more strongly defined structure of dark and light tones.

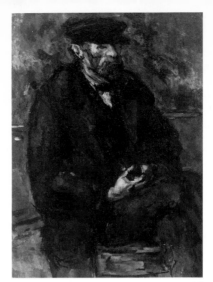

49

Both the present version and v716, which shows the same pose, have a strip of canvas added at their base which converts a standard portrait-sized canvas into a more elongated format which emphasizes the monumentality of the figure. In the present canvas, the paintwork is noticeably thinner on the added strip, whereas in v716 there is little or no difference. This shows that the strip was added during the execution of the present one – presumably because without it the composition seemed unduly squat – and suggests that v716 was begun later, perhaps with the strip already added. This practice of making a less densely painted version of the precise theme of an extremely heavily worked canvas is closely paralleled in two of Cézanne's last views of the Montagne Sainte-Victoire; vi529 (Kunstmuseum, Basle) seems to be a less wrought recreation of v803 (Pushkin Museum, Moscow; cf. Paris 1978 [90 and 91]). The later versions present, more boldly and effortlessly, what Cézanne had learned in the long labour of making the earlier ones.

Cézanne introduced little characterization into the faces in his late figure paintings of peasants, but used their poses to express character. For Vallier, and for many other peasant figures, he chose simple, static poses which emphasize their solidity; this monumentality and equilibrium gives them a quality similar to that which Cézanne gave to his pictures of the landscape in which they worked. These paintings belong to a long tradition of portraits in which the pose is used to express personality (e.g. by Degas and Van Gogh, cf. nos 63 and 98), and in Cézanne's frontal portrait of Vallier (v717, Paris 1978 [13]) he may have been deliberately translating into a peasant context a famous archetypal portrait of a man of a rather different type of substance and solidity, Ingres' *Portrait of Monsieur Bertin* of 1832 (Musée du Louvre, Paris, acquired in 1897). J.H.

REFERENCES
Not in v
Paris 1978 (14), and cf. (12 and 13)

Chabas, Paul 1869–1937

Born in Nantes, Chabas was trained at the Ecole des Beaux-Arts in Paris under Dagnan-Bouveret and Robert-Fleury. His career was a conventional one. He remained loyal to the 'old' Salon des Artistes Français, exhibiting annually, and was a member of its organizing body, the Société des Artistes Français. He was regularly awarded medals at this Salon. Although his output included portraits, it was as a painter of nudes that he received greatest acclaim.

50 *Happy Frolics* 1899

Joyeux ébats
sdbr. Paul Chabas 1899 202 × 315 cm/79½ × 124 ins
Lent by the Musée des Beaux-Arts, Nantes

Set in a landscape showing the banks of the river Erdre near Nantes, this picture of women bathing in the evening light can be interpreted on at least three levels, and summarizes some of the central concerns of Salon art in the 1890s. First it captures the frivolity and titillation of the current Rococo revival (cf. La Touche, no. 112); it remains an essentially decorative painting with its broad, rather loose touches of paint – the hallmark of much Salon painting of the 1890s (cf. nos 25 and 112). Second, as Paul Desjardins pointed out at length in his review of the painting at the Salon in 1899, it represents a logical step in the development of naturalism; having studied the dissolution of form by light, Chabas turned his attention to the dissolution of form and light by water. Desjardins noted that it was probably Roll (cf. no. 178) to whom Chabas was most indebted for this bold and sparkling representation. Finally, conscious of the debate between naturalism and idealism in painting raised in the Salons by Béraud's controversial *Mary Magdalene in the House of the Pharisee* (no. 11), and Aman-Jean's portraits (cf. no. 3), Desjardins also indicates a more serious purpose for this painting – Chabas demonstrates that all material elements in this world are as fleeting as the reflections, caught in the water, of the young women and the light. M.A.S.

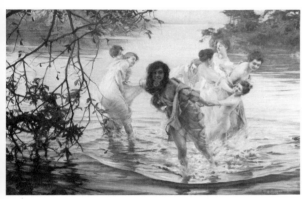

50

EXHIBITIONS
1899, Paris, Salon des Artistes Français (405)
1900, Paris, Exposition Universelle, *Exposition Décennale* (420)
REFERENCES
Paul Desjardins, 'Les Salons de 1899 – I', *Gazette des Beaux-Arts*, June 1899, pp. 450–1; 'Les Salons de 1899 – v', *Gazette des Beaux-Arts*, September 1899, p. 258
Nantes, *Catalogue du Musée des Beaux-Arts*, 1903, no. 808; 1913, no. 858; 1953, no. 858

Cottet, Charles 1863–1924

Born in Le Puy, Cottet moved to Paris to receive training from Puvis de Chavannes and Roll. Although he exhibited for the first time at the Salon of 1889, it was at the 1893 Salon that his unique treatment of Breton subjects was noted. Cottet visited Brittany very regularly and concerned himself with the portrayal of its grandeur and melancholy. His paintings tended to be grouped under composite headings, e.g. *Au Pays de la mer*, to illustrate the major events of Breton peasant life. In the 1890s he was recognized as the leader of a new school of 'dark' painting, known as the 'Bande noire', which included Simon and Dauchez, whom he had met in 1895.

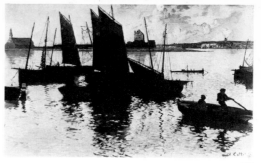

51

51 *Evening Light: the Port of Camaret* 1893

Rayons du soir: port de Camaret
sdbr. Ch. Cottet [?...] 1892 72 × 110 cm/28¼ × 43¼ ins
Lent by the Musée d'Orsay, Paris

Cottet exhibited his first Breton painting in the Salon of 1890 (*L'Anse de Toulinguet, Camaret* [Finistère]). During the next three years he exhibited three further paintings, including this one, which he sold to the Musée du Luxembourg in 1893.

Despite close contact with Gauguin and the Nabis through joint exhibitions with them at Le Barc de Boutteville, Cottet chose to adopt the sombre, semi-realistic style of this painting in order to capture the most tragic moods of Brittany. This affinity between tone, technique and subject in his paintings was frequently remarked upon by critics. Paul Desjardins ('Les Salons de 1899 – I', *Gazette des Beaux-Arts*, June 1899, p. 449), commenting upon a group of port scenes, declared that 'M. Cottet puts as much emotion into his port scenes devoid of people as he does into the human face ... even the tone is sad, with the wan façades and the black criss-cross pattern of masts, yard-arms, ropes, hung-up nets; all the objects are imbued with sadness. The painter's somewhat awkward and rugged technique accentuates this impression.'

Cottet continued to paint port scenes throughout the 1890s (cf. no. 52). With the execution of *The Burial* (exhibited at the 1895 Salon), he began a sequence of monumental Breton-peasant paintings including no. 53. M.A.S.

EXHIBITION
1893, Paris, Société Nationale (254)
REFERENCES
H. Bouchot, 'Les Salons de 1893 – I: la Peinture', *Gazette des Beaux-Arts*, June 1893, p. 474
G. Mourey, 'Charles Cottet's "Au Pays de la mer" and other works', *The Studio*, vol. 15, 1899, repr. p. 236
L. Bénédite, *La Peinture au XIX siècle*, 1909, repr. in colour, opp. p. 184

52 *In the Port* 1895

Dans le port
sdbr. Ch. Cottet 95 oil on canvas mounted on panel
47 × 57 cm/18½ × 22½ ins
Lent by the Musée St-Denis, Reims

This painting was executed in the year when Lucien Simon (cf. no. 217) introduced himself to Cottet at Georges Petit's gallery. Through Simon, Cottet also met Dauchez (cf. no. 59), Simon's brother-in-law. These three names were soon linked by several critics (e.g. Paul Desjardins, 'Les Salons de 1899 – I', *Gazette des Beaux-Arts*, June 1899, p. 474), who saw them as representatives of an important new school of painting in which Brittany took 'the place of the classic Italy' (M. Nordau, *On Art and Artists*, 1907, p. 216). Referred to as 'La Bande noire' by L. Bénédite in *La Peinture au XIX siècle*, 1909, p. 209, it is not certain whether they used this

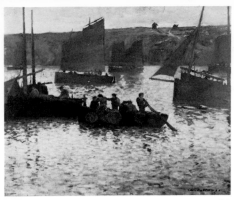

52

name themselves, for during the 1890s they neither adopted a uniform technique nor shared their interpretation of the Breton subjects which they all chose to paint. M A.S.

53 *The People of Ouessant Watching Over a Dead Child* 1899

Gens d'Ouessant veillant un enfant mort
sbr. Ch. Cottet 91 × 125 cm/35¾ × 49 ins
Lent by the Musée du Petit Palais, Paris

This picture belongs to a group of paintings under the collective title *Au Pays de la mer*, which records the different aspects of the fishing community on the Breton island of Ouessant. Cottet's care over local details, the baby's cap and crude, bright ribands, places this painting within the tradition of regional genre subjects popular in France from *c.* 1840 and frequently resorted to by artists illustrating Breton life (e.g. Sérusier no. 191; Dauchez no. 59).

Almost all Cottet's critics also pointed to his deep personal affinity with the Breton people. This painting is, therefore, a record of the harsh, precarious life in Ouessant and represents one of the accepted views of Brittany as a land dominated by harsh toil, abject poverty, ever-present death and blind religious faith. This was the Brittany noted by Odilon Redon in Quimper, 3 July 1876 (*A Soi-même*, 1961, p. 49), by Emile Bernard ('L'Aventure de ma vie', in *Lettres de Paul Gauguin à Emile Bernard 1888 à 1891*, 1954, p. 30) and by J. K. Huysmans in *Là-bas* (1891, pp. 99–100). It also formed part of popular Breton folklore as in the folk song, reprinted by André Theuriet in *La Vie rustique*, 1888: 'O you who toil, you have really suffered in this world. O you who toil, you are really happy! For God has said that the gateway to his paradise would be opened to those who have wept on this earth. When you arrive in heaven, the saints will recognize you as brothers by your wounds. The saints will say to you: Brother, it was not good to be alive; Brother, life is sad and it is good to be dead. And they will receive you into Glory and eternal joy.' M A.S.

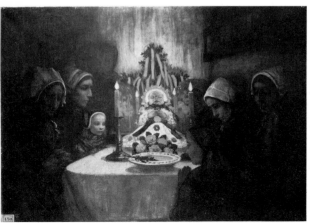

53

EXHIBITIONS
1899, Société Nationale (380)
1913, Ghent, Exposition Universelle et Internationale, French section (66)
REFERENCES
P. Desjardins, 'Les Salons de 1899 – IV', *Gazette des Beaux-Arts*, August 1899, pp. 141–2
H. Frantz, 'The Paris Salons of 1899: the New Salon', *Magazine of Art*, 1899, pp. 438–9
M. Nordau, *On Art and Artists*, 1907, pp. 213–14
L. Bénédite, 'Charles Cottet', in catalogue to exhibition *Charles Cottet*, Paris, 1911, p. 108
J. Chantovoine, 'Charles Cottet', *Gazette des Beaux-Arts*, August 1911, p. 108
J. F. Louis-Merlet, *Trois artistes: J. François Aubertin, E. Antoine Bourdelle, Charles Cottet*, Paris 1912, p. 67
A. Cariou, 'Le Peintre Charles Cottet et la Bretagne', *Annales de Bretagne*, September 1973, pp. 649–61

Cross, Henri Edmond 1856–1910

Originally from Douai, Cross settled in Paris in 1881, and evolved his early style of painting from Bastien-Lepage, and then from Manet and the Impressionists. He exhibited with the Indépendants from 1884, but only adopted the pointillist technique in 1891, and used it with increasing freedom in later years. In 1891, too, he moved his base to the Mediterranean coast, where he painted landscapes, and figure subjects whose often idyllic mood reflected his Utopian Anarchist ideals.

ABBREVIATION
c – I. Compin, *H. E. Cross*, Paris, 1964

54 *La Pointe de la Galère* 1891/2

[repr. in colour on p. 234]
sbl. Henri Edmond Cross 63.5 × 91.5 cm/25 × 36 ins
Lent by a Private Collector

Although Cross had exhibited regularly with Seurat and Signac at the Indépendants since 1884, he only adopted the pointillist execution *c.* 1890; his *Portrait of Madame Cross* (Palais de Tokyo, Paris), shown at the Indépendants in 1891, uses the 'point' in much the same way as Seurat. But at the Indépendants in 1892 Cross showed a sequence of Mediterranean scenes, including *La Pointe de la Galère*, in which he used the technique quite differently, in a very schematic and decorative way; here small, separate dots are arranged, sometimes in precise rows, over more broadly painted zones of a different colour, with the sky treated in four distinct horizontal bands. The result is an evocative but strangely hieratic recreation of the light and atmosphere of a sunset over the sea, with strong echoes of the Japanese print. Signac had used the 'point' for decorative effect in his *Portrait of Fénéon* (no. 211), and was seeking decorative and rhythmic effects in his Concarneau seascapes (cf. no. 212), exhibited with Cross's southern paintings in 1892, but he did not at this date adopt such stylized and taut patterns of forms and brushstrokes as Cross did in *La Pointe de la Galère*. J.H.

EXHIBITIONS
1892, Paris, Indépendants (313)
1892, Paris, Le Barc de Boutteville, 2nd exhibition
1892–3, Paris, Hôtel Brébant (11)
1893, Brussels, Les XX (Cross 2)
1893, Antwerp, Association pour l'Art (2)
1906–7, Munich, Frankfurt, Dresden, Karlsruhe, Stuttgart, *Französische Künstler* (17)
REFERENCES
c30
C. Saunier, in *Revue indépendante*, April 1892, p. 44

55 *Nocturne* 1896

sdbl. Henri Edmond Cross 96 65 × 92 cm/25½ × 36¼ ins
Lent by the Petit Palais, Geneva

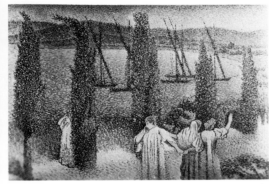

55

Cross painted occasional peasant scenes until the mid-1890s, but turned increasingly in his figure paintings to more idealist subjects – idyllic scenes of naked or draped women by the sea. He found it difficult at times to reconcile such themes with the Anarchist political views which he shared with his Neo-Impressionist colleagues, and explained his position in 1905 to Van Rysselberghe (cf. no. 412): 'A long time ago, I discovered my insensitivity to the peasant. I find him here [in the south] especially without plastic interest, and I would not know how to paint him. . . . On the rocks, on the sand of the beaches, nymphs and naiads appear to me, a whole world born of beautiful light' (quoted New York, Guggenheim Museum, *Neo-Impressionism*, 1968, p. 47). Cross's Bather subjects were particularly important in the conception of Matisse's *Luxe, calme et volupté* (fig. 3), begun while Matisse was working in the south with Cross and Signac in 1904.

Nocturne is exceptional among Cross's figure subjects, since it is probably based in a literary source – on a scene from a play by Dujardin, *Le Chevalier du passé* (first staged in 1892 with a décor by Denis), in which four Floramyes lament their departure from Antonia's island (cf. c56); Cross's muted colour-scheme conveys this melancholy mood, which is amplified by the trees and the sails of the boats, which all point leftwards – in the 'sad' direction according to Charles Henry's theories of line (cf. nos 199 and 204). J.H.

EXHIBITIONS
1897, Paris, Indépendants (271)
1901, Brussels, Libre Esthétique (138)
REFERENCE
c56

56 *The Blue Boat* 1899

La Barque bleue
sdbl. Henri Edmond Cross 99 60 × 81 cm/23½ × 32 ins
Lent by the Musée des Beaux-Arts, Dijon (Donation Granville)

Cross, like Signac (cf. no. 215), brightened his colour and broadened his handling in his southern scenes of the later 1890s. The whole composition of *The Blue Boat* is based on contrasts, which recur throughout the canvas; oranges and yellows are opposed to mauves

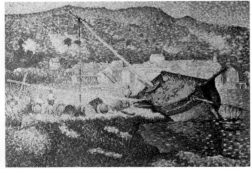

56

and intense blues, with more occasional accents of red and green. The colour flows more freely between areas than it does in Signac's *Saint-Tropez, Pine-wood* (no. 215), and Cross, treating an effect of full sunlight, emphasized colour contrasts at the expense of the dark and light tonal oppositions which Signac had used in his sunset effect. The colour gives the whole picture a great homogeneity, which is augmented by the brushwork – soft dabs and lozenges placed in varied directions, which give a fluid movement across the canvas. J.H.

REFERENCES
c74
Dijon, Musée des Beaux-Arts, *Donation Granville*, I, 1976, p. 85, no. 55

57

57 *Landscape at Bormes* 1907

Paysage de Bormes
sbl. Henri Edmond Cross 73 × 92 cm/28¾ × 36¼ ins
Lent by a Private Collector

In summer 1907 Cross discovered the village of Bormes, just inland from his home on the Mediterranean coast near Le Lavandou, east of Toulon. He was attracted by its 'admirable plain, sprinkled with little houses and groups of trees, as far as the hills and the sea. In the morning, it is extremely delicate in colour, and I want to make this the starting point for new harmonies' (cf. c197). By this date, Cross generally worked from nature only in small watercolours and drawings, executing his finished paintings in the studio. In *Landscape at Bormes* the scene is recreated in rich harmonies of colour, and in bold patterns of brushwork, sometimes blocklike, sometimes more fluid and cursive; areas of luminous tone are set off against intense colours, which are sometimes distorted for pictorial effect as in the trunk of the principal tree.

Maurice Denis, writing of Cross's paintings in spring 1907, contrasted them with the 'rash and blinding translations of the pitiless sun' of the Fauves (cf. nos 73, 131 and 35). Cross, he said, was 'more and more substituting the play of colour for the play of light. . . . He does his utmost to imagine harmonies equivalent to sunlight, and to institute a style of pure colour. . . . Cross has resolved to represent the sun, not by bleaching his colours, but by exalting them, and by the boldness of his colour contrasts. . . The sun is not for him a phenomenon which makes everything white, but is a source of harmony which hots up nature's colours, authorizes the most heightened colour-scale, and provides the subject for all sorts of colour fantasies' (Denis, *Théories*, 1964 edn, pp. 153–4). J.H.

EXHIBITIONS
1910, Paris, Bernheim Jeune, *Cross* (22)
1911, Brussels, Libre Esthétique, *Cross* (46)
1913, Paris, Bernheim Jeune, *Cross* (48)
REFERENCE
c197

Dagnan-Bouveret, Pascal Adolphe Jean
1852–1929

Dagnan-Bouveret entered Gérôme's atelier at the Ecole des Beaux-Arts in 1869, and under his influence opened his Salon career in 1876 by showing two mythological subjects. After 1879 he changed to contemporary subject matter treated in a naturalist style, possibly adopted from his close friend Bastien-Lepage. He exhibited his first Breton subject in the Salon of 1887 (*The Pardon – Brittany*), followed two years later by *Breton Women at a Pardon*, together with a religious painting; this pair set the tone of his subject matter throughout the 1890s. Apart from his successful portraits of Parisian aristocracy, religious paintings dominate the close of his career.

58 *Breton Women at a Pardon* 1887

Bretonnes au Pardon
sdbl. PAJ Dagnan-B 1887 125 × 141 cm/49¼ × 55½ ins
Lent by the Calouste Gulbenkian Foundation, Lisbon

Following his début at the Salon in 1876, it was a subsequent series of dazzling, naturalistic, contemporary genre scenes such as *The Wedding Party at the Photographer's* (Salon, 1879) which caused Dagnan-Bouveret to be hailed as Bastien-Lepage's successor on Bastien's death in 1884. Dagnan-Bouveret exhibited his first Breton subject, *The Pardon – Brittany* (Metropolitan Museum, New York), at the 1887 Salon, where it was compared to that of Guillou (cf. no. 108).

On one level, Dagnan-Bouveret seems concerned in this painting to capture the characteristic activities of Brittany in the manner of such artists as Feyen-Perrin (*Return from Fishing at Low Tide*, 1880, untraced) and Jules Breton (*Evening – Finistère*, 1882). However, the choice of a religious subject and the simplification of technique to express the archaic aspects of this ceremony separated this painting, in the eyes of the critics, from the purely picturesque. Paul Mantz, for example, emphasized the way in which Dagnan-Bouveret summarized the simplicity of soul, the link with past ages, the sadness, and the religiosity of the Breton people through 'semi-archaic, semi-modern techniques', thus isolating them 'from the sounds of the profane world, from the life that belongs to Satan'. In this, Dagnan has caught the same qualities of the Breton peasant that attracted Gauguin and Bernard (cf. nos 82 and 15).

This concentration on the piety and poverty of Brittany established for Dagnan-Bouveret a distinct position within French art during the succeeding decade. Denis, in his generally critical analysis of academic art in 'Définition du néo-traditionnisme', 1890 (in *Théories*, 1964 edn), concedes that Dagnan, by setting aside the

naturalism of genre scenes, has now declared a desire to return to the Great Tradition. Paul Desjardins ('Les Salons de 1899 – avant propos', *Gazette des Beaux-Arts*, May 1899, p. 359) develops this further by defining Dagnan's paintings of Bretons as expressions of the beauty of the soul, rather than the trivial idealization of external beauty. M.A.S.

EXHIBITIONS
1889, Paris, Salon (681), gold medal
1898, London, Guildhall (29)
1900, Paris, Exposition Universelle, *Exposition Décennale* (533)
REFERENCES
A. Aurier, 'Salon de 1889', *Moderniste illustré*, 25 May 1889, p. 61
P. Mantz, 'Le Salon de 1889 – la peinture', *Gazette des Beaux-Arts*, June 1889, pp. 448–9
Walter Armstrong, 'Current Art – the Salon', *Magazine of Art*, 1889, p. 418, repr. p. 416
A. Michel, 'Les Salons au Palais de l'Industrie de 1855 à 1897', *Gazette des Beaux-Arts*, April 1897, p. 280
D. S. MacColl, 'French Paintings at the Guildhall', *The Saturday Review*, 8 June 1898, p. 813
J. Dampf, *Catalogue des Oeuvres de M. Dagnan-Bouveret (Peintures)*, Paris, 1930

Dauchez, André 1870–1943

A Breton painter responsible for introducing Simon to Brittany in 1890, and a member of the 'Bande noire', Dauchez was trained in Paris. He exhibited for the first time at the Société Nationale in 1894, and thereafter concentrated almost exclusively upon Breton subjects. He was known to paint in front of the motif and he tended to depict extensive landscapes or characteristic agricultural activities in the region. He also illustrated books, including *Le Foyer breton* by E. Souvestre.

59

59 *The Seaweed Burners* c. 1898

Les Brûleurs de goëmon
sbl. A. Dauchez 150 × 226 cm/59 × 89 ins
Lent by the Musée de Moulins, dépôt de l'Etat

Dauchez was the third leading member of the 'Bande noire', having been introduced to Cottet by Simon probably in 1895 (cf. nos 52, 217). Like Simon's, his subject matter was more varied than Cottet's, although his Breton pictures were striking enough to make critics classify him as a Breton painter.

Together with apple picking, buckwheat and hay harvesting, gathering seaweed was one of the most characteristic agricultural activities in Brittany. The subject was treated by a variety of different artists. Dauchez produced a similar subject to this, painted in the same, rather broad, naturalist style, for the Salon of 1897, while Gauguin, in his *The Seaweed Gatherer* (Wildenstein 349, Folkwang Museum, Essen) and Sérusier, in *The Seaweed Gatherer* (Josefowitz Collection, Lausanne), both of 1889, employed the non-naturalist techniques of Pictorial Symbolism. These harvest activities appealed to artists because they represented the backward state of Breton

farming compared with the rest of France and could be seen as one of the manifestations of Breton primitivism (cf. no. 15). Backward though the methods may have been, Dauchez does show both men and women working at the harvest, a change from the conditions prevailing in the 1870s when, according to Blackburn (*Breton Folk*, 1880, p. 25), it was the Breton women who did all the manual work, while their menfolk apparently passed the day in idleness. M A.S.

EXHIBITIONS
1898, Paris, Société Nationale (367)
1900, Paris, Exposition Universelle, *Exposition Décennale* (566)
1908, London, Franco-British Exhibition (137)

Degas, Edgar 1834–1917

Degas received a full academic training from pupils of Ingres, and studied in Italy during 1856–9. After that time he lived in Paris, and, from the mid-1860s onwards, concentrated on a restricted range of modern urban subjects – the ballet, café-concerts, racecourses, women working and bathing – alongside portraits of friends. He made important technical experiments, particularly in pastel, which he used increasingly after *c.* 1877 as his eyesight began to fail. He exhibited occasionally in the Salon in the 1860s, but after 1870 showed mainly in group exhibitions and dealers' galleries.

ABBREVIATION
L – P. A. Lemoisne, *Degas et son oeuvre*, Paris, 1946

60 *Dancer in Her Dressing-room* c. 1880

Danseuse dans sa loge
[repr. in colour on p. 33]
sbr. Degas pastel on paper 59 × 45 cm/23¼ × 17¾ ins
Lent by a Private Collector

In the later 1870s Degas began to execute fully finished pictures in pastel. The medium better suited his failing eyesight, and it also gave him a means of introducing rich yet delicate nuances of colour, by superimposing layers of pastel, laid on with free and varied strokes.

His ballet subjects generally show dancers rehearsing, resting or dressing, rarely the performance itself. He consistently sought unexpected angles of vision, using compositions with cut-off forms and jumps of space and scale which suggest the ways in which a spectator actually experiences the scenes around him – truncated and interrupted by intervening forms, not presented as an uninterrupted frontal view. In *Dancer in Her Dressing-room* the cut-off figures at the sides, together with the chair, give the effect of a glimpse into a cramped dressing-room. For all their apparent immediacy, Degas worked out his compositions to the last detail, as his academic training would have taught him (cf. Seurat, no. 197). The cut-offs, high viewpoints and raking diagonals so common in them are devices which he borrowed from Japanese prints to recreate the animated scenes around him. Comparisons with early photography do not seem relevant, since Degas' compositional traits were established by the mid-1870s, long before such effects were possible or sought after in the photography of moving objects even with outdoor lighting, let alone in indoor scenes.

Dancers being prepared by their dressers are not an unusual theme for Degas, but *Dancer in Her Dressing-room* is quite exceptional among his finished pastels for including a male onlooker – a voyeuristic intruder whose presence is emphasized by his walking-stick. He introduces a sexual tension otherwise only found in the small monotypes of brothel interiors which Degas was executing at this period. The juxtaposition between performer and admirer echoes Manet's *Nana* (Kunsthalle, Hamburg; rejected at the 1877 Salon) and also the passage in Zola's novel *Nana* (1879–80) in which Count Muffat watches Nana undress (Manet must have known of this passage when painting his *Nana*, though it had not yet been published). Certainly Degas' picture carries far stronger narrative connotations than his other ballet subjects do (on Degas' interests in literature, cf. T. Reff, *Degas*, 1976, Chs IV and V). J.H.

REFERENCES
L497
P. Lafond, *Degas*, II, 1919, p. 30
L. Browse, *Degas Dancers*, 1949, pl. 60 and p. 359

61 *Woman Ironing* c. 1880

Repasseuse à contre-jour
Stamped br. Degas 81 × 63.5 cm/32 × 25 ins
Lent by the Walker Art Gallery, Liverpool

In contrast to the colour nuances which Degas introduced into his pastels *c.* 1880 (cf. no. 60), his oils of the period are more broadly treated, and rarely taken to exhibition finish. *Woman Ironing*, with its visible outlining and its flat paint surfaces, remained in his studio until his death. It is less fully worked than Degas' other two versions of this composition (L356, 685), which differ from it only in details of the figure's pose and relationship to the background. Though dated by Lemoisne *c.* 1885, the present version probably belongs to the beginning of the 1880s; however, it clearly postdates by some years the earliest version (L356, Metropolitan Museum of Art, New York), thus showing how Degas continually re-explored themes and compositions from his previous work.

In 1874, when he first began painting laundresses and women ironing, he told Edmond de Goncourt about their work, 'speaking their language, explaining to us in technical terms the *applied* stroke of the iron, the *circular* stroke, etc.' (Goncourt, *Journal*, 13 February 1874, ed. R. Ricatte, 1956, II, p. 968). Such precise observation was Degas' essential starting-point for treating any subject, as it was for the Naturalist novelists, such as Zola. A laundry was the central focus for *L'Assommoir* (1876), Zola's first great success, but, except in rare instances (cf. no. 60), Degas' treatment of his themes was wholly non-literary. Whereas Zola used the details of his characters' surroundings to amplify his characterization, Degas avoided any psychological *entrée* into the picture, and sought instead the physical gestures most typical of the work they were doing. The viewer's eye, in *Woman Ironing*, only reaches the figure via the diagonals of table, ironing-board, and her arms. J.H.

REFERENCES
L846
Liverpool, Walker Art Gallery, *Foreign Catalogue*, 1977, p. 51

61

62

62 *Woman in a Tub* c. 1885

Femme au tub
str. Degas pastel on paper 68×68 cm/$26\frac{3}{4} \times 26\frac{3}{4}$ ins
Lent by Mrs Anne Kessler

At the 8th Impressionist exhibition in 1886, Degas exhibited 10 pastels under the collective title *Sequence of Nudes, of Women Bathing, Washing, Drying, Wiping Themselves, Combing Their Hair or Having It Combed (Suite de nus de femmes se baignant, se lavant, se séchant, s'essuyant, se peignant ou se faisant peigner)*. From a description in Fénéon's review of the show, *Woman in a Tub* can be identified with some certainty as one of those shown: 'From the front, kneeling, with disjointed thighs, her head bowed down on to her flaccid torso, a girl wipes herself' (Fénéon, 1886).

These pastels present women caught unawares, in inelegant poses, from unexpected angles. Degas certainly intended them as an attack on the traditional idea of the nude; instead of figures posing in pretty surroundings (cf. Renoir no. 175), he presented them as they would look when naked in everyday situations. Painters and critics had for many years been trying to justify the nude within a modern-life aesthetic (Baudelaire's *Salon de 1846* contains an early example of this), and Degas' nudes are the most complete realization in the later nineteenth century of the everyday nude. However, Degas' rejection of tradition was far from absolute. In the image of the woman in a tub there is some echo of the theme of Venus rising from her shell; the idea of finding modern equivalents for the Venus theme – of creating a contemporary female goddess – was a critical commonplace at the time, and in his women in tubs Degas rein-terpreted the theme of Venus in her shell in wholly modern terms, without the overt references to artistic tradition of Manet's great modern Venus-type figure, *Olympia* (1863, Jeu de Paume, Paris).

Huysmans interpreted the pictures as misogynist, but their psychological mood seems dispassionate rather than savage. Around this date Degas told George Moore that his aims in his bathing women were to show 'a human creature preoccupied with herself – a cat who licks herself; hitherto, the nude has always been represented in poses which presuppose an audience, but these women of mine are honest and simple folk, unconcerned by any other interests than those involved in their physical condition. . . . It is as if you looked through a key-hole' (Moore, in *Magazine of Art*, 1890, p. 425, reprinted *Impressions and Opinions*). Degas recreated his observations of the gestural language of the female figure in complex patterns of lines and shapes; in *Woman in a Tub*, as so often in his work, the varied implied diagonals which dominate the image are set off against a sequence of crisp verticals at one of the upper corners.

By the mid-1880s Degas was using pastel with increasing freedom to create nuances and contrasts of rich colour – here, dominantly orange against blue, with a few dramatic red flecks. Long, vertical strokes appear in much of the picture, even in the figure, where parallel hatchings, varied in colour, cut across the rounded modelling of the forms. J.H.

EXHIBITION
1886, Paris, 8th Impressionist exhibition
REFERENCES
L738
F. Fénéon, in *Les Impressionnistes en 1886*, quoted *Oeuvres plus que completes*, I, 1970, p. 30
J. K. Huysmans, in *Certains*, 1889, pp. 22–7

63 *Portrait of Mademoiselle Hélène Rouart* 1886

Portrait de Mademoiselle Hélène Rouart
[repr. in colour on p. 36]
stamped br. Degas 161×120 cm/$63\frac{1}{2} \times 47$ ins
Lent by a Private Collector

Degas' portrait of Hélène Rouart, daughter of his friend Henri Rouart, formed part of a planned sequence of the Rouart family which was cut short by the death of Rouart's wife. Rouart made his fortune as an engineer and spent it on building up a fine art collection; he was also an amateur painter, and showed in most of the Impressionist exhibitions of 1874–86. Hélène is shown in her father's study, among his collection. Behind her, on the wall, are a Chinese hanging, a small early landscape by Corot, and a drawing of a peasant by Millet; on the left are three Ancient Egyptian wooden figures in a free-standing glass case – a challenging effect for Degas to capture.

This is a late example of a type of portrait which had preoccupied Degas since the 1860s, in which personality is expressed as much by posture and surrounding attributes as by facial expression. He had often incorporated pictures within pictures as attributes (cf. Reff 1976), and he was also interested in using traditional theories of expression to amplify the content of his portraits – not only the ideas of Lavater on physiognomy, but also those of Delsarte on bodily gesture (cf. Reff, *Notebooks of Degas*, I, 1976, pp. 25–7). Hélène Rouart's pose was the subject of a number of studies before Degas finalized it (cf. L870, 870 bis, 871, all dated 1886).

The painting is not equally finished in all its parts, and remained in Degas' studio until his death. At a late stage in its execution, he freely restated some of the figure's outlines in bright red paint, which pulls it forward from the background and animates the surface; but these would presumably have been worked over if he had fully finished the canvas. J.H.

REFERENCES
L869
D. Rouart, *Degas à la recherche de sa technique*, 1945, pp. 42–4
'Notable Works of Art now on the Market', *Burlington Magazine*, December 1952, pl. XXII and caption
London, Sotheby, catalogue of sale 6 July 1960, lot 152
J. S. Boggs, *Portraits by Degas*, 1962, pp. 68–9 and pl. 124
R. Gimpel, *Diary of an Art Dealer*, 1966, p. 400
T. Reff, *Degas, the Artist's Mind*, 1976, pp. 136–40, 267

64 *Dancers in Salmon-coloured Skirts* c. 1895

Danseuses, jupes saumon
stamped bl. Degas pastel on paper 89×65 cm/$35 \times 25\frac{1}{2}$ ins
Lent by a Private Collector

Some of Degas' late dance subjects are not placed in a specific theatre setting, and in *Dancers in Salmon-coloured Skirts* the back-ground gives no hint of stage flats. It is an open landscape, closely related to the group of landscapes in pastel and monotype which

Degas exhibited in 1892, of hilly scenes based on a visit to Burgundy in 1890. The whole pastel is composed of contrasts of blue and salmon, with the complex patterns of the figures set off against the gentle shapes of the landscape. Degas' use of pastel was now broader and far less descriptive than it had been in the 1880s – more dominated by long raking verticals which cut across the modelling of the figures. J.H.

REFERENCES
LI281
cf. LI277–82

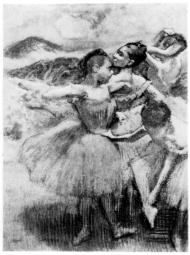

64

Denis, Maurice 1870–1943

Denis was educated at the Lycée Condorcet, where he met the future Nabis Vuillard and Roussel. He attended the Atelier Balla, then the Académie Julian, where he met Ranson, Bonnard and Sérusier, with whom he formed the Nabis in 1888. Like the other Nabis, Denis organized and participated in group exhibitions, executed both easel and large-scale decorative paintings and produced book illustrations, prints, stained glass designs, stage sets and theatrical costume designs. As a writer, he propagated the Nabis' artistic programme in articles (e.g. 'Définition du néo-traditionnisme', 1890) and in books. An ardent Roman Catholic, his writings came to reflect his concern for the reform of religious art. He exhibited widely outside France from 1892 onwards.

ABBREVIATIONS
BD – S. Barazzetti-Demoulin, *Maurice Denis*, Paris, 1945
Denis, 1970 – Paris, Orangerie, *Maurice Denis*, 1970

65 *Catholic Mystery* 1890

Mystère Catholique
sdbl. Maurice Denis; insc in Greek
tr. ΑΣΠΑΣΜΟΣ [Hail]
51 × 77 cm/20 × 30¼ ins
Lent by J. Fr. Denis, France

Highly acclaimed by the critics when it was exhibited at the Indépendants of 1891, this painting attracted a number of requests for replicas from patrons such as Jules Claretie, Coquelin *cadet* and Lugné-Poë (cf. no. 234). Denis had already executed a version of this subject in 1889 (Collection Mme M. Poncet, Switzerland), using a smooth, Nabi technique. The replicas followed

65

either the 1889 example or the pointillist version exhibited here (e.g. Rijksmuseum Kröller-Müller, Otterlo, Inv. 115–21, dated 1891).

The critics drew attention to both the technique and the subject matter of this painting. On the one hand, Fénéon, in his review of the Château de St Germain-en-Laye exhibition of August–September 1891 ('Quelques peintres idéalistes') described the technique as 'pointillist dots which he dabs on to flat grounds of colour to give the picture a sort of second layer of skin', thus identifying the way in which Denis, like Vuillard in *The Stevedores* (no. 231), has transformed the naturalist Neo-Impressionist technique into pure decorative surface. On the other hand, the underlying areas of flat, cool colour, the simple outline and the naïve representation of the landscape beyond the window were seen by the critic Hirsch as an illustration of Denis' admiration for the early Italian primitives, especially Fra Angelico and Piero della Francesca. Denis had recorded this love for the primitives in his *Journal* as early as August 1885 (I, p. 42), and he spent much time in the Louvre studying their techniques.

The subject of the painting illustrates an important modification of the traditional representation of the Annunciation. The Angel Gabriel has been replaced by a priest who hands to the Virgin the open Gospel. The meaning of the painting thus becomes more than the mere illustration of a single historical event, and now refers to the constant renewal of God's promise of salvation to mankind. Not only is this adaptation of a traditional theme characteristic of Denis' religious art, but it also reveals the profound Catholicism noted by Jacques Daurelle when he interviewed Denis for the *Echo de Paris* in December 1891. MA.S.

EXHIBITIONS
1891, Paris, Indépendants (565)
1891, August–September, St Germain-en-Laye
1891, Paris, Le Barc de Boutteville, 1st exhibition
1894, Toulouse, Dépêche de Toulouse (17)
REFERENCES
F. Fénéon, 'Quelques peintres idéalistes', 14 September 1891, in *Oeuvres plus que complètes*, I, 1970, p. 200
J. Daurelle, 'Chez les jeunes peintres', *Echo de Paris*, 28 December 1891
C. Hirsch, 'Notes sur l'impressionnisme et le symbolisme des peintres', *Revue blanche*, February 1892
BD, pp. 27, 31, 36, 75, 89, 141–2, 277, repr. in colour p. 88
Denis, *Journal*, I, 1957, pp. 103, 225
Denis, 1970 (10)
London, Hayward Gallery, *French Symbolist Painters*, 1972 (36, lists early reviews)

66 *Sunlight on the Terrace* 1890

Taches de soleil sur la terrasse
ns; dbr. Oct. 90 oil on board 20 × 20 cm/7¾ × 7¾ ins
Lent by a Private Collector, St Germain-en-Laye

Executed two years after the arrival of Sérusier's *The Talisman* (no. 187) at the Académie Julian, this little picture illustrates the importance of Denis' debt to Sérusier, first expressed in a *Journal* entry for January 1889: 'Lord, we are a group of young people, devotees of the symbol, misunderstood by a world which mocks us

66

Mystics! Lord, I pray you, may our reign come! Remember also the glory of Paul Sérusier who has permitted me to progress towards the best Art; and may he be saved!' (I, p. 73).

As in *The Talisman*, Denis avoids the use of Gauguin's blue bounding line and, more importantly, bases his painting upon a specific landscape, the terrace of the château at St Germain-en-Laye. This retention of a reference to external nature, despite its radical deformation through zones of flat, brilliant, non-naturalistic colour, helps to elucidate the aims of the new school of Nabi painting which Denis defined in August 1890 in his famous manifesto, 'Définition du néo-traditionnisme'. Dismissing the traditional aim of painting to imitate nature, Denis declared: 'Remember that a painting, before it is a war horse [*cheval de bataille*], a female nude or some little genre scene, is primarily a flat surface covered with colours arranged in a certain order' (*Théories*, 1964 edn, p. 1). Denis is not advocating the creation of a fully abstract form of painting. Rather, in keeping with similar demands in the contemporary literary Symbolist manifestos, he insists that the new subject matter of art, the *état d'âme*, or Idea, should be expressed through the formal properties of a painting – colour and two-dimensionality – rather than through emotive or illustrative subject matter. MA.S.

REFERENCES
Denis, 1970 (14)
G. Mauner, *The Nabis*, 1978, pp. 220–1, fig. 69

67 *Procession Under the Trees* 1892

Procession sous les arbres
[repr. in colour on p. 109]
sdbr. MAUD 92 56 × 81.5 cm/22 × 32 ins
Lent by Arthur G. Altschul

In his designs for Verlaine's *Sagesse* (1889–90) and paintings such as *Martha at the Piano* (Private Collection, St Germain-en-Laye) of 1891, Denis was already using that 'embroidery of arabesques . . . an accompaniment of expressive lines' ('Définition du néo-traditionnisme', 1890, in *Théories*, 1964 edn, p. 44) which he, like Bonnard (cf. nos 28–9), had taken from Japanese prints. The interplay between depth and decorative surface in this painting also relates it closely to paintings such as *April* (1892, Rijkmuseum Kröller-Müller, Otterlo) and *The Muses* (1893, Palais de Tokyo, Paris). In addition *Procession Under the Trees* has, unlike these two pictures, a religious content. The young girls in white and the praying nuns in the background are also found in a study of uncertain date called *The First Communion* (Arthur G. Altschul Collection). This drawing in turn seems to refer to an entry in Denis' *Journal* for the Feast of the Assumption, 15 August 1884; 'Procession of the little girls of the Virgin: they are charming, these children of Mary with these white veils: they are candour, modesty, angels' (I, p. 16).

Denis was invited to show this painting in Brussels at the first

exhibition of the Libre Esthétique, the body which succeeded Les XX and introduced a conscious policy of encouraging the applied arts. While they looked to the Arts and Crafts Movement in England, artists in Brussels were also interested in paintings such as this one, which implies that the emergence of Art Nouveau owed much of its concern with linear surface pattern to the example of French artists like Denis. Indeed, Denis' affinity with the new style can be seen in the wallpaper design called *The Boats* which he exhibited in 1895, one year after *Procession Under the Trees*, at the Libre Esthétique (195–8). MA.S.

EXHIBITIONS
1893, Paris, Indépendants (368, as *Procession pascale*)
1893, Paris, Le Barc de Boutteville, 5th exhibition (52)
1894, Brussels, Libre Esthétique (135)
1894, Toulouse, Dépêche de Toulouse
REFERENCES
BD, p. 278
La Revue blanche, 18 April 1893

68

68 *The Cup of Tea* or *Mystical Allegory* 1892

La Tasse de thé ou *Allégorie mystique*
sdtl. MAUD 92 46 × 55 cm/18 × 21½ ins
Lent by a Private Collector, France

The assumption by Denis that an everyday domestic event, such as afternoon tea, can be interpreted as a symbolic allegory, is a common characteristic of his work. As with Vuillard's treatment of domestic scenes (e.g. *The Outspoken Dinner Party*, no. 235, and *Madame Vuillard Sewing*, no. 237), Denis emphasizes this visually by forcing the two models (possibly his fiancée, Marthe Meunier, and her sister, Eve) into a shallow picture space which stresses the patterns of colour and line that wind across the picture surface. It is no longer possible to read the image as a mere naturalistic transcription of two women engaged in an everyday activity.

The mystical allegory alluded to in the title of this painting may invite the spectator to interpret the two women as virgins making a votive offering to the patron saint of the home. Drawing upon his immediate family environment, Denis frequently made this translation of the prosaic into the Ideal. For example, he transformed Marthe Meunier in a contemporary kitchen into *Saint Martha Doing the Washing Up* (1891, J.-Fr. Denis Collection, France), and Marthe and their first child, Noële, into *Motherhood at Mercin* (1896, Private Collection, France). MA.S.

EXHIBITIONS
1892, St Germain-en-Laye (102)
1892, Paris, Le Barc de Boutteville, 2nd exhibition (31)
REFERENCES
BD, p. 278
Denis, 1970 (91)

69 *April* 1894

Avril
s. MAUD 200 cm/78¾ ins diameter
Lent by the Famille Ernest Chausson Collection, France

This ceiling decoration was executed for a close friend of Denis', the composer Ernest Chausson, for his home in the boulevard des Courcelles, Paris. It was the first of three decorative panels commissioned by Chausson, the other two being *Spring* (1896) and *The Denis and Chausson Families at Fiesole* (1899).

This decorative scheme was not Denis' first large-scale project. Like his fellow Nabis, Sérusier, Vuillard and Bonnard, he had been involved in designing sets for the Symbolist Théâtre d'Art, e.g. *Antonia* (1891) and *Fin d'Antonia* (1893) by Edouard Dujardin, and *Théodat* (1881) by Rémy de Gourmont, as well as for the Théâtre de l'Oeuvre, founded in 1893 (cf. no. 234), e.g. *La Nuit d'avril à Céos* (1894) by Trarieux. These bold sets, all now destroyed, were designed to be the visual equivalents of the subjects of the plays, non-representational in style, with dominant colour tones creating moods appropriate to each scene.

Outside the theatre, Denis had also already executed one large-scale decorative panel prior to the commission from Chausson. In 1892, another close friend, the painter Henri Lerolle, invited Denis to take over the decoration of his dining-room ceiling from Maillol. He executed *Ladder in the Foliage* (Private Collection, St Germain-en-Laye) and also established a firm friendship with the ousted Maillol (cf. Maillol, no. 123).

Denis undertook other decorative schemes in the 1890s apart from the Chausson commissions. Samuel Bing invited him to execute a scheme for a bedroom for the opening exhibition in 1895 of his Maison de l'Art Nouveau (*Frauenliebe und Leben, after Schumann*), and in 1897 he created *The Legend of St Hubert* for the dining-room of M. Denys Cochin. In 1889, he embarked upon the first of a long series of church decorative schemes at the Chapelle du Collège de Sainte-Croix at Vesinet, which eventually led to the foundation of his Atelier d'Art Sacré in 1921. MA.S.

EXHIBITION
1894, Paris, Indépendants
REFERENCES
BD p. 279
Denis, 1970 (67 *bis*)

69

70

70 *The Blessing of the Boats* c. 1895

Baptême des bateaux
sbcr. MAUD 75 × 80 cm/29½ × 31½ ins
Lent by the Josefowitz Collection, Switzerland

Denis records his interest in Brittany as early as 1885. In a *Journal* entry for 26 August, he notes that: 'During the last few days, they [students at the Atelier Balla in Paris] have been talking about the "celtophiles", amongst whom figure Renan and A. Beltrand, the sons of Brittany . . . these are the friends of my old Brittany, and as such, the celtophiles have my affection' (1, p. 44). The date of Denis' first visit to Brittany is uncertain, but he was definitely staying in Pont-Aven in the summer of 1890 (J. Rewald, *Post-Impressionism*, 1978, p. 280). From 1892 he stayed in the family house at Perros-Guirec, in 1895 he went to Loctudy, in Finistère, and in 1899 to the south coast, notably Le Pouldu and Plougastel (cf. no. 71).

The subject of this picture represents a Breton religious event, as typical of the region as the Pardons (cf. no. 108) and the processions (cf. no. 217), in which the events of everyday life were turned into pious ritual. Denis' appreciation of the religious fervour in Brittany came early in his life. In his *Journal* he dreamed of the day when '. . . I can retire to [Brittany], the land of saints and costumes. I would live there, the friend of the parish priest and of the mayor and of everyone, in a fishing village, . . . I would live a poor, humble, peaceful life, contented, under the protective eye of God, far away from this noisy, wealthy Paris crowd, which obsesses me. . . . Then for a few pennies, I would paint the walls of the poor churches in the district' (1, pp. 44–5). MA.S.

REFERENCES
London, Tate Gallery, *Gauguin and the Pont-Aven Group*, 1966 (239)
Denis, 1970 (70)

71 *Bathers* 1899

Baigneuses
sdbl. MAUD 99 73 × 100 cm/28¾ × 39½ ins
Lent by the Musée du Petit Palais, Paris

Set on the beach of Le Pouldu, Brittany, where Denis had spent the summer of 1899, both the classic subject matter and technical treatment of this painting separate it from earlier works such as *Procession Under the Trees* (no. 67). It represents Denis' solution to the impossibility of giving pictorial definition to the abstract idea, reflecting similar developments in the work of Roussel (cf. no. 183), and summarizes his own development over the preceding four years.

On 27 April 1895, the 9th exhibition at Le Barc de Boutteville opened, accompanied by a catalogue with an introduction by Denis. Evidently concerned about the move towards abstraction which he had advocated in his 1890 manifesto and again in his review of

71

Séguin's one-man show (*La Plume*, 1 March 1895), Denis considered the possibility of restoring a greater degree of fidelity to nature in art. That autumn he went to Italy for the first time, returning there in November 1897. Both visits had been inspired by his concern to improve his technique (letter to Mme Chausson, 19 October 1897, in *Journal*, I, pp. 122–3), and during his stay he studied the Italian primitives and visited Rome, where he arrived early in January 1898. Like Renoir 17 years earlier (cf. no. 171), Denis found this visit decisive in the evolution of his art and ideas. There he met the writer André Gide, whom he had known since 1889 and who was resolving his own dissatisfaction with Symbolism. They discussed the forms and methods of classical art, and together they looked at Antique, early Christian and High Renaissance examples. The effect was immediate. Denis wrote to Vuillard on 15 February (*Journal*, I, p. 133) that 'all this [Classical Art] has produced a host of ideas. . . . I am now beginning to understand Raphael, and I believe that is a decisive moment in the life of an artist.' On his return from Rome he published an article in *Le Spectateur catholique* (nos 22 and 24, October–December 1898) entitled 'Les Arts à Rome ou la méthode classique', in which the Old Masters' deliberation and reflection were contrasted with the rapid, casual execution of the Impressionists. In 1899 he sealed his conversion to the Classical Ideal by painting overtly traditional and monumental works such as this *Bathers*, and in a reassessment of his appreciation of Cezanne, celebrated both in the *Homage to Cézanne* of 1900 (Palais de Tokyo, Paris) and in his pilgrimage to the master six years later. M A.S.

REFERENCES
Denis, 1970 (137)
BD, p. 281
London, Hayward Gallery, *French Symbolist Painters*, 1972 (45)

Derain, André 1880–1954

Born at Chatou near Paris, Derain met Matisse while studying with Carrière in 1899, and Vlaminck after a minor rail-accident in 1900. After a period of military service, he evolved his Fauve style while working with Vlaminck at Chatou in 1904–5, and with Matisse at Collioure in summer 1905. Subsequently he was much influenced, in turn, by Gauguin, Cézanne and primitive art, and turned to more eclectic and traditional styles. From 1905 he exhibited with the Indépendants and at the Salon d'Automne.

72 *The Bedroom* c. 1901

La Chambre à coucher
sbr. A. Derain 33 × 40 cm/13 × 16 ins
Lent by a Private Collector

Derain met Matisse in 1899, and his *Bedroom* of c. 1901 shares the simple execution and emphatic colour accents of Matisse's interiors of this date – less varied in colour and touch than his canvases of 1899 (cf. no. 130). Derain plays off against each other sets of diagonals at different angles, creating a complex space and pattern also found in Matisse, and in the contemporary interiors of Bonnard and Vuillard (cf. nos 34 and 239). J.H.

REFERENCES
D. Sutton, *Derain*, 1959, p. 146, pl. 6
London, Arts Council, *Derain*, 1967 (3)

72

73 *Fishermen at Collioure* 1905

Pêcheurs à Collioure
[repr. in colour on p. 235]
sbr. A. Derain 46 × 54 cm/18 × 21½ ins
Lent by Perls Galleries, New York

Derain spent the summer of 1905 with Matisse at Collioure, a little fishing port on the Mediterranean coast close to the Spanish border. Before they arrived, Matisse was already using intense and exaggerated colours, in a framework of mosaic-like brushstrokes which owed much to Signac, as in his *Luxe, calme et volupté* (fig. 3, cf. Signac, no. 216), whereas Derain, though working with a more subdued palette, was distorting natural colour more freely, and varying his handling greatly within a single canvas. Out of their interaction they forged a style which fused Matisse's purer colour with Derain's willingness to improvise. Some echoes remain of the oil-sketches of the Neo-Impressionists (cf. no. 213), particularly in the paintings from the earlier part of their stay, with their touches of colour freely and openly applied across the primed canvas; but later in the summer they adopted a more patterned surface, with flatter planes of colour, probably as a result of a visit which they paid from Collioure to Daniel de Monfreid's collection of paintings by Gauguin.

Derain's *Fishermen at Collioure*, painted, atypically, on a light beige and not a white priming, treats the contours of figures and shadows in the most simplified way. There is a deliberate naïveté about the composition in the way in which the forms read in bold ribbons up the canvas, and in the omission of the horizon. Warm and cool colours generally differentiate light and shadow, and con-trasting colours are juxtaposed, but rarely strict complemen-taries – Derain was consciously avoiding what had become the hall-mark of the Neo-Impressionists, in favour of harsher and more unexpected relationships. In a letter to Vlaminck from Collioure, Derain explained the two key elements in the new style that he was evolving: '1. A new conception of light which consists in this: the negation of shadow. The light here is very strong, the shadows very luminous. The shadow is a whole world of clarity and luminosity which contrasts with the light of the sun – this is what is known as reflections. . . . 2. I am learning, when working beside Matisse, to rid

myself of the whole business of the division of tones. Matisse goes on, but I've completely got over it, and hardly ever use it now. It is a logical procedure in a luminous and harmonious picture, but it injures things that derive their expression from deliberate disharmonies' (Derain, *Lettres à Vlaminck*, pp. 154–5, letter of 28 July 1905). J.H.

REFERENCES
J. Elderfield, *Fauvism and its Affinities*, 1976, pp. 50–1, 153
London, Lefevre Gallery, *Fauvism*, 1978 (3)

74 The Dance c. 1906

La Danse
[repr. in colour on p. 161]
ns. 185 × 228.5 cm/72½ × 90 ins
Lent by a Private Collector

The largest of Derain's Fauve paintings, *The Dance* sums up the lessons of Fauvism and introduces the preoccupation with the primitive and the exotic which became so important for the art of Derain, Matisse and Picasso in the following years. It was probably painted in 1906, perhaps late in the year in direct response to the Gauguin retrospective at the Salon d'Automne; but, like Derain's other major Fauve figure painting, *The Age of Gold* (c. 1905, Museum of Modern Art, Teheran), it was not exhibited at the time – a symptom perhaps of the anxiety about his stylistic direction which led Derain to destroy many of his most ambitious paintings of the next few years.

Gauguin lies behind *The Dance*'s frieze-like composition and flat colour-planes, but the space is flatter and the drawing more schematic than Gauguin's ever was. Colour is treated very arbitrarily, as in the blue ground plane, and in the right-hand tree which suddenly changes where its background passes from yellow to blue. The curving linear arabesques are harsher and more urgent than those in Matisse's major figure painting of spring 1906, *Le Bonheur de vivre* (Barnes Foundation, Merion, Pa.).

Clear references to the fall of Eve and the theme of good versus evil can be seen in the figure by the fruit-laden tree at back left, and the snake at the bottom of the picture. The central group can be read as showing Eve (again), led willingly by a Satan-figure with a little demon at his feet, or, perhaps less plausibly, about to be expelled from the garden by an angel. But the picture denies a consistent narrative reading. These ambiguities are an essential part of its meaning, for they leave the viewer free to recreate a mood from these hints, and from the rhythms and colours of the canvas.

In its visual sources, the painting is overtly eclectic. The pose of the central dancing figure is directly borrowed from the Isaiah on the Romanesque carved portal at Souillac in south-western France (there was a cast of this at the time in the Museum of Comparative Sculpture in the Trocadéro in Paris). The left figure, in its drapery patterns, is also reminiscent of Romanesque carving and painting, but its face may show the first traces of the influence of African masks in Derain's art. Derain had admired the '*musée nègre*' in London in March 1906 (cf. *Lettres à Vlaminck*, pp. 196–7, letter of 7 March 1906; it is not clear which museum Derain is referring to), and he had acquired from Vlaminck, probably in 1905, a negro mask whose simplified facial lines seem to be echoed in the face of this draped figure. However, the figure on the right has Oriental overtones; its pose is close to the right-hand figure in Delacroix's *Women of Algiers* (1834, Louvre, Paris), though the head and shoulders are flatter than Delacroix's, and the hand-gestures schematized in a way reminiscent of Indian sculpture, which makes it hard to tell whether its relationship to Delacroix is a deliberate quotation, as the use of the Souillac Isaiah certainly is.

These diverse sources, as well as the general exotic mood, suggest Gauguin's influence. The Eve theme had been one of Gauguin's central motifs, suggesting both the fallen woman and the triumph of the flesh. Moreover, in some of his Tahitian paintings Gauguin had juxtaposed visual references to several different civilizations, as in *Ia Orana Maria* (1891, Wildenstein 428), in which the Christian Nativity story is set in a Tahitian setting, with attendant angels in poses directly borrowed from the Buddhist temple frieze of Borobudur in Java. Gauguin sought in this way to give his images a universal suggestiveness which transcended any single cultural framework. Derain seems to be following the same path, in creating a ritual dance which evokes the eternal conflict between good and evil. J.H.

REFERENCES
D. Sutton, *Derain*, 1959, pl. 15, and p. 147
J. Elderfield, *Fauvism and its Affinities*, 1976, pp. 105–7, 109, 157
H. Dorra, 'The Wild Beasts – Fauvism and its Affinities' at the Museum of Modern Art', *Art Journal*, fall 1976, pp. 90–4

Dubois-Pillet, Albert 1846–90

Self-taught as an artist, Dubois-Pillet was throughout his career a professional soldier, based in Paris from 1880 until 1889, when he was transferred to Le Puy, where he died. He was a motive force behind the founding of the Indépendants in 1884, and his work for the Indépendants brought him into frequent conflict with the military authorities. Dubois-Pillet moved from the naturalist style of his *Dead Baby* of 1881 (a painting which probably inspired a passage in Zola's *L'Oeuvre*) through an Impressionist phase to the adoption of the 'petit point' by 1886–7.

75

75 Wash-house Boat at Saint Maurice 1886/7

Bateau-lavoir à Saint Maurice
sbl. duBois Pillet 27 × 40.5 cm/10½ × 16 ins
Lent by the Musée d'Art et d'Industrie, Saint Etienne

After painting in a rather rigid self-taught Impressionist manner, Dubois-Pillet began in 1886 to adopt a smaller, more regular touch, under the influence of Seurat and Signac. This appears in a still unsystematic form in the *Wash-house Boat*, with little flecks of colour added in parts of the picture to broader paint zones, to introduce small-scale contrasts and atmospheric nuances. Saint Maurice is near Charenton on the river Marne on the south-eastern outskirts of Paris, and Dubois-Pillet was here treating the semi-urban, semi-rural working-class themes favoured by many of the other Neo-Impressionists (cf. nos 117 and 197). A *bateau-lavoir* was a moored boat in which clothes could be washed in river water. J.H.

EXHIBITIONS
1887, Paris, Indépendants (150)
1888, Brussels, Les XX (Dubois-Pillet 6)
1888, Paris, Revue indépendante, *Dubois-Pillet*
REFERENCES
Huysmans, in *Revue indépendante*, April 1887
L. Bazalgette, *Albert Dubois-Pillet*, 1976, pp. 98–103

76

76 *Saint Michel d'Aiguilhe in the Snow* 1890

Saint Michel d'Aiguilhe sous la neige
sbl. duBois Pillet 61 × 38 cm/24 × 15 ins
Lent by the Musée Crozatier, Le Puy

Saint Michel d'Aiguilhe is more systematically executed than the *Wash-house Boat*, but even here the 'points' of paint vary much in size. The snow, which largely veiled the local colours of the scene, let Dubois-Pillet base his composition on soft variations of blue and mauve, against yellow and orange, with warm flecks introduced into the cooler areas and vice versa, to give the whole an atmospheric unity. In his theories of colour Dubois-Pillet advocated the introduction of 'passages', to express the presence, in every colour, of elements from the other parts of the spectrum – in addition to the basic elements normally studied by the Neo-Impressionists (local colour, lighting, reflections, and induced complementary colours); this seems to increase the colour-rhymes in his pictures which link each area to the other (cf. J. Christophe, 'Dubois-Pillet', *Les Hommes d'aujourd'hui*, 1890, no. 370). Camille Pissarro was exploring similar ideas at the same time (cf. no. 155). The town of Le Puy, where Dubois-Pillet spent his last months, gave him a completely new range of subjects; for the church of Saint Michel d'Aiguilhe, on its extraordinary volcanic pinnacle, he chose an abnormally narrow canvas to emphasize the verticality of the motif.

The painting was presented to the Musée Crozatier, Le Puy, in 1890 by the artist's father. J.H.

EXHIBITIONS
1890, Paris, Indépendants (322)
1891, Paris, Indépendants, *Dubois-Pillet* (438)
REFERENCES
R. Gounot, 'Le peintre Dubois-Pillet'. *Cahiers de la Haute-Loire*, 1969, pp. 116–26
L. Bazalgette, *Albert Dubois-Pillet*, 1976, p. 144

Fantin-Latour, Henri 1836–1904

Fantin-Latour failed to gain admission to the Ecole des Beaux-Arts; instead, he copied Old Masters in the Louvre and attended Courbet's 'atelier du réalisme' in 1861. Fantin is best known for his portraits (e.g. *Studio in the Batignolles District*, c. 1870, Jeu de Paume, Paris) and flower-pieces in a realist style, similar to the early works of Degas and Monet. He had close friends in Parisian musical circles, especially among the early Wagnerites. As a graphic artist, he was a founding member of the Société des Aquafortistes in 1862, and his mastery of lithography was a major influence on Seurat and Redon.

77 *Immortality* 1889

L'Immortalité
sdbr. Fantin 89 117 × 87 cm/46 × 34¼ ins
Lent by the National Museum of Wales, Cardiff

Set against a backdrop of Paris, suggesting the view from the cemetery of Père Lachaise, the Muse of Immortality is poised over the tombstone of Delacroix in that cemetery. Fantin had already executed a picture celebrating this French artist (*Homage to Delacroix*, Jeu de Paume, Paris). Painted soon after Delacroix's death in 1863, it portrayed in a sombre, naturalistic technique Fantin's friends, gathered around a self-portrait by Delacroix. The homage is couched in strictly realist terms.

While *Homage to Delacroix* demonstrates the younger generation's reverence for Delacroix as a colourist, a reputation which Signac was to perpetuate in his book, *D'Eugène Delacroix au néo-impressionnisme* (1899), the technique and the composition of *Immortality* suggest that in the late nineteenth century Delacroix's art was open to other interpretations. In technique alone, Fantin has moved away from the literal notation of his 1863 painting by adopting a chalky, rich-toned paint surface, acquired from sixteenth-century Venetian masters and previously used in his paintings of musical and literary subjects. Equally importantly, Fantin has borrowed the pose of his muse from a drawing executed some six years previously on the death of Wagner. Entitled *En Mort* or *Le Réveil* (Musée de Peinture et de Sculpture, Grenoble), it showed a winged muse poised over the tombstone of Richard Wagner. Used three years later in 1886 as one of the lithographic illustrations to Adolphe Jullian's biography of Wagner (G. Hédiard, *Les Maîtres de la lithographie. Fantin-Latour. Etude suivie du catalogue de son oeuvre*, 1892, no. 74) it is tempting to suggest that the reference in this painting to Wagner's muse indicates both Fantin's celebration of the acknowledged musicality of colour in Delacroix's work and his belief, shared by many artists at the end of the nineteenth century, that Delacroix and Wagner were the century's towering geniuses.

The juxtaposition of the real landscape with the unreal figure of the winged muse places this painting within the more general debate, taken up by artists such as Maignan (cf. no. 120) and Béraud (cf. no. 11) during the 1890s, concerning the balance between realism and idealism in a history painting which ought to convey a universal message. M A.S.

77

EXHIBITIONS
1889, Paris, Salon (987)
1890–1, Paris, Durand-Ruel, *Un Groupe d'artistes* (57)
REFERENCE
V. Fantin-Latour (ed.). *Catalogue de l'oeuvre complète de Fantin-Latour*, 1911, p. 143,
no. 1362

Filiger, Charles 1863–1928

A mystic and recluse, Filiger was born in Alsace but trained in Paris
at the Atelier Colarossi. In July 1889 he went to Le Pouldu where he
met Gauguin, Laval, Meyer de Haan and Sérusier. Although he
spent the rest of his life in Brittany, Filiger participated in a number
of exhibitions in Paris and contributed prints to various periodicals.
He committed suicide.

78

78 *Virgin and Child* c. 1892

Vierge et enfant
str. Filiger gouache on panel 31 × 25 cm/12¼ × 10 ins
Lent by Arthur G. Altschul

This was almost certainly one of the six paintings shown by Filiger
at the 1st Salon de la Rose+Croix in spring 1892, the only time that
he exhibited with this body. In its hieratic style and religious subject
matter this picture conforms perfectly to the rules for painting which
Sâr Péladan considered acceptable to the Salon de la Rose+Croix. In
spite of this, at least two critics, Fénéon and Vallotton, wrote
disparaging reviews, accusing Filiger of painting 'medieval pastiche
instead of Renaissance pastiche, neither providing a solution to the
dilemma of modern art' (Vallotton). However Rémy de Gourmont
and, one year later in his extensive study of Filiger, Antoine de la
Rochefoucauld, recognized more positive features in the work. Ack-
nowledging the importance of its Byzantine and Flemish influences,
they also acclaimed its innovatory and Breton character, 'more
abstract than the virgins of the past' (A. de la Rochefoucauld).
Indeed, the rigorous simplification of the landscape in the back-
ground reflects Filiger's friendship with Gauguin and the setting of a
virgin and child within a Breton landscape summarizes the deeply
religious character of Brittany, a theme taken up by other artists
such as Dagnan-Bouveret (no. 58), Cottet (no. 53), Bevan (no. 276)
and Gauguin himself (no. 92).

A variant of this picture, entitled *Ora pro nobis*, was printed in a
limited edition of 20 for an *édition de luxe* of the review *l'Ymagier*,
published in October 1894. M A.S.

EXHIBITION
?1892, Paris, Salon de la Rose + Croix (59 or 63), lent by Comte Antoine de la
Rochefoucauld
REFERENCES
F. Fénéon, 'R + C: (Galerie Durand-Ruel, mars–avril)', *Le Chat noir*, 19 March 1892,
in *Oeuvres plus que complètes*, 1, 1970, p. 211
J. Vallotton, 'Salon de la Rose + Croix', *Gazette de Lausanne*, 22 March 1892
A. de la Rochefoucauld, 'Filiger', *Le Coeur*, July–August 1893, pp. 3–6, repr.
Rémy de Gourmont, 'Les premiers salons', *Mercure de France*, May 1892, pp. 63 ff
New Haven, Yale University Art Gallery, *Neo-Impressionists and Nabis in the Collection of
Arthur G. Altschul*, catalogue by R. Herbert, 1965, p. 74 (26)

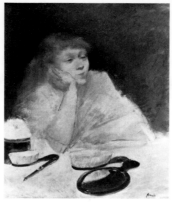

79

Forain, Jean Louis 1852–1931

Forain lived all his life in Paris, and, in addition to painting, worked
as a caricaturist, illustrator and graphic artist. His earlier paintings
of modern urban subjects reflect his friendship with Degas, and he
exhibited with the Impressionists between 1879 and 1886, but his
later oils are closer to Daumier in their colour and their satirical
observation.

79 *Woman at Her Dressing-table* c. 1885

Femme à sa toilette
sbr. Forain 65 × 54.5 cm/25½ × 21½ ins
Lent by a Private Collector

Woman at Her Dressing-table was probably exhibited at the 8th
Impressionist exhibition, at the same time as Degas' sequence
of pastels of women in tubs (cf. no. 62). Forain places the
viewer face to face with the model, and allows us to read her
expression – he was always interested in physiognomy and
caricature – whereas Degas presented his women as if caught
unawares. Forain owed much to Degas' themes and pictorial com-
positions in his paintings up to c. 1890, but in this instance he was
closer to Manet. In her pose and her abstracted mood, *Woman at Her
Dressing-table* is particularly close to Manet's *The Plum* of c. 1877,
which Forain would have seen at the Manet retrospective exhibition
in 1884. Though Forain apparently considered the canvas not fully
finished (cf. Browse 1978), its sketchy execution would not have
seemed out of place among the more informal of the works shown at
the 8th Impressionist exhibition. J.H.

EXHIBITION
1886, Paris, 8th Impressionist exhibition (29)
REFERENCE
L. Browse, *Forain*, 1978, pl. IV and pp. 27 and 81

Gauguin, Paul 1848–1903

Gauguin was born in Paris, but lived in Peru 1849–55. He travelled
widely as a merchant seaman and in the navy 1865–71, before
taking a job on the stock exchange, which he lost in 1883 as a result
of a financial slump. He began to paint c. 1873, and met the Impres-
sionists through his guardian, Gustave Arosa. He painted with
Pissarro on occasion from 1879, and with Cézanne in 1881, at the
same time building up a collection of Impressionist paintings and
showing in the group exhibitions from 1879. He painted in Brittany
in 1886, 1888 and 1889, becoming the leader of the so-called Pont-
Aven Group. He visited Martinique in 1887, and lived in Tahiti
1891–3 and 1895–1901, before moving to the Marquesas islands
where he died.

ABBREVIATIONS
w – G. Wildenstein, *Gauguin*, I, catalogue, Paris, 1964
Lettres – M. Malingue (ed.), *Lettres de Gauguin à sa femme et à ses amis*, Paris, 1946
Bodelsen 1964 – M. Bodelsen, *Gauguin's Ceramics*, London, 1964
Jirat-Wasiutynski – V. Jirat-Wasiutynski, *Paul Gauguin in the Context of Symbolism*, London and New York, 1978

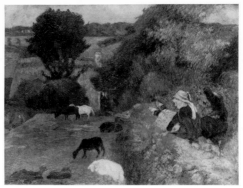

81

80 Still-Life with a Horse's Head c. 1886

Nature morte à la tête de cheval
[repr. in colour on p. 38]
sbr. Paul Gauguin 49 × 38 cm/19¼ × 15 ins
Lent by a Private Collector, Switzerland

Still-Life with a Horse's Head is one of the very few canvases in Gauguin's oeuvre which suggest a flirtation with Neo-Impressionist technique – in the flecks of paint which animate its surface alongside crisp areas of diagonal hatching, over a more broadly handled paint layer. Its subject, too, is unusual, less a real still-life group than a programmatic juxtaposition of the Greek and the Japanese, with a cast of the head of the horse of Selene, from the Elgin Marbles in the British Museum, alongside a Japanese doll and fans.

In later years Gauguin was very hostile to the Neo-Impressionists, but he seems to have been quite close to Seurat and Signac during winter 1885–6, at the moment when they were evolving the Divisionist technique (cf. nos 206 and 199). He showed with them at the 8th Impressionist exhibition in May 1886, and was planning to do so again at the Indépendants in August when a quarrel with Seurat led him to split with them (cf. *Lettres*, 32; Pissarro, *Lettres à son fils Lucien*, p. 104; J. Rewald, *Post-Impressionism*, 1978, p. 39). *Still-Life with a Horse's Head* probably belongs to spring 1886, before Gauguin left for Brittany in June; it may well have been painted in response to Seurat's and Signac's experiments – like it, Signac's first Divisionist canvases are not systematic in handling and show flecks of colour beside more varied touches (cf. no. 206). The coloured accents in the shadows, too, suggest contact with Seurat and Signac.

In its subject, *Still-Life with a Horse's Head* belongs to a tradition of emblematic still-lives which present art objects as a means of making an aesthetic statement. Gauguin's juxtaposition of Greek and Japanese has been paralleled with the closing passage of Whistler's *Ten O'Clock Lecture* of 1885: 'The story of the beautiful is already complete – hewn in the marbles of the Parthenon – and broidered, with the birds, upon the fan of Hokusai – at the foot of Fusi-Yama.' Whistler repeated the lecture at Dieppe in summer 1885; Gauguin was in Dieppe during that summer, and may have heard, or heard about, Whistler's exposition (cf. Bowness 1971). The Greek–Japanese parallel was, though, not a new one; it had emerged in the later 1860s in the paintings of Whistler and Albert Moore in England, and as a means of expressing an ideal of beauty in opposition to Realism, and also in Fantin-Latour's *Studio in the Batignolles Quarter* (c. 1870, Jeu de Paume, Paris). Gauguin, in turn, took up the analogy when he was seeking ways of going beyond Impressionism (cf. no. 81). The arrangement of *Still-Life with a Horse's Head* – scarcely intelligible in naturalistic terms – has parallels with prints of Japanese motifs made by etchers such as Félix Buhot in the 1870s (cf. Cleveland Museum of Art, *Japonisme*, 1975, pp. 81–3 [96a, 98]). Gauguin had already made up still-lives of similarly contrasting elements (e.g. w174), and was later to use still-life imagery to make emblematic statements (cf. no. 85). He made the Greek–Japanese parallel again in 1888 (cf. no. 86). J.H.

REFERENCES
w183
W. Kane, 'Gauguin's "Le Cheval blanc"', *Burlington Magazine*, July 1966, p. 355
New York, Guggenheim Museum, *Neo-Impressionism*, 1968 (113)
A. Bowness, *Gauguin*, 1971, p. 6, pl. 4

81 The Breton Shepherdess 1886

La Bergère bretonne
sdbl. P. Gauguin 86 61 × 73.5 cm/24 × 29 ins
Lent by the Laing Art Gallery, Newcastle-upon-Tyne

Gauguin's landscapes from his first stay at Pont-Aven in Brittany in 1886 show him, in the main, working within the Impressionist tradition which he had inherited from Camille Pissarro; figures are generally subordinated to landscape, but in two canvases, *The Breton Shepherdess* and *The Four Breton Women* (no. 82), they play a larger part. Both were worked out in a number of preparatory studies; the poses of figures and sheep in *The Breton Shepherdess* were all separately drawn (cf. Bodelsen 1964), which shows that the painting was built up in a composite way, not painted directly on the spot. The rhythmic, rather schematic, patterns of brushwork in the foliage confirm this. Indeed, this may well be the size 20 landscape which Delavallée remembered seeing Gauguin begin in the studio at Pont-Aven in 1886, declaring 'I'll finish it out of doors.' He advocated painting in long, separate strokes of contrasting colour, applied with sable brushes to stop the colours mixing and to achieve maximum luminosity; 'He laid on his colours as boldly as possible, above all in stripes' (Chassé 1965). This striping effect marks a turn against the Neo-Impressionists' technique (cf. no. 80), but his preoccupations with the effects of divided colour remain comparable to theirs.

Compositionally, Gauguin avoids any single focus, creating multiple spatial planes – the bank on the right, the zone with the sheep, and the dip on the left with the small figure. This spatial fragmentation echoes Degas' compositions, as does the unexpected angle of vision on the figure of the shepherdess. Delavallée remembered that, during this summer, Gauguin talked most often about Degas and Pissarro (Chassé 1965), and Gauguin was on close personal terms with Degas at the end of 1886 (cf. J. Rewald, *Post-Impressionism*, 1978, p. 39; Pissarro, *Lettres à son fils Lucien*, p. 111).

In pictures such as this, Gauguin began to develop his ideas of 'synthesis', which he was working out in letters and notebooks by early 1885 (cf. *Notes synthétiques*; and *Lettres*, 11, to Schuffenecker, 14 January 1885); he was seeking a means of expressing thought and ideas (*la pensée*) without recourse to narrative or literal symbols, by means of relationships of colours and lines – a preoccupation comparable to that which Seurat and Signac developed through their contact with Charles Henry in 1886 (cf. nos 199 and 211). In *The Breton Shepherdess*, by simplifying and exaggerating the rhythms of the Breton landscape Gauguin was trying to go beyond the Impressionists' preoccupation with specific effects, and to find pictorial forms which expressed more fully the quality of the scenery and its inhabitants (cf. too no. 82). Delavallée found him repeatedly talking of 'synthesis' in 1886, and applying the term to the simplification of his drawing, since he was more concerned, at this point, with questions of technique than of doctrine. J.H.

REFERENCES
W203
Bodelsen 1964, pp. 35–8
C. Chassé, *Gauguin sans légendes*, 1965, p. 24
M. Bodelsen, in *Burlington Magazine*, January 1966, p. 37
London, Tate Gallery, *Gauguin and the Pont-Aven Group*, 1966 (3)
Jirat-Wasiutynski, pp. 52–3

82 *The Four Breton Women* 1886

Les Quatre bretonnes
sdbl. P. Gauguin 86 71 × 90 cm/28 × 35½ ins
Lent by the Bayerische Staatsgemäldesammlungen, Munich

Of the pictures which derive from Gauguin's Breton trip of 1886, *The Four Breton Women* is the most anti-naturalistic. Distance and horizon are suppressed, and there is no suggestion of a specific topographical location; three of the faces are in strict profile, and the composition is held together by taut linear patterns which run from figure to figure. Coloured nuances express the modelling of the figures and the wall which separates them, but the geese and grass beyond are treated in a very schematic way. Detailed studies survive for several elements in the picture, and it was clearly not painted out of doors; indeed, it may have been executed in Paris after Gauguin's return from Brittany in November 1886.

Degas remains an important influence in the figures (cf. no. 81) – in particular the right figure, that of the woman adjusting her shoe, is so similar to a pose in two of Degas' ballet pastels that the quotation must have been intended (Lemoisne 587, 588, the latter in National Gallery, London). However, spatially *The Four Breton Women* is quite unlike Degas' plunging perspectives; its extreme flatness suggests that Gauguin was looking to conventions of a quite different type, to popular woodblock prints such as the *Images d'Epinal*, in which forms are often disposed in tiers up the picture surface. Camille Pissarro may also have had popular prints in mind in 1886, in seeking a 'modern primitive' feel in his *View from My Window* (no. 153), and, at least during 1887, such images were circulating in Paris in the circle around Van Gogh, Bernard and Anquetin (cf. Van Gogh, letter B7).

The book illustrations of Randolph Caldecott were also important for Gauguin; A. S. Hartrick, who met him in Brittany in 1886, remembered: '[Gauguin] had been making some drawings of geese which he showed me. He then produced one of Caldecott's coloured books, in which some geese were depicted in that artist's very characteristic way. These he praised, almost extravagantly as it seemed to me then. "That", he said, "was the true spirit of drawing"' (Hartrick, *A Painter's Pilgrimage*, 1939, p. 33; cf. Bodelsen 1964, p. 45). The geese which Gauguin was drawing were probably related to those in *The Four Breton Women*, and the flat colour-planes and crisp outlining in Caldecott's illustrations may well have contributed to Gauguin's process of simplification. Caldecott had also made a

major contribution to the imagery of Brittany, in his illustrations to Henry Blackburn's *Breton Folk* (1880), which contains an evocative description of the life which, as early as this, artists lived in the Pension Gloanec, the inn where Gauguin stayed at Pont-Aven (pp. 130–2).

The Four Breton Women is also closely linked to Gauguin's first experiments in ceramic work. Several motifs from the painting recur in two vases which almost certainly belong to the first group of pots which Gauguin made in winter 1886–7 under the direction of Ernest Chaplet (cf. Bodelsen 1959 and 1964). In these, the forms are tautly outlined and treated in flat planes, clearly as a result of the ceramic techniques which Gauguin had learned from Chaplet, who was habitually working in this manner at the time (cf. Bodelsen 1964, figs 9, 19, 35). This technique, in turn, seems to have influenced Gauguin's painting style in 1887–8 (cf. no. 83), but the handling of *The Four Breton Women*, with its more modelled forms and softer contours, must predate the ceramics.

In *The Breton Shepherdess* (no. 81), Gauguin had been seeking the mood of the Breton landscape, and in *The Four Breton Women* he was trying, by the rhythms and movements of the figures, to express the mood of the people who lived there, which he described to Schuffenecker in March 1888, early in his second stay at Pont-Aven: 'I love Brittany; I find there the savage, the primitive. When my clogs ring out on this granite soil, I hear the dull, muted, powerful tone which I seek in my painting' (*Lettres*, pp. 321–2). There may be a lighter note, too, in *The Four Breton Women*, in the juxtaposition of the head of the talking woman at the left with the attentive, childlike geese – perhaps a joke about women's gossip. In several later paintings, Gauguin used walls or barriers, with figures on either side of them, to suggest different levels of experience (e.g. *Bonjour Monsieur Gauguin* [W321–2] and *The Yellow Christ* [W327]), but it is hard to tell whether, in *The Four Breton Women*, there is any significance in the placing of one woman, with the geese and the small wood-gatherer, on the further side of the wall.

This was the second of Gauguin's canvases to be sold by Théo Van Gogh on behalf of the firm of Boussod & Valadon; Gauguin left a group of canvases on consignment with Théo in 1887–8 for him to sell as he could (cf. Rewald 1973). J.H.

EXHIBITION
1888, Paris, *chez* Diot (cf. Van Gogh, letter T2)
REFERENCES
W201
R. Goldwater, *Gauguin*, 1957, pp. 78–9
M. Bodelsen, in *Gazette des Beaux-Arts*, May–June 1959, pp. 333–8, 344
Bodelsen 1964, pp. 24–6, 38–9
M. Bodelsen, in *Burlington Magazine*, January 1966, p. 35
J. Rewald, in *Gazette des Beaux-Arts*, January–February 1973, pp. 31, 90
Jirat-Wasiutynski, pp. 54–9

83 *Martinique Landscape* 1887

Paysage de la Martinique
sdbr. P. Gauguin 87 115.5 × 89 cm/45½ × 35 ins
Lent by the National Gallery of Scotland, Edinburgh

Gauguin set sail for Panama with Laval in April 1887, and they quickly moved on to the island of Martinique, west of the isthmus, where Gauguin had his first opportunity to paint the exotic life and light of the tropics. His Martinique figure-pieces follow the directions set in Brittany in 1886 (cf. no. 82), in seeking the dominant rhythms of the life of the people (Théo and Vincent Van Gogh bought two of these for their collection, W222 and 224, now in the Rijksmuseum Vincent Van Gogh, Amsterdam). In landscapes such as *Martinique Landscape* he sought monumentality from the scenery alone. The view is conceived as a succession of planes, varied in

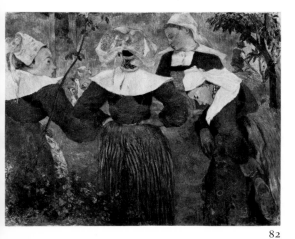

82

texture yet dominantly flat in effect, and often outlined; only the cockerel, half hidden by the bush on the right, suggests the scale of the scene. The colour exploits contrasts of red and green, orange and blue, but intense colours are used only in small areas, and the overall effect is resonant and comparatively austere, rather than one of luminous atmosphere.

The composition echoes Cézanne (cf. no. 42), and there is also some residual influence from Cézanne in the parallel brushstrokes which animate many of the planes – Gauguin owned his *The Castle of Médan* (no. 40). However, the effect of this brushwork is unlike his, since the separate strokes belong on the picture surface, rather than suggesting three-dimensional modelling. The flatness is emphasized by the outlines, which act as contours for flat zones, whereas Cézanne used his outlines to suggest a demarcation in space (cf. no. 47). Gauguin's ceramic work of winter 1886–7 (cf. no. 82) may well have influenced this development in his painting style, but the outlining also has parallels with Japanese prints, and with the experiments which Anquetin and Bernard were making at the same time in Paris, which led to the style known as Cloisonnism (cf. nos 7 and 12). Gauguin had met Bernard in passing in Brittany in 1886, but there is no evidence that he renewed contact with him or met Anquetin before his departure for Martinique.

Gauguin always felt that his upbringing in Peru gave a savage element to his personality, and his tastes for the exotic were fostered by the voyages of his youth, and by his stay on Martinique. After that period he dreamed of returning to paint the tropics, thinking up a succession of projects which materialized when he left for Tahiti in 1891. His ideal of the tropics shared something with his feelings for Brittany: both represented an escape from urban civilization and a return to a way of life founded on man's relationship with the soil, on superstition, not rationalism. However, Brittany was a 'hard' primitive ideal; Gauguin valued its mournfulness (*tristesse*), whereas his idea of the tropics combined mystery with a sensuous, easy life lived from the fruits of nature (cf. *Lettres*, 106, 105, 100 [in this order] for the development of his idyll). J.H.

EXHIBITIONS
1894, Brussels, Libre Esthétique (188), lent by the composer Chausson
?1906, Paris, Salon d'Automne (211)
REFERENCES
W232
M. Bodelsen 1964, p. 178
Edinburgh, National Gallery of Scotland, *Shorter Catalogue*, 1978, p. 40

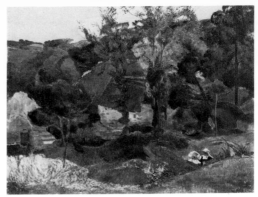

84

84 *Landscape at Pont-Aven* 1888

Paysage à Pont-Aven
sdbr. P. Gauguin 88 72 × 91.5 cm/28¼ × 36 ins
Lent by a Private Collector, Switzerland

Gauguin's paintings from his second trip to Brittany in 1888 divide into two groups – his landscapes, and a few overtly experimental paintings, mainly of figures. The landscapes, such as *Landscape at Pont-Aven*, take up the directions set in his outdoor scenes of the previous two years (cf. nos 81 and 83). Here, the natural scene is treated as a succession of differently coloured planes, which pull forward on to the picture surface rather than suggesting atmospheric perspective; the brushwork creates a homogeneous texture reminiscent of tapestry. The space is complex, with the foreground figures and cottage cut off by the intervening hillside; these figures echo the poses of the two central figures in *The Four Breton Women* (no. 82).

Gauguin continued painting landscapes, more residually Impressionist in their brushwork, alongside his more experimental work. He announced the new direction in his work in a letter of 8 July to Schuffenecker: 'I have just done some nudes, which you will like. They're not at all like Degas. The latest is two boys wrestling by the river, wholly Japanese, by a Peruvian savage. Very lightly worked, with green grass and the top white' (*Lettres*, 66; the painting is W273). This simplification and rejection of rich paint surfaces thus began before Bernard's arrival at Pont-Aven in August (cf. *Lettres*, 67). However, it was after Bernard's arrival, and probably as a result of seeing his *Breton Women at a Pardon* (no. 15), that Gauguin painted his most schematic canvas to date, and his first Breton religious subject, *Vision After the Sermon* (fig. 8). Even at Arles, later in 1888, his landscapes remain more naturalistic in treatment than figure paintings such as *In the Garden at Arles* (no. 86), and he may, in part at least, have painted some of these landscapes out of doors. J.H.

REFERENCES
W253
London, Tate Gallery, *Gauguin and the Pont-Aven Group*, 1966 (11)
M. Bodelsen, in *Burlington Magazine*, January 1966, p. 36
M. Roskill, *Van Gogh, Gauguin, and the Impressionist Circle*, 1970, p. 134
Jirat-Wasiutynski, p. 99

85 *Still-Life Fête Gloanec* 1888

Nature morte Fête Gloanec
d and insc br. Fête Gloanec Madeleine B 88
oil on canvas mounted on panel 38 × 53 cm/15 × 21 ins
Lent by the Musée des Beaux-Arts, Orléans

In his still-lives of 1888, Gauguin broke away from the Chardin-based tradition which he had inherited from Cézanne in the early 1880s (cf. no. 41), at about the same time as Cézanne was adopting

83

richer and more fluid forms in his still-lives (cf. no. 43). In *Still-Life Fête Gloanec* the frontal view is abandoned in favour of a table-top seen from above with no legible space beneath it; its bottom edge becomes a flat, curving band, and the still-life objects read up from this to the top of the canvas, in loose rhythms which have some similarities with the arrangements in Monet's still-lives of the early 1880s (cf. no. 135). The treatment of the table-edge echoes the device of the rounded frame within an oblong format found in certain Japanese prints, which Gauguin used in a rather different way in *La Belle Angèle* of 1889 (w315, Palais de Tokyo, Paris).

The picture, Maurice Denis recorded, was signed with the name of Bernard's 17-year-old sister Madeleine, because some of the more reactionary painters staying with Gauguin at the Pension Gloanec at Pont-Aven were unwilling to have his work hanging alongside theirs on the *fête* of the patroness, when it was customary for every artist there to hang one of his pictures; Gauguin presented his canvas as Madeleine's work, though few can have been deceived by the ruse.

The painting may perhaps contain another reference to Madeleine of a rather different kind. On her arrival at Pont-Aven (probably late in August 1888), Gauguin had at once been much attracted by her, and had painted a flirtatious portrait of the girl (w240, Musée de Peinture et de Sculpture, Grenoble), very unlike the hieratic, saint-like images which her brother made of her (cf. no. 14). It is possible that the lavish vase of flowers and two pears in *Still-Life Fête Gloanec* evoke her head and breasts, and that in a sense it is a picture of her, as well as masquerading as one by her. The luminous red table-top, too, suggests an imaginary dimension in the picture – Gauguin used the red field in *Vision After the Sermon* (fig. 8; painted at very much the same time) to express the unreal plane of the vision. This would not be the only occasion on which Gauguin used the imagery of his still-lives to make emblematic statements about his relationship with women; *Still-Life with a Japanese Print* of 1889 (w375) has very plausibly been presented as a symbolic representation of his relation-ship with Schuffenecker's wife (cf. Bodelsen 1964, p. 119). Gauguin certainly associated Madeleine Bernard with flowers, since in 1889, in a letter to her, he used the metaphor of 'three beautiful flowers' to express the prime virtues which he found in her (*Lettres*, 96). He also, in October 1888, characterized her as an androgyne, since she represented for him both true emotion and the unattainable (*Lettres*, 69); Madame Schuffenecker, also personified as a vase of flowers in *Still-Life with a Japanese Print*, came in turn to stand for the unattain-able. The androgyne metaphor recurs in Gauguin's description of his friendship with a boy in Tahiti in 1891 (cf. no. 89). J.H.

REFERENCES
w290
M. Denis, 'L'Epoque du symbolisme', *Gazette des Beaux-Arts*, 1934 (1), p. 169

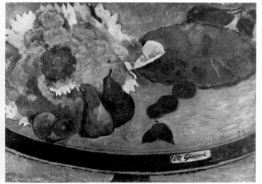

85

86

86 *In the Garden at Arles* 1888

Dans le Jardin à Arles
sdbl. P. Gauguin 88 73 × 92 cm/28¾ × 36¼ ins
Lent by the Art Institute of Chicago, Gift of Annie Swan Coburn to the Mr and Mrs Lewis L. Coburn Memorial Collection

In the Garden at Arles is a key example of Gauguin's art at its most anti-naturalistic, with space and form reduced to schematized patterns. It was painted while he was staying with Van Gogh at Arles late in 1888, in the aftermath of his *Vision After the Sermon* (fig. 8) and his spell working with Bernard at Pont-Aven (cf. nos 14–15 and 84–5), at a point when he was 'sacrificing everything, execution, colour, in favour of style' (*Lettres*, 71, to Schuffenecker, 8 October 1888, from Brittany), and was insisting on the primacy of painting from the imagination. In the jumps of scale, the simplified forms, and the swerving diagonal which crosses the composition, *In the Garden at Arles* has much in common with *Vision After the Sermon*.

In his relationship with Van Gogh, both men assumed that Gauguin was the master (cf. Van Gogh, letters 544, 544a, 563, and Gauguin, in *Avant et après*, English edn, 1930, pp. 11–21), and he had no hesitation in criticizing what he saw as the faults in Van Gogh's work – his excessive dependence on nature and his over-loaded impasto (cf. *Lettres*, 78, and Van Gogh, letters 562–3 and w9). *In the Garden at Arles* was undoubtedly painted from the imagination – presumably in Gauguin's room in the Yellow House which they shared. Gauguin's choice of subject is given its point by the decorations which Van Gogh had hung in this room – his own Poet's Garden sequence (cf. no. 100). In this context, *In the Garden at Arles* must be seen as Gauguin's answer to the Poet's Garden paintings, and as a demonstration of how such a theme ought to be treated – not by fastening an idea on to a set of studies executed from nature, as Van Gogh had, but by starting with the idea and then seeking pictorial form for it in the imagination. Winding path, fence, bushes and bench occur in Van Gogh's previous garden paintings (cf. nos 100 and 101, and de la Faille 470–1), but Gauguin has ruthlessly subordinated them to a dominant surface pattern, suppressing horizon and perspective. He has added the fountain and pond at upper right, perhaps feeling that every well-appointed public garden should have them, and thereby pointing out, as he repeatedly did, the inadequacies of Arles (cf. *Lettres*, 78, and Van Gogh, letter 558b).

The figures are far more prominent than in Van Gogh's Gardens, and, instead of being companionable lovers (cf. no. 100), they are gaunt and mournful, with the added oddity of the horned head-dress of the second one; the nearest woman resembles Madame Ginoux, whom both men had used as a model (cf. w305, and related drawing, repr. Roskill 1970, pl. 118; and de la Faille 488–9). The figures are shut into the picture by the barrier of bush and

fence (cf. no. 82), and, on the bush, there are hints of an added face with eyes and moustache, which resembles Gauguin's own – possibly a comic reference to the presence of the artist. A further ambiguity is added by the orange conical forms to the right of the picture – perhaps bushes or stooks; Gauguin made preparatory drawings for these, along with many other features in the picture, in his Arles sketchbook (ed. R. Huyghe, 1952).

In style, too, the picture is quite unlike Van Gogh's Gardens, with its asymmetrical, tipped-up composition and flattened forms. Gauguin described in a letter to Bernard the two men's different vision of Arles: 'It's strange, but the place inspires Vincent to paint like Daumier, while on the contrary I'm finding a coloured version of Puvis mixed with Japan. The women here, with their elegant headdresses, have a Greek beauty; their shawls create folds like those in primitive paintings, and make them look like a Greek procession. . . . Anyway, there's a source here of beautiful *modern style*' (*Lettres*, 75). This comment shows how Gauguin found in Japanese art a licence to stylization, which he could parallel with the Greek (on this analogy, cf. no. 80), whereas Van Gogh saw it as a means of getting closer to nature (cf. no. 99).

While Gauguin was at Arles, Van Gogh painted a garden canvas from his imagination, *Souvenir of the Garden at Etten* (de la Faille 496, cf. no. 102), which in space and composition has much in common with *In the Garden at Arles*, and owes a great debt to Gauguin. There has been some discussion of the relationship between the two paintings (cf. Roskill 1970), but the presence of Van Gogh's Poet's Garden canvases in Gauguin's room suggests the most plausible sequence: Gauguin painted *In the Garden at Arles* as a corrective to the Poet's Garden, to show how much more richly and suggestively the theme could be treated by working from a synthesis of memory and imagination, and Van Gogh, in his role as pupil, followed this with his *Souvenir*, a fusion of Arles with memories of his mother and sister in Holland, to show that he too could put Gauguin's ideas into practice.

Théo Van Gogh seems to have bought *In the Garden at Arles* from Gauguin, under the title *Arlésiennes, mistral*, on his own account, not on behalf of Boussod & Valadon; however, he apparently sold it again soon afterwards, perhaps to Schuffenecker (cf. Rewald 1973). J.H.

REFERENCES
W300
M. Roskill, *Van Gogh, Gauguin and the Impressionist Circle*, 1970, pp. 146–8
W. V. Andersen, *Gauguin's Paradise Lost*, 1971, pp. 80–1
J. Rewald, in *Gazette des Beaux-Arts*, January–February 1973, pp. 35–7, 63 n. 82
Jirat-Wasiutynski, pp. 107–9
J. Rewald, *Post-Impressionism*, 1978, pp. 230–3

87 *The Beach at Le Pouldu* 1889

La Plage au Pouldu
sdbl. P. Gauguin 89 73 × 92 cm/28¾ × 36¼ ins
Lent by a Private Collector, USA

The Beach at Le Pouldu, whose first owner was Maillol, takes up the theme of the rocky Breton coastline pounded by waves which Monet had painted in 1886 (cf. no. 138; many of Monet's Belle-Isle canvases were shown in the Monet–Rodin exhibition of summer 1889), but reinterprets it in terms of the stylized arabesques of the Japanese print. Its curling forms are particularly reminiscent of Hiroshige's treatment of waves (cf. Y. Thirion, in *Gazette des Beaux-Arts*, January–April 1956, pp. 102–6). Gauguin had treated one seascape in this manner in 1888 (w286), but had generally reserved this extreme schematization for his imaginary subject pictures (cf. no. 86). If *The Beach at Le Pouldu* was painted in front of nature, its simple colour-planes show how Gauguin put into effect

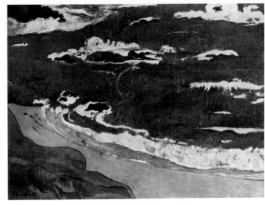

87

the famous instructions which he gave Sérusier in October 1888 (cf. no. 187): 'How do you see that tree? It's green? Then paint it green, the most beautiful green on your palette; and that shadow, it's more like blue? Don't be afraid to paint it as blue as possible' ('L'Influence de Paul Gauguin', *L'Occident*, October 1903, in *Théories*, 1964 edn, p. 51). Lacombe was to take up this very decorative treatment of seascapes in the 1890s (cf. no. 111).

During 1889, Gauguin gave the theme of sea and waves a metaphorical meaning in *Nirvana* and *Undine* (w320, 336), but *The Beach at Le Pouldu* carries no obvious deeper significance. J.H.

REFERENCES
W362
J. Rewald, *History of Impressionism*, 1973, p. 555, repr. in colour

88 *Naked Breton Boy* 1889

Petit breton nu
sdbr. 89 P. Gauguin 93 × 73.5 cm/36½ × 29 ins
Lent by the Wallraf-Richartz Museum, Cologne

Simplified in space and gauche in composition, *Naked Breton Boy* develops the characteristics which in 1888 Gauguin had pinpointed in his canvas of boys wrestling (w273) – 'wholly Japanese, by a savage from Peru, and very thinly painted' (*Lettres*, 66, cf. no. 84); the composition here, and the accentuated outlines, certainly echo Japanese prints, though the lack of perspective also shows the deliberately naïve vision which Gauguin had been cultivating since 1886 as a means of expressing the primitive quality of the Breton scene (cf. no. 82). This canvas echoes Gauguin's instructions to Chamaillard at Pont-Aven, that 'every object had its form and colour, properly specified with a precise contour. This, together with his love of line and of the arabesque, formed the essential part of his theory' (quoted London, Tate Gallery, *Gauguin and the Pont-Aven Group*, 1966, p. 9).

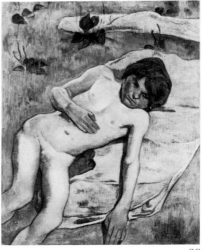

88

Gauguin painted several canvases of nude Breton boys, either wrestling (a popular Breton custom) or after bathing. In part at least, this was the result of the difficulty of finding women to pose nude at Pont-Aven, though an interest in physical immaturity – in both boys and girls – played a recurrent part in his sexual attitudes (cf. nos 85, 89 and 91). J.H.

REFERENCES
W339
London, Tate Gallery, *Gauguin and the Pont-Aven Group*, 1966 (19)

89 *The Man with the Axe* 1891

L'Homme à la hache
[repr. in colour on p. 40]
sdbl. P. Gauguin 91 92 × 69 cm/36¼ × 27¼ ins
Lent by Mr and Mrs Alexander Lewyt

On his arrival in Tahiti in 1891, Gauguin could not at once fully adapt his pictorial vision to his new surroundings; his most important paintings from 1891, such as *The Man with the Axe*, present a complex fusion of direct observation, artistic tradition, and symbolic meaning, treated with the simple colour-planes and curving arabesques which he had worked out in his previous figure paintings (cf. no. 86).

Gauguin described in *Noa-Noa* the visual experience which led to *The Man with the Axe* – a scene which he saw from his hut at Mataiea (the native village to which he moved soon after his arrival on Tahiti), of a man cutting down a dead coconut tree, with, beyond, a woman stowing nets in a dug-out canoe. However, even in this description the scene gained an extra dimension: 'On the purple ground, long serpentine leaves of a metallic yellow, a whole oriental vocabulary, letters, it seemed to me, belonging to an unknown mysterious language. I seemed to see that word of Oceanic origin, *Atua*, "God". As Taäta or Takata it reached India and is to be found everywhere and in everything – (Religion of Buddha). . . .'

The pose of the axe-man, far from being directly observed, is borrowed, in reverse, from a figure on the west frieze of the Parthenon – Gauguin had with him in Tahiti a set of photographs of the Parthenon friezes (cf. Kane 1966), and very many figures in his South Seas paintings have poses taken from the large collection of photographs and prints which he took with him as 'a whole world of comrades who will talk to me every day' (letter to Redon, September 1890, *Lettres à Odilon Redon*, 1960, p. 193). In 1892, Gauguin joked about his borrowings in a letter admitting one such theft: 'You mustn't mention it, but who cares? One does what one can, and when marbles or wood engravings draw a head for you, it is so tempting to steal it' (*Lettres à Georges Daniel de Monfreid*, letter 5). However, this seems to be an attempt to laugh off something which had a more positive role in his art, since his borrowings, even before they are precisely recognized, evoke reminiscences of the culture from which they come, and give his canvases more universal terms of reference (cf. nos 90 and 93). It is, though, dangerous to seek too specific meanings in individual visual sources once they have been identified.

In *Noa-Noa*, the description of the man wielding the axe occurs shortly before a long account of an expedition which Gauguin made with a native boy to find a piece of wood for a sculpture. As Gauguin walked behind him, the boy became for him sexless, an androgyne, a symbol of the free sexuality of the savage; he began to desire him, until the boy turned to face him, quite innocent; 'It was a young man, after all'. When they found a tree to fell Gauguin exorcised his emotions in hacking it down and destroying it: 'Well and truly destroyed indeed, all the old remnant of civilized man in me. I returned at peace, feeling myself henceforward a different man, a

Maori.' Gauguin had already used the metaphor of the androgyne – the figure which belonged to neither or both sexes – as an expression of a profound but ultimately unattainable emotion, in his relationship with Madeleine Bernard at Pont-Aven in 1888 (cf. no. 85, and *Lettres*, 69). He seems to transpose his experience during the wood-cutting expedition on to the axe-man in *The Man with the Axe*, whose nipples and vestigial breasts suggest such an ambiguity. From these associations he was able to make the image a metaphor for his rejection of western civilization.

The Man with the Axe has an immediate impact, from its colours and lines, and from the dramatic gesture which dominates it. But its complex origins give it deeper levels of meaning, in its autobiographical associations and in the juxtaposition of Greek pose with echoes of oriental script evoking the Buddha. Artistic references are synthesized with personal meaning, since in his early Tahitian paintings Gauguin was seeking a visual language which could transcend particular civilizations. He would have known Spiritualist writings such as Schuré's *Les grands initiés* (1889), which describe the quest for the spiritual unity underlying the world's religions, and in *The Man with the Axe* he was using forms reminiscent of Greece and the Orient, set in a Tahitian milieu, to express the search for spiritual wholeness which his wood-cutting expedition had come to symbolize. At much the same time, in *Ia Orana Maria* (w428, Metropolitan Museum of Art, New York), he made a similar synthesis within a religious context, presenting the Madonna and Child as Tahitians, attended by angels derived from a Buddhist temple frieze, to create an image of universal significance from a fusion of Christian, Buddhist and Oceanic. Van Gogh built up the levels of meaning in his canvases in a very different way (cf. no. 100). J.H.

EXHIBITION
1893, Paris, Durand-Ruel, *Gauguin* (15)
REFERENCES
W430
Gauguin, *Noa-Noa*, 1924, pp. 41–2, 62–8; and original text, transl. 1962, pp. 19–20, 23–5
J. Rewald, *Post-Impressionism*, 1978, pp. 459–61, 466, 474
W. Kane, in *Burlington Magazine*, July 1966, pp. 356–7
W. V. Andersen, *Gauguin's Paradise Lost*, 1971, pp. 202–9
R. S. Field, *Paul Gauguin, the Paintings of the First Voyage to Tahiti*, 1977, pp. 50–4 and cat. 12

90 *When Will You Marry?* 1892

Nafea Faa ipoipo (Quand te maries-tu?)
sdbl. P. Gauguin 92; insc br. NAFEA Faa ipoipo
101.5 × 77.5 cm/40 × 30½ ins
Lent by the Rodolphe Staechelin Foundation, Basle

Only in spring 1892, when he had been in Tahiti for a year, did Gauguin feel that he had come to terms with its particular character: 'I am hard at work, now I know the place and its scent; the Tahitians, whom I'm treating in a very enigmatic way, are Maoris and not Orientals from the Batignolles [in Paris]; it has taken me almost a year to understand this' (*Lettres*, 130, to his wife, May 1892). *When Will You Marry?* belongs to this period. It is built up of bands of colour, set off against the curves of the figures and the stylized zone of blue shadow by the tree. Blues and greens introduce colour contrasts, but the central area of the picture is dominated by relationships between reds, pinks and oranges. Gone are the asymmetries and deliberate distortions of his paintings of 1888–9 (cf. no. 86), and the overt use of Japanese prints, in favour of a simple monumentality which confronts the spectator directly.

In theme, *When Will You Marry?* is predominantly a Tahitian genre scene. The gardenia in the hair of the nearer girl shows that she is seeking a husband (cf. Field 1977), and her companion seems

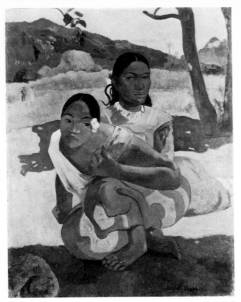

90

contrast between her warm flesh-tones and the blue chair cover.

The inscription at top right, in pidgin Tahitian, some of it half-obscured by overpainting, adds a dimension to the picture's meaning when taken in conjunction with the apples of temptation beneath it. It means 'The child-woman Judith is not yet breached', and refers to Judith, the 12-year-old daughter of William Molard, who lived in the flat beneath Gauguin's in rue Vercingétorix in Paris (cf. Danielsson 1965, pp. 149 ff., for the inscription, and for extensive quotations from Judith's diaries). Gauguin had flirted with Judith before Annah's arrival diverted his attention; the two girls, one white and virginal, the other coloured and sexual, came to stand in his mind for the ambivalence of Eve's fall, which is suggested by the apples (cf. no. 93 for Gauguin's Eves, and nos 85, 88 and 89 for his interest in adolescents). Contrast Munch's treatment of the theme of puberty (no. 265). J.H.

REFERENCES
W508
A. Vollard, *Souvenirs d'un marchand de tableaux*, 1937, pp. 199–200
Lettres, pp. 253, n. 2, 260, n. 2
B. Danielsson, *Gauguin in the South Seas*, 1965, p. 156

to be asking the question of the title. However, the hand gesture of the second figure has clear Buddhist overtones, and suggests a more generalized dimension to the relationship between the figures, as a juxtaposition between knowledge and innocence – a central theme in Gauguin's later art (cf. no. 93). Gauguin's mention of his 'enigmatic' treatment of his figures shows that the canvas should not be read as a simple narrative; the picture as a whole poses the spectator with the question in the title. Gauguin often insisted that he wanted the content of his paintings to operate, not by known allegories and legible narratives, but by presenting forms which suggest moods and raise questions which the spectator has to explore at leisure (cf. e.g. *Lettres*, 174, to Morice, July 1901). His titles augment these ambiguities, though when he exhibited his Tahitian paintings in 1893 he provided French translations for those titled in Tahitian, such as the present picture. J.H.

EXHIBITIONS
1893, Paris, Durand-Ruel, *Gauguin* (19)
?1906, Paris, Salon d'Automne
REFERENCES
W454
B. Danielsson, 'Gauguin's Tahitian Titles', *Burlington Magazine*, May 1967, p. 231
J. Elderfield, *European Master Paintings from Swiss Collections*, 1976, pp. 20–1
R. S. Field, *Paul Gauguin, the Paintings of the First Voyage to Tahiti*, 1977, pp. 132–6 and cat. 35

91 *Annah the Javanese* 1893/4

Annah la Javanaise
[repr. in colour on p. 105]
ns; insc tr. AITA PARARI Tamari vahina Judith te
116 × 81.5 cm/45¾ × 32 ins
Lent by a Private Collector, Switzerland

Quite exceptional in Gauguin's work, this canvas depicts a 13-year-old Oriental half-caste, given the name Annah the Javanese, whom the dealer Vollard found as a model for Gauguin; she soon became his companion and mistress. He has portrayed her enthroned and confident, as a carnal goddess, with the pet monkey (a symbol of promiscuity) which he bought for her. The sexuality of the image is emphasized by the fact that it is perhaps the first major painting of the female nude within the Western tradition to include the pubic hair. The flat decorations on the background wall, and the frontally placed chair (presumably carved or invented by Gauguin himself), present Anna to the spectator, and her body is thrust forward by the

92 *Christmas Night*
(The Blessing of the Oxen) c. 1896?

Nuit de Noël (La Bénédiction des boeufs)
sbr. P. Gauguin 72 × 83 cm/28¼ × 32¾ ins
Lent by a Private Collector, Switzerland

This canvas and another Breton snow scene (W525, Jeu de Paume, Paris) were found among Gauguin's effects in the Marquesas islands after his death. The other painting, which has no figures, shows the scene in the background of *Christmas Night*, and it is very possible that the present picture, despite its subject, was executed in the South Seas, perhaps *c.* 1896 in Tahiti. Its figures look Tahitian in type, though this is also true of one Breton scene definitely painted on his return to Brittany in 1894 (W521).

At the right of *Christmas Night* stands a Breton wayside shrine with a carving of the nativity, but the role of the oxen is uncertain: they can either be seen as attending the nativity, and thus breaking the boundary between the real scene and the images in the carving, or as taking part in some ritual in front of the shrine, as is suggested by the title under which the painting was exhibited in 1906, *La Bénédiction des boeufs*. In 1889, Gauguin had used the religious carvings of Brittany as the basis for two of his most important religious paintings, *The Yellow Christ* (W327, Albright-Knox Art Gallery, Buffalo) and *Breton Calvary* (W328, fig. 9); he found in the simplified forms of Breton sculpture a means of expressing the quality of Breton life and its superstitions. J.H.

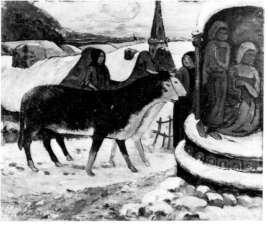

92

EXHIBITION
1906, Paris, Salon d'Automne (69)
REFERENCES
W519
A. Alexandre, *Gauguin*, 1930, pp. 251–2
London, Tate Gallery, *Gauguin and the Pont-Aven Group*, 1966 (42)
W. Jaworska, *Gauguin et l'école de Pont-Aven*, 1971, p. 31, repr. in colour

93 *Contes barbares* 1902

[repr. in colour on front cover]
sdbr and insc. Contes Barbares Paul Gauguin 1902 Marquises
131.5 × 90.5 cm/51¾ × 35½ ins
Lent by the Folkwang Museum, Essen

Contes barbares is one of Gauguin's last major paintings, executed in the Marquesas islands in 1902; it was bought by Karl Ernst Osthaus from Vollard *c*. 1903. It returns to one of the central themes of his later work, the contrast between innocence and knowledge, the savage and the civilized. The Marquesan girls, one assumes, are telling, or dreaming of, the barbarous stories of the title, while beside them squats the eavesdropping figure of Meyer de Haan, with whom Gauguin painted in Brittany in 1889 (cf. no. 134); the animal claws on his foot evoke the image of the fox, 'the Indian symbol of perversity' (*Lettres*, 87, to Bernard, 1889), which Gauguin had used to characterize de Haan in paintings at that time (W317, 320). De Haan, who was deeply involved with the arcane and the occult, is thus opposed to the creatures of Nature.

The two girls are rendered in poses borrowed from different parts of the friezes of the Buddhist temple of Borobudur on Java, of which Gauguin had photographs (cf. Dorival 1951; F. Cachin, *Gauguin*, 1968, p. 242); even without knowledge of this specific source, the posture of the dark-haired girl has obvious Buddhist references, which give a more universal meaning to the image (cf. no. 90). The title suggests another sense in which the picture is not simply derived from nature; it implies that the girls are recounting traditional legends. However, when Gauguin reached the South Seas the continuous tradition of Oceanic mythology had finally been broken by the activities of Christian missionaries. When he introduced or hinted at such myths in his Oceanic paintings, his sources were published ones – the compilations of Moerenhout (1837) and Bovis (1855; on these, cf. Danielsson 1965, pp. 110–11, 125); by

suggesting, as he did in *Contes barbares*, that traditional legends were current, he added a dimension to his paintings which he did not find in reality.

Gauguin had explored the theme of innocence and knowledge in his great allegory of 1897, *Where Do We Come From? What Are We? Where Are We Going To?* (W561, Museum of Fine Arts, Boston), and it forms the basis for his repeated exploration of the subject of Eve. Eve's role in Gauguin's art is ambiguous: sometimes her sin brings guilt and despair (cf. W333, of 1889), sometimes she glories in it (as in *Te Arii Vahine* of 1896, W542, in which the serpent supplies the reference to Eve, and in *Annah the Javanese*, no. 91), and sometimes she is poised on the brink of her decision (W389, 455); in *Contes barbares*, innocence breeds beauty, and knowledge becomes diabolic.

These issues were central to Gauguin's life as well as his art – in his attempt to shed western civilization and become a savage, while constantly reiterating the contrast between the two states. He expressed this paradox most clearly in a letter to de Monfreid in 1901, explaining his aims in his collaboration with Charles Morice on *Noa-Noa*: 'I had the idea, in writing of the uncivilized, to point the contrast between their character and ours, and I thought it quite a novel idea to write, myself, quite simply as a savage; and to have beside what I wrote the style of a civilized man, Morice' (*Lettres à Georges Daniel de Monfreid*, letter 81). The sudden switch of his own identity in this passage, from civilized to savage, reveals on one level the impossibility of a European becoming a true savage, since comparisons with civilization are always in his mind; however, Gauguin felt able to say defiantly to Morice in April 1903, in his last letter to Europe: 'I am a savage' (*Lettres*, 181).

It is this paradox which gives Gauguin's art its richness of meaning. By synthesizing his love of the rhythms and colours of Oceanic life with a complex network of allusions to western and oriental mythologies and artistic traditions, he found a way of expressing the basic dilemmas of human existence in the most powerful and direct way. J.H.

EXHIBITION
?1903, Paris, Vollard, *Gauguin* (24)
REFERENCES
W625
B. Dorival, in *Burlington Magazine*, April 1951, p. 121
R. Goldwater, *Gauguin*, 1957, pp. 154–5
B. Danielsson, *Gauguin in the South Seas*, 1965, p. 244
W. Andersen, *Gauguin's Paradise Lost*, 1971, pp. 107–8

Van Gogh, Vincent 1853–90

Son of a Dutch Protestant minister, Van Gogh tried various careers – the art trade, teaching, the ministry and missionary work – before deciding to become a painter *c*. 1880. He studied briefly under Mauve in The Hague in 1883, then worked mainly at home in Nuenen, before leaving to study in Antwerp in winter 1885–6, and then joining his brother Théo in Paris in March 1886. There he briefly studied with Cormon, learnt from the paintings of the Impressionists, and met many artists, including Gauguin, Bernard, Signac, the Pissarros and Toulouse-Lautrec. He left in February 1888 for Arles in Provence, where Gauguin stayed with him from October until Van Gogh's breakdown in December 1888. He lived in the hospital at Saint Rémy, near Arles, from May 1889 to May 1890, and then moved to Auvers in northern France, where he killed himself in July 1890.

ABBREVIATIONS
F – J. B. de la Faille, *The Works of Vincent van Gogh*, London, 1970
Letters – *The Complete Letters of Vincent van Gogh*, London, 1958
Welsh-Ovcharov – B. Welsh-Ovcharov, *Vincent van Gogh, his Paris period*, Utrecht and The Hague, 1976

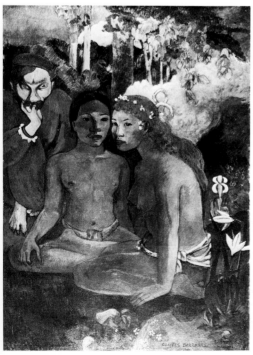

93

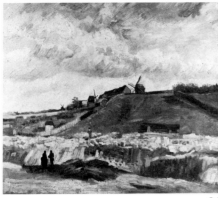

94

94 *Quarry on Montmartre* 1886

ns. 56 × 62 cm/22 × 24½ ins
Lent by the Rijksmuseum Vincent Van Gogh, Amsterdam

Van Gogh was interested in developing an art based on colour before he arrived in Paris in March 1886, but he had seen no Impressionist paintings and his ideas on colour were largely based on what he had read; he felt that Delacroix's work represented the latest developments in the use of colour (cf. letters 401, 428, 430). He saw Impressionist paintings in Paris in the spring and summer of 1886, but they made no immediate impact on his landscapes of this year, such as *Quarry on Montmartre*. In the following year, he described this group of paintings as 'frankly *green*, frankly *blue*' (letter 459a), but they are comparatively subdued in colour, and are painted in a dense impasto reminiscent of his work in Holland of 1885.

Van Gogh lived in Montmartre, and chose sites around its fringes, where the edges of the city merged into the *zone* – the area of undeveloped terrain which lay within the city fortifications. Such themes interested Naturalist writers and many other painters at the time, including Seurat, Signac, Angrand and Luce (cf. nos 5, 117), but it remains an open question whether Van Gogh knew their work when he began to paint these sites in 1886, though Signac had exhibited similar subjects at the 8th Impressionist exhibition in May 1886. J.H.

EXHIBITIONS
1905, Amsterdam, *Van Gogh* (59)
1905, Utrecht, *Van Gogh* (18)
1906, Rotterdam, *Van Gogh* (18)
REFERENCES
F230
Welsh-Ovcharov, p. 146

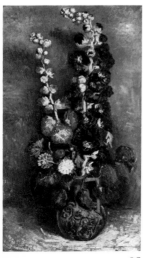

95

95 *Hollyhocks in a One-eared Vase* 1886

sbl. Vincent 91 × 51 cm/35¾ × 20 ins
Lent by the Kunsthaus, Zürich

In the summer and autumn of 1886 Van Gogh painted a long sequence of flower-pieces, which he described in 1887 as 'a series of colour studies in painting, simply flowers . . . seeking oppositions of blue with orange; red and green; yellow and violet, seeking *les tons rompus et neutres* [broken and neutral colours] to harmonize brutal extremes. Trying to render intense colour and not a grey harmony' (letter 459a). Like his landscapes of 1886 (cf. no. 94), these flower paintings show no obvious debt to Impressionism; their inspiration, instead, comes from the Provençal painter Monticelli, who died in June 1886, and whose work Van Gogh saw in Delarebeyrette's gallery in Paris (cf. no. 144). In their dense, bold impasto, and in the way in which their colours are set off against more neutral backgrounds, the influence of Monticelli is clear. Van Gogh wrote later of how 'Monticelli sometimes made a bunch of flowers an excuse for gathering together into a single panel the whole range of his richest and most perfectly balanced hues' (letter 471). Even when Impressionist colour had greatly lightened Van Gogh's palette, he retained his admiration for Monticelli, as he did for Delacroix, feeling that their use of colour was inspired by their emotions, that it expressed human feelings and was not simply a quest for optical effects (cf. letters 477a, 539, 542, w8). J.H.

EXHIBITIONS
1905, Paris, Indépendants, *Van Gogh* (4)
1912, Cologne, Sonderbund (69)
REFERENCE
F235

96 *Fishing in Spring* 1887

ns. 49 × 58 cm/19¼ × 22¾ ins
Lent by the Art Institute of Chicago, Gift of Charles Deering McCormick, Brooks McCormick and Roger McCormick

Only in the winter of 1886–7 did Van Gogh come into close contact with Impressionist and Neo-Impressionist painters; he became particularly friendly with Signac and Bernard, whom he met in the shop of the colour-merchant and dealer Père Tanguy (cf. nos 98 and 13). He painted with both men in spring 1887, when he produced his most obviously Impressionist-inspired paintings, such as *Fishing in Spring*, despite the fact that his two friends were already moving away from Impressionism (cf. nos 208 and 12). On 15 May 1887, Van Gogh's brother Théo wrote to their sister Lies that 'Vincent's paintings are becoming lighter and he is trying very hard to put more sunlight into them' (J. Hulsker, 'What Théo really thought of Vincent', *Vincent*, vol. 3, no. 2, 1974, p. 12). Van Gogh's closest debt, in the varied, emphatic brushwork and luminous colour of these paintings, is perhaps to Monet, whose paintings Théo Van Gogh, manager of the boulevard Montmartre branch of the dealers Boussod & Valadon, began to buy in April of this year. Many of Van Gogh's landscapes of spring 1887 treat the stretch of the river

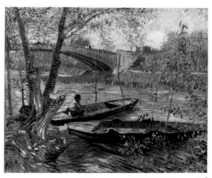

96

Seine west of Paris, around Asnières and Courbevoie – partly industrialized, partly suburbanized – and his subjects closely parallel those of Bernard and Signac (cf. nos 12 and 209), as well as Seurat. Indeed, *Fishing in Spring* may have been painted from the Ile de la Grande Jatte, scenario of Seurat's great canvas, which Van Gogh would have seen in 1886, at the 8th Impressionist exhibition and at the Indépendants (cf. no. 198 and fig. 5). J.H.

REFERENCES
F354
Welsh-Ovcharov, pp. 95, 168–9

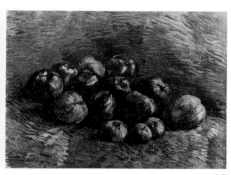

97

97 *Still-Life, Apples* 1887

ns. 45.5 × 61 cm/18 × 24 ins
Lent by the Rijksmuseum Vincent Van Gogh, Amsterdam

Still-life occupied much of Van Gogh's attention in the latter part of 1887, as of 1886, but the later paintings differ from the earlier ones in their brighter colour and their fluent directional brushwork. The loose structure of his 1887 fruit-pieces, such as *Still-Life, Apples*, in which the fruit is spread up across much of the picture surface, suggests that by this date he knew the fruit still-lives of Monet (cf. no. 135). However, Van Gogh has begun to accentuate his brush-work in all parts of the canvas, so that the table surface seems to undulate and act as a halo around the fruit, and he is pursuing more unified colour-schemes than Monet, based on a single colour, which can be related to the experiments in one-colour paintings made during the same year by Bernard's friend Anquetin (cf. no. 7). J.H.

EXHIBITIONS
1905, Amsterdam, *Van Gogh* (56)
1905, Utrecht, *Van Gogh* (17)
1906, Rotterdam, *Van Gogh* (17)
1914, Berlin, Cassirer, *Van Gogh* (19)
REFERENCE
1254

98 *Portrait of Père Tanguy* 1887

[repr. in colour on p. 39]
ns. 65 × 51 cm/25½ × 20 ins
Lent by the Stavros S. Niarchos Collection

Probably late in 1886, Van Gogh began to frequent the shop of the colour-merchant and dealer Tanguy (cf. no. 13), whose portrait he painted three times during 1887 – once, probably during the spring, against a plain background (F263), and twice in the autumn, when he set Tanguy against a background of Japanese prints. The present version is the smaller of these, boldly yet simply handled, with the Japanese prints quite summarily indicated, and with one of Van Gogh's own canvases, a still-life with a painted frame, seen at the top left. The larger version (F363, Musée Rodin, Paris) is more meticulous in execution, and the figure more strictly frontal. The

present painting has a narrow painted border, possibly added by Van Gogh himself.

There has been some debate about the order of these two canvases, but it seems likely that the present one is the earlier, and the one included in the exhibition organized by Van Gogh in the Restaurant La Fourche in November 1887. Its informal handling, and Tanguy's lively expression, suggest that it was painted in front of the sitter. Tanguy is more hieratic and expressionless in the other version, in which the forms were arranged with great precision, as can be seen from a drawing (F1412) which Van Gogh used to crystallize the relationship between the head and the print of Mount Fuji behind it. Indeed, Van Gogh may have painted the larger one in the sitter's absence, using the present version as his starting-point – he often made replicas or variants of paintings originally executed from nature or from the model (cf. nos 103 and 104).

Even the present version cannot be a simple representation of Tanguy in his own surroundings: the still-life on the wall is a canvas which Van Gogh inscribed and dedicated to his brother Théo (F383), and it presumably hung in the brothers' flat. Moreover the Japanese prints, usually about 35 cm (14 ins) high, seem too large in comparison with the figure, and were probably executed separately from it – an anomaly far more marked in the larger version.

The composite nature of the composition shows that its ingredients were carefully chosen. Van Gogh had begun to collect Japanese prints in Antwerp late in 1885 (cf. letter 437), and while he was in Paris the image of Japan which they presented became for him an ideal of a peaceful life lived in contact with nature (cf. letter B2). Tanguy was not his principal source of Japanese prints (this was Bing), but the idea of Japan was at the front of his mind when he painted these portraits, while he was planning his escape from Paris to Arles, which he saw as an equivalent to Japan itself (cf. no. 99). Writing in September 1888 from Arles of his own ambitions, Van Gogh hinted at the relationship which he saw between Tanguy and Japan: 'Here my life will become more and more like a Japanese painter's, living close to nature *en petit bourgeois*. . . . If I can live long enough, I shall be something like old Tanguy' (letter 540). He had previously (letter 506) paralleled the stoical, independent Tanguy with Socrates and the Ancient Christian martyrs and slaves. Both ideas – Tanguy as a tradesman living close to nature, and Tanguy the contemplative – are fused in these portraits, where Tanguy is juxtaposed with Japanese prints, symbols for Van Gogh of communion with nature (cf. e.g. letter 542), and presented in a posture similar to Japanese Buddha figures which he could have seen in the Musée Guimet in Paris. Though he never compared Tanguy to a Buddhist in his letters to his brother, Van Gogh used such an image, in September 1888, to express the quality which he was seeking in his own life; in painting his own portrait, he was taking on 'the character of a simple bonze worshipping the eternal Buddha' (letter 544a). The pose in which he presented Tanguy suggests that Van Gogh saw Tanguy as belonging in this role to which he himself aspired. J.H.

EXHIBITIONS
?1887, Paris, Restaurant La Fourche
1896, Rotterdam, *Van Gogh* (39)
1905, Amsterdam, *Van Gogh* (63)
1908, Paris, Druet, *Van Gogh*, (18)
·1912, Cologne, Sonderbund (106)
1913, Frankfurt, Kunstverein (27)
REFERENCES
F364
London, Arts Council, *The Niarchos Collection*, 1958 (24)
M. Roskill, *Van Gogh, Gauguin and the Impressionist Circle*, 1970, p. 81
F. Orton, 'Vincent's Interest in Japanese Prints', *Vincent*, vol. 1, no. 3, autumn 1971, pp. 7–10, n. 34 on p. 12
Welsh-Ovcharov, pp. 113–14, 178, 195–6, 213–14
F. Orton, in *Japanese Prints collected by Vincent Van Gogh*, 1978, pp. 16–17

99

99 *Snowy Landscape with Arles in the Background* 1888

sbc. Vincent 50 × 60 cm/19¾ × 23½ ins
Lent by a Private Collector, England

Van Gogh left Paris for Arles in February 1888 in search of an ideal, a warm, luminous countryside where he could work without disturbance, and equated this idyll with the image of Japan which he had formed from the Japanese colour prints which he collected (cf. no. 98). He travelled south to Arles looking out of the train window 'to see if it was Japan yet' (letter B22), and his early impressions of the place fulfilled his dreams: 'This country seems to me as beautiful as Japan as far as the limpidity of the atmosphere and the gay colour effects are concerned' (letter B2).

Japanese prints of snow scenes must have been at the front of his mind when he painted *Snowy Landscape*, 'a study of a landscape in white with the town in the background', (letter 466, cf. letter 463), executed during a cold spell soon after his arrival in Arles. The foreground tree and fencing owe something to the graphic qualities of Japanese art, and Van Gogh expressed the limpid atmosphere by building the composition round soft pinks and blues (a response to the southern light which can be compared with Monet's, cf. no. 139). The background details are less descriptive – the colour variations on the far hedge, and the graphic touches on the small tree, serve to create rhythms and contrasts on the surface of the picture. J.H.

EXHIBITION
1908, Paris, Druet, *Van Gogh* (31)
REFERENCES
F391
Letters 464, 466

100 *The Poet's Garden, Arles* 1888

ns. 73 × 92 cm/28¾ × 36¼ ins
Lent by a Private Collector, USA

Van Gogh painted a number of canvases of public gardens in Arles in September and October 1888, in the weeks before Gauguin's arrival at Arles. He set aside four of them, including this painting, as decorations for the room which Gauguin was to occupy, and it was these paintings which he called *The Poet's Garden*, although the gardens themselves had no poetic connotations.

Van Gogh's letters show how he gave the gardens these associations, and illustrate the way in which he infused natural scenes with meaning. He had begun a sequence of large garden paintings before mentioning any poets; the links began to be made in letter 539: the proximity of the brothels gave the gardens 'a touch

of Boccaccio', but he also compared their intimacy with Manet's gardens (cf. no. 124). Later in the same letter, he recalled an article which he had read on Dante, Petrarch, Boccaccio, Giotto and Botticelli: 'And Petrarch lived quite near here in Avignon, and I am seeing the same cypresses and oleanders. I have tried to put something of that into one of the pictures' (probably F468). A few days later he made the association much more specific, in discussing two garden pictures: '. . . this garden has a fantastic character which makes you quite able to imagine the poets of the Renaissance, Dante, Petrarch, Boccaccio, strolling among these bushes and over the flowery grass' (letter 541). Van Gogh had already envisaged the sequence of large paintings on which he was working (of gardens, sunflowers, and other themes) as a decorative scheme for the Yellow House, into which he had recently moved, but the Poet's Garden idea only crystallized fully when, at the end of September, Gauguin announced that he would probably join Van Gogh in Arles. Van Gogh wrote to him: 'I have expressly made a decoration for the room you will be staying in, a poet's garden. . . . The ordinary public garden contains plants and shrubs that make one dream of landscapes in which one likes to imagine the presence of Botticelli, Giotto, Petrarch, Dante and Boccaccio. . . . And what I wanted was to paint the garden in such a way that one would think of the old poet from here (or rather from Avignon), Petrarch, and at the same time of the new poet living here – Paul Gauguin' (letter 544a). At this stage, Van Gogh only included two of his garden paintings in the Poet's Garden idea (letter B18, 546); but he made the number up to four in October, painting two canvases expressly to complete the sequence – the present picture and F485.

So Van Gogh first fused in his mind a natural setting – the garden – with the mood evoked by an article which he had read about the poets. Then he harnessed this idea to his hoped-for collaboration with Gauguin, who became the poet whose presence would give meaning to the metaphor.

The present picture was described in letter 552: 'Now imagine an immense pine-tree of greenish blue, spreading its branches horizontally over a bright green lawn, and gravel splashed with light and shade. Two figures of lovers in the shade of the great tree. . . . This very simple patch of garden is brightened by beds of geraniums, orange in the distance under the black branches.' It shares one important feature, the figures of lovers, with F485, the other canvas painted after Van Gogh had crystallized his idea (on this, cf. letter 556); the lovers seem to evoke the mood of friendship and companionship which Van Gogh wanted to be the hallmark of his collaboration with Gauguin.

Van Gogh painted the gardens with a full impasto – in bold, varied brushwork, more graphic in some parts, and flatter in others, than the broken surfaces which he had adopted in 1887 under the

100

influence of the Impressionists (cf. no. 96); he acknowledged a debt to Monticelli in his impasto in the garden canvases (letter 541; cf. nos 101 and 144). Anti-Impressionist too was the freedom which Van Gogh felt to modify and adapt the motif in front of him (letter 541), and his insistence on the expressive powers of colour, for which he cited Delacroix and Monticelli as his mentors (cf. letters 542, w8). Earlier, he had longed to 'express the love of two lovers by the wedding of two complementary colours' (letter 531), and Monticelli, again, was a stimulus to him in introducing lovers into his paintings (cf. letter 541). In one respect, though, Van Gogh remained close to the Impressionists in these paintings: he felt that direct study of nature was the essential starting-point for his work, whereas Gauguin at this time was advocating working from the imagination (cf. no. 86). J.H.

EXHIBITION
1908, Paris, Druet, *Van Gogh* (10)
REFERENCES
F479
Letters 552, 556
M. Schapiro, *Vincent Van Gogh*, 1951, pp. 74–5
J. Hulsker, 'The Poet's Garden', *Vincent*, vol. 3, no. 1, 1974, pp. 22–32

101 *An Autumn Garden* or *The Public Park* 1888

ns. 72 × 93 cm/28¼ × 36½ ins
Lent by a Private Collector, USA

Like no. 100, *An Autumn Garden* is one of the sequence of large garden paintings which Van Gogh executed in September and October 1888, during the month before Gauguin's arrival at Arles; but unlike it, Van Gogh seems not to have considered this canvas as part of his group of paintings of the Poet's Garden (cf. no. 100). Van Gogh described the present painting in a letter to his brother: 'I have done another size 30 canvas, "An Autumn Garden", with two cypresses, bottle green, shaped like bottles, and three little chestnut trees with tobacco and orange-coloured leaves. And a little yew tree with pale citron foliage and a violet trunk, and two little bushes, blood-red and scarlet purple leaves. And some sand, some grass, and some blue sky' (letter 551). Monticelli was at the front of Van Gogh's mind when he painted this canvas (cf. nos 95, 100 and 144, and letter 550), and in its dense and improvised impasto, applied wet on wet, it echoes Monticelli's work, though Van Gogh added taut, graphic strokes to express tree-trunks and foliage. J.H.

EXHIBITION
1905, Amsterdam, *Van Gogh* (126)
REFERENCES
F472
Letters 549, 551
J. Hulsker, 'The Poet's Garden', *Vincent*, vol. 3, no. 1, 1974, pp. 22–32

102

102 *The Novel Reader* 1888

ns. 73 × 92 cm/28¾ × 36¼ ins
Lent by Louis Franck, Chalet Arno, Gstaad

Painted while Gauguin was living with Van Gogh at Arles late in 1888, *The Novel Reader* is one of the very few canvases which Van Gogh painted, on Gauguin's urging, entirely from his imagination. Its flat surface and simplified contours set it aside from his paintings from nature, which are far more varied in pattern and texture (cf. no. 100), and its style echoes Gauguin's contemporary work (cf. no. 86).

In Brittany, during the summer of 1888, Gauguin had been evolving his ideas of art as an 'abstraction', and urging his friends to rely on their imagination rather than on direct observation of nature. Van Gogh had tried painting from his imagination before Gauguin's arrival in Arles, but had destroyed these experiments (cf. letters 505, 540, B19). During Gauguin's stay he tried again, because 'Gauguin gives me the courage to imagine things, and certainly things from the imagination take on a more mysterious character' (letter 562); the idea of mystery was central to Gauguin's aesthetic, but generally alien to Van Gogh, who wanted to paint 'so that anyone who has eyes could understand my work' (letter 526). These experiments led to two canvases, a *Souvenir of the Garden at Etten* (F496, Hermitage, Leningrad), evoking memories of his mother and sister in Holland, and *The Novel Reader*. In these paintings he was trying to create a mood, akin to music, by the arrangement of colours (letter w9).

The subject of *The Novel Reader*, too, echoes Van Gogh's idea of Gauguin – the figure is reading a novel, by artificial light; it is inspired by verbal images, not by the direct experience of nature. It was thus that he characterized Gauguin's chair (F499), painting it by artificial light, with novels on it, in contrast to his own chair, seen in clear daylight, with sprouting bulbs beyond it suggesting natural growth (F498, Tate Gallery, London). After his breakdown and Gauguin's departure from Arles in December 1888, Van Gogh rejected these experiments with his imagination in favour of the natural inspiration expressed by the picture of his own chair. A year later he wrote to Bernard: '. . . Once or twice, while Gauguin was in Arles, I gave myself free rein with abstractions, for instance in *La Berceuse* and in the woman reading a novel, black in a yellow library; and at the time abstraction seemed to me a charming path. But it is enchanted ground, and one soon finds oneself up against a stone wall' (letter B21). J.H.

REFERENCES
F497
Letters w9, 562, B21

101

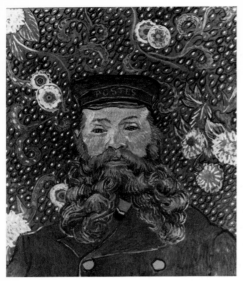

103

103 *Head of the Postman Roulin* 1889

ns. 64 × 54.5 cm/25¼ × 21½ ins
Lent by a Private Collector

Van Gogh met the postman Roulin at Arles in summer 1888, and
painted two portraits of him then. Late in the year, while Gauguin
was staying with him, he painted a set of canvases of Roulin and his
whole family (cf. letter 560), and made a number of copies from
them at the beginning of 1889. The later portraits of Roulin show
him against a decorative background very similar to that in Van
Gogh's contemporary pictures of *La Berceuse* (F504–8), and
probably based on Japanese decorative prototypes.

Roulin became a firm friend and supporter of Van Gogh,
particularly after the artist's breakdown in December 1888. From
the start of their friendship Van Gogh had fitted him into one of his
archetypes of the noble character – the elderly man, stoical and
independent, like the colour-merchant Tanguy (cf. no. 98); and he
compared both men to Socrates (letters 516, B14). Roulin's frontal
pose and impassive expression echo the Tanguy portraits of 1887
(cf. no. 98).

The present version seems to be a copy made from F435, which
was probably painted in front of the model. Van Gogh's copies
generally have a tauter handling than paintings done directly from
their subject. He frequently copied his own paintings, particularly
when, as in this case, illness made him unable to paint either
landscapes out of doors, or portraits from the model. His copies from
the works of other artists of 1889–90 fulfilled a similar
function. J.H.

EXHIBITION
1905, Amsterdam, *Van Gogh* (443)
REFERENCE
F436

104 *The Olive Pickers* 1889

[repr. in colour on p. 106]
ns. 73 × 92.5 cm/28¾ × 36½ ins
Lent by a Private Collector, Lausanne

Van Gogh began to paint olive trees in late summer 1889 while
living in the asylum at Saint Rémy; he painted 14 canvases in
all of this theme between then and spring 1890. *The Olive Pickers*
belongs to a group of four canvases of the olive harvest painted in

December 1889 (cf., too, F655, 656, 587), and the present version is
the original study made from nature, on which Van Gogh based
F655 and 656 – copies made in the studio; the touch here is softer
and more varied, the figures smaller and less schematically outlined,
than in the studio copies (cf. no. 103).

As a subject, olives appealed to Van Gogh on a number of levels:
as the characteristic tree of the south, and the basis for endless
variations of colour and light; as the home of a rich insect life,
and, in harvest, as an illustration of the cycle of the seasons;
and as a natural form which in its twisting lines could express
human emotions. The olive and the cypress were the trees of the
south for Van Gogh in the same sense that willows belonged to his
native Holland and apple trees to Normandy (letters 614a, 615). In
his landscapes of any place he sought natural subjects which
expressed the fullness of the local climate, just as he was fascinated
by portrait sitters whose faces bore the stamp of their surroundings
(cf. nos 98 and 103). The olive trees, blanched and gnarled by the
sun and the mistral of the Midi, gave him, in their changing colours,
the basis for the exaggerated and improvised colour which Gauguin
had encouraged him to use (letters 607, 614a, 615). Beside these
broad effects, the insects which swarmed around the trees added
many small variations of colour, and gave Van Gogh a sense of
contact with the smallest living things, which, unlike Gauguin, he
felt to be an integral part of nature's meaning (letter 614a, cf. 542).

Van Gogh saw his paintings of olives as an answer to the
'abstractions' which Gauguin and Bernard were painting at this
time – canvases painted from the imagination like their versions of
Christ in the Garden of Olives (repr. J. Rewald, *Post-Impressionism*,
1978, pp. 285, 337; cf. letters 614, 615, B21); Van Gogh had tried to
paint this theme in 1888, but had abandoned it, because, unlike his
friends, he found himself unable to conceive a subject painting from
his imagination (cf. no. 102, and letters 505, 540, B19). He saw the
forms and colours of nature as standing for human passions,
describing one of the canvases of the asylum garden which he was
painting at the same time as the olives as 'giving an expression of
anguish without aiming at the historic garden of Gethsemane'
(F660; cf. letter B21); his choice of olives as a theme at this time was
probably itself an attempt to find a metaphor, based on nature, for
Christ's Agony in the Garden. J.H.

EXHIBITIONS
1905, Amsterdam, *Van Gogh* (203)
1905, Utrecht, *Van Gogh* (52)
1906, Rotterdam, *Van Gogh* (49)
1912, Cologne, Sonderbund (95)
REFERENCES
F654
Letters 617, 619, 621, W17, W18, W19
New York, Metropolitan Museum of Art, *French Paintings*, III, catalogue by C. Sterling
and M. Salinger, 1967, pp. 189–90

105 *Road Menders at Saint Rémy* 1889

ns. 71 × 93 cm/28 × 36½ ins
Lent by the Phillips Collection, Washington

While in the asylum at Saint Rémy, Van Gogh painted outside the
hospital grounds when his health allowed it – in the hills, or, as
here, in the town itself. *Road Menders* belongs to a group of studies of
December 1889, in which 'there are no more impastos. I prepare the
thing with a sort of wash of essence, and then proceed with strokes
or hatchings in colour with spaces between them. That gives atmo-
sphere, and you use less paint' (letter 618). The result was surfaces
quite unlike the overall impasto of paintings of the previous year
such as *The Poet's Garden* (no. 100). Van Gogh often painted outdoor
scenes with their characteristic figures, but less often in towns; the

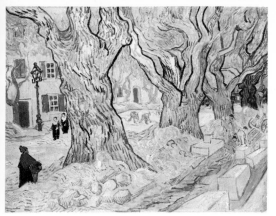

105

presence of figures was important to him, since it was the people who lived and worked there who gave a scene its full meaning, which he found in its relationship to human experience, and not simply in its optical effects. Compositionally, *Road Menders* shows his interest in Japanese prints, in the juxtaposition of small figures and massive trees, and in the jumps in space and scale between foreground and distance. There is some doubt whether this or Van Gogh's other version of the subject (F657) is the original outdoor painting or the replica, 'perhaps more finished', which he made soon afterwards (letter 621). J.H.

EXHIBITIONS
1896, Rotterdam, *Van Gogh* (21)
1905, Berlin, Cassirer, *Van Gogh* (27)
1905, Amsterdam, *Van Gogh* (190)
REFERENCES
F658
Letters 618, 621
cf. J. Leymarie, *Van Gogh*, 1957, pl. 123 and p. 128
cf. M. Schapiro, *Van Gogh*, 1951, pp. 112–13

106 *Poppy Field* 1890

[repr. in colour on p. 106]
ns. 71 × 91 cm/28 × 35¾ ins
Lent by the Kunsthalle, Bremen

Poppy Field was clearly painted in Saint Rémy, from its colour and handling and the type of scenery shown, although it is not mentioned in Van Gogh's letters. Its subject – a vehicle for red-green contrasts – has parallels with Monet, and in its brushwork it shows what Van Gogh had learned from Impressionism, and from Monet in particular – that varied rhythms of the brush can evoke the variety of the natural scene and at the same time create a richly patterned pictorial surface. The canvas is knit together by contrasts between crisper accents and more fluent, cursive handling, and between warm and cool colours. Monet greatly admired this canvas when he saw it at the Bernheim Jeune gallery in 1901 (cf. Meier-Graefe, *Modern Art*, I, p. 205); on another occasion, Monet put his finger on one of the paradoxes of Van Gogh's life and art, in expressing his surprise that 'a man who so loved flowers and light, and rendered them so well, could be so unhappy' (L. Daudet, *Ecrivains et artistes*, I, 1927, p. 154). The painting was acquired by the Bremen Kunsthalle in 1911. J.H.

EXHIBITIONS
1901, Paris, Bernheim Jeune, *Van Gogh* (34)
1905, Amsterdam, *Van Gogh* (229)
1910, Berlin, Cassirer, *Van Gogh* (18)
REFERENCE
F581

Guillaumin, Armand 1841–1927

Guillaumin was born in Moulins, but lived mainly in Paris. He was a part-time painter, earning his living in the Paris civil service and other jobs, until in 1891 he won a lottery prize which enabled him to travel widely and paint more. He met Pissarro and Cézanne in 1861, and painted with them regularly in the 1860s and 1870s; he showed at most of the Impressionist exhibitions of 1874–86. In the 1880s he met and encouraged many younger artists, including Gauguin, Signac, Seurat and Van Gogh. He exhibited with the Société des Indépendants in 1884, and at the Salon d'Automne from 1903.

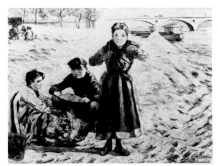

107

107 *Charcoal Thieves on the Quai de Bercy* c. 1882

Les Voleurs de charbon au Quai de Bercy
sbr. Guillaumin 73 × 92 cm/28¾ × 36¼ ins
Lent by the Petit Palais, Geneva

Alone of the Impressionist landscapists, Guillaumin regularly treated industrial themes in the 1870s, and from c. 1875 onwards he painted a long sequence of canvases of the working-class *quais* of the Seine to the east of the Ile de la Cité. Jongkind and Lépine had already worked in this part of Paris, but Guillaumin placed more emphasis on the local inhabitants and their work. Around 1885 he painted with Signac and Dubois-Pillet on the *quais*. In these years, he and Camille Pissarro were the only two of the original Impressionist group who were keen to help and advise younger artists, and Guillaumin alone of the older group exhibited with the Indépendants. His paintings of the 1880s are broadly handled and often bright in colour; in some, as in *Charcoal Stealers*, figures take on an importance, set off against the barren spaces of the quayside, which underlines the social content of the landscape. Guillaumin rarely dated his canvases, but *Charcoal Stealers* was exhibited during his lifetime with the date 1882 (at the retrospective exhibition of the Indépendants in 1926). J.H.

REFERENCE
G. Serret and D. Fabiani, *Armand Guillaumin, catalogue raisonné de l'oeuvre peint*, 1971, no. 124

Guillou, Alfred 1844–1926

Guillou, a Breton by birth, trained in Paris under Cabanel and Bouguereau. He made his reputation in the Salons with paintings of the different types of fishing activity along the coast of Brittany.

108 *The Arrival of the Pardon of St Anne at Fouesnant* 1887

L'Arrivée du Pardon de Ste Anne à Fouesnant
sbl. Alf. Guillou 281 × 216 cm/110½ × 85 ins
Lent by the Musée des Beaux-Arts, Quimper

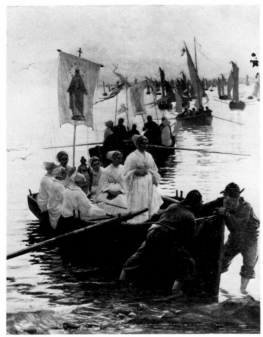

108

Held in several Brittany towns in the summer months, this celebration of a patron saint's feast-day was peculiar to the region. Decked out in local costume, pilgrims would arrive, processing on foot or by sea, bearing banners and statuettes of the patron saint, as carefully recorded in Guillou's painting. The effect is of a brilliant, decorative, picturesque event, greatly admired by writers such as Henry Blackburn (*Breton Folk, an Artistic Tour in Brittany*, 1880) and by well-heeled tourists, who, according to Jules Breton (*La Vie d'un artiste*, 1890, p. 314), were drawn, in the early 1880s, equally to the bathing at seaside resorts and to the Pardons of Brittany.

Georges Ollendorff (1887) pointed to a further attraction offered by Brittany and recorded in Guillou's painting: 'M. Guillou has been able to give greater poetry to his Pardon by representing one of the curious cortèges which come in across the sea from islands and coast, the boats decked with banners, carrying young virgins and statues of "the Good Saint Anne", rather vulgar, the images of a slightly idolatrous faith.' The putative links between Brittany and its Celtic, pagan heritage were emphasized by writers and artists alike. Jules Breton refers to the 'dolmens of Celtic forests' (1890, p. 301), and Horace-Annesley Vachell talks of the Bretons as 'the ever-dwindling survivors of an amazing race, a race at core pagan and primitive, saturated in mysticism and fatalism' (*Brittany, Art Season at Pont-Aven: the Académie of Mlle Julia*, n.d.). Gauguin, Sérusier and Cottet (cf. no. 53) also captured this Christian–pagan duality in Breton religiosity. M A . S .

EXHIBITIONS
1887, Paris, Salon (1143)
1889, Paris, Exposition Universelle, French section (724)
REFERENCE
G. Ollendorff, 'Le Salon de 1887', *Gazette des Beaux-Arts*, July 1887, pp. 73–4

Hayet, Louis 1864–1940

Originally trained as a painter–decorator, Hayet was self-taught as an artist. He studied the writings of colour theorists in the early 1880s, and met the Pissarros in 1883, adopting a pointillist technique after meeting Signac and Seurat in 1885–6. He experimented

widely with different media and colour techniques in the later 1880s, but gave up the Neo-Impressionist technique after 1890. He met Lugné-Poë in 1894, and executed some theatre decorations; in the later 1890s he showed paintings at Le Barc de Boutteville.

109 *River Landscape* 1887

Bords d'une rivière
[repr. in colour on p. 112]
sdbr. L. Hayet 87 51 × 71.5 cm/20 × 28 ins
Lent by the Josefowitz Collection, Switzerland

Hayet painted few canvases as ambitious or as highly finished as *River Landscape*, which uses the Neo-Impressionist 'point' with great flexibility and delicacy to create an effect of hazy summer sunshine. The distance is built up of shimmering specks of blue and pink, while the colour contrasts become brighter towards the foreground, creating a network of colour in which the dominant hues of the picture appear in each area in different proportions and intensities – brighter in the shadows, more luminous and lighter-toned in the sunlight. Hayet was a close friend of the Pissarros, and *River Landscape* has an atmospheric quality very like Camille Pissarro's *View from My Window, Eragny* (no. 153). J.H.

Helleu, Paul 1859–1927

Born near Vannes in Brittany, Helleu was trained in Paris in the art of ceramics, and studied painting under Gérôme at the Ecole des Beaux-Arts. He won his public reputation as a fashionable portraitist, working in pastel and in drypoint, but continued to paint in oils, treating subjects such as the park at Versailles, the cathedrals of France, landscapes and boating scenes.

110 *Young Woman on a Pier* c. 1900

Jeune femme sur une estacade
sbl. Helleu 80.5 × 65 cm/31¾ × 25½ ins
Lent by the Musée des Arts Décoratifs, Paris

Helleu was rarely satisfied by his oil paintings, though they won the warm praise of his friends Sargent, Blanche and Monet. He was an enthusiastic yachtsman, and one of his favoured subjects in his oil-sketches was women in boats or by the seaside – themes treated also by Sargent and Blanche (cf. nos 333 and 24), and by Monet in the late 1880s. The broadly handled painterly brushwork of *Young Woman on a Pier* belongs to the Manet tradition, but the rich blue

110

shadows and colour nuances in flesh and hair echo Monet. The fleeting pose, with parasol, glimpsed from below, is indebted to Japanese prints, which contributed much to the way in which artists presented the image of the fashionable woman of the late nineteenth century.

Helleu was a close friend of Marcel Proust, and one of his chief models for the character of Elstir in *A la Recherche du temps perdu*; Helleu's paintings of women by the sea, like *Young Woman on a Pier*, are an essential ingredient in the seaside imagery of Proust's *A l'Ombre des jeunes filles en fleurs*. J.H.

REFERENCE
On Helleu, cf. Blanche, 'Souvenirs sur Helleu', in *Propos de peintre*, III, 1928, pp. 115 ff.

III

Lacombe, Georges 1868–1916

Lacombe was born at Versailles into comfortable and cultivated circumstances. He trained under Roll and Gervex and at the Académie Julian. The summers of 1888–97 were spent in Brittany. In 1892 he met Sérusier, which resulted in his adoption as a member of the Nabis ('*le Nabi sculpteur*') and his introduction to the work of Gauguin, whose influence can be seen in both Lacombe's paintings and in his crudely carved, polychrome wood sculpture.

III *Blue Seascape – Effect of Waves* c. 1894

Marine bleue, effet de vagues
sbr. GL tempera on canvas 49 × 65 cm/19¼ × 25½ ins
Lent by the Musée des Beaux-Arts, Rennes

Lacombe had been painting the landscape and coast of Brittany since his first visit to Camaret in Finistère in 1888. However, it was only after his meeting with Sérusier in 1892 that he began to adopt this non-naturalist style of painting derived by the Nabis from Gauguin.

Lacombe's reference in this painting to the relentless attrition by waves of the Breton coast is not innovatory. Both Harrison (cf. no. 305) and Gauguin (cf. no. 87) had chosen similar images, suggesting that the theme was recognized as one of the distinctive emblems of Brittany. However, even more overtly than Gauguin, Lacombe concentrated upon the structure of the breaking wave and the contrast between its rounded, generous form and the thin, rigid line of the horizon, revealing the influence of Japanese prints, especially those in Vol. 7 of Hokusai's *Manga*. The extreme decorative treatment of the breaking surf in the foreground reflects Lacombe's interest in various aspects of the decorative arts, including murals, furniture and sculpted relief panels.

Unlike his more characteristic seascapes, e.g. *The Yellow Sea, Camaret* (c. 1892, Musée des Beaux-Arts, Brest), Lacombe has not forced the forms into anthropomorphic images. Yet he has used

natural elements to symbolize human attributes. The billowing clouds on the horizon and the pink water droplets, which break from the crest of the wave, seem to refer to femininity and fecundity, two themes which Lacombe had treated more overtly in the four carved wood panels of the bed executed in 1892 (Palais de Tokyo, Paris). M.A.S.

EXHIBITION
1895, Paris, Indépendants (806)
REFERENCES
J. Ansiau, 'Georges Lacombe'. *Bulletin des Amis du Musée de Rennes*, No. 2, 1978, pp. 81–7
Quimper, Rennes, Nantes, *L'Ecole de Pont-Aven dans les collections publiques et privées de Bretagne*, 1978–9 (45) repr. in colour

La Touche, Gaston 1854–1913

Gaston La Touche's rise to a leading position within French painting at the end of the nineteenth century was meteoric. The essence of his success seems to have resided in his supreme skills as a colourist and his choice of subject matter, which was immediately appealing. Exploiting the current vogue for both Brittany and the eighteenth century, he produced easel-paintings, pastels and large-scale decorative schemes (e.g. for the Senate, Palais du Luxembourg) in which pious Breton peasants succeeded *fêtes galantes* and pierrots, all uniformly bathed in an iridescent haze of nostalgia.

112

112 *Pardon in Brittany* 1896

Pardon en Bretagne
sdbl. G. La Touche 96 100.5 × 110.5 cm/39½ × 43½ ins
Lent by the Art Institute of Chicago,
Mr and Mrs Martin A. Ryerson Collection

Unlike Guillou and Dagnan-Bouveret, who concentrate upon the piety and humility of the Breton peasants in their paintings of this subject (nos 108 and 58), La Touche has chosen to portray the carnival atmosphere of these annual, religious celebrations. La Touche painted several pictures of Breton subjects, but still tended to employ the same style of painting which he used for his evocations of the world of eighteenth-century France, interior genre scenes, masques and *fêtes champêtres*, in the manner of Watteau and Pater. La Touche was not alone in his interest in the eighteenth century at this time, which can also be seen in the paintings of Chabas (no. 50), Le Sidaner and Blanche (nos 115 and 25). The extraordinary handling of light and colour in the *Pardon* not only relates La Touche's work to that of Besnard (cf. nos 21–2), but it was also the secret of his brilliant Salon success: 'M. Gaston La Touche is

undoubtedly one of the true colourists of the French school . . . the scale of colour at his command is both varied and extensive, and wherever his fancy settles he finds some fresh magic of colour. There would seem to be nothing . . . that M. La Touche cannot express, from the blazing glory of the sun to the softening haze in which he shrouds his Breton fishing boats. Light, merely as light, is a thing of beauty in M. La Touche's hands, and charms the eye' (H. Frantz, 'The Paris Salons of 1899: the New Salon', *Magazine of Art*, 1899, p. 440). M.A.S.

EXHIBITION
1912, Chicago, Art Institute, *Exhibition of Works by Members of the Société des Peintres et des Sculpteurs* (87)
REFERENCE
Chicago, Art Institute, *Catalogue*, 1961, p. 255

Laval, Charles 1862–94

Laval was trained at Bonnat's atelier. In 1886 he met Gauguin at Pont-Aven, became his disciple, and travelled with him to Martinique in 1887. By June 1888 he was at Pont-Aven again, joining the group around Gauguin and Bernard, and the following year he was exhibiting with them at the Café Volpini show. Engaged to marry Madeleine Bernard *c.* 1890, his tuberculosis forced him to leave France and go to live in Egypt. Here he was joined by, and possibly married, Madeleine Bernard in the year of his death. Ill-health greatly curtailed the volume of his output, and the similarity of their styles has led to some of Laval's few extant paintings being attributed to Gauguin.

113 *Going to Market, Brittany* 1888

> *Allant au marché – Bretagne*
> sdbc. C. Laval 1888 36 × 46 cm/14¼ × 18¼ ins
> Lent by the Josefowitz Collection, Switzerland

This painting dates from the summer after Laval's return to France from Martinique. In June of 1888 he went to Pont-Aven to work under Gauguin, and through him met Bernard in mid-August. The impact of Bernard's arrival can be seen in this painting. With the execution of *Breton Women at a Pardon* (no. 15), Bernard had provided both Gauguin and Laval with a new synthetic style which, in the case of this painting, is reproduced in the blue outline, flat colours, absence of logical perspective and the dominant, decorative feature of the Breton peasants' head-dresses. The proximity of style established between the three artists by the end of summer 1888 was commented upon by Bernard in his autobiography (*L'Aventure de ma vie*, Mss.) when he wrote that 'We three had become all the more friends for being united by the same artistic concerns' (p. 79). However when Laval exhibited this painting, together with eight other works, at the 1889 Café Volpini exhibition, the proximity of style, especially to that of Gauguin, brought adverse criticism from

Félix Fénéon ('Autre groupe impressionniste', *La Cravache*, July 1889, in *Oeuvres plus que complètes*, I, p. 158).

Despite the detrimental effect of Gauguin upon the independent development of Laval's art, their friendship produced Gauguin's *Still-Life with Profile of Laval* (1886, Wildenstein 207) and brought Laval into contact with Vincent Van Gogh, for whom he painted his *Self-Portrait in a Landscape, to His Friend Vincent* (1888, Rijksmuseum Vincent Van Gogh, Amsterdam). This was sent to Arles after Gauguin's arrival at the end of October 1888, and formed a companion piece to the self-portraits of Gauguin and Bernard dedicated to Van Gogh (cf. no. 16). M.A.S.

EXHIBITION
1889, Paris, Café Volpini (85)

114

Legrand, Paul 1860–?

Born at Vitry-sur-Seine, Legrand was trained in Paris under Gérôme and Saint-Pierre. He made his début at the Salon of 1888, received an honourable mention at the 1893 Salon, and a 3rd-class medal at the Exposition Universelle of 1900. His reputation was established with his paintings of contemporary genre scenes.

114 *In Front of 'The Dream' by Detaille* 1897

> *Devant 'Le Rêve' de Detaille*
> sbl. Paul Legrand 134 × 105 cm/52¾ × 41¼ ins
> Lent by the Musée des Beaux-Arts, Nantes

Exhibited at the Salon des Artistes Français of 1897, this painting of a contemporary scene would at first sight seem to belong to that 'large number of paintings which aim at representing recent events which have fired our patriotism' (A. Maignan, 'Salon de 1897 – Société des Artistes Français', *Gazette des Beaux-Arts*, July 1897, p. 49).

Le Rêve (Musée de l'Armée, Paris), a vision of Napoleon I's victorious army, had won him a 1st-class medal at the Salon of 1888. The reference to a past age of glory appealed immediately to the mounting militarism and patriotism in France during the 1880s, and its popularity was sustained by wide circulation as a print.

The desire to avenge France's bitter defeat at the hands of the

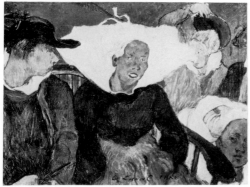

113

Prussians in 1870 continued to be referred to in paintings exhibited at the Salons during the succeeding decades. However, Legrand's contrast between the studied lack of interest of the 1870 war veteran and the rapturous attention which the small boys pay to Detaille's print suggests a more ambiguous attitude, on the part of Legrand, towards the patriotism question. This painting was executed at the height of the Dreyfus affair, involving the wrongful conviction of a Jewish army officer in 1894 on charges of spying for the Germans. After further trials and the intense involvement of writers and painters, Dreyfus was finally acquitted at a retrial in 1899 and the case closed in 1902. The affair did, however, split French society, since it raised questions about the competence of such revered institutions as the government, church, judiciary and army, while further fuelling anti-semitism, chauvinism and patriotism. M.A.S.

EXHIBITIONS
1897, Paris, Salon des Artistes Français (1003)
1899, Nantes, Salon de la Société des Amis des Arts (183)
REFERENCE
Nantes, *Catalogue du Musée des Beaux-Arts*, 1903, no. 937; 1913, no. 1064; 1953, no. 1064

Le Sidaner, Henri 1862–1939

Born in the West Indies, Le Sidaner went to Paris in 1880 to study under Cabanel at the Ecole des Beaux-Arts. Influenced by Manet and Monet, he rejected this academic training and from 1882 to 1887 lived in Etaples, painting nostalgic records of the surrounding land-scape. He made his Salon début in 1887. Contact with Henri Martin and Ernest Laurent introduced a more literary content into his work *c.* 1896. For the rest of his life, he applied a modified form of Impressionism to the evocation of silence, absence and anticipation in deserted landscapes, townscapes and gardens.

115 *The Table – Autumn* c. 1905

> *La Table d'automne*
> [repr. in colour on p. 236]
> sbl. Le Sidaner 66 × 82.5 cm/26 × 32½ ins
> Lent by Richard Green Galleries

The concern to record specific objects in this painting seems secondary to a desire to evoke a poetic mood. The balance of mauve and green, pink and grey, and the touches of faded gold together with the absence of movement in the foliage, the human presence represented only by the objects on the table, suggest a scene painted from memory, a nostalgic recollection in which the spectator is suspended, as in a dream, awaiting an imminent arrival or reviewing a recent departure.

The technique which Le Sidaner uses in this painting is based upon his contact with the work of Monet in the early 1880s. However, as Camille Mauclair describes, although 'born out of Impressionnism, [Le Sidaner] is as much the son of Verlaine than of the snowscenes of Monet' ('Le Sidaner', *L'Art en silence*, 1901, p. 156). In the same essay, Mauclair amplifies this poetic reference in Le Sidaner's work by linking it to music and the eighteenth century, especially to the age of Louis XV.

The eighteenth-century revival had been ushered in to French painting by the Goncourts' book, *L'Art du dix-huitième siècle* (1859–75). However, in contrast to the robust response to that century found in the paintings of Tissot and the operas of Massenet, Le Sidaner and Gaston La Touche (cf. no. 112) gave that period a more evocative, nostalgic interpretation when they approached the

subject in the 1890s. Le Sidaner reflects similar responses found in Verlaine's *Fêtes galantes*, in the verses of Albert Samain and in the intimist compositions of Debussy and Fauré. Attempting to summarize the part played by Le Sidaner in this revival within the history of modern painting, Blanche later suggested that: 'The persistent vogue for Le Sidaner is explained by the similar enthusiasm for the verses of Samain, for the notable sonata of Lekeu and for the melodies of Reynaldo Hahn. One should also consider the music of the intimist composers as well. Furthermore, Le Sidaner has the same relationship to Monet as do the charming disciples of Gabriel Fauré to this French Schumann' (*Les Arts plastiques*, 1931, p. 118). M.A.S.

Lévy-Dhurmer, Lucien 1864–1953

Lévy-Dhurmer began his career as a lithographer and decorator, but a visit to Italy in 1895 revealed a taste for classical art and he decided to devote himself to painting. With his first one-man show at the Galerie Georges Petit in 1896 he established himself as a fashionable Parisian portraitist, as a painter of subjects drawn from mythology or inspired by Beethoven, Debussy and Fauré, and as a gifted pastellist.

116

116 *Our Lady of Penmarc'h* 1896

> *Notre-Dame de Penmarc'h*
> sdbr. L. Levy-Dhurmer 1896 41 × 33 cm/16¼ × 13 ins
> The picture is shown in its original dark wood frame, decorated with a rustic Breton geometric design and the engraved inscription 'Notre-Dame de Penmarc'h'
> Lent by M. Michel Perinet, Paris

Although far more naturalistic than Filiger's *Virgin and Child* (no. 78), the landscape in the background of this painting is also a Breton one, representing the rocky plain which stretches south of Finistère to the point of Penmarc'h. Lévy-Dhurmer has transformed a realistic portrait of a mother and child into the Virgin and Christ, as did both Henri Martin in *Young Saint* (1891, Musée de Brest) and Gauguin in *Ia Orana Maria* (1891, Wildenstein 428), by adding halos and raising the hand of Christ in benediction. Even without these signs the costumes alone evoked religious sentiments. The severe dress of the Douarnenez region, which the Virgin wears, made the women look 'like pictures of the Virgin, with their mitre-shaped head-dresses, their ruffs . . . this monastic rusticity, this mystic wildness . . .' (Jules Breton, *La Vie d'un artiste*, 1890, p. 297). M.A.S.

EXHIBITIONS
1896, Paris, Salon des Artistes Français (1260)
1896, Paris, Galerie Georges Petit (7)
1900, Paris, Exposition Universelle, *Exposition Décennale* (1239)
1900, Paris, Société d'Edition Artistique
REFERENCES
H. Eon, 'Exposition Lévy-Dhurmer à la Galerie Georges Petit', *La Plume*,
 February 1896, p. 132
G. Mourey, 'The Salon of the "Champs Elysées"', *The Studio*, July 1896, p. 108
G. Mourey, 'A Dream Painter, M. L. Lévy-Dhurmer', *The Studio*, February 1897, p. 11
G. Soulier, 'Lévy-Dhurmer', *Art et Décoration*, 1, 1898, p. 11
F. Fagus, 'Petite Gazette d'Art. Exposition Lévy-Dhurmer', *Revue blanche*,
 January 1900, p. 64
London, Hayward Gallery, *French Symbolist Painters*, 1972 (116)
Paris, Grand Palais, *Autour de Lévy-Dhurmer*, 1973 (61)

Luce, Maximilien 1858–1941

Luce was initially trained as a wood engraver, but learnt painting in
the early 1880s from Carolus-Duran and others. By 1887 he had met
Seurat, Signac and the Pissarros; in that year he began to use the
'petit point', and from then onwards exhibited regularly with the
Indépendants. He painted landscapes, and also figure scenes and
townscapes of Paris, and later of the Belgian mining districts; these
echoed his Anarchist political allegiances, as did his work as a
printmaker. In 1894 he was jailed, but not brought to trial, as an
Anarchist sympathizer.

117 *Outskirts of Montmartre* 1887

> *Environs de Montmartre*
> sdbr. Luce 87 45.5 × 81 cm/18 × 32 ins
> Lent by the Rijksmuseum Kröller-Müller, Otterlo

This canvas was originally owned by Camille Pissarro, and was
probably exhibited at the Indépendants in 1888 with the title
Terrain, rue Championnet. It is one of Luce's first canvases in the
pointillist manner, but he never used the 'point' as systematically as
Seurat or Signac; here, the dabs of paint vary much from area to
area of the painting, and the soft atmospheric blues, introduced
alongside the local colours of the scene, reveal Luce's debt to
Impressionism.

In its subject, *Outskirts of Montmartre* is a prime example of the
working-class Parisian themes favoured by many of the Neo-
Impressionists in the 1880s. It shows the fringes of the city – the
'*zone*' between the built-up area and the city's outer fortifications,
with its allotments and shacks side by side with houses and
factories; two small figures look on from the open road. This
no-man's-land between town and country housed beggars and
outcasts, the victims of urbanization. Its life was described in
Germinie Lacerteux, the Goncourt brothers' pioneering working-class
novel of 1865, and it was taken up as a prime pictorial theme by
Raffaëlli *c.* 1880 (cf. no. 162). In 1880, Huysmans presented a verbal
vignette in *Croquis parisiens* of the 'View from the Ramparts of North
Paris', in which he used the barren physiognomy of the landscape as
an expression of the suffering of the people who lived there.

Luce's choice of themes has a close relationship with his
committed Anarchist beliefs; but this milieu was also important to
writers and painters whose humanitarian concerns were not linked
to revolutionary ideals. Van Gogh, for instance, like Luce, was living
in Montmartre and painting its fringes in 1886–7 (cf. no. 94). J.H.

EXHIBITIONS
? 1888, Paris, Indépendants (437)
1889, Brussels, Les XX (Luce 6)
REFERENCES
New York, Guggenheim Museum, *Neo-Impressionism*, 1968 (38)
Otterlo, Kröller-Müller Museum, *Catalogue of Paintings*, 1969, no. 451

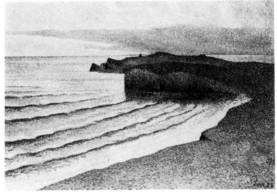

117

118 *Coastal Scene* 1893

> *Bord de mer*
> sdbr. Luce 93 65 × 92 cm/25½ × 36¼ ins
> Lent by the Petit Palais, Geneva

In this seascape Luce adopted the rather schematic treatment of
waves and lighting characteristic of Signac and Cross in their
seascapes of the early 1890s (cf. nos 212 and 54). It probably
derives from his stay in 1893 at Camaret, a little fishing port on the
southern side of the approaches to Brest harbour, on the western
end of Brittany. Luce exhibited many seascapes and port scenes
from Camaret at the Indépendants in the 1890s, but this canvas
cannot be firmly identified as one of those shown. J.H.

118

119 *The Iron Foundry* 1899

> *La Fonderie*
> sdbl. Luce 99 113 × 161 cm/44½ × 63½ ins
> Lent by the Rijksmuseum Kröller-Müller, Otterlo

In the 1890s, Luce began to focus on specifically industrial land-
scapes, particularly after 1895, when be began a series of visits to the
southern Belgian mining areas around Charleroi. Luce's friend, the
Belgian poet Emile Verhaeren, was probably the initial inspiration
for these visits, and Luce's vision of industry shares much with
Verhaeren's as expressed in his volume of poems, *Les Villes
tentaculaires*, of 1896: the city and industrialization are the cause of
our present problems, denuding the countryside and destroying
rural communities; but any hope for the future will have to depend
on harnessing these forces to good effect. Luce's paintings hover on
the same borderline, sometimes emphasizing the devastation of the
industrial landscape, and sometimes, as in *The Iron Foundry*, the
heroism of the scene. In a letter to Cross in 1896, Luce made his dual
response clear, speaking of the difficulties of painting the 'terrible
and beautiful' character of Charleroi (cf. Rousseau 1966).

The forms of Luce's *The Iron Foundry* reveal a debt to another pioneer of industrial imagery, the Belgian painter and sculptor Constantin Meunier. The hieratic, rather stylized gestures of Luce's figures echo the forms of Meunier's relief sculptures on the monument to Labour in Brussels (1895), part of which Luce had copied in a series of lithographs for the Anarchist magazine *La Sociale* in 1896. Soon after this, Luce met Meunier himself. *The Iron Foundry*, a monumental composition executed in Luce's Paris studio, is handled in fluent dabs and dashes which show little trace of the pointillist technique, and is built from rich contrasts of warm and cool colours. J.H.

EXHIBITION
1900, Berlin, Secession
REFERENCES
Otterlo, Kröller-Müller Museum, *Catalogue of Paintings*, 1969, no. 454
cf. R. Rousseau, 'Maximilien Luce et la Belgique', in catalogue of *Luce* exhibition, Palais des Beaux-Arts, Charleroi, 1966

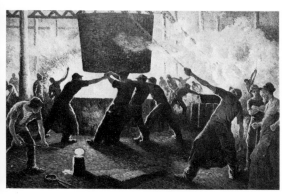

119

Maignan, Albert 1845–1908

A pupil of Noël and Luminais, Maignan made his début at the 1867 Salon with two paintings in the tradition of the Barbizon School. Although they were well received by the critics, he discarded this style of painting in 1868 to embark on a successful career as a history painter. The recipient of prizes throughout the 1870s and 1880s, he was awarded the Salon's medal of honour in 1892 for *Carpeaux*, bought by the State for the Musée du Luxembourg. This painting marked the beginning of his concern to find a balance in history painting between the specificity of contemporary subject matter and the generalization of the Ideal, a problem which was to occupy him until his death.

120 *The Passage of Fortune* c. 1895

La Fortune passe
sbr. Albert Maignan 73 × 100 cm/28¾ × 39¼ ins
Lent by the Musée St-Denis, Reims

120

Although the imagery of this painting shows similarities to Camille Pissarro's drawing *The Temple of the Golden Calf*, from his series *Turpitudes sociales* of 1889–90 (publ. Geneva, 1972, pl. 3), there is no evidence that Maignan intended his picture to be a socialist judgment of the kind passed by Pissarro upon the iniquities of the Paris Stock Exchange.

Faced with the acknowledged decline in history painting in 1891, Maignan, together with Besnard, Aman-Jean and Martin, belonged to the generation of Salon artists of the 1890s who, as he himself argued in a review of Martin's *Towards the Abyss* (exhibited at the Salon des Artistes Français, 1897), sought to express the Eternal through a combination of topicality, naturalistic detail and philosophical message. That Maignan was considered to have achieved this combination in his own work can be seen from the unstinting praise with which his painting of the sculptor Carpeaux was greeted in the Salon des Champs-Elysées of 1892 (Edmond Potier, 'Les Salons de 1892–1', *Gazette des Beaux-Arts*, June 1892, pp. 462–3). This version of *The Passage of Fortune* was apparently never exhibited, but it is a variant or replica of an untraced canvas shown at the Salon des Artistes Français in 1895 (1272) and again at the Exposition Décennale at the 1900 Exposition Universelle (1292). M.A.S.

REFERENCE
Reims, *Catalogue du Musée de Reims*, 1909, no. 349

Maillol, Aristide 1861–1944

Maillol trained first in Perpignan and afterwards in Paris, where he enrolled at the Ecole des Beaux-Arts under Gérôme and then Cabanel. Swept up in the debate over style in the 1880s, Maillol moved from landscapes executed in sombre, Barbizon tonalities to an admiration for Impressionism and for the work of Puvis de Chavannes. By 1889 friendship with Daniel de Monfreid had opened up contact with Gauguin, and in 1892 relationships with Lerolle and Rippl Ronai led to membership of the Nabis. Failing eyesight caused him to turn to sculpture in the late 1890s, and after his first one-man show at Vollard's gallery in 1902 he devoted himself almost exclusively to this art form until his death.

121 *The Little Hut in Roussillon* 1885/90

La Maisonnette à Roussillon
sbr. A. Maillol 128 × 160 cm/50½ × 63 ins
Lent by a Private Collector, England

This painting was probably executed while Maillol was staying with his brother-in-law in Bas Languedoc. It is one of a series of landscapes in which the careful observation of southern sunlight combines with a degree of stylistic uncertainty to suggest a date before Maillol's contact with Gauguin's Brittany paintings (cf. no. 122) and his friendship with the Nabis (cf. no. 123).

121

The intensity of stylistic debate in Paris in the 1880s is represented in this painting's range of techniques. The Impressionist lightness of palette, feathery brushstroke and application of simple, complementary colours in parts of the painting have replaced the sombre tones of Maillol's early landscapes. However, other features link this painting also to a more academic tradition within which Maillol had received his artistic training. The canvas is large by Impressionist standards, suggesting that Maillol intended it to be exhibited at the Salon. The blocky, open network of brushstrokes, accented by dabs of pure colour in the foreground, bears comparison with the technique of Bastien-Lepage (cf. no. 10). The simplicity of form in the cubic building and in the planar organization of space reflects both the style of Puvis de Chavannes and Maillol's own concern with form. The latter received fuller expression when Maillol himself turned to sculpture after c. 1899, and it was also recognized by Maurice Denis, who wrote in 1925, 'But it is precisely in his early works . . . that one detects beneath the delicacy of colours a profound feeling for form' (M. Denis, *Aristide Maillol*, 1925, p. 20). MA.S.

122 *Half-length Study of a Young Peasant Girl* 1891

Jeune paysanne en buste
sdbl. Maillol 91 46 × 55 cm/18 × 21¾ ins
Lent by the Musée St-Denis, Reims

The simplification of the image, by means of flat zones of colour and crisp outlines, denotes Maillol's lack of interest in capturing a naturalistic likeness of his sitter in this picture. Probably absent from Paris in summer 1891, and not recorded as making contact with the Nabis before spring 1892, it would seem that Maillol was looking at the time of this painting to Puvis de Chavannes and Paul Gauguin in his search for a non-naturalistic style.

Throughout his life Maillol retained a deep admiration for Puvis and Gauguin. By 1891 he had already been able to see much work by Puvis at the Salons and in Puvis' one-man exhibition at Durand-Ruel's in 1887. He had also copied Puvis' *The Poor Fisherman* (1880, exhibited at the Salon 1881; Louvre) and, in c. 1890, he executed a *Prodigal Son* (Private Collection) as a variant of Puvis' own *Prodigal Son* (1879, Bührle Foundation, Zurich). Later in life he summarized his admiration for Puvis as '[Puvis'] fine sense of composition, filled in with an impression of poetry' (quoted C. Cladel, *Maillol*, 1937, pp. 151–2).

In a conversation with Rewald ('Maillol Remembered', New York, Guggenheim Museum, *Aristide Maillol*, 1975, p. 10), Maillol also referred to the importance for his own development of Gauguin's Brittany paintings, which he could have studied at the Café Volpini exhibition of 1889 and at the Gauguin sale of February 1891. Maillol's immediate debt to Gauguin is found in *The Wave* (1896, Petit Palais, Paris), which is based upon Gauguin's *Ondine* (Wildenstein 336), exhibited in both 1889 and 1891. From Gauguin

he also took the flat areas of colour and strong outline. In a letter of early spring 1907 to Maurice Denis, sent from Banyuls, Maillol declared that 'Gauguin had used colours as a means and not as an end . . . by line and colour, a great result. Like you, I have always had the greatest admiration for Gauguin's painting. I have studied his art with great care and I believe that he has helped me a lot – he always seems to be a point of departure for me' (quoted M. Denis, *Journal*, II, p. 61). MA.S.

123

123 *The Laundresses* c. 1893

Les Lavandières
sbl. A. Maillol 64 × 80 cm/25¼ × 31½ ins
Lent by a Private Collector, Switzerland

Executed almost certainly in the year in which Maillol had set up his own tapestry loom at Banyuls, the bright colours and fluid outlines indicate Maillol's increasing interest in the decorative qualities of paintings. Maillol's contact with the Nabis seems to have been significant for this development. In spring 1892 Rippl Ronai suggested to Henri Lerolle, an academic painter and friend of the Nabis, that he should approach Maillol to execute a ceiling decoration for his house. Unhappy with the results, Lerolle passed the commission over to Maurice Denis, who produced *Ladder in the Foliage* (Private Collection, St Germain-en-Laye; cf. no. 69). Despite this rebuff for Maillol, he and Denis became friends. Maillol began to exhibit with the Nabis at Le Barc de Boutteville and, swept up into the Nabis' enthusiasm for the decorative arts, he embarked on a programme of designing and executing ceramics, wood carving, bronze lamps, stained glass and tapestries. In 1894, at the Libre Esthétique in Brussels, he exhibited a tapestry for the first time, woven from home-dyed wools and rich threads unpicked from old Persian carpets. The resulting brilliant colour and flattened space was paralleled in his paintings as they came to resemble the Gothic tapestries which, he admitted, even late in his life, 'give me more pleasure than a Cézanne' (Cladel, *Maillol*, 1937, p. 10).

REFERENCE
New York, Guggenheim Museum, *Maillol*, 1975 (6)

Manet, Edouard 1832–83

Manet lived all his life in Paris. Trained by Thomas Couture in 1850–6, he studied in Italy, but after 1859 treated scenes of modern urban life, consistently submitting them to the Salon despite frequent refusals. The stir which his paintings caused made him a focal point for young artists in the 1860s, and from 1869 he was a

122

close friend of Monet, and began to sketch out of doors. However, he did not exhibit in the Impressionists' group exhibitions, and concentrated on figure compositions for his major paintings.

ABBREVIATION
RW – D. Rouart and D. Wildenstein, *Edouard Manet, catalogue raisonné*, I, *Peintures*, Lausanne and Paris, 1975

124 *A Path in the Garden at Rueil* 1882

Une Allée du jardin à Rueil
ns. 61 × 50 cm/24 × 19¾ ins
Lent by the Musée des Beaux-Arts, Dijon

Manet painted several outdoor studies in the garden of the villa which he rented in summer 1882 at Rueil, just west of Paris. This example, quickly painted and not worked up to exhibition finish, is held together by its colour relationships and the rhythm of its brushwork, although the forms in it are only suggested in the most summary way. Manet regularly painted out of doors in oils after 1870, but never felt that the study of open air effects was a sufficient subject for serious and finished paintings – in contrast to Monet, who was at this time making unpeopled landscapes the subjects for his most ambitious canvases. It was the simplicity of Manet's brushstrokes, and the clear contrasts of dark and light tones in his paintings, which made his art a focus of attention in the late 1880s for younger artists who were reacting against Monet's brand of Impressionism. J.H.

EXHIBITION
1884, Paris, before Manet studio sale, Drouot, 4–5 February (lot 73)
REFERENCES
RW403
E. Moreau-Nélaton, *Manet par lui-même*, II, 1926, p. 92

124 125

125 *Roses in a Champagne Glass* 1882

Roses dans un verre à champagne
sbr. Manet 32.5 × 25 cm/12¾ × 9¾ ins
Lent by the Burrell Collection, Glasgow Art Gallery and Museum

Manet painted many small flower studies at Rueil during the last summer of his life; this example was first owned by Méry Laurent (cf. no. 126). The broadly brushed forms are suggested with great economy in four colours against a neutral background, with the rich blues of the crystal vase picked up in the leaves and the yellow flower, creating consciously simplified colour patterns. J.H.

REFERENCE
RW419

126

126 *Méry, Autumn* 1882

Méry, l'automne
ns. 73 × 50 cm/28¾ × 19½ ins
Lent by the Musée des Beaux-Arts, Nancy

At his death, Manet left unfinished a project to paint the beauties of the age as the Four Seasons. He completed only two canvases, *Spring* (RW372), a portrait of the young actress Jeanne de Marsy, which was a great success at the 1882 Salon, and the present painting, a portrait of his close friend, the actress and courtesan Méry Laurent, as *Autumn*, contrasting her maturer beauty with Jeanne's freshness. Méry Laurent had a fur-lined cloak specially made *chez* Worth for this painting.

Manet had a precedent for the idea of a modern-life recreation of the Four Seasons in the work of his friend, the Belgian painter Alfred Stevens. But, in contrast to the elaborate trappings used by Stevens, Manet reduced the elements in his pictures to a minimum, simply suggesting Autumn by Méry's costume, by her golden, harvest-like colour, and by the mood of the decorative backdrop. Manet told the young artist Georges Jeanniot at this time: 'Concision, in art, is a necessity and a point of style; a concise man makes one reflect . . .; cultivate your memory, since nature can only supply you with information'; Jeanniot watched Manet at work on *A Bar at the Folies-Bergère* (1881, Courtauld Institute Galleries, London), constantly simplifying and adjusting the elements in front of him to make them conform with his idea of the picture (Jeanniot, in *La Grande revue*, 10 August 1907). In *Autumn*, one detail reveals this process of simplification: at a late stage in its execution, Manet erased two flowers in the background, close by Méry's nose and chin, to make her profile stand out more clearly.

The background suggests a hanging or paper of some sort, and is very Japanese in design (Manet had long been an enthusiast of Japanese art); but we do not know whether it was an actual wall-covering, or invented by Manet to symbolize autumn. The grass and flowers on it are irregularly arranged, without repeats. Very Japanese, too, is the free, delicate brushwork by which Manet suggested the grass and flowers; it has the closest parallels with Oriental calligraphic brush drawing, which was widely known in Paris at this date.

The importance of Manet's last subject-paintings, like *Autumn*, is that he had begun to use the modern-life scenes around him suggestively, as a means of evoking mood or feeling, rather than simply as subjects for description. He was closely paralleled in this by his friend, the poet Mallarmé, and these levels of meaning gave Manet's art a particular relevance to the artists of the Symbolist generation. J.H.

EXHIBITIONS
1884, Paris, before Manet studio sale, Drouot, 4–5 February (lot 21)
1884, Paris, Ecole des Beaux-Arts, *Manet* (113)
REFERENCES
RW393
E. Moreau-Nélaton, *Manet par lui-même*, II, 1926, pp. 97–8
A. Proust, *Manet, souvenirs*, 1913, p. 114
J. Richardson, *Manet*, 1958, pp. 130–1
J. Raoul-Duval, 'Méry Laurent', *L'Oeil*, May 1961, pp. 38–9, 80
M. Bodelsen, in *Burlington Magazine*, June 1968, p. 343

Martin, Henri 1860–1943

The award of the Grand Prix from the Ecole des Beaux-Arts at Toulouse enabled Martin to attend the Ecole des Beaux-Arts in Paris, where he studied under J. P. Laurens. Success at the Salon came quickly. In 1889, under the influence of Ernest Laurent and possibly the Italian Segantini, Martin adopted Neo-Impressionism. Although an easel painter throughout his life, it was as a decorative artist that he made his name in the 1890s. The subject matter of his paintings became increasingly orientated towards landscapes and scenes of contemporary bucolic life.

127 *Serenity* 1899

Sérénité
ns. 345 × 550 cm/136 × 216½ ins
Lent by the Musée d'Orsay, Paris

This work, based on Book VI of Virgil's *Aeneid* and depicting the blessed souls strolling through the Elysian Fields, reflects in its scale the continuing demand by public bodies during the 1890s for large-scale, decorative art. Martin had already been given a public commission in 1895 (Hôtel de Ville, Paris), and artists such as Puvis, Aman-Jean, Besnard, Roll and Séon also received requests to decorate schools, town halls, museums and hospitals.

The planar composition and the classically draped figures floating through the air indicate Martin's debt to Puvis de Chavannes' mural decorations, especially *The Sacred Grove* (Salon 1884; Musée des Beaux-Arts, Lyon; cf. no. 161) and *The Muses of Inspiration Acclaim Genius, Messenger of Light* (Salon, 1895; Public Library, Boston). However, the intense colour of the palette apparently derives from his teacher Laurens (cf. Roger Marx in *Revue encyclopédique*, 1899, p. 548), and from Martin's own conversion to Neo-Impressionism in 1889. The expression of the ideal of serenity through a timeless classical subject was totally alien to established Neo-Impressionism, but, by combining the two in the same painting, Martin offers another solution to the Naturalism–Idealism debate in the Salon of the 1890s which also concerned Béraud, Maignan and Aman-Jean.

The painting had a mixed reception from the critics when it was exhibited at the Salon des Artistes Français in 1899. Both D. S. MacColl and Paul Desjardins regarded the use of the pointillist technique as totally inappropriate in a monumental painting. On the other hand Henri Frantz of the *Magazine of Art* praised the success with which modernity and tradition had been combined, and Roger Marx found in *Serenity* 'nobility and poetry of feeling . . . the discovery of pre-existing relationships between spiritual states and the spectacles of nature . . . [the] ability to designate those landscapes and those moments as signs of the beyond' (p. 548). M.A.S.

EXHIBITIONS
1899, Paris, Salon des Artistes Français (1343)
1900, Paris, Exposition Universelle, *Exposition Décennale* (1324)
REFERENCES
D. S. MacColl, 'In Paris', *The Saturday Review*, 20 May 1899, p. 62
P. Desjardins, 'Les Salons de 1899–11', *Gazette des Beaux-Arts*, July 1899, pp. 43–4
R. Marx, 'Les Salons de 1899', *Revue encyclopédique*, 1899, pp. 545–8
H. Frantz, 'The Paris Salons of 1899', *Magazine of Art*, 1899, p. 410
A. K. Ostenevich, '*La Danse* and *La Musique* by Henri Matisse: a New Interpretation', *Apollo*, December 1974, pp. 504–13, fig. 6

Matisse, Henri 1869–1954

Born in Picardy in northern France, Matisse was first trained as a lawyer. He took up painting in 1890, studying under Moreau at the Ecole des Beaux-Arts in 1895–7, where he met Camoin, Evenepoel, and some of the Fauves-to-be, and at a free studio with Carrière in 1899 where he met Derain. He spent most of 1898 in the south; he worked regularly on the Mediterranean from 1904 onwards (in 1904 with Signac, in 1905 with Derain), and in later years was based mainly on the Riviera. Matisse first visited North Africa in 1906, and Italy in 1907. In the later 1890s he exhibited occasionally with the Société Nationale, from 1901 onwards with the Indépendants, and from 1903 with the Salon d'Automne.

128 *Woman Looking After a Pig* 1896

Femme gardant un cochon
sdbr. H. Matisse 1896 59.5 × 73 cm/23½ × 28¾ ins
Lent by the Musée Matisse, Cimiez, Nice

Matisse visited Brittany in 1896 and 1897. On both occasions he painted on Belle-Isle, where he met J. P. Russell (cf. no. 332); in 1896 he travelled to the extreme west of the Breton peninsula, to Beuzec-Cap-Sizun on the bay of Douarnenez, where *Woman Looking After a Pig* was apparently painted (cf. Duthuit 1950). Between his two trips to Brittany Matisse began to be influenced by Impressionism, probably as a result of the display of the Caillebotte bequest of Impressionist paintings at the Musée du Luxembourg in February 1897. His 1897 Belle-Isle scenes echo Monet's, unlike his Breton paintings of 1896, such as *Woman Looking After a Pig*, in which he was using a precise yet simple touch and a delicate tonal range – predominantly greys and beiges, with occasional colour accents – which shows no trace of Impressionism. Breton farmyard genre scenes such as this were common in the Salons at this date;

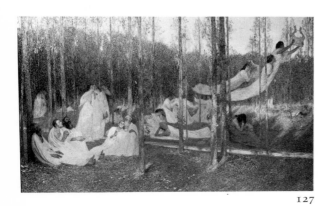

127

128

however, Matisse does not seem to have exhibited this painting, though he showed with the Société Nationale at this time. J.H.

REFERENCES
G. Duthuit, *The Fauvist Painters*, 1950, p. 59, n. 1
G. Diehl, *Matisse*, 1954, pl. 3 and p. 131

129 *The Courtyard of the Mill, Ajaccio* 1898

La Cour du moulin, Ajaccio
sdbl. H. Matisse 98 38 × 45.5 cm/15 × 18 ins
Lent by the Musée Matisse, Cimiez, Nice

After his initial response to Impressionism in 1897, Matisse began to explore colour more fully in 1898 during a long stay in Corsica, where his experience of the light of the south was fortified by Signac's *D'Eugène Delacroix au néo-impressionnisme*, which he read as it came out in parts in the *Revue blanche* between May and July (Barr, *Matisse*, p. 47 and n. 3). *The Courtyard of the Mill* shows little direct influence from Signac – its varied brushwork owes more to Impressionism; but the warm reflections and coloured accents on the shadowed walls of the house may indicate some influence from Signac's book. Nevertheless, the whole canvas has a dominantly tonal structure, and there is little colour in the foreground shadows (contrast no. 130). Though not large, *The Courtyard of the Mill* is quite highly finished. The existence of another version of the subject, less finished, but virtually identical in size and lighting (repr. Barr, *Matisse*, p. 300), suggests that the present version was executed in the studio. J.H.

REFERENCE
Paris, Grand Palais, *Henri Matisse*, 1970 (21)

129

130 *First Orange Still-Life* 1898/9

Première nature morte orange
sbr. H. Matisse 56 × 73 cm/22 × 28¾ ins
Lent by the Musée National d'Art Moderne –
Centre Georges Pompidou, Paris

From Corsica (cf. no. 129), Matisse moved on in August 1898 to spend six months in the area around Toulouse. In the paintings done there, and during 1899 in Paris, he began to use colour and brushwork with great freedom, deliberately avoiding any overall system of organization; some canvases show a loosely applied Neo-Impressionist handling, others are far flatter in treatment. *First Orange Still-Life* has been placed during the Toulouse period, but it may have been painted in Paris later in 1899.

Natural colour was Matisse's starting-point in this picture, but areas such as the tablecloth and the wall are treated so variously that one cannot deduce their local colour, and in other parts apparently arbitrary colours are introduced, such as the blue on the

130

plate and on two of the fruit. Marquet later said that he and Matisse had been working 'in what was later called the Fauve manner' in 1898–1901 (quoted Duthuit, *The Fauvist Painters*, p. 23), and these distortions of natural colour, in the interests of heightening the effect of the lighting, show in embryo the practices which re-emerged in Matisse's work in 1904–5 (cf. no. 131), after an interval of more subdued colouring in 1901–4.

First Orange Still-Life belongs to a sequence of ambitious still-lives by Matisse, showing motifs seen at a diagonal and contre-jour. It lies between *The Dessert* of 1897 (Niarchos Collection), in which the influence of Impressionism first became apparent in his work, and *The Red Dessert* of 1908 (Hermitage, Leningrad). Although both of these canvases include a figure, *First Orange Still-Life* shares with them a concern for trying to reconcile an emphatic spatial recession with a rich overall surface pattern – a concern which was to become a central preoccupation in Matisse's art. He continually thought of his current paintings in relation to his past work, as he showed in exhibiting *First Orange Still-Life* at the Indépendants in 1905, alongside *Luxe, calme et volupté* (fig. 3); presumably its freedom of colour gave it a new relevance at the moment when Matisse was reintroducing strong colour to his paintings. J.H.

EXHIBITION
1905, Paris, Indépendants (2774 or 2775?)
REFERENCES
Paris, Grand Palais, *Matisse*, 1970 (28)
J. Elderfield, *Fauvism and its Affinities*, 1976, p. 20

131 *Study for a Portrait* or *Woman in Front of a Window* 1905

Etude pour portrait or *Femme devant la fenêtre*
[repr. in colour on p. 233]
scl. Henri Matisse 32 × 30 cm/12½ × 11¾ ins
Lent by a Private Collector

In the later part of his stay with Derain at Collioure in summer 1905 (cf. no. 73), Matisse finally abandoned the broken brushwork and contrasts of complementary colours which he had adopted from Neo-Impressionism in 1904 (cf. Signac, nos 213 and 216), in favour of a style dominated by flat planes of luminous colour, as in this painting; the colour here is residually naturalistic in parts, such as the sea, but deliberately anti-natural in others, such as the face and hair – red and green respectively in shadow, yellow and pink in the light.

He and Derain may have evolved this new manner after seeing Daniel de Monfreid's collection of paintings by Gauguin during their stay at Collioure, although Derain seems to have preceded Matisse in finally suppressing local colour and complementary contrasts in favour of independently conceived relationships of hues which could recreate the effects of light without imitation (cf. no. 73). In *Study for a Portrait* the harmonies of reds, oranges and purples down the

centre and right of the picture, cut only by schematic blue and green outlines, show how luminosity and volume can be evoked, in an area of nominal shadow, by relationships between closely related hues alone.

The picture shares the extreme simplification and boldness of *Woman with a Hat* and *Open Window, Collioure*, which created such a furore at the Salon d'Automne in 1905, and led to the christening of the style as Fauvism. *Study for a Portrait* was exhibited, with this title, at Druet's gallery in the following spring. J.H.

EXHIBITION
1906, Paris, Druet, *Matisse* (7)
REFERENCES
Paris, Grand Palais, *Matisse*, 1970 (61)
J. Elderfield, *Fauvism and its Affinities*, 1976, p. 56

132 *Young Sailor I* 1906

Le Jeune marin I
[repr. in colour on p. 240]
sbl. Henri Matisse 100 × 78.5 cm/39¼ × 32¾ ins
Lent by a Private Collector

In *Young Sailor I*, probably painted at Collioure in summer 1906, Matisse used both tonal and colour contrasts to model the figure, as opposed to his Collioure paintings of 1905 (e.g. no. 131), which mark his most extreme venture into pure colour. The figure's sense of substance, though, is deliberately set off against devices which re-emphasize the two-dimensionality of the image. Bold lines and zones of darker tonal value model the figure, but in places the colour remains determinedly anti-naturalistic – in the background, and in parts of the face, where more natural flesh tints are used alongside the yellow beneath the left eye and the greens on cheek and neck. The suppression of the left foot and of parts of the chair deny a full illusion of space and modelling, and small accents such as the clear light blue patch below the left thigh pull the image firmly forward on to the picture plane.

In several ways the picture marks the absorption of Cézanne's lessons into Matisse's Fauvist style. The monumental pose is comparable to many of Cézanne's later figure-pieces (cf. no. 49), and the rapid, almost scrubby brushwork recalls some of his less highly worked landscapes (cf. no. 44). Moreover, the use of colour to achieve modelling has obvious parallels with Cézanne's ideas on modulation (cf. no. 45). However, these debts are fully assimilated. Cézanne's art helped Matisse to recombine form with colour in 1906, but Matisse's own personality stands out in the flowing linear patterns, and in the bold colour rhymes which link distant zones of the canvas to each other.

In a second version of *Young Sailor* (Private Collection, Mexico City), apparently painted soon after the first, he transformed the image into a set of flat planes and arabesques, in marked contrast to the texturing and modulation of *Young Sailor I*. This contrast is an early example of one of the crucial tendencies in Matisse's art of 1906–12, his ability to work simultaneously in two different styles. Matisse was thus perhaps the first painter in the western tradition to reject the idea that pictorial style was the defining characteristic of artistic personality. For him, different styles became tools in his attempts to resolve his central pictorial problem, the reconciliation of space and surface – as he put it in 1908, to 'reach that state of condensation of sensations which constitutes the picture' ('Notes d'un peintre', *La grande revue*, 25 December 1908, in Barr, *Matisse*, p. 120).

The first owners of *Young Sailor I* were Michael and Sarah Stein, brother and sister-in-law to Gertrude Stein; it was one of their first major purchases. J.H.

EXHIBITIONS
1909–10, Odessa and Kiev, Salon de l'Exposition Internationale (396)
1914, Berlin, Gurlitt, *Matisse*
REFERENCES
A. Barr, *Matisse, His Art and His Public*, pp. 93, 541
New York, Museum of Modern Art, *Four Americans in Paris*, 1970, p. 43
J. Elderfield, *The 'Wild Beasts', Fauvism and its Affinities*, 1976, p. 81
London, Christie, sale catalogue 3 July 1979, lot 99

Maurin, Charles 1856–1914

Maurin came from Le Puy; he studied at the Ecole des Beaux-Arts in Paris under Lefèvre and Boulanger, and attended the Académie Julian where he met Vallotton. He exhibited at the Salon 1882–90, at the Indépendants in 1887–8, and was invited to the Salon de la Rose + Croix in 1892, 1895 and 1897. His paintings showed a debt to Ingres, and a dependence upon Japanese prints and Flemish primitives for their heightened realism, clean outline and flat, rich colour.

133 *The 'Prelude' to 'Lohengrin'* 1892

Le 'Prélude' de 'Lohengrin'
sd and insc br. Acquisition de la ville du Puy Souvenir du 14 juin, 1893 Prélude de Lohengrin Maurin 1892
55 × 45 cm/21½ × 17¾ ins
Lent by the Musée Crozatier, Le Puy

The theme of this painting is homage to Wagner. Together with *Homage to Baudelaire* and *Homage to Verlaine* from the triptych *Dawn* (1891), it constitutes Maurin's tribute to the men whose work inspired much of the Symbolist movement in France. After the notorious failure of Wagner's *Tannhäuser* at the Paris Opéra in 1861, it was not until the 1880s that his music-dramas and theoretical writings received widespread attention in France. Concert performances of the music-dramas were given from 1882 onwards by the Concerts Lammoureux, joined by two further promoting bodies in 1884, the Concert Colonne and the Concerts du Conservatoire. In 1887 an attempt to mount *Lohengrin* at the Eden-Théâtre ended in disaster as patriotic mobs rioted in the street outside, protesting against the performance on French soil of a modern German work. Wagner's theoretical writings were reviewed and discussed by several critics, notably in the pages of the *Revue wagnérienne*, which was conceived in Munich in 1884 by Edouard Dujardin, Houston Chamberlain and Téodor de Wyzéwa, and published in Paris in February 1885. For painters and writers, the mystical aspects of Wagner's music-dramas provided a gold mine of symbolic or non-natural subject matter. His theories on salvation through art and the equality of all art-forms provided the basis for programmes of reform in the arts, and reinstated the power of art over the materialism of the contemporary world.

133

The clean outline and intense naturalism of the images in the foreground of this painting owe much to Maurin's friendship with Vallotton, whom he had met at the Académie Julian in 1885; they shared a deep admiration for the Flemish and German primitives. Furthermore, Vallotton's adoption in 1891 of the rigorously simplifying technique of woodcuts (cf. no. 273) was copied by Maurin in 1892, and absorbed into his own painting style.

Maurin's interest in music is little documented. However, he had met Toulouse-Lautrec in *c.* 1885 at the Académie Julian, and through him he could have been introduced to such Wagnerians as Edouard Dujardin and Téodor de Wyzéwa. Maurin treated other musical subjects in his oeuvre, for example his decorative panel *Music*, designed for the theatre of Le Puy in 1893, and an aquatint called *The Orchestra*, published by Sagot and undated. M A.S.

EXHIBITIONS
1893, Paris, Galerie Joyant (blvd Montparnasse)
REFERENCES
U. Rouchon, *Charles Maurin*, 1922, pp. 37, 38, 54, repr. p. 28
Le Puy, *Charles Maurin*, 1978 (103)

Meyer de Haan, Jacob 1852–95

Born into a well-to-do Amsterdam family of biscuit manufacturers, Meyer de Haan first worked for the family firm, but his amateur enthusiasm for painting proved a stronger attraction and in 1888 he moved to Paris. On his arrival he stayed with Théo Van Gogh, through whom he met Vincent and was introduced to Gauguin, with whom he painted at Pont-Aven. His plans to accompany Gauguin to Tahiti were frustrated when his allowance was withdrawn.

134 *Le Pouldu* 1889

> sdbl and insc. Meyer de Haan Le Pouldu 1889
> 73.5 × 93 cm/29 × 36¾ ins
> Lent by the Rijksmuseum Kröller-Müller, Otterlo

This painting, executed after the arrival of Meyer de Haan and Gauguin at Le Pouldu in October 1889, belongs to the brief two-year period during which de Haan was in Brittany. According to Charles Chassé the view in the painting is of the hamlet of Kersulec, near Le Pouldu, Gauguin painted this hamlet in 1890 (*Farmyard Near Le Pouldu*, Wildenstein 394). Despite de Haan's closer view of the farmhouse and courtyard and an angle of vision shifted round slightly to the left, both Gauguin's and de Haan's paintings of Kersulec concentrate upon characteristic features of the Breton landscape: the barrier gate; the infertile, rocky soil; the hard colours of the building materials; and the toiling peasant in the background drawing water from the courtyard well.

Apart from the affinity of subject matter, the similarity of style between Gauguin and de Haan illustrates the relationship between the two artists. De Haan's unquestioning adoption of Gauguin's synthetic technique indicates his reverential attitude towards the artist whom he regarded as his master. De Haan gave Gauguin financial support during 1889–90, providing, among other things, studio space in Le Pouldu, first at the Villa des Maudits and then at Marie Henry's inn. But the esteem was mutual. Gauguin appreciated de Haan's fine intelligence and wide education which enabled them to have deep discussions on philosophical and literary matters. This admiration was given expression by Gauguin in a series of portraits of de Haan, executed either from life (e.g. *Portrait of Meyer de Haan*, 1889; *Nirvana*, 1889, Wildenstein 317, 320); or from memory (e.g. *Contes barbares*, no. 93). He also considered de Haan to be a gifted

134

artist. In the scheme to decorate Marie Henry's inn at Le Pouldu, Gauguin accorded pride of place to de Haan's *Motherhood* (*c.* 1889, Josefowitz Collection, Switzerland), and in a letter to Vincent Van Gogh lavished praise on a 240 cm long (94½ ins) mural by de Haan (*Breton Women Stretching Hemp*) which covered one wall of the inn's dining-room. M A.S.

REFERENCES
C. Chassé, *Gauguin et son temps*, 1955, p. 83
London, Tate Gallery, *Gauguin and the Pont-Aven Group*, 1969 (126)
Otterlo, Kröller-Müller Museum, *Catalogue of Paintings*, 1969, no. 506
W. Jaworska, *Gauguin et l'ecole de Pont-Aven*, 1971, pp. 98, 100
J. Rewald, *Post-Impressionism*, 1978, repr. p. 408

Monet, Claude 1840–1926

Born in Paris but brought up on the Channel coast at Le Havre, Monet was introduced to landscape painting by Boudin *c.* 1856. He met Pissarro in Paris in 1859, and Renoir, Sisley and Bazille in 1862 while studying under Gleyre. Some of his landscapes and figure scenes were accepted by the Salon in the 1860s, but after 1870 he exhibited mainly in group exhibitions and dealers' galleries, favouring smaller and more informal canvases. He lived and worked mainly in the Seine valley, settling at Giverny in 1883, where he later constructed his water garden; but in the 1880s he travelled widely, painting very varied sites. After 1890, he concentrated on painting the same subjects in different conditions, and exhibited these canvases together, as series.

ABBREVIATION
w – D. Wildenstein, *Claude Monet, biographie et catalogue raisonné*, I (1840–81); II (1882–6); III (1887–98), Lausanne and Paris, 1974, 1979

135 *Pears and Grapes* 1880

> *Poires et raisins*
> sdtl. Claude Monet 1880 65 × 80 cm/25½ × 31½ ins
> Lent by the Kunsthalle, Hamburg

135

Still-life paintings only played an important part in Monet's work between 1878 and 1882, when he seems to have found them easier to sell than his landscapes. In both flower- and fruit-pieces he spread his forms freely across the canvas, creating rich patterns and textures. The open, informal grouping of *Pears and Grapes* is markedly unlike the taut, frontal still-life compositions on which Cézanne was working during the same years (cf. no. 41). Monet was perhaps the first French still-life painter to free himself from the example of Chardin, which had dominated the still-lives of the Realist generation, and Cézanne was to follow him later in the 1880s into a more fluid and dynamic conception of still-life (cf. no. 43).

Pears and Grapes is one of a group of paintings of *c*. 1880 which Monet executed on a mid-toned tan priming. Though in later years he generally painted on a white ground, he continued into the 1880s to explore the effects of setting off his bold, separate strokes of colour against variously toned primings.

This canvas, bought for the Kunsthalle, Hamburg, by the Friends of the Gallery in 1897, seems to have been the first painting by Monet to have been bought for any museum. J.H.

EXHIBITION
1883, Paris, Durand-Ruel, *Monet* (6)
REFERENCES
W631
Katalog der Meister des 19. Jahrhunderts in der Hamburger Kunsthalle, 1969.

136 *Varengeville Church* 1882

L'Eglise de Varengeville
[repr. in colour on p. 34]
sdbr. Claude Monet 82 65 × 81 cm/25½ × 32 ins
Lent by the Barber Institute of Fine Arts, University of Birmingham

After working mainly in the Seine valley in the 1870s, Monet travelled widely in the 1880s, aiming to vary his subjects and to capture the most extreme and difficult natural effects. With its bold, asymmetrical composition and sumptuous sunset effect, *Varengeville Church*, painted on the cliffs west of Dieppe, makes a marked contrast with the horizontal lines and softer colour schemes of his river scenes.

Like many of his clifftop scenes, *Varengeville Church* echoes the compositions favoured in Japanese landscape prints, of which Monet was an avid collector. Japanese prints did not lead Monet to rearrange nature, but helped him to visualize his motifs in fresh ways, showing him how to set off the silhouetted trees and the irregular contours of the background against a high horizon line; in this way he could create an effect truer to the way in which such scenes appear, and could bypass the schemes of ordered perspectival recession typical of the French classical landscape tradition.

At a late stage in painting *Varengeville Church*, Monet emphasized the contrast between the oranges and reds of the sunset and the blues and greens of the hillside, by adding a network of warm strokes to the sunset and to the foliage at lower right, and by linking them by a passage of red and pink accents across the intervening hillside. At this date Monet was trying to finish his paintings more fully, and was finding it increasingly necessary to retouch his paintings of ephemeral effects in the studio. It is very possible that some of the late elaboration of colour and surface in *Varengeville Church* was added away from the motif.

The painting's final colour-scheme, based on strong contrasts, foreshadows the development of Monet's art over the next decade, towards richer and more calculated harmonies of colour. His experience of painting the light of the Mediterranean in 1884 and 1888 (cf. no. 139) has been cited as a crucial factor in this process,

but *Varengeville Church*, completed before his first southern trip, shows that he had already begun to recreate atmospheric effects in terms of rich colour compositions. J.H.

EXHIBITIONS
1889, Paris, Petit, *Monet–Rodin* (61)
1899, Paris, Durand-Ruel, *Monet, Pissarro, Renoir et Sisley* (19)
1900, Paris, Exposition Universelle, *Exposition Centennale* (487)
1905, London, Grafton Galleries (147)
REFERENCES
W727
J. House, *Monet*, 1977, pp. 9–10 and pl. 29

137

137 *The Rocks of Belle-Isle* 1886

Les Rochers de Belle-Isle
sdbl. Claude Monet 86 65 × 81 cm/25½ × 32 ins
Lent by the Musée St-Denis, Reims

Monet's friends Renoir (cf. no. 173) and Octave Mirbeau (cf. no. 138) encouraged him to visit Brittany in September 1886, but it was apparently a description in a guide-book which led him to Belle-Isle, a rocky island in the Atlantic off the south coast of the Breton peninsula (G. Geffroy, *Pays d'Ouest*, 1897, pp. 253–4). Initially he planned to spend only a few weeks there, and his first canvases, like *The Rocks of Belle-Isle*, showed the island's granite crags and the richly coloured ocean in calm and sunny conditions. He was inspired to prolong his stay by the storms which hit the island in October (cf. no. 138), but when they passed he had difficulty in finishing his sunny scenes because the season had changed. On leaving Belle-Isle in November, he realized that he would have much to do to his canvases in the studio (cf. w letters 741, 742). In *The Rocks of Belle-Isle*, some changes in the contours of the background rocks, after the first paint layer was dry, may have been made in the later part of his stay on the island, but the painting's rich colour-scheme and carefully worked surface suggest that it was revised in the studio. J.H.

EXHIBITIONS
1888, Copenhagen, *Franske Kunstwaerte* (210)
? 1889, Paris, Petit, *Monet–Rodin* (80 or 90?)
REFERENCE
W1107

138 *Storm on Belle-Isle* 1886

Tempête à Belle-Isle
sdbr. Claude Monet 86 60 × 73.5 cm/23½ × 29 ins
Lent by a Private Collector, New York

In contrast to no. 137, *Storm on Belle-Isle* is a rapidly worked canvas, with no sign of afterthoughts and later repainting. Only when storms swept over the island in October 1886 did Monet see its full pictorial potential, and seek motifs which expressed the full force of

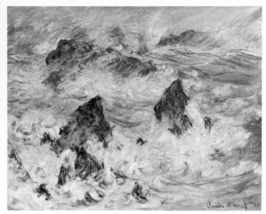

138

When Monet visited Antibes early in 1888, he intended its tender mood and its atmosphere of blue, rose and gold to contrast with the savagery of his Belle-Isle canvases of 1886 (w letter 855; cf. no. 138); the Antibes canvases took up the mood of the paintings from his first Mediterranean stay, at Bordighera and Menton in 1884. Painting the light of the south did not initiate Monet's move towards richer colour harmonies in the 1880s (cf. no. 136), but the experience of trying to render the luminosity of the Mediterranean forced him, as he realized in 1884, to emphasize contrasts of blue and rose (cf. e.g. w letters 441–2). These contrasts appear in bright colour in the foregrounds of his southern paintings, and are picked up in the delicate pastel tints of the distant mountains. Renoir and Cézanne had faced similar problems in painting the south (cf. nos 171 and 42); this light was greatly to influence the colour of Van Gogh, Signac and Cross, and, later, of Matisse and Derain (cf. nos 215 and 73).

As at Belle-Isle, most of Monet's Antibes paintings are quite highly finished (e.g. *Antibes*, w1192, Courtauld Institute Galleries, London), but *Cap d'Antibes in the Mistral* is an exception; the dynamic handling which expresses the force of the Mistral is left unsoftened, and the principal accents are applied with great freedom, without fully covering the summary underpainting – as, for instance, in the long sequence of luminous light pink dabs added at a late stage along the mountain peaks. However, despite the freedom of the painting as we now see it, there are extensive layers of dry paint beneath its surface, which seem to belong to another composition, of a different view across the bay – presumably a false start which Monet could not afford to throw away owing to a shortage of canvases. J.H.

EXHIBITIONS
1889, Paris, Petit, *Monet–Rodin* (125)
1905, Boston, Copley Hall, *Monet* (37)
REFERENCE
W1176

the ocean against its rocks. He wrote with delight that he had found a sheltered corner from which he could make quick sketches (*pochades*) of the storm at its height (w letter 713). *Storm on Belle-Isle* must have been one of these, and it clearly satisfied Monet at once, since he signed and dated it when its paint was still wet (usually he only signed his paintings in the studio, when they were ready for sale or exhibition). Its handling, which suggests the surge of the sea by sweeping calligraphic brushwork, makes it one of the boldest and most successful sketches which Monet ever made of natural forces at their most extreme.

Its first owner was the critic and writer Octave Mirbeau, who had urged Monet to visit Brittany in the first place, and Monet probably left the painting with Mirbeau when he visited his home on the island of Noirmoutiers, on his journey homewards from Belle-Isle. Its sketchy execution made it a canvas which a friend could appreciate, in contrast to more highly finished paintings like no. 137, which Monet regarded as more suitable for the trade (cf. e.g. w letter 1116).

The dealer Durand-Ruel was worried that Monet's storm paintings would disconcert collectors who were beginning to appreciate his sunny effects, but Monet insisted that he should not specialize in a single mood: 'I'm inspired by this sinister landscape, precisely because it is unlike what I'm used to doing; I have to make a great effort, and find it very difficult to render this sombre and terrible sight' (w letter 727). The qualities which Monet found in the Breton coastline are similar to those which attracted his contemporaries, in paintings (cf. nos 51 and 149), and in books like Pierre Loti's hugely popular *Pêcheur d'Islande* (1886). J.H.

REFERENCES
W1117
W. C. Seitz, *Monet*, 1960, pp. 23, 33, 36, 130

139 *Cap d'Antibes in the Mistral* 1888

Au Cap d'Antibes par vent de mistral
sdbl. Claude Monet 88 65 × 80 cm/25½ × 31½ ins
Lent by the Museum of Fine Arts, Boston,
Bequest of Arthur Tracy Cabot

140 *Spring Effect at Giverny* 1890

Effet de printemps à Giverny
sdbl. Claude Monet 90 60 × 100 cm/23½ × 39¼ ins
Lent by a Private Collector

In contrast to the dramatic effects which he sought away from home, Monet's Seine valley landscapes of the 1880s and 1890s – from Vétheuil, and after 1883 from Giverny – treat subjects without immediate picturesque appeal. After 1880 he regularly painted meadows, treated in simple bands against a fretwork of trees, animating them primarily by effects of colour and texture; in *Spring Effect at Giverny* he emphasized this horizontality by choosing an abnormally long, narrow canvas. In paintings like this Monet gave grass and foliage great richness of colour; here, they are treated primarily in many varied greens, with rich blues in the shadows and light yellow-greens in the sunlight; pink touches by the trees echo the flowers, and the soft blue signature picks up the shadows. Space

139

140

and form are created by these constant modulations of colour, and the picture surface is knit together by colour relationships and by the homogeneity of its heavily worked, almost crusty paint surface. J.H.

EXHIBITIONS
1899, Paris, Durand-Ruel, *Monet, Pissarro, Renoir et Sisley* (30)
1905, London, Grafton Galleries (143)
1907–8, Manchester, Art Gallery, *Modern French Paintings* (87)
1908, Paris, Durand-Ruel, *Paysages par Monet et Renoir* (32)
1910, Brussels, Exposition Universelle (233)
1914, London, Grosvenor House, *Art Français* (45)
REFERENCE
W1245

141 *Haystacks, Snow Effect* 1891

Meules, effet de neige
sdbr. Claude Monet 91 65 × 92 cm/25½ × 36¼ ins
Lent by the National Gallery of Scotland, Edinburgh

The centrepiece of Monet's exhibition at Durand-Ruel's gallery in May 1891 was a sequence of 15 canvases, all showing one or two haystacks, variously grouped, in a field near Monet's house at Giverny at different seasons and in a variety of weathers. This was the first time that he had exhibited a series of this sort, and the Haystacks introduced a method of working to which he kept for the rest of his career (cf. nos 142–3).

He had often previously painted a single subject several times, in different conditions, but he had never before made such variations the central feature of an exhibition. The full effect of the Haystacks depended on the way in which they were exhibited, since, as he said in 1891, the individual paintings 'only acquire their full value by the comparison and succession of the whole series' (W. Bijvanck, *Un Hollandais à Paris en 1891*, 1892, p. 177). He had painted a few canvases of Haystacks in 1889, but the idea of making them into a longer sequence came to him in the late summer of 1890. He often told the story of how, one misty day, he had been forced to begin canvas after canvas as the light effects changed; he continued work on the theme through the next winter, making the Haystacks into a cycle of the seasons.

However, as completed, the series embodied a paradox which is at the root of Monet's later work. He was seeking in these paintings to capture the most ephemeral natural effects – 'instantaneity, above all the enveloping atmosphere [*enveloppe*], the same light spread over everything', as he wrote in October 1890 (w letter 1076); but the effects which he was painting passed so quickly that he had to recreate them, at his leisure, in the studio. He told his friends that he wanted these paintings to be more than mere sketches – to be the result of a 'long, continued effort', and to have 'more serious qualities' (Diary of Theodore Robinson, 3 June 1892, quoted catalogue of *Monet* exhibition, Art Institute, Chicago, 1975, p. 35).

The elaborate colour-schemes and dense surfaces of the Haystacks set them apart from the quick sketches of transitory effects which Monet had made in the 1870s (such as *Impression, Sunrise*, 1872, Musée Marmottan, Paris), and their final effect was the result of extensive reworking. The lavish orange-blue contrast which dominates *Haystacks, Snow Effect* was much accentuated late in the execution of the painting, when many other coloured nuances were added, and the contre-jour effect was heightened by ribbons of orange down the left margin of the nearest haystack. Monet also took great care over the formal structure of the paintings, making substantial alterations to several of them – in *Haystacks, Snow Effect*, he enlarged the nearer haystack by about three inches to the right, after the initial paint layer had dried, and adjusted the shapes of the shadows, to create two distinct forms.

By this careful organization of individual canvases, and by exhibitir them as closely integrated groups, Monet was able, in his later work, to go beyond the sketchiness and informality which had been so criticized in the Impressionists' work of the 1870s. J.H.

EXHIBITIONS
?1891, Paris, Durand-Ruel, *Monet* (7)
1904, Weimar, *Monet, Manet, Renoir, Cézanne* (11)
1905, London, Grafton Galleries (153)
1907–8, Manchester, Art Gallery, *Modern French Paintings* (81)
REFERENCES
W1277
A. Stokes, *Monet*, 1958, pp. 18–19, repr. in colour
Edinburgh, National Gallery of Scotland, *Shorter Catalogue*, 1978, p. 64

142 *The Poplars, the Three Trees, Autumn* 1891

Les Peupliers, les trois arbres, automne
sdbr. Claude Monet 91 92 × 73.5 cm/36¼ × 29 ins
Lent by the Philadelphia Museum of Art, Gift of Chester Dale

In contrast to his first series, the Haystacks (cf. no. 141), Monet only worked out of doors for a short spell on the Poplars, in the late summer and autumn of 1891, having paid a timber merchant to delay felling the trees. Fifteen Poplars canvases were exhibited by Durand-Ruel in February 1892, presumably after retouching in the studio; the richly varied colours and textures of *The Poplars, the Three Trees, Autumn*, which was among those shown, are quite unlike the simple surfaces of the unreworked *Poplars by the Epte* (W1300, Tate Gallery, London), which he never exhibited and only signed and misdated late in his life.

The linearity of the Poplars contrasts with the simple masses of the Haystacks, and reveals Monet's delight in the 'pattern' made by nature – leaves against sky, reflections – of which he spoke to a friend around this time (Diary of Theodore Robinson, 17 February 1894, Frick Art Reference Library, New York); like many of his compositions after 1880, the Poplars are reminiscent of Japanese prints (cf. no. 136). J.H.

141

142

143 *Water-lilies* 1906/9

Nymphéas, paysage d'eau
sdbl. Claude Monet 1906 81 × 100 cm/32 × 39½ ins
Lent by a Private Collector

Monet began to build a water garden near his house at Giverny in the 1890s, and his first series on this theme, exhibited in 1900, showed the original small pond, crossed by a Japanese footbridge (example in National Gallery, London). In 1901 he greatly enlarged the pond, and in 1903 began a series devoted almost wholly to its water surface – to the lily pads floating on it, and the breezes and reflections which crossed it. Forty-eight of these canvases, including the present one, were finally exhibited in 1909, but only after protracted reworking, which drove Monet to distraction and gave some of the paintings a densely wrought, almost granular surface which belies the apparently transitory subject which was their starting-point. The canvas's date, 1906, probably indicates the year in which it was begun.

By concentrating on the water surface alone, Monet avoided spatial recession of a traditional sort, replacing it with a counterpoint between the reflections and the freely disposed lily pads; space is suggested, but without disturbing the overall unity of the surface, a unity accentuated by the carefully integrated colour-schemes of each canvas. While he worked on the series exhibited in 1909, Monet had in mind a project of making his lily pond the theme for a continuous decoration to run round a room, a scheme finally realized in a long sequence of monumental paintings, begun in 1916, from which Monet chose the canvases which were installed after his death in two halls in the Orangerie in Paris. J.H.

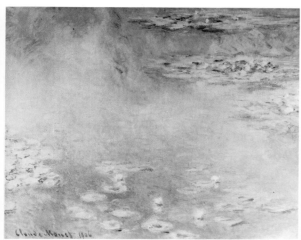

143

Monticelli, Adolphe 1824–86

Born in Marseille, Monticelli lived there for most of his life. He was taught first in Marseille by Ziem and others, then in 1846–7 by Delaroche in Paris, where he met Diaz. He worked with Diaz when he returned to Paris in 1855–6, and through him turned to rococo-type themes, which he developed while based in Paris during 1863–70. He returned to Marseille for good in 1871, and worked occasionally with Cézanne. In colour and handling his late work, in landscapes, still-lives, portraits and imaginary figure-scenes alike, became increasingly improvisatory.

144

144 *Wild Flowers* c. 1880

Fleurs des champs
sbl. Monticelli oil on panel 61 × 47 cm/24 × 18½ ins
Lent by the Trustees of the National Gallery, London

Monticelli's still-lives apparently date from the last decade of his life (cf. A. Sheon, *Monticelli*, 1979, pp. 74–5). In these pictures he worked up a lavish paint surface, worked wet in wet in bold colour, without the distractions of working out of doors, and without the demands of verisimilitude which portraiture made of him. He explained to one sitter 'that the model could be a bother, that a work in which the painter does not intervene freely is not really a work of art' (Charles Faure, quoted Sheon, p. 76).

It was still-lives of a similar type to *Wild Flowers* that Théo Van Gogh bought for his own and his brother's collection (now in the Rijksmuseum Vincent Van Gogh, Amsterdam) from the dealer Delarebeyrette, who was the only source of Monticelli's work in Paris at the time of his death; Monticelli's art and life were a powerful influence on Vincent Van Gogh (cf. nos 95 and 100–1). His reputation was first built in Britain, through exhibitions organized by Alexander Reid, who may have introduced the Van Goghs to Monticelli's work in Paris in 1886. J.H.

Moreau, Gustave 1826–98

Moreau studied under Picot at the Ecole des Beaux-Arts. His friendship with Chassériau and the impact of two visits to Italy, in 1841 and in 1857–9, had most influence on his work. Moreau was known for his paintings of classical, biblical and literary subjects, in a technique derived from Leonardo, Mantegna and Delacroix. He last showed at the Salon in 1880 and retreated into a private world, to emerge only on the death of his friend Elie Delaunay, when Moreau took over his atelier at the Ecole des Beaux-Arts, where he exerted a formative influence on Evenepoel, Rouault and Matisse.

145

145 The Sirens c. 1890

Les Sirènes
sbl. Gustave Moreau 93 × 62 cm/36½ × 24½ ins
Lent by the Musée Gustave Moreau, Paris

The exact status of this painting is uncertain. Its relationship to the watercolour *The Sirens* (Fogg Museum, Harvard) and to the finished picture *The Poet and the Siren* (dated 1893, Collection Francis Warrain) suggests that it might be an intermediate study. However, coming as it does towards the end of Moreau's life, it could also be an independent work, one of the many paintings such as *The Triumph of Alexander* (Musée Gustave Moreau, Paris) upon which Moreau worked continuously in his studio but never considered complete.

 Both the classical subject matter and the rich and varied technique of paintings such as this appealed to a younger generation of artists eager to escape from the shackles of naturalist painting. André Mellério summarized the attraction of Moreau's subject matter when he wrote in *Le Mouvement idéaliste en peinture* (1896): 'Here is a man, an artist, who found his age ugly, his contemporaries desperately vulgar, From this viewpoint, as if enveloped in his own little world, he has confined his art to all that is archaic and exotic. Here there is no longer any reality, not even a reality which is purified and elevated; Gustave Moreau has created a reality which is almost a complete abstraction' (p. 17).

 The oil paint laid on with brushstroke and palette knife, the rich colours placed jarringly beside one another, and the faint hint of a graphic outline defining some of the forms, illustrate the principle of *richesse nécessaire* in Moreau's work. Starting from the premise that thought in a painting is expressed through arabesques and paint surface, Moreau maintained that to limit colour and texture to the careful depiction of the external world deprived these two characteristics of painting from expressing 'that which is worthy of admiration in an artist's work: imagination, caprice and feeling' ('La Principe de la richesse nécessaire', in Gustave Moreau's *Notebook*, Ms., Musée Gustave Moreau). The surface of the painting, therefore, is as important as the image. The effect which Moreau's technique had upon artists and writers alike was indicated by Max Nordau in *On Art and Artists*, 1907: 'Moreau's amazing art produces from his palette of oil-colours effects that lie far outside its technique; they are huge Limoges plates with rivers of transparent enamel; paintings on glass with sun-illumined, jewel-like fragments of colour; Byzantine mosaics of bits of *lapis-lazuli*, jasper, cornelian' (p. 161). M A.S.

REFERENCE
MGM 103
cf. Paris, Musée Gustave Moreau, *Catalogue sommaire*, 1923, no. 103

146 Sketch 147 Sketch

Esquisse *Esquisse*
both ns. oil on panel 27 × 22 cm/10½ × 8½ ins
Lent by the Musée Gustave Moreau, Paris

146 147

Both these sketches illustrate Moreau's interest in the relationships between areas of pure colour and between different textures of paint. They may also have been used as models for the colour exercises which Moreau set his students when he took over Delaunay's atelier in the Ecole des Beaux-Arts in 1892. Moreau's reputation as a teacher was based upon his rather unstructured, experimental teaching methods, his disregard for realism and his adherence to the principle of *richesse nécessaire* (cf. no. 145). This emphasis on the abstract aspects of painting had its repercussions in the work of such pupils as Rouault, Evenepoel (cf. no. 399) and Matisse (cf. no. 130). M.A.S.

REFERENCES
(For no. 146) MGM1151
(For no. 147) MGM1136

Moret, Henry 1856–1913

Moret studied under Laurens in Paris, but soon rejected this formal training in favour of Impressionism. In 1888 he made contact with Gauguin and Bernard at Pont-Aven. The following year he worked with several members of the Gauguin group at Le Pouldu and adopted a modified version of Gauguin's painting style. After c. 1894, while still painting Breton subjects, he again changed his style to a robust form of Impressionism indebted primarily to Monet.

148 Breton Meadow c. 1891

Prairie en Bretagne
sbl and insc. Avril Henry Moret
58 × 83 cm/22¾ × 32½ ins
Lent by the Petit Palais, Geneva

In summer 1888, at Pont-Aven, where Moret had rented a loft in the house of the harbour-master, he met Gauguin and Bernard, who had been working together that summer, executing such radical visual interpretations of Brittany as *Vision After The Sermon* (fig. 8) and *The Buckwheat Harvest* (no. 17). Between 1888 and *c.* 1894, Moret's adoption of this new style of painting can be traced as he captured what Séguin argued were the 'synthetic' qualities inherent in the Breton landscape: 'This was Brittany in all its nobility, and I have to admit that the landscape which [the artists] had in front of them every day helped them enormously in their search to capture the synthetic and the characteristic, the objective of their desires' ('Paul Gauguin,' *L'Occident*, March 1903, p. 166). However, Moret's previous experience as an Impressionist painter seems to have restrained him from the unequivocal application of Gauguin's synthetic style as found in Lacombe (no. 111), Sérusier (no. 187) and Meyer de Haan (no. 134). His return to a modified form of Impressionism by *c.* 1894 (cf. no. 149) makes his membership of the School of Pont-Aven based more on subject matter and shared friendships than on technical conformity. M A.S.

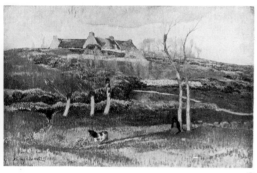

148

149 *Waiting for the Fishermen, Brittany* 1894

L'Attente du retour des pêcheurs en Bretagne
sdbl. Henry Moret 94 54 × 65 cm/21¼ × 25½ ins
Lent by the Petit Palais, Geneva

The close relationship between the Breton people and the sea was recognized in both painting and literature. It was described in its more tranquil guise in paintings of oyster gatherers and lobster harvesters (e.g. Guillou's 1880 Salon entry [1757], fishing boats in port (e.g. Vernier, no. 227) and sunlight on cliffs and water (e.g. Monet, no. 137; Russell, no. 332). Yet the sea's power to destroy was also understood by some artists and writers. If Monet chose to record this destructive force in Breton life by means of pure landscape (no. 138), Moret, together with Cottet, Emile Bernard (in poems such as 'Tempête', *Voyage de l'être*, 1898, p. 39), Tristan Corbière, Hugo, and Loti (*Pêcheur d'Islande*, 1886) concentrated upon the human drama. Although the women waiting on the shore are not yet

widows, unlike Cottet's *Three Breton Women in Mourning* (1903, Koninklijk Museum, Antwerp), Moret's painting captures the fearful suspense of the longed-for return of the boats out of the storm, which Cottet also was to express in his series titled *Au Pays de la mer*, and in *Au Pays de la mer douleur* (1908, Palais de Tokyo, Paris).

In comparison to *Breton Meadow* (no. 148), the use of a more Impressionist technique in the manner of Monet illustrates the shift in Moret's style which took place *c.* 1894. While the date of the change reflects the prolonged absence of his mentor, Gauguin, from France, it can also be related to the moment when Moret was taken up by Monet's dealer, Durand-Ruel. M A.S.

Picasso, Pablo 1881–1973

Born in Malaga, Picasso moved to Barcelona in 1895, where he studied painting, visiting Madrid in 1895 and 1897. He spent time in Paris in October–December 1900, June 1901–January 1902, and October 1902–January 1903, before he returned there permanently in April 1904. Thereafter he lived in France, visiting Spain frequently until Franco seized power in 1936.

150 *The Couple* 1904

Le Couple
sbl. Picasso 100 × 80.5 cm/39¼ × 31½ ins
Lent by a Private Collector, Ascona

On his first visit to Paris in 1900, Picasso took up the type of painting of Montmartre and Parisian night life characteristic of Toulouse-Lautrec (cf. nos 219 and 222), but during 1901 he began to concentrate more on moods and feelings, and the colour blue became an increasingly important element in his pictures. In Barcelona in 1902–4 he developed this into a consistent style, painting almost entirely in blue, and representing mainly the poor and the suffering, with elongated, emaciated forms. *The Couple* dates from the end of the 'Blue' Period, and was painted shortly after Picasso had settled in Paris in April 1904. Unlike many of the Barcelona blue paintings, it is very lightly worked, suggesting modelling and lighting by simple dabs and slashes of paint, and forcing the two figures into a schematic rectangular zone within the composition.

Much has been written about Picasso's use of blue, but two points emerge: first, that one-colour paintings, expressing a dominant mood, belong to a tradition which goes back to Whistler and to the one-colour paintings of Anquetin and Van Gogh of 1887–8 (cf. nos

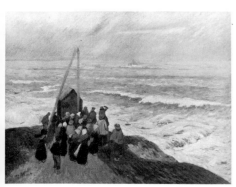

149

150

7 and 97); and secondly, that there is an essential connection between the use of blue and the themes of suffering depicted – blue is used to evoke this mood (on Picasso's use of blue, cf. e.g. Blunt and Pool, *Picasso, the Formative Years*, 1962, pp. 19–20, and Rubin, *Picasso in the Collection of the Museum of Modern Art*, 1972, pp. 26–7). Picasso's themes echo those of his friend the Spanish painter Isidro Nonell (1873–1911), and the forms which he evolved are based on a synthesis of many visual stimuli – from Nonell, Daumier, El Greco and Mannerist painting, Gothic sculpture – but he united colour and forms to produce a taut and economical style into which these contributing elements are wholly fused. J.H.

EXHIBITION
1909, Munich, Thannhäuser, *Picasso*
REFERENCE
P. Daix and G. Boudaille, *Picasso 1900–1906*, XI, 5

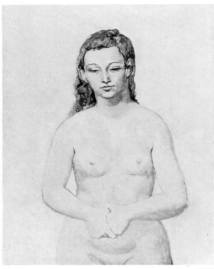

151

151 *Nude with Clasped Hands* 1906

Nu aux mains serrées
sd and insc on rev. A mon vrai ami Picasso 1er Janvier 1907
gouache on canvas 96.5 × 75.5 cm/38 × 29¾ ins
Lent by the Art Gallery of Ontario,
Gift of Sam and Ayala Zacks, 1970

In themes, forms and colour Picasso transformed his style between 1904 and 1906. The poverty-stricken characters of the 'Blue' Period gave way to circus performers and then, late in 1905, to classicizing themes without specific references or locations. The forms of his figures became rounder and more fully modelled, and, by 1906, overtly indebted to Classical prototypes. Finally blue gave way to a juxtaposition of blue and pink, in the circus pictures, and then to a dominant light pink reminiscent of Greek vase painting or Pompeian murals.

Some of these changes have been ascribed to changes in Picasso's material circumstances – his increasing success as an artist, his friendship with French writers and in particular the poet Apollinaire, and his relationship with Fernande Olivier, who was probably the model for *Nude with Clasped Hands*. However, his move to classicizing themes and style is closely paralleled in the work of other artists at the time, such as Denis, Roussel and some of the Neo-Impressionists (cf. nos 71, 183 and 412); Matisse's *Luxe, calme et volupté* (1904–5, fig. 3) is another product of this cultural situation *Nude with Clasped Hands* belongs to the early months of 1906; it

retains the cursive modelling of the girls whom Picasso had painted in Holland on a visit of summer 1905 (when, Fernande Olivier remembered, he had been amazed by the size of the Dutch girls; cf. F. Olivier, *Picasso and his Friends*, 1964, pp. 40–1); but the figure is presented with a frontality and symmetry which suggests the influence of Egyptian and early Greek sculpture which Picasso was already studying. Later in 1906 his forms became increasingly simplified and massive, as a prelude to the sudden creative leap which led, in the spring and summer of 1907, to *Les Demoiselles d'Avignon* (Museum of Modern Art, New York). J.H.

REFERENCE
P. Daix and G. Boudaille, *Picasso 1900–1906*, XV, 28

Pissarro, Camille 1830–1903

Pissarro was born of Jewish parents on St Thomas in the West Indies, but lived in France from 1855 onwards, mainly in the countryside north of Paris. He received some teaching from Corot in the later 1850s; in 1859 he met Monet, and in 1861 Cézanne, with whom he worked on occasions for many years, particularly in the 1870s. Pissarro exhibited some landscapes in the Salon in the 1860s, but after 1870 showed mainly in group exhibitions and dealers' galleries, favouring smaller, more informal landscapes, often peopled with peasants. After 1896 he painted many townscapes in Rouen and Paris. In 1886–8 Pissarro adopted the pointillist technique after meeting Seurat and Signac, and he shared the Anarchist beliefs of most of the Neo-Impressionist group.

ABBREVIATION
PV – L. R. Pissarro and L. Venturi, *Camille Pissarro, son art, son oeuvre*, Paris, 1939
Lettres – C. Pissarro, *Lettres à son fils Lucien*, Paris, 1950

152 *Peasant Woman Digging* 1882

Paysanne bêchant
sdbl. C. Pissarro 82 65 × 54 cm/25½ × 21¼ ins
Lent by Durand-Ruel, Paris

Figure-subjects became more important in Pissarro's work in the early 1880s, and he painted a long sequence of canvases of peasants going about their tasks in the countryside, and sometimes in the local towns. In the handling of his finished paintings of the period, like *Peasant Woman Digging*, he created a dense, quite homogeneous surface, built up from successions of small brushstrokes, often lying parallel to each other, which give the canvas its rhythm and a consistent texture to all its forms.

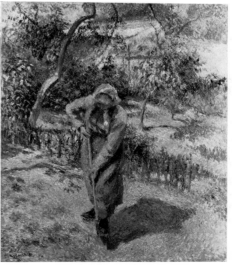

152

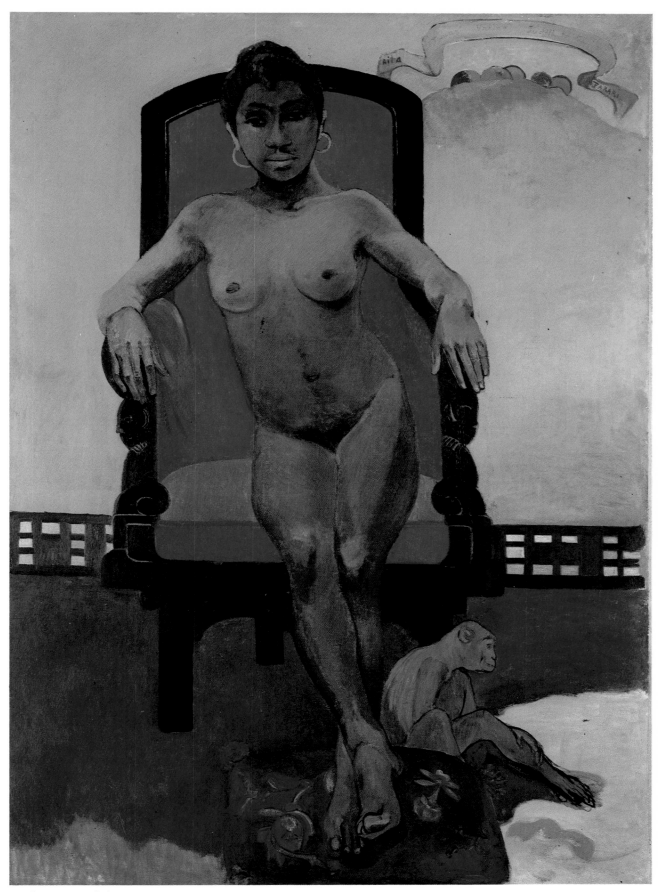

91 Gauguin *Annah the Javanese*

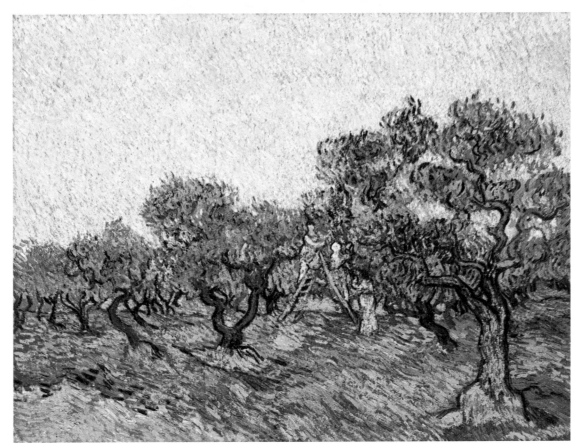

104 Van Gogh *The Olive Pickers*

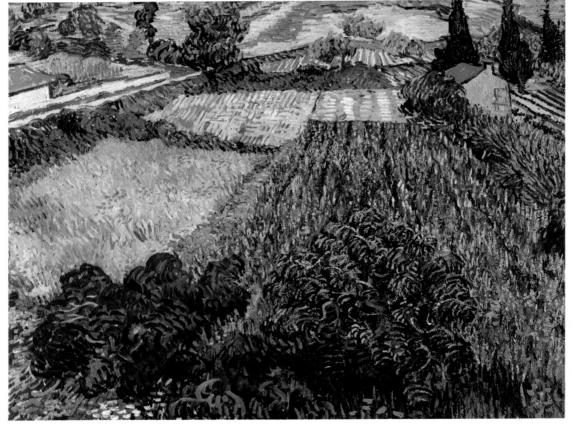

106 Van Gogh *Poppy Field*

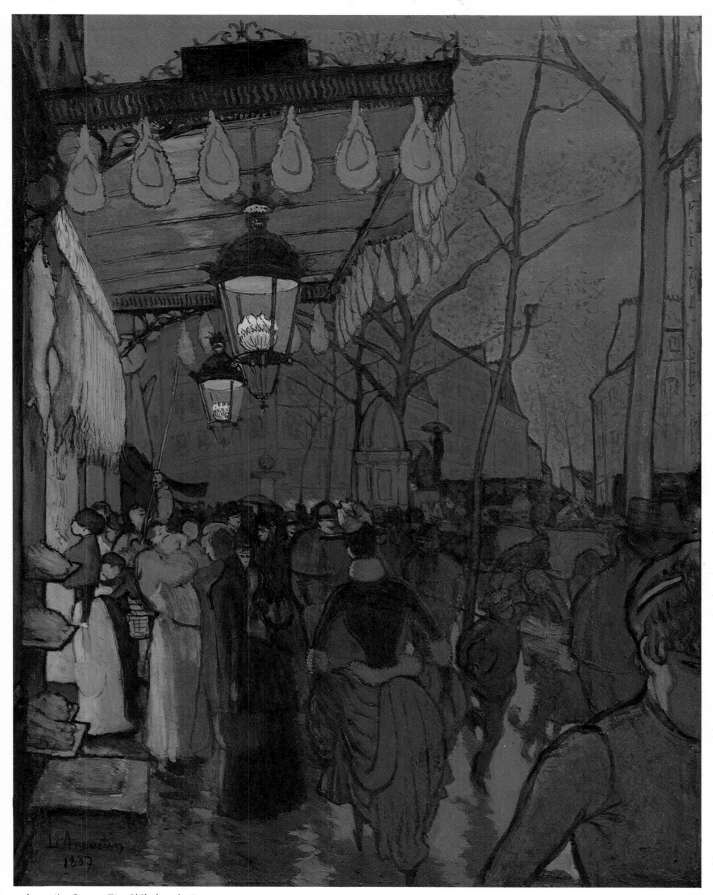

7 Anquetin *Street – Five O'Clock in the Evening*

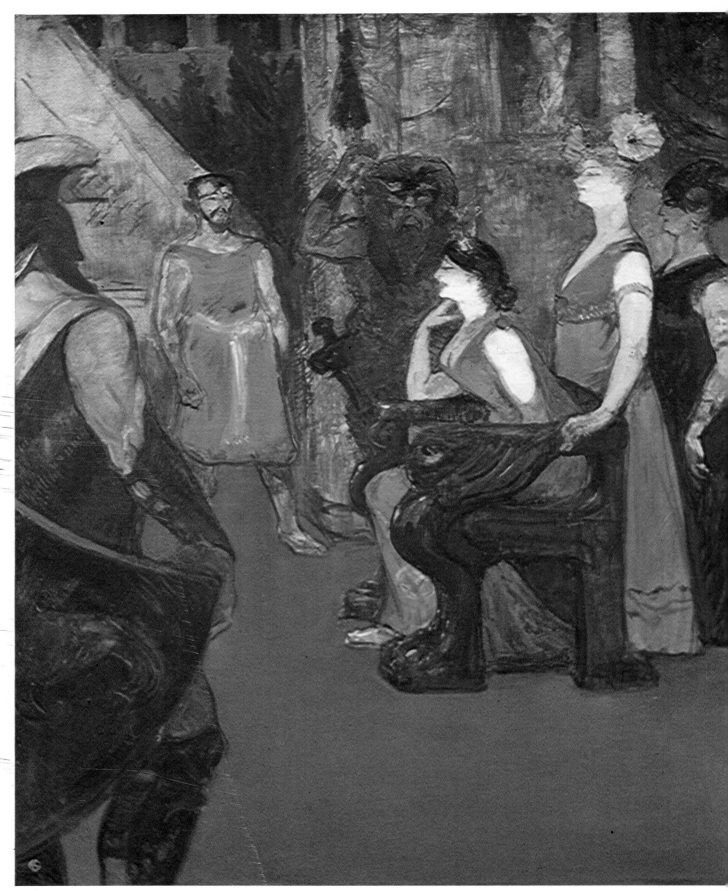

225 Toulouse-Lautrec *Messaline Seated*

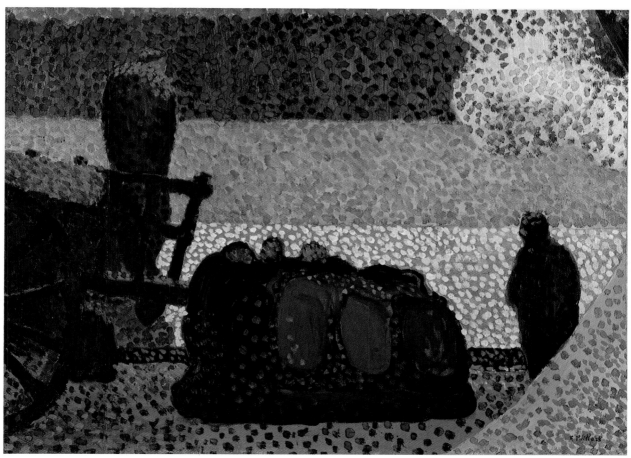

231 Vuillard *The Stevedores*

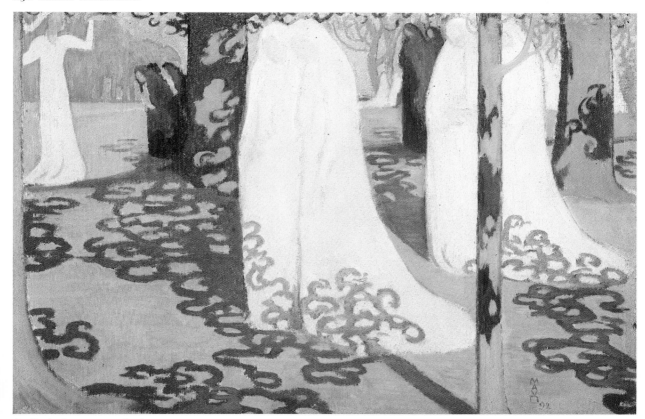

67 Denis *Procession Under the Trees*

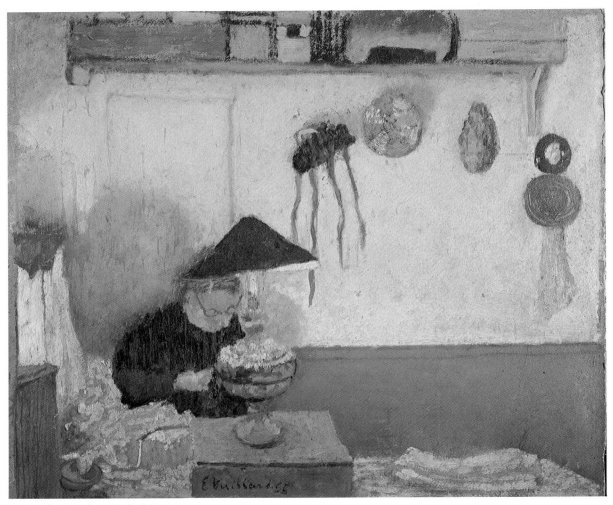

237 Vuillard *Madame Vuillard Sewing*

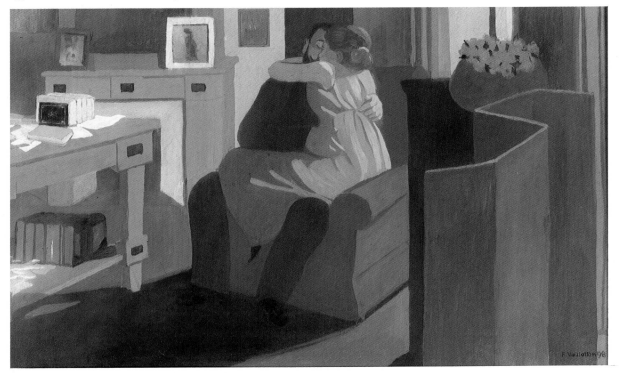

274 Vallotton *Intimacy: Interior with Lovers and a Screen*

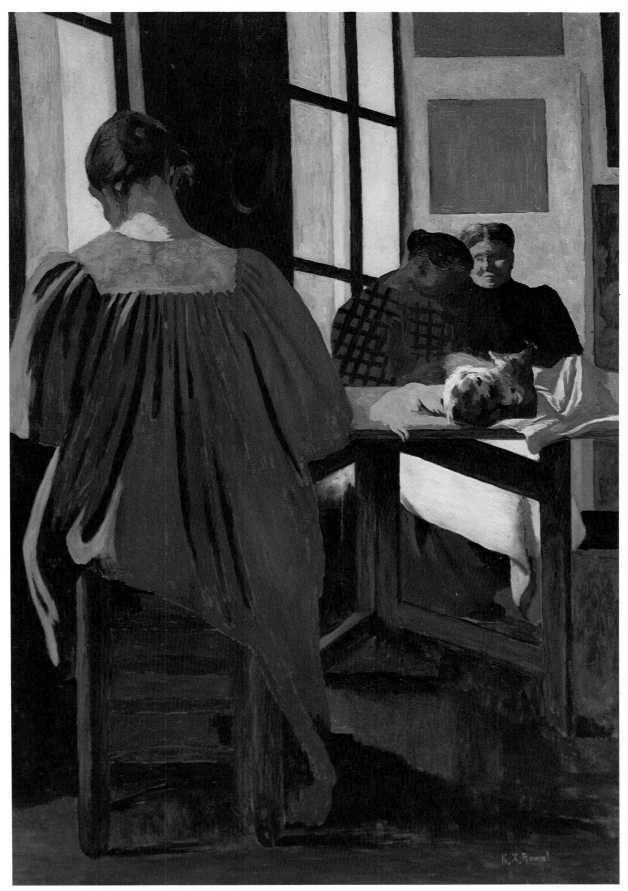

182 K.-X. Roussel *The Seamstresses' Workshop*

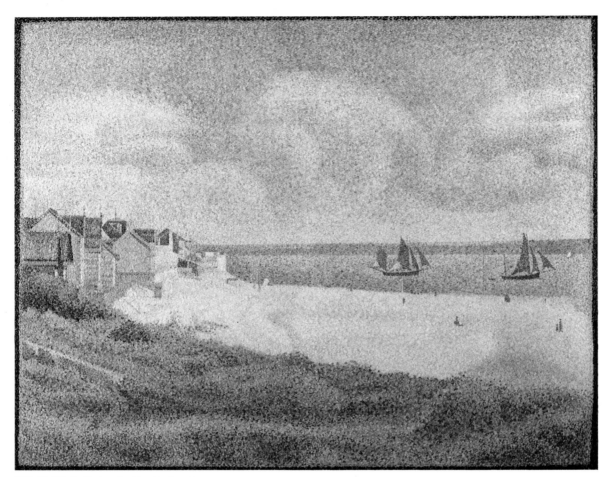

202 Seurat *Le Crotoy, Looking Upstream*

109 Hayet *River Landscape*

Since the mid-1870s Pissarro had been seeking ways of imposing unity on his brushwork, in reaction against the informality and variety of his handling of c. 1870–3. In 1874–5, like Cézanne around the same period, he had experimented with the palette knife, and in 1876 he began to give his surfaces the close weave of strokes seen in *Peasant Woman Digging* and, in an early form, in *The Côte des Boeufs at the Hermitage, Pontoise* of 1877 (PV380, National Gallery, London). Using this technique, he could introduce varied nuances of colour and suggest the textures of grass and foliage while at the same time imposing cohesiveness on the two-dimensional surface of the picture. His quick sketches from nature, and the less thickly painted areas of his more finished paintings of the period, are more broadly handled; the ordered patterns of small brushstrokes were added as he worked up his initial notations into finished form. This development in Pissarro's work can be securely dated (he regularly dated his paintings), and it seems to coincide with Cézanne's gradual adoption of the 'constructive stroke' (cf. no. 40). The two artists continued to work together on occasion during these years, and seem to have adopted an increasingly systematic handling of paint for similar reasons, to gain surface unity without sacrificing the variety of coloured nuances.

Pissarro's landscapes are rarely unpeopled. Since 1874 he had been toying with the idea of executing genre paintings 'of figures and animals in the real countryside' (cf. letters to Duret, 22 October and 11 December 1874, and 12 June 1875, in A. Tabarant, *Pissarro*, 1924, p. 27), but only in 1881 did figures regularly become the dominant feature of his outdoor scenes, giving them a stronger social meaning. The publication of Sensier's life of Millet in 1881 may well have spurred him in this direction, and he felt that Millet shared his own social preoccupations with the unequal lot of the peasant. In 1887, on the publication of some of Millet's letters, Pissarro was disillusioned to find that Millet had in fact repudiated the Commune of 1871, and had viewed the toil of the peasant with biblical fatalism, not socialist zeal (*Lettres*, p. 142, letter to Lucien, 2 May 1887). J.H.

REFERENCE
PV573

153 *View from My Window, Eragny* 1888

Vue de ma fenêtre
sdbl. C. Pissarro 1888 65 × 81 cm/25¾ × 32 ins
Lent by the Visitors of the Ashmolean Museum, Oxford

Though dated 1888, *View from My Window* was very probably complete in some form by July 1886, when Durand-Ruel refused to buy it because, Pissarro reported to his son Lucien, 'It seems its

153

subject is not saleable because of the red roof and the farmyard – just what gives the picture all its character; it has a *modern primitive* feel to it' (*Lettres*, p. 109, letter of 30 July 1886). Though the painting is executed in small and meticulous flecks of paint, the variety of touch reveals Pissarro beginning to abandon the 'pointillist' execution to which Seurat had converted him in winter 1885–6.

Camille Pissarro was the first artist to adopt Seurat's 'point' which he was using in reworking his *Grande Jatte* (cf. no. 198) late in 1885. Signac followed Pissarro soon afterwards, and all three artists showed paintings in the new technique at the 8th Impressionist exhibition in May 1886 (cf. no. 206). Pissarro became a devoted propagandist of the pointillist technique over the next two years, preaching in favour of Seurat's 'scientific' Impressionism, as opposed to the 'romantic' Impressionism of his former colleagues (cf. his letter to Durand-Ruel, 6 November 1886, in Venturi, *Les Archives de l'Impressionnisme*, 11, 1939, pp. 24–5). Earlier in the 1880s he had been using a taut, regular brushstroke (cf. no. 152) which predisposed him in favour of the 'point', but the disciplines of the technique caused him many problems, which he expressed in a letter in September 1888: 'I'm thinking a lot about how to paint without the "point". I'm hoping to achieve this, but I haven't yet been able to resolve the question of using pure, divided colour without harshness. How can one combine the purity and simplicity of the "point" with the solidity, the suppleness, the freedom, the spontaneity, the freshness of sensation of our Impressionist art? That is the question; it preoccupies me a lot, for the "point" is thin, without any consistency, translucent, monotonous rather than simple, even in Seurat's work – particularly in Seurat's work. I'm going to visit the Louvre to see certain painters who interest me from this point of view. Isn't it absurd to have no Turners in Paris?' (*Lettres*, pp. 177–8, letter of 6 September 1888).

View from My Window reflects these problems. The largely over-painted signature to the right of the present one presumably belongs to the picture's first completion in 1886, but we cannot tell how far Pissarro reworked it in 1888. In its present form, and perhaps as a result of this reworking, the brushwork varies from area to area, with broader paint layers beneath the smaller touches; the flecks of paint in the foliage give each area a sense of directional movement. The colour, too, is varied throughout – predominantly reflecting the local colour of the objects, but with a network of soft blues and mauves to suggest atmosphere, and soft oranges in the distance picked up in the stronger reds of roof, foreground foliage and signature.

Pissarro's comment about the 'modern primitive' feel of this farmyard with its red roof suggests that he was seeking a way of expressing pictorially his feelings for farm buildings in their rural setting. The scene, viewed from an upstairs window, has a simple structure which reads up the picture surface, reminiscent perhaps of French popular wood-block prints (*Images d'Epinal*). Pissarro may have felt that this similarity gave the scene its 'modern primitive' feel, and that a 'naïve' structure of this sort best expressed the down-to-earth character of the land and those who worked it. J.H.

EXHIBITION
1889, Paris, Durand-Ruel, *Peintres-Graveurs* (224)
REFERENCES
PV721
Lettres, p. 109
New York, Guggenheim Museum, *Neo-Impressionism*, 1968 (53)

154 *Ile Lacroix, Rouen, Effect of Fog* 1888

L'Ile Lacroix, Rouen, effet de brouillard
sdbr. C. Pissarro 1888 46.5 × 55 cm/18¼ × 21¾ ins
Lent by the John G. Johnson Collection, Philadelphia

154

Ile Lacroix was probably painted entirely in the studio, since Pissarro did not visit Rouen in 1888, and it is a precise recreation, in colour, of an etching which he had made at Rouen in 1883 (Delteil 69). In contrast to the varied atmospheric colours of no. 153, here he treats a unified atmospheric effect, in luminous light-toned colour, with occasional reds, and soft greens and blues to draw attention to various parts of the painting. The brushwork, varying from area to area, reflects the problems which Pissarro was having in 1888 in using the 'point' (cf. no. 153). The overpainted signature, seen through the paint at lower left, shows that the canvas caused Pissarro some uncertainties, though its comparatively thin paint layers make it unlikely that this initial working was executed in 1883 in Rouen, at the time that Pissarro made the related etching. The painting was bought in November 1888 by Théo Van Gogh for the firm of Boussod & Valadon. J.H.

EXHIBITIONS
1889, Brussels, Les XX (Pissarro 6)
1890, Paris, Boussod & Valadon, *Pissarro* (14)
REFERENCES
PV719
J. Rewald, *Pissarro*, 1963, pp. 138–9
J. Rewald, 'Théo van Gogh, Goupil and the Impressionists', *Gazette des Beaux-Arts*, January–February 1973, pp. 75, 102

155 *Women Haymaking* 1889

Les Faneuses
sdbl. C. Pissarro 1889 65.5 × 81 cm/25¾ × 32 ins
Lent by the Dr H. C. Emile Dreyfus Foundation, Kunstmuseum, Basle

In 1887–9, as he was working his way away from the rigours of the Neo-Impressionist technique (cf. no. 153), Pissarro undertook a group of ambitious figure compositions, which he executed from

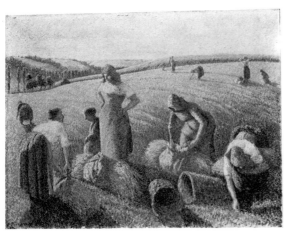

155

studies in the studio. This procedure caused him problems, because he found that his previous studies from the figure did not give him enough documentation, and he needed to make further drawings from models. The present picture, possibly begun in 1888, was reworked in 1889, and, from descriptions by Geffroy and Lecomte, can be identified as *Les Faneuses*, exhibited at Théo Van Gogh's branch of the Boussod & Valadon gallery in February 1890 (cf. *Lettres*, pp. 149, 168–9, 181, letters of 15 May 1887, 28 April 1888, and 12 August 1889).

Women Haymaking is one of Pissarro's most elaborate and highly finished figure paintings, built up in dense, small strokes, regular in length but varied in direction, which echo his work of the early 1880s (cf. no. 152). However, in colour it is much influenced by Pissarro's experience of Neo-Impressionism: lit zones and shadows alike are built up from a mesh of colours – the shadows have full blues, and deep reds in the foreground, with greens, yellows and pinks in the sunlit areas. The colours of each area are picked up by related colours in the other areas of the canvas, which gives it great homogeneity. Pissarro introduced this harmonizing element as a result of the theory of 'passages' which he shared with Dubois-Pillet (cf. no. 76, and *Lettres*, pp. 180–1). It was this, Signac wrote later, which had separated Pissarro from the Neo-Impressionists, who primarily sought contrasts (quoted *Lettres*, p. 181, n. 1).

In 1892, Pissarro explained to an interviewer his reasons for executing his major compositions of the period in the studio: 'The unity which the human spirit gives to vision can only be found in the studio. It is here that our impressions – previously scattered – are co-ordinated, and give each other their reciprocal value, in order to create the true poem of the countryside' (Gsell, in *Revue bleue*, 26 March 1892, p. 404). Monet, by rather different means, was also seeking a type of pictorial unity at this date, in his series (cf. no. 141).

Millet's example is a particularly important influence on *Women Haymaking*, in the simple monumental figures set in a shallow space against an open distance (Millet's *The Gleaners*, 1856, Louvre, Paris). Pissarro did not share Millet's social attitudes (cf. no. 152), but Millet remained a central inspiration in his vision of the countryside, as he was for Van Gogh at the same period. Pissarro's emphasis on the physical nature of agricultural labour is very different from Renoir's more idyllic vision of peasant life in *Grape Pickers at Lunch* (no. 174). In the early 1890s Pissarro articulated his attitude towards the peasant in relation to the views of the theoreticians of the Anarchist movement. He noted with pleasure in 1891 that Proudhon had associated love of the soil with the revolution (*Lettres*, p. 258, letter of 8 July 1891), but in 1892 he felt unable to endorse all the views expressed in Kropotkin's latest book, *The Conquest of Bread*: 'So Kropotkin believes that one must *live* as a peasant in order to understand them. Certainly one must be involved in one's subject to paint it well, but is it necessary to *be a* peasant? Let us instead be *artists*, and we will be able to feel everything – even a *paysage* without being *paysan*' (letter to Mirbeau, 21 April 1892, in *Revue de l'art*, April 1930, p. 228). J.H.

EXHIBITION
1890, Paris, Boussod & Valadon, *Pissarro* (2)
REFERENCES
Lettres, p. 181, letter of 12 August 1889
G. Geffroy, preface to 1890 exhibition catalogue, in *La Vie artistique*, I, 1892, pp. 43–4
G. Lecomte, 'Camille Pissarro', *Hommes d'aujourd'hui*, no. 366, 1890

156 *Goose-girl* 1893

Gardeuse d'oies
sdbr. C. Pissarro 1893 46 × 55 cm/18 × 21½ ins
Lent by Sir Jack Lyons, CBE

156

rather bolder and less subtle than his father's; he treats the natural scene in crisp dashes and hooks of paint, which introduce nuances of varied colour and give the surface a strong overall rhythm. In 1911 Lucien presented this canvas as a wedding present to Spencer Gore and his wife (cf. no. 299), and inscribed and dated it at this moment. It remains a symbol of Lucien Pissarro's importance for the younger generation of artists in London after 1900, as a direct link back to one of the founding fathers of the Impressionist movement. J.H.

In 1892, Pissarro became worried by the refinement of his handling. Although he had abandoned the strict 'point', he was still using a very delicate touch (cf. nos 153 and 155); he told Mirbeau that he wanted to paint in a 'rougher, cruder, more savage' manner (C. Kunstler, in *Revue de l'art*, April 1930, pp. 231–2, letter of 30 September 1892). The broader handling of *Goose-girl* reflects this, and it marks a return, of sorts, to the freer treatment of his canvases of *c.* 1880. By this means Pissarro found a way 'to follow my sensations, and thus to convey life and movement, to follow the fugitive and admirable effects of nature, to give an individual character to my draughtsmanship' (letter to Van de Velde, 27 March 1896, in J. Rewald, *Seurat*, 1948, pp. 131–2).

Goose-girl shares with a number of Pissarro's other peasant scenes of the early 1890s an idyllic mood, rather different from his harsher peasant themes of the 1880s (cf. nos 152 and 155). It is not impossible that their evocative quality owes something to the influence of late Pre-Raphaelite painting in England, through the intermediary of the contemporary paintings and book illustrations of Pissarro's son Lucien (cf. no. 159), although in 1891 Pissarro had warned Lucien against succumbing to this influence (*Lettres*, pp. 226–7, 257–8, letters of 1 April and 8 July 1891). J.H.

REFERENCES
PV856
London, Tooth, *An exhibition of Impressionist Paintings held in memory of the late Dudley Tooth*, 1972 (12)

Pissarro, Lucien 1863–1944

Born in Paris, the eldest son of Camille Pissarro, Lucien was taught painting by his father. After 1885 he was influenced by Seurat and the Neo-Impressionists. He exhibited at the 1886 Impressionist exhibition, the Indépendants 1886–94, and with Les XX. During 1883–4 he worked in England and in 1890 moved to London, where he mixed with the Arts and Crafts circle. He founded the Eragny Press in 1894. In 1906 he joined the NEAC, and in 1907 the Fitzroy Street Group, where he was an important influence on the younger members. He was a founder member of the Camden Town Group in 1911, the London Group in 1913 and the Monarro Group in 1919.

157 *The Thierceville Road* 1885

La Route de Thierceville
sdbr. LP 1885 46 × 38 cm/18 × 15 ins
Lent by a Private Collector

This little landscape shows Lucien Pissarro working very much in the style of his father (cf. no. 152), before the two men adopted the Neo-Impressionist technique in 1886. Lucien's handling, though, is

157

158 *The Rue Saint-Vincent, Winter Sunshine* 1890

La Rue Saint-Vincent, soleil d'hiver
sdbr. Lucien Pissarro 1890 65.5 × 81.5 cm/25¾ × 32 ins
Lent by the Flint Institute of Arts, Michigan

Identified by R. Herbert (*Neo-Impressionism*, 1968) as the canvas painted from a Montmartre window in winter 1889–90, *The Rue Saint-Vincent* shows Lucien Pissarro treating Montmartre scenes similar to those of his close friend Luce (cf. no. 117), though without stressing the poverty of the area as Luce had. Into a winter effect dominated by soft blues and yellows, Lucien introduced dashes and flecks of the widest range of colours, which animate even the shadowed areas; his taut but variegated technique is close to that evolved by his father in 1888–9, as a means of avoiding the dryness of the Neo-Impressionist 'point' while retaining its luminosity (cf. nos 153 and 155). J.H.

EXHIBITION
1890, Paris, Indépendants (621)
REFERENCE
New York, Guggenheim Museum, *Neo-Impressionism*, 1968 (60)

158

159

159 *Cinderella* 1892

Cendrillon
sdbl. LP 92 72 × 53.5 cm/28¼ × 21 ins
Lent by Arthur G. Altschul

In *Cinderella* Lucien incorporated elements of his woodcut style with his Impressionist technique – the painting is executed with broken colour brushwork, but the forms are drawn with a heavy dark line. Indeed, several related sketches in the Ashmolean for *Cinderella* verify that there was a connection between Lucien's painting and his wood-engraving from this period since these sketches were also preliminaries for a woodcut in Lucien's first book, *The Queen of the Fishes*, published by the Eragny Press in 1894. The marked English tendencies in *Cinderella* are a reflection of the interests of Lucien's English friends in the Arts and Crafts movement. The Cinderella theme was popular in English Aesthetic circles after the publication of Walter Crane's toybook in 1877; sunflowers were another hallmark of English Aestheticism. Lucien became acquainted with this circle via a letter of introduction from Fénéon to Charles Ricketts, and he would have felt naturally disposed to it because its socialist views were in sympathy with those of the Anarchist circle he had left in France. Ricketts and his friend Charles Shannon also exposed Lucien to their enthusiasm for the Pre-Raphaelites by taking him to meet Ford Madox Brown and to see the Rossetti paintings owned by W. M. Rossetti and D. G. Rossetti's mistress, Fanny Cornforth.

The English features in this painting, characteristic of much of Lucien's work at the time, were tendencies which his father Camille deeply distrusted. He started to warn Lucien about what he called 'Pre-Raphaelite influences' in March 1891, and in July he voiced this disapproval again. Referring to Lucien's drawing *Sister of the Woods*, he complained about 'a sentimental element characteristically English and quite Christian, an element found in many of the Pre-Raphaelites' (8 July 1891); and Lucien's reply, 'I am going to change inevitably now that I am in other circumstances,' indicated the dilemma he experienced, being in England (cf. *Lettres à son fils Lucien*, ed. J. Rewald, 1950, pp. 221–2, 257–8, and *Burlington Magazine*, July 1949, p. 192). He might have expected to join the NEAC, but apart from Steer he found the NEAC painters unsatisfactory, and he was more attracted by the renewed interest in Pre-Raphaelitism which was encouraged in all English circles in the 1890s as part of the attempt to revive an English national school of painting.

Cinderella may have been exhibited as *The Fairy in the Garden* at the AAA in 1912, the year in which several early works were shown by exhibitors to draw attention to 'Post-Impressionist' tendencies in England prior to Roger Fry's exhibitions. A.G.

Pourtau, Léon *c.* 1872–97

Little is known of Pourtau's life. Trained as a musician, he worked as an amateur painter in the Neo-Impressionist style, apparently making contact with Seurat and other Neo-Impressionist painters. He left for Philadelphia *c.* 1895 to work as a musician, and died in a shipwreck on his way home.

160 *Beach Scene* 1890/3

Vue d'une plage
sbl. L. Pourtau 73 × 92 cm/28¾ × 36¼ ins
Lent by the Josefowitz Collection, Switzerland

Pourtau's *Beach Scene* is a coastal recreation of Seurat's *Grande Jatte* (fig. 5, cf. no. 198), which Pourtau could have seen at the Seurat retrospective at the 1892 Indépendants, or in Seurat's studio before his death, since he apparently knew him personally. Luce owned a study for *Beach Scene*, but no more details are known of Pourtau's contacts with the Neo-Impressionists. Local colour predominates in the figures, with variegated flecking to express lighting and reflections, while light and shade on the beach are built up of soft oppositions of yellow and blue 'points'. J.H.

160

Puvis de Chavannes, Pierre 1824–98

Born in Lyon, Puvis was destined to follow his father as a mining engineer. However, ill-health forced him to go to Italy in 1847, and the following year he went to Paris, determined to become an artist. He studied briefly under Henri Scheffer, Delacroix and Couture, and the sight of Chassériau's recently completed decorations for the Cour des Comptes convinced him to turn to monumental mural painting. Puvis' two large-scale paintings, *Bellum* and *Concordia*, received favourable notice at the Salon of 1861, and for the next 37 years he devoted himself primarily to the execution of public decorative schemes (e.g. Musée de Marseille, 1869; the Panthéon, Paris, 1874–6 and 1896–8; the Palais des Arts, Lyon, 1883–6; and the Paris Hôtel de Ville 1892–4). After frequent adverse criticism during the 1860s and 1870s, during the 1880s the enthusiasm of the younger generation of artists established Puvis both as a precursor of the Symbolist movement and as the leading decorative artist in France at the end of the century.

161 *The Fisherman's Family* 1887

La Famille de pêcheurs
sdbl. P. Puvis de Chavannes 1887 82.5 × 71 cm/32½ × 28 ins
Lent by the Art Institute of Chicago,
Mr and Mrs Martin A. Ryerson Collection

Puvis de Chavannes used the theme of fishing and fishermen several times in his oeuvre (e.g. *The Miraculous Draught of Fishes*, 1854, a panel for his brother's dining-room at Le Brouchy, and *The Poor Fisherman*, 1881, fig. 11) and this painting is itself based upon a picture bearing the same title, painted in 1875 and since destroyed.

Comparison between this painting and the surviving cartoon for the 1875 picture (Musée Saint-Nizaire, Bourbon-Lancy) points to a significant compositional reorganization and, set beside other works of the 1870s, the technique which Puvis employs in this painting is distinctly of the 1880s. As far as compositional changes are concerned, Puvis has exaggerated the separation of the child from the mother, the isolation of the old man on the right and the proximity of the young mother and the young fisherman. This has the effect of drawing attention to the symbolic meaning of the painting, which, as with Puvis' *Young Girls by the Sea* (1879, Musée du Louvre), represents the three ages of man. Two aspects of the technique are characteristic of Puvis' 1880s' work. The prominent high horizon line emphasizes the cramped space in the foreground, thus increasing the two-dimensional, decorative quality of the picture. Secondly, the use of a single, dominant colour tone, while present in works of the 1870s such as *Summer* (1873, Chartres), was only fully exploited from 1880 onwards (e.g. *The Poor Fisherman*, fig. 11), as the technique by which the mood, and therefore the message, of a painting could be conveyed.

Like almost all his easel-paintings, this picture demonstrates the close relationship between Puvis' small- and large-scale works. Here, for example, he has borrowed the poses of the young man and the woman from his 1873 mural painting, *Summer*. Similarly, the simplification of the picture into three planes, the simple bounding line, the chalky-textured paint and the flat colour are techniques which Puvis developed for his mural paintings, as durable substitutes for frescos which also emphasize the two-dimensional wall-surfaces upon which the canvases were stuck.

This painting illustrates the reasons for Puvis' great popularity among the young generations of artists during the 1880s and 1890s. First, there is Puvis' firm avoidance of any attempt photographically to reproduce external reality, which he justified by the argument that 'Painting is not merely an imitation of reality, but a parallel with nature' (A. Alexandre, *Puvis de Chavannes*, p. XVII), a view shared by the Nabis. Secondly, in the influential proto-Symbolist periodical, *La Revue wagnérienne*, the writer Téodor de Wyzéwa hailed Puvis' paintings as consciously non-naturalistic: 'Puvis has a just disdain for the exact reproduction of real forms and colours. He

has created passionate, incomparable poems through the symphonic play of line and form' ('Notes sur la peinture wagnérienne et le Salon de 1886', May 1886, p. 110). Third, the simple reliance upon the formal means of line and colour to convey the message of the painting, without literary references, was an example to younger artists in expressing the new subject matter of art, 'the Idea' or '*état d'âme*'.

Denis, in his manifesto of 1890, 'Définition de néo-traditionnisme', asked whether the Sorbonne Hemicycle by Puvis (1887) demanded a literary explanation: 'Certainly not, for that explanation is false. The examiners of the Baccalauréat may well know that a beautiful form such as that of the young man who stretches out towards the suggestion of water symbolizes studious youth. Aesthetes! It is a beautiful form, is it not? And the depth of our emotion comes from the capacity of these lines and these colours to speak for themselves, as simply beautiful and divine in their beauty' (in *Théories*, 1964 edn, p. 42). Finally, the simplicity of technique and message in his paintings, which illustrates his belief that 'in all my work, . . . there has been no deliberate seeking after symbolism. I have always tried to say as much as possible in the fewest possible words' (Michel and Laran, *Puvis de Chavannes*, 1912, p. 20), appealed to artists such as Martin who were involved in providing the large-scale mural decorations so much in demand from public bodies during the 1890s (cf. no. 127). MA.S.

EXHIBITIONS
1899, Paris, Durand-Ruel, *Puvis de Chavannes* (11)
?1904, Paris, Salon d'Automne (33)
1913, Paris, Petit, *Exposition des tableaux anciens . . .
 composant la collection de feu M. Edouard Aynard* (12)
1914, London, Grosvenor House, *Exhibition of French Paintings* (60)
REFERENCES
M. Vachon, *Puvis de Chavannes*, 1896, p. 51
T. M. Wood, 'The Grosvenor House Exhibition of French Art', *The Studio*,
 October 1914, p. 11, repr.
Chicago, Art Institute, *Paintings in the Art Institute of Chicago,
 A Catalogue of the Picture Collection*, 1961, p. 361
J. H. Neff, 'Puvis de Chavannes: Three Easel Paintings',
 Museum Studies, The Art Institute of Chicago, No. 4, 1969, pp. 68, 73–5, 77, repr. fig. 8
Paris, Grand Palais, and Ottawa, National Gallery of Canada,
 Puvis de Chavannes, 1824–1898, 1976–7 (108)

Raffaëlli, Jean François 1850–1924

Raffaëlli was born in Paris and spent his whole life there. He began a career as a singer before enrolling at Gérôme's studio, and first exhibited at the Salon in 1870. He turned to Realist subjects after a trip to Brittany in 1876, and was introduced into the Impressionist circle through his friendship with Duranty and other Naturalist novelists, exhibiting with the Impressionists in 1880–1. He won a gold medal at the Exposition Universelle in 1889, and exhibited with the Société Nationale from 1891, turning later from working-class figure subjects to landscapes and Parisian townscapes.

162 *Blacksmiths Drinking* 1885

Les Forgerons buvant
sbr. J. F. Raffaëlli
drawing heightened with oil paint, on card stuck on wood
72 × 57 cm/28¼ × 22½ ins
Lent by the Musée de la Chartreuse, Douai

In a long sequence of paintings begun *c*. 1879, Raffaëlli established himself as the prime interpreter of the suburbs and working-class life of Paris. He eschewed the rich colour and brushwork of the Impressionists, using a crisp graphic technique to describe his subjects, and emphasizing their varied gestures and physiognomies.

161

162

Raffaëlli's eyes were opened to the pictorial potential of the suburbs by the Naturalist novelist Duranty, who introduced him to the painters of the Impressionist group and to other Naturalist writers, such as Edmond de Goncourt, Zola and Huysmans. To them he was the ideal painter, who could characterize the urban worker in his milieu in a way that the Impressionists had never attempted; for Huysmans, he was the descendant of the Le Nain brothers, and the Millet of the Parisian scene (*L'Art moderne*, 1883, pp. 242–6). In 1884 Raffaëlli mounted an exhibition of his work. In the catalogue he published a statement of his aesthetic beliefs under the title 'A Study of the Movements of Modern Art and of Characteristic Beauty' (*beau caractériste*); in it he insisted that the modern artist should seek 'character', or rather the 'moral and physical laws which determine individualities and the phenomena of nature' – a positivistic credo very close to the theory of historical and psychological determinism which lay behind Zola's novels. When exhibiting at Petit's gallery in 1885–7, he presented his paintings in series with collective titles, including *Characters of the Suburbs*, *Typical Portraits of the Common People* and *Scenes of Manners*, and in the paintings from these sequences, such as *Blacksmiths Drinking* (a *Scene of Manners*), he defined the distinctive features and gestures of different types and professions and placed each in its characteristic environment, creating a repertory of images of workers in barren, semi-urbanized landscapes.

Blacksmiths Drinking was exhibited in 1887 as a 'drawing heightened with oil paint', and Raffaëlli's concise yet free draughtsmanship – perhaps influenced by Japanese calligraphy – allowed him to characterize his types far more precisely than the Impressionists could with the loaded brush alone. Colour is subdued and sparingly used; some soft blues model the forms, but without suggesting atmospheric space.

Alongside his working-class subjects, Raffaëlli exhibited at the Salons in the 1880s a number of modern history paintings, of contemporary heroes in their milieus, such as *The Public Meeting* (1885, Versailles), of Clemenceau giving a speech, and *At the Foundry* (1886, Musée des Beaux-Arts, Lyon), showing the casting of Dalou's monument to Mirabeau and Dreux-Brézé. J.H.

EXHIBITIONS
1885, Paris, Salon (3131)
1887, Paris, Petit, Exposition Internationale (123), as a *Scène de moeurs*
1889, Paris, Exposition Universelle, French section (1599)
1900, Paris, Exposition Universelle, *Exposition Centennale* (541)
REFERENCE
L. Bénédite, *Great Painters of the XIXth Century*, 1910, pp. 196–7

Ranson, Paul 1862–1909

Co-founder of the Nabis, Ranson was born in Limoges. In 1886 he entered the Paris Ecole des Arts Décoratifs and then the Académie Julian. He quickly established friendships with Bonnard, Denis and Sérusier who, joined by Vuillard and Roussel in 1889, formed the Nabis. They met regularly at Ranson's atelier where his scholarly interests led to extensive discussions on philosophy and Theosophy as well as on more general art matters. Ranson executed easel- and decorative panel paintings, tapestries, ceramics, book illustrations, sets and costumes for puppets and, when Bing opened his Maison de l'Art Nouveau in December 1895, a stained glass panel to hang over the fireplace of a room designed by Henri Van de Velde. In 1908 he founded the Académie Ranson at which Denis, Bonnard, Maillol, Sérusier, Vallotton and Van Rysselberghe taught.

163 *Christ and Buddha* c. 1890

Christ et Boudha
ns; insc in Arabic bcr, *furusiya nabiy* [knighthood of prophets]
72.5 × 51.5 cm/28½ × 20¼ ins
Lent by Arthur G. Altschul

By combining Buddhist monks with the crucified Christ, reminiscent of Gauguin's *Yellow Christ* (1889, Wildenstein 327), the two images of Buddha, the sacred lotus of the Hindu and the Arabic inscription standing for Mohammedanism, Ranson expresses his theosophical beliefs in pictorial form. Although many of the Nabis were superficially interested in Theosophy, the philosophy of a recently-founded para-religious fraternity which drew its articles of faith from all the major religions of the world, Ranson's commitment was deep. He amassed a large library on the subject as well as on magic and the occult. On the evidence of such material in his paintings, the critics quickly identified him as the Nabi who was 'the occultist interested in mysterious, strange and hieratic decorative works' (G. Roussel, *La Plume*, 1 October 1891).

Ranson's Theosophy also reflects a more general development of fringe religious activity around 1890. Founded by Mme Blavatsky in 1881, Theosophy became very popular in France at the end of the decade, when, together with Rosicrucianism, occultism, radical Catholicism and mysticism, its speculations seemed to complement the Symbolist movement's rejection of naturalism. A flood of articles, including 'Théosophie et occultisme', *Revue encyclopédique*, 1892, pp. 333ff. and 'La Réaction idéaliste', *La Justice*, 21 March– 3 June 1892, explained these ideas to the general public. M.A.S.

REFERENCE
New Haven, Yale University Art Gallery, *Neo-Impressionists and Nabis in the Collection of Arthur G. Altschul*, 1965, p. 85

163 164

164 *Woman Standing Beside a Balustrade with a Poodle* c.1895

Femme debout contre une balustrade avec un caniche
sbr. P. Ranson 85 × 29.5 cm/31½ × 11½ ins
Lent by Arthur G. Altschul

The decorative quality of this painting, achieved through the use of areas of flat colour, sinuous bounding line and the virtual exclusion of all spatial recession, illustrates Ranson's interest in the applied arts. Like his fellow Nabis, Ranson became involved in this field during the 1890s. In 1892, he executed designs for plates and in 1895, encouraged by Maillol (cf. no. 123), he produced designs for tapestries. Related to this enthusiasm for the applied arts was Ranson's desire, shared with Sèrusier (cf. no. 192), to abolish 'easel painting'. He was delighted when in 1892 one of the Nabis' patrons, Coulon, purchased a painting from him and set it directly into a wall to form a decorative panel (letter to Verkade, dated 1892, in Mauner, *The Nabis*, 1978, Appendix VIII, p. 280).

The decorative aspect of Ranson's work was recognized by the critics. In 'Les Peintres symbolistes' (*Revue encyclopédique*, April 1892, in *Oeuvres posthumes*, 1893, p. 308) Aurier foretold Ranson's creation of a 'new and unsettling decorative style', and by the following year the reviewer of Ranson's three paintings exhibited at the Antwerp Association pour l'Art felt that this new style had now reached maturity (*L'Art moderne*, 14 May 1893). Mauner (1978, p. 122) has suggested that these three exhibits had a strong influence on the development of Art Nouveau in Belgium. M.A.S.

REFERENCE
Cleveland, Ohio, Museum of Art, etc. *Japonisme*, 1975–6 (190), repr. in colour p. 132

Redon, Odilon 1840–1916

Redon went to Paris in 1859 to train first as an architect and then, under Gérôme, as a painter. After a mental breakdown he returned to his home town, Bordeaux, in c. 1864 where he met Bresdin, the etcher and engraver, from whom he learnt black-and-white techniques; after 1879, he devoted himself almost exclusively to charcoal drawing. These charcoals provided the basis in technique and image for the 166 highly acclaimed lithographs he produced between 1879 and 1899. Although he had always produced a few oil paintings, it was only c. 1895 that they became highly coloured. By c. 1900 all his work, mainly watercolours, pastels and oils, had become a celebration of explosive colour. He showed at Les XX in 1886, 1887, 1890, in The Hague (Kunstkring) in 1894 and at the Vienna Secession in 1903.

ABBREVIATION
Lettres – Lettres d'Odilon Redon, 1878–1916, 1923

165 *Flower-Piece* c.1885

Pot de fleurs
sbr. Odilon Redon 46.5 × 38.5 cm/18¼ × 15 ins
Lent by the Gemeentemuseum, The Hague

Redon's concentration on black-and-white media under the influence of Rodolphe Bresdin in c. 1865 did not mean that during the next 20 years he totally neglected his training as a painter, received from Stanislas Gorin, a watercolourist in Bordeaux, and during his brief passage through Gérôme's atelier in Paris. Throughout the period of the charcoals and lithographs Redon was also producing studies of Barbizon, Breton and Landes landscapes in the manner of Corot, Chintreuil and Cazin. His interest in flower-pieces also dates from this time. By the 1880s these flower-pieces

165

were being executed in a sombre tonality comparable to the colour-key which he was using in his contemporary pastels (e.g. *Mme Redon Embroidering*, 1880, Ari Redon Collection, Paris). Given Redon's later interest in intense colours, the careful balance achieved in the colours of this flower-piece, and its affinities with Manet and Vollon, suggest that Redon is using this genre of painting in an experimental way similar to Monet, Renoir and Van Gogh in the 1880s. M.A.S.

166 *Fallen Angel* c.1900

L'Ange déchu
sbr. Odilon Redon 81.5 × 100.5 cm/32 × 39½ ins
Lent by Mrs Bertram Smith, New York

This painting is a variant of a subject frequently handled by Redon in his charcoals and lithographs. Although in these earlier versions (e.g. a charcoal of 1871, Rijksmuseum Kröller-Müller, Otterlo, and a lithograph, pl. III of *La Nuit*, 1886) the Angel faces more forward, looking more female than the Angel in the painting, all three reflect Redon's manipulation of religious and mythological sources to evoke a visionary world of the indeterminate. In the painting the biblical reference is reinforced by the inclusion of a serpent in the Fallen Angel's hand. The meaning of the picture thus comprises both Lucifer and Eve who together imply Evil.

This painting is closely related to the lithographs of the previous 20 years in three other ways. First, the use of a firm, graphic outline, especially around the figure and wings of the Angel, reflects the defining outline of a lithographic chalk. Second, the Angel's blocky wings look like a rock wall out of which the face emerges. This image relates to such lithographic plates as *The Idol* (frontispiece for E. Verhaeren, *Les Soirs*, 1887) in which Redon illustrates his belief in the interchangeability between man and natural forms, an idea possibly derived from his friend Armand Clavaud and demonstrated fully in his lithographic series *Les Origines* (1883). Finally, despite the difference between colour and black-and-white media, and the psychological significance of Redon's adoption of colour in the 1890s

166

(cf. no. 167), the tonal gradations of lithographic chalk and charcoal were very similar to those of paint and pastel crayons: 'I believe that I have always been a painter, certainly I have always felt myself to be such, especially in my charcoals and lithographs' (letter to a journalist, published in *Le Jour*, April 1892). M A.S.

REFERENCE
New York, Museum of Modern Art, and Chicago, Art Institute, *Odilon Redon,
Gustave Moreau, Rodolphe Bresdin*, 1961–2, p. 65 repr. in colour

167 *The Turquoise Vase* c. 1905

Le Vase turquoise
sbr. Odilon Redon 65 × 50 cm/25½ × 19¾ ins
Lent by a Private Collector, Switzerland

In March 1906, Redon held a one-man exhibition at Durand-Ruel's, the culmination of seven years of growing exposure of his work to the public. He had already exhibited at Durand-Ruel's in March 1899, and was invited to contribute to the Vienna Secession in 1903 and to the Salon d'Automne in 1904. Out of the 45 paintings and pastels included in the 1906 exhibition, well over half were flower-pieces. Deeply impressed by this subject matter in Redon's oeuvre, Francis Jammes, the poet and critic, wrote an article, 'Odilon Redon, botaniste', for Paul Fort's review, *Vers et prose* (December 1906–February 1907, pp. 29–36), in which he claimed that these radically modern flower-pieces proved that Redon had cast aside all associations with Literary Symbolism. He also characterized Redon's move from black-and-white media to colour as the expression of a psychological shift from depression to happiness.

During the first half of the 1890s Redon continued to concentrate on the lithographic technique, which appears to have provoked intense self-doubt (e.g. letter to A. Bonger, 28 April 1896, in R. Bacou, *Odilon Redon*, 1956, p. 129) and psychological exhaustion. In a letter to Emile Bernard of 28 April 1895, he admitted that 'it is true that I am increasingly abandoning the "Noirs". Between you and me, the medium has drained me for I believe that it derives its source from the deepest recesses of our very being . . .' (*Lettres de . . . Redon à Emile Bernard*, 1942, pp. 150–1). In 1897 Redon's childhood home of Peyrelebade, near Bordeaux, had been sold, an event which appears to have released him from the lonely, bitter childhood memories which haunted his charcoals and lithographs, thus opening the way to colour and new imagery. In 1902 he explained to a friend, M. Fabre, that 'I have become wedded to colour!' (21 July, *Lettres*, p. 50) and, at about the same date, as recorded in *A Soi-même*, he adopted the practice of 'opening my eyes wide to see all of Nature' (p. 132), implying the discovery of the surface charms of nature as well as its hidden, inner meanings. This new attitude

meant that he could look more closely at the superficial beauty of natural objects, such as flowers, recording them in all their brilliance of colour, set off against the carefully colour-related tones of vases and subtle backgrounds. M A.S.

REFERENCE
Winterthur, Kunstmuseum, *Künstlerfreunde um Arthur und Hedy Hahnloser-Bühler*, 1973 (195)

168 *Wild Flowers* c. 1905

Fleurs des champs
sbr. Odilon Redon 65 × 50 cm/25½ × 19¾ ins
Lent by the Kunstmuseum, Winterthur

The broadening of Redon's vision at the end of the 1890s to include colour and an appreciation of the beauty of objects in the visual world did not mean that he transformed himself into a realist artist. He had always been suspicious of realism and criticized it in a series of articles entitled 'Le Salon de 1868' (*La Gironde*, 19 May, 9 June, 1 July 1868). In 1913, after some 15 years of executing flower-pieces and still-lives, he still had deep reservations. Impressionism, for Redon, was too slavish in its devotion to the external appearance of an object, an approach which shut off the artist from the essence or internal qualities of the object, from its spiritual light: 'Everything which moves beyond, illuminates or amplifies the object and raises the spirit into the realms of mystery, into the anxiety of the unresolved, and into the delicious world of uncertainty has been totally cut out by them [the Impressionists]. Everything which tends toward the symbol, everything in our art which bears upon the unexpected, the imprecise, the indefinable and which gives it a shape which confines it to the world of the enigmatic, they have set themselves apart from, they have been afraid of. True parasites of the object, they have cultivated an art which is uniquely rooted in the visual world, and have closed their eyes to that which goes beyond, to that which endows the most humble object, even in black-and-white media, with the light of spirituality. I mean by this an irradiation which takes hold of our soul – and which escapes all definition' (*A Soi-même*, 1961, pp. 131–2).

In his flower-pieces Redon captures this light which emanates from the essence of the object. The colour and texture of the vase respond to the colour and texture of the flowers, and their separation from the immediate physical world is expressed by locating them in an undefined, ambiguous space. M A.S.

REFERENCE
Winterthur, Kunstmuseum, *Künstlerfreunde um Arthur und Hedy Hahnloser-Bühler*, 1973 (190)

169 *Dream Shadows* c. 1905

sbl. Odilon Redon pastel on paper 49.5 × 63.5 cm/19½ × 25 ins
Lent by Joan Crowell

Redon was already using pastel in the early 1880s, primarily for portraits (e.g. *Madame Redon Embroidering*, 1880, Collection Ari Redon, Paris). In them the sitter is usually in profile, and set against a subtle background from which sombre light emanates. By the end of the 1890s, following a similar development in his lithographs (e.g. *Beatrice*, 1897, and *Woman's Head with a Corsage of Flowers*, 1900), Redon was placing the profiles against intensified light sources, transformed into brilliant coruscations of coloured flowers, shells, butterflies and insects (e.g. *Portrait of Madame Arthur Fontaine*, c. 1901, Metropolitan Museum of Art, New York).

From the outset Redon seems to have understood the range of effects obtainable from the pastel technique. This pastel exemplifies his varied use of crayon strokes – some short and hatched, some

167

168

169

long and pressed softly over the ribbed paper, and others forming dense blocks of intense colour. As Redon extended pastel to express the full range of its properties, so he approached the other media in which he worked, declaring to his friend André Mellerio, 'I believe that suggestive art is dependent upon the impact of the medium upon the artist. An artist who is truly sensitive will not find the same invention in different media, because each one will influence him in a unique way' (letter of 16 August 1898, *Lettres*, p. 33) M A.S.

170 *The Red Sphinx* c. 1910

Le Sphinx rouge
[repr. in colour on p. 238]
sbr. Odilon Redon 61 × 50 cm/$25\frac{1}{2}$ × $19\frac{3}{4}$ ins
Lent by a Private Collector, Switzerland

As with many of Redon's pastels and paintings, the source of this painting's subject matter lies in two lithographs, 'My gaze that nothing can deflect . . .' (pl. 5, *Tentation de Saint-Antoine, A Gustave Flaubert II*, 1886) and 'I have sometimes caught sight in the sky . . .' (pl. 21, *Tentation de Saint-Antoine, A Gustave Flaubert III*, 1896). However Redon has not attached a caption to this painting, but has resorted to a merely descriptive title, which represents an important shift in his aesthetic attitude. In his lithographs, the juxtaposition between caption and image had been intended to create deliberate ambiguity: 'The designation of too strict a title to my drawings is often superfluous. The title is only justified when it is vague, indeterminate, and aims, even confusingly, towards the equivocal' (*A Soi-Même*, 1961, pp. 26–7). Faced with this relationship, the spectator was invited to enter the creative process with the artist: 'The only aim of my art is to produce within the spectator a sort of diffuse but powerful affinity with the obscure world of the indeterminate, and to predispose him to thought' (letter to A. Mellerio, 21 July 1898, in *Lettres*, pp. 31–2). Redon abandoned captions as the means of creating ambiguity in a work of art because he had come to believe that his lithographs had been dogged by literary connotations; here, as in his flower-pieces (cf. nos 167–8) he fuses image and technique in order to create the desired effects of ambiguity and indeterminacy within the confines of the picture.

The arrangement of an Egyptian sphinx, flowers, butterflies and molluscs within the same composition refers to the images in Redon's lithographic series, *Les Origines* (1883), and represents a quiet homage to Redon's close friend Armand Clavaud. A botanist by training, he introduced Redon to microscopy and, through his extensive library and eccentric theories, writers such as Shakespeare, Baudelaire and the eastern mystics, religions such as Buddhism and medieval cabbalistic systems, and his own variant of the Darwinian theory of evolution. M A.S.

REFERENCES
M. Raynal, *De Baudelaire à Bonnard*, 1950, p. 50
K. Berger, *Odilon Redon*, 1964, p. 189, no. 110
R. Hobbs, *Odilon Redon*, 1977, pp. 100, 124
M. Wilson, *Nature and Imagination, the Works of Odilon Redon*, 1978, p. 63, no. 47

Renoir, Pierre Auguste 1841–1919

Renoir lived for most of his life in Paris, until in 1902 he moved his base to the Riviera. After working in his youth as a porcelain painter, he met Monet, Sisley and Bazille in Gleyre's studio in 1862, and in the 1860s turned to modern-life figure scenes. They remained his principal theme until he turned to more timeless subjects of nudes and figures after a visit to Italy in 1881, when he was questioning the basic assumptions of Impressionism. He exhibited at the Salon occasionally in the 1860s, and again in 1878–83 and 1890, but otherwise showed at group exhibitions and with dealers.

ABBREVIATION
D – F. Daulte, *Auguste Renoir*, I, *Figures 1860–1890*, Lausanne, 1971

171 *Rocky Crags at L'Estaque* 1882

Rochers à L'Estaque
sdbl. Renoir 82 66 × 80.5 cm/26 × $31\frac{3}{4}$ ins
Lent by the Museum of Fine Arts, Boston,
Juliana Cheney Edwards Collection,
Bequest of Hannah Marcy Edwards in memory of her mother

Renoir painted *Rocky Crags at L'Estaque* while he was staying with Cézanne at L'Estaque, on the Mediterranean coast west of Marseille, early in 1882. He had just returned from a three-month stay in Italy, where he had studied the art of antiquity and the Renaissance in search of a firmer basis of drawing and composition for his own art. He wrote from L'Estaque to his patroness Madame Charpentier about what he had learned in Italy: '. . . Raphael, who did not work out of doors, had all the same studied sunlight – his frescoes are full of it. So, by studying outdoor effects, I have ended up by only seeing broad harmonies without preoccupying myself with the small details which extinguish sunlight instead of lighting it up' (M. Florisoone, in *L'Amour de l'art*, 1938, p. 36).

This change can be seen in the simple forms and lighting of his figure paintings such as the *Blonde Bather* (D387, 393), in contrast with the forms dissolved in the light of his figures of the mid-1870s, and in landscapes such as *Rocky Crags at L'Estaque*. Here Cézanne's presence, and the forms of the rocks themselves, may have helped Renoir to simplify his treatment of light. The touch is still soft and feathery in the foliage, but the rocks are worked over in small, chunkier strokes. Renoir did not at this point (unlike 1885, cf. no. 172) adopt Cézanne's system of parallel hatched brushwork (cf. no. 40), but the increasing tautness and order of his handling suggests Cézanne's influence, as does the consistent opposition between rocky highlights and blue shadows, to create luminosity. J.H.

EXHIBITION
?1883, Paris, Durand-Ruel, *Renoir* (58)

171

172 *La Roche-Guyon* c. 1885

[repr. in colour on p. 34]
sbl. Renoir 47 × 56 cm/18½ × 22 ins
Lent by Aberdeen Art Gallery

Renoir visited La Roche-Guyon, a village on the Seine downstream from Paris, between Mantes and Vernon, in the summers of 1885 and 1886. This canvas probably belongs to 1885, when Cézanne spent some weeks there with him, and it shows Cézanne's influence clearly. Virtually throughout the picture, Renoir has adopted Cézanne's system of sequences of parallel brushstrokes (cf. no. 40), which give the picture a tautly structured surface, but allow varied nuances of colour to be introduced into any area. This tautness was one of the means which Renoir explored during the 1880s of reintroducing into his art the structure which he felt had been lacking in his work of the 1870s. J.H.

REFERENCE
A. Callen, *Renoir*, 1978, pp. 94–5

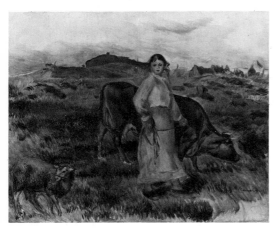

173

173 *The Return from the Fields* 1886

Le Retour des champs
sbr. Renoir 54 × 65 cm/21¼ × 25½ ins
Lent by the Fitzwilliam Museum, Cambridge

The subject derives from Renoir's stay at St Briac on the north coast of Brittany in summer 1886, with a clifftop and characteristic Breton cottages beyond the meadow. Renoir painted two versions of it, virtually identical in size. The present one is less highly finished than the other (D499), which was very probably executed in the studio, since all the compositional relationships are made more precise, and it is taken to a consistent high finish, with figures and animals crisply defined against the meticulously delineated grass. Parts of the present version show a similar interest in detail, characteristic of Renoir's work in the mid-1880s when he was trying to reintroduce drawing into his art. On some canvases he drew in small details in ink before starting to paint; in this one, rough pencil drawing can be seen through the thinner paint layers, and the opaque white ground, which Renoir probably added himself (cf. Callen 1978), shows through the translucent paint and gives the canvas its luminosity. J.H.

EXHIBITION
1892, Paris, Durand-Ruel, *Renoir* (57)
REFERENCES
D498
A. Callen, *Renoir*, 1978, pp. 19–20, 86–7

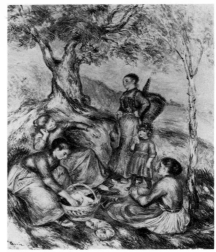

174

174 *Grape Pickers at Lunch* c. 1888

Le Repas des vendangeuses
sbl. Renoir 55.5 × 46.5 cm/22 × 18¼ ins
Lent by the Armand Hammer Collection

In his figure scenes of the later 1880s, Renoir moved away from scenes of modern urban life to more timeless themes – nudes, and also peasant subjects, which he painted on his visits to Essoyes, in the Aube region south-east of Paris, the home town of his future wife Aline Charigot, who bore his son Pierre in 1885. His Arcadian treatment of peasants at luncheon can be contrasted with Camille Pissarro's contemporary scenes (cf. no. 155), in which the theme of labour is more emphatic. In *Grape Pickers*, the local colours of grass and foliage are subordinated to the luminous oranges and blues which recur throughout the picture, often mixed with white, which gives the whole canvas a chalky tonality, reminiscent of the effects of fresco painting which Renoir was trying to emulate in some of his paintings in the 1880s. However the dense, quite oily paint layers mark a return to a more supple execution than he had used in some canvases of the mid-1880s, in which he had tried to reduce the oil in his paints to a minimum.

The dating of Renoir's paintings of the 1880s remains very problematic. The softer execution of *Grape Pickers* suggests a date later in the decade, and the picture is a virtual pair to *The Washerwomen* (D572, Baltimore Museum of Art), particularly if the child in both is Renoir's son Pierre. From letters *The Washerwomen* can be dated with some certainty to autumn 1888 (cf. Renoir's letter to Berthe Morisot, early December 1888, quoted D p. 53); another group of letters seems likely to belong to the same visit to Essoyes, in which Renoir mentions *The Washerwomen*, defining his new manner of painting, as 'very soft and coloured, but luminous', and in another letter, as 'a follow-up to the paintings of the 18th century', comparing it to Fragonard (letters to Durand-Ruel, nos 25 and 22, in L. Venturi, *Les Archives de l'Impressionnisme*, 1, pp. 131–4, dated there to 1885). J.H.

REFERENCES
D467 (as 1884)
Los Angeles, County Museum of Art, and London, Royal Academy of Arts, *The Armand Hammer Collection*, 1971–2 (22)

175 *Young Girl Bathing* 1892

Baigneuse
sdbl. Renoir 92 81.5 × 65 cm/32 × 25½ ins
Lent by the Metropolitan Museum of Art, New York, Robert Lehman Collection

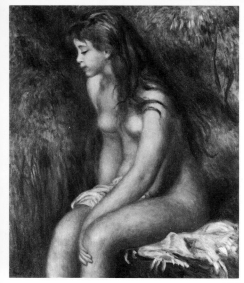

175

By the early 1890s, Renoir had given up the crisp drawing and densely worked paint surfaces to which, at different times in the 1880s, he had resorted in his search for tighter form and structure in his art (cf. nos 173 and 174). *Young Girl Bathing* is thinly painted, with the light-toned priming showing through the paint in many areas. The soft brushwork leaves the background largely undefined, and the colour, for Renoir, is unusually subdued, with only occasional blue nuances in the shadows.

The picture's soft tonality and touch are very reminiscent of Corot, and it was painted at the time of Renoir's greatest admiration for him. In later years he often praised Corot's procedure of executing his finished compositions in the studio – in the conditions in which the picture was going to be viewed – on the basis of studies made out of doors (cf. Vollard, *Renoir*, in *En écoutant Cézanne, Degas, Renoir*, 1938, p. 214). *Young Girl Bathing* must have been painted in this way, since the background gives no impression of a real landscape, and there is no trace of outdoor lighting on the figure, who was presumably posed in the studio. The first owner of the picture was Monet, who realized this discrepancy; showing the canvas, which hung over his bed, to a visitor *c.* 1920, he commented: 'Yes, the nude is beautiful, but look how conventional the landscape is – it looks like a photographer's décor' (Dauberville 1967).

In theme, the canvas is one of the sequence of timeless Bather paintings which Renoir painted continually after 1880. At the end of his life, he told his son that he regretted not having always painted the same subject: 'Maybe I have painted the same three or four pictures all my life! One thing is certain, since my trip to Italy I've been concentrating on the same problems' (J. Renoir, *Renoir My Father*, 1962, p. 345). J.H.

REFERENCES
J. Rewald, *The History of Impressionism*, 1973, p. 581, repr. in colour
H. Dauberville, *La Bataille de l'impressionnisme*, 1967, p. 202

176 *Woman with a Necklace* c. 1905

Femme au collier
sbl. Renoir 55 × 46 cm/21½ × 18 ins
Lent by a Private Collector

As he came to paint more in the south in the later 1890s, and particularly after he moved to the Riviera in 1902, Renoir's palette became warmer and richer; the dominant pinks and oranges of his

late work seem to have been a direct response to the light of the Mediterranean. *Woman with a Necklace* shows how, in these late paintings, he could give a figure modelling and colour at the same time, by allowing the brush to follow the contours of his subject 'in curves, as if he were following the curve of a young breast' (J. Renoir, *Renoir My Father*, 1962, p. 182). The lessons of French eighteenth-century painting, and particularly of Fragonard, remain clear in the free, painterly brushwork and in the mood of his late canvases. J.H.

REFERENCE
A. Vollard, *Tableaux, pastels et dessins de Pierre-Auguste Renoir*, I, 1918, p. 28, no. 111

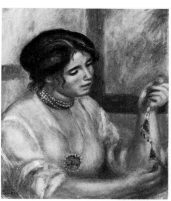

176

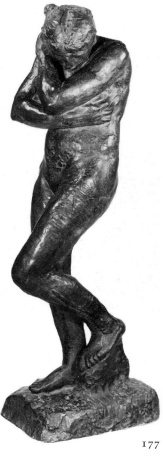

177

Rodin, Auguste 1840–1917

Born in Paris, Rodin studied under Lecoq de Boisbaudran, and learned sculpture from Carpeaux and Carrier-Belleuse. He caused a sensation in Paris with *The Prodigal Son* in 1877, and consolidated his reputation with major exhibitions in Paris in 1889 and 1900, and by showing his sculpture very widely all over Europe.

177 *Eve* 1881

s. on base Rodin bronze 173 cm/68 ins high
Lent by the National Museum of Wales, Cardiff

Histories of sculpture in the later nineteenth century have tended to over-emphasize Rodin at the expense of his contemporaries, and the presence of *Eve* as the sole sculpture in the Royal Academy's Post-Impressionism exhibition is not intended to perpetuate this mis-representation. *Eve* is included in the exhibition for three reasons:

first, as a physical focus for the central octagon of the Academy's galleries; second, because *Eve* was exhibited at Les XX in Brussels in 1887, and thus provides another facet of the internationalism which made this exhibiting society so important; and third, because the theme of *Eve*, of guilt and lost innocence, is a recurrent thread in the art of the late nineteenth century (cf. nos 74, 93, 266). J.H.

EXHIBITIONS
1888, Paris, Salon (2174)
1889, Paris, Exposition Universelle, French section (1219)
REFERENCES
A. Michel, in *Gazette des Beaux-Arts*, June 1888, pp. 443–4
H. Houssaye, *Le Salon de 1888*, p. 55
P. Mantz, in *Gazette des Beaux-Arts*, October 1889, pp. 366–7

Roll, Alfred Philippe 1846–1919

Roll was born and lived in Paris. A pupil of Gérôme, Bonnat and Harpignies, he first showed at the Salon in 1870, winning a 1st class medal in 1877; he showed with the Société Nationale from 1890. He painted portraits, scenes of modern life, idealist figure-subjects and landscape, all freely executed and based on deep study of nature.

178

178 *Manda Lamétrie, Farmer's Wife* 1887

Manda Lamétrie, fermière
sdbl. Roll 87 214 × 161 cm/84¼ × 63¼ ins
Lent by the Musée du Louvre, Paris

Roll's exhibits at the Salons in the 1880s were varied in theme – idyllic scenes as well as modern-life subjects – but all were based on direct observation. *Manda Lamétrie* belongs to a sequence of large canvases on which he worked sporadically between 1883 and 1894. He portrayed in them the archetypal characters of his age – a cement-maker, a landscapist, an architect, a wet-nurse and a pauper, as well as the farmer's wife. Each was a portrait of a named individual, not a study of a characteristic type like Raffaëlli's working-class subjects of the period (cf. no. 162).

Manda Lamétrie was hailed in the *Gazette des Beaux-Arts* as picture of the year at the 1888 Salon. It is typical of Roll's execution – broad in handling and revealing a debt to the painterly tradition championed by Manet, and luminous and blonde in tonality, but without intense colour. This light-toned palette (common in the Salon by the later 1880s) was a response to Impressionism, though atmosphere is conveyed by light-toned nuances rather than richer contrasts. In this painting, and in others of the sequence, there is a spatial ambiguity between figure and distance, a problem which Bastien-Lepage too had faced in painting figure-subjects set in their characteristic landscape (cf. no. 10). J.H.

Rousseau, Henri 1844–1910

Born at Laval in the Mayenne, Rousseau served in the army during 1863–8, apparently without leaving France. From 1871 to 1893 he held a low-ranking post in the *octroi* service, manning toll-gates on the edges of Paris, and began to paint, untaught, in his spare time, probably *c*. 1880. Rejected at the Salon in 1885, he exhibited from 1886 with the Indépendants, and through this gradually became well known in avant-garde circles, meeting Gauguin and Jarry in the 1890s, and Picasso and his associates in the last years of his life. Rousseau painted portraits and landscapes, ambitious figure scenes and jungle paintings.

179 *Waiting* *c*. 1886

Dans l'attente
sbl. H. Rousseau 70 × 60.5 cm/27½ × 23¾ ins
Lent by the Kunsthaus, Zürich

Henri Rousseau first exhibited in Paris in 1886, at the Indépendants. The present painting can very probably be identified as *Dans l'attente* from that show (cf. Alley 1978); it is similar stylistically to *Carnival Evening* (Philadelphia Museum of Art), which was definitely shown then. It is a composed scene (contrast no. 180); the trees and bushes create rich patterns which surround the figure and balance each other across the canvas.

In exhibition paintings such as this, Rousseau was seeking a precise, highly finished execution, in emulation of the Neo-Classical painters Gérôme and Clément, from whom he claimed to have received advice. The oddities of scale in the picture – between leaves and trees, and in the bushes – can be explained by Rousseau's normal method of working; he executed details of foliage from twigs and branches which he took back to his studio and copied there. He executed his jungle scenes in a similar way, from studies made in the Jardin des Plantes in Paris. In *Waiting*, the simplified silhouette of the figure may have been derived from a fashion plate – Rousseau regularly used visual sources, often from popular illustration, to supply him with the raw material for his figure arrangements.

Only with the formation of the jury-free Société des Indépendants did it become possible for an entirely untaught artist like Rousseau, with no contacts, to emerge on to the art scene with a genuinely

179

independent pictorial vision. In 1895 Rousseau explained his personal ideology in an autobiographical note written in the third person: 'As a characteristic sign, he has a bushy beard and has for a long time belonged to the Indépendants, believing that the initiator, whose thought is fed on the beautiful and the good, should be free to enjoy full liberty of production' (quoted Certigny, *La Vérité sur le Douanier Rousseau*, 1961, p. 157). This belief was shared by many of his fellow exhibitors at the Indépendants, as part of an Anarchist credo (cf. nos 117 and 214). The qualities of Rousseau's art won him the admiration of many fellow artists, who could appreciate the simplicity and directness of his means of depicting objects, and his unerring eye for the placement of forms across the picture surface. J.H.

EXHIBITIONS
? 1886, Paris, Indépendants (337)
1912, Paris, Bernheim Jeune
REFERENCES
D. Vallier, catalogue in *L'opera completa di Rousseau il Doganiere*, 1969, no. 23
R. Alley, *The Art of Henri Rousseau*, 1978, p. 12 and pl. 10

Roussel, Ker-Xavier 1867–1944

Meeting Lugné-Poë and Vuillard at the Lycée Condorcet, Roussel, followed by Vuillard, first attended the Ecole des Beaux-Arts, where he studied under Maillart and Robert-Fleury, and then the Académie Julian. Although a member of the Nabis by the summer of 1889, he only played a small part in such joint activities as group exhibitions and involvement with the applied arts. During the early 1890s his technique and intimist subject matter owed much to Vuillard, whose sister he married in 1893. However, an early interest in decorative panels (e.g. *The Seasons of Life*, c. 1892) set the pattern for his future involvement in large-scale decorative schemes. In later life he turned to classicizing subject matter and his name was sometimes linked with the Fauves.

181

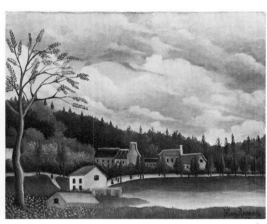

180

180 *The Bièvre at Gentilly* c. 1895

La Bièvre à Gentilly
sbr. H. Rousseau 38 × 46 cm/15 × 18 ins
Lent by a Private Collector

Throughout his career, alongside his major figure paintings and the jungle scenes of his later years, Rousseau executed small-scale landscapes, generally of scenes around the outskirts of Paris, half-country, half-town, and very often with factories – scenes very like those painted by many of the Neo-Impressionists in the 1880s (cf. nos 5 and 117). *The Bièvre at Gentilly*, painted perhaps c. 1895, shows a tributary of the Seine just outside the southern fortifications of Paris. Although probably painted after 1893, when Rousseau ceased work as a toll-gate official on the entrance gates to Paris, it shows an area close to the southern gates, which he would have got to know during the course of his work.

Even these small canvases were not painted out of doors, but were based on smaller rough sketches in which only the broad outlines of the scene were laid in. Back in the studio, Rousseau manipulated their forms and executed the finished landscapes at his leisure, giving each object across the scene an equal emphasis and clarity of definition, and often, as here, using one or more trees as a framing device and *repoussoir*. J.H.

REFERENCES
D. Vallier, catalogue in *L'opera completa di Rousseau il Doganiere*, 1969, no. 74
R. Alley, *The Art of Henri Rousseau*, 1978, pl. 26, repr. in colour

181 *Woman in a Blue Flecked Peignoir* c. 1891

Femme au peignoir bleu moucheté
ns. 35 × 27 cm/11¾ × 10½ ins
Lent by a Private Collector, Paris

Roussel's early work is stylistically and iconographically very varied and illustrates the range of pictorial expression found in the Nabi group. His mythological and religious subject matter (e.g. *The Virgin on a Path*, c. 1891, Private Collection), is closely related to Sérusier and Denis, but in this painting his handling and subject matter comes closer to that of Bonnard and Vuillard (cf. nos 28, 233). Despite the emphasis on the woman's gown, the figure and background merge into an overall design to create a decorative, rather than a naturalistic, account of an intimate scene. His interest in decoration as opposed to representation was taken further in his pair of decorative panels, *The Seasons of Life* (Private Collection, Paris), executed c. 1892 possibly for a town hall or other public building.

M.A.S.

REFERENCE
G. Mauner, *The Nabis*, 1978, pp. 263–4

182 *The Seamstresses' Workshop* c. 1894

L'Atelier de couture
[repr. in colour on p. 111]
sbr. K. X. Roussel 112 × 76.5 cm/44 × 20 ins
Lent by Arthur G. Altschul

The intimate subject matter, the subtly directional lighting and the quietly ambiguous organization of space relate this painting to works by Vuillard (e.g. *Women Sewing*, 1895, Museum of Fine Arts, Boston; *L'Atelier*, 1893, Smith College Museum of Art, Northampton, Mass.). However, unlike the *Women in a Blue Flecked Peignoir* (no. 181), the individual areas of colour are much more flatly handled, suggesting parallels with the painting of Félix Vallotton (cf. nos 273–4). Furthermore, the picture is on a larger scale than the majority of Vuillard's paintings at this time, prefiguring the more monumental scale on which Roussel was later to work (cf. no. 182). MA.S.

REFERENCE
G. Mauner, *The Nabis*, 1978, pp. 261–2

183 *Two Nude Women Seated Near the Seashore* 1903

Deux femmes nues, assises dans un paysage marin
sbr. K. X. Roussel 85 × 140 cm/33½ × 55 ins
Lent by a Private Collector

In 1895 Roussel had been impressed by the Galerie Vollard exhibition of 150 paintings by Cézanne, and thereafter became increasingly attracted to classical mythological subjects for his paintings. His rejection of non-naturalism and his return to the Classical Ideal *c.* 1900 were presaged by such Symbolist writers as Jean Moréas and Téodor de Wyzéwa, but were also accompanied by a similar move on the part of Maurice Denis (cf. no. 71).

Writing in 1920 (*L'Amour de l'art*, December 1920, p. 281), Denis declared that 'Ker-Xavier Roussel, of all painters, is the only one who has continued the tradition of Cézanne . . . the splendour of his mythological paintings relates them through Cézanne to the decorative schemes of the palaces of Rome which he has never seen; he creates Poussin in front of nature; and naturally he also possesses the grace of Guido Reni and the nobility of Annibale Carracci.' This emphasis upon Cézanne and the classical tradition of Poussin as well as the stress on representing external nature are in direct opposition to Roussel's Nabi work of the 1890s. In *Two Nude Women*, therefore, Roussel resolves the basic dilemma of the Nabis' programme, the impossibility of defining the Idea, by returning to the traditional Ideals as described by Denis.

In contrast to the synthetic technique of *The Seamstresses* (no. 182), Roussel probably made studies of the landscape in front of the motif. Likewise, he has replaced the large areas of muted colour with a modified form of the blocky, highly-coloured pointillist technique developed by Signac and Cross in the 1890s (cf. nos 56, 215). Indeed it has been suggested that two landscapes by Cross (*The Beach at Saint-Clair*, Compin 96, and *The Sheltered Beach*, Compin 97), both of which were exhibited at the Indépendants of 1903, could have provided the model for the technique displayed in Roussel's painting. MA.S.

REFERENCE
Paris, Orangerie, *Edouard Vuillard, K.-X. Roussel*, 1968 (231)

183

Schuffenecker, Emile 1851–1934

A colleague of Gauguin's at the stockbroking firm of Bertin and a close friend of Emile Bernard, Schuffenecker had an amateur's enthusiasm for painting and not only encouraged Gauguin to take it up but also engineered Gauguin's introduction to Pissarro. The formative years of Schuffenecker's life as an artist were dominated by Gauguin, whose close friendship with him meant that, despite the impossibility of spending more than short vacations in Brittany, Schuffenecker was regarded as a member of the Pont-Aven group. It also led to his playing a central role in the Café Volpini exhibition in 1889. Generous by nature, Schuffenecker made his home the centre for the Pont-Aven group in Paris, and gave financial support to Gauguin until his departure for Tahiti in 1891.

184

184 *Landscape – Two Cows in a Meadow* 1886

Deux vaches dans un pré
sdbl. Schuffenecker 1886 49 × 65 cm/19¼ × 25½ ins
Lent by Mr and Mrs R. Fitzmaurice

This painting dates from Schuffenecker's first visit to Brittany in summer 1886. Little is known of his artistic output during this visit, except that he was based at Concarneau and maintained close contact with Gauguin who was staying nearby at Pont-Aven.

Schuffenecker's early paintings (e.g. *Study of a Nude, Back View*, Palais de Tokyo, Paris) were executed in a style indebted to the Impressionists, notably Pissarro and Degas. However, the dominance of the pairing of red and green, together with the broken brushwork of this painting, indicate that Schuffenecker must have studied the Neo-Impressionist works on view in 1886 at the 8th Impressionist exhibition (cf. no. 206).

Although short-lived, Schuffenecker's Neo-Impressionist phase provided a crucial link in the evolution of Pictorial Symbolism during the two years following the execution of *Landscape – Two Cows in a Meadow*. During his walking tour of Normandy and Brittany in 1886, Emile Bernard came upon Schuffenecker working 'amongst the rocks [near Concarneau]. He was executing studies in an impressionist technique' (*Aventure de ma vie*, Ms. p. 59). The two artists became friends, and Schuffenecker encouraged Bernard to visit Gauguin at Pont-Aven. More importantly at this point, he seems to have been responsible for initiating Bernard into the Neo-Impressionist style, which ultimately led Bernard to visit Signac's studio in autumn 1886 and consequently to dismiss all forms of naturalistic art in favour of painting in which 'Ideas dominate the technique' (cf. nos 12, 7).

The friendship between Schuffenecker and Bernard lasted until Schuffenecker's death in 1934. Apart from his collaboration in the Café Volpini exhibition of 1889, Schuffenecker encouraged Bernard's scheme to establish a non-commercial exhibiting society in 1891 (Bibliothèque Nationale, Paris, Mss. n.a.fr. 14722. ff. 4–6). He also undertook to write a notice on Bernard for *Les Hommes d'aujourd'hui* (never published; Mss. ibid, ff. 21–6) and he frequently provided him with financial and psychological support.

In line with similar developments in Bernard's career, Schuffenecker moved away from Impressionism, and by 1890 he was executing 'mystical' landscapes, mainly in pastel. M.A.S.

Séguin, Armand ?1869–1903

Séguin was of Breton origin, but his date of birth is uncertain. He attended the Académie Julian but does not appear to have met the Nabis there. After a putative phase of pointillist work he was converted to the synthetic style of Gauguin after visiting the Café Volpini exhibition in 1889, and remained a devoted follower of Gauguin throughout his life. His first painting trip to Brittany took place in 1890, 1891 or 1894 and he had close contact with Gauguin on the latter's return to Brittany from Tahiti in 1894. Gauguin's influence brought about Séguin's first one-man show in 1895 at Le Barc de Boutteville. Séguin worked for the rest of his short life primarily in Brittany, where he continued his friendships with both English artists, such as Forbes-Robertson and O'Conor, and French members of the Pont-Aven School. He was supported financially by Chamaillard and by Sérusier, in whose house he died of tuberculosis.

185

185 *Breton Peasants at Mass* c. 1894

> *Paysannes bretonnes à la messe*
> ns. 54.5 × 38 cm/21½ × 16 ins
> Lent by the National Museum of Wales, Cardiff

The graphic outline, flat colour and subject matter of this painting place it firmly within the orbit of Gauguin and his followers at Pont-Aven, and Séguin has very plausibly been suggested as its artist. The date of Séguin's first meeting with Gauguin is uncertain. Both 1891 (Quimper, Rennes, Nantes, *L'Ecole de Pont-Aven*, 1978–9, n.p.) and 1894 (*Gauguin and the Pont-Aven Group*, 1966 [163]; Ingamells 1967,

p. 93) have been suggested. Contemporary evidence, however, seems to suggest that he was part of the Gauguin circle by summer 1890 (A. Séguin, 'Paul Gauguin', *L'Occident*, March, April, May, 1903; anon. letter, signed and dated 'Un de ses admirateurs et de l'Ecole de Pont-Aven, 30 October 1893', in 'Gauguin et l'Ecole de Pont-Aven', *Les Essais d'art libre*, November 1893, p. 165). Gauguin's acceptance of Séguin's position as one of his 'pupils' is suggested by the older artist's desire to organize, through the intervention of the art critic Arsène Alexandre, Séguin's Le Barc de Boutteville exhibition of spring 1895. Gauguin wrote the preface to the catalogue, in which he recognized the affinity between Séguin's work and his own: 'Séguin, above all else, is a thinker; – by this I certainly do not mean that he is a literary artist; – he does not paint just what he sees, but what comes from his thoughts, and this he does through an innovative harmony of lines....' The synthetic quality of his work was also cited by Denis, in his review of the exhibition, when he used Séguin's work to demonstrate to hostile critics the true essence of Symbolist art ('Armand Séguin', *La Plume*, March 1895).

The mention of Séguin's distinctive line by Gauguin emphasizes the close relationship between Séguin's paintings and his work as a graphic artist. Apart from providing prints to newspapers such as *Le Rire* and *Le Chut* during the 1890s, he also taught both Amiet (cf. no. 240) and O'Conor (cf. no. 324) lithography, and in 1900 accepted commissions from Vollard for illustrations to Aloysius Bertrand's *Gaspard de la nuit*.

The subject matter is typical of Brittany (cf. nos 58, 112). Ingamells (1967, pp. 93–4) suggests that a passage in Verkade's autobiography, *Le Tourment de Dieu. Etapes d'un moine peintre* (1923), describing the religions processions that took place at Pont-Aven throughout May in honour of the Virgin Mary, could have provided the source for Séguin's painting. Séguin fully understood the deep, superstitious piety of Brittany, seeing it absorbed into the colour symbolism of the painters of the School of Pont-Aven: 'Red seemed to them to be a vertical colour: it was the blood which poured from the wound, the generosity and fervour and also the audacity and love; blue when placed horizontally expressed calm, sweetness, the dream, the heavenly peace in which we believed, the perfect bliss...' ('Paul Gauguin', *L'Occident*, April 1903, p. 236). M.A.S.

REFERENCES
London, Tate Gallery, *Gauguin and the Pont-Aven Group*, 1966 (163)
J. Ingamells, *The Davies Collection of French Art*, 1967, pp. 93–4

Sérusier, Paul 1864–1927

Born in Paris, Sérusier entered the Académie Julian and in 1888 exhibited for the first time in the Salon. However, he met Gauguin at Pont-Aven later that year, an encounter which was to result in *The Talisman*. This revolutionary landscape became the pictorial manifesto for a group of Sérusier's fellow students who christened themselves the Nabis. His age, intelligence and friendship with Gauguin established Sérusier as one of the leaders of this group. During the 1890s he visited Brittany regularly. He was involved in typical Nabi activities in the applied arts. In 1895 he travelled to Tuscany and Lombardy with Maurice Denis. Later in his career he taught at the Académie Ranson and became increasingly involved in the sacred systems of proportion and colour relationships elaborated by the School of Beuron, and explained his theories in *ABC de la peinture* (1921).

ABBREVIATION
Guicheteau 1976 – M. Guicheteau (in collaboration with Paule Henriette Boutaric),
 Paul Sérusier, 1976

186 187

186 *The Breton Weaver* 1888

Le Tisserand breton
sdbl. Sérusier 1888 72 × 59 cm/28¼ × 23¼ ins
Lent by the Musée du Haubergier, Senlis

This painting was Sérusier's first Salon exhibit and it gained him an
honourable mention. Sérusier's painting conforms to two of the
dominant themes of that year's Salon: a concern to capture the
effects of light, especially in interiors, and the depiction of humble
subject matter. Equally importantly, this painting was one of some
45 entries to that Salon which made use of Breton material. The
painting records the beginning of Sérusier's lifelong association with
Brittany, which he had visited for the first time the previous
summer, but it predates the historic lesson from Gauguin which
produced *The Talisman* (no. 187). The style, therefore, reveals
evidence of his training at the Académie Julian and his recorded
admiration for such 'academic' painters of Breton scenes as Dagnan-
Bouveret (cf. no. 58), Alexander Harrison (cf. no. 305) and Guillou
(cf. no. 108) (Guicheteau 1976, p. 14 n. 7). In keeping with these
artists, Sérusier concentrates upon the unchanging, traditional
activities of the Breton peasants, defined as 'picturesque' by writers
such as Henry Blackburn (*Breton Folk – An Artistic Tour in Brittany*,
1880), and depicted by Guillou (cf. no. 108) and Vernier (cf. no. 227)
rather than on representing the poverty-stricken, downtrodden,
pious peasantry which he, Gauguin and Bernard were later to
paint. M.A.S.

EXHIBITION
1888, Paris, Salon (2284)
REFERENCE
Guicheteau 1976, no. 1

187 *The Talisman* 1888

Le Talisman
insc on rev. Fait en Octobre 1888 sous la Direction de Paul
Gauguin par P. Sérusier Pont-Aven [Executed in October 1888 under
the guidance of Paul Gauguin by P. Sérusier Pont-Aven]
oil on panel 27 × 22 cm/10¾ × 8¾ ins
Lent by J. Fr. Denis, France

This panel was executed early in October 1888 during the lesson
given to Sérusier by Gauguin in the Bois d'Amour outside Pont-
Aven. Sérusier had spent the first part of the summer of 1888 in
Concarneau. He then moved to Pont-Aven, where Bernard and
Gauguin had been working together since mid-August and
producing such radical pictorial statements as *Vision After the
Sermon* (fig. 8) and *Breton Women at a Pardon* (no. 15). Through
his friendship with Bernard, Sérusier was introduced to Gauguin

just before his return to Paris. Maurice Denis records how Gauguin
seated Sérusier in front of the landscape and demanded, 'How do
you see that tree? 'It's green? then choose the most beautiful green
on your palette. – And this shadow? it's more like blue? Do not be
afraid to paint it with the purest blue possible' ('L'Influence de Paul
Gauguin', *L'Occident*, 1903, in *Théories*, 1964 edn, p. 162). Back in
Paris the picture was greeted with great excitement by Sérusier's
fellow pupils at the Académie Julian – Denis, Bonnard, Ibels and
Ranson.

Denis claimed that *The Talisman* was a decisive image for the
evolution of the second generation of Symbolist artists, since, rather
than concerning itself with a photographic representation of the
external world, it demonstrated that 'all works of art are a trans-
position, a caricature, the passionate equivalent of an experienced
sensation' (*Théories*, p. 162). Although Denis described the painting
in terms used by Gauguin to define Pictorial Symbolism, two
features differentiate it from the older artist's work: it does not have
the blue bounding lines common in Gauguin's work and used later
by the Nabis; and, although concerned to distort the external world
and perhaps to suggest that the reflection in the water is more 'real'
than the landscape itself, the painting was still executed from life,
rather than from memory. This latter feature compounded the
problem of the relationship between nature and memory, with
which Sérusier was wrestling in 1889 (*ABC de la peinture*, 1950 edn,
p. 39), and which led Denis to stop short of advocating complete
abstraction in painting in his manifesto of Nabi art ('Définition du
néo-traditionnisme', in *Théories*, 1964 edn). M.A.S.

REFERENCES
Paris, Grand Palais, *Le Symbolisme en Europe*, 1975–6 (219, with full bibliography)
Guicheteau 1976, no. 2
G. Mauner, *Les Nabis*, 1978, pp. 16, 19, 20, 25–6, 207, 209, 219

188 *Portrait of Paul Ranson in Nabi Costume* 1890

Portrait de Paul Ranson en tenue Nabique
sdbr. P. Sérusier 90 61 × 46 cm/24 × 18 ins
Lent by a Private Collector

Although Maurice Denis suggests (*Paul Sérusier, sa vie, son oeuvre*,
1942, p. 46) that the wearing of Nabi costume decorated with
theosophical emblems was not normal practice among the Nabis,
this portrait of Ranson in such a garment summarizes several
aspects of the group. Based upon friendships established at school
and at the Académie Julian, and fired by a desire to reform painting
according to the principles illustrated in *The Talisman*, the Nabis
came together as a group in 1889. They were primarily artists –
Ranson, Sérusier, Denis, Bonnard, Vuillard, Roussel and Ibels –
although writers, musicians and actors could acquire associate

membership. The name was derived from the Hebrew *Nebiim*, meaning 'prophets', and had been suggested to them by a friend and Hebrew scholar, Auguste Cazalis.

Ranson and Sérusier held central positions within the Nabis. It was in Ranson's atelier at 25 boulevard de Montparnasse that the regular meetings of the group took place. Here discussions on philosophy, art, religion and theosophy were interspersed, after 1894, with the lighter relief of a marionette theatre (cf. no. 192). Ranson and Sérusier drew upon Ranson's extensive library of theosophical and cabbalistic texts for the theosophical theories to justify the group's innovatory art (cf. no. 163). M A . S .

REFERENCES
Guicheteau 1976, no. 40
G. Mauner, *The Nabis*, 1978, p. 219

188

189

189 *Melancholia* or *Breton Eve* c. 1890

Mélancolie or *Eve bretonne*
ns. 71 × 57 cm/28 × 22½ ins
Lent by Mlle Henriette Boutaric

This painting clearly reveals Sérusier's stylistic debts to Puvis de Chavannes and Gauguin. The composition owes much to Puvis' *Prodigal Son* (1879, Bührle Foundation, Zürich), which was exhibited at his Durand-Ruel exhibition of 1887. The pose of Eve, while being in part taken from Puvis' picture, also suggests references to Gauguin's *Eve* (Wildenstein 333), which Sérusier could have seen at the Café Volpini exhibition.

As in *The Talisman* (no. 187), but unlike Puvis and Gauguin, Sérusier has avoided the use of a firm bounding outline, which contributes to the decorative aspect of the painting. Yet Sérusier does not allow this emphasis upon decoration to obliterate the subject matter, and the depiction of Eve after the Fall expresses the melancholy atmosphere of Brittany felt by many visitors at that time, e.g. Redon, in *A Soi-même*, 1961, p. 49. Sérusier discussed the importance of retaining subject matter in a letter to Denis from Le Pouldu in 1889. He asserted that, although subject matter should be secondary to the expression of the artist's personality, it should never be totally eliminated since his choice of subject was an integral and significant aspect of his artistic personality (P. Sérusier, *ABC de la peinture*, 1950 edn, p. 44). M A . S .

REFERENCES
London, Hayward Gallery, *French Symbolist Painters*, 1972 (30)
Guicheteau 1976, no. 12

190 *Still Life by the Window* 1891

Nature morte à la fénêtre
sdbr. P. Sérusier 91 61 × 73 cm/24 × 28¾ ins
Lent by Mlle Henriette Boutaric

190

The interplay between the solid forms of the apples and vase and the decorative handling of colour and space in this painting reflect Sérusier's debt to Cézanne. The Nabis, especially Roussel (cf. no. 183), Denis (cf. no. 71), and Sérusier were attracted to the non-literary elements in Cézanne's art, in particular to the way he used objects in his paintings to express the purely painterly concepts of colour and form (M. Denis, 'Paul Cézanne', *L'Occident*, 1907, in *Théories*, 1964 edn, p. 164). Cézanne's importance in the development of Nabi art during the 1890s was noted by the contemporary critics Fénéon ('Paul Gauguin', *Le Chat noir*, 23 May 1891, in *Oeuvres plus que complètes*, I, p. 192) and André Mellerio (*Le Mouvement idéaliste en peinture*, 1896, p. 26), and exemplified by Denis' *Homage to Cézanne* (1900, Palais de Tokyo, Paris), a group-portrait of the Nabis standing before a still-life by Cézanne, once owned by Gauguin (Venturi 341). M A . S .

REFERENCES
Guicheteau 1976, no. 44
London, Tate Gallery, *Gauguin and the Pont-Aven Group*, 1966 (198)

191 *Pont-Aven Triptych* 1892/3

Triptych Pont-Aven
ns. 73 × 33 cm/28¾ × 52¼ ins overall
Lent by Jean Claude Bellier

Abandoning the more 'picturesque' treatment of Breton subject matter found in *The Breton Weaver* (no. 186), Sérusier here uses technique and subject to present an image of the symbiotic relation-ship between peasant and land, generally identified by writers and artists alike as one of the dominant characteristics of Brittany.

Sérusier's understanding of Brittany was remarked upon several times during the period in which this picture was painted. Auguste Barrau, in his book about Brittany (*En Bretagne*, 1893), devoted a whole chapter to 'that worthy painter [Sérusier]' and Maurice Cremnitz ('Les Beaux-Arts', *Les Essais d'art libre*, December 1893) declared that, from the evidence of the paintings exhibited at Le Barc

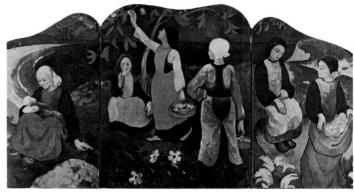

191

de Boutteville, Sérusier captured the qualities peculiar to Breton life more perfectly than Gauguin, Bernard, Séguin or Filiger.

The shape of the painting is curious. On the one hand its reference to a medieval, three-panel altarpiece might suggest that Sérusier intended the spectator to relate the picture to the intense piety for which the Breton peasants were famed (cf. no. 15). Alternatively, its screen-like format may refer to Sérusier's view that all painting was decoration. A short notice in the *Mercure de France* in June 1892 stated that 'Paul Sézusier [sic] has abandoned the "picture" for "decoration"', and in January 1893 he embarked upon the first series of murals as a result of a commission given to him by his fellow Nabi, Lacombe (cf. no. 111), to decorate Lacombe's studio at Versailles (now destroyed). M A.S.

REFERENCES
W. Jaworska, *Gauguin et l'ecole de Pont-Aven*, 1971, repr. in colour pp. 134–5
Guicheteau 1976, no. 52

192 *Tobias and the Angel* c. 1894

Tobie et l'ange
sbr. P. Sérusier 112 × 69 cm/44 × 27¼ ins
Lent by James Kirkman, Esq., London

This picture is based on the Book of Tobit in the Apocrypha, but Sérusier has modified the traditional iconography of the subject as seen in paintings by two artists whom he greatly admired, Botticelli and Filippo Lippi. The wooden poses of the figures and the schematic background also reflect Sérusier's interest in puppets. The search for non-naturalism at the end of the 1880s was not confined to literature and the visual arts. It was also expressed in the theatre, where the desire to reject naturalism brought with it an interest in circuses (cf. fig. 1), mime, pierrot-plays and marionettes. On 28 May 1888, Signoret founded the Petit Théâtre des Marionnettes, which was hailed as an expression of Symbolism through its concern to express the *irréalité évidente* (A. Remacle, *Mercure de France*, April 1892). The plays which Signoret produced using puppets concentrated upon mystical themes and were read by such young actors as Lugné-Poë, the future founder of the Symbolist Théâtre de l'Oeuvre (cf. no. 234); Maillol was among those who designed backdrops for Signoret.

Sérusier was closely involved in the puppet theatres established by the Nabis, first at the home of a friend, Coulon, in 1892, then in Ranson's atelier in 1894 and again in the apartment of Bonnard's brother-in-law in 1896. More specifically, friendship with Lugné-Poë, the adoption of Maillol as a Nabi after 1892 (cf. no. 123), and the fact that the two plays written by Maurice Buchor (Signoret's successor as director of the Petit Théâtre des Marionnettes), *Tobie* (1889) and *Mystères d'Eleusis* (1894), correspond to the titles of two of Sérusier's paintings, also suggest that he was concerned with the Petit Théâtre, which lay at the centre of Symbolist drama theory c. 1890. M A.S.

REFERENCES
London, Hayward Gallery, *French Symbolist Painters*, 1972 (332)
Guicheteau 1976, no. 136

193 *The Downpour* c. 1895

L'Averse
ns. 73 × 60 cm/28¾ × 23½ ins
Lent by Mlle Henriette Boutaric

Despite its Breton subject, the extreme flatness of the colour surfaces and the exaggeration of outline make this one of Sérusier's most overtly Japanese paintings. Like his fellow Nabis, Sérusier had visited

192 193

the 1890 Ecole des Beaux-Arts exhibition of Japanese art, and the integration of this source into his work was recognized by Charles Saunier in December 1892 ('Les Peintres symbolistes', *Revue indépendante*). However, unlike the more pragmatic Nabis, especially Bonnard (cf. no. 28), Sérusier also brought Japanese art into his aesthetic theories. In a letter addressed to Maurice Denis, (in P. Sérusier, *ABC de la peinture*, 1950 edn, pp. 42–5), he suggested that the achievement of harmony between line and colour in Japanese art guaranteed the preservation of Absolute Beauty despite the vagaries of stylistic change. M A.S.

REFERENCE
Guicheteau 1976, no. 84

Seurat, Georges 1859–91

Son of a property owner, Seurat studied under a pupil of Ingres at the Ecole des Beaux-Arts (1877–9). He lived all his life in Paris, where he treated modern urban and suburban subjects, in drawings and small studies before 1884, and thereafter in a sequence of major canvases. His travels were confined to summer visits to the coast to paint landscapes, and a trip to Brussels for the exhibition of Les XX in 1887. Seurat probably knew the work of the Impressionists from 1879, and evolved his pointillist technique in 1885–6 after meeting Paul Signac. He exhibited regularly with the Indépendants in Paris, and from 1887 with Les XX in Brussels.

ABBREVIATIONS
DR – H. Dorra and J. Rewald, *Seurat, l'oeuvre peint, biographie et catalogue raisonné*, Paris, 1959
deH – C. M. de Hauke, *Seurat et son oeuvre*, Paris, 1961
Guggenheim 1968 – New York, Guggenheim Museum, *Neo-Impressionism*, catalogue by R. L. Herbert, 1968
Artemis 1978 – London, Artemis, David Carritt Ltd, *Seurat, Paintings and Drawings*, catalogue by J. Richardson, 1978

194

194 *Sunset* 1881

Coucher de soleil
stamped br. Seurat oil on panel
15.5 × 25 cm/6 × 9½ ins
Lent by the City of Bristol Museum and Art Gallery

This panel is among the earliest surviving oils by Seurat; it was probably painted near Barbizon in the forest of Fontainebleau in 1881. Similar contre-jour sunset effects had been favourite motifs of Daubigny and Théodore Rousseau, and Seurat's handling here, and his use of strong contrasts between dark and light tones, also show his allegiance to the oil-sketches of the Barbizon School landscapists. Soft nuances of orange and blue in the field echo the colours of the sky, but there is no clear sign of the influence of Impressionist painting. The field is largely painted with earth colours, which Seurat progressively abandoned in 1882–4, as he developed his ideas on 'optical painting' (cf. nos 195–8). J.H.

REFERENCES
DR18
deH8
W. I. Homer, 'Seurat's Formative Period', *Connoisseur*, August 1958, pp. 58, 61

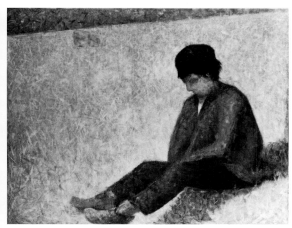

195

195 *Boy Seated on the Grass* c. 1883

Garçon assis dans l'herbe
ns. 63 × 79.5 cm/25 × 31¼ ins
Lent by the Glasgow Art Gallery and Museum

This was Seurat's largest oil painting to date, probably painted in 1883 when he was executing the studies for *Une Baignade, Asnières* (cf. no. 197). Its figure, like those in the *Baignade*, is seated and immobile, against a simple grass background. Seurat variegated the grass with criss-crossing brushwork across a smoother initial layer, in contrast with the more blended texture of the figure. The grass is basically painted in green – light and yellowish in the sunlight, darker in the shadows – and Seurat introduces, in the lit parts, yellows and oranges (to express the sunlight), and soft blues towards the top (perhaps suggesting the atmosphere, or the reflected blue sky), while, in the shadows, we find fuller blues and soft mauves (to contrast with the direct sunlight), and some oranges (suggesting reflections from the sun). This colour has obvious parallels with Impressionism, in treating light and shade by juxtaposed touches of varied hue, but it also reflects the more theoretical discussions of the separate ingredients present in outdoor colour in Ogden Rood's *Modern Chromatics*, which Seurat read soon after its publication in France in 1881.

In theme and handling, too, *Boy Seated on the Grass* has been compared with Impressionism, and particularly with Pissarro's recent paintings of peasants in landscape, treated with a close-knit and homogeneous brushstroke technique (cf. no. 152). However, unlike Pissarro's figures, Seurat's is not integrated into its surroundings, nor do his criss-crossing brushstrokes suggest the textures of foliage as Pissarro's do. In spatial treatment and in brushwork the painting owes more to Bastien-Lepage, who, in paintings like *Poor Fauvette* (no. 10), was presenting peasant figures pushed close up to the picture surface, in the tradition of Millet, and was expressing grass and weeds by distinct, graphic brushstrokes. However, Seurat replaced Bastien's pathos by complete impassiveness, and the tonal contrasts of his grass by a network of colour. For a different synthesis between Bastien and Impressionism at this date, compare Angrand's *In the Garden* (no. 4). J.H.

EXHIBITION
1900, Paris, Revue blanche, *Seurat* (3)
REFERENCES
DR 30
deH15
A. Z. Rudenstine, *The Guggenheim Museum Collection*, II, New York, 1976, pp. 644–6
J. Russell, *Seurat*, 1965, pp. 74–5, 112–13

196 *Forest of Barbizon* c. 1883

Forêt de Barbizon
stamped br. Seurat
oil on panel 16 × 25 cm/6¼ × 9½ ins
Lent by Mr and Mrs Alexander Lewyt

Executed on a panel of orange-coloured wood, which is seen in many parts of the picture, this little study shows Seurat introducing a range of atmospheric colour, with rich blues in the shadows contrasting with yellows and pinks in the sunlight. This colour can be related to Impressionism, and to the ideas on outdoor colour in Ogden Rood's *Modern Chromatics*, (cf. no. 195). The brushwork too, in soft dabs of paint running in various directions, has affinities with Impressionism, but the stark vertical of the tree reveals Seurat's interest in a type of pictorial order alien to Impressionist landscape. J.H.

EXHIBITION
1908–9, Paris, Bernheim Jeune, *Seurat* (16)
REFERENCES
DR66
deH24

196

197 *Horses in the River* 1883

Chevaux dans le fleuve
ns. oil on panel 16 × 25 cm/6¼ × 9½ ins
Lent by a Private Collector,
on loan to the National Gallery, London

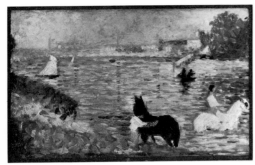

197

Seurat made a large number of studies for his first monumental canvas, *Une Baignade, Asnières*, which was refused at the 1884 Salon and first exhibited at the Salon des Indépendants in May 1884 (fig. 4). These studies take two forms – small oil-sketches on panel, like the present one, of the riverbanks at Asnières variously peopled, and conté crayon drawings in which Seurat worked out the poses of the figures in more detail. *Horses in the River* is one of a small group of these sketches into which Seurat introduced horses – an idea which he discarded in the final picture.

Seurat's methods in working up the composition of the *Baignade* bear the stamp of his academic training. The quick oil-sketches like *Horses in the River* play the role of the *esquisse*, as notations of possible compositional formats and colour relationships, while the black-and-white drawings, studies of separate elements for the final picture, are *études* in the traditional sense. In the oil-sketches, however, Seurat reveals another inspiration, which presumably led to the picture's rejection at the 1884 Salon – the influence of Impressionism, seen in the luminous atmospheric colour and bold brushwork of the final painting. This relationship is even closer in the oil-sketches which, in their free and varied handling, are the closest of all Seurat's works to the spontaneity of Impressionist landscape of the 1870s.

Une Baignade, Asnières and its studies are set against the backdrop of the factories of Asnières, which are juxtaposed with the working men who people the final picture's foreground. Only Guillaumin of the Impressionists had regularly treated industrial scenes in the 1870s, but by the early 1880s a number of painters had begun to explore them, such as Raffaëlli, and Paul Signac (whom Seurat met only after the *Baignade* was exhibited), and they were not unknown in the Salon. Such milieux were also common in Naturalist literature, pioneered by the novels of the Goncourt brothers in the 1860s – the Goncourts, Aman-Jean remembered, were like gods to Seurat in these years (G. Coquiot, *Seurat*, 1924, p. 29). Seurat's theme, of working-class recreation, was also a concern of political radicals at the time, but his treatment of it carries no overt social comment, though he doubtless intended to point the contrast between the relaxed poses of the working people in the *Baignade* and the stilted, hieratic shapes of the fashionable figures in his next major painting, set on the Ile de la Grande Jatte, the island seen on the far right of the *Baignade* and its studies. J.H.

EXHIBITION
1900, Paris, Revue blanche, *Seurat* (6)
REFERENCES
DR88
deH86
B. Nicolson, in *Burlington Magazine*, November 1941, p. 140
Artemis 1978 (15)
D. Cooper, *Une Baignade à Asnières*, 1946, p. 13
D. Cooper, *The Courtauld Collection*, 1954, p. 113, no. 60
J. Russell, *Seurat*, 1965, pp. 115–29
Guggenheim 1968 (71, and cf. 72)

198 *Couple Walking* 1884/5

Couple se promenant
ns. 81 × 65 cm/32 × 25½ ins
Lent by a Private Collector

For *A Sunday Afternoon on the Ile de la Grande Jatte* (fig. 5), his second major figure painting, Seurat made small sketches and separate drawings of figures as he had for *Une Baignade, Asnières* (cf. no. 197); however, he also painted three larger studies in oil, in which he brought together colour and form, presumably shortly before embarking on the final canvas. *Couple Walking*, originally owned by Maximilien Luce, is one of these – painted in broad strokes, economically applied and carefully arranged, in contrast to the more spontaneous small oil-sketches. It is also one of the first paintings in which Seurat wholly abandoned earth colours in favour of relationships of clear, often bright colours.

Traces of squaring up show beneath the paint in *Couple Walking*, which show that it was meant as a detailed compositional study, although Seurat made some changes to the forms in the final painting of the *Grande Jatte*. The brushwork, ordered in direction and regular in size, shows how Seurat was tautening his execution, using a network of criss-crossing textures and colours to unify the surface – a unity increased by the white priming of the canvas, which is seen between the paint strokes in all parts of the picture. The *Grande Jatte* itself was originally completed in spring 1885 with brushwork of a similar type, but after his spell on the coast at Grandcamp in summer 1885 Seurat worked over the whole painting again, in small 'points' of paint which give it a far more systematized surface than *Couple Walking*.

The purer colour which Seurat adopted late in 1884 was perhaps the result of his meeting with Signac, who was later to claim that he himself (inspired by the Impressionists' example) had led Seurat to abandon earth colours (*D'Eugène Delacroix au néo-impressionnisme*, 1964 edn, pp. 97–100). However, in paintings like *Couple Walking*, Seurat treated his colour more freely than Signac had up to that time. The local colours of each area are modified by the lighting, with yellows in the sunlit grass and some blues in the shadows (cf. no. 195); however the blue, red and pink colouring of the main figures is less logical – it is used primarily to set them apart from the other elements in the scene. In the final version of the *Grande Jatte* their colour is far more explicable from a naturalistic point of view.

The stilted forms, seen in strict profile, in *Couple Walking* and the *Grande Jatte* are very different from the more rounded figures in the

198

Baignade – a contrast which Seurat must have intended to highlight the different social rituals which he was portraying: the relaxed workers and the self-conscious promenaders. Contemporary fashion plates and caricatures may have suggested some of his forms, but Seurat used these stimuli to help him in his aim in the *Grande Jatte*, which was, he told Gustave Kahn, to make the moderns file past, in procession, like the figures on the Pan-Athenaic Frieze of Phidias (*Revue indépendante*, January 1888, p. 142). Seurat's next major painting, *Les Poseuses* (cf. fig. 6), shows that the stiff forms in the *Grande Jatte* and *Couple Walking* are not simply the result of a stylistic development away from the naturalism of the *Baignade*; the nude models in *Les Poseuses* are in relaxed, soft-contoured poses, while beyond them, on Seurat's studio wall, we see the stilted figures of the right-hand portion of the *Grande Jatte* (roughly the portion which appears in *Couple Walking*). The contrast seems to lie between the artificiality of the clothed figures in the natural setting of the Ile de la Grande Jatte, and the naturalness of the nudes in the artificial situation of the artist's studio. This contrast between nature and artifice which underlies the *Grande Jatte* and *Couple Walking* is taken up again in *Young Woman Powdering Herself* (no. 204). J.H.

REFERENCES
DR136
deH138
Artemis 1978 (19)
D. C. Rich, *Seurat and the Evolution of 'La Grande Jatte'*, 1935, p. 36
M. Schapiro, in *Art News*, April 1958
B. Nicolson, in *Burlington Magazine*, May 1962, pp. 213–14
R. Fry and A. Blunt, *Seurat*, 1965, pl. 19 and pp. 79–81
J. Russell, *Seurat*, 1965, pp. 141 ff.

199

199 *Honfleur, Evening, Mouth of the Seine* 1886

Honfleur, un soir, embouchure de la Seine
sbr. Seurat
65.5 × 81 cm/25¾ × 32 ins, plus painted frame
Lent by the Museum of Modern Art, New York

Seurat's Honfleur seascapes of summer 1886 were his first major group of paintings begun after he had reworked the *Grande Jatte* (cf. no. 205), and they are more consistently worked over in small separate 'points' of paint than any of his previous paintings; but their execution is by no means uniform. In *Honfleur, Evening* the small dots are added over broader strokes of paint, and only in some parts of the painting – in areas of sea, beach and sky – where they are used to make one colour stand out against another, to animate this particular zone of the picture. Even in these areas they remain large enough to be felt as separate touches when the painting is seen from a normal viewing distance (cf. no. 206); Camille Pissarro defined this *c.* 1889 as three times the length of the painting's

diagonal, cf. Homer, *Seurat and the Science of Painting*, 1964, p. 294). Elsewhere in the picture, where a more uniform colour effect is sought, the touches are softer and rather larger, and closely related tints are allowed to blend together on the canvas. There are delicate variations of colour throughout the picture, and the dominant colours of each area are softly echoed across the rest of the canvas.

It is very possible that the 'points' were added, in part at least, in Seurat's studio in Paris. Shortly before leaving Honfleur, he described the picture as 'not yet satisfactory' (letter to Signac, quoted DR, p. 155), and he did not exhibit it until the following year, though a less highly worked Honfleur canvas appeared in the 1886 Indépendants exhibition which opened in August, very soon after his return to Paris. The painted frame was added later; Seurat seems to have begun to make these during 1887 (cf. DR, p. XXII). Its dominant colours contrast with the adjacent areas of the painting.

In spring 1886 Seurat had met Charles Henry, and had learned of his theories about the emotive power of line – lines moving upwards and to the right expressing gaiety, downward and to the left expressing sorrow. The Honfleur seascapes show tauter linear structures than his previous paintings, but *Honfleur, Evening* does not reflect Henry's views in any explicit way; the recurrent verticals (which can be read as upward- or downward-moving) give the painting an equilibrium, and it was a soothing stillness which Huysmans found in the Honfleur paintings when he reviewed them in 1887. The only study for this picture (DR170) confirms Seurat's interest in line and silhouette; it focuses on the contrast between two posts of the breakwater and the rock at bottom right. J.H.

EXHIBITIONS
1887, Brussels, Les XX (Seurat 7)
1887, Paris, Indépendants (441)
1892, Brussels, Les XX, *Seurat* (8)
REFERENCES
DR171
deH167
Guggenheim 1968 (79)
J. K. Huysmans, in *Revue indépendante*, April 1887, pp. 51–8
G. Kahn, in *La Vie moderne*, 9 April 1887, pp. 229–30
H. Dorra, in *Gazette des Beaux-Arts*, January 1958, pp. 43–8
R. L. Herbert, in *Gazette des Beaux-Arts*, December 1959, pp. 318–28

200 *Study for The Seine at the Grande Jatte, Spring* 1888

Etude pour La Seine à la Grande Jatte, printemps
ns. oil on panel 16 × 25 cm/6¼ × 9¾ ins
Lent by a Private Collector

For many of his later landscapes Seurat executed small preparatory studies, probably out of doors, either in conté crayon or in oil on panel. In the oils he noted down the general disposition of the scene and possible colour combinations without finalizing the arrangement of his composition. His finished landscapes are consistently

200

squarer in format than the oblong wood panels which he used for these studies. A large sailing boat can be seen incompletely erased at the left of the present study.

In spring 1888 Seurat and Angrand returned to paint the site depicted in Seurat's great canvas shown in 1886, the *Grande Jatte* (cf. no. 198), and Angrand was the first owner of the present study for Seurat's version of the scene (Musées Royaux, Brussels; both men's finished canvases repr. J. Rewald, *Post-Impressionism*, 1978, p. 114). In this study, as in *The Eiffel Tower* (no. 201), but unlike his earlier panel sketches (cf. nos 196–7), the wood was covered with a dense white priming before Seurat began to paint, and he worked throughout in a loose version of the 'point', instead of sketching in a more Impressionist manner on an unprimed wood. J.H.

REFERENCES
DR182
deH175
J. Sutter, *The Neo-Impressionists*, 1970, p. 36, repr. in colour

201 *The Eiffel Tower* 1889

La Tour Eiffel
[repr. in colour on p. 162]
ns. oil on panel 24 × 15 cm/9½ × 6 ins
Lent by the Fine Arts Museums of San Francisco

One of the very few small oils from Seurat's last years which are not preparatory for larger paintings, this panel shows the Eiffel Tower nearing completion, at the height which it had reached by the early days of 1889. The tower, constructed for the Exposition Universelle of 1889, transformed Paris's skyline and became a bone of contention between traditionalists and supporters of the modern. Seurat's friend Hayet had painted it in the early stages of construction, and Henri Rousseau was to use it as an emblem of modern Paris in his self-portrait of 1890 (National Gallery, Prague). Camille Pissarro, however, used the phrase, 'It is worthy of the epoch of the Eiffel Tower,' as a paradigm of bad taste (*Lettres à son fils Lucien*, 1950, p. 184, letter of 9 September 1889).

This painting is executed in 'points' over a more broadly brushed priming of near-white paint which covers the wood panel and appears around the 'points' in some zones. Seurat left the top of the tower virtually unpainted, to suggest its incomplete form dissolving into the sky. It is not clear whether, when Seurat painted it, the tower had yet acquired its own paint – progressive shades from copper red at its base to yellow at the top. In his painting he uses the tower as a pivot for a composition of oranges against blues, which is picked up in the ambiguous shape cutting into the sky from the left – perhaps a tree, though it appears implausibly high above the buildings. J.H.

EXHIBITION
1895, Paris, Galerie Moline
REFERENCES
DR191
deH196
J. Rewald, 'Journal inédit de Paul Signac', *Gazette des Beaux-Arts*, June–September 1949, p. 117, entry for 22 February 1895
M. Schapiro, in *Art News*, April 1958, pp. 45, 52
R. Fry and A. Blunt, *Seurat*, 1965, pl. 34 and p. 82
Guggenheim 1968 (86)
Artemis 1978 (24)

202 *Le Crotoy, Looking Upstream* 1889

Le Crotoy, aval
[repr. in colour on p. 112; detail in colour on back cover]
sbr on border. Seurat 70.5 × 86.5 cm/27 × 34 ins
Lent by the Stavros S. Niarchos Collection

On his summer visit of 1889 to Le Crotoy, on the estuary of the Somme between Dieppe and Boulogne, Seurat only executed two paintings, this and no. 203, which were exhibited as a pair in Paris in 1889 and in Brussels in 1891. More open in composition and simpler in forms than his port scenes from Port-en-Bessin of 1888, these canvases are held together by the most apparently insignificant elements – boats and small posts, changing textures on land, beach or sea, and shapes echoed between foreground and sky.

It was in discussing the Le Crotoy marines in 1889 that the critic Fénéon, so often the mouthpiece for Seurat's latest ideas, first mentioned Seurat's use of painted borders on his paintings – used, like his painted frames (cf. nos 199, 203), to set off the colours of the paintings. It seems that all the borders now existing on paintings dating from before 1889 were added after the execution of the canvas, often over the margins of the picture itself; only from 1889 onwards were they part of the painting's original conception. However, in 1886 Seurat mentioned adding '*une bordure*' to a canvas (quoted DR, p. LII), and he may have begun to experiment with borders of some sort at this time. J.H.

EXHIBITIONS
1889, Paris, Indépendants (241)
1891, Brussels, Les XX (Seurat 3)
1892, Paris, Indépendants, *Seurat* (1103)
1892, The Hague, Kunstkring (34)
?1892, Brussels, Les XX, *Seurat* (16)
1892, Antwerp, Association pour l'Art (5)
1908–9, Paris, Bernheim Jeune, *Seurat* (74)
1910–11, London, Grafton Galleries, *Manet and the Post-Impressionists* (54)
REFERENCES
DR192
deH195
Fénéon, in *L'Art moderne*, 27 October 1889, p. 339
J. Rewald, *Seurat*, 1948, pp. 132–4
Guggenheim 1968 (87)

203 *Le Crotoy, Looking Downstream* 1889

Le Crotoy, amont
s on rev. Seurat 70.5 × 86.5 cm/27¾ × 34 ins, plus painted frame
Lent by the Detroit Institute of Arts, Bequest of Robert H. Tannahill

The pair to no. 202, this canvas has the largest surviving frame painted by Seurat; as he wrote to Beaubourg in 1890, he treated his frames 'in the harmony opposed to those of the tones, colours and lines of the picture' (quoted DR, p. LXXII). Comparison with a photograph of the site (DR, p. 243) suggests that Seurat simplified and exaggerated the curve of the foreground shoreline, and he used the rhythms of clouds and shore to contrast with the central horizontals. Fénéon, in 1889, compared this device with the use of linear contrasts in the posters of Jules Chéret, which Seurat much admired (cf. R. L. Herbert, in *Art Bulletin*, June 1958). The coloured 'points', still visible from a normal viewing distance, create a mobile and harmonious surface; seeing the picture again in 1894, Signac wrote

203

of it: 'One does not feel the handling. All the irritating side of the technique disappears, leaving only the advantages of a type of painting which does not need bright lighting since it itself creates light.' J.H.

EXHIBITIONS
1889, Paris, Indépendants (242)
1891, Brussels, Les XX (Seurat 2)
1892, Paris, Indépendants (1104)
1892–3, Paris, Hôtel Brébant (52)
1900, Paris, Revue blanche, *Seurat* (33)
1908–9, Paris, Bernheim Jeune, *Seurat* (75)
REFERENCES
DR193
deH194
Fénéon, in *L'Art moderne*, 27 October 1889, p. 339
Signac, *Journal*, 29 December 1894, in *Gazette des Beaux-Arts*,
 June–September 1949, p. 114

204 *Young Woman Powdering Herself* 1888/90

Jeune femme se poudrant
sbr. Seurat 94.5 × 79 cm/37¼ × 31 ins
Lent by the Home House Trustees,
Courtauld Institute Galleries, London

This is the only one of Seurat's paintings which reflects anything about his private existence. It shows his mistress, Madeleine Knobloch, at her toilette. Seurat's own face originally appeared in the frame on the wall behind her, but a friend warned him that this might appear laughable (cf. Rey 1931), and he replaced it with a vase of flowers on a table, which is placed at an angle which makes it impossible to read as a mirror reflection.

The painting is composed of a sequence of contrasts between rounded and angular forms – figure and table against the wall with its picture-frame and arrow-shaped patterning – and also shows visual incongruities: between the massive figure and her impracticably small table, and between the curving lines and pseudo-*dix-huitième* ornament of this table and the imitation bamboo frame on the wall.

There is no first-hand evidence about the picture's meaning, but it contains one sign whose significance Seurat explained – the ↓ motif of lines rising from a point, which is used to decorate the wall. In a letter to Beaubourg in 1890 in which he explained his theories of art (DR, p. LXXII), Seurat used this upward-moving motif to symbolize gaiety, following the ideas of his friend Charles Henry on the emotive power of line (cf. no. 199). Other lines in the picture echo this form – the frame top, the bow on top of the table mirror, the plant form at bottom left. But Seurat does not seem to be using these linear directions in a wholly literal way, to raise the spirits of the viewer; the weighty model and her impassive expression counteract them, and the spirit which emerges from the painting is ironic.

In this light, *Young Woman Powdering Herself* echoes the contrast which Seurat had explored in the *Grande Jatte* and *Les Poseuses* (figs 5–6), between nature and artifice – and reapplies it to the art of cosmetics, which, by cloaking nature, are designed to enliven and uplift woman. Seurat used upward-moving lines analogously in his contemporary large paintings, *The Chahut* (1889–90, Kröller-Müller Museum, Otterlo) and *The Circus* (fig. 1), to express the mood projected by urban entertainments – not natural joy, but synthetic gaiety. Seurat's book-cover design of 1889 for Joze's *La Ménagerie sociale, l'homme à femmes* (DR196, 196a) confirms that he was willing to use Henry's ideas about upward-moving lines as a tool for satire.

In *Young Woman Powdering Herself*, the satire is not directed against the model herself; Seurat had recently executed a sensuous nude drawing of her (deH660), and in the painting it is her trappings

which are Seurat's butt – trappings which were part of modern urban life. After Seurat's death, Signac stated that his paintings of urban performances had been satires which expressed his 'keen sentiment of the vileness of our epoch of transition' (*La Révolte*, June 1891, in E. W. Herbert, *The Artist and Social Reform*, pp. 189–90), but there is no evidence that Seurat actively endorsed Signac's Anarchist tenets; the mood of his later paintings is one of ironic humour and detachment rather than savage social critique.

Although *Young Woman Powdering Herself* was not exhibited until March 1890, it may belong to winter 1888–9. Signac ascribed it to this date, and Angrand remembered it as having been painted in a studio which Seurat left in autumn 1889 (G. Coquiot, *Seurat*, 1924, p. 39); moreover, Madeleine was pregnant in winter 1889–90 (cf. Perruchot 1965). J.H.

EXHIBITIONS
1890, Paris, Indépendants (727)
1892, Paris, Indépendants, *Seurat* (1085)
1892, Brussels, Les XX, *Seurat* (14)
1900, Paris, Revue blanche, *Seurat* (35)
1906–7, Munich, Frankfurt, Dresden, Karlsruhe, Stuttgart, *Französische Künstler* (103)
1908–9, Paris, Bernheim Jeune, *Seurat* (73)
1913, Berlin, Secession (218)
REFERENCES
DR195 and pp. LXIX – LXXI, XCVI – XCVIII
deH200
G. Lecomte, in *L'Art moderne*, 30 March 1890, p. 101
R. Rey, *La Renaissance du sentiment classique*, 1931, pp. 128–9
R. Goldwater, in *Art Bulletin*, June 1941, pp. 120–1
J. Rewald, *Seurat*, 1948, pp. 134–5
D. Cooper, *The Courtauld Collection*, 1954, no. 79
R. Fry and A. Blunt, *Seurat*, 1965 (reprinting Fry's 1926 essay), pp. 16, 84
J. Russell, *Seurat*, 1965, pp. 244–6
H. Perruchot, *La Vie de Seurat*, 1966, pp. 137–8

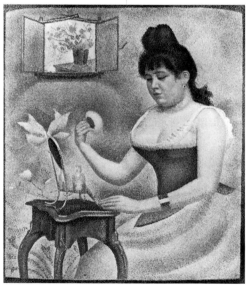

204

205 *The Gravelines Channel, Grand Fort-Philippe* 1890

Le Chenal de Gravelines, Grand Fort-Philippe
ns. 64 × 81 cm/25¼ × 31¾ ins
Lent by Lord Butler of Saffron Walden, KG, PC, CH

Seurat regularly visited the coast in the summer, he told Verhaeren, 'to cleanse his eyes of the days spent in the studio and to translate as exactly as possible the luminosity of the open air, with all its nuances' (Verhaeren, essay of 1891, in *Sensations*, 1927, p. 199).

205

and balanced, and mixing optically, following a rational method' (*D'Eugène Delacroix au néo-impressionnisme*, 1964 edn, p. 89). This formulation has caused great problems in the discussion of Neo-Impressionist technique, since the notion of 'optical mixture' does not describe what takes place when the canvases are seen from a normal viewing distance (cf. no. 199); in fact, the separate accents remain visible, and the colours react against each other, rather than fusing to produce a resultant hue. The effect sought is, rather, that which the German physicist Dove had described as *lustre*, in a passage cited by Fénéon in his discussion of the paintings exhibited by Seurat and Signac in 1886: 'The retina, forewarned that separate rays of light are operating on it, perceives, by very rapid alternation, both the separate coloured elements and the resultant hue.' In *The Railway Junction* the brushwork is not uniform – the touches vary in size and shape; however, even in canvases from the later 1880s which are more consistently executed, the 'points' remain visible, and their varying colour animates the surface (cf., e.g. nos 204 and 211). *The Railway Junction* is also unlike mature Neo-Impressionist canvases in being painted on a tan-toned priming – white primings were consistently used later, to lend luminosity to the image.

In subject, *The Railway Junction* is deliberately anti-picturesque, emphasizing the grid-like shapes of tracks, fence, trees and signals in a suburban station on the western outskirts of Paris, close to Asnières and the Ile de la Grande Jatte – very much the same milieu and type of theme that Seurat, Luce and Angrand were treating at the time (cf. especially nos 117 and 5).

The Opus number inscribed on the canvas was presumably added later, probably when Signac gave it to the writer Rodolphe Darzens; other canvases painted later in 1886 have no such inscription, and Signac began to number his canvases regularly in 1887 (cf. 208). J.H.

EXHIBITIONS
1886, Paris, 8th Impressionist Exhibition (195)
1886, Paris, Indépendants (370)
REFERENCES
P14 (lists early reviews)
Fénéon, *Les Impressionnistes en 1886*, in *Oeuvres plus que complètes*, I, 1970, p. 37

He spent the last summer of his life at Gravelines, on the Channel coast near Dunkerque and the Belgian border. *The Gravelines Channel* is, in formal terms, perhaps the sparest of all Seurat's finished landscapes, utterly unpicturesque in theme, and held together by the most apparently elusive elements – two posts, a boat, a flagpole, and the strip of grass at bottom left – whose placing gives the whole canvas the tautest of structures. Wide areas are variegated by delicately differentiated flecks of colour, which give the scene a shimmering luminosity. J.H.

EXHIBITIONS
1891, Brussels, Les XX (Seurat 4)
1891, Paris, Indépendants (1103)
1900, Paris, Revue blanche, *Seurat* (36)
1905, Paris, Indépendants, *Seurat* (3)
1908–9, Paris, Bernheim Jeune, *Seurat* (79)
REFERENCES
DR206
deH205
D. Cooper, *The Courtauld Collection*, 1954, p. 118, no. 71

Signac, Paul 1863–1935

Signac was brought up in the Paris area and lived there until 1892, when he moved his base to Saint-Tropez on the Mediterranean. His early art was largely self-taught, deriving from his study of Impressionism. He met Seurat in 1884, the Pissarros in 1885, and Van Gogh in winter 1886–7. In 1886 he began to paint in small 'points', though his technique later broadened greatly. He exhibited regularly with the Indépendants in Paris, and his painting was widely shown elsewhere in Europe. His convinced Anarchist views were shared by other Neo-Impressionists, in particular Luce, Cross and the Pissarros. Mainly a landscapist, he painted occasional major figure paintings before 1900.

ABBREVIATION
P – Paris, Louvre, *Signac*, catalogue by M. T. Lemoyne de Forges, 1963–4

206 *The Railway Junction at Bois-Colombes* 1886

> *L'Embranchement à Bois-Colombes*
> sdbr. P. Signac 86; insc bl. Op 130 R. Darzens
> 33 × 47 cm/13 × 18 ins
> Lent by Leeds City Art Gallery

The Railway Junction is one of the first three canvases in which Signac began to systematize his technique in terms of colour and touch, following the example set by Seurat in his reworking of the *Grande Jatte* (fig. 5, cf. no. 198) in winter 1885–6. In 1898, Signac described these paintings as executed 'solely with pure tints, divided

206

207 *The River Bank, Petit-Andely* 1886

> *La Berge, Petit-Andely*
> sdbr. P. Signac 86 65 × 81 cm/25½ × 32 ins
> Lent by Mme Ginette Signac

Signac painted in summer 1886 at Petit-Andely, a village on the Seine between Vernon and Rouen. His canvases of the place were his most consistently 'pointillist' to date, though their stippling varies in size and direction, and is added over broader paint layers.

The touch is larger and more varied than in Seurat's contemporary Honfleur seascapes (cf. no. 199). *The River Bank, Petit-Andely* is one of Signac's most ambitious canvases from this summer. It was not ready for the 1886 Indépendants exhibition, which opened in August, but appeared at the group's next show, in spring 1887, dated in the catalogue to August 1886.

During the 1880s, Signac's colour was at its brightest in his treatment of northern scenes, such as the Andely views, in which he emphasized the varied local colours of the scene. By contrast, his canvases from his first Mediterranean trip, to Collioure in 1887, are luminous and blonde, to capture the qualities of the southern light. He felt at this time that artists who accentuated their colour when painting the south failed to capture its true quality (cf. nos 42, 139, and quotations from Signac in P21, 28); however, in the 1890s, he himself adopted a highly coloured vision of the south (cf. no. 215). J.H.

EXHIBITION
1887, Paris, Indépendants (450)
REFERENCES
P16 (lists early reviews)
New York, Guggenheim Museum, *Neo-Impressionism*, 1968 (92)
J. Rewald, *Post-Impressionism*, 1978, p. 77, repr. in colour

207

208 *The Dining-room* 1886/7

La Salle à manger
sdbl. 86 P. Signac 87; insc br. Op. 152
89 × 115 cm/35 × 45¼ ins
Lent by the Rijksmuseum Kröller-Müller, Otterlo

The Dining-room is the second of three major paintings of figures in interiors which Signac painted in the later 1880s, after *The Modistes* (1885–6, Bührle Foundation, Zürich), and before *The Parisian Sunday* (1888–90, Private Collection). They form a group of modern history paintings of the customs of the age, comparable to Seurat's *Baignade* and *Grande Jatte* (cf. nos 197–8). Signac has here adopted strict profiles and front views, as Seurat had in the *Grande Jatte*, and perhaps for a similar reason – to emphasize the artificiality of bourgeois rituals. This contrived effect is here augmented by the meticulously arranged forms of the interior, which fuse the lessons of the Dutch seventeenth-century interior with the cut-off forms and crisp silhouettes of Japanese prints.

In technique, the 'points', added across broader paint layers, vary greatly in size – the smallest are in the flesh, where Signac introduces the widest range of colour-nuances. Throughout the canvas flecks of varied colour, in shadows and lit zones alike, complement the bold dark-light contrast created by the contre-jour lighting.

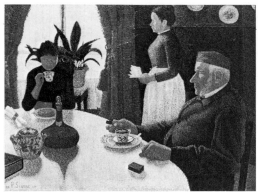

208

Between 1887 and 1893 Signac gave his paintings Opus numbers. In 1890 Fénéon wrote: 'M. Signac has given up putting literature beneath his paintings; he numbers them. Signature, date and number are harmonized with their background – related colours for a light background, contraries for a dark one' (in *Oeuvres plus que complètes*, I, p. 177). In 1935, Signac cited Whistler's musical titles as a precedent for the Opus numbers (in *D'Eugène Delacroix au néo-impressionnisme*, 1964 edn, p. 159). Generally, Signac exhibited his paintings with, in the catalogue, descriptive titles alongside their Opus numbers, but in 1888 at Les XX he showed 12 canvases, including *The Dining-room*, listed by Opus numbers and dates alone (cf., too, no. 212 for the titles which Signac used at Les XX). Analogies between painting and music were common among artists and writers in the later 1880s, and Signac wanted to find parallels between his technique and Wagnerian musical harmony (G. Kahn, in *Mercure de France*, 1 April 1924, p. 15). Symbolist critics (with whom Signac and his friends had close contacts) used Wagner's ideas on the connections between the arts as the basis for discussions of Wagnerian or musical tendencies in modern painting (e.g. in the *Revue wagnérienne*, 1885–8), and at the same time Charles Henry was exploring relationships between sight, sound and psychological states in his *Introduction à une esthétique scientifique* (1885) and later works (cf. Arguelles, *Charles Henry*, pp. 96–9, 178; on Henry, cf. too nos 199, 204, 211). Vanor, in *L'Art symboliste* (1889) described the local contrasts and overall harmonies of Neo-Impressionist painting as analogous with music (cf. P39). J.H.

EXHIBITIONS
1887, Paris, Indépendants (449)
1888, Brussels, Les XX (Signac 1)
1892–3, Paris, Hôtel Brébant (66)
REFERENCES
P18, with quotations from contemporary criticism,
Otterlo, Kröller-Müller Museum, *Catalogue of Paintings*, 1969, no. 622
New York, Guggenheim Museum, *Neo-Impressionism*, 1968 (93)
F. Cachin, *Paul Signac*, 1972, pp. 36–8

209 *The Bridge at Asnières*
(*The Stern of The Tub in the Sun*) 1888

Le Pont d'Asnières (L'arrière du Tub, soleil)
sdbl. P. Signac 88; insc br. Op. 175 46 × 65 cm/18 × 25½ ins
Lent by Sir Jack Lyons, CBE

The background of this canvas shows the twin road and rail bridges of Asnières, with, as always, a train crossing the latter to make its function clear. Both Van Gogh and Bernard had painted the same subject from the river bank in 1887 (cf. no. 12), and Signac had worked with Van Gogh in the area during the same year (cf. no. 96). Asnières lies on the Seine north-west of Paris, just downstream from the Ile de la Grande Jatte.

209

In the foreground is the stern of Signac's sailing boat *The Tub* – the reason for the light-hearted title which Signac gave the picture when he presented it to Paul Adam, the Symbolist poet and critic. Signac was always an enthusiastic yachtsman; *The Tub*, one of his first boats, sank off Herblay in 1890 (cf. P23). The cut-off form of the stern reveals the influence of Japanese prints, used in similar ways by many of Signac's friends and contemporaries to create compositions which conveyed the unexpected juxtapositions of objects and jumps in scale and space characteristic of the way in which we actually see the world (cf. e.g. nos 7, 60, 136). J.H.

REFERENCE
P23

210

210 *Sunset at Herblay* 1889/90

Coucher de soleil à Herblay
sdbr. P. Signac 90; insc bl. Op. 206 58.5 × 90 cm/23 × 35½ ins
Lent by Glasgow Art Gallery and Museum

Though dated '90', Signac exhibited this canvas in 1891 with the indication that it had been painted at Herblay in September 1889; he may have reworked it in 1890 on a return visit to Herblay (a village on the Seine north-west of Paris). It treats a river sunset in a bold and schematic way. Monet (cf. no. 136) had used sunsets for a display of lavish colour, but Signac's colour-transitions are more measured – the sky shows a gradual progression from the dominant blues at the top to hot oranges and reds along the horizon. The blues in the trees are strongest where they meet the oranges in the sky, and clear oranges and reds animate the shadowy foliage. The frontal, horizontal composition echoes some of Monet's river and meadow scenes (cf. no. 140), but Signac's treatment of detail and silhouette is tauter and more stylized. J.H.

EXHIBITIONS
1891, Brussels, Les XX (Signac 7)
1891, Paris, Indépendants (1109)
REFERENCES
P32 (lists early reviews)
cf. P33

211 *Against the Enamel of a Background Rhythmic with Beats and Angles, Tones and Colours, Portrait of M. Félix Fénéon in 1890* 1890

Sur l'email d'un fond rhythmique de mesures et d'angles, de tons et de teintes, portrait de M. Félix Fénéon en 1890
sdbr. P. Signac 90; insc bl. Op. 217 73.5 × 92.5 cm/29 × 36½ ins
Lent by a Private Collector, New York

Signac's *Portrait of Fénéon*, like Seurat's *Circus* (fig. 1), also shown at the Indépendants in 1891, marks an extreme in the development of Neo-Impressionism towards a decorative artificial style. This had little in common with the more naturalistic aims which lay behind the earlier stages of Divisionism, conceived as a means of refining the analysis of natural light and colour. Fénéon's hieratic silhouette, apparently holding a cyclamen, is set against a lavish set of abstract patterns, adapted from a Japanese print which Signac owned. Signac introduced into figure and background a series of more or less private references to his own and Fénéon's interests, and particularly to the ideas of Charles Henry. On Fénéon, cf. no. 273.

From the start, Signac planned 'a very composed picture, with carefully organized lines and colours. An angular, rhythmic pose. A decorative Félix.' The small Japanese print (perhaps a kimono design) which he transformed into the huge design behind Fénéon gave him the idea for the spiralling linear movements and contrasting colours and texture, but this adaptation was given its topicality by Henry's ideas (cf. Cachin 1969). At this date Signac was working in collaboration with Henry on designs for Henry's publications, to illustrate his theories about the psychological effects of colours and linear directions, and of correlations between them (cf. Fénéon, 'Signac', *Les Hommes d'aujourd'hui*, no. 373, 1890, in *Oeuvres plus que complètes*, 1, pp. 174–9). The rising reds and descending greens in the left of the picture are references to Henry's ideas, and the whole background is based on contrasts of colour, tone and line. The elaborate title also clearly recalls Henry.

However, the picture should in no way be read as a serious manifesto or a painting with a programme, nor should we give precise meanings, culled from Henry's theories, to individual parts of it. For all their belief in the value of Henry's ideas, Signac and Seurat (cf. no. 204), realized that scientific ideas such as his could not provide a literal formula for painting (a point made in 1891 both by Gustave Kahn, about Seurat [in *Seurat in Perspective*, ed. N. Broude, p. 23], and by Antoine de la Rochefoucauld, about Signac, cf. P38). The ingredients in Signac's *Portrait of Fénéon* are used as attributes, and refer to private dialogues between artist and sitter. Fénéon's often-noticed 'Uncle Sam' profile is set beside yellow stars in a blue field which hint at the American flag, and the flower gains relevance from the flower nicknames which Fénéon and Signac were using at the time (cf. Cachin 1969). If it is a cyclamen, a joking reference to cycles may be meant – cycles underlie the movement in the background (cf. Arguelles 1972). However, many further private references in the picture may now be lost.

211

Fénéon's article on Signac of 1890 provides another key to the humour and play-acting which characterized their relationship and the *Portrait of Fénéon*. After a serious dissection of Signac's ideas, Fénéon ended by mentioning Signac's library, with its books bound in the colour most appropriate for each author, then his fleet of ocean-going sail-boats, and his imminent election 'by the tetrarch Emerald-Archetypas as official landscapist of the Esoteric White Islands' (*Oeuvres plus que complètes*, I, pp. 174–9).

Not surprisingly, few of the painting's original audience had full access to its meaning, and it was received with some puzzlement (cf. P37 for quotations from these responses). However, in retrospect Signac's *Portrait of Fénéon* emerges as a key example of a type of private, attributive portraiture, pioneered in the 1860s by Manet (in his *Portrait of Zola*, 1868, Jeu de Paume, Paris) and by Degas (cf. no. 63), and developed by Van Gogh (cf. no. 98) and Gauguin, among others, in the 1880s. J.H.

EXHIBITIONS
1891, Paris, Indépendants (1107)
1892, Brussels, Les XX (Signac 1)
REFERENCES
P37 (lists early reviews)
G. Moore, in *The Speaker*, 10 September 1892, p. 317
C. Pissarro, *Lettres à son fils Lucien*, 1950, p. 222, letter of 30 March 1891
New York, Guggenheim Museum, *Neo-Impressionism*, 1968 (90)
F. Cachin, 'Le Portrait de Fénéon par Signac; une source inédite', *Revue de l'art*, 6, 1969, pp. 90–1
J. A. Arguelles, *Charles Henry and the Formation of a Psychophysical Aesthetic*, 1972, pp. 131–42

212 *Presto (finale)* or *Breeze, Concarneau* 1891

> *Presto (finale)* or *Brise, Concarneau*
> [repr. in colour on p. 235]
> sdbl. P. Signac 91; insc br. Op. 222 66.5 × 82 cm/26¼ × 32¼ ins
> Lent by the Executors of the late Sir Charles Clore

This painting, originally in the collection of Van Rysselberghe's mother-in-law, was exhibited at Les XX in Brussels in 1892 as the fifth and last of a sequence entitled *La Mer, les barques (Concarneau 1891)*, with the individual canvases only specified by Opus number and musical titles – *Scherzo, Larghetto, Allegro maestoso, Adagio,* and *Presto (finale)*. These were replaced by descriptive titles when the paintings were shown at the Indépendants in Paris. The musical titles, turning the series of paintings into a sequence of symphonic movements, were the most elaborate musical analogy which Signac ever made for his paintings (cf. no. 208). He may have felt that they better suited an exhibition of Les XX – a calculated avant-garde manifestation, selected to represent particular trends, and accompanied every year by many musical performances – than they did the jury-free mixed bag of the Indépendants.

In *Presto (finale)*, the 'point' is still used as the basic unit of brush-work, but patterns and linear rhythms are also emphasized in the composition (cf. Cross, no. 54). The waves in particular contain echoes of the decorative patterning of Japanese prints, which Signac greatly admired (cf. no. 211), but the clouds are animated by swirling forms which suggest the impact of Van Gogh's paintings from Saint Rémy. Some of these were shown at the Indépendants in 1891, and Signac, as a friend of Van Gogh, could doubtless have seen others, including the *Starry Night* (1889, de la Faille 612). Signac translates Van Gogh's dynamic brushwork into spiralling patterns of 'points', to convey the effects of the stormy seas and skies of Brittany (contrast Monet's Belle-Isle seascapes, e.g. no. 138). J.H.

EXHIBITIONS
1892, Brussels, Les XX (Signac 6)
1892, Paris, Indépendants (1130)
REFERENCE
P40 (lists early reviews) cf. P38, 39

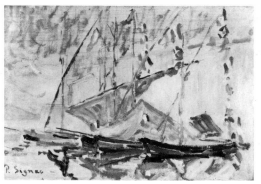

212

213 *Saint-Tropez* 1893

> sbl. P. Signac; insc on rev. P.S. St Tropez oil and pencil on panel
> 19 × 27 cm/7½ × 10½ ins
> Lent by the Courtauld Institute Galleries, London

During the 1890s Signac began to execute his finished paintings entirely in the studio, working outside only on small studies in oil or (particularly after 1900) watercolour. In contrast to the precise handling of the finished canvases, these studies are highly improvisatory – quick sketches in the Impressionist tradition which set brightly coloured patches of paint freely against the white priming of the canvas, or, as in no. 214, the wood panel. This sketch is a study for *The Port of Saint-Tropez*, first exhibited in December 1893 (P46); its forms are transposed quite precisely into the final painting. Later in the decade, Signac composed his pictures more deliberately, seeking 'the idea only in the sketch, the arrangement only in a cartoon of the same format as the final painting' (*Journal*, 8 September, 1894, in *Gazette des Beaux-Arts*, 36, 1949, p. 102), and feeling free to rearrange nature's forms as he pleased (cf. e.g. *Journal*, 9 August 1897, in *Gazette des Beaux-Arts*, vol. 39, 1952, pp. 269–70).

The bold notation of colours and forms in Signac's and Cross's oil studies had an important influence on the Fauve style evolved by Matisse and Derain at Collioure in 1905 (cf. nos 131, 73). Matisse had worked with both men at Saint-Tropez in 1904, and Signac included a sequence of *Notations à l'huile* in his one-man show at Druet's gallery in December 1904. He regularly exhibited small oils and watercolours alongside his finished paintings. J.H.

REFERENCE
D. Cooper, *The Courtauld Collection*, 1954, p. 119, no. 72

214 *Poppies* c. 1894

> *Les Coquelicots*
> ns. oil on panel 15 × 24 cm/6 × 9½ ins
> Lent by a Private Collector, Paris

Like no. 213, *Poppies* is a study for a larger painting, but, unlike it, it is probably not an outdoor sketch but a notation of possible colour relationships made in the studio. It seems to belong with Signac's preparatory work for his major figure composition *In the Time of Harmony* (fig. 2), though it does not correspond closely with any part of the final composition. In its more regular, though loose, block-like touch, it contrasts with the variety of outdoor sketches such as no. 213.

In the Time of Harmony was Signac's most important pictorial statement of his Anarchist beliefs. Exhibited at the Indépendants in 1895 with the sub-title (taken from the Anarchist philosopher Malato): 'The age of gold is not in the past, it is in the future,' it is a

214

modern-life Arcadia, showing recreation and agricultural work side by side in an idyllic coastal setting. Signac expressed these underlying Utopian ideals most clearly in 1893 (the year of its conception), in a letter to the Anarchist writer and editor Jean Grave, thanking him for his latest book; he spoke of 'our hope for this future, which is soon to come, when, at last, for the first time, all individuality will be free. Within the great poetic scenario, *à la* Puvis, which Kropotkin has created, what practical and habitable monuments you are erecting! How well one breathes there!' (quoted E. W. and R. L. Herbert, in *Burlington Magazine*, December 1960, p. 519). Like Camille Pissarro (cf. no. 155), Signac seems to have rejected industry in his vision of the ideal society, whereas Luce, in the same years, was more willing to harness the benefits of mechanization (cf. no. 119). J.H.

REFERENCES
P50
cf. P51
F. Cachin, *Paul Signac*, 1971, p. 93, repr. in colour

215 *Saint-Tropez, Pine-wood* 1896

Saint-Tropez, bois de pins
sdbl. P. Signac 96 65 × 81 cm/25½ × 32 ins
Lent by the Musée de l'Annonciade, Saint-Tropez

After he had settled on the Mediterranean coast at Saint-Tropez in 1892, Signac's touch gradually became larger and less systematic, his colour richer and more harmonious. On his first visits to the Mediterranean in 1887 and 1889 he had been surprised to find how white and luminous everything seemed in the south, in contrast to the intense colours which Van Gogh had found there (cf. no. 106; quotations cf. P21, 28), but by the mid-1890s he had left behind his strictly analytical approach to light and colour: 'Nowadays, I am content to say: I paint like this because it is the technique which seems to me best suited to produce the most harmonious, the most luminous and the most colourful result (*Journal*, 23 August 1894, in *Gazette des Beaux-Arts*, 36, 1949, p. 101). At the same time he began to treat his natural subjects with more freedom, painting bold, small sketches to seek the idea for his canvases, but working out their final arrangements in the studio (cf. no. 213). In *Saint-Tropez,*

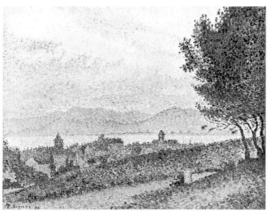

215

Pine-wood, rich reds, pinks and mauves are added across the soft blues and greens of the foreground, to pick up the warmth of the sunset; the brushstroke is no longer round, but mainly lozenge-shaped, creating rhythmical movements which give each area a directional momentum. Signac's close friend Cross was moving in very much the same direction at this period (cf. no. 56). J.H.

EXHIBITION
1907, Paris, Bernheim Jeune, *Signac* (26)

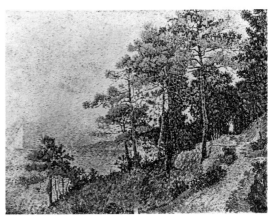

216

216 *Saint-Tropez, le sentier de douane* 1905

sdbl. P. Signac 1905 73 × 92 cm/28¾ × 36¼ ins
Lent by the Musée de Peinture et de Sculpture, Grenoble

After *c.* 1900 Signac adopted a larger brushstroke, and began to work in mosaic-like blocks of paint, placed separately on the white-primed canvas, and sometimes at an angle to suggest directional movement. The priming is often left visible around the touches, as here, and gives the painting a luminosity, alongside the richness of its colour. Throughout *Saint-Tropez, le sentier de douane*, the colour is bold and heightened – natural observation is its starting-point, but strong contrasts are emphasized, particularly between orange-reds and blues. In 1898, in his book *D'Eugène Delacroix au néo-impressionnisme*, Signac described his process of colour-composition: the painter, 'starting from the contrast of two colours, opposes, modified and balances these elements on either side of the boundary between them, until he meets another contrast, and starts the process over again; so, working from contrast to contrast, he covers his canvas' (1964 edn, p. 108). This prescription closely echoes a passage in John Ruskin's *Elements of Drawing* (1856), which Signac had read (cf. P33), and also Delacroix's ideas on colour-composition (Delacroix's *Journals* were first published in 1893–5); it recurs, in a very similar form, in Matisse's *Notes d'un peintre* (1908). Matisse worked with Signac at Saint-Tropez in summer 1904, and briefly adopted a similar mosaic-like touch, particularly in his major figure painting *Luxe, calme et volupté* (fig. 3), which Signac bought when it was exhibited at the Indépendants in 1905.

Ancient Roman mosaic work in the Louvre may have caught Signac's attention, but he mentioned mosaic only in passing in his 1898 book (1964 edn, p. 121); he had adopted this technique before his first opportunity to see the colour effects of mediaeval mosaic when he visited Venice in 1904 (cf. Gage, in *Art History*, March 1978). J.H.

EXHIBITION
1907, Paris, Bernheim Jeune, *Signac* (22)
REFERENCES
P67
A. M. Mura, *Signac*, 1967, pl. XV, repr. in colour

Simon, Lucien 1861–1945

Born in Paris, Simon exhibited for the first time in the Salon of 1885. He first visited Brittany in 1890. Impressed by Charles Cottet's interpretation of Brittany, he introduced himself to Cottet at Petit's gallery in 1895. Together with Dauchez, Ménard, Lobre, Meunier, Gay Milcendea and Prinet, these artists became known as members of the new 'dark' school of painting during the 1890s. Throughout his life Simon also painted fashionable Parisian genre scenes.

217 *The Procession* 1901

La Procession
sbl. L. Simon 136 × 175 cm/53½ × 69 ins
Lent by the Musée d'Orsay, Paris

Described as a painter who 'has explored the truly Breton aspects of Brittany' (Paul Desjardins, 'Les Salons de 1899–IV', *Gazette des Beaux-Arts*, August 1899, p. 141), Simon visited Brittany for the first time in 1890. He had been encouraged to go by his marriage to the sister of the Breton artist Dauchez. In the Société Nationale of 1893, he exhibited one Breton painting, *Mass at Pergue (Finistère)*, and two intimist Parisian interiors, which established the pattern of his work for the rest of the decade. In 1895, greatly impressed by Cottet's *Burial*, he met this artist and, together with Dauchez, they formed a friendly association (cf. Cottet, no. 52).

The impact of Cottet's work on Simon can be seen in *The Procession*. Simon captures the relationship between harsh existence and religious feeling by a semi-naturalistic style (cf. Cottet, *The People of Ouessant Watching Over a Dead Child*, no. 53). However, certain features of this painting are unique to Simon: the integration of figures into the landscape (noted by P. Desjardins, 1899, p. 141), the broad brushwork which critics believed Simon owed to Manet, and the fairly light and rich palette. These tended to make Simon's Breton subjects 'more colourful and more pictorial' (Frantz, 'The Paris Salons of 1899: the New Salon', *Magazine of Art*, 1899, p. 439) than those of Cottet. Yet, it is possible that, after c. 1900, Simon's more colourful style caused Cottet to lighten his palette and produce such paintings as *Women of Plougastel at the Pardon of Sainte-Anne-la-Palud* (1903, Musée des Beaux-Arts, Rennes). M.A.S.

EXHIBITION
1901, Paris, Société Nationale (831)
REFERENCE
L. Bénédite, *La Peinture au XIX siècle*, 1909, p. 213

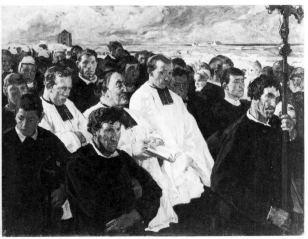

217

Tissot, James Jacques Joseph 1836–1902

Tissot was born at Nantes, and moved to Paris *c.* 1856, studying there with Flandrin and Lamothe, in whose studio he met Degas. He showed at the Salon from 1859, turning to modern life themes *c.* 1864. After involvement with the Commune in 1871 he moved to London, where he lived until 1883 and won a reputation for scenes of fashionable urban life. In 1886, he undertook a *Life of Christ*, completed in 1895, followed by an *Old Testament* which he left unfinished at his death; for these he travelled several times to Palestine. He won a gold medal at the Exposition Universelle of 1889.

218 *The Ladies of the Chariots* 1883/5

Ces Dames de chars
sbr. J. J. Tissot 146 × 101 cm/57½ × 39¾ ins
Lent by the Museum of Art, Rhode Island School of Design, Providence, Gift of Walter Lowry

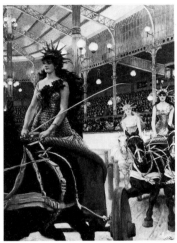

218

On his return to Paris from London in the mid-1880s Tissot mounted two major exhibitions there, in 1883 and 1885; the second included a sequence of 15 large paintings on the theme of the Parisian woman, entitled *Quinze tableaux sur la femme à Paris*, which show different types and classes of Parisian women in their professional and social milieux (listed in full in *Tissot*, 1968, sv no. 35). Tissot had won a reputation in London in the 1870s for genre scenes of fashionable urban life, but the Parisian Women are a far more programmatic series, and treat a wider range of types – working women as well as ladies of leisure. Like many others of the series, *The Ladies of the Chariots* used the compositional cut-offs and jumps of space and scale which both Tissot and Degas had adopted from Japanese art as a means of conveying the unexpected angles and vistas characteristic of city life (cf. no. 60); crisp lines and rounded shapes are counter-balanced to make an elaborately composed ensemble.

The Ladies of the Chariots depicts the Hippodrome de l'Alma, and the Roman chariot race with female charioteers which was mounted there (cf. *Tissot*, 1968). They are seen under electric light, only recently introduced into places of public entertainment. Tissot's vision of the urban scene combines detached observation with touches of humour; his Parisiennes in the guise of antique charioteers would have seemed a witty anomaly to an audience used to the dramatic scenes of ancient chariot-racing regularly shown at the Salon by Neo-Classical painters such as Gérôme. Tissot

is conveying no obvious social message; however, he may well have shared with Seurat a sense of the artificiality of the social rituals of Paris (cf. no. 204) – he had supported the Commune in 1871, but we know nothing of his later political views. Scenes such as *The Ladies of the Chariots* belong to the tradition of history paintings of the characteristic scenes of city life to which Seurat added in canvases such as *The Circus* (fig. 1). J.H.

EXHIBITIONS
1885, Paris, Sedelmeyer, *Tissot* (2)
1886, London, Tooth, *Pictures of Parisian Life by J. J. Tissot* (11)
REFERENCE
Providence, Rhode Island School of Design, *J. J. J. Tissot*, 1968 (36), and cf. (35)

Toulouse-Lautrec, Henri, de 1864–1901

Known as much for his experimental lithographs as for his paintings, Toulouse-Lautrec was born into an aristocratic family near Albi. Accidents during his childhood damaged his legs and arrested his growth. After informal art lessons from the horse-painter, Princeteau, Lautrec joined Bonnat's atelier in 1882, and then that of Cormon, where he met Bernard, Van Gogh and Anquetin and became part of Anquetin's circle at Aristide Bruant's café-cabaret Le Mirliton. In 1884 he moved into a studio on Montmartre, and from then onwards drew upon the local scenes of prostitution and popular entertainment for his paintings and litho-graphs. From 1888 he gained critical acclaim from writers such as Arsène Alexandre, Octave Mirbeau and Roger Marx, and was invited to exhibit at Les XX in that year. In 1891 he made a breakthrough in his lithographic technique. A cure for acute alcoholism which he took in 1899 proved only temporary and he died two years later.

ABBREVIATIONS
M. Joyant, *Lautrec* – M. Joyant, *Henri de Toulouse-Lautrec*, I, 1926, II, 1927
Mack – G. Mack, *Toulouse-Lautrec*, 1938
MGD – M. G. Dortu, *Toulouse-Lautrec et son oeuvre*, 1971 [P – paintings; D – drawings]

219

219 *In Batignolles* 1888

A Batignolles
ns. 92 × 65 cm/36¼ × 25½ ins
Lent by a Private Collector

This canvas belongs to a small group of paintings of single girls, all executed in 1888 and all given the title of a ballad composed by Aristide Bruant. The other paintings in this group have titles such as *At Montrouge – Rosa la rouge* (P305), *At the Bastille – Jeanne Wenz* (P307), *At Grenelle – Absinthe* (P308) and *At Grenelle – Waiting* (P328), and this painting had the following lines from the ballad *A Batignolles* attached to it:

> Quand on s'balladait sous le ciel bleu,
> Avec ses ch'veux couleur de feu,
> On croyait voir eun'aureole,
> A Batignolles.

After his popular success with light ballads and songs performed at such fashionable café-concerts as L'Epoque, La Scala and L'Horloge, Bruant turned to more tragic subject matter for his ballads *c.* 1885. Written in Parisian slang and set in the poorer areas of the city, they were performed at his own café-cabaret, Le Mirliton, opened in 1885. Lautrec became part of Bruant's cafe circle probably in 1884 through his friendship with Anquetin. Like Anquetin and Bernard, Lautrec found the atmosphere and company of Bruant's establishment stimulating. In 1885, in *The Refrain of the Louis XIII Chair at Aristide Bruant's Cabaret* (P260), he represented Bruant singing his popular song of the moment, and the following year Lautrec painted *At Saint-Lazare* (P275), based on one of Bruant's Parisian ballads. His association with Bruant continued into the 1890s, when he produced, for instance, four popular colour lithographs advertising Bruant's cabaret.

The technique of this painting, *In Batignolles*, illustrates a step in Lautrec's development from his earlier realist and Impressionist styles. After the modified Bastien-Lepage technique of his paintings of the early 1880s (e.g. *Seated Old Woman at Céleyran*, 1882, P148) and the subdued Impressionism of pictures such as *Portrait of Emile Bernard* (1885, P258), Lautrec adopted a loose version of the criss-cross technique of short brushstrokes from Camille Pissarro's painting of the period (1882–5 (cf. no. 152). He used this technique to give a dense patterning in the paintings of 1887 such as *Madame la Comtesse de Toulouse-Lautrec in the Château de Malromé* (P277). By the date of *In Batignolles*, however, the hatching has become much more open and the graphic line, which was to become dominant in his work after 1890 (cf. no. 222), becomes more prominent.

There are two drawings related to this painting, D3.030 and D3.031, and a related study (P294). M A.S.

REFERENCES
M. Joyant, *Lautrec*, I, pp. 94, 264; II, p. 145
Mack, pp. 100, 293, 304
H. Perruchot, *La Vie de Toulouse-Lautrec*, 1958, pp. 144–6
MGD P306

220 *Portrait of François Gauzi* 1888

Portrait de François Gauzi
sbl and insc. A. François, H. Tréclau 78.5 × 39 cm/30¾ × 15½ ins
Lent by the Musée des Augustins, Toulouse

François Gauzi was a fellow student of Toulouse-Lautrec's at the Atelier Cormon and his future biographer (*Lautrec et son temps*, 1954). Although in his biography Gauzi claims that he entered Cormon's in October 1885, he must already have known Lautrec for at least a year, since during 1884 Lautrec shared his studio at 19*bis* rue Fontaine.

The portrait of Gauzi belongs to a group of portraits of Lautrec's fellow students at Cormon's atelier, which included *Portrait of Emile Bernard* (1885, P258), *Vincent Van Gogh* (1887, P278) and the inclusion of Anquetin in *The Refrain of the Louis XIII Chair at Aristide*

Bruant's Cabaret (1885, P260) and a caricature of him (D3.052). Lautrec executed pencil sketches of Gauzi (D2.892) in 1885 and another portrait of him in 1887 (P276).

The steeply-raked space in this portrait, created by the abrupt dive into the background of the floorboards, together with the somewhat ambiguous spatial relationship between the figure and the opened double doors, points to Degas' influence. Noted by one of his atelier friends, Henri Rachou (in G. Coquiot, *Lautrec ou 15 ans de moeurs parisiennes*, 1921, pp. 26–7), this debt can also be seen in Lautrec's theatre scenes of 1885 such as *Ballet Scene* (P241), and it appears in later pictures such as *Portrait of M. Samary of the Comédie Française* (1889, P330), *Au Bal du Moulin de la Galette* (1889, P335) and *Portrait of Dr Tapié de Céleyran* (1894, P521). MA.S.

REFERENCES
M. Joyant, *Lautrec*, I, p. 263
Mack, p. 269
F. Gauzi, *Lautrec et son temps*, 1954, pp. 8, 150
MGD P297

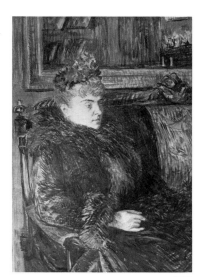

220 221

221 Portrait of Madame de Gortzikoff 1893

Portrait de Madame de Gortzikoff
ns. 76 × 51 cm/30 × 20 ins
Lent by Sir Isaac Wolfson, London

Dortu claims that there is no record of the identity of this sitter, and concludes that this was one Lautrec's very few portraits to have resulted from a commission (cf. *Madame Aline Gibert* [1887, P280] and *Woman with a Dog, Portrait of Madame Fabre* [1891, P395]). As such, it is unlike most of Lautrec's portraits, which showed members of his family or close friends such as François Gauzi (cf. no. 220).

Lautrec's portrait technique varied considerably, Henri Rivoire claimed, in *Revue de l'art ancien et moderne* (December 1901), that 'he never painted a portrait without having thought about it for months, sometimes years, without having lived in actual daily contact with his model. . . . But the actual execution . . . was rapid. Two or three sittings, sometimes only one, were enough for him. . . . And all of these portraits are manifestly true, even without knowing the models it is impossible to imagine them different from his conception.' (quoted Mack, p. 273). However, he needed some 75 individual sittings to bring Joyant's portrait to completion. More sittings may have been required for commissioned portraits such as *Madame de Gortzikoff*, and Lautrec, according to Rivoire (*Revue de*

l'art ancien et moderne, April 1902, quoted Mack, p. 274), paid great attention to detail. Despite the loose technique and rapid graphic outline in *Portrait of Madame de Gortzikoff*, passages such as the sitter's right hand and the fur of her collar reveal this intense care. MA.S.

REFERENCES
T. Duret, *Lautrec*, 1920, p. 60
G. Geffroy, *Lautrec*, 1921, p. 122
M. Joyant, *Lautrec*, I, p. 280
Mack, p. 273
MGD P487

222 Portrait of M. Delaporte at the Jardin de Paris 1893

Portrait de M. Delaporte au Jardin de Paris
sbr and insc. Pour M. Delaporte – H. T. Lautrec
oil on board 76 × 70 cm/30 × 27½ ins
Lent by the Ny Carlsberg Glyptothek, Copenhagen

Delaporte's identity is uncertain. He may have been either the director of a Montmartre advertising business with interests in hoardings and posters, or a Republican member of the Assemblée Nationale, an opportunist and *bon viveur* (cf. F. Gauzi, *Lautrec et son temps*, 1954, p. 158).

The Jardin de Paris, opened by Zidler and Oller in 1893 on the fashionable Champs-Elysées, catered for a classier clientele than their other establishment, the Moulin Rouge on Montmartre. Star entertainers were, though, shared between the two. On the closure of the Moulin Rouge around 11.30 pm, La Macarona, Yvette Guilbert and Jane Avril went down to the Champs-Elysées for a second session. Jane Avril appears in the centre of no. 222.

Compared to the formality of Lautrec's commissioned portraits (e.g. no. 221), the *Portrait of M. Delaporte* is relaxed in tone, in the sitter's pose and in his environment. Lautrec regularly used an environment to suggest a sitter's personality or profession. In 1889, he showed the young actor Samary performing on stage (P330), and in 1892, in his group portrait *At the Moulin Rouge* (P427), he used the surroundings to express the tastes of his friends Dujardin, Sescau, and Gabriel Tapié de Céleyran. In *Portrait of M. Delaporte*, detail is confined to the sitter, and the background is treated in broad patterns of colour which evoke the bustle and smoky atmosphere of the café-concert. Lautrec further elaborated this treatment in his *Portrait of Dr Tapié de Céleyran* (1894, P521).

Portrait of M. Delaporte was purchased by the Société des Amis du Luxembourg in 1905 as a gift to the national collections, but its acceptance was barred by Léon Bonnat, which may reveal Bonnat's antipathy to Lautrec's art, established as early as 1882 when Lautrec was a student in his atelier. Lautrec recorded Bonnat's reaction in a letter to his uncle in May 1882: 'He tells me "Your painting isn't bad, it's clever but still it isn't bad, but your drawing is simply atrocious"' (quoted Mack, p. 53). MA.S.

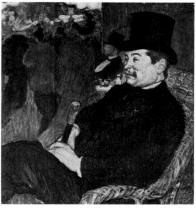

222

REFERENCES
T. Duret, *Lautrec*, 1920, pp. 43, 44, 45, 46, pl. 21
M. Joyant, *Lautrec*, I, pp. 140, 277, repr. p. 165; II, pp. 58, 139, 141, 142, 157
Mack, pp. 53–4, 258, repr. p. 52
M. G. Dortu, *Toulouse-Lautrec*, 1952, p. 5
F. Jourdain and J. Adhémar, *Toulouse-Lautrec*, 1954, p. 57
D. Cooper, *H. de Toulouse-Lautrec*, 1955, p. 110, repr. in colour, p. 111
MGD P464

223 *Alone* 1896

Seule
sbr. H. T. Lautrec oil on board 31×40 cm/$12\frac{1}{4} \times 16$ ins
Lent by Mrs Florence Gould, USA

Together with his friend and fellow student at the Atelier Cormon, Emile Bernard, Lautrec used prostitutes as subjects from the mid-1880s. Between 1892 and 1895 he lived in various Paris brothels, collecting material for paintings such as *In the Salon of the rue des Moulins* (1894, P559) and for lithographs, the most famous of these being the series *Elles*, published in colour in 1896. As in *Alone*, Lautrec's approach to prostitution was neither that of a moralizer nor that of a voyeur. This painting gives a seemingly dispassionate record of the woman laid across the bed, exhausted, dressed only in her stockings and a chemise, but Lautrec did not share the uninvolved, aloof approach of Naturalists such as Zola, the Goncourts and Huysmans. Rather, perhaps because he felt an affinity with these outcasts of society, Lautrec treats his subject matter with sympathy and understanding.

Despite the introduction of colour into this painting, the dominance of the schematic graphic outline relates it to a preliminary drawing and to a lithograph called *Lassitude – Woman On Her Back – Farniente* (G. Adriani, *Toulouse-Lautrec, das gesamte graphische Werk*, 1976, no. 120), published in *La Plume* (May 1896) and in *Le Courrier Français* (3 May 1896). This lithograph, while extending the space of the bedroom on the left of the composition, retains the image and the mood of Lautrec's painting. M.A.S.

REFERENCES
M. G. Dortu, M. Grillaert and J. Adhémar, *Toulouse-Lautrec en Belgique*, 1955, p. 24
MGD P635

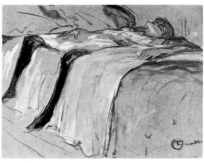

223

224 *Woman Doing Her Hair* c. 1896

Femme qui se coiffe
ns. oil on board 68.5×53.5 cm/27×21 ins
Lent by Louis Franck, Chalet Arno, Gstaad

Like *Alone* (no. 223), and the lithograph album *Elles* (1896), *Woman Doing Her Hair* seems to be based on material collected by Lautrec in 1892–5, when he was living in various brothels in Paris. This study is related to another painting, *Woman Putting On Her Corset* (P617), which Lautrec used as the basis for Plate IX of *Elles* (G. Adriani, *Toulouse-Lautrec: das gesamte graphische Werk*, 1976,

no. 186). However, here the composition has been reversed, the woman's pose changed, and the man has become a more active participant. The man cannot be identified, but in *Woman Putting On Her Corset* and the lithograph an identity for the onlooker has been suggested: in the painting it is Charles Conder, a close friend of Lautrec (cf. no. 283), in the lithograph possibly Oscar Wilde (cf. Musée d'Ixelles, *Henri de Toulouse-Lautrec*, 1973 [102]).

The theme of a man watching a woman at her toilette had been handled by Manet in *Nana* (Kunsthalle, Bremen; rejected at the 1877 Salon), and by Degas in no. 60. However, in the present picture, the admirer is no longer a mere observer, but is stretching out to touch the woman with a proprietary gesture. M.A.S.

REFERENCE
Not in MGD
1935, Brussels, Palais des Beaux-Arts, *Toulouse-Lautrec* (93)

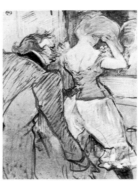

224

225 *Messaline Seated* 1901

Messaline assise
[repr. in colour on p. 108]
stamped bl. HTL 96×77.5 cm/$38\frac{1}{2} \times 31$ ins
Lent by the Henry and Rose Pearlman Foundation

The artist presents from a position in the wings of the Opera House in Bordeaux a moment from de Lara's opera, *Messaline*. The painting belongs to a group of six (P703–8) which Lautrec executed of various scenes from this opera during the winter of 1900–1. Departing from his usual practice of returning to Paris at the end of the summer Lautrec stayed in Bordeaux that year. Here, according to his letters, while being kept financially on a very tight string, he was captivated as much by de Lara's opera and Offenbach's operetta *La Belle Hélène* as he was by his more usual haunts of brothels and café-cabarets.

In his letters from Bordeaux, it would appear that this painting and its five companion pieces were not necessarily accurate records of the production at the Bordeaux Opera House that season. Lautrec wrote to Joyant early in December 1900, asking for 'any photographs, good or bad', of *Messaline* (quoted Mack, p. 356) and on 23 December he eagerly requested Joyant to send him 'the programmes and the texts of *L'Assommoir* and *Messaline*' (quoted pp. 356–7). This combination of immediate visual observation and images of past productions, together with the unnatural viewpoint and the carefully harmonized colours, suggest that, as in so many of Lautrec's theatre and café-cabaret pictures, he was primarily concerned with the evocation of the theatrical or musical mood of the scene rather than the exact transcription of the event. M.A.S.

REFERENCES
T. Duret, *Toulouse-Lautrec*, 1920, p. 122
M. Joyant, I, pp. 236–7, 300; II, p. 38
F. Jourdain and J. Adhémar, *Toulouse-Lautrec*, 1952, p. 130
D. Cooper, *Henri de Toulouse-Lautrec*, 1955, p. 47, repr. in colour p. 151
MGD P705

Valtat, Louis 1869–1952

Born in Dieppe, Valtat studied under Moreau at the Ecole des Beaux-Arts *c.* 1892, and came in contact with Nabi circles and with Lautrec in Paris in the early 1890s. He worked with Maillol, and collaborated with Lautrec on a decorative scheme, *c.* 1895. From 1894 he painted much in the south, settling at Anthéor in 1899, and painted with Signac at Saint-Tropez in 1903–4. In the south he evolved an increasingly brightly coloured landscape style. He exhibited at the Indépendants from 1894 and at the Salon d'Automne from 1904.

226

226 *The Red Rocks at Anthéor* *c.* 1901

Les Rochers rouges à Anthéor
sbr. L. Valtat 65 × 80 cm/25½ × 31½ ins
Lent by the Musée des Beaux-Arts, Besançon

Valtat was one of a number of artists, not closely allied to any particular group, who in the later 1890s were painting in a bold and varied manner which combined the lessons of Impressionism with those of Gauguin and his followers. His colour was often bright, and his brushwork reflected sometimes the flattened planes of the Nabis, sometimes the divided touch of the Neo-Impressionists. After 1900, perhaps as a result of the Bernheim Jeune Van Gogh exhibition in 1901, a greater animation came into his handling. Between 1901 and 1905 Valtat painted a sequence of Mediterranean coastal scenes. One of these, a canvas very like *The Red Rocks at Anthéor*, was reproduced in *L'Illustration* in 1905 in its famous display of Fauve paintings from the Salon d'Automne (repr. Elderfield, *Fauvism*, p. 44), although in it Valtat was using a manner which he had evolved several years before Matisse and Derain had begun to work in pure colour (on Valtat's relations with the Fauves, cf. Elderfield, *Fauvism*, pp. 24–9).

In *The Red Rocks*, the residual influence of Monet is clear – there are echoes of the animated brushwork of the Belle-Isle storm paintings (cf. no. 138) and the heightened colour of his southern canvases (cf. no. 139). However, the rippling movements of the brush in the rocks echo Van Gogh (cf. no. 106, exhibited at Bernheim Jeune in 1901). The dominant colour of the foreground rocks is derived from the startling local colours of the area, the Esterel mountains between Cannes and Saint Raphael – an intense orange-red which stands out against the blue sea. However, Valtat has used this as a basis for free improvisation, particularly in the startling points of rich green among the rocks. J.H.

Vernier, Emile 1829–87

Vernier trained with Colette and made his début at the 1857 Salon. As a painter he soon gained a reputation as a specialist in rural and marine scenes, most of which were drawn from Brittany and Normandy (e.g. *The Fishermen's Return to Saint-Yves Carmonale*, Musée des Beaux-Arts, Arras; *Chapel at Concarneau*, Musée des Beaux-Arts, Narbonne). Vernier was also highly acclaimed as a lithographer.

227 *The Harbour at Concarneau* *c.* 1880

Le Port à Concarneau
sbl. Emile Vernier oil on panel 48 × 64.5 cm/19 × 25½ ins
Lent by a Private Collector

This painting seems to date from the early 1880s. Its bright palette and sparkling light put it among those Salon landscapes which exhibited greater naturalism combined *c.* 1880 with the use of a modified Impressionist technique. Compared with Cottet's port scenes of the 1890s (nos 51–2), Vernier's view of the harbour lies within a more picturesque tradition.

In 1836 Jacques Cambry had suggested that painters and poets should draw inspiration from Brittany, since it was 'the most rural and the most picturesque region in France' (*Voyage dans la Finistère*, p. 396). Untouched nature, the varied landscape, the temperate climate which allowed a long summer sketching season, the

227

costume peculiar to the region, and the particular qualities of the light were all aspects of Brittany illustrated from 1838 onwards by such 'picturesque' artists as Leleux, Boudin, Dureau, Feyen and Breton. By the mid-1870s these picturesque qualities were largely responsible for the development of the international artists' colonies at Cancale, Douarnenez, Pont-Aven and Concarneau. M.A.S.

Vlaminck, Maurice de 1876–1958

A novelist and racing cyclist before he became an artist, Vlaminck turned to painting under the inspiration of the Van Gogh exhibition at Bernheim Jeune in 1901, though he may have begun to paint in 1900 after meeting Derain. He was self-taught, and evolved his Fauve style with Derain at Chatou in 1904–5, and from the paintings which Derain and Matisse executed in summer 1905.

From *c*. 1907, under the influence of Cézanne, he turned to more subdued colour, and evolved the sombre expressive landscapes of his later years. He showed with the Indépendants and the Salon d'Automne from 1905, and always lived around Paris.

228

228 *The Kitchen (Interior)* 1904/5

La Cuisine (intérieur)
sbl. Vlaminck 65 × 54 cm/25½ × 21¼ ins
Lent by the Musée National d'Art Moderne –
Centre Georges Pompidou, Paris

The Kitchen is exceptional among Vlaminck's Fauve work in its use of flat colour-planes rather than his characteristic broken, dynamic handling; here, for once, the lessons of Gauguin and the Nabis predominate over those of Van Gogh. The colour is strong and schematic, though without the pure primaries which Vlaminck probably adopted only after seeing Matisse's and Derain's paintings from Collioure in the autumn of 1905 (cf. nos 131, 73).

Little of Vlaminck's work survives from before 1904, when he began to paint regularly, often in Derain's company, in and around Chatou. His development presents great problems of dating: *The Kitchen* was not exhibited until spring 1906, but it was probably painted rather earlier than this. Its simple planes, and its colour – resonant, yet darker in some areas and without clear primaries – are reminiscent of Derain's work in winter 1904–5, such as *The Old Tree* (Musée National d'Art Moderne, Paris). The theme of *The Kitchen*, a complex interior space, is unusual for Vlaminck, but echoes Matisse and Derain, as well as Vuillard (cf. nos 130, 72, 239). J.H.

EXHIBITION
1906, Paris, Indépendants (5100)
REFERENCE
J. Elderfield, *Fauvism and its Affinities*, 1976, p. 154, n. 43

Vuillard, Edouard 1868–1940

Educated at the Lycée Condorcet where he met Lugné-Pöe, Denis and Roussel, Vuillard was initially destined for an army career, but enrolled at the Ecole des Beaux-Arts in 1887, studying first under Maillart and then under Gérôme, and subsequently at the Académie Julian. He was quickly absorbed into the recently formed Nabis, and established a close friendship with Bonnard. He selected his subject matter from contemporary domestic scenes, and his activities during the 1890s reflect his membership of the Nabis, involving group exhibitions and work in the applied and decorative arts and for the theatre. With the disintegration of the Nabis *c*. 1900 Vuillard, like Bonnard, turned towards greater naturalism.

ABBREVIATIONS
Russell – J. Russell, *Edouard Vuillard (1868–1940)*, 1971
Mauner – G. Mauner, *The Nabis*, 1978

229 *Self-Portrait* *c*. 1890

Autoportrait
ns; atelier stamp br. L2497a oil on octagonal cardboard
36 × 28 cm/14¼ × 11 ins
Lent by a Private Collector, Paris

A comparison with self-portraits such as *Portrait of the Artist by Himself – Half-length* (Palais de Tokyo, Paris), executed some three years before this painting in a naturalist style similar to Sérusier's *Breton Weaver* (no. 186), demonstrates how far Vuillard has moved away from a concern with the accurate observation of the external world. While the application of decorative pointillist brushwork around the head of the artist links this portrait to his *The Stevedores* (no. 231), in the abrupt transition between light and shadow and the bold application of flat areas of non-naturalistic colour in this portrait foreshadows such tautly decorative paintings as *The Reader* (no. 230). However, the *Self-Portrait* should not necessarily be regarded as a serious investigation of the decorative distortion of nature which marks the Nabis' painting after the appearance of Sérusier's *The Talisman* (no. 187), when it may be no more than a light-hearted demonstration of the variety of pictorial techniques employed by the group at this date.

The two rectangular variants of this painting (Mr and Mrs Leigh Black Collection, Chicago, and Mr and Mrs Sydney F. Brody Collection, Los Angeles) both lack the decorative pointillist detail. M.A.S.

REFERENCES
J. Salomon, 1961, p. 29
Paris, Orangerie, *Edouard Vuillard, K.-X. Roussel*, 1968 (11)
Mauner, p. 210

229

230

230 *The Reader* *c*. 1890

Le Liseur
ns; atelier stamp bl. L2497a oil on board
35 × 19 cm/13¾ × 7½ ins
Lent by a Private Collector, Paris

Although the position of the sitter is similar to that found in the *Portrait of Lugné-Poë* (no. 234), the technique is slightly less taut. If, as has been suggested (Paris 1968), *The Reader* is really a portrait of Ranson, it is likely that the painting was executed while Vuillard was using Ranson's atelier, the Nabis' 'Temple', in 1890.

In a painting entitled *Dinner-time* (1889, Museum of Modern Art, New York) Vuillard had already introduced the strong, blue, bounding line used in Bernard's and Gauguin's work, which he would have seen in 1889 at the Café Volpini exhibition, but not a feature of Sérusier's *Talisman* (no. 187). The presence of the bounding line in both this painting and the portrait of Lugné-Poë illustrates Vuillard's interest in Gauguin's innovatory style, but it was to disappear almost entirely from his work after 1893. M A.S.

REFERENCE
Paris, Orangerie, *Edouard Vuillard , K.-X. Roussel*, 1968 (12)

232 233

231 *The Stevedores* c. 1890

> *Les Débardeurs*
> [repr. in colour on p. 109]
> sbr. E. Vuillard 45 × 61 cm/17¾ × 24 ins
> Lent by Arthur G. Altschul

At about the same date that Denis was executing his *Catholic Mystery* (no. 65). Vuillard appears to have produced a small group of paintings (cf. no. 229) which employ the Neo-Impressionists' dot technique in a similar decorative manner. Vuillard's initial contact with Neo-Impressionism may have come through his friendship with Cross and Léo Gausson; Gausson had adopted the technique in 1886 and was included in the first group exhibition at Le Barc de Boutteville in 1891. However, although it has been suggested that the organization of the composition into horizontal bands may owe something to the late landscapes of Seurat, and the subject matter may derive from Guillaumin (cf. no. 107) and Signac's scenes of industrial labour along the Seine, Vuillard has organized his dots into a sparse pattern painted over flat colour areas, which completely obviates any attempt to achieve a naturalistic representation of light according to the principles of optical mix. M A.S.

REFERENCES
J. Salomon, *Vuillard admire*, 1961, p. 26
New York, Guggenheim Museum, *Neo-Impressionism*, 1968 (119)
Russell, pp. 21, 226, pl. 1, repr. in colour

232 *The Landing, rue de Miromesnil* 1891

> *Le Palier, rue de Miromesnil*
> sdtr. e. vuillard 91 40.5 × 23 cm/16 × 9 ins
> Lent by Mrs Samuel Godfrey

This view across a landing, with a scarcely perceptible figure in the background, depicts no. 10 rue de Miromesnil, where the Vuillard family was living. It is related to a group of paintings (e.g. *The Two Doors*, *The Open Door*, both Private Collection, Paris) in which Vuillard repeatedly pierces flat wall surfaces with concentrated areas of recession. At the same time, the emphasis on the decorative surface of the painting creates a permanent tension between pattern and perspective. This ambiguity of image may owe something to fifteenth-century tapestries, which Vuillard and other Nabis, especially Maillol (cf. no. 123) and Ranson (cf. no. 164), greatly admired. M A.S.

REFERENCES
Russell, p. 226, no. 11, repr. in colour
Mauner p. 258

233 *Little Girls Walking* c. 1891

> *Filles se promenant*
> sblc. E. Vuillard 81 × 65 cm/32 × 25½ ins
> Lent by a Private Collector, Switzerland

The variety of patterned areas, achieved by the quiet emphasis upon the designs of the girls' dresses and stockings and the interplay of greens on the shrubs on the right-hand side, relate this picture to the contemporary work of Bonnard (cf. no. 28) and Roussel (cf. no. 181). However the intimacy of the two girls, the merging of figures into the background and the subtlety of the colour harmonies are unmistakable hallmarks of Vuillard's oeuvre. M A.S.

REFERENCE
Russell, p. 228, no. 5

234 *Portrait of Lugné-Poë* 1891

> *Portrait de Lugné-Poë*
> sdbl. EV 91 oil on paper mounted on panel
> 22 × 26.5 cm/8¾ × 10½ ins
> Lent by the Memorial Art Gallery of the University of Rochester, Gift of Fletcher Steele

Lugné-Poë's friendship with Vuillard, dating from their days together at the Lycée Condorcet, brought him into the circle of the Nabis while Lugné was still a pupil at the Conservatoire. He shared a studio with Vuillard, Bonnard and Denis in 1891, the year in which this portrait was probably painted. Studiously avoiding all possibility of immediate recognition, the portrait nevertheless marks the close relationship between artist and sitter. By 1889, Lugné-Poë had embarked upon what proved to be a highly successful career in the theatre, first as an actor with Antoine's Théâtre Libre, and then, after 1891, as the co-founder and actor-manager of two leading Symbolist theatres, the Théâtre d'Art and the Théâtre de l'Oeuvre. In all three capacities he played an important role in the Nabis' fortunes during the 1890s, publicizing their work and ideas on art by exploiting his contacts with the literary and theatrical avant-garde

234

of Paris. With Jean Julien he arranged for the publication of Denis' group manifesto, 'Définition du néo-traditionnisme' in the August 1890 issue of *Art et critique*. He encouraged his actor-friends, such as Coquelin *cadet*, to become early patrons and in August 1891 he himself wrote an enthusiastic review in *Art et critique* of the Nabis' first group exhibition, held at the Château de St Germain-en-Laye.

Lugné-Poë also involved the Nabis directly in work for the theatre. After securing Vuillard a commission for a poster for the Théâtre Libre in 1890, Lugné-Poë requested other Nabis to design programmes and non-naturalistic sets for productions of plays by Maeterlinck, Rimbaud, Ibsen and de Gourmont at the Théâtre d'Art and the Théâtre de l'Oeuvre. On a general level this involvement with theatre design complemented the Nabis' interest in painting as decoration, further exercised in Vuillard's decorative panels, and Denis' *April* (no. 69), and paralleled their own involvement with puppet-theatres (cf. Sérusier, no. 192). Vuillard was perhaps the most deeply involved in Lugné-Poë's theatrical enterprises; together with Camille Mauclair he was invited to be co-founder of the Théâtre de l'Oeuvre in 1893, and to take responsibility for virtually all the programme designs and most of the sets for the new theatre's first season, a control which seems to have kept the designs rigorously Symbolist. Vuillard, assisted by Lautrec, also decorated the new offices of the Théâtre de l'Oeuvre when it moved from 23 to 22 rue Turgot in 1896. M.A.S.

EXHIBITION
1893, autumn, Paris, Le Barc de Boutteville, *Portraits du prochain siècle*
REFERENCES
Russell, p. 228, no. 6, pl. 6
Rochester, University Memorial Art Gallery, *Treasures from Rochester*, 1977, p. 78
Mauner, p. 130

235

235 *The Outspoken Dinner Party (After the Meal)* c. 1891

Le Dîner vert (Après le repas)
sbr. E. Vuillard 34 × 49 cm/13½ × 19¼ ins
Lent by the Hon. John Montagu

This painting depicts, from left to right, Mme Michaud, Marie Vuillard, Alexandre Vuillard and Vuillard's mother at dinner. It was probably not painted from life, but perhaps with the aid of Vuillard's Kodak camera. It probably dates from 1891 since the handling of Marie's dress is related to that of the girl in *Woman in a Check Dress Darning a Stocking* (Palais de Tokyo, Paris), firmly dated to 1891.

The small-scale, domestic character of this painting initially seems to place it outside the context of the Pictorial Symbolism which Vuillard's fellow Nabis had inherited from Gauguin. However, reference to the current interpretations given to similar subject matter in Ibsen's plays suggests otherwise. Both Count Prozor, in the preface to his translation of Ibsen's *The Doll's House* (1889) and Maeterlinck, in a long article on the March 1893 production of *The*

Master Builder at the Théâtre de l'Oeuvre ('Solness, le constructeur', *Le Figaro*, 2 April 1893), pointed out that Ibsen intended his sequences of mundane, domestic events to be read not as Naturalistic description but rather as symbols. Indeed, Maeterlinck went further. He saw an affinity between contemporary developments in music and painting and the theatre of Ibsen. The absence of detailed action in Ibsen's plays revealed the 'serious tone and tragic secret hidden within everyday life', in the same way that the consciously distorted representation of the external world in recent avant-garde painting draws attention to the greater spiritual meaning within the physical appearance of objects in nature. Given Vuillard's interest in Ibsen throughout the 1890s, (he designed sets and programmes for the March 1893 production of *The Master Builder*), it seems reasonable to suppose that paintings such as this one and *Madame Vuillard Sewing* (no. 237), described as intimist paintings, have a more symbolic intention rather than being mere exercises in light, patterned surfaces and the evocation of everyday life. M.A.S.

REFERENCE
Russell, p. 226, no. 111, repr. in colour

236 *Mother and Sister of the Artist* c. 1892

Mère et soeur de l'artiste
sbr. E. Vuillard 46.5 × 56.5 cm/18¼ × 22¼ ins
Lent by the Museum of Modern Art, New York,
Gift of Mrs Sadie A. May 1934

Mauner has suggested that this painting should be dated to 1892 rather than the following year, on the grounds that it belongs to a series of paintings (e.g. Winterthur, and National Gallery of Scotland) and drawings (e.g. one published in 1892 in the *Livre d'art*) in which mother and daughter co-exist in a silent space. Although not entirely uniform in style, these pictures tend, as in this example, to show the daughter melting into a patterned background while the mother is represented as a solid, monumental form. The painting does not invite immediate iconographic interpretation, but Vuillard's involvement with Symbolist writers suggests that it may represent the contrast between the transitory, in the form of the frail daughter, and the eternal, in the form of the solid, static mother. This interpretation is echoed in Maeterlinck's views on the transitory and eternal qualities of life to be found within the context of the 'Home', views which must have been known to Vuillard since he had been involved in the stage sets of both Maeterlinck's *L'Intruse* (Théâtre d'Art, May 20 and 21 1891) and his *Les Sept princesses* (puppet theatre performance, March 22 1891). The writer and critic Albert Aurier, in an article in the *Revue encyclopédique*, April 1892 ('Les Peintres symbolistes'), also recognized the poetic meanings within Vuillard's representations of domestic interiors. M.A.S.

REFERENCE
Mauner, pp. 260–1, fig. 142

236

237 *Madame Vuillard Sewing* 1895

Madame Vuillard cousant
[repr. in colour on p. 110]
sdbc. E. Vuillard '95 oil on board 32 × 36 cm/12½ × 14¼ ins
Lent by a Private Collector, England

The lamp under which Madame Vuillard sits, engaged in her work as a dressmaker, provides the colour key for the quiet harmonies of this painting and the light and shadow source which sets up the interplay between plane and depth found also in *The Landing, rue de Miromesnil* (no. 232). While Vuillard shared an interest in concentrated light sources with Bonnard and Vallotton (cf. no. 273), this feature was recognized at an early stage as a distinctive characteristic of his own work. Gustave Geffroy, reviewing the 3rd Le Barc de Boutteville exhibition of 1892 (*La Vie artistique*, II, 1893, p. 372), noted the use of lamplight to create a 'magical, startling effect' in an otherwise quiet painting. Alfred Jarry (*L'Art littéraire*, January–February 1894, p. 21), in a review of Vuillard's sets for Hauptmann's *Ames solitares* (Théâtre de l'Oeuvre, 13 December 1893), also drew particular attention to the dramatic effect of actors caught in pools of intense light cast by green lamps set on red tables.

Vuillard intended to convey more in his paintings with lamps (cf. no. 235) than mere pattern and light. Light appears to have come to symbolize for him the emotions concealed beneath the surface of the objects and settings of an ordinary domestic interior. This interpretation was endorsed by Albert Aurier when he quoted a stanza from Verlaine's 'La Bonne chanson' as a literary counterpart to Vuillard (*Revue encyclopédique*, April 1892):

> The home, the narrow beam of the light of the lamp,
> The dream, with fingers placed against the temples
> And the eyes which lose themselves within those of the loved one,
> The hour of steaming tea and closed books,
> The sweetness of sensing the end of the day,
> The pleasant weariness and the longed-for wait
> For the nuptial shadow and the sweet night. . . .

M A.S.

238 *Seated Woman* c. 1901

Femme assise
sbr. E. Vuillard oil on board mounted on panel
77.5 × 51 cm/30½ × 20 ins
Lent by a Private Collector, USA

Though quiet and unassuming, this painting illustrates Vuillard's view, expressed in a letter to Maurice Denis dated 19 February 1898 (Denis, *Journal*, I, p. 136), that the subject matter of a painting should be subordinate to the ideas which the artist wishes to express. The success or failure of a painting rests on the artist's ability to manipulate his subject matter to achieve this aim.

A greater degree of naturalism relates this painting to the tendency in Vuillard's work after 1900 (cf. no. 239). However, the spatial ambiguity of the view through the door on the left, the walls, the patterned carpet and the solid chimney breast, set beneath the mirror and its reflections, recalls Vuillard's series of interior views, such as no. 237, as well as some of the plates, e.g. *Interior with a Hanging Lamp* (pl. IV) and *Pink Interior III* (pl. VII), in the volume of colour lithographs, *Landscapes and Interiors*, commissioned by Vollard in 1899. M A.S.

238

239 *The Red Mantelpiece* c. 1905

La Cheminée rouge
[repr. in colour on p. 236]
sdbr. E. Vuillard 1905 51.5 × 77.5 cm/20¼ × 30½ ins
Lent by the Trustees of The National Gallery, London

This painting illustrates an even greater involvement with naturalism than no. 238. To this extent, it represents Vuillard's solution to the dilemma inherent in the Nabis' programme of the 1890s. Building on Literary Symbolism and the works of Gauguin and Bernard, the Nabis had adopted the belief that the new subject of art, the Idea, demanded a new visual vocabulary, namely the 'deformation' of nature (cf. nos 187, 66). But this new art-form also entailed the destruction of all objective criteria for measuring excellence in a work of art; instead, a painting could only be successful if it were innovatory. Even by 1895, the Nabis seem to have found difficulties in this constant pressure to innovate, and they sought a resolution through a return to more established criteria. Denis and Roussel (cf. nos 71, 183) returned to the classical ideal, Sérusier and Verkade to the mathematical mystical systems of the Beuron School, and Vuillard and Bonnard (cf. no. 34) to nature.

A move towards greater naturalism had been suggested by Maurice Denis in the preface to the 9th Le Barc de Boutteville exhibition in April 1895. However, it was not until 1897 that Denis first indicated Vuillard's move in that direction. In a journal entry dated autumn 1897 (*Journal*, I, p. 120), Denis expressed concern that Vuillard was looking too much at nature and thus failing to comprehend the Idea within nature. The result, he felt, was an incomplete art. The *Anet Panels* of 1898 (Private Collection) suggest a closer relationship to nature, but only after 1900, in paintings such as no. 238 and *The Red Chimney*, can the full implications of this move away from the Symbolist programme laid down in Denis' 'Définition du néo-traditionnisme' of 1890 be properly observed. M A.S.

REFERENCE
London, National Gallery, *French School, 19th Century*, catalogue by M. Davies and C. Gould, 1970, p. 142

Germany, Norway and Switzerland

Idealism and Naturalism in Painting

Norman Rosenthal

'Post-Impressionist schools are flourishing, one might say raging in Switzerland, Austro-Hungary and most of all Germany. But so far as I have discovered they have not added any positive element to the general stock of ideas.' These words are Roger Fry's, in his introduction to the catalogue of the 2nd Post-Impressionist Exhibition held in London in 1912. The show included English and Russian paintings hung next to masterpieces by Cézanne and Gauguin, Picasso and Matisse. Fry was expressing the prejudice of the English against foreign art that was not French, and made an exception only for Russia. He was right to say that Post-Impressionism was 'raging' in Germany, and, allowing for the looseness of the term, it had been since the 1880s. Centres, responding in many different ways to impulses coming from France, were to be found in almost every sizeable German city, in Munich and Berlin, Düsseldorf and Hamburg, and also in smaller towns such as Weimar, Darmstadt and Dresden. Each had its individual artistic characteristics.

Germany, politically united since 1870 under the Prussian monarchy, remained in many ways culturally fragmented, and although Berlin was to play an increasingly important and aggressive role in the art life of Germany in this period, it was never the undisputed centre as was Paris or London. This diffusion makes the history of painting in Germany in this period more complex and fuller of internal contradictions than that of France. It is no coincidence that the history of Impressionism and Post-Impressionism in France has been discussed and understood either in terms of technical mastery and innovation, or as a product of the life of the artist and his interaction with his friends,[1] while art in Germany has often been viewed as a symptom of the cultural, even political world in which it was created.[2] Few systematic studies of individual artists exist. Even in the case of Edvard Munch, the best known and most studied of the artists under consideration here, the catalogue raisonné, which alone can give a complete survey of the artist's work, is lacking. German painters such as Liebermann, Corinth, Slevogt, and many other artists working in Germany have been less studied, and the difficulty in getting an overview is greater.

Impressionism had a strange history in Germany; indeed it is arguable that the very expression is misleading. Although artists like Manet, Renoir and Monet were well known by the end of the century (no. 135 was probably the first painting by Monet to be bought for any public collection), their direct influence on the so-called Impressionist artists in Germany was not profound. Liebermann, for example, evolved his style partly through his admiration for German realists such as Wilhelm Leibl, who in turn had derived much through contact with Courbet,[3] and the direct foreign influences on his stylistic evolution were from the quiet naturalism of the Barbizon and Hague Schools. He visited Barbizon in 1874 to be near Millet and in the 1880s he spent several summers in Holland working with Jozef Israels. The German painters who visited Paris in the 1880s knew little of their French Impressionist contemporaries, with the possible exception of Manet. Not until Neo-Impressionism is there a clear and unambiguous link with France in German painterly technique, and even this was in the first instance mediated by the Belgian Henri Van de Velde (1863–1957), before being transmitted to artists such as Paul Baum (1859–1932), Christian Rohlfs (1849–1938) and Curt Herrmann (no. 249). What is known as German 'Impressionism' has its roots partly in the early paintings of the Berlin artist Adolf Von Menzel (1815–1905), and partly in the work of realists based in Munich in the 1860s and 1870s – Wilhelm Leibl, Hans Thoma and Wilhelm Trübner. However strands of Symbolism and Idealism derived from Romantic sources were never far from the surface in the 1880s. Artists such as Arnold Böcklin (1827–1901) and Hans Von Marées (1837–1887) were the admired though often controversial models who exerted an influence not dissimilar to that of Puvis de Chavannes in France. The younger generation in the 1880s thus had to contend with huge stylistic contradictions which were not resolved until the very end of the century.

In addition to these stylistic contradictions there were also social pressures. The Impressionists and Post-Impressionists in France initially reached a relatively narrow public, while the German painters, like larger fish in smaller ponds, became the focus of considerable attention if they were reasonably talented! Liebermann, for example, played an active role in society from an early age, founding exhibiting institutions and mixing with the new social and economic elites that were rapidly developing in Germany. Academic painters such as Anton Von Werner (1843–1915) and their champions in the establishment opposed the 'Impressionists' and Kaiser Wilhelm II personally denounced their work as *Freilichtmalerei* (open-air painting). One of these

painters was Corinth, who demonstrates this tension between naturalism and Idealism in his exuberant *The Childhood of Zeus* (no. 245). It represents his own wife and son – a typical Wilhelmine family – but faintly disguised in a mythological setting. Only two artists resolved this contradiction between modern life and myth that was the fundamental artistic search in the 1880s and 1890s. Neither painter was German. Both, however, played an influential role in Germany and found their most important platforms there. They were a Norwegian, Munch, and a Swiss, Hodler.

Munch is the only northern artist of this period who has gained a comparable international status to the great Post-Impressionists working in France. His importance lies in his creation of a shocking and archetypal image of an alienated northern European society, which has obvious affinities with the work of Strindberg and Ibsen, two great Scandinavian writers who, like Munch, extracted a universal mythic potential out of their bourgeois Scandinavian milieu. All three were first acclaimed abroad in Germany. Munch's landscapes, interiors and portraits all reflect that dark enclosed environment where physical and spiritual light were at a premium. Although Munch was recognized as a talent in Norway at an early age, it was in Germany that he found a large enough stage from which to make his first major contribution to European painting. Like painters from all over Europe he studied in Paris, where, in the late 1880s, he saw the work of the Impressionists and Post-Impressionists, quickly absorbing the lessons of their art. After a brief period in which his work reflected the objective approach of the Impressionists (as in *Rue Lafayette*, 1891, National Gallery, Oslo), he developed a bold colouristic symbolism influenced by the work of Gauguin and his circle, which he used to convey scenes full of psychological drama.

In 1892, Munch, who had just had his second one-man exhibition in the Norwegian capital, Christiania, was invited to exhibit at the Verein Berliner Künstler (Association of Berlin Artists), the principal exhibiting society in Berlin for those artists working in a 'realist-impressionist' manner. His paintings were publicly announced as '*Ibsen'sche Stimmungbilder*' (Ibsenish mood paintings).[5] They caused a critical outrage – the first of several that Munch was to provoke when his pictures were shown in various parts of Germany. These works played an important part in encouraging German artists to experiment with new styles and techniques. The members of the Verein, shocked by the *succès de scandale* in the press which marked the appearance of the paintings at the exhibition, voted by 120 to 105 to have the pictures removed. Munch had his defenders, among them Liebermann and the art critic Julius Meier-Graefe, who more than any other critic was responsible in this period for supporting every stylistic development in painting and the applied arts as it arose, whether from France, from England or within Germany itself. Munch's supporters even included a few rich young collectors. Encouraged by his *succès de scandale*, he decided to settle in Berlin where he soon found a place in the intellectual circle around Strindberg and the Polish Decadent novelist Stanislaw Przybyszewski. In his paintings and prints Munch began a period of intense

creative activity, and conceived many themes that were to recur throughout his life, including the *Frieze of Life*, a cycle on love and death, of which *Ashes* (no. 264), *Puberty* (no. 265), *Jealousy* (no. 266) and *The Scream* (1893, National Gallery, Oslo) form a part. He stayed in Berlin only until 1895, though he continued to exhibit there regularly. But this short period was arguably the most important of his career.

Like Munch, Ferdinand Hodler came from a geographical environment that was isolated and mountainous. In Switzerland as in Norway, there was a tradition which went back to the eighteenth century of a sublime approach towards landscape painting, with the mountains and lakes providing the perfect subject, but by *c.* 1880 the artistic climate in both countries was dominated by realism. By the end of the 1880s, Hodler, as a result of a religious experience which almost caused him to enter the church, began to transform the realistic approach of his early paintings, developing an increasingly complex symbolism in a series of very large canvases, symmetrical and rhythmic, which can be compared to Munch's cycles on the themes of life and death. In the most famous of them, *Night* (1891, Kunstmuseum, Berne), the various aspects of sleep – nightmares, dreams, love and rest – are emblematically represented. These paintings are religious, but not in any Christian sense. Rather they are manifestations of beauty, purity and redemption through art – altarpieces of a new personal faith. In *Eurhythmy* (1895, no. 250) a frieze of old men move slowly across the canvas. Their stylized gestures have something in common with the dance movements evolved by teachers such as Emile Jacques Dalcroze, with whom Hodler later became friendly. The painting represents a contemplative search, full of tragic implications, for spiritual equanimity. It is a search for an alternative to the positivist and materialist world which dominated the culture of late nineteenth-century Europe.

After showing *Night* in Switzerland, Hodler took it with him to Paris, where it was accepted in 1891 at the Société Nationale by a jury which included Puvis de Chavannes, Dagnan-Bouveret and Roll. Hodler also exhibited at the Salon de la Rose+Croix in 1892. However, it was in Germany at various Secessionist exhibitions that he achieved his greatest success. *Night* was exhibited in Berlin in 1894, and in 1897 it and *Eurhythmy* won a gold medal at the Munich Glasplast. From the 1890s onwards Hodler was receiving commissions to decorate town halls, universities and museums, first in Switzerland, and then in Germany.

In addition to his murals and large canvases, Hodler also evolved a manner of treating landscapes, of which one of the earliest mature examples is *Lake Geneva from Chexbres*, 1895 (no. 251). These landscapes of the mountains and lakes of Switzerland also express the unity, balance and permanence of the universe. The parallels between them and Cézanne's landscapes have often been drawn; in 1913 the well-known German art critic Fritz Burger made this comparison the subject of a book entitled *Cézanne und Hodler*.[6] Both artists monumentalized the forms of rocks, mountains and lakes, ignoring the human presence, but Cézanne focused on the coloured nuances in the scene as a means of suggesting form

and space and ultimately reality, while Hodler created a heightened reality through precision of line and the elimination of aerial perspective.

Whereas Munch and Hodler aimed to create a sublime yet modern thematic repertoire, the aims of many of the most interesting German artists in the 1880s and 1890s were more modest in their interpretation of subject matter. The generation of Idealist painters, Hans Von Marées and Böcklin, were rejected in Germany by many of these modernists who supported the Impressionist movements. The opposition was illustrated in the controversial attack by Meier-Graefe (the principal supporter of the Impressionists in Germany) on Böcklin in 1905, called *Der Fall Böcklin* (*The Case of Böcklin*), in which he called Böcklin's paintings irrelevant to reality as well as fanciful and 'wrong' in technique.[7] However, Idealist strands continued, for example in the work of Max Klinger, and particularly in Munich in the work of Stuck and Heine. Their decorative style and representation of erotic decadence contrast with the more philosophical seriousness of Munch or Hodler.

Many of the most interesting German painters were in search of a more direct naturalism. Amongst them were three artists represented here, Liebermann, Corinth and Slevogt, who became the advanced artistic establishment in Berlin during the 1890s, and ultimately its leading Secessionist painters. Liebermann was a Berlin-based artist; Corinth and Slevogt originally worked in Munich, but in the late 1890s both moved to Berlin, where they found a more favourable critical reception. They evolved a realistic approach to painting through an increasingly rapid painterly handling which foreshadows some of the techniques adopted by the Brücke group.

Liebermann's earlier painting *Eva* of 1883 (no. 256), was apparently painted in a single day,[8] in spite of its strong and direct composition. The broad handling of paint and bright colour has little in common with the contemporary work of the French Impressionists, despite the open-air effects in the background. The painting possesses a pathos which is much closer to those works by Bastien-Lepage which many English painters took as their model in French art. The Dutch subjects which Liebermann favoured, and the tradition of painterly handling, looked back to two artists much admired by Liebermann and his contemporaries – Frans Hals (1580–1666) and Rembrandt (1606–69). Hals appealed on account of his brilliant technique, Rembrandt for his *Innerlichkeit* (inwardness). In 1876 and 1877 Liebermann painted a series of copies after Hals, whose influence is seen in his portraiture and in the broad, virtuoso strokes of *The Parrot Walk* of 1902 (no. 257), a picture freer in technique than *Eva*.

The values of Hals and Rembrandt were also understood in terms of their German or Nordic qualities. Holland was to be absorbed as 'Low Germany' into a pan-Germanic cultural empire which was discussed on many levels in Germany at the end of the nineteenth century.[9] Rembrandt became a potent cultural symbol. In his *Self-Portrait with Model* of 1901 (no. 244) Corinth is identifying himself both with Rembrandt and with Bismarck.[10] At this point the myth of Rembrandt and the myth that had grown around the old Iron Chancellor

of Germany had much in common. Many books appeared in Germany from the 1890s onwards with titles such as *Rembrandt als Erzieher* (1890) and *Der Rembrandtdeutsche* (1892), both by Julius Langbehn. In *Rembrandt, ein kunst-philosophischer Versuch* (1916), Georg Simmel, one of the most noted sociologists of his time, wrote of that 'expression of the spiritual' (*Ausdruck des Seelichen*) which he saw as Rembrandt's achievement. It was this which the German 'Impressionist' artists strove to combine with naturalistic observation, and which the Expressionists were later to achieve through different techniques; the concept of 'the spiritual' (*das Geistige*), which Kandinsky also made into the central element in his art and theory, was deeply rooted in German art.

In 1890 Corinth and Slevogt were in Munich, then an important art centre. Franz von Lenbach (1836–1904), who had also created Rembrandtesque portraits of Bismarck, was the most respected Munich painter at this time. The more progressive artists, led by Von Stuck, were in contact with Symbolist circles in Paris, and formed the first Secession in Germany in 1892. The artists who showed at this first exhibition included Corinth, Slevogt, Uhde and Trübner – the latter two products of the school of Leibl. Degas and Monet were also among those who were persuaded to send work from Paris. In Berlin, the storm surrounding Munch's exhibition in 1892 led to 11 artists setting up their own exhibiting organization (Gruppe XI), which formed the nucleus of the Berlin Secession, founded in 1899. Its members included Liebermann and the Symbolist artist Hofmann (no. 252). Many foreigners exhibited at the Berlin Secession, including artists as varied as Blanche, Brangwyn, Cottet, Hodler, La Touche, Luce, Monet, Pissarro, Raffaëlli, Segantini, Vallotton, Vuillard, Whistler and Rodin. The growing prominence of art dealers, such as Gurlitt and Cassirer in Berlin and Arnold in Dresden, led to the extensive exposure of the works of the Impressionists and Post-Impressionists. Van Gogh, Seurat, Cézanne and Gauguin, for instance, all became well known around the turn of the century. Their works were illustrated in periodicals and books and they achieved a mythic status a decade before they became famous in England or the United States. The influx of French Post-Impressionist paintings into Germany after 1900 paved the way for the stylistic experiments of early Expressionist painting, in which colour, drawing and subject matter became increasingly distorted, expressing a greater psychological intensity than Corinth conveyed in *The Childhood of Zeus*.

There remains one further strand of German painting to be considered. Just as in France artists from all over the world were drawn to Brittany, English artists to Cornwall, and Scottish artists to Cockburnspath, so in Germany the desire to escape from the cities found expression in artists' colonies that sprang up all over the country. Two of the most famous and artistically significant were Worpswede in the north and Dachau in the south. These colonies were not as remote geographically as Pont-Aven. Worpswede was a village about 20 miles from Bremen, itself a significant art centre, near Hamburg and the other major urban centres of

North Germany. Dachau was close to Munich. Artists from both colonies exhibited at Secessionist and other exhibitions in the cities from which they were so keen to escape. This escape into the country, where *Gemeinschaft* (community) could exist as an alternative to the *Gesellschaft* (society) of life in the city, was the basis of many literary, philosophical and artistic manifestations of the time. In 1889 Fritz Mackensen and Otto Modersohn, two painters in their early twenties, came to Worpswede from the Munich and Düsseldorf Academies in an attempt to escape from what they perceived to be the bourgeois realism of the traditional art institutions of the cities. Soon they were joined by other artists and in the winter of 1894–5 they held their first group exhibition at the Kunsthalle in Bremen, an exhibition which was then moved to the Munich Glaspalast, where their work was seen as the German equivalent of the Glasgow Boys. Birch trees, the heathland, moors and canals were the subjects of their paintings, naturalistic themes which were often combined with Jugendstil influences. This was also true of the Dachau painters, as the work of Ludwig Dill shows (no. 246). The poet Rainer Maria Rilke sought out Worpswede, as he was later to 'seek out' Rodin; he wrote poetic evocations of both artistic phenomena. He found in Worpswede the quintessential significance of northern landscape, as perfected by Jacob Ruisdael or Rembrandt. Writing of Modersohn, he spoke of the artist in the following manner:

[He is the] acknowledgment of the truth of the Rembrandt-German. For him, too, the fowl, the herring [and] the apple are more colourful than the parrot, the goldfish and orange. This is, however, no restriction but rather a difference. He does not wish to paint the southern aspect, which wears its colour on its sleeve and swaggers with it . . . Things which are inwardly full of colour, which he himself described in a manner which cannot be bettered, as the secret devotional colour of the north, are his task. We will learn to value this task and not overlook that life which tries to solve this task. It is a still deeply feeling man, who has his own myths [*Märchen*], his own Germanic nordic world.[11]

In 1898 the 23-year-old Paula Becker arrived in Worpswede where she befriended the other young artists, met Rilke in 1900, and married Otto Modersohn in 1901. However she found the work of her mentors too genre-like,[12] and sought a simplicity of form and colour, derived in part from her admiration for Von Marées and Böcklin, but more importantly from the work of Van Gogh and Gauguin which she had seen in Paris. She was thus one of the first direct transmitters to Germany of the lessons of the great French Post-Impressionists. Her paintings represent a rejection of naturalistic technique, without abandoning naturalist subject matter.

The conflict between idealism and naturalism was the central issue facing German artists of this period. Their naturalism became progressively more colourful and freer in execution until it resembled something akin to Impressionism, though it had quite different sources. But above all, the Ideal, which since the end of the eighteenth century had been the dominant strain in German art, never really deserted the work of even the most 'Impressionist' artists. Superficially there seemed to be some sort of 'international style' in European painting, *c.* 1900. In 1904 a German critic, Albert Dresdner, wrote:

Pissarro in Paris, Liebermann in Berlin. . . . Klimt in Vienna, Claus in Belgium, Breitner in Holland . . . Maljavine in Russia seem at first glance nationally and individually very different artistic personalities – only on closer examination does a quite surprising similarity in spirit, character and purpose show itself in the works of all these artists. They are recognizable as variations of the impressionist concept of art and show themselves so ruled by that concept that national differences are blurred and in some cases almost eliminated. In truth – never was art so 'un-national' as today in this epoch of the national principle.[13]

Fritz Burger did, however, perceive important national differences between French and German art. For him, the French appeared pragmatic but nonetheless firmly based in a classical tradition. The German artist, he felt, was too concerned with subject matter to develop a consistent technique: *'Er sucht den Geist in den Dingen.'* (He seeks the essence in the subject itself).[14]

Munch and Hodler were less caught up in this dilemma, perhaps because neither was German. In Germany, it was only after 1905 that the Expressionists found ways of fusing technique and content, observation and expression. However, these dilemmas had given strength to the best German art of the previous generation. Liebermann and Corinth in particular, the outstanding German painters of this generation, shared with their French contemporaries a concern to graft the lessons of naturalism on to the continuing traditions of their own national art.

NOTES

1. This approach is illustrated in two books by J. Rewald: *The History of Impressionism*, 1973, and *Post-Impressionism*, 1978.
2. In, e.g., R. Hamann and J. Hermand's series of books on late nineteenth-century German art, *Stilkunst bis 1900*, *Naturalismus*, and *Impressionismus*, 1968.
3. cf. Hamburg, Kunsthalle, *Courbet und Deutschland*, 1978–9.
4. These influences are discussed in Washington, National Gallery of Art, *Edvard Munch, Symbols and Images*, introduction by R. Rosenblum, 1978. Rosenblum draws particular attention to the influence of Gustave Caillebotte.
5. R. Heller, 'Love as a Series of Paintings and a Matter of Life and Death. Edvard Munch in Berlin 1892–1895. Epilogue, 1902', in *Edvard Munch, Symbols and Images*, p. 87.
6. F. Burger, *Cézanne und Hodler*, 1919 (3rd edn).
7. J. Meier-Graefe, *Der Fall Böcklin und die Lehre von den Einheiten*, 1905.
8. H. Ostwald (ed.), *Das Liebermann-Buch*, 1930, p. 364.
9. cf. F. Stern, *The Politics of Cultural Despair*, 1961, especially Chapter 8, 'Art and the Revolt against Modernity'.
10. Cologne, Kunsthalle, *Lovis Corinth*, 1976, p. 53.
11. R. M. Rilke, *Worpswede* in Collected Works, v, 1965, p. 87 (first publ. 1903).
12. cf. G. Perry, *Paula Modersohn-Becker, Her Life and Work*, 1979, p. 6.
13. A. Dresdner, *Der Weg der Kunst*, 1904, pp. 165–6.
14. *Cézanne und Hodler*, op. cit., p. 153.

Amiet, Cuno 1868–1961

Born in Solothurn, Switzerland, Amiet began work in 1884 under a local painter and later studied at the Munich Academy. He was in Paris 1888–91, at the Académie Julian. While in France he visited Pont-Aven and was much influenced by the artists there. In 1897 he was commissioned along with Giacometti, Segantini and Hodler to paint a frieze for the Paris International Exhibition of 1900, but the design was never executed. He joined the Die Brücke group in 1906. In 1910 he began working on the *Fountain of Youth* fresco for the Zürich Kunsthaus and in 1912 he exhibited at the Sonderbund in Cologne. His sixtieth birthday, in 1928, was commemorated by an exhibition at the Kunstmuseum, Berne. In 1931 50 of his paintings were destroyed in a fire at the Munich Glaspalast.

240

240 Reclining Breton Girl with Orange 1893

Femme bretonne allongeant avec une orange
sdbl. Amiet 93; insc bc. Meinem lieben Giovanni ... 1900
65.5 × 80.5 cm/25¾ × 31¾ ins
Lent by the Kunsthaus, Zürich, Vereinigung Zürcher Kunstfreunde

This painting is one of the surviving works from Amiet's Pont-Aven period, several of which were destroyed in the Munich Glaspalast fire of 1931. While in Brittany in 1892–3 he lived at the Pension Gloanec and met Bernard, Séguin, O'Conor and Sérusier, artists who were then unfamiliar to him: 'There was a strange art, never seen before. The dining-room of the inn was papered with pictures by painters whose names I had never read. Laval, Moret, Gauguin, Sérusier – bright, clear objectivity' (Amiet, quoted P. Selz, *German Expressionist Painting*, 1957, p. 96). Although Amiet has not adopted a cloisonnist system of outlines and simplified forms, the subject matter and the rich colouring reflect the influence of the Pont-Aven circle; he has abandoned natural colour in favour of warm harmonies of orange and yellow. He later gave the painting as a wedding present to his close friend, the painter Giovanni Giacometti, hence the inscription 'To my dear Giovanni ... 1900'. G.P.

REFERENCES
London, Tate Gallery, *Gauguin and the Pont-Aven Group*, 1966 (221)
Zürich, Kunsthaus, *Pont-Aven, Gauguin und sein Kreis in der Bretagne*, 1966 (71)
Berne, Kunstmuseum, *Jubiläumsausstellung Cuno Amiet – Giovanni Giacometti, Werke bis 1920*, 1968 (12)
Pennsylvania, Museum of Modern Art, *Three Swiss Painters*, 1973 (4)

241 Departure of the Fishermen 1894

Le Départ des pêcheurs
sbr. CA; dtr. 1894 polychrome wood relief 16 × 147 cm/6½ × 58 ins
Lent by the Josefowitz Collection, Switzerland

Amiet executed this work in Switzerland in 1893–4, shortly after his return from Brittany. The theme of Breton peasants in local costume, who are seated on cliffs overlooking boats at sea, is also found in the work of other Pont-Aven painters, in particular Denis, Sérusier and Séguin. Flat colour areas and framed ends give this panel a strong decorative quality which is accentuated by the stylized head-dresses and the parallel rhythm of the sails. In the sea, light and movement are suggested by broken patches of blue and green paint. G.P.

REFERENCES
Berne, Kunstmuseum, *Cuno Amiet*, 1919 (33)
London, Tate Gallery, *Gauguin and the Pont-Aven Group*, 1966 (224)
Zürich, Kunsthaus, *Pont-Aven, Gauguin und sein Kreis in der Bretagne*, 1966 (87)
Pennsylvania, Museum of Modern Art, *Three Swiss Painters*, 1973 (5)

Corinth, Lovis 1858–1925

Born in East Prussia, Corinth received his initial art training in Königsberg and Munich. During 1884–6 he studied in Antwerp and in Paris, where he worked with Bouguereau and Fleury at the Académie Julian. He subsequently painted in Berlin and Munich, becoming a founder member of the Munich Secession in 1892 and exhibiting regularly with the Berlin Secession. In 1903 he married Charlotte Berend. After a stroke in 1911 he suffered several years of ill health and developed a looser, more emotionally charged style of painting. He became president of the Berlin Secession in 1915.

ABBREVIATIONS
BC – C. Berend-Corinth, *Die Gemälde von Lovis Corinth, Werkcatalog*, Munich, 1958
Biermann – G. Biermann, *Lovis Corinth*, Bielefeld and Leipzig, 1913
Berlin 1926 – Berlin, Nationalgalerie, *Lovis Corinth*, 1926
Berlin 1958 – Berlin (West), Nationalgalerie, *Lovis Corinth*, 1958
Cologne – Cologne, Wallraf Richartz Museum, *Lovis Corinth: Gemälde, Aquarelle, Zeichnungen und druckgraphische Zyklen*, 1976

242 Portrait of Mutter Rosenhagen 1899

Bildnis Mutter Rosenhagen
sdbr. Lovis Corinth 1899 Nov. oil on board
63 × 78 cm/24¾ × 30¾ ins
Lent by the Staatliche Museen Preussischer Kulturbesitz, Nationalgalerie, Berlin

The subject of this portrait was the mother of Hans Rosenhagen, an art critic and supporter of the Berlin circle of so-called Impressionist painters whose publications included books on *Liebermann* (1900), *Uhde* (1908) and *Trübner* (1909). Portraits formed a major part of Corinth's oeuvre, and *c*. 1900 he painted many contemporary artists, critics and friends, often completing works in as little as two days (BC p. 192). In 1899, the year of this portrait, he also painted Hans Rosenhagen and Max Liebermann. Mutter Rosenhagen is shown seated in comfortable domestic surroundings, her ageing face

241

highlighted against a darker background. Corinth's preoccupation with portraits set in darkish interiors, in which composition and perspective are organized around the lines of the furniture which frame the subject, may reflect the influence of Degas and Vuillard, whose work became known in Berlin and Munich at the end of the nineteenth century – works by Degas were shown at Cassirer's gallery in the late 1890s and Vuillard exhibited with the 1900 Berlin Secession. The free handling of paint in the *Portrait of Mutter Rosenhagen*, particularly on her dress and the cushion, anticipates the looser style which Corinth developed *c*. 1905, illustrated in works such as the *Portrait of Bacchus* of 1905 (BC304). G.P.

243

EXHIBITION
1901, Berlin, Cassirer
REFERENCES
BC182
In *Die Kunst für Alle*, 18, 1903, p. 97
In *Kunst und Künstler*, 16, 1918, p. 342
E. Waldmann, *Die Kunst der Realismus und Impressionismus im 19 Jahrhundert*, 1927
L. Justi, *Von Corinth bis Klee*, 1931, no. 7
London, Tate Gallery, *A Hundred Years of German Painting*, 1956 (21)

242

243 *Portrait of Gerhart Hauptmann* 1900

Bildnis Gerhart Hauptmann
stl. Lovis Corinth; insc tr. Gerhart Hauptmann October 1900
88 × 107 cm/34¼ × 41¾ ins
Lent by the Städtische Kunsthalle, Mannheim

Gerhart Hauptmann (1862–1946), the dramatist and writer, was first introduced to Corinth by the painter Leistikow. Hauptmann was well known in intellectual circles in Germany at the turn of the century and he and his brother, Carl Hauptmann, were two of the many eminent visitors to the Worpswede artists' colony (cf. nos 258–60, 262). Corinth's association with Gerhart Hauptmann reflects the painter's growing interest in the theatre, and while in Berlin he became friendly with the theatre director Max Reinhardt, for whom he designed the sets for *Salome* in 1903. This portrait, which is similar in style to the *Portrait of Mutter Rosenhagen* (no. 242), was painted in the sitter's home in Grunewald, Berlin. By emphasizing the dark walls and surrounding his subject with books, Corinth has created a suitably literary atmosphere. The strong contrasts of light and shadow and the highlighted face give this painting a psychological intensity and a sense of mystery reminiscent of works by German symbolist painters such as Von Stuck (nos 271 and 272) or Hoffmann (no. 252), with whom Corinth associated while in Munich. The catalogue of *20th Century Portraits* (National Portrait Gallery, London, 1978, p. 43) describes this painting as 'one of the last traditional images of the literary figure in his proper surroundings'. G.P.

EXHIBITION
1915, Berlin, F. Gurlitt (20)
REFERENCES
BC202
Biermann 53
L. Wangemann, in *Fine Arts Journal*, October 1914
Berlin 1926 (75)
Berlin 1958
London, National Portrait Gallery, *20th Century Portraits*, 1978 (33)
Cologne (13)

244 *Self-Portrait with Model* 1901

Selbstbildnis mit Modell
sdtr and insc. Lovis Corinth Juni 1901 88 × 68 cm/34½ × 26¾ ins
Lent by the Kunstmuseum, Winterthur

This confident self-image is typical of Corinth's earlier self-portraits before he suffered a stroke in 1911. As a follower of the German philosophy of *Kunstpolitik* (expounded by the cultural critic Julius Langbehn in *Rembrandt als Erzieher* of 1890, and *Der Rembrandtdeutsche* of 1892) he believed that the artist had a vital role to play in regenerating German society, seeing himself in an exalted position as a gifted individual. This sense of self-importance is reflected in his continuing preoccupation with self-portraiture, although many of the later self-portraits reveal a more introspective obsession with his personal decline. In this painting his physical appearance is very similar to that of his political idol Bismarck, a resemblance which Corinth deliberately accentuated (BC216). Both the subject matter and compositional organization suggest the influence of Rembrandt's series of self-portraits with a model, in particular his *Self-Portrait with Saskia* of *c*. 1634 (Dresden). In his autobiographical writings Corinth continually reiterates his admiration for Rembrandt's work.

Despite the dark background of this painting there is a rich sensuality in the colouring and application of paint; the loosely painted, gleaming bronze nude on the right is echoed in the gold ear-ring and brooch worn by the young model. G.P.

244

EXHIBITIONS
?1902, Berlin, Secession (41)
1913, Berlin, Secession (62)
1915, Berlin, F. Gurlitt
REFERENCES
BC216
In *Kunst und Künstler*, 16, 1918, p. 330
A. Kuhn, *Lovis Corinth*, 1925, no. 105
Berlin 1926 (81)
Berlin 1958
Cologne (16)

245 *Childhood of Zeus* 1905

Die Kindheit des Zeus
[repr. in colour on p. 168]
sdtl. Lovis Corinth 1905 120 × 150 cm/47¼ × 59 ins
Lent by the Kunsthalle, Bremen

Corinth's interest in mythological themes, nurtured by his academic training in Munich, Antwerp and Paris, is evident in a series of large figure paintings worked on between *c*. 1899 and *c*. 1910. The 'baroque' character of this painting, suggested by the elaborate design, rich colours and strong sense of movement, is reminiscent of Rubens, whose work Corinth much admired. Like Rubens, he often depicted naked flesh, and the heavy voluptuousness of the figures is emphasized by the use of warm, pinkish flesh tones.

After moving to Berlin in 1900 Corinth's style began to loosen under the influence of other *Freilichtmalerei* painters such as Slevogt (cf. no. 270) and Liebermann (cf. nos 256–7), both founder members of the Berlin Secession. The broad strokes of luminous colour in this work are also reminiscent of Delacroix's later mythological canvases, which Corinth had seen in Paris. The theme of classical revelry or bacchanals recurs in Corinth's work, and in 1905 he painted himself as Bacchus (Private Collection, Berlin, BC304), a reference to his personal belief in a cult of uninhibited physical expression which was fashionable in Germany at the turn of the century and often associated with so-called '*volkisch*' thought. Corinth's wife Charlotte, who claimed that their one-year-old son Thomas was the inspiration for this painting, argued that it represented the artist's ability to interpret mythological scenes as if they were real events enacted by living people, as opposed to remote classical legend (BC305). There is a preliminary oil sketch for the *Childhood of Zeus* in the Kunsthalle, Bremen (BC307), and a watercolour sketch reproduced in *Arnolds Graphische Bücher*, Dresden, 1920, p. 28. G.P.

EXHIBITIONS
1906, Berlin, Secession (50)
1913, Berlin, Secession (104)
1915, Berlin, F. Gurlitt
REFERENCES
BC305
In *Die Kunst für Alle*, 21, 1906, p. 413
In *Das Leben*, October 1906
Biermann 71
H. Eulenburg, *Corinth, Maler unserer Zeit*, 1920
Berlin 1926 (118)
Berlin 1958
Cologne (25)

Dill, Ludwig 1848–1940

Born in Gernsbach, Baden, Dill studied engineering and architecture at the Stuttgart Polytechnic. He served in the Franco-Prussian War and in 1872 studied at the Akademie der Bildenden Künste, Munich, working under Raab, Seitz and Piloty; there he developed an interest in the painters of the Barbizon School. In 1894 he became president of the Munich Secession and visited Neu-Dachau.

246 *Poplar Wood* 1901

Pappelwald
sbr. L. Dill tempera on board 93 × 79 cm/36½ × 31 ins
Lent by the Bayerische Staatsgemäldesammlungen, Munich

This painting is typical of Dill's series of landscapes with trees, painted in the late 1890s and early 1900s, and inspired by the Dachau countryside near Munich. In the mid-1890s Dill, Adolf Hölzel and Arthur Langhammer formed the Neu-Dachau Group, concentrating on decorative *plein-air* pictures which captured the hazy, watery atmosphere of the local woods and moors. In *Poplar Wood* Dill has used the sturdy trees as the central motif, creating strong vertical rhythms. The decorative, two-dimensional emphasis also reflects the influence of Hölzel, for whom painting became increasingly an exercise in formal relationships. The composition of Dill's painting is very close to works by other Dachau painters such as Hermann Linde and Felix Burgers, who also used tree-trunks as the dominant motif in their landscapes. Both contemporary and more recent criticism has compared this style of landscape painting with the atmospheric moor scenes by the north German Worpswede painters such as Otto Modersohn (cf. no. 260), whose work was well received when exhibited at the Munich Glaspalast in 1895.

REFERENCES
Munich, Bayerische Staatsgemäldesammlungen, *Die Freilichtmalerei in Dachau 1850–1914*, 1967 (8336)
R. Hamann and J. Hermand, *Naturalismus*, 1968, p. 290
Darmstadt, *Ein Dokument Deutscher Kunst 1901–1976: Akademie Secession, Avant-garde um 1900*, 1976 (21)

246

Heckel, Erich 1883–1970

Heckel attended the Realgymnasium at Chemnitz 1897–1904. In 1904–5 he studied at the Technische Hochschule in Dresden with Bleyl, Kirchner and Schmidt-Rottluff, with whom he formed Die Brücke in 1905. In 1906 he met Pechstein and Nolde and in 1911 he settled in Berlin with the other Brücke artists. He became friendly with Max Beckmann and Ensor in 1915. Many of his works were later removed from German museums as part of the Nazi purge of Degenerate Art.

247 *Seated Child* 1906

Sitzendes Kind
sdtl. EH 06 70 × 64 cm/27½ × 25¼ ins
Lent by the Brücke Museum, Berlin

247

In this painting the child theme, popular in German art at the turn of the century, has become a vehicle for a free and excited use of line and colour. Broad brushstrokes of strident colour have been used to create independent formal tensions: 'The things and objects do not speak as much through their form or drawing as through the expression of colour, i.e. the peculiar selection of colour tensions' (E. Heckel, letter to P. Selz, 16 July 1952, in P. Selz, *German Expressionist Painting*, 1957, p. 93). Much of the brushwork in this painting follows gently curving rhythms which are found in more exaggerated form in Heckel's woodcuts from the same period. This style, similar to that adopted by Kirchner during 1905–8 (cf. nos 253 and 254), contains remnants of the Jugendstil whiplash line, and may also reflect the influence of Van Gogh whose works were exhibited at the Galerie Arnold in Dresden in 1905. The disquieting green skin tones, set against strident reds, are also found in Kirchner's early Brücke portraits (cf. no. 255).

REFERENCES
P. Vogt, *Erich Heckel*, 1965, no. 1906/1
Berlin, Brücke Museum, *Katalog der Gemälde, Glasfenster und Skulpturen* (6), pl. 1

Heine, Thomas Theodor 1867–1948

Born in Leipzig, Heine studied at the Düsseldorf Academy under Peter Janssen, 1884–9. He settled in Munich in 1889, and worked as an illustrator on Jugendstil journals. With Albert Lang and Ludwig Thomas he was a founder member of the satirical journal *Simplicissimus* in 1896. With the rise of National Socialism he was forced to leave Germany in 1933, and died in Stockholm.

248 *Evening Walk* c. 1900

> *Abendspaziergang*
> ns. oil on copper 45 × 52 cm/17¾ × 20½ ins
> Lent by a Private Collector, London

Although Heine is best known for his graphic works, he also executed many paintings, several on copper. In this picture the copper base accentuates the warm yellowish glow in the colouring. The undulating curves in the lines of the path and the delicate, stylized figures echo his Jugendstil illustrations, and the oval frame contributes to the decorative quality of the whole composition. Winding or sharply receding paths, and skies tinted with symbolic colours, are recurring motifs in Heine's paintings. In, for example, *Before Sunrise* of 1890 (F. Bürger, *Cézanne und Hodler*, 1919, p. 115), a

steep winding street leads to a factory set against a reddish sky, which symbolizes social oppression. In *Evening Walk* the yellowish glow suggests an atmosphere of evening peace. The four bulldogs may be a reference to Heine's famous red bulldog motif, the symbol of political satire adopted by *Simplicissimus*. In his own time Heine's graphic works were seen to overshadow his paintings. In *Entwicklungsgeschichte der modernen Kunst* (*Development of Modern Art*) Meier-Graefe claimed that 'Heine's qualities as a painter would never make him a great artist', while acknowledging that his paintings, despite occasional literary references, point to 'the beginning of a new architecture made up of line and colour, not of thought' (*Development of Modern Art*, 1908, p. 318). G.P.

REFERENCE
Munich, Haus der Kunst, *Secession – Europäische Kunst der Jahrhundertwende*, 1964 (178)

248

Herrmann, Curt 1854–1929

Herrmann entered the studio of Karl Steffecks in Berlin in 1873, studied for a year at the Munich Academy in 1883, and during the 1880s established a reputation as a portrait painter. He moved to Berlin in 1893 where he opened a private art school. In 1897 he married Sophie Herz and spent the summer months in her family's house in Pretzfeld, Switzerland, which he visited frequently in later years. In the same year he formed a close friendship with the Belgian painter Henri Van de Velde, and in 1898 became a founder member of the Berlin Secession, exhibiting in their first show in 1899. In 1902 he travelled to Paris where he met Signac, and in 1903 he visited Greece, Turkey and the Near East with Van de Velde. He published *Der Kampf um den Stil*, his personal theoretical treatise on art, in 1911.

249 *Early Morning: The Old Timber Bridge, Pretzfeld* 1901

> *Morgenstimmung: Holzbrücke in Pretzfeld*
> sbc. C.H. 70 × 100 cm/27½ × 39½ ins
> Lent by a Private Collector, England

Pretzfeld, in the Swiss Alps, was a favourite retreat for Herrmann and his wife, and provided the inspiration for many of his landscape paintings. In the late 1890s he developed a strong interest in the work of French Neo-Impressionist painters. Encouraged by his friendship with Van de Velde, it was partly fired by an exhibition of Neo-Impressionist works at Kessler's gallery in Berlin in 1898, and by the publication of a shortened version of Signac's essay 'D'Eugène Delacroix au néo-impressionnisme' in the magazine *Pan* (IV, pp. 55–62) in 1898 (it was translated into German by Sophie

249

Hermann in 1903). However, as this painting shows, Hermann adapted the principles of French Neo-Impressionism to suit his own stylistic interests, developing a freer, less precise use of dots of individual colour than his French exemplar, Seurat. In his theoretical treatise *Der Kampf um den Stil* (1911) Herrmann wrote: 'For me personally the emergence of Neo-Impressionism meant an artistic release, the final solution to my struggle of many years towards light and colour' (p. 130). With Paul Baum, Hermann was one of the first German painters to experiment with this style of painting, which was received with both enthusiasm and consternation by German critics. After this painting had been exhibited (under the title *Sommermorgen*) with one other landscape in the Berlin Secession exhibition of 1902, the critic Hans Rosenhagen wrote: 'Curt Herrman excels with amusing Neo-Impressionist landscapes' (*Die Kunst*, 5, 1902, p. 442). G.P.

EXHIBITIONS
1902, Berlin, Secession (83)
1903, January, Hamburg, Cassirer, *Ausstellung Deutscher und Französischer Neoimpressionisten*
1903, summer, Weimar, *Deutsche und Französische Impressionisten und Neo-Impressionisten* (27)
REFERENCES
London, Matthiesen Gallery, *The Work of Curt Herrmann*, 1956 (13)
New York, Guggenheim Museum, *Neo-Impressionism*, 1968 (156)
Kassel, Städtische Kunstsammlungen, *Curt Herrmann 1854–1929*, 1971, pl. 21

Hodler, Ferdinand 1853–1918

Born in Berne, Hodler was first apprenticed to a painter of tourist pictures, then moved to Geneva in 1872 and became a pupil of Barthelémy Menn at the Ecole des Beaux-Arts. He visited France in 1881 and Munich in 1883; his first one-man show was held at the Cercle des Beaux-Arts, Geneva, in 1885. In 1892 he exhibited *The Disillusioned* at the Salon de la Rose + Croix in Paris and joined the group. He taught painting and drawing at the Musée des Arts Décoratifs in Fribourg, 1896–9. In 1898 he befriended Cuno Amiet (cf. nos 240 and 241). Hodler became a member of the Berlin and Vienna Secessions in 1900, and participated in the Salon de la Libre Esthétique, Brussels, in 1901. In 1904 he joined the Munich Secession and the Verein Berliner Künstler. He exhibited with Klimt at the Berlin Secession in 1905 and in 1907 was commissioned to design a mural for the University of Jena. He was the featured artist in the Paris Salon d'Automne of 1913.

ABBREVIATIONS
EB – E. Bender, *Die Kunst Ferdinand Hodlers*, Zürich, 1923
PS – Berkeley, University Art Museum, *Ferdinand Hodler*, catalogue by P. Selz, 1972

250 *Eurhythmy* 1895

Eurhythmie
sdbr. Ferd. Hodler 1895 167 × 245 cm/$65\frac{3}{4}$ × $96\frac{1}{2}$ ins
Lent by the Kunstmuseum, Berne

In his works from the mid-1880s onwards Hodler sought to achieve a controlled, rhythmic movement, an 'inter-relationship of the harmony of the form-rhythm of nature with the rhythm of emotion: this I call Eurhythmy' (F. Hodler, quoted H. Mühlestein, *Ferdinand Hodler*, Weimar, 1914, p. 259). In this painting he uses the parallel vertical lines of the figures, each assuming a subtly different position, to create a gentle rhythmic flow. This work also illustrates his related theory of 'Parallelism', a compositional device which (according to Hodler) reflects the order and repetition inherent in nature. He believed that human beings, like trees or mountains, each possess a universal quality which unites them. Thus the men in *Eurhythmy* are all dressed in long white gowns, and are moving in the same direction with their heads gently inclined; they are 'Five men representing humanity, marching towards death' (F. Hodler, *Notes intimes*, 1917–18, PS, p. 118). The progressive movement across the canvas and their stoical, resigned expressions symbolize the inevitability of death and an advance towards infinity. E. Bender has compared their faces with those of Dürer's *Four Apostles* (1526, Pinakothek, Munich) (EB, p. 27), and the composition has often been compared with the hieratic frieze of saints in Sant' Apollinare Nuovo, although, as P. Selz has pointed out, 'the fluidity of movement is distinct from the static movement enacted at Ravenna' (PS, p. 36).

Hodler's emphasis on rhythm and carefully orchestrated gesture in this and other frieze paintings from the 1890s may reflect his interest in the modern dance movement at the turn of the century, an interest later encouraged by his friendship with Emile Jacques Dalcrose, a choreographer and professor at the Geneva Conservatoire. The symbolic use of stylized gestures within a flat, decorative design also places this painting within the European Symbolist and Art Nouveau movements. It was widely exhibited in Europe between 1895 and 1904 and was awarded gold medals at the Munich International Exhibition of 1897 and the Paris Exhibition of 1900. Hodler's simple, often symmetrical designs arranged around central vertical or horizontal axes have been compared with Munch's *Frieze of Life* series, in which the Norwegian artist also employs 'heraldic compositions commonly based on patterns of elementary symmetry ... pictorial means, that is, which tend to immobilize the image as a universal, primitive emblem', (R. Rosenblum, in *Edvard Munch, Symbolic Images*, Washington, National Gallery of Art, 1978, p. 3). G.P.

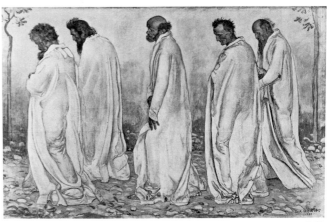

250

EXHIBITIONS
1895, Paris, Société Nationale (655)
1896, Geneva, Landesausstellung (256)
1897, Munich, Glaspalast (748)
1900, Paris, Exposition Universelle, Swiss section (92)
1904, Vienna, Secession
REFERENCES
In *Die Kunst*, 3, 1900–1, repr. p. 373
In *Kunst and Künstler*, 111, November 1904, repr. p. 25
In *Deutsche Kunst und Dekoration*, IX, 1905–6, repr. p. 295
EB. p. 27
F. Burger, *Cézanne und Hodler*, 1913, pp. 44ff, pl. 24
C. A. Loosli, *Ferdinand Hodler*, 1921–4, 11, pl. x
Berne, Kunstmuseum, *Ferdinand Hodler*, 1921 (264), pl. 18
W. Hugelshofer, *Ferdinand Hodler*, 1952, pp. 54–5, pl. 41
P. Selz, *German Expressionist Painting*, 1957, p. 155, pl. 54a
J. Brüschweiler, *Ferdinand Hodler im Spiegel der zeitgenössischen Kritik*,
 1970, pp. 62–3, pl. 63
PS22, p. 36
S. Kuthy, 'Die Ehren Hodler', in *Tatort Bern*, Bochum, Museum, 1976, pp. 22–5

251

251 *Lake Geneva from Chexbres* 1895

Genfersee von Chexbres aus
sbr. F. Hodler 100 × 130 cm/39¼ × 51¼ ins
Lent by the Gottfried Keller Foundation, on loan to the
Kunsthaus, Zürich

Views of Swiss lakes, in particular Lake Geneva, recur in Hodler's work. As in *Lake Geneva from Chexbres*, he often looks down at a boundless expanse of water framed by the symmetrical curve of the shore. His underlying principle of 'Parallelism' is illustrated in the simple symmetrical design and the repetition of horizontal rhythms in the sea and sky. This landscape possesses a strange static quality, accentuated by the absence of human figures. There is little suggestion of aerial perspective and the foreground trees are precise, motionless images which counteract the horizontal emphasis. The predominance of blue and purple tones in the water contributes to this cold, lifeless atmosphere.

 R. Rosenblum has identified this style of landscape painting with a northern tradition of quasi-religious awe in the face of nature; Hodler's uninhabited landscapes become timeless symbols of eternity (*Modern Painting and the Northern Romantic Tradition*, 1975, pp. 126–8). In a similar vein, P. Selz has stressed the pantheistic element in Hodler's landscapes, comparing this with the sentiments expressed in the Symbolist poetry of Rilke (PS, p. 42). G.P.

REFERENCES
Berne, Kunstmuseum, *F. Hodler – Gedächtnisausstellung*, 1921 (308), pl. 22
C. Loosli, *Ferdinand Hodler*, 1931 (816)
Zürich, Kunsthaus, *Meisterwerke der Gottfried Keller Stiftung*, 1965 (246), p. 181
Berne, Kunstmuseum, *F. Hodler*, 1968 (31)
London, Hayward Gallery, *A. Böcklin, F. Hodler*, 1971
PS23, p. 44

Hofmann, Ludwig Von 1861–1941

Born in Darmstadt, Hofmann studied at the Berlin Academy and then under Ferdinand Keller in Karlsruhe. While in Paris in 1889–90 he attended the Académie Julian and was much influenced by Puvis de Chavannes (cf. no. 161) and Albert Besnard. He worked in Berlin from 1890 where he formed the Gruppe XI in 1892 with Liebermann, Hermann and Leistikow as a protest against the closure of the Munch exhibition at the Verein Berliner Künstler.

252 *Spring Dance* c. 1900

Frühlingsreigen
sbr. L. v Hofmann 63.5 × 76 cm/25 × 30 ins
Lent by the Kunsthalle, Bremen

In this work the German taste for atmospheric landscape painting is combined with a Jugendstil Symbolism influenced by the allegorical canvases of Puvis de Chavannes. Hofmann's preoccupation with the theme of naked human figures in a landscape also reflects the influence of the German painters Hans Von Marées (1837–87) and Arnold Böcklin (1827–1901), although Hofmann generally interprets his subject matter in a looser, less academic style.
The themes of the dance and the seasons were often employed as allegories of life by German Symbolist writers such as Stefan George and Hugo von Hofmannsthal, both of whom were well known to Hofmann. U. Finke has suggested that there is a connection between this painting and Stefan George's cycle of poems *Teppich des Lebens* (*Tapestry of Life*) of 1899: 'it is interesting that Stefan George addressed two poems in his cycle to Hofmann: the tapestry as a symbol of the "frozen dance" of phenomena came, around 1900, to apply to art as a whole' (*German Painting from Romanticism to Expressionism*, p. 194).

 The loose, almost unfinished style, and the subtle blending of different shades of purples and greens, give this work an atmosphere of mystery appropriate to the theme. The catalogue for the Berlin Secession of 1904 lists it as a 'Design for a Stage Curtain'. G.P.

252

EXHIBITION
1904, Berlin, Secession (93)
REFERENCES
U. Finke, *German Painting from Romanticism to Expressionism*, 1974, p. 194, pl. 144
Darmstadt, *Ein Dokument Deutscher Kunst 1901–1976: Akademie, Secession,
 Avantgarde um 1900*, 1977 (46)

Kirchner, Ernst Ludwig 1880–1938

Kirchner originally studied architecture in Dresden, but in 1903–4 went to Munich to study painting under Debschitz and Obrist. In 1905 he formed Die Brücke in Dresden with Heckel, Schmidt-Rottluff

and Bleyl, who first exhibited as a group in 1906. After settling in Berlin with the other Brücke painters in 1911, he founded the Art School MUIM (Moderner Unterricht in Malerei) with Pechstein. While in Berlin he developed an angular, spiky style in his depiction of metropolitan scenes, and contributed to a large Brücke exhibition in spring 1912. In 1913 he edited the *Chronik der Brücke*, after which he became increasingly antagonistic towards his former Brücke associates.

ABBREVIATIONS
RNK – Hamburg, Exhibition of paintings from the *R. N. Ketterer Collection*, Hamburg, 1960
WG – W. Grohmann, *E. L. Kirchner*, Stuttgart, 1961
DG – D. L. Gordon, *E. L. Kirchner*, Munich, 1968

254

253

253 *The Loam Pit* c. 1906

Die Lehmgrube
sbl. E. L. Kirchner oil on cardboard on panel
51 × 71 cm/20 × 28 ins
Lent by the Thyssen-Bornemisza Collection, Lugano

This painting, characteristic of the earliest Brücke style, is based on a local landscape, a theme popular in German art at the turn of the century. It is one of 'a series of paintings done out-of-doors, probably during the spring and summer months of 1906, [which] marks Kirchner's first extensive period of devotion to *plein-air* painting in the traditional late impressionist manner' (DG, p. 48). The bright colours, exaggerated brushwork and rather sudden perspective lines may indicate the influence of Van Gogh, whose work was exhibited in Dresden in the Galerie Arnold in 1905. Several of his paintings were included in the early Berlin Secession shows and in 1901 he exhibited four Provençal landscapes and a self-portrait. G.P.

REFERENCES
RNK (169)
WG, p. 90
DG, no. 15, p. 275
Basle, Kunsthalle, *E. L. Kirchner und Rot-Blau*, 1967 (3)
Berlin, Brücke Museum, *Künstler der Brücke. Gemälde der Dresdener Jahre 1905–10*, 1973 (14), pl. 4

254 *Woman in a Birch Wood* 1906

Frau im Birkenwald
ns. 68 × 78 cm/27 × 30½ ins
Lent by the Thyssen-Bornemisza Collection, Lugano

Kirchner painted *Woman with a Pointed Hat* (*Dame mit spitzen Hut*), dated 1936–7 by Gordon (DG22), on the reverse side of this canvas, continuing the early Brücke tradition of using both sides of the canvas. In *Woman in a Birch Wood* there is no formal distinction between the figure and surrounding landscape; both are painted in

loose brushstrokes of bright colours, echoing Kirchner's so-called 'Neo-Impressionist' style of around 1904. While in Munich he probably saw the 1904 Neo-Impressionist exhibition organized by Kandinsky's Phalanx group. The show included works by Signac and Van Rysselberghe, also Toulouse-Lautrec and Vallotton. As this painting demonstrates, however, Kirchner was too involved in the expressive potential of individual colours to experiment with the more scientifically based theories of the French Neo-Impressionist painters. The strong colours and vigorous strokes of paint create an agitated sense of movement which is in many ways closer to works by Emil Nolde from the same period. G.P.

REFERENCES
RNK (3)
WG, p. 89
DG22, p. 276
F. Whitford, *Expressionism*, 1970, p. 50, fig. 46
Berlin, Brücke Museum, *Künstler der Brücke. Gemälde der Dresdener Jahre 1905–10*, 1973 (22), pl. 12
Bremen, Kunsthalle, *Moderne Kunst in der Sammlung Thyssen-Bornemisza*, 1975 (32)

255 *Doris with a Ruff* 1908/9

Doris mit Halskrause
ns. oil on board 70 × 52 cm/27½ × 20½ ins
Lent by the Thyssen-Bornemisza Collection, Lugano

This painting, like *Woman in a Birch Wood* (no. 254) is both unsigned and undated (Gordon has dated it 1906/1908–9). During the early Brücke period, particularly while the group was living together in a converted butcher's shop in the Berlinerstrasse, signatures and dates were deliberately omitted from works in an attempt to emulate the

255

266 Munch *Jealousy*

74 Derain *The Dance*

201 Seurat *The Eiffel Tower*

382 Segantini *Rest in the Shade*

410 Van Rysselberghe *Family in Orchard*

377 Pellizza *Washing in the Sun*

10 Bastien-Lepage *Poor Fauvette*

280 Clausen *Peasant Girl, Quimperlé*

324 O'Conor *The Lezaver Farm, Finistère*

347 Steer *Boulogne Sands*

389 Breitner *Lauriergracht, Amsterdam*

338 Sickert *L'Hôtel Royal, Dieppe*

245 Corinth *The Childhood of Zeus*

262 Modersohn-Becker *Reclining Mother and Child*

anonymity and communal spirit of a medieval workshop. The influence of French Neo- and Post-Impressionism is combined in this painting with an agitated application of paint and strident colour combinations. The repetition of arabesque rhythms in the brush-strokes suggests the influence of Van Gogh's later portrait style. The sinuous lines and disquieting combinations of red and green may also be derived from Edvard Munch, who exhibited regularly at the Berlin Secession during 1899–1910 (cf. J. Neumann, introduction to exhibition catalogue, *Munch und die Künstler der Brücke*, Bremen, 1920). G.P.

REFERENCES
Kirchner Archiv, I, 28
RNK(IO)
Essen, Folkwang Museum, *Brücke*, 1958 (54), pl. I
WG, pp. 32, 36, pl. II
DG, no. 16, p. 276
Basle, Kunsthalle, *E. L. Kirchner und Rot-Blau*, 1967 (7)
Bremen, Kunsthalle, *Moderne Kunst in der Sammlung Thyssen-Bornemisza*, 1975 (33)
Warsaw, Museum Narodowe, *Die Künstlergruppe Brücke*, 1978–9 (8a), pl. 85

Liebermann, Max 1847–1935

Born in Berlin, Liebermann studied under Eduard Holbein and Karl Steffeck 1863–9, and at the Weimar School of Art 1869–72. After working in Paris, Holland and Munich he settled in Berlin and in 1892 founded the Gruppe XI with Leistikow, Herrmann and Hofmann as a protest against the closure of a Munch exhibition at the Verein Berliner Künstler. In the late 1890s he became increasingly interested in French Impressionism and was one of the founder members of the Berlin Secession in 1898. From *c.* 1914 his iconography is dominated by motifs from the Wannsee district of Berlin, where he died in 1935 shortly before a large number of his works were purged by the Nazis from German museums.

ABBREVIATIONS
G. Pauli – G. Pauli, *Max Liebermann, Des Meisters Gemälde*, Stuttgart and Leipzig, 1911
FS – F. Stuttmann, *Max Liebermann*, Hanover, 1961

256 *Eva* 1883

sdbr. M. Liebermann 83 95.5 × 67 cm/37½ × 26½ ins
Lent by the Kunsthalle, Hamburg

Eva was a Dutch peasant girl and an orphan, both themes which preoccupied Liebermann during his visits to Holland in the 1870s and 1880s. This painting also illustrates his early experiments with *Freilichtmalerei* (open-air painting), encouraged by the painter Fritz

256

Von Uhde (1848–1911), with whom he became friendly while in Munich between 1878 and 1884. Although Liebermann has retained a traditional three-dimensional picture space with a clearly defined foreground and background, the depiction of light through areas of brightly coloured paint, sometimes applied with a palette knife, anticipates his later quasi-Impressionist style. The almost symmetrical composition, in which the figure dominates the foreground picture-plane, was also taken up by Paula Modersohn-Becker in many of her paintings of child subjects. G. Pauli has shown that Liebermann used the same motif of a standing girl in the right of his *Children Playing* of the same year (n. 53). G.P.

EXHIBITIONS
?1886, Berlin, Jubiläumsausstellung (687)
?1899, Berlin, Secession (112)
1912, Berlin, Cassirer, *Gruppe Ausstellung* (15)
REFERENCES
G. Pauli, p. 62, n. 53
K. Scheffler, *Max Liebermann*, 1923, pl. 19
Schaffhausen, Museum zu Allerheiligen, *Deutsche Impressionisten.*
 Liebermann, Corinth, Slevogt, 1955 (8)
H. Ostwald, *Das Liebermann Buch*, 1930, pp. 41, 364, pl. 14
London, Tate Gallery, *100 Years of German Painting*, 1956 (115)
U. Finke, *German Painting from Romanticism to Expressionism*, 1974, p. 163, pl. 134
Berlin, Nationalgalerie, *Max Liebermann in seiner Zeit*, 1979

257

257 *The Parrot Walk* 1902

Papageienallee
sbr. M. Liebermann 88 × 72.5 cm/34½ × 28½ ins
Lent by the Kunsthalle, Bremen

This painting, which depicts the Parrot Walk in the Zoological Gardens in Amsterdam, is seen by Stuttmann to represent the full development of Liebermann's Impressionist style (FS, p. 72). This is apparent in the diminished importance of subject matter in relation to the handling of light and colour; bright colours and highlights are applied in loose, sketchy brushstrokes, creating a flickering atmosphere. Despite this emphasis on the canvas surface, Liebermann has used the lines of the path and trees to suggest three-dimensional recession. The theme of an alley-way of trees recurs in his work from this period, and another version of the same title was painted in 1901 (H. Ostwald, *Das Liebermann Buch*, 1930, pl. 166). The subject matter and style are closely related to *The Parrot Man* of 1902 (Folkwang Museum, Essen), which was also exhibited at the Berlin Secession of 1903. A preliminary pastel drawing for *The Parrot Walk*, dated 1901, was exhibited in the graphics section of the 1901 Berlin Secession (388). G.P.

EXHIBITION
Berlin, Secession, 1903 (133)
REFERENCES
FS, p. 72, pl. III
G. Meissner, *Max Liebermann*, 1974, pl. 23
H. Bünemann, *Von Menzel bis Hodler*, 1971, pl. 68
Darmstadt, *Dokument Deutscher Kunst 1901–76, Akademie, Sezession,
 Avantgarde um 1900*, 1976 (104) pl. 110

Mackensen, Fritz 1866–1953

Mackensen studied at the Düsseldorf Academy and then at the
Akademie der Bildenden Künste in Munich under Kaulbach and
Dietz. In 1889 he established himself in a village north of Bremen
called Worspwede, where he founded an artists' colony with two
other students from Düsseldorf, Otto Modersohn (cf. nos 259–60)
and Hans am Ende. In 1895 the Worpswede group exhibited
at the International Exhibition in the Munich Glaspalast, and
Mackensen won a gold medal for his painting of a religious
gathering of peasants on the Worpswede moors, *Prayers on the Moor*
(*Gottesdienst im Moor*) of 1895. During 1908–18 he was director of
the Hochschule für Bildende Kunst, Weimar, and in 1933–4 he
was director of the Nord Kunsthochschule, Bremen.

258

258 *Girl at the Garden Gate* 1897

Mädchen am Gartenzaun
sdbr and insc. Fritz Mackensen Worpswede 1897
65 × 40 cm/25½ × 15½ ins
Lent by Bernard Kaufmann, Haus am Weyerberg, Worpswede

The subject of this painting is the daughter of Heinrich Vogeler,
another artist from the Worpswede colony. Mackensen was much
influenced by the German Realist school of painters, including
Wilhelm Leibl (1844–1900) and Adolf Von Menzel (1815–1905),
and many of his works from the early 1890s are detailed studies of
local peasant subjects and customs. In this painting, however, he is
experimenting with a looser, more two-dimensional style, which is
close to Heinrich Vogeler's Jugendstil compositions. Mackensen,
like many other German artists at the turn of the century, held an
idealized view of the simple, unsophisticated lifestyle of the
indigenous German peasantry (cf. P. Mackensen, *Das Weltdorf
Worpswede*, 1938, Worpswede Archives). In this painting the
young girl is dressed in a traditional Worpswede peasant costume, a
reference which accentuates the local flavour of the work. G.P.

REFERENCES
Munich, Haus der Kunst, *Secession – Europäische Kunst der Jahrhundertwende*, 1964
B. Kaufmann, *Die alten Worpswede Meister*, Worpswede, 1979, p. 11

Modersohn, Otto 1865–1943

Born in Soest, Modersohn studied at the Düsseldorf Academy
1884–8, where he was a contemporary of Fritz Mackensen
(cf. no. 258). In 1888 he worked at the Munich Academy and
1888–9 was at the Karlsruhe Academy, which specialized in
landscape painting. He was one of the founder members of the
Worpswede artists' colony in 1889, and in 1895 exhibited with other
members of the group at the Bremen Kunsthalle and at the
International Exhibition at the Munich Glaspalast. In 1901 he
married Paula Becker (cf. nos 261–3), with whom he worked closely
in Worpswede, 1902–3. In Paris in 1906–7 Modersohn was
impressed by the work of Van Gogh, Gauguin and Cézanne.

259 *Worpswede Peasant Girl Under a Willow Tree* 1895

Worpsweder Bauernmädchen unter einem Weidenbaum
sdbr. Otto Modersohn. 95 115 × 85 cm/45¼ × 33½ ins
Lent by the Kunsthalle, Bremen

The theme of a peasant girl standing under a tree, with its symbolic
connotations of youth at one with nature, was popular within the
Worpswede circle. It is often repeated in Modersohn's series of
drawings and paintings from 1900–1, and appears frequently in the
work of Fritz Overbeck (1869–1909) and Paula Modersohn-Becker.
In this painting the standing figure echoes the horizontal lines and
brown colouring of the tree-trunks, accentuating a unity with her
natural surroundings. Modersohn, like other early members of the
Worpswede colony, was a follower of fashionable cultural ideas
expounded by writers such as Julius Langbehn in his *Rembrandt als
Erzieher* of 1890 (in a diary entry of 27 October 1890 Modersohn
praises Langbehn's book; *Tagebuch*, Worpswede Archives).
Langbehn exalted the unspoilt 'natural' qualities to be found in
children and simple peasants, contrasting them with a decadent and
corrupt urban civilization; he believed that a new German art must
harness these 'primitive' forces. These attitudes are reflected in
Modersohn's choice and interpretation of subject matter, and they
provided a strong impetus for the formation of regional artists'
colonies such as Worpswede and Neu-Dachau, near Munich. G.P.

REFERENCES
Bremen, Kunsthalle, *Worpswede – Aus der Frühzeit der Künstlerkolonie*, 1970 (42)
Fischerhude, Kunsthalle Friedrich Netzel, *Otto Modersohn*, 1977, pl. 235
Bremen, Kunsthalle, *Zurück zur Natur*, 1977–8 (492)

259

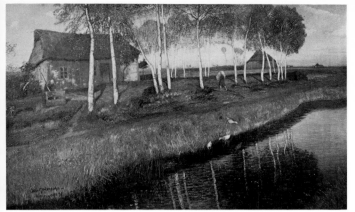

260

260 *Autumn Morning on the Moor Canal* 1895

Herbstmorgen am Moorkanal
sdbl. Otto Modersohn Worspwede 95 96 × 151 cm/37¾ × 59½ ins
Lent by Bernhard Kaufmann, Haus am Weyerberg, Worpswede

This painting is typical of the style of 'nature lyricism' (*Natur-lyrismus*) favoured by the Worpswede landscape painters and much influenced by the Barbizon School. In his 1903 monograph on Worpswede, Rilke wrote in praise of this landscape: 'The language was new, the expression unusual, the contrasts resound together like gold and glass.' The warm autumnal colours, the cosy cottages and the peacefully toiling peasants suggest an idyllic rural scene. The peasants are seen as an integral part of the landscape; they are small details in the overall composition which is dominated by the vertical rhythms of the birch trees. This was one of eight moor landscapes which Modersohn exhibited at the International Exhibition in the Munich Glaspalast in 1895. They attracted much critical acclaim and caused F. Von Ostini to single out Modersohn as the 'strongest talent amongst the Worpswede painters' (*Münchener Neuesten Nachrichten*, 11 August 1895). G.P.

EXHIBITION
1895, Munich, Glaspalast, *Jahresausstellung* (483)
REFERENCES
F. Von Ostini, in *Münchener Neuesten Nachrichten*, 11 August 1895
R. M. Rilke, *Worpsweder Monographie*, 1903, p. 54
B. Kaufmann, *Die Alten Worpsweder Meister*, 1979

Modersohn-Becker, Paula 1876–1907

Paula Becker was born in Dresden, moving to Bremen in 1888. She attended the Berlin School of Art for Women in 1896–8, after which she settled in the artists' colony of Worpswede near Bremen and took instruction from Fritz Mackensen. She first exhibited publicly with the Worpswede exhibition in the Bremen Kunsthalle in winter 1899. Her early Worpswede works were mostly dark-toned moor scenes and detailed charcoal drawings of local peasant subjects, but after her first trip to Paris in 1900 she began to develop a more simplified, two-dimensional style. In 1901 she married the Worpswede landscape painter Otto Modersohn. Increasingly dissatisfied with the insular artistic outlook of the colony, she returned to Paris in 1903, enrolling at the Académie Cola Rossi. She visited the Académie Julian in 1905, and in 1906–7 she attended classes at the Ecole des Beaux-Arts.

ABBREVIATIONS
Pauli – G. Pauli, *Paula Modersohn-Becker*, Leipzig, 1919
B & T – Paula Modersohn-Becker, *Briefe und Tagebuchblätter*, Munich, 1957
Busch et al. – G. Busch and associates, *Paula Modersohn-Becker zum Hundertsten Geburtstag: Gemälde, Zeichnungen, Graphik*, Bremen Kunsthalle, 1976
GP – G. Perry, *Paula Modersohn-Becker, Her Life and Work*, London, 1979

261 *Portrait of Werner Sombart* 1906

Bildnis Werner Sombart
ns. oil on canvas on wood 50 × 46 cm/19½ × 18 ins
Lent by the Kunsthalle, Bremen

Werner Sombart (1863–1941) was a German sociologist whom Modersohn-Becker met while she and Otto Modersohn were staying with Dr Carl Hauptmann in Schreiberhau in 1906. She mentions the visit in a letter of 17 January 1906 to her sister Milly (B & T, p. 220), describing with admiration the intellectual debate which took place between Hauptmann and Sombart. In this portrait Sombart's features have been reduced to flat colour areas, giving his face a mask-like quality which can also be found in her portrait of the poet Rainer Maria Rilke (Ludwig Roselius Sammlung, Böttcherstrasse, Bremen), painted in the same year. In her later portrait style, epitomized in the Sombart painting, Modersohn-Becker consciously absorbed influences from 'primitive' sources which she had seen in Paris, in particular antique, Egyptian and medieval works in the Louvre. In a diary entry of 25 February 1903, she wrote: 'Now I feel deeply how I can learn from antique heads. How they are seen in the large and with such simplicity! Forehead, eyes, mouth, nose, cheeks, chin, that is all' (B & T, p. 199). In this painting (and to a lesser extent in the Rilke portrait) she uses luminous red outlines around the head and beard, accentuating Sombart's dark colouring and contrastingly bright eyes. Busch (Busch et al. 173) has cited the possible influence of works by Van Gogh which also employ red contours, such as his *Shepherd in Provence* of 1888 (de la Faille 444). G.P.

REFERENCES
Pauli 84b
Bremen, Kunsthalle, *Paula Modersohn-Becker*, 1947 (25)
O. Stelzer, *Paula Modersohn-Becker*, 1958, p. 78, pl. 54
G. Busch, in *Edvard Munch, Probleme—Forschungen—Thesen*, 1973, p. 166, pl. 105
Busch et al. (173)
GP pp. 131–4, pl. 88

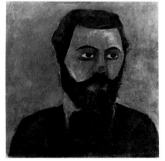

261

262 *Reclining Mother and Child* 1906

Mutter und Kind, Liegende Akt
[repr. in colour on p. 168]
sbl. PMB 82 × 124.5 cm/32¼ × 49 ins
Lent by the Ludwig Roselius Sammlung, Böttcherstrasse, Bremen

Throughout her career Modersohn-Becker was preoccupied with the theme of maternity, often painting and drawing Worpswede peasant mothers holding or suckling their babies, and several diary entries suggest that she viewed motherhood as a heroic, life-giving process (cf. e.g. diary entry of 29 October 1898, B & T, p. 72). The theme was also popular within the Worpswede circle and recurs in the work of her teacher, Fritz Mackensen. This canvas, painted in Paris, represents the latest phase of her formal development. Under the influence of French Post-Impressionist sources, in particular works

by Gauguin and the Nabis, Van Gogh, Maillol and Cézanne, she evolved what she called her 'great simplicity of form' ('*die grosse Einfachheit der Form*'; diary, 25 February 1903, B & T, p. 199). In most of her later mother and child compositions of 1906–7 the mothers are monumental naked figures with heavy, protective bodies and in this painting the facial features have been reduced to a minimum; there is no suggestion of an individual. The subject has become an anonymous matriarchal symbol.

There is a charcoal sketch for this work in the Bremen Kunsthalle (Busch et al. 357) and there are two similar sketches from 1906 in her sketchbook (in a Private Collection and the Ludwig Roselius Sammlung respectively). Stoermer originally dated the painting Paris 1907 (C. Stoermer, *P. Becker Modersohn*, 1913, no. 36) but it is now generally acknowledged to have been painted in 1906 (Busch et al. 207). It was owned until 1927 by Modersohn-Becker's close friend from Worpswede and Paris, Clara Rilke-Westhoff. G.P.

REFERENCES
C. Stoermer, *P. Becker-Modersohn, Katalog ihrer Werke*, 1913, no. 36
Pauli 144
Dresden, Galerie Emil Richter, *Paula Modersohn-Becker*, 1926 (2)
Hanover, Kestner Gesellschaft, *Paula Modersohn-Becker*, 1934 (58)
C. G. Heise, *Paula Becker-Modersohn – Mutter und Kind*, 1961, p. 12
Busch et al. (207)
GP, pl. XVIII

263 Seated Nude Girl with Flowers 1907

Sitzender Mädchenakt mit Blumen
sbl. P. M-B. 89 × 109 cm/35 × 43 ins
Lent by the Von der Heydt Museum, Wuppertal

During 1906–7 Modersohn-Becker painted several compositions based on the theme of a nude girl with flowers. In this painting the figure suggests the influence of primitive sources, possibly African or Egyptian, which she had seen in Paris. The girl's head-dress and facial features are reminiscent of Egyptian mummy portraits which have also been cited as a source for Modersohn-Becker's *Self-Portrait with Camellia Branch* (Folkwang Museum, Essen), painted in the same year (Busch et al. 199, 388). The use of rich colours and surface pattern, and the general tendency to simplify forms, reflect the influence of Gauguin and the Nabi painters. She had visited the Gauguin memorial exhibition in the 1906 Salon d'Automne and in her letters and diaries she often mentions her visits to the galleries around the rue Lafitte, where she saw works by Denis, Vuillard and Bonnard among others. The flowers play both a decorative and symbolic role in this composition. They emphasize the symmetrical design, creating a balance of reds and purples against the blue background, and may also be metaphors of growth. G.P.

REFERENCES
C. Stoermer, *P. Becker-Modersohn, Katalog ihrer Werke*, 1913, no. 52
Pauli 29
H. Seiler, *Paula Modersohn-Becker*, 1959, pl. 32
Busch et al. (209)
GP, pp. 83, 84, pl. XXII

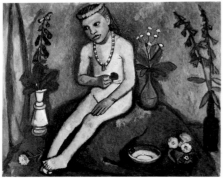

263

Munch, Edvard 1863–1944

Born in Norway, Munch began to train as an engineer but started taking painting lessons 1882–3. He first visited Paris in 1885; later he studied in Bonnat's atelier and was impressed by the work of Van Gogh, Gauguin and the Neo-Impressionists. He went to Berlin in 1892 and exhibited at the Association of Berlin Artists (Verein Berliner Künstler). After a controversial reception the show was closed down, and a protest group of painters, the Gruppe XI, was formed. His friends among the Berlin intellectual avant-garde included Richard Dehmel, Stanislav Przybyszewski, Julius Meier-Graefe and August Strindberg. In autumn 1908 he entered a clinic in Copenhagen after a nervous collapse, returning to Norway in 1909, when he began work on murals for Oslo University. Many of his works were purged from German museums in 1937 as 'Degenerate Art' (*Entartete Kunst*).

ABBREVIATIONS
IL – I. Langaard, *Edvard Munch, modningsär*, Oslo, 1960
JH – J. Hodin, *Edvard Munch*, London, 1972
Hayward – London, Hayward Gallery, *Edvard Munch*, 1974
Washington – Washington, National Gallery, *Edvard Munch, Symbolic Images*, 1978

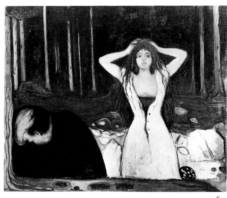

264

264 Ashes 1894

Aske
str. E. Munch 120.5 × 141 cm/47½ × 55½ ins
Lent by the Nasjonalgalleriet, Oslo

After the *succès de scandale* of his 1892 exhibition at the Verein Berliner Künstler, Munch began to work on a series of paintings for his *Frieze of Life* cycle; he wrote about it to the Danish painter Johan Rohde: 'It will have love and death as its subject matter' (Washington, p. 90). *Ashes* was part of this *Frieze* and one of 15 paintings exhibited at Ugo Barroccio's gallery in Berlin, March 3–25 1895, under the group title *Love*. Munch wrote of this series: 'These paintings are moods, impressions of life of the soul, and together they represent one aspect of the battle between man and woman, called love' (Munch-museet Ms. N30; Washington, p. 99). The painting reflects a personal *angst* in the crouching figure on the left, and a destructive sexuality is suggested by the woman's open dress and dishevelled red hair. The vertical emphasis in the tree-trunks and the standing woman is broken by the shoreline and the foreground log which is turning to ashes, creating a smoky grey haze around the crouching man; the ashes seem to symbolize a dying love. The theme of the beach or seashore, repeated in other paintings from the *Frieze*, was inspired by the summers Munch spent in Norway at Åsgårdstrand on the Oslo Fjord, a landscape characterized by an endless, undulating shoreline and large

boulders. 'Through them all [the *Frieze* paintings] runs the undulating shoreline, while beyond lies the sea – always in motion – and behind the leafy trees life, in all its varied manifestations, with its joys and its sorrows, goes on' (E. Munch, quoted IL, p. 459).

This painting combines an emphasis on surface pattern and flat colour areas reminiscent of Gauguin and the 'synthetist' painters, whose work Munch had admired in Paris during 1889–90 and 1896, with harsh colour combinations and disturbing contrasts between highlighted areas and misty, shadowed ones. It has been suggested by Hodin that the decorative linear rhythms may have been influenced by 'the old Nordic ornamental style known to Munch from the excavation of the Oseberg ship' (JH, p. 58).

When the *Frieze* was exhibited at the Berlin Secession of 1902, Munch hung this painting in a prominent position at the beginning of the main wall, calling it *After the Fall*, suggesting both a biblical symbolism and the remorse-ridden period after sexual passion. Munch repeated the composition in an 1896 lithograph in which the log has become a heap of ashes, thus reinforcing the symbolism of dying love (Washington [232]). G.P.

EXHIBITIONS
1895, March, Berlin, Ugo Barroccio
1902, Berlin, Secession
REFERENCES
Oslo, Nasjonalgalleriet, *Edvard Munch*, 1927
J. Thiis, *Edvard Munch og hans samtid*, 1933, pp. 218–19
F. Deknatel, *Edvard Munch*, 1950, pp. 26, 28, 29, 113
IL, pp. 226–7, pl. XIV
Oslo, Munch-museet, *Edvard Munch og den tsjekkiske Kunst*, 1971
JH, p. 58, pl. 39
R. Stang, *Edvard Munch, mennesket og kunstneren*, 1977, pp. 117–20
Washington (47)

265 *Puberty* 1894

Pubertet
sbr. E. Munch 151.5 × 110 cm/59½ × 43¼ ins
Lent by the Nasjonalgalleriet, Oslo

This picture was painted from a young model while Munch was living in Berlin in a rented room in the Friedrichstrasse. Adolf Paul, a member of the Berlin circle of intellectuals with whom Munch became associated, has described a visit to the artist's room while work was in progress: 'On the edge of the bed a naked girl was sitting. She did not look like a saint, yet there was something innocent, coy and shy in her manner – it was just those qualities which had prompted Munch to paint her, and as she sat there in the dazzling light of the brilliant spring sunshine, the shadow cast by her body played as though fatefully above her' (JH, p. 63). The theme of this painting, which belongs to the *Frieze*, is often united in Munch's

work with that of death (in, e.g., his repetition of the theme of the sick child, or his *Death and the Child*, Bremen), a reference suggested by the 'fateful' shadow looming behind the young girl. The strange lighting, which accentuates her shy, nervous pose, evokes a disquieting atmosphere. In his use of a simple symmetrical composition arranged around strong horizontal–vertical axes, Munch has created a haunting image of awakening sexuality. He painted several versions of this theme, but claimed that an earlier version from the mid-1880s had been destroyed in a studio fire (Washington p. 50). For a different vision of pubescent sexuality, cf. Gauguin's *Annah the Javanese* (no. 91). G.P.

EXHIBITIONS
1895, March, Berlin, Ugo Barroccio
1895, Oslo, Blomqvist
1905, Prague, Manès Gallery, *Edvard Munch*
1909, Oslo, Blomqvist
REFERENCES
Oslo, Nasjonalgalleriet, *Edvard Munch*, 1927
F. Deknatel, *Edvard Munch*, 1950, pp. 14–15, 18, 113
IL, pp. 28–32, pl. IV
JH, pp. 62, 86, pl. 43
Hayward (16)
R. Stang, *Edvard Munch, mennesket og kunstneren*, 1977
Washington (38)

266 *Jealousy* 1895

Sjalusi
[repr. in colour on p. 162]
sdbr. E.M. 95 67 × 100 cm/26½ × 39½ ins
Lent by the Rasmus Meyers Sammlinger, Bergen

While in Berlin in 1893 Munch introduced a Norwegian student, Dagny Juell, into the circle of bohemian writers who gathered at a beer-hall called the Schwarze Ferkel (Black Piglet). Her magnetic appeal and belief in a cult of free love caused intense sexual rivalries and jealousies within the group, in particular among Munch, Strindberg and the writer Przybyszewski, whom she married later in 1893. It is generally acknowledged that this painting represents the three-cornered relationship of Munch, Dagny and Przybyszewski. She and Munch, her suitor, assume and Adam-and-Eve-type pose under the tree; she is presented as the temptress about to pluck an apple in the Garden of Eden, while Przybyszewski stares out of the shadows with a melancholy, foreboding expression. Sexual passion is symbolized by the red of the apples and Dagny's robe, and is echoed in the contours around the two male figures.

This work, exhibited as part of the *Love* series at Ugo Barroccio's gallery in 1895, echoes the frieze-like organization, sinuous outlines and almost sketchy style of many other paintings from the *Frieze of Life* cycle. Although these vary in size, Munch was insistent that the cycle made sense as 'a series of paintings which together present a picture of life' (JH, p. 55), a relationship reinforced by the stylistic continuity. *Jealousy* was also exhibited at Blomqvist's, Oslo, in 1895; the exhibition aroused public outrage, causing a local critic to describe the *Love* series as 'the dream visions of a sick man' (IL, p. 443). Thadée Natanson, editor of the *Revue blanche*, visited this exhibition and wrote an article claiming that Munch neglected pictorial concerns 'for the purely human' (*Revue blanche*, 1895, quoted IL, p. 455). The following year the same magazine included an article on Munch, written by Strindberg in the form of a prose-poem, based on several of Munch's paintings, including *Jealousy*: 'Jealousy, sacred feeling of spiritual purity, which abhors the idea of mingling itself, through an intermediary, with another of the same sex. Jealousy, a justifiable egoism, born from the instinct for self-preservation, for me and my race' (A. Strindberg, *Revue blanche*, 1 June 1896).

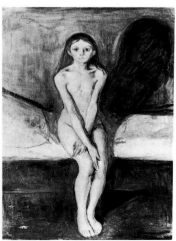

265

EXHIBITIONS
1895, March, Berlin, Ugo Barroccio
1895, Oslo, Blomqvist
1897, Paris, Indépendants (831)
1902, Berlin, Secession (196)
REFERENCES
IL, pp. 455ff, pl. XV
JH, p. 70, pl. 48
Hayward (26)
Washington (39)

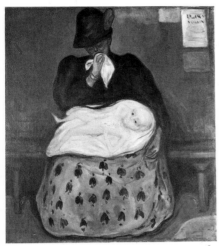

267

267 *Inheritance* 1897/9

Arv
sdtl. E. Munch 97–99 141 × 120 cm/55 × 47 ins
Lent by the Munch-museet, Oslo

This title of this painting is a reference to hereditary syphilis (Munch also called it *The Syphilitic Child*). J. Langaard claims that this work was inspired by a visit to the St Louis Hospital in Paris where Munch saw a distressed woman with a sick child who had been infected by the father (*Edvard Munch*, 1963, p. 21). The child is depicted as a ghostly green symbol of disease, and the falling leaves on the woman's dress symbolize the imminence of death. The disturbing nature of the subject matter is accentuated further by the reference to the traditional Christian madonna and child theme. When the painting was first exhibited at the Paris Indépendants of 1903 it caused controversy and was considered by many to be unsuitable for public display. As in his *Puberty* (no. 265), Munch has used a symmetrical composition and a simple frontal position to create a direct, haunting image, and the disquieting juxtaposition of reds and greens echoes the colour combinations which recur in other *Frieze* paintings.

Arne Eggum has suggested that this painting is also a symbolic reference to Munch's own 'inherited nervous disposition and physical weakness' (Washington, p. 56). He was a sickly, nervous child and suffered a mental breakdown in later life, a weakness which he may have inherited from an anxiety-ridden father. Munch's preoccupation with imminent death may also reflect the series of bereavements which he experienced in his own family. His mother died of tuberculosis when he was five, and his sister of the same disease nine years later: 'Disease, insanity and death were the angels which attended my cradle, and since then have followed me through my life' (E. Munch, quoted K. E. Schreiner in 'Minner Fra Ekely', *Edvard Munch, Som Vi Kjente Ham, Venene Forteller*, 1946).

Munch repeated this motif in several drawings and lithographs,

using the theme in his designs for Max Reinhardt's production of Ibsen's *Ghosts* in 1906–7 (cf. Zürich, Kunsthaus, *Munch und Ibsen*, 1976, pp. 15, 33 and [32, 33]). G.P.

EXHIBITIONS
1903, Paris, Indépendants (1834)
1904, Copenhagen, Den fri Udstilling
1904, Christiania, Dioramalokalet, *Edvard Munch*
1905, Prague, Manès Gallery, *Edvard Munch*
REFERENCES
New York, Museum of Modern Art, *Edvard Munch*, 1950
IL, p. 458
J. Langaard, *Edvard Munch*, 1963, p. 21
Oslo, Munch-museet, *Edvard Munch og den tsjekkiske Kunst*, 1971 (6)
Hayward (29)
Washington (44)

Nolde, Emil 1867–1956

Nolde was born Emil Hansen in north Schleswig. In 1892 he went to St Gallen in Switzerland to teach at the Museum of Industrial Arts, and in 1898 returned to Munich, studying under Adolf Hoelzel. In 1889 he studied at the Académie Julian in Paris. In 1905 he held his first one-man show at the Galerie Ernst Arnold in Dresden and exhibited at the Berlin Secession. He was invited to join Die Brücke in 1906 and met Edvard Munch in the same year. He became co-founder of the Berlin Neue Sezession in 1910. In 1911 he visited Ensor in Munich, and joined an ethnographical expedition to the South Seas two years later. Despite his support for National Socialism, his works were included in the Nazi 'Degenerate Art' exhibition held in Munich in 1937.

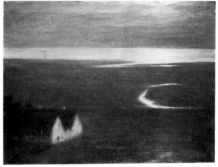

268

268 *Moonlit Night* 1903

Mondnacht
sbr. Emil Nolde; insc on rev. Mondnacht Emil Nolde
65 × 82.5 cm/$25\frac{1}{2}$ × $32\frac{1}{2}$ ins
Lent by the Ludwig Museum, Cologne

The soft grey and yellow tones in this landscape, partly inspired by a summer on the island of Alsen, suggest the influence of Adolf Hölzel's (1853–1934) atmospheric Dachau landscapes with which Nolde became familiar while studying under him in Munich in 1899. In his autobiography Nolde describes his painterly experiments of 1903: 'As an experiment I painted pictures in greyest grey, in which sky and water run into each other' (*Jahre der Kämpfe*, 1967, p. 39). Brought up on a Schleswig farm, he was attracted to flat, wind-swept, northern landscapes, often responding in an almost mystical way to natural forces. He transferred these responses on to the canvas through a synthesis of what he called 'ability, fantasy and poetic power' (letter to Hans Fehr in H. Fehr, *Nolde*, 1957, p. 23).

In this painting the diffused yellow light of a hidden moon and the solitary house evoke a sense of mystery and remoteness, a feature of Nolde's work which R. Rosenblum has identified with a 'northern romantic tradition'. Rosenblum argues that Nolde's bleak northern landscapes echo the visions of Friedrich and Turner (*Modern Painting and the Northern Romantic Tradition*, 1975, p. 136). G.P.

REFERENCES
P. Selz, *Emil Nolde*, 1963, p. 12
Cologne, Wallraf Richartz Museum, *Emil Nolde*, 1973, pl. 3
Darmstadt, *Ein Dokument Deutscher Kunst 1901–76: Akademie, Sezession, Avantgarde*, 1976 (137)

269 *Milkmaids I* 1903

Melkmädchen I
ns. 64.5 × 82.5 cm/25½ × 32½ ins
Lent by the Sammlung der Nolde-Stiftung, Seebüll

While in Paris in 1899–1900, Nolde became familiar with the French Impressionists and Post-Impressionists, and was particularly impressed with Van Gogh and Gauguin, writing later in his autobiography: 'I got to know the work of Van Gogh, Gauguin and Munch, they inspired me with admiration and love' (*Jahre der Kämpfe*, 1967, p. 76). Van Gogh's influence is evident in the loosely applied brushstrokes of bright colour and the strong diagonal rhythms across the canvas. The sense of vigorous movement is accentuated by the diagonal emphasis; the line of milkmaids intersects the incline of the hill and the dresses blowing violently in the wind. In this painting, Nolde's taste for dynamic movement has transformed his early Impressionism into 'a more passionate and energetic statement of great intensity' (P. Selz, *Emil Nolde*, p. 14). G.P.

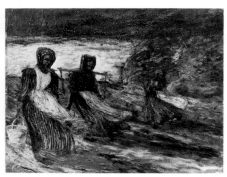

269

REFERENCES
Frankfurt, Kunstverein, *Emil Nolde*, 1958 (3)
Hanover, Kunstverein, *Emil Nolde*, 1961 (3), p. 25
Vienna, Museum des 20. Jahrhunderts, *Emil Nolde*, 1965–6 (2)
Cologne, Wallraf Richartz Museum, *Emil Nolde*, 1973 (2), pl. 4
Belgrade, Museum of Modern Art, *Emil Nolde* (1)

Slevogt, Max 1868–1932

Slevogt studied at the Munich Academy 1885–9 under Von Hackl, Raupp, Heterich and Von Diez. In 1889 he attended the Académie Julian in Paris and then travelled to Italy. He was in Munich 1890–7 and worked on the magazines *Jugend* and *Simplicissimus*. He visited Holland in 1898 and moved to Berlin in 1901. After travelling to Egypt in 1913 he was called up for military service on the outbreak of war. He later illustrated books and taught at the Berlin Academy.

ABBREVIATION
HJI – H. J. Imiela, *Max Slevogt*, Karlsruhe, 1968

270 *The Champagne Aria from 'Don Giovanni'* 1901/2

Die Champagner-Arie aus 'Don Giovanni'
sdbr. Slevogt 1902 105 × 131.5 cm/41¼ × 51¾ ins
Lent by the Niedersächsische Landesgalerie, Hanover

Slevogt executed several paintings of the Portuguese baritone Francesco d'Andrade (1859–1921) performing the title role in Mozart's opera *Don Giovanni*. In this painting d'Andrade is shown in a white costume performing the so-called Champagne Aria in the Theater des Westens in Berlin-Charlottenburg. Leporello is the character in the background. Originally entitled *Stage Sketch* (*Bühnenskizze*), this work is painted in a rapid, sketchy style, influenced by the Berlin Impressionist circle which included painters such as Liebermann (cf. nos 256–7) and Corinth (cf. nos 242–5). The bright, quasi-Impressionistic style of the stage and the figure of d'Andrade is echoed in the areas of light which catch the heads of members of the orchestra. H. J. Imiela has compared Slevogt's composition and dramatic use of theatrical lighting with Daumier's *Drama* (1864, Bayerische Staatsgemäldesammlungen, Munich) and Adolf Von Menzel's *Théâtre Gymnase* (1856; Berlin, Nationalgalerie). Imiela also argues that the view from the side of the orchestra pit is reminiscent of Degas, who exhibited in Berlin at Cassirer's in 1899 (HJI, p. 70).

In this painting, unlike his many other single figure studies of d'Andrade, Slevogt emphasizes the architectural structure of his composition, setting the vertical lines of the performer and the receding stage-set against the strong diagonal of the stage platform. D'Andrade's pose, in which his right hand is raised holding a white glove, is repeated in the Stuttgart version, *The White d'Andrade* (*Der Weisse d'Andrade*) of 1902. Other versions include *The Black d'Andrade* (*Der Schwarze d'Andrade*) of 1903 (Hamburg, Kunsthalle) from the death scene, and *The Red d'Andrade* (*Der Rote d'Andrade*) of 1912 (East Berlin, Nationalgalerie).

Although Slevogt dated the work 1902 it is now thought more likely that it was executed at the end of 1901, probably in November or December when d'Andrade was performing in Berlin (HJI, p. 69 and L. Schreiner, *Die Gemälde des Neunzehnten und Zwanzigsten Jahrhunderts in der Niedersächsischen Landesgalerie Hannover*, 1973, p. 466). G.P.

EXHIBITION
1902, Berlin, Secession (5)
REFERENCES
H. Rosenhagen in *Die Kunst für Alle*, 17, 1902, p. 43 ff.
W. Hausenstein, *Die Bildende Kunst in der Gegenwart*, 1914, p. 144
L. Justi, *Deutsche Malkunst im 19 Jahrhundert*, 1920, p. 102
E. Waldmann, *Max Slevogt*, 1923, pp. 88 ff, 143
W. von Alten, *Max Slevogt*, 1926, p. 24 ff, pl. 32
K. Scheffler, *Max Slevogt*, 1940, p. 60
Hanover, Landesmuseum, *Max Slevogt*, 1952 (37)
J. Guthmann, *Max Slevogt in seiner Zeit*, 1954, p. 11
H. J. Imiela, *Max Slevogt und Mozart*, Homburg, Museum der Stadt, 1956, pp. 24 ff, 32, 40, 50
H. J. Imiela, 'Max Slevogt: Das Bildnis des Sängers Francisco d'Andrade als Don Giovanni, 1902', in *Wallraf-Richartz-Jahrbuch*, XXIII, 1961, p. 255
HJI pp. 69–71, pl. 33

270

Stuck, Franz Von 1863–1928

Born in Tettenweis, Bavaria, Von Stuck studied at the Kunstgewerbe
Schule in Munich 1878–81 and the Akademie der Bildenden Künste,
Munich, 1881–5. During the 1880s he worked as an illustrator on
several magazines and periodicals, and in 1889 won a gold medal at
the International Exhibition in the Munich Glaspalast. He was one of
the founder members of the Munich Secession in 1892. In 1905 he
was made a member of the Sächsische Akademie der Künste,
Dresden. In 1909 the Venice International Exhibition devoted a
room to Von Stuck's work, and in 1911 he was made an honorary
member of the Akademie der Künste, Berlin.

ABBREVIATION
HV – H. Voss, *Franz von Stuck 1863–1928 – Werkkatalog der Gemälde* 1973

272

271

271 *Homage to Painting* 1889

Huldigung an der Malerei
sbr. Franz Stuck oil with gold on paper 58.5 × 100 cm/23 × 39 ins
Lent by the Piccadilly Gallery, London

This painting is a sketch for the poster for the first Jahresausstellung
(Annual Exhibition) at the Munich Glaspalast in 1889. Von Stuck
exhibited three works in the exhibition: *Innocentia* (no. 272),
The Guardian of Paradise (*Der Wächter des Paradies*, HV10/90) and
Fighting Fauns (*Kämpfende Faune*, HV11/85). He often used
and adapted themes from classical mythology, an interest influenced
by the work of Arnold Böcklin and Hans Von Marées; in this sketch
Painting is symbolized by a pseudo-classical figure dressed in a white
toga and seated on a raised throne. The theme of a winged man
holding a horn and a crown of laurel leaves recurs in a different
disguise in Von Stuck's *Angel of Victory* (*Siegergenius*) of the same year
(HV7/88), although in this sketch he is paying homage to the exalted
symbol of Painting. Her god-like status is emphasized by the use of
gold, the metal of the gods. Von Stuck frequently used gold paint and
often insisted on gold frames for his paintings, thus ostentatiously
demonstrating the value which he placed on his own art. He
repeated the composition in a second, more finished sketch for the
same Glaspalast poster (HV3/326).

REFERENCES
HV3/325
Munich, Stuck-Villa, *Franz von Stuck*, 1968 (62)
London, Piccadilly Gallery, *Franz von Stuck 1863–1928*, 1974 (1)

272 *Innocentia* 1889

sbl. Franz Stuck München 68 × 61 cm/26¾ × 24 ins
Lent by N. Manoukian, Paris

This is one of three paintings by Stuck which aroused much
favourable criticism when exhibited at the Munich Glaspalast
exhibition of 1889; one of them, *The Guardian of Paradise*, was
awarded a gold medal. This decorative, allegorical work, painted in
soft shades of blue and white, contrasts starkly with the dark-toned
seductive women of Stuck's *Sin* (*Sünde*) series. While his evil
temptresses are accompanied by writhing snakes, this innocent girl
holds a lily, a Christian symbol of purity. P. Schultze-Naumburg,
writing on Von Stuck in the *Magazine of Art* in 1897, described this
painting as 'a symphony in white, an exquisite poem of pure
girlhood' (*Magazine of Art*, 1897, p. 155). The theme of the
young woman or the pubescent girl was popular among Symbolist
painters at the turn of the century, and takes on a different emphasis
in the awakening sexuality of Munch's nervous subject in *Puberty*
(no. 265). Von Stuck's interpretation of the motif, however, is
closer to English Pre-Raphaelite painting. H. Voss has cited the
possible influence of portraits by Rossetti, Burne-Jones and Walter
Crane (HV, pp. 258–9). Portraits by Whistler – whose paintings were
quite widely exhibited in Germany in the late 1880s and 1890s – in
particular his *White Girl* of 1862, may also have influenced the
subject matter and colouring of Von Stuck's portrait.

EXHIBITION
1889, Munich, Glaspalast, Jahresausstellung (1017)
REFERENCES
HV9/101
In *Kunst für Alle*, 1888/9, 4, p. 309
O. J. Bierbaum, *Franz Stuck*, 1893, pp. 48, 60, pl. 2
In *Magazine of Art*, 1897, p. 155
F. Von Boetticher, *Malerwerke des neunzehnten Jahrhunderts*, 1898 (4)
F. Meissner, 'Franz Stuck', *Das Künstlerbuch III*, 1899, pp. 53, 64, 99
O. J. Bierbaum, *Irrgarten der Liebe*, 1906, pp. 252–3
F. Von Ostini, *Franz von Stuck*, 1909, p. VII, repr. p. 18
E. Diem, *Franz von Stuck*, 1927, p. 6, pl. 9
H. Hofstätter, *Symbolismus*, 1965, pp. 88, 191, 201, pl. 9
Munich, Stuck-Villa, *Franz von Stuck*, 1968, p. 43
London, Piccadilly Gallery, *Franz von Stuck 1863–1928*, 1974 (2)

Vallotton, Félix 1865–1925

Born in Lausanne, Vallotton went to Paris in 1882 to attend both
the Ecole des Beaux-Arts and the Académie Julian. Under the
influence of Charles Maurin and the important 1890 exhibition of
Japanese art he discarded his sombre, meticulously realist painting
style and embarked on radically simplified woodcuts and
lithographs, transposing this new style into his paintings.
He exhibited at the 1st Salon de la Rose + Croix in 1892 and became
a Nabi. Apart from exhibiting at the Indépendants and the Société
Nationale, he also participated in Nabi group exhibitions at

Le Barc de Boutteville, at Bing's Maison de l'Art Nouveau and in Brussels. By *c.* 1901 Vallotton had turned from graphic art to the execution of large, composed landscapes and classical nudes.

ABBREVIATIONS
LR – *Livre de Raison* (list of pictures kept by Vallotton)
VG – M. Vallotton and C. Georg, *Félix Vallotton, Catalogue raisonné of the Printed Graphic Work*, Lausanne and Paris, 1972

273 *Félix Fénéon in the Offices of the 'Revue blanche'* 1896

Félix Fénéon au bureau de la 'Revue blanche'
sdtl. F. Vallotton 96 oil on board 52.5 × 66 cm/20¾ × 26 ins
Lent by the Josefowitz Collection, Switzerland

Félix Fénéon had been at the *Revue blanche* for two years when Vallotton executed this portrait of him. During the previous decade he had become a leading figure within the world of avant-garde reviews; he founded the *Libre revue* in 1883 and the *Revue indépendante* in 1884, and was a regular contributor of articles on both literature and painting to the *Revue wagnérienne, La Vogue, Le Symboliste, La Plume* and *L'Art moderne* of Brussels. He was a friend of Mallarmé and Kahn, and edited works by Rimbaud (1886, 1887), Laforgue (1890) and Lautréaumont (1890). As interested in the new movements in the visual arts as he was in the Decadent and Symbolist movements in literature, he wrote numerous articles on Seurat and the Neo-Impressionists; prepared, together with Luce and Signac (cf. no. 211), the inventory of Seurat's studio after his death; and arranged an exhibition of Seurat's work at the offices of the *Revue blanche* in 1900. Like many of the Symbolists, he was also an Anarchist, and in 1894, when he was acquitted at the Anarchist trial known as the *Procès des trente*, his counsel, Thadée Natanson, offered him a job as literary advisor and secretary to his periodical, the *Revue blanche.*

Founded in 1891 by the brothers Natanson, the *Revue blanche* quickly established itself as the leading Symbolist periodical of the 1890s in Paris. In 1892, Bonnard was invited to contribute a print to its October number. This set the pattern for 1893 and 1894, when original prints by Vallotton, Lautrec and the other Nabis were published as frontispieces; they were reissued in the following year as the *Album de la Revue blanche*. The *Revue blanche* also supported Vallotton and the Nabis by publishing their works in limited editions advertised in its offices, and by reviewing their exhibitions.

Fénéon first noticed Vallotton when he exhibited 14 woodcuts at the 1st Salon de la Rose + Croix in 1892. Although utterly unsympathetic to almost all the entries in this exhibition when he reviewed it for *Le Chat noir* (18 March 1892, in *Oeuvres plus que complètes*, I, pp. 210–11), he admitted enthusiasm for Vallotton's work, appreciating perhaps the ironic, almost Anarchic, humour of the bold black-and-white images. This admiration for Vallotton,

together with their shared interest in Anarchism – Vallotton executed several woodcuts on this theme, e.g. *The Anarchist* (VG104, 1892) – may have helped to establish Vallotton as one of the chief contributors to the *Revue blanche* after the publication of his first commission, *The Three Bathers*, (VG133), in the February 1894 number.

The extreme flatness of the colour and the sharp contrasts between blocks of light and shadow in this portrait reflect Vallotton's woodcut technique. He had taken up this medium in 1891, drawing his inspiration both from Japanese originals and from the experimental work done in 1889 by Auguste Lepère and Henri Rivière. Attracted by its rigorous simplification, and justified in his desire to express himself through the original print by the Symbolist aesthetic principle that any art form controlled by the artist was capable of expressing the Idea, Vallotton rapidly established for himself a permanent position in the contemporary revival of the original woodcut (Octave Uzanne, 'La Renaissance de la gravure sur bois – un néo-xylographe: M. Félix Vallotton', *L'Art et l'Idée*, February 1892). M.A.S.

REFERENCES
Paris, Musée d'Art Moderne, *Vallotton*, 1966 (18)
G. Mauner, *The Nabis*, 1978, pp. 239–40, fig. 92
Winterthur, Kunstmuseum, etc., *Félix Vallotton*, 1978–9 (21)

274 *Intimacy: Interior with Lovers and a Screen* 1898

Intimité: Intérieur avec amants et paravent
[repr. in colour on p. 111]
sdblc. F. Vallotton 98 oil on board 35 × 57 cm/13¾ × 22½ ins
Lent by the Josefowitz Collection, Switzerland

This painting, together with *The Lie* (LR38, Baltimore Museum of Art), is based on a woodcut entitled *The Lie* (VG188), the first of a series of 10 woodcuts of 1897–8, collectively called *Intimités* and published by the *Revue blanche* (cf. no. 273). The series is concerned with intimate interiors in which scenes of love and marriage are depicted through a variety of confrontations between man and woman. Although the subject matter may have been provided by Jules Renard's novel *La Maîtresse*, for which Vallotton had produced a sequence of small, expressive woodcut illustrations in 1896, the transformation of an anecdote into an evocation of mood, through the careful arrangement of flat colour areas, relates it to the intimist paintings of the Nabis, especially Vuillard.

Vallotton established close relationships with the Nabis in 1893 and until the end of the century he was involved in a number of group activities. He exhibited with them at the Le Barc de Boutteville exhibitions from 1893 onwards, at the Dépêche de Toulouse in 1894, and at the opening of Bing's Maison de l'Art Nouveau in December 1895. His prints were included in group albums, *Album de la Revue blanche* (1895), *Petite suite de la Revue Blanche* (1895), the two volumes of Vollard's *Peintres-Graveurs* (1896 and 1897) and in Meier-Graefe's *Germinal* (1897). In 1898 he was also involved in the decoration of the Nabis' puppet theatre, established in 1896, the Théâtre des Pantins. However, it was with Vuillard that Vallotton developed his closest relationship. Vuillard had sold some of Vallotton's woodcuts to Thadée Natanson in 1893 and the following year secured for him a commission from the Théâtre de l'Oeuvre to design a programme for Strindberg's *The Father*. In 1897 Vallotton painted a portrait of Vuillard (LR350), and two years later Vuillard executed two portraits of Vallotton, *Vallotton and Misia* (Palais de Tokyo, Paris) and *Portrait of Vallotton* (Kunsthaus, Berne). M.A.S.

REFERENCES
LR387
Winterthur, Kunsthaus, etc., *Félix Vallotton* (30)

273

Great Britain and Ireland

Two Reactions to French Painting in Britain

Anna Gruetzner

Roger Fry invented the term Post-Impressionism to describe the group of French paintings exhibited at the Grafton Galleries in 1910, but the term describes equally well the two waves of British artists whose responses to French painting can be seen in the present exhibition. The period 1880–1912 witnessed two separate phases during which British painters felt dominated by French painting and looked to Paris for their inspiration, though between these phases there was a period of retrenchment when British artists turned their backs on French painting and concentrated on becoming thoroughly British again. In a nutshell, we are looking at a period of internationalism (*c.* 1878–92), followed by a period of nationalism (*c.* 1892–1905), followed by a second period of internationalism (*c.* 1906–15).

Symptomatic of this first international phase was the vast migration of British art students to Paris, to finish their art education in the ateliers there. This compulsion to study in Paris has been given a simplistic explanation by past art historians, who have looked entirely to Britain for its causes, assuming that it was due to the state of teaching in British art schools, or even that it resulted, quite simply, from the fact that the Frenchman Alphonse Legros, then Professor at the Slade, urged his students to go to Paris. This, in fact, is precisely what he did not do; 'Many of the master's pupils went on to Paris, much to his regret. He liked to think he was founding a school of artists who respected tradition and Paris unsettled them, they went after strange Gods.'[1] While it is true that the relative merits of the British art school and the French atelier were a matter of great controversy in the 1880s, this was not a cause of the exodus, but a result of it. The controversy arose from the anxiety felt by established British artists under the threat of foreign invasion.

To understand what lured students to Paris in the 1880s, we should look not to London but to Paris itself, because by then Paris had come to be generally considered as the world's art capital. The endless memoirs, letters, diaries and contemporary periodicals which chronicle how this supremacy was promoted and achieved cannot be dealt with here; one crisp categorical statement from the *Magazine of Art* in 1881 can serve as their summary: Paris, it said, was 'the art centre of the world . . . the art school of the world . . . and the art market of the world'.[2] The magnetism of Paris was international. British students tended to remain within Anglo-American circles which spoke the same language,

shared the same viewpoints and frequented the same colonies during the summer, but they had in fact entered an international milieu. The ateliers contained students from all over the world, and the British painter who was successful became part of the truly international contingent which exhibited at the annual Salon.

Bastien-Lepage was the artist who, far above any other, influenced British art students in the early 1880s, and their enthusiasm was shared by young artists of every nationality. By 1883 his influence was so ubiquitous that one critic wrote in his review of that year's Salon: 'Everyone today paints so much like M. Bastien-Lepage that M. Bastien-Lepage seems to paint just like everyone else.'[3] Bastien had become an international stylistic phenomenon. As far as the British were concerned, they had unusually generous exposure to his work. His paintings were exhibited in London and Glasgow, and British artists met him personally in London, in Paris and at Concarneau. And, even if one were not blessed with these direct contacts, it was possible to pick up his technique after exposure to the 'house style' of any of the Anglo-American colonies in Britain or France which practised his methods.

Why was Bastien-Lepage so particularly successful? First of all, he was young – practically of the same generation as his followers. He was also extraordinarily versatile, producing portraits and landscapes as well as large subject pictures, and he picked and chose from the most popular and attractive painting techniques available, integrating them smoothly into his own work. While the *plein-airisme* of the Impressionists was still highly controversial, Bastien made *plein-air* pictures of high finish and meticulous technique which, though 'contemporary', were also readily acceptable.

In his relationship with British painting, Bastien benefited from the fact that most of the French painting exhibited and sold in Britain in the 1880s was work by Baribizon landscapist and peasant pictures by Millet, Jules Breton and Lhermitte. Bastien's own peasant subjects (cf. no. 10) were the most up-to-date version of this genre of painting. Furthermore, his technical expertise, and the detailed finish of his canvases, had certain affinities with Pre-Raphaelitism and thus had a special appeal in Britain.

The vogue for outdoor naturalism led to the proliferation in the 1880s of artists' colonies in rural areas, where Bastien's influence was paramount. Painters emulating his style were to be found in Brittany and at Gretz-sur-Loing, and at Newlyn

in Cornwall and Cockburnspath in Scotland. These colonies often progressed from their original intention and developed a distinctive group style, such as the bright, decorative painting which emerged from Cockburnspath (cf. no. 306). Bastien had painted his local scenery at Damvillers; Clausen, La Thangue, Edward Stott and others settled down to paint the English villages.

Bastien's followers, though painting in a French manner, were never regarded as the most progressive British artists. That mantle fell on the painters who worked in London under the aegis of Whistler, and who then turned from him to study Degas and Monet; it was they who constituted the real British avant-garde. Whistler's power to attract followers after his return from Venice in the early 1880s is clearly illustrated in some of the work of Sickert, Starr and Roussel in the present exhibition (cf. nos 336, 344, 331). His followers accompanied him around London and to St Ives, painting small oil panels, and in the studio they copied his carefully considered portrait style, often even using the same models. They saw themselves as a small, select, self-contained group following Whistler and attempting to expand their experience. They became the first British Impressionists.

Of the French Impressionists, Degas and Monet were the most influential in Britain. By the later 1880s, both had a following there. Let us consider the case of Degas in particular, because his relationship with British artists is paradigmatic of the dialogue between French painting and the British avant-garde in the period. Sickert and George Moore were his most committed British admirers. As friends, they visited his studio in Paris; as enthusiasts, they were zealous proselytizers, always seeking new converts, and as art critics they lost no opportunity to praise his work. In his review of the 1886 Impressionist exhibition Moore wrote: 'Another ten years will pass before it is generally admitted that Degas is one of the greatest artists the world has ever known.'[4] Sickert was equally eulogistic, calling him 'the one great French painter, perhaps one of the greatest the world has ever seen'.[5]

As a painter it was Sickert who reaped most benefit from Degas. From the moment he returned to Paris in autumn 1885 and explained to the Whistler followers Degas' idea that compositions should be arranged as if looking through a keyhole, Sickert had the good fortune to be the principal source of information about Degas for British artists. He continued to meet him in Paris, and collected photographs and lithographs which were 'an education in selection and treatment, as all the art schools and ateliers of Europe rolled into one could not supply'.[6] Since there were few opportunities to see original paintings by Degas in London, such an assemblage was extremely valuable for young artists.

Through his special access to the man and his work, Sickert quickly came to understand Degas' ideas and methods, which inspired him and influenced his art greatly. Degas' effect on those who did not enjoy this close contact is, in many cases, more questionable. Take the case of Starr: his knowledge of Degas came through Sickert, his friend and collaborator, and this experience at one remove accounts for the slightly awkward look of his Degas-like compositions

(cf. no. 344). But his depictions of the stations and suburban streets of London, which were inspired by Degas' modern subjects, do have an individual quality. However, in the hands of the less talented, Degas' subjects were imitated without understanding and his compositions reduced to a formula. Sickert, in despair, wrote: 'Surely, it is time that we had done with the form of criticism in which . . . a ballet girl, no matter how inane in execution, . . . evokes a reference . . . to Degas.'[7]

By the 1890s Degas' work was better known, but there was no evidence in London's exhibitions that it was any better understood. Sickert's lament was taken up by D. S. MacColl:

It is the fate of modern styles to be rapidly reduced by followers to a foppery; what has happened to the style of Whistler happens to that of Degas. In Steinlen and Forain we see already its adoption in the hands of the wit and the journalist as a caricature-formula; in the English imitators . . . there is a further remove; more of the formulae, less justification by the addition of personal wit and observation.[8]

Those who had a more creative understanding of modern French painting obviously wanted to exhibit their work in a context over which they had some control. They chose the New English Art Club as their forum. The Club had been formed in 1886 by French-trained British artists who felt that they were being neglected by the Royal Academy; so they adopted a method of jury selection based on the practice of the Paris Salon. Indeed, the work shown in the first exhibition so resembled what was to be seen at the mentor establishment in France that one critic commented that it resembled a 'miniature Salon'. But the situation changed rapidly. After the first exhibition closed, La Thangue made the first move for reform by proposing that the club should become a truly national exhibition open to every artist in Britain. But he soon came to realize that this role was not suitable for the New English Art Club and would have been more appropriate to a liberalized Royal Academy. On the other hand, it was clearly not possible to remain faithful to the club's original intention that it should show 'really good modern painting irrespective of style'.

In 1888 Sickert, Steer, Starr and Roussel, together with Fred Brown and Francis Bate, were elected to the committee of the New English Art Club. They decided that the Club should have small exhibitions of carefully controlled quality which presented the aesthetic of the progressive school in Britain. So, in that year's exhibition, while other factions (for instance the Scottish School) were still represented, it was the work of this committee-controlling clique which dominated and attracted most attention. Steer's *A Summer's Evening* (no. 345) was hung in the place of honour and so gained the attention which the clique thought it deserved. Degas' *The Green Dancer* (Lemoisne 572), shown in the same year, was the first of several French Impressionist paintings in the Club's exhibitions. Whistler had set a precedent for showing Impressionist and British paintings together when he invited Monet to show four paintings at the Royal Society of British Artists in winter 1887–8. At the New English Art Club in 1889, the conservative, Bastien-influenced faction attempted to stage a counter-revolution, but the Sickert clique was quite

firmly in the saddle and the pattern established in 1888 continued for the next few years.

It was at the New English Art Club that Sickert first took on his long-running and often renewed role as leader of the British avant-garde. In 1889 he tried, without success, to get Degas elected to the committee, and as art critic on the *New York Herald* he mounted a crusade on behalf of himself and his *confrères* – a crusade continued in *The Whirlwind* (1890), the organ of British Impressionism. Moreover, he launched the 'London Impressionists' with the catalogue preface for their show at the Goupil Gallery in 1889, and arranged exhibitions of their work in his studio.

From 1888 until the mid-1890s, the most radical British painting – painting based on knowledge of Degas, Monet and Neo-Impressionism – was exhibited at the New English Art Club. This could have provided the launching-pad for new experiments, pushing the work further in directions which it had already taken. But instead the very artists who had championed the cause became disenchanted with it. Sickert spent more and more time abroad. Steer abandoned the pure colour and broken brushwork he had learned from Monet and the Neo-Impressionists, and painted landscapes which recalled Constable. Generally speaking, the dominant style of the New English Art Club from the mid-1890s was one derived from English and French painting of the eighteenth century. What had happened?

Primarily, painters had come to realize, after the elation of the first heady ride on the back of the new school in France, that this borrowed excitement was no substitute for that more organic force – a recognizably British style. Prior to 1880, of course, there had been one; Pre-Raphaelitism and British Subject Painting had not only been powerful at home, but had, since the Paris Exposition Universelle of 1855, been greatly admired abroad.

In 1884 the French critic Ernest Chesneau, in his book *The English School of Painting*, had written glowingly of the qualities and strengths of British painting, but three years later, in a letter to the *Magazine of Art*, he expressed fears for its continued existence. He felt that, as a result of the dominance of France, it was losing 'that very originality which gave it the rare and enviable distinction of being a truly national school'.[9] And Degas himself, who had strong feelings about the importance of national qualities in art, expressed the same misgivings. As he walked round the British section of the 1889 Exposition Universelle with George Moore, he said:

I am disappointed with your English school; it seems to have lost a great part of the naïveté which distinguished it in '60 [*sic* – he was referring to 1867] and even in '78, and without which art is worthless. You come over here and learn to draw from the nude and acquire the trick of professional French painting (*la bonne peinture*) and then you return to your country neither fish, nor fowl, nor good red herring.[10]

During the period of foreign influence, people had often criticized the artists' rejection of the home-grown tradition. In reviewing the second New English Art Club exhibition, in 1887, the *Daily News* commented that it was 'remarkable that the cleverest of our young men . . . should have followed

French principles while abandoning not only Turner but also the Pre-Raphaelite Brotherhood'. Degas' lessons, properly assimilated, had clearly been beneficial, but the effects of the headlong British love affair with Monet were, with the single exception of Steer, more questionable. Monet's influence in Britain had taken much the same course as Degas', and the work of Monet's followers fared very badly when compared with that of their master. In reviewing the New English Art Club exhibition of 1891, *The Star* commented: 'The real Monets put the sham Monets out of countenance.'[11] They had of course looked to Monet for the art of making studies of light and colour, but perhaps they would have done better to concentrate on their English predecessors for, as Chesneau pointed out, 'In studying the history of English painting it is impossible to overlook the love of colour transmitted from generation to generation.'[12]

A series of exhibitions in the 1890s, combined with the criticism of MacColl and other promoters of the 'English School', helped to resurrect the reputation of the Pre-Raphaelites, and in 1900 the New English Art Club helped to resolve the painful dilemma of whether to look to the Pre-Raphaelites or to the Impressionists by hanging Monet and Holman Hunt side by side:

The Committee has prepared an artistic surprise which is sure to be much discussed in art circles. A prismatic snow scene by the French artist is placed next to the PreRaphaelite portrait of Rossetti and again a dazzling landscape by the former is against the latter's *The Importunate Neighbour*. . . . These four works are, after all, truly attuned and are successful solutions of problems in real light.[13]

So, in the later 1890s, the British artists who had fallen under the spell of the Impressionists felt the rival claims of their roots at home and their borrowings from France, and concentrated on beginning a new school which would be truly British. They realized that momentous Post-Impressionist developments had taken place in France. Indeed Moore, one of the English painters' gurus throughout the period, maintained French contacts which kept him abreast of developments.[14] MacColl, too, was aware of Post-Impressionist painting. In the early 1890s he had been taken to Père Tanguy's shop to see 'Flowers by "Vincent" [Van Gogh] and landscapes by youths from Pont-Aven'. He also saw 'scores of still lifes by Cézanne' at Vollard's; 'Anquetin had just abandoned his "synthetic" manner, that of strong outline and flat tint, and that master of the Japanese convention Toulouse Lautrec was terrifying the hoardings.'[15] MacColl did recognize at this time that the British could not cling to their old heroes in perpetuity – to Puvis and Legros, Whistler, Degas, Watts, Burne-Jones and Manet; 'Would it not be prudent to cast about for their successors?' However, he had no desire to recommend in their stead any of the perpetrators of the new art in Paris: 'I do not pretend that the prospect for our generation is very hopeful! Art for the moment is not in the family way . . .; in France the great wells of inspiration are running dry.'[16]

All in all, things in Paris had moved too fast for the British artists. Their preoccupation with their own position, which they were examining in a more English light, precluded any of the same painters (with Sickert always the exception)

from going off to take on board wholly new inspiration from across the Channel. There were British painters who were influenced by Post-Impressionism, but they were not based in London. They were in Brittany, remote from the misgivings of British artists and critics. The works of these Brittany painters – Bevan, Forbes-Robertson and O'Conor (cf. nos 276, 289, 322) – show the strong influence of Van Gogh and Gauguin which dominated the painting done there in the 1890s. Just as in the early 1880s British painters had gone to Brittany and adopted the techniques of Bastien-Lepage, those who went there now were lured by the School of Pont-Aven. It is one of many examples during the period of artists' work being crucially affected by their being in the right place at the right time.

By contrast, the students at the Slade between 1895 and 1905 were strongly influenced by the painting of Velasquez and Goya. This was brought on by the publication of R. A. M. Stevenson's *Velasquez* in 1895. Stevenson's admiration for Velasquez dated back to the 1870s when, as a student in Carolus-Duran's atelier, he had been affected by his teacher's enthusiasm. The publication of Stevenson's book coincided with a revival of interest in Whistler (also much influenced by Velasquez in his later work), and Stevenson's pronouncements that technique was art, and that Velasquez was an Impressionist, had enormous importance for British art students. In emulation of the Spaniard's style, they created thinly painted works in clear low-key tonalities, and thus established what is recognized to this day as an 'English' style. These Slade students did go to Paris to see the newly installed Caillebotte bequest of Impressionist paintings (opened 1897), and to attend Whistler's classes at the atelier, or to admire Puvis de Chavannes. But these were visits to places which held a specific interest for them; there was at this point no strong overall link between Paris and London.

It is dangerous to pinpoint a change of direction at one specific date, but January 1905 was a turning-point, with the exhibition of 315 Impressionist paintings mounted by Durand-Ruel at the Grafton Galleries. It came at a point when the British were just beginning to look again at French painting. That year Sickert returned to London after hearing encouraging tales about British painting from Spencer Gore the previous summer, and Frank Rutter, the critic, began his education in French painting by rushing off to France to meet Monet.

Gore was one of the first British artists to look to France in this second period. He began at the point where the British painters had stopped in the early 1890s. He did not need to go to France because the veterans of this first period were in London to teach him what he wanted to know. Sickert's enthusiasm for Degas had not diminished and his advice was much appreciated, as Gore explained in 1908 in a letter to his pupil Doman Turner: 'Nearly everything I have told you comes through Walter Sickert from Degas. Sickert is one of the few persons who knows Degas really well.'[17] Lucien Pissarro's instruction in Impressionist landscape and Neo-Impressionist colour theory was equally appreciated. Gore assimilated these lessons with great assurance, quickly putting them to original use in his music hall paintings.

This renewed interest in Paris, which got an extra fillip from the advent of the Fauves, had better channels of communication than the Francophile phase of the 1880s. Once again French painting was felt to have a lot to offer; it was easier to discover where the most exciting paintings were, though there was a lot of catching up to do. Young artists such as Gore exhibited at the Indépendants. Others, such as Fergusson, settled in Paris and became involved in the circle of the Salon d'Automne. Anglo-American circles were still important in Paris, and British painters could visit the Steins to see their collection and meet their French colleagues.

One sign of a new attitude in Britain was the creation of a number of new exhibition forums – almost the first time that young artists had been offered new places at which to show since the foundation of the New English Art Club in 1886. Although the New English Art Club did accept the most talented Slade students, such as Orpen and John, it was no longer the place to hang truly radical painting. As in the 1880s there were, broadly speaking, two bases on which new exhibiting societies could be founded. Either they could be select groups of artists with similar aims, or they could be large exhibitions open to all comers. This time, both kinds of society came into being. In 1905, Vanessa Bell founded the Friday Club for annual exhibitions, meetings and lectures, and in 1907 Sickert established the Fitzroy Street Group, explaining that he wanted to create a Salon d'Automne atmosphere in London. Both of these were for small groups with shared aims. The Allied Artists' Association, by contrast, aimed to be a non-juried exhibiting society equivalent to the Société des Indépendants in Paris. Its first exhibition, in July 1908, attracted over 3,000 exhibits, and some new talents came to light; Bevan and Ginner, for example, both came to the attention of the Fitzroy Street Group. In addition, foreign painters new to Britain appeared at exhibitions at this time – Kandinsky at the Allied Artists' Association in 1909, and Gauguin, Van Gogh and Matisse (who was exhibiting outside France for the first time) at the International Society in 1908. The free exchange between these exhibiting societies encouraged new friendships between young painters and helped foster broader awareness.

After London had once again declared itself interested in French art, things began to happen very quickly. One of the first indications of this was Fry's *Manet and the Post-Impressionists* exhibition which opened at the Grafton Galleries in 1910; most of the paintings were by Gauguin, Cézanne and Van Gogh. While this exhibition did create a good deal of public controversy, this was not its most important result. More significant were its repercussions for British modernism, for it heralded a basic change in the spirit of the London art scene. It was followed between 1910 and 1914 by a number of large exhibitions of foreign painting including Fry's 2nd Post-Impressionist Exhibition of 1912–13 and Rutter's large and varied *Post-Impressionists and Futurists* at the Doré Gallery in 1913. It was this wave of exhibitions which made Britain a participant in the modern movement. As Fry pointed out in his introduction to the first Post-Impressionist Exhibition, the movement was already

'widely spread. . . . The school had ceased to be specifically a French one, it had found disciples in Germany, Belgium, Russia, Holland and Sweden. There are Americans, Englishmen and Scotsmen in Paris who are working and experimenting along the same lines.'[18]

After the first Post-Impressionist Exhibition there was a good deal of excitement about the modern movement in London, and, besides the exhibitions, a number of books were published which discussed the significance of modern art – often with Fry's term 'Post-Impressionist' in their title. One of the first was Rutter's *Revolution in Modern Art* (1910). Rutter had followed developments in France and was in close contact with artists in Paris. While his interpretation was more prosaic than Fry's, Rutter dedicated his book 'to the rebels of either sex all the world over who in any way are fighting for freedom of any kind'. A study of Gauguin and Cézanne was necessary, he wrote, to any study of revolutionary art, but it was Picasso, Matisse, Derain and others who represented the most recent phase in French art. This phase was so far unknown in Britain. C. L. Hind also interpreted Post-Impressionism as a movement which liberated the artist, 'opening out, inviting the pilgrim who is casting off the burdens of mere representation and of tradition. . . .'[19]

This new spirit of modernism gave a great boost to young British painters, providing the incentive to experiment with form and colour and with bolder painting techniques; artists were, though, still faced with the problem of how best to cope with influences from outside. It was Cézanne who attracted most attention from British painters. Fry was strong in his

enthusiasm for Cézanne's merits, and others were quick to follow him. In his preface ('The English Group') to the English section of the 2nd Post-Impressionist Exhibition, Clive Bell explained: 'Their debt to the French is enormous. . . . For instance it could be shown that each owes something directly or indirectly to Cézanne.'[20] The Cézanne mania became as hotly debated a topic as Degas and Monet had been 20 years earlier. Sickert for one attacked it in an article called 'Mesopotamia-Cézanne', recalling 'the swells of the eighties whom we succeeded in vaccinating with a knowledge of the existence of Monsieur Degas . . .; converts are proverbially somewhat amateurish in their gestures of devotion'.[21] *The Times* also realized the danger implicit in the situation, and gave its verdict on the 2nd Post-Impressionist Exhibition:

On the whole, the English pictures are inferior to the French just where we should expect them to be, in the rendering of mass and form. . . . If Post Impressionist art becomes popular in England we shall have hundreds of nonsense pictures . . .; already in the English pictures we see a tendency to sacrifice mass to colour; and this must be checked if the movement is not to end in an empty decorative convention.[22]

The development of British modernism ended during the First World War. Even its most innovative group, the Vorticists, did not sustain its original momentum in the post-war years. After the war Paris no longer had the same appeal and once again British artists drew upon their own heritage. Such vacillation between art which remains insular and self-perpetuating and art which sacrifices its own identity in the face of dominant foreign influences has remained to the present day a problem in British twentieth-century painting.

NOTES

1. C. Holroyd, 'Alphonse Legros, Some Personal Reminiscences', *Burlington Magazine*, 1911, p. 273.
2. *Magazine of Art*, 1881, pp. 379–80.
3. *Ville de Paris*, 11 May 1883.
4. G. Moore, 'Half a Dozen Enthusiasts', *The Bat*, 25 May 1886.
5. Sickert, interview in *The Sun*, published in *The Artist*, 1 October 1889, p. 275.
6. Sickert, in *New York Herald*, 7 May 1889.
7. Sickert, in *New York Herald*, 23 April 1889.
8. MacColl, in *Saturday Review*, 16 April 1898, p. 520.
9. *Magazine of Art*, 1888 (issue for November 1887), p. 25.
10. Moore, in *The Hawk*, 24 December 1889.
11. *The Star*, 30 November 1891.
12. *Magazine of Art*, 1888, p. 28.
13. *Manchester Courier*, 7 April 1900.
14. Moore, 'The Division of the Tones', *The Speaker*, 10 September 1892.
15. MacColl, 'A Year of "Post-Impressionism"', *What is Art?*, 1940, p. 18.
16. MacColl, in *Saturday Review*, 21 November 1896.
17. Unpublished letter of 8 September 1908.
18. 'The Post Impressionists', introduction to Grafton Galleries catalogue, 1910, p. 12.
19. C. L. Hind, *The Post-Impressionists*, 1911, p. 2.
20. C. Bell, 'The English Group', p. 2.
21. Sickert, 'Mesopotamia-Cézanne', *The New Age*, 5 March 1914.
22. *The Times*, 21 October 1912.

Bell, Vanessa 1879–1961

Born in London, Vanessa Bell, daughter of Leslie Stephen, studied at the RA Schools. In 1905 she organized the Friday Club for exhibitions, lectures and discussions, and in 1907 she married Clive Bell. She exhibited at the NEAC, the AAA, the Indépendants Anglais at the Galerie Barbazanges and the 2nd Post-Impressionist Exhibition. A co-director of the Omega Workshops 1913–19, she carried out many decorative projects.

275 Conversation Piece 1912

sdbr. VB 1912 oil on board 63 × 76 cm/25¾ × 30 ins
Lent by the University of Hull Art Collection

The figures in *Conversation Piece* are, from left to right, Adrian Stephen, the artist's younger brother, Leonard Woolf, husband of the artist's sister Virginia, and Clive Bell, the artist's husband. The scene, the sitting-room of Asham House, Sussex, is one of a series of interiors painted by Vanessa Bell in 1911 and 1912 which show family and friends engaged in conversation, napping, taking tea and painting in studios. Their intimist mood has much in common with Nabi interiors and the 'English' interiors of Rothenstein, Gilman and others. However the equilibrium of the mood and the formal components of the painting, in which the figures and the surrounding space are reduced to a two-dimensional design so that it becomes an exercise in shape and line, indicate an advanced understanding of picture-making. This uncompromising attitude to subject and form was expressed with even less restraint in landscapes such as the startlingly abstract *Studland Bay* (1911, Tate Gallery). A.G.

EXHIBITION
1912, Paris, Galerie Barbazanges, Quelques artistes indépendants anglais
REFERENCE
Hull, University, *Art in Britain 1890–1940*, catalogue by M. Easton, 1967 (1)

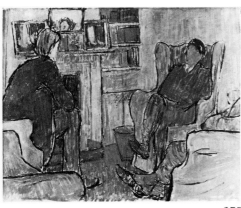

275

Bevan, Robert 1865–1925

Born in Hove, Sussex, Bevan studied at the Westminster School of Art and at the Académie Julian in Paris. In 1890–1 and 1893–4 he was at Pont-Aven; in between, in 1892, he visited Tangier. When he settled in London in 1900 he kept himself informed about developments in French art, but seems to have worked in isolation until his work was discovered by the Fitzroy Street Group at the AAA in 1908. Bevan was a founder member of the Camden Town Group, the London Group and the Cumberland Market Group.

276 Madonna and Child c. 1894

ns. wax on panel 9.5 × 10.5 cm/3¾ × 4 ins
Lent by Mrs Robert Bevan

In this depiction of Breton peasants in a religious scene Bevan gives a cloisonnist interpretation of the landscape, translating it into sinuous, flat shapes of pure green, red and blue with a heavy black outline. The use of wax as a medium, the textured gold paint of the halos and the decorated frame all suggest that Bevan must have been familiar with Charles Filiger's work (cf. no. 78), a likely supposition since Filiger was a close friend of Forbes-Robertson (cf. no. 289), who worked with Bevan in Brittany. A.G.

276 277

277 Breton Mother and Child c. 1894

ns. wax on panel 9.5 × 6.5 cm/3¾ × 2½ ins
Lent by Mrs E. H. Baty

This is the only other wax painting (cf. no. 276) which Bevan is known to have executed. A.G.

278 The Courtyard 1903/4

sbl. Robert Bevan 56 × 68 cm/22 × 27 ins
Lent by M. C. Peraticos Esq.

The Courtyard was painted from a number of preliminary sketches done in Poland, which in certain respects reminded Bevan of Brittany and which he visited several times between 1899 and 1904. During these years he still made frequent trips to Paris to see exhibitions. This stimulus and his contact with Gauguin inspired Bevan's experiments with colour; in *The Courtyard* the colour is more intense and the Expressionistic swirling forms more dramatic

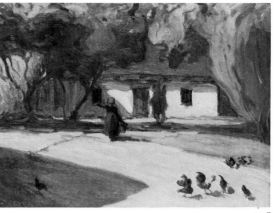

278

than in any of his previous work. It is interesting to compare critical reactions to this painting on the two occasions when it was exhibited in London. In 1905 the critics found the brilliant colour difficult to accept: *Black and White* thought it 'garish' and considered that it had 'an evil habit of losing control over itself', while the *Glasgow Herald* was prompted to comment: '. . . compared to some of his works in oil, where he seems to reconcile violent greens, yellows and reds . . . even the most Monetesque of Monets must appear reticent.' In 1905 exposure to 'Post-Impressionist' work was very limited and Monet was the most advanced 'known' artist with whom Bevan could be compared. When *The Courtyard* was exhibited again in 1911 the lessons of Fry's exhibition had been assimilated, and *The Observer* wrote: 'He adopts the boldly juxtaposed primaries of the Matisse school, turning this peaceful courtyard into a very configuration of riotous red and orange and emerald green applied in swishing sweeping streaks which recall some of the much-discussed pictures at last year's Grafton Gallery.' A.G.

EXHIBITIONS
1905, London, Baillie Gallery (53)
1911, London, AAA (I)
REFERENCES
Glasgow Herald, 4 March 1905
Black and White, 8 March 1905
P. G. Konody, in *The Observer*, 9 July 1911
J. Wood Palmer, 'Robert Bevan', *The Studio*, January 1957, p. 15
R. A. Bevan, *Robert Bevan, a Memoir by His Son*, 1965, p. 13

279 *Ploughing the Hillside* 1906/7

ns. 62 × 82.5 cm/24½ × 32½ ins
Lent by Aberdeen Art Gallery

Between 1906 and 1908–9 Bevan used a Divisionist technique which, after the riotous Expressionism of *The Courtyard*, allowed him to exercise greater control while still using a range of bright colours in the purple, blue, red range. Until 1907, Bevan worked in the studio from sketches painted from nature. There are two known studies for *Ploughing the Hillside*. In one, painted from nature (exhibited at the D'Offay Couper Gallery, 1969 [31]), the paint is applied as loose blobs of colour in areas of blue, purple, green, pink, yellow and orange. The second (W. Baron, *The Camden Town Group*, 1979, pl. 49) is a completely worked-out study, but the Divisionist brushwork is not as tightly executed as in the final work.

Horses greatly appealed to Bevan. He first painted them in Brittany and his search for London subjects led him to paint horses in cab yards. In 1912 he started painting horse sales. A.G.

EXHIBITION
1908, London, Baillie Gallery (5)
REFERENCES
J. Wood Palmer, 'Robert Bevan', *The Studio*, January 1957, p. 16
R. A. Bevan, *Robert Bevan, a Memoir by His Son*, 1965, p. 14

279

Clausen, George 1852–1944

Born in London, Clausen was the son of a painter of Danish descent and attended South Kensington School of Art. In 1875–6 he visited Belgium and Holland and in 1876 made his début at the RA with a painting of a Dutch subject. In the late 1870s Whistler was a dominant influence, but in 1880 Clausen transferred his allegiance to Bastien-Lepage; later, in the 1890s, French Impressionism took over. He moved to Hertfordshire in 1881, and then to Berkshire. In 1883 he studied in Paris under Bouguereau at the Académie Julian. He was a founder member of the NEAC, became an ARA in 1895 and RA in 1908.

280 *Peasant Girl Carrying a Jar, Quimperlé* 1882

[repr. in colour on p. 165]
sdbr and insc. G. Clausen 1882 Quimperlé 46 × 27.5 cm/18 × 10¾ ins
Lent by the Victoria and Albert Museum, London

After seeing Bastien-Lepage's work and meeting him in London, Clausen later recalled, he completely changed his approach to painting. He informed his dealer, Tooth, that he no longer wished to do Dutch 'costume' pictures, and went to live in Hertfordshire in order to search for real peasant subjects ('Autobiographical Notes', *Artwork*, spring 1931, pp. 12–19). This aim must also have prompted his trip to Brittany in 1882. Numerous articles had been written about Brittany in English periodicals; one of the most accessible for Clausen would have been Henry Blackburn's 'Pont Aven and Douarnenez' in the *Magazine of Art* (1879, pp. 6–9). Blackburn recommended Brittany as the place for artists '. . . in search of picturesque costume and scenes of pastoral life' (p. 6). Most English accounts of travel in Brittany, like Blackburn's, stressed that the peasantry was its greatest attraction. But little or no interest was taken in the social conditions of the Breton peasant, who was simply considered a picturesque extension of the landscape.

One aspect of Bastien's work that fascinated Clausen was '. . . the wonderful foreground . . . the weeds all searched and painted, with the subtlest truth, and yet not obtrusive' ('Bastien-Lepage and Modern Realism', *Scottish Art Review*, October 1888, p. 114). Clausen's concentration on this aspect in his own paintings allowed him to experiment with colour and texture. But, as in Bastien's pictures, only the natural details have this rough surface; a smoother treatment is used for the face of the figure (cf. no. 10).

In this painting Clausen still used a heightened version of the blue, green and beige palette of his Dutch paintings of the 1870s. The bright orange and blue accents can be compared to Guthrie's *A Hind's Daughter* (no. 304) and Osborne's *Apple Gathering, Quimperlé* (no. 326). A.G.

EXHIBITIONS
1895, London, Guildhall (40)
1903, Nottingham, *British Artists 1878–1903* (69)

281 *The Stone Pickers* 1886/7

sdbl. G. Clausen 1887 106.5 × 79 cm/42 × 31 ins
Lent by the Laing Art Gallery, Newcastle upon Tyne

By 1887 Clausen had achieved his ambition to do in England what Bastien-Lepage had done in France. This is most evident in *The Stone Pickers*, which is closely related in composition to Bastien's *Poor Fauvette* (no. 10). *The Stone Pickers* also shares the same high horizon line, the vertical format and the abrupt change from the detailed foreground to the more thinly painted background. Clausen would have first seen *Poor Fauvette* when it was exhibited in London in

281

1882, but would also have had an opportunity to study it at leisure after it passed into the McCulloch collection, to which he evidently had access. McCulloch also owned Bastien's *Saison d'Octobre* or *The Potato Pickers* (National Gallery of Victoria, Melbourne), a painting which Clausen mentioned as one he had studied. The treatment of the detail in the foreground of *The Stone Pickers* is more similar to this painting.

Social overtones can be imputed to the title but they appear to have been of little interest to Clausen. In a statement made in 1890 he is quoted as saying that peasant life was interesting, 'if for no other reason than that it is the bottom crust of society' (R. A. M. Stevenson p. 292), and in fact it was his children's nursemaid, Mary 'Polly' Baldwin, who posed for the painting.

All of Clausen's figures in the 1880s share the same characterless and passive immobility, so that the dominant impression created is of his sensitivity to light and colour and the delicacy of the treatment of the natural details. Clausen confirmed this impression when he said that 'a beautiful type of face in the model [was] apt to distract one from the serious pursuit of artistic qualities' (R. A. M. Stevenson p. 292). Given this quality of painting, it was questioned whether Clausen need imitate Bastien at all. As *The Graphic* commented in 1887: '*The Stonepickers* . . . is marked by truthful characterisation, beauty of colour and finished workmanship, but it would be quite as good if it did not so strongly resemble the work of Bastien-Lepage.'

The painting was originally owned by J. Staats Forbes, Stanhope Forbes' uncle, who formed a large collection of Barbizon and other French painting. It was painted at Cookham Dean, Berkshire, in autumn and winter 1886–7. A.G.

EXHIBITIONS
1887, April, London, NEAC (32)
1889, Paris, Exposition Universelle, British section (27)
1900, London, *West Ham Free Pictures Exhibition*
1903, London, Whitechapel (376)
REFERENCES
The Graphic, 15 April 1887
R. A. M. Stevenson, 'George Clausen', *Art Journal*, 1890, p. 294
K. McConkey, 'The Bouguereau of the Naturalists: Bastien-Lepage and British Art', *Art History*, September 1978, p. 377

282 *The Little Flowers of the Field* 1893

sdbl. G. Clausen 1893; s and insc on rev. Clausen The Little Flowers of the Field 1893
41 × 56.5 cm/16¼ × 22¼ ins
Lent by J. G. A. Cluff Esq.

By 1892 critical attacks against Clausen for borrowing from Bastien-Lepage reached mammoth proportions. In a virulent review of *Labourers after Dinner* (1884), exhibited at the New Gallery in 1892, George Moore wrote in *The Speaker*: 'I hope that it is the last of its kind, and that . . . Mr Clausen has abjured Bastien-Lepage, his evil ways and all the derivative vices, for ever.' This criticism had its desired effect, as D. S. MacColl later recalled: 'Clausen took warning, removed his peasants to a safer distance, renounced squareness and hatched over the lines of their boots and trousers and found his own angle of delight in natural beauty, flowery hayfields . . .' (*Saturday Review*, 22 May 1897).

With this change of focus Clausen started to borrow from Degas and Monet. Since 1888 he had owned a fan painted by Degas; as with most of Degas' admirers, it was his sharply cut-off figures and unusual viewpoints which were of most value to Clausen when creating new figure compositions. Clausen's study of Monet brought about a reaction against the cool palette of the 1880s; his colour became purer and brighter and he started experimenting with broken colour techniques. The effect of sunlight on colour and colour in shadows, which had been a preoccupation in the 1880s, was pushed to further limits once he had a thorough knowledge of Monet's techniques. Of all the English painters influenced by Monet, his knowledge was probably the most thorough and 'academic', and he was able to make these lessons available in his lectures on painting at the RA Schools (first published 1904). A.G.

282

Conder, Charles 1868–1909

Born in London, at the age of 15 Conder went to Australia where he took up painting and showed at the 9 × 5 Exhibition in 1889. In 1890 he left for Paris and enrolled at the Académie Julian; there he became friends with Anquetin, Lautrec and William Rothenstein, with whom he shared an exhibition in 1891. He made frequent trips to the French countryside to visit Barbizon, Chantemesle, Vétheuil, La Roche-Guyon and Dennemont. He was made a member of the Société Nationale des Beaux-Arts in 1893 and also sent to the NEAC that year. In 1895 he designed screens for Bing's Art Nouveau exhibition. His later work was mostly in watercolour on silk. In 1894 he moved to London, but returned to France frequently and continued to exhibit in Paris.

283 *Blossom at Dennemont* 1893

sdbr and insc. Charles Conder Dennemont. 93
73 × 60 cm/28¾ × 23½ ins
Lent by the Visitors of the Ashmolean Museum, Oxford

283

Trees in blossom were often included in Conder's early Impressionist-influenced Australian landscapes. However, in this treatment the emphasis has shifted so that the blossom is the dominant motif. In the foreground the individual petals are painted with single large brushstrokes, while the background consists of smaller strokes of vibrant pastel colour. This palette and the use of a motif as a eulogy to nature were inspired by Monet, whose *Haystacks* Conder saw at Durand-Ruel's in May 1891 (letter to Tom Roberts, in J. Rothenstein, *The Life and Death of Conder*, p. 67). But it was Whistler and Puvis de Chavannes who had the greatest influence on his flat, decorative treatment of the landscape. His response to the landscape at Dennemont, a few miles below Mantes on the Seine, where he was first taken in spring 1892 by Edouard Dujardin, is explained in a letter of 16 June 1892 to William Rothenstein: 'Perhaps Omar or Browning don't seem small beside all this [the landscape], but then these people arrive at being perfect symbolists using external things as an architect uses colour – only beautiful colour mind you,' (W. Rothenstein, *Men and Memories*, I, 1931, p. 117).

Blossom at Dennemont was purchased by J. C. Legge, an early patron who was introduced to Conder by D. S. MacColl. MacColl reviewed Conder's work at the Société Nationale enthusiastically from 1892, and championed him at the NEAC, where his evocative eighteenth-century themes were admired throughout the 1890s for their inventive, delicate colour sense and their decorative pictorial qualities, which did much to influence the direction that English painting took in that decade. A.G.

EXHIBITION
1903, London, Whitechapel (232)
REFERENCES
J. Rothenstein, *The Life and Death of Conder*, 1938, p. 274.
P. Lee, *Some Aspects of the Work of Charles Conder*, unpublished MA report, Courtauld Institute of Art, 1976, pp. 31–2.

Dismorr, Jessica 1885–1939

Born in Gravesend, Jessica Dismorr studied at the Slade and later at the Ecole de la Palette (subsequently the Atelier Blanche) under Metzinger, Fergusson, Segonzac and Blanche. She contributed illustrations to *Rhythm* in 1911, and in 1912 showed with Fergusson and others at the Stafford Gallery. She exhibited at the AAA 1912–14, and at the Salon d'Automne. In 1914 she joined the Rebel Art Centre and signed the manifesto in *Blast* no. I. She showed at the Vorticist exhibitions in London (1915) and New York (1917).

284 *Night Scene, Martigues* 1911/12

sbr. Dismorr oil on panel 33.5 × 42 cm/13¼ × 16½ ins
Lent by a Private Collector

Jessica Dismorr's painting trips to the south of France – she was certainly there in summer 1911 and probably in 1912 also – were an appropriate complement to the winter months' lessons in colour from J. D. Fergusson at the Atelier Blanche, since the south was a place of liberation for the landscape painter. The rich colour and the flat, decorative shapes in *Night Scene, Martigues* are characteristic of her Mediterranean landscapes on panel. Although her paintings are more lyrical than Fergusson's they share a stylistic affinity with him which shows the influence he wielded on a number of students at this period. This is one of several panels given to the artist's youngest sister, Margaret Thompson, between 1912 and 1924. A.G.

EXHIBITION
1912, October, London, Stafford Gallery (37)

284

Etchells, Frederick 1886–1973

Born in Newcastle-upon-Tyne, Etchells studied at the Royal College of Art 1908–11, after which he rented a studio in Paris where he met Picasso, Braque and Modigliani. He exhibited at the Friday Club, the Indépendants Anglais at the Galerie Barbazanges and the 2nd Post-Impressionist Exhibition. In 1912 he joined the Omega Workshops but left with Wyndham Lewis and others in October. He was a founder member of the London Group and joined the Rebel Art Centre in spring 1914. He contributed to the Vorticist exhibitions in London (1915) and New York (1917).

285

285 *Two Women Sitting on the Grass* c. 1911

ns. oil on panel 36 × 51 cm/14 × 20 ins
Lent by the Visitors of the Ashmolean Museum, Oxford

This painting was probably exhibited as *On the Grass* at the 2nd Post-Impressionist Exhibition, 1912–13, in which case it represents Etchell's younger sister and her friend sitting in the garden of a house he rented in West Horsley, Surrey, near the Frys' house – Etchells worked closely with the Bloomsbury circle during this period. The palette, technique and subject can be compared with Duncan Grant's *Pamela* (no. 303). In 1911 Roger Fry grouped the artists together, writing: 'Both realise more clearly than any other modern English artists the value of the bare statement of structural planes and lines of movements and the importance of scale and interval in design,' but whereas Duncan Grant had 'a spontaneous lyrical feeling . . . Etchells has a more dramatic sense of character and the contrasts of life' (R. Fry, prefatory note to catalogue of Contemporary Art Society Loan Exhibition, Manchester City Art Gallery, 1911, pp. XXI – XXII). A.G.

EXHIBITION
?1912–13, London, 2nd Post-Impressionist Exhibition (124)
REFERENCE
London, Arts Council, *Vorticism and Its Allies*, catalogue by R. Cork, 1974 (36)

Fergusson, John Duncan 1874–1961

Born in Scotland, Fergusson studied to be a naval surgeon before deciding in 1894 to devote himself to art. Between 1898 and 1907, when he settled in Paris, he spent time in France, Spain and Morocco. He taught at the Ecole de la Palette and the Atelier Blanche with Metzinger, Segonzac and Blanche. In 1911 he helped to launch *Rhythm*, and in 1914 he returned to London and went on painting trips to Scotland.

286 *Dieppe, 14 July 1905 : Night* 1905

sd on rev. J. D. Fergusson 1905 77 × 77 cm/30¼ × 30¼ ins
Lent by the Scottish National Gallery of Modern Art, Edinburgh

In 1905 Whistler was still a strong force among English and Scottish artists, for whom, in many circles, his painting was the most 'advanced' they had encountered. It is predictable that a young painter should have tried to emulate him, and to Fergusson Whistler was a symbol of artistic freedom. A fireworks painting exhibited at the Whistler Memorial Exhibition in London and Paris in 1905 was probably the inspiration for *Dieppe, 14 July 1905 : Night*. The connection with Whistler is close, but the brighter touches of colour

286

were characteristic of many Scottish painters whom he influenced (cf. no. 318). This is one of the last Whistlerian paintings by Fergusson, who in 1907 settled in Paris and quickly assimilated the influence of the Fauves. The painting was owned by the artist's wife. The figure in grey to the right of the left-hand group is the painter S. J. Peploe. A.G.

EXHIBITIONS
1906, London, RBA (157)
1907, Paris, Salon d'Automne (596)
REFERENCES
H. MacFall, 'The Paintings of J. D. Fergusson', *The Studio*, 1907, p. 207
London, Fine Art Society, *J. D. Fergusson*, catalogue by R. Billcliffe, 1974 (24)

287

287 *The Violet Beast* c. 1911

La Bête violette
ns. 77 × 77 cm/30¼ × 30¼ ins
Lent by Mr and Mrs Alexander Irvine

While in Paris between 1907 and 1910 Fergusson absorbed lessons from Matisse and the Fauves, a debt which he acknowledged in a review of the Salon d'Automne in which he named Matisse as one of the most interesting painters to be seen there (*The Art News*, 21 October 1909). He shared the current preoccupations of the Salon d'Automne circle – Fauve colour, Cézanne, Kandinsky and primitive art. After 1910 these became important sources in his work, as instanced in the rich colour, the rhythmic geometric patterning, the emotional intensity and the atavistic appearance of the animal in *The Violet Beast*. The rhythmic, decorative expressiveness of this style was greatly admired and gained Fergusson recognition in France, Germany and in the USA. Through his teaching at the Atelier Blanche he also influenced a group of American and British painters, including Jessica Dismorr, which had an exhibition at the Stafford Gallery in 1912. Fergusson used the same style for a series of works including the painting *Rhythm* (University of Stirling), which provided the title for the art magazine started by Michael Sadler and Middleton Murry, of which Fergusson was art editor.

In later life Fergusson emphasized the Scottish qualities in his work, which he linked to the Glasgow School; these attributes were independence, vigour, colour and a particular quality of paint. 'Paris', he wrote, 'is simply a place of freedom. It allowed me to be Scots as I understand it' (J. D. Fergusson, *Modern Scottish Painting*, 1943, p. 170). A.G.

EXHIBITION
1912, March, London, Stafford Gallery, *Pictures by Fergusson* (12)
REFERENCE
London, Fine Art Society, *J. D. Fergusson 1874–1961*,
 catalogue by R. Billcliffe, 1974

Forbes, Stanhope 1857–1947

Born in Dublin, Forbes studied in London at the Lambeth School of Art and then at the RA Schools, 1874–8. In 1880 he enrolled at Bonnat's atelier in Paris, but after 1881 spent little time there. From 1884 he worked at Newlyn in Cornwall and was later considered to be the leader of the Newlyn School; he founded the Newlyn School of Art in 1899 with his wife Elizabeth (née Armstrong). He became an ARA in 1892 and an RA in 1910. Although he was a founder member of the NEAC in 1886, his sympathies were always with the Royal Academy, where he exhibited from 1878.

288 *A Street in Brittany* 1881

> sdbl and insc. Stanhope A. Forbes à Cancale 1881
> 104 × 75.5 cm/41 × 29 ins
> Lent by the Walker Art Gallery, Liverpool

After spending winter 1880–1 at Bonnat's atelier, Forbes, accompanied by H. H. La Thangue, followed the practice of most art students in Paris by going to Brittany to paint *plein-air* – in their case to Cancale near St Malo. Forbes later recalled that *A Street in Brittany* '. . . was the very first out-of-door subject picture I painted and exhibited' (letter of 9 January 1928, Walker Art Gallery). *Plein-air* painting offered the opportunity to study natural light, which for Forbes was a painstaking and meticulous exercise. The painting took from July to October to complete and he only worked on it when the light conditions were right (he had another, interior, picture for unsuitable days). The 'blued' palette which Forbes worked into the beige and white to create a *plein-air* effect worried him. He wrote to his mother about a later, similar, Brittany picture, asking about reactions to it: 'I am most anxious to know if any critics noticed the disparity in the size of the figures in the foreground and those farther off and was it found too blue?' (letter of 21 November 1883, in *Artists of the Newlyn School*, p. 74).

In the following two summers Forbes went to paint at Quimperlé, but in January 1884 he went to Cornwall, and after discovering Newlyn he wrote home in delight, describing it as 'a sort of English Concarneau' (*Artists of the Newlyn School*, p. 58). Although Forbes was not the first to discover Newlyn, he was instrumental in making the reputation of the Newlyn School. Like Forbes, many of the Newlyn artists had painted in Brittany before going to Cornwall.

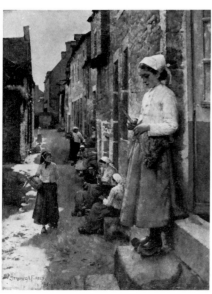

288

That the Newlyn style was based on painting techniques learned in France has long been recognized, but the influence of Breton themes and subjects on Newlyn painting is an area yet to be explored. A.G.

EXHIBITIONS
1882, London, Royal Academy (104)
1882, autumn, Liverpool, Walker Art Gallery (464)
REFERENCES
W. Meynell, 'Mr Stanhope Forbes ARA', *Art Journal*, 1892, p. 65
P. Hamerton, 'The Lighthouse', *Scribner's Magazine*, June 1894, pp. 688–9
Strand Magazine, 1901, p. 492
C. Hind, 'The Art of Stanhope Forbes', *Art Journal*, Christmas 1911
Newlyn, Art Gallery, *Artists of the Newlyn School*, catalogue by Caroline Fox and Francis Greenacre, 1979, pp. 73–4

Forbes-Robertson, Eric 1865–1935

Forbes-Robertson first went to France in 1885 when he attended the Académie Julian; he visited Pont-Aven in August 1890, probably with Robert Bevan, and stayed at the Villa Julia with various other artists until 1894. By the end of 1891 he was on close terms with Séguin and included among his other friends Jan Verkade, Sérusier, Filiger and Alfred Jarry. He was the only English artist to contribute to *L'Ymagier* (1895); four years later he contributed also to the *Mercure de France*. Gauguin painted his portrait in 1894. In 1900 Forbes-Robertson returned to England but he continued to spend time in France. He showed at AAA exhibitions from 1911.

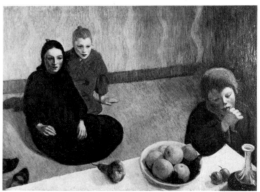

289

289 *Great Expectations* 1894

> sdbl and insc. Eric Forbes-Robertson Pont-Aven 94
> 75 × 100.5 cm/29½ × 39½ ins
> Lent by Northampton Art Gallery

The Gauguin influence, already apparent in Forbes-Robertson's work before the two artists met, is very strong in this picture which was painted after their meeting in 1894. Its colouring is very much like Gauguin's and the composition Forbes-Robertson uses to create a feeling of psychological distance and alienation between the characters is similar to Gauguin's in *The Schuffenecker Family* (1889, Palais de Tokyo, Paris). But the actual figures in the painting – the mysterious and melancholy young girl and the boy with hopes and dreams – have more in common with the interests of Séguin and Alfred Jarry, who were Forbes-Robertson's closest friends. *Great Expectations* may have been exhibited as *Rêves d'enfants* at Le Barc de Boutteville in September 1894. A.G.

EXHIBITION
?1894, Paris, Le Barc de Boutteville (95)
REFERENCE
D. Sutton, 'Echoes from Pont-Aven', *Apollo*, May 1964, p. 404

Fry, Roger 1866–1934

Born in London, Fry studied science at Cambridge before taking painting lessons from Francis Bate, one of the London Impressionists. In 1891 he first visited Italy and then went to Paris and enrolled at Julian's. He began writing about art, and lecturing on the Italian Renaissance; his articles were published in the *Pilot*, the *Athenaeum* and the *Burlington Magazine*. Fry became curator of the Department of Painting at the Metropolitan Museum, New York, in 1906, and was later appointed editor of the *Burlington Magazine*. In 1910 he met Duncan Grant and Clive and Vanessa Bell. An indefatigable organizer of exhibitions to bring new art to public attention, he put on *Manet and the Post-Impressionists* at the Grafton Galleries in 1910, and in 1912 both *Quelques Artistes Indépendants Anglais* in Paris and the 2nd Post-Impressionist Exhibition in London. In 1913 he opened the Omega Workshops.

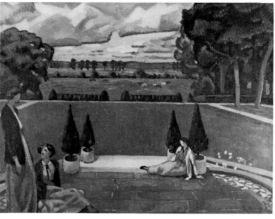

291

290 *Blythborough, the Estuary* 1892/3

ns. 61 × 74 cm/24 × 29 ins
Lent by Mrs Diamand

The flat, arabesque shapes of the estuary and surrounding land and the sinuous, stylized trees in this landscape can be compared to Art Nouveau. Fry's contact with William Rothenstein and the Lautrec/ Anquetin circle in Paris, coupled with his youthful admiration for Burne-Jones, are probable sources of this style. In a letter of 25 September 1892 to Edward Alkmann, Fry wrote: 'As for me I have been in Paris studying painting since I saw you, and learned all the latest theories of the Indépendants, Symbolistes, members of the society of Rose Croix, Sâr Péladan and Wagnerites...' (quoted *Virginia Woolf Quarterly*, 1972, 1, no. 1, p. 6). Fry intended *Blythborough, the Estuary* to be exhibited at the NEAC in 1893, but it was rejected by the selection committee. Referring to the incident in a letter to MacColl, Fry wrote: 'One of my earliest oil paintings was essentially Post-Impressionist but was so derided at the time – I never showed it publicly – that I gave in to what I thought were wise counsels, and my next rebellion against the dreary naturalism of our youth lay in the direction of archaism' (3 February 1912). In his return to archaism Fry followed the general trend at the NEAC. Two years later his landscapes *The Suspension Bridge* and *Afternoon* were compared with Corot's own work: '[Fry] is more frankly a follower of Corot than many others who are equally indebted; and in both *The Suspension Bridge* and *Afternoon* there is a real touch of the silver or golden haze with which the French artist could at will suffuse his pictures' (*Illustrated London News*, 23 November 1895). A.G.

REFERENCES
D. Sutton (ed.), *Letters of Roger Fry*, 1, 1972, pp. 156, 253
F. Spalding, *Roger Fry: Art and Life*, 1980, pp. 45–6

291 *The Terrace* 1912

sbl. Roger Fry 63.5 × 79.5 cm/25 × 31¼ ins
Lent by Mr and Mrs Richard King

Cézanne's influence, which can be seen in the formalized, geometric shapes of *The Terrace*, was first noticed in the work Fry showed in his one-man exhibition at the Alpine Club Gallery in January 1912. Since 1906, when he had written favourably, if with some reservations, about the Cézannes at the International Society, Fry had championed his cause in England, but by 1912 Cézanne was an accepted master and Fry no longer needed to be his apologist. After studying the Cézannes in the first Post-Impressionist exhibition – paintings which he had not previously seen – he realized that Cézanne was a far greater artist than he had originally thought. This exposure and Fry's increased respect for Cézanne account for the appearance of Cézannesque elements in his painting at this time.

In Fry's initial analysis of Cézanne he saw his volumes as 'purely decorative elements of design' ('The Last Phase of Impressionism', *Burlington Magazine*, March 1908, p. 377). This interpretation was confirmed by Maurice Denis, whose article on Cézanne Fry translated for the *Burlington Magazine* in 1910. After 1910, however, Fry came to recognize the solidity of Cézanne's forms and it was this which provided the basis for his own investigations of form. The distortions and simplifications in *The Terrace* were an attempt to create a vivid sense of reality, a quality which, Fry stressed, was present in Cézanne (*Fortnightly Review*, May 1911, p. 115). On the other hand these forms, in particular the treatment of the clouds, also have a decorative function in the painting. Fry's interpretation had an enormous effect on English painters and influenced a large number of Cézanne imitators who reduced the English landscape to geometric forms. *The Terrace* was painted at Ethel Sands' house in Newington. It shows Ethel Sands, Nan Hudson and the novelist Anne Douglas-Sedgwick. A.G.

EXHIBITION
1912, London, Grafton Galleries, 2nd Post-Impressionist Exhibition (122)
REFERENCE
F. Spalding, *Roger Fry: Art and Life*, 1980, pp. 45–6

Gauld, David 1865–1936

Born in Glasgow, Gauld attended the Glasgow School of Art 1882–5. He enrolled again in 1889 as well as studying in Paris that year. From 1887 he worked as a black-and-white illustrator for the *Glasgow Weekly Citizen*, and designed stained glass windows for Guthrie and Wells. In 1896 he painted at Gretz.

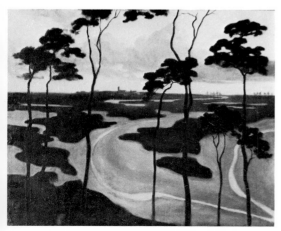

290

292 Saint Agnes 1889/90

sbr. David Gauld 61.5 × 35.5 cm/24 × 14 ins
Lent by Andrew McIntosh Patrick Esq.

The subject of Saint Agnes and Gauld's depiction of her as a fragile, fervid figure suggest a connection with Rossetti. Gauld himself admitted this influence, saying that 'during many different phases of [my] development [I] was moved and moulded by the richness that characterized Rossetti's work' (P. Bate, Scottish Arts and Letters, September–November 1903, quoted The Glasgow Boys, pp. 19–20). Gauld's black-and-white illustrations and stained glass designs must have influenced the flat, decorative style of Saint Agnes. The ornamental patterns of the landscape are similar to Charles Rennie Mackintosh's watercolours of stylized natural details, c. 1893; Gauld and Mackintosh certainly knew each other by this date. The similarities in their work pose questions about the origins of the Mackintosh style which had important repercussions for Art Nouveau; Japanese prints, Celtic art, Symbolism and the decorative tendencies which characterize Glasgow School painting were sources common to Gauld and Mackintosh. Alexander Reid, a friend of Gauld, acquired Saint Agnes for his collection. A.G.

EXHIBITION
?1890, Munich, Glaspalast
REFERENCES
D. Martin, The Glasgow School of Painting, 1897, p. 15
Scottish Arts Council, The Glasgow Boys, I, 1968, pp. 19–20
D. and F. Irwin, Scottish Painters at Home and Abroad 1700–1900, 1975, p. 386
W. Hardie, Scottish Painting 1837–1939, 1976, pl. 108 (colour)

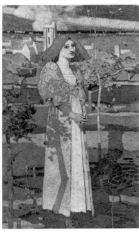
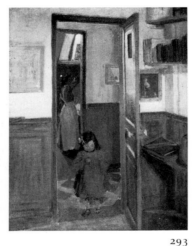

292 293

Gilman, Harold 1876–1919

Gilman studied at the Slade 1897–1901, and c. 1902–3 spent a year in Spain. He was a founder member of the Fitzroy Street Group in 1907 and the Camden Town Group in 1911; in 1913 he became first president of the London Group, and the following year was a founder member of the Cumberland Market Group. Gilman exhibited at the Indépendants and the AAA in 1908. In 1911 he went to Paris with Ginner, and painted in Scandinavia in 1912 and 1913. In 1914 he exhibited with Ginner as a Neo-Realist.

293 In Sickert's House, Neuville c. 1907

stamped br. H. Gilman 60.5 × 45 cm/23¾ × 17¾ ins
Lent by Leeds City Art Galleries

Around 1902–3 Gilman spent more than a year in Madrid, where he was almost constantly in the Prado making copies of Velasquez (H. Gilman, 'The Venus of Velasquez', The Art News, 28 April 1910). The limpid handling and low, cool tones of Velasquez are still evident in his work in 1907. Smoothly painted interiors showing intimate scenes reminiscent of Vuillard were the first pictures that Gilman showed at Fitzroy Street.

In Sickert's House, Neuville was the title given to the painting, suggesting that it was painted while Gilman was staying at Sickert's house in summer 1907. However, it is possible that this picture was exhibited as Intérieur vert at the Indépendants in May 1908 (2533) and as Green Door, Interior at the AAA in July 1908 (1387). A.G.

REFERENCES
M. de Sausmarez, 'The Camden Town Group', Leeds Art Calendar, vol. 3, no. 12, 1950, p. 14
London, Fine Art Society, Camden Town Recalled, catalogue by W. Baron, 1976 (24)

294 The Swing Bridge 1911

Le Pont tournant
ns. 30.5 × 40.5 cm/12 × 16 ins
Lent by a Private Collector

In 1911 Ginner took Gilman to Paris with Frank Rutter. As Ginner later recalled, they looked at 'everything that could be seen', including a roomful of Van Goghs at Bernheim's and the Pellerin collection of Cézannes (C. Ginner, 'Harold Gilman, an Appreciation', Art and Letters, summer 1919, p. 130). Gilman was already separating his tones, painting in a manner which he described as 'the juxtaposition of small pieces of paint . . . [working] . . . from light to dark . . . or from dark to light' (H. Gilman, 'The Venus of Velasquez', The Art News, 28 April 1910). The Swing Bridge was painted at Dieppe in Ginner's company, and the variety of pure, bright colours is undoubtedly the consequence of Ginner's enthusiasm and their experiences in Paris. Ultimately Van Gogh had the most importance for Gilman, who collected postcards and, whenever he was particularly pleased with one of his paintings, would hang it on the wall next to a Van Gogh reproduction.

Although Gilman did not fully assimilate Van Gogh's style until 1913–14 it can be argued that Van Gogh's paintings of bridges may have inspired The Swing Bridge. The novelty of the motif obviously impressed him and Wyndham Lewis recalled him saying, 'How like that bridge is to Van Gogh' (W. Lewis and L. F. Fergusson, Harold Gilman: An Appreciation, 1919, p. 14).

The Swing Bridge was given to Sickert and Christine Drummond Angus as a wedding present by the Camden Town Group. A.G.

EXHIBITION
1911, December, London, Carfax Gallery, The Camden Town Group (33)
REFERENCE
W. Baron, The Camden Town Group, 1979, no. 83.

294

295 *Nude at Window* c. 1912

sbr. H. Gilman 62 × 51 cm/24½ × 20 ins
Lent by Mrs Robert Bevan

Nudes contre-jour were a Camden Town theme painted by Sickert and Gore, who set a precedent for Gilman's explorations of the theme in 1911. Gilman's discovery of Post-Impressionist painting led him to employ bolder and brighter colour, and also marks his move away from applying the pigment in small, mosaic-like touches towards a much freer technique. In *Nude at Window* the paint is applied in streaks and slashes of contrasting colour to make patches, which anticipate the slab-like planes of colour of Gilman's later paintings such as *Mrs Mounter* (1916–17, Tate Gallery). Gilman exhibited two nudes at the Camden Town exhibition in December 1911, three at the Indépendants in 1912, and four in his joint exhibition with Gore at the Carfax in 1913. None of these nudes has a detailed title; all are referred to simply as *Nude*, sometimes with a number, sometimes without. A.G.

295

Ginner, Charles 1878–1952

Born in Cannes, France, Ginner first worked in an architect's office; from 1904 to 1908 he studied painting at the Académie Vitti under Gervais, then at the Ecole des Beaux-Arts and then again at Vitti under Anglade y Camarasa. In 1908 he exhibited at the AAA and then came to England, where he served on the AAA's hanging committee in 1910 and met Gore and Gilman. He joined the Fitzroy Street Group, and was a founder member of the Camden Town Group, the London Group and the Cumberland Market Group. He took Gilman to Paris in 1911 and the two artists became close friends. In 1912 Ginner exhibited with the Indépendants Anglais at the Galerie Barbazanges. He exhibited as a Neo-Realist with Gilman in 1914 and published a manifesto for Neo-Realism in *The New Age* in January 1914. In 1945 he became an ARA.

296 *Tache décorative – tulipes* 1908

sbr. CIG oil on panel 22 × 14 cm/8½ × 5½ ins
Lent by Mr and Mrs Peyton Skipwith

Ginner had a special talent for decorative still-life themes, of which this is an early example. In his use of rich, thick impasto in brilliant colours he was influenced by Anglade y Camarasa, and it was this handling that impressed the AAA when Ginner exhibited there in

296

1908. Rutter recalled that Gore stopped in front of the Ginners and said, 'This man is a painter' (F. Rutter, *Some Contemporary Artists*, 1922, p. 143).

After *Tache décorative – tulipes* returned from exhibition in Buenos Aires it was put on show at 19 Fitzroy Street. Judge William Evans, a major patron of the Fitzroy Street Group, who originally owned the sketch, probably bought it at one of their Saturday afternoon showings. The 'I' in the signature, standing for Isaac, was only used by Ginner in his early work. A.G.

EXHIBITION
1909, Buenos Aires, Salon Costa
REFERENCES
C. Ginner, *Notebooks*, I, unpublished, p. XXIX
W. Baron, *The Camden Town Group*, 1979, no. 50

297

297 *Victoria Embankment Gardens* 1912

sbr. C. Ginner 61 × 45 cm/24 × 17¾ ins
Lent by Anthony d'Offay

Ginner visited Paris with Gilman in 1911 and saw the Bernheim Collection; he wrote of 'a room entirely decorated with works of Van Gogh, a sight unsurpassed in beauty and intensity' (C. Ginner, 'Harold Gilman, an Appreciation', *Art and Letters*, summer 1919, p. 130). *Victoria Embankment Gardens* is an explicit, enthusiastic gesture to Van Gogh's Arles Garden paintings (cf. nos 100–1). The pastel colours of the sky were also used in Ginner's slightly earlier

Sheaves of Corn (Private Collection). This palette and the motif, the Houses of Parliament, suggest a connection with Monet. However, Ginner's subject also reflects his desire to paint distinctly English pictures. He had painted London landscapes since his arrival in 1910, and after 1912 his paintings included two crowded street scenes, *Piccadilly Circus* and *Leicester Square*.

This search for recognizable London motifs anticipates Ginner's Neo-Realism for which he formulated a credo published in *The New Age* in January 1914. For Ginner (and for Gilman, who exhibited with Ginner under this label in 1914), Neo-Realism was an attempt to renounce synthetic, imitative painting formulae which were based on Van Gogh, Gauguin and Cézanne and gave little indication of study of nature or of an understanding of the technique. Ginner's inclusion of the statue in the park is an early instance of his passion for recording London monuments. A.G.

EXHIBITIONS
1912, London, AAA (75)
1914, The Little Gallery [?London; ref. from *Notebooks*]
1914, London, Goupil, *Harold Gilman, Charles Ginner* (51)
REFERENCES
C. Ginner, *Notebooks*, 1, unpublished, p. 57
M. Easton, 'Viewing and Finding', *Apollo*, March 1970, p. 205

298

298 *The Wild Ducks* 1911/12

> sbr. Ginner 35.5 × 40.5 cm/14 × 16 ins
> Lent by a Private Collector

Ginner exercised his love of pattern and texture with perfect freedom in *The Wild Ducks*. By 1912 he had developed a technique based on careful construction in which he used small touches of thick paint in pure colour, applied in a rhythmic movement, which accentuate and define every detail of the painting. Frank Rutter compared Ginner's meticulousness and minute detail to that of the Pre-Raphaelites (*Some Contemporary Artists*, 1922, p. 152).

Gilman, who had become a close friend and collaborator, bought *The Wild Ducks* from Fitzroy Street. The painting appears in Gilman's *Girl with a Teacup* (Private Collection) and in another portrait of the same sitter, Mary L. A.G.

EXHIBITION
1914, London, Whitechapel, *20th Century Art* (376)

Gore, Spencer 1878–1914

Born at Epsom, Surrey, Gore studied at the Slade from 1896. He visited Spain with Wyndham Lewis and in 1904 met Sickert in Dieppe. Gore was a founder member of the Fitzroy Street Group in 1907, the AAA in 1908, the Camden Town Group in 1911 and president of the London Group in 1913. He exhibited at the Indépendants from 1907, also at the Indépendants Anglais at the Galerie Barbazanges, Paris, and at the 2nd Post-Impressionist Exhibition in 1912.

299 *Someone Waits* c. 1907

> stamped bl. S.F. Gore 51 × 40.5 cm/20 × 16 ins
> Lent by the City Museum and Art Gallery, Plymouth

In *Someone Waits* Gore used the broken colour technique and careful construction of Neo-Impressionism, which began to influence him in 1907 after he had been introduced to its theories by Lucien Pissarro, whom he probably met through the NEAC. Lucien combined a Divisionist technique with an Impressionist palette; however his knowledge of colour theory was of benefit to Gore, who started to use touches of light, pure colour as a result.

The composition of *Someone Waits* is very similar to Camille Pissarro's last *Self-Portrait* (1903, Tate Gallery), which Lucien Pissarro brought back to London after the Pissarro exhibition at Durand-Ruel's in 1904. Camille was a most important influence on Gore's development. To him Camille was an 'astonishing' artist who 'shows a constant development of observation and power to record it, from first to last' ('A Neo-Impressionist' [S.F. Gore], *The Art News*, 19 May 1910, p. 225). What Gore particularly shared with Camille was a liking for carefully constructed space: 'I have sat in a railway train with the square of the window as my picture and seen a multitude of ways of filling the space' ('A Neo-Impressionist' [S.F. Gore], *The Art News*, 31 March 1910, p. 166).

Gore's contacts with the established Neo-Impressionist group were closer than have been realized. The critic Frank Rutter, founder of the Allied Artists Association (AAA) and a major influence on British modernism, wrote on several different occasions that Gore was in the habit of regarding himself as a Neo-Impressionist (cf. e.g. F. Rutter, *Some Contemporary Artists*, p. 131). This is especially pertinent because Rutter, as editor of *The Art News*, ran a column signed 'A Neo-Impressionist' which was almost certainly written by Gore. Furthermore Gore appears to have been on good terms with some of the original advocates of Neo-Impressionism. When a sale was held at Goupil's (25 May–4 June 1914) to raise money to hold a Spencer Gore memorial exhibition, Signac, Luce, Van Rysselberghe and the various Pissarros all sent work, including a painting by Camille. Gore sent work to the Indépendants from 1907, and his friendship with Lucien in London must have encouraged his contacts with the Neo-Impressionists at the Paris shows.

299

A label on the back of the stretcher of *Someone Waits* identifies the man seen through the window as Sickert. This confirms their close relationship, which was of considerable mutual benefit. A.G.

EXHIBITION
1908, spring, London, NEAC (62)
REFERENCE
W. Baron, *The Camden Town Group*, 1979, no. 65

300 *Rule Britannia* 1910

insc on rev. Spencer F. Gore Rule Britannia 19 Fitzroy Street
76 × 63.5 cm/30 × 25 ins
Lent by a Private Collector

300

Rule Britannia depicts a scene from the ballet *Our Flag*, which was performed on 20 December 1909 at the Alhambra, Leicester Square, a theatre at which Gore painted on many occasions between *c.* 1905 and 1911. Unlike Sickert, he was not interested in the audience – it was the spectacle of the stage that attracted him. Goya, whose work was a very important influence on him in his formative years, had felt the same attraction.

In *Rule Britannia* Gore adapted the Divisionist technique to build up a dense paint surface and to create a rich mosaic of pattern and colour. His great delight in the strong ornamental design of the backdrop and the shimmering pink, blue, purple, green and orange illuminated by stark theatrical lighting is very apparent. A.G.

EXHIBITIONS
1910, summer, London, NEAC (204)
1911, London, Chenil Gallery (3)
1911, Manchester, Contemporary Art Society, Manchester City Art Gallery (57)
1913, London, Goupil, Contemporary Art Society (130)
1914, London, Whitechapel, *20th Century Art* (204)

301 *Gauguins and Connoisseurs at the Stafford Gallery* 1911/12

sbr. S. F. Gore 84 × 72 cm/33 × 28¼ ins
Lent by a Private Collector

In November 1911 the Stafford Gallery held an exhibition of paintings by Gauguin and Cézanne. Gore recorded the event, including among the spectators the bearded Augustus John in the

301

left foreground; Tom Neville, the gallery owner, biting his thumb nervously in the middle; and a stupefied Wilson Steer standing hatless on the right. Gore's homage to Gauguin may be seen as slightly tongue-in-cheek both in subject and in style; he deliberately reiterated the composition of Gauguin's *Vision After the Sermon* (fig. 8) which is hanging on the wall to the right. Its red ground becomes red carpet, the Breton women have been turned into spectators, and the arm of the tree is transformed into the overhanging arch of the gallery. In addition the gallery walls are given the same Impressionistic treatment as the women's bonnets in Gauguin's painting. The other Gauguins depicted are *Manao Tupapau* (left, Wildenstein 457) and *Christ in the Garden* (centre, Wildenstein 326).

Gore was very aware that Gauguin was well received in England. Reviewing the first Post-Impressionist exhibition, he wrote: 'Of all the painters here Gauguin seems to be the least disliked', and went on to point out the importance of Camille Pissarro for Gauguin, which is also significant in Gore's own work: 'Those interested in lineage might find amusement in tracing the influence of Camille Pissarro, not only in the Breton pictures, but also in the Tahitian' ('Cézanne, Gauguin, Van Gogh at the Grafton Gallery', *The Art News*, 15 December 1910). A.G.

REFERENCE
W. Baron, *The Camden Town Group*, 1979, no. 66

302 *The Cinder Path* 1912

ns. 68.5 × 79 cm/27 × 31 ins
Lent by the Trustees of the Tate Gallery

From August to November 1912 Gore and his wife stayed in Gilman's house at Letchworth, where Gore painted at least 17 views of the new Garden City development, founded in 1903. This painting shows the cinder path which ran from the end of Works Road, Letchworth, about a mile from Gilman's house, across the fields towards Baldock.

In the distortions and simplification of forms, particularly in the treatment of the clouds, there is an obvious similarity between *The Cinder Path* and Fry's *The Terrace* (no. 291), and it is probable that Gore was influenced by Fry's Cézannesque treatment of the landscape. This geometric stylization allowed him to paint formalized landscapes while remaining true to the outward appearance of the object, an approach which he had already followed in the geometrically arranged compositions of his earlier Neo-Impressionist period. Gore thought this course was an essential

302

one for the painter. He wrote that it was 'untrue to say of Cézanne and Gauguin that they simplified objects to express the emotional significance which lies in things. Both of them were equally interested in the character of the thing painted, and if the emotional significance which lies in things can be expressed in painting, the way to it must be through the outward character of the object painted' (*The Art News*, 15 December 1910).

Gore also used this criterion for his experiments with colour. The Letchworth series was one of the boldest experiments; throughout the series, *The Cinder Path* included, he used a sensitive and unusual range of reds and combinations of bright green and brilliant oranges, but he always used colour to define the essential character of the object painted. This colour may reflect the influence of Matisse, whom he had admired since 1910. In a review of the International Society he had wistfully predicted '... an International fifteen years hence with a selection of Matisses' ('A Neo-Impressionist', *The Art News*, 21 April 1910). So he must have welcomed the opportunity to study Matisse and the other Fauves at the Grafton Galleries later that year. It was characteristic of Gore to look eagerly at each new discovery.

There are two versions of *The Cinder Path*. The other (Ashmolean, Oxford) is smaller (35.5 × 40.5 cm/14 × 16 ins). It is likely that the present painting was the one shown at the 2nd Post-Impressionist Exhibition, while the smaller version was at the Carfax Gallery. A.G.

EXHIBITION
?1912–13, London, Grafton Galleries, 2nd Post-Impressionist Exhibition (116)
REFERENCES
Colchester, The Minories, *Spencer Gore*, catalogue by J. Woodeson, 1970 (47)
London, Anthony d'Offay, *Spencer Frederick Gore 1878–1914*,
 catalogue by F. Gore, 1974, pp. 13–14
London, Tate Gallery, *1974–1976 Illustrated Catalogue of Acquisitions*, 1978, pp. 100–1
W. Baron, *The Camden Town Group*, 1979, no. 113

Grant, Duncan 1885–1978

Born in Scotland, Grant studied at the Westminster School of Art, the Ecole de la Palette and the Slade. In 1909 he met Matisse and Gertrude Stein, and began to associate with Clive and Vanessa Bell and Roger Fry. He exhibited at the NEAC and the Friday Club and was a member of the Camden Town Group. He also showed with the Indépendants Anglais at the Galerie Barbazanges in 1912 and at the 2nd Post-Impressionist Exhibition. He was a co-director of the Omega Workshops and carried out many decorative projects.

303 *Pamela* 1911

> ns. 51 × 76 cm/20 × 30 ins
> Lent by Mrs Diamand

The painting depicts Roger Fry's daughter sitting in the garden of the Frys' home, Durbins, near Guildford. The portrait was commissioned by Fry in 1911, the year in which, apart from Grant, Henry Doucet and possibly also Vanessa Bell and Fry himself were to paint Pamela.

The separate diagonal brushstrokes of soft colour in the blue, green, purple, ochre range can be compared to Spencer Gore's studies of figures in gardens dating from *c.* 1909–11. When *Pamela* was exhibited at the 2nd Post-Impressionist Exhibition P. G. Konody wrote that it has '... all the subtle charm of a Vuillard's colour'. The decorative arrangement and design of the lily pond which is integral to the conception of the painting can also be compared to Vuillard. This feeling for decoration was to be important in Grant's future development. The painting was owned by Roger Fry. A.G.

EXHIBITION
1912, London, 2nd Post-Impressionist Exhibition (102)
REFERENCES
P. G. Konody, *The Observer*, 27 October 1912
J. Laver, *Portraits in Oil and Vinegar*, 1925, p. 145
New Brunswick, Canada, Beaverbrook Art Gallery, *Bloomsbury Painters and Their Circle*, 1976 (2)

303

Guthrie, James 1859–1930

Guthrie originally enrolled to study law at Glasgow University but abandoned it in 1877 and studied painting for a short time with John Pettie in London. After a visit to Paris in 1882 his style changed. He became the leader of the Cockburnspath artists, and established a reputation as a portraitist. He exhibited at the NEAC, was president of the Glasgow Art Club, and received a number of international honours.

304 *A Hind's Daughter* 1883

> sdbl. James Guthrie December 83 91.5 × 76 cm/36 × 30 ins
> Lent by the National Gallery of Scotland, Edinburgh

Seeing Bastien-Lepage's work at the Glasgow Institute in 1881 may have prompted Guthrie's trip to Paris in 1882, after which there is a noticeable change in his painting, which can be observed in *A Hind's Daughter*. Its *plein-air* qualities, the aspect of the figure and the abrupt changes in the paint surface all point to Bastien. However, the rich brown tonalities, heightened with touches of orange and blue, may show the influence of the Hague School (Israels and the Maris brothers), whose work was popular in Scotland.

Young girls standing in cabbage patches was a favourite theme of Bastien's British followers. Often the cabbages are magnified out of

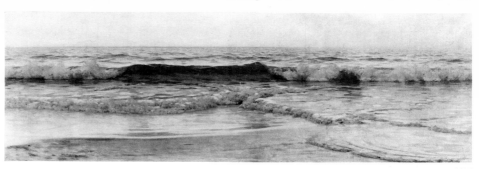

305

304

proportion to their natural size, thus fulfilling the same function in the composition as Bastien's weeds (cf. no. 10), and as a 'signpost' for naturalism. When *A Hind's Daughter* was shown at the Glasgow Institute in 1884, the *Art Journal* commented on '. . . the pervasive French influence which has misled many clever young Scotch artists into mere imitation of some of the passing phases of French art and those not the healthiest' (*Art Journal*, 1884, p. 126). A.G.

EXHIBITION
1884, Glasgow, Institute (197)
REFERENCES
J. Caw, *Sir James Guthrie*, 1932, pp. 24–5
W. Hardie, *Scottish Painting 1837–1939*, 1976, p. 76

Harrison, Thomas Alexander 1853–1930

Born in Philadelphia, Harrison spent four years working for the United States Coast Survey before deciding to be a professional artist. He studied in San Francisco and at the Pennsylvania Academy of Arts before going to Paris in 1879. He studied under Gérôme at the Ecole des Beaux-Arts and also with Bastien-Lepage whom he met after Bastien noticed his *Castles in Spain* (Metropolitan Museum of Art, New York) at the 1882 Salon. By the mid-1880s he had a following at Gretz and Concarneau. He lived in Paris all his life and knew Monet, Whistler, Puvis de Chavannes and many others. In the 1880s he was an important link with Paris for young British artists. He served on the NEAC committee in 1889. His brother was the painter Birge Harrison.

305 *The Wave* 1884/5

La Vague
sbl. Alex Harrison 100 × 300 cm/39¼ × 118 ins
Lent by the Pennsylvania Academy of the Fine Arts,
Temple Fund Purchase, 1891

Harrison had a studio in Concarneau in summer 1883. In Blanche Willis Howard's *Guenn: A Wave on the Breton Coast* (1883) he is portrayed as the ambitious Everett Hamor who converts an empty granary into a studio and approaches his craft of painting with single-minded dedication. Like the other artists at the Hôtel des Voyageurs, Harrison's main concern was to paint successful Salon paintings: 'He had been heard to make the savage assertion that to

reach his goal he would not hesitate to walk over the bodies of babes and virgins' (*Guenn*, p. 101). It was when walking along the seashore at Concarneau with his friend and teacher Bastien-Lepage that Harrison was first inspired to paint the sea. Working from sketches made on the spot over the winter, he painted *Moonrise* (Corcoran Gallery of Art, Washington). He spent the following winter developing the composition for *The Wave*, which was painted from memory with the aid of a number of sketches. The light effects during the winter months in Brittany were particularly useful to Harrison's researches into tone and colour: '. . . the whole landscape had toned down from summer Brittany into the softness which is the painter's joy and despair. [There] lay an unspeakable glamour of atmosphere and warmth of tone revealed not lavishly but in beautiful touches here and there, . . .' (*Guenn*, p. 244).

The Wave was hung in a place of honour at the Salon. Subsequently Harrison painted more sea studies which were a prominent feature of the Salon. His greatest success was *In Arcadia* (untraced; formerly Musée du Luxembourg, Paris), which secured his reputation in Paris when exhibited at the 1886 Salon. A.G.

EXHIBITION
1885, Paris, Salon (1233)
REFERENCES
C. L. Borgmeyer, 'Alexander Harrison', *Fine Arts Journal*, 1913, pp. 536–7
W. Rothenstein, *Men and Memories*, I, 1931, p. 77
Dayton, Ohio, Art Institute, *American Expatriate Painters of the Nineteenth Century*, catalogue by M. Quick, 1976 (18)

Henry, George 1858–1943

Born in Irvine, Scotland, Henry attended Glasgow School of Art and in 1883 painted *plein-air* with Guthrie and others at Brig o'Turk and Rosmeath and later at Cockburnspath. In 1885 he met Hornel, which resulted in a close and creative friendship. He exhibited at the NEAC in 1887 and in 1893 visited Japan with Hornel. Henry was elected president of the Glasgow Art Club, 1901–2; ARSA in 1892 and RSA in 1902; ARA in 1907 and RA in 1920.

306 *Autumn* 1888

sdbl. George Henry 1888 45 × 38 cm/17 × 15 ins
Lent by Glasgow Art Gallery and Museum

Henry's studies of figures in landscape painted between 1885 and 1887 were influenced by Bastien-Lepage. In this painting of 1888 Bastien's device of emphasizing details of plants and foliage by distorting their proportions in relation to the other elements of the picture has been used to create a decorative pattern across the picture plane. In addition, Henry used the strong 'squared' brushwork associated with Bastien's followers to build up

contrasting areas of colour in vermilion, orange, turquoise and green. This palette is probably derived from Monticelli (cf. no. 144), whose work was shown at the International Exhibition in Edinburgh in 1886. A.G.

EXHIBITIONS
1890, Glasgow, Institute (709)
1891, Edinburgh, Royal Scottish Academy (65)
REFERENCES
D. Martin, *Glasgow School of Painting*, 1897, p. 26
J. Caw, *Scottish Painting Past and Present*, 1908, p. 401
G. Buchanan, 'A Galloway Landscape', *Scottish Arts Review*, 1960, p. 13

307

306

Hornel, Edward Atkinson 1864–1933

Born in Australia, Hornel was brought to Scotland while still a child. He studied at the Trustees Academy, Edinburgh, and then at the Antwerp Academy under Verlat. In 1885 he met George Henry, with whom he painted for several years at Kirkcudbright and who was his travelling companion to Japan in 1893. Hornel contributed to Les XX in 1893. After 1895 he lived in Kirkcudbright and made various painting trips to the Far East.

307 *The Goatherd* 1889

sdbl. E. A. Hornel 1889 38 × 45 cm/15 × 17 ins
Lent by a Private Collector

In 1889 Henry and Hornel painted several pictures in which the landscape is flattened into curving shapes and a single figure fronts a high horizon line. All these paintings depict pastoral subjects painted in rich ochre, green and brown. The compositions have an affinity with Gauguin, though it is uncertain whether either artist would have seen his work at this date. Hornel might have known about the work exhibited at Les XX through a connection established during his student days in Antwerp. However it is more likely that their compositions were derived from Japanese prints, which were admired and collected by the 'Glasgow Boys'. In 1893 Hornel exhibited a painting entitled *The Goatherd* at Les XX, and one critic noted the influence of Japan, especially in the use of colour 'in broad decorative areas in a way which has a relation to Japanese art and is strongly akin to Gauguin' (Glasgow, Scottish Arts Council, *Mr Henry and Mr Hornel Visit Japan*, catalogue by W. Buchanan, 1978–9, p. 9). The present painting is closely related to Henry's *Galloway Landscape* (1889, Glasgow Art Gallery). A.G.

308 *A Japanese Garden* 1894

sdbr. E. A. Hornel 94 61 × 51 cm/24 × 20 ins
Lent by Mrs Ian MacNicol

The interest in Japanese prints and artefacts in England and Scotland in the 1880s prompted a number of painters to visit Japan. They included Mortimer Menpes (in 1887), Alfred East (in 1889) and Alfred Parsons (in 1892). The majority of paintings produced by them in Japan were anecdotal and show little knowledge of or interest in the pictorial innovations suggested by Japanese prints. On seeing these works in London, Oscar Wilde remarked: 'If you desire a Japanese effect, you should not be a tourist and go to Tokyo.'

However Hornel, in partnership with George Henry, had shown an understanding of Japanese compositions from 1889 and it must have seemed a wonderful opportunity when Alexander Reid, the Scottish dealer who had known Van Gogh and had introduced Impressionist painting to Scottish collectors, sent them to Japan in 1893. Hornel commented: 'Japanese art rivalling in splendour the greatest art in Europe, the influence of which is now fortunately being felt in all the new movements in Europe, engenders in the artist the desire to see and study the environment out of which this great art sprang' (quoted Glasgow, Scottish Arts Council, *Mr Henry and Mr Hornel Visit Japan*, catalogue by W. Buchanan, 1978–9, p. 9).

In *A Japanese Garden* the animated figures are incorporated into a rich decorative pattern of arabesque shapes. Although the flattened space and the broad areas of colours can be compared with Japanese prints, the thick impasto of the surface and the variety of brilliant colour evolved from Hornel's admiration for Monticelli.

In April 1895 40 of Hornel's Japanese paintings were exhibited at Reid's gallery. *A Japanese Garden* was presumably one of them, but it is difficult to prove since no catalogue was issued. The painting was once owned by Alexander Reid. A.G.

308

EXHIBITION
?1895, April, Glasgow, Société Nouvelle des Beaux-Arts
REFERENCES
Edinburgh, Scottish Arts Council, *A Man of Influence: Alex Reid*,
 catalogue by R. Pickvance, 1967 (59)
W. R. Hardie, 'E. A. Hornel Reconsidered', *The Scottish Arts Review*, 1968, pp. 22–3

Innes, James Dickson 1887–1914

Born in Llanelli, Innes attended Carmarthen Art School 1904–5 and the Slade 1906–8. In 1907 he met Augustus John, moved to Fitzroy Street and regularly visited 19 Fitzroy Street. In 1908 he travelled round France with John Fothergill. He lived in Paris in 1910, where he was close to Matthew Smith and visited Leo Stein's collection and Vollard's gallery. He painted in North Wales with Augustus John; he also painted in Spain, at Collioure, and elsewhere in the south of France. He exhibited at the NEAC, the AAA, with the Camden Town Group and at the Armory Show. He was a member of the NEAC (1911) and the Camden Town Group (1911). He had one-man shows at the Chenil Gallery in 1911 and 1913.

309

309 *The Coast Near Collioure* c. 1912

ns. 38 × 46 cm/15 × 18 ins
Lent by Southampton Art Gallery

Innes first went to Collioure in 1908 with John Fothergill, but he was not aware of its connections with the Fauves (cf. nos 73, 131). Predictably, in the intense light of the south he lightened his palette, but it was the sight of Matisse's paintings at Leo Stein's in Paris in 1910, and of Augustus John's Provençal studies at the Chenil Gallery in 1911, that encouraged him to make his colours bolder and brighter. The mountain in *The Coast Near Collioure* is a fanciful invention which confirms the element of emotive fantasy suggested by the intense pink, purple and blue colour. The short, choppy brushstrokes, characteristic of Innes, were adapted from Lucien Pissarro's Neo-Impressionist technique. However in Innes' work they fulfil a different function; as stylized annotations which articulate details of the landscape, they provide definition of the flat areas of very bright colour and give the painting a decorative appearance which points to the influence of Japanese prints. A.G.

REFERENCE
Southampton, Art Gallery, *James Dickson Innes 1887–1914*,
 catalogue by J. Hoole, 1978 (112)

John, Augustus 1878–1961

Born in Wales, the brother of Gwen John, Augustus John studied at the Slade 1894–8, taught painting at Liverpool University 1901–4, and at the same time was co-principal with William Orpen of the Chelsea Art School. He exhibited at the NEAC, becoming a member in 1903, the International Society and the AAA. John was a member of the Camden Town Group but only sent to the first exhibition in June 1911. In 1907 he met Picasso in Paris. He travelled and painted in Wales, France, Dorset and Ireland until 1914. He was elected ARA in 1921 and RA in 1928.

310 *A Family Group* c. 1908

ns. 209.5 × 181 cm/79½ × 68¼ ins
Lent by the Hugh Lane Municipal Gallery of Modern Art, Dublin

This painting, an idealization of family life, shows John's two wives, Ida and Dorelia, with their children. Several pen and ink drawings dating from c. 1905 relate to the composition, but John did not begin the painting until after Ida's death in March 1907.

Two important experiences in Paris in 1907 inspired him to paint a simplified composition on a large canvas. John had originally been introduced to the work of Puvis de Chavannes by Rothenstein, saw Rothenstein's own Puvis drawings, and was directed by him to look at Puvis' work in Paris in 1900. However the impact on him of the 1907 exhibition of Puvis' drawings was much greater. He wrote to Rothenstein: 'I went to see Puvis' drawings in Paris. He seems to be the finest modern . . . full of Greek lightness. Longings devour me to decorate a vast space . . . I am getting clearer about colour tho' still very ignorant' (M. Holroyd, *Augustus John*, I, 1974, p. 253). Puvis' influence can be seen in the monumental large figures, the shallow space and the flat, decorative landscape. John's reference to colour is pertinent because in *A Family Group* he discards the brown tonalities of his earlier paintings to create a rhythmic pattern of red, blue and yellow against a blue-green background.

Visiting Picasso's studio was also important: 'I saw a young artist called Picasso whose work is wonderful in Paris' (letter to Henry Lamb, 5 August 1907, in Holroyd, I, p. 273). John saw paintings from the 'Blue' and 'Rose' Periods, together with *Les Demoiselles d'Avignon* (Museum of Modern Art, New York).

It was the simplification in John's paintings that was admired by the young guard in England. Referring to its startling effect, Roger Fry wrote: 'It already rejected so many accessory facts that the spectator was in the habit of expecting' (Manchester, City Art Gallery, Contemporary Art Society, catalogue preface by R. Fry, autumn 1911, p. XXII). *A Family Group* anticipates the large paintings *The Way Down to the Sea* (1909–11; Lamont Art Gallery, Exeter, New Hampshire) and *The Lyric Fantasy* (1911–14, Tate Gallery), both of which show Dorelia and Ida in idealized settings. A.G.

310

EXHIBITION
1909, April–May, London, Grafton Galleries, *Chosen Pictures* (53)
REFERENCES
L. Binyon, *Saturday Review*, 29 May 1909, p. 683
Cardiff, National Museum of Wales, *Augustus John: Studies for Compositions*, catalogue
 introduction by A. D. Fraser Jenkins, 1978 (82)

311

311 *Dorelia and the Children at Martigues* 1910

sbr. John oil on panel 23.5 × 33 cm/9¼ × 13 ins
Lent by the Fitzwilliam Museum, Cambridge

This picture is one of a series painted at Martigues in summer 1910.
Dorelia is seated with David to the left and two other John children,
possibly Romilly and Pyramus, to the right. A comparison of this
painting with *A Family Group* (no. 310) illustrates how John's
experiments with form and colour advanced with the Martigues
series. By using smaller panels he gave himself greater freedom of
handling to create flat, simplified forms in pure colours. These
Provençal studies were admired by the English critics: C. J. Holmes
announced dictatorially that 'Cézanne, Van Gogh and Gauguin
(with Augustus John in England) are the only figures worth
discussing in connection with Post-Impressionism' (*Notes on the
Post-Impressionist Painters*, 1910, p. 17), and C. L. Hind wrote: 'John
is the chief of the English representatives of the new movement in
art. All the art world is his hunting ground in these Provençal
studies. Each is entirely his own, each is vital' (*Post-Impressionists*,
1911, p. 73).

When Clive Bell was organizing the English section of the 2nd
Post-Impressionist Exhibition he invited John to send some
paintings. John accepted, but did not in fact contribute because he
was unwilling to be associated with a defined group. *Dorelia with
Three Children* is, however, almost certainly one of the 48 Provençal
studies exhibited at the Chenil Gallery in 1910. The title in the
catalogue to which it corresponds most closely is *Mother with
Children, Evening* (20). A.G.

EXHIBITION
?1910, London, Chenil Gallery (20)
REFERENCE
M. Easton and M. Holroyd, *The Art of Augustus John*, 1974, p. 66, pl. 11

John, Gwen 1876–1939

The sister of Augustus John was born in Wales and studied at the
Slade. In 1898 she went to Paris and attended the Académie Carmen
where Whistler taught part-time. Though she returned to London in
1899 she went back to Paris in 1903 and never again lived in
England for any length of time. The sculptor Rodin and the poet
Rilke were among her friends. Gwen John exhibited at the NEAC and
the Salon d'Automne and in 1910 John Quinn became an important
patron. In 1913 she was converted to Roman Catholicism.

312 *A Corner of the Artist's Room in Paris* 1907/9

ns. 31 × 25.5 cm/12 × 10 ins
Lent by Sheffield City Art Galleries

This painting shows the room at 87 rue du Cherche-Midi where
Gwen John lived from 1907 to 1909. The wicker chair was included
in several works painted in this period: one of them, a self-portrait
entitled *Girl Reading at the Window* (Museum of Modern Art, New
York), shows the artist with her foot perched on it, reading a book.
This continual return to a single familiar object reflects her practice
of painting in series. *A Corner of the Artist's Room in Paris* can be
compared to Nabi interiors, but the feeling of detached intensity
which is imparted to this single domestic object make the picture
more closely related to the Slade tradition of interior painting.
The fluid handling of the paint, with its English associations, is
characteristic of Slade work in the 1890s and early 1900s, and can
be traced back to Whistler. Gwen John's contact with Whistler in
Paris was also important, since she acquired from him the basis for a
precise and scientific approach: 'She used to prepare the canvasses
according to a recipe of her own and invented a system of
numbering her colour mixtures . . .' (London, A. Matthiesen Ltd,
Gwen John Memorial Exhibition, introduction by Augustus John,
1946, p. 3). A.G.

REFERENCES
J. Rothenstein, *Modern English Painters*, 1, 1976, p. 167
London, Arts Council, *Gwen John*, catalogue by M. Taubman, 1968, p. 21

312

313 *Portrait of Chloë Boughton-Leigh* 1910/14

ns. 60.5 × 38 cm/23¾ × 15 ins
Lent by Leeds City Art Galleries

Ellen Theodosia (Chloë) Boughton-Leigh and her sister Maude were
both students at the Slade. Gwen John first painted Chloë in 1908
(Tate Gallery), and probably started the present portrait in October
1910. Both paintings have a quality of withdrawn intensity, some-
thing which can also be found in certain of Whistler's late portraits
(she may have seen Whistler's *Gold and Brown* self-portrait when she
and Augustus visited him in his studio in 1898). Like most of her
portraits of women, Gwen John's paintings of Chloë contain an
element of self-portraiture. The reduction and simplification to
create the austere, sloping shape against a flat background were
probably inspired by her admiration for Puvis de Chavannes,
described by her as 'surely the greatest painter of the century' (letter
to John Quinn, 28 November 1911, in G. L. Reid, *The Man from New
York*, 1968, p. 112). The portrait shows the transition from her early
fluid style, seen here in the handling of the figure, to the dry, chalky
impasto of her later work, exemplified here in the painting of the
background.

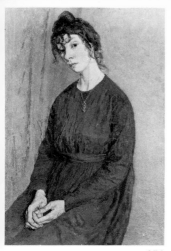

313

Portrait of Chloë Boughton-Leigh was acquired by the New York collector, John Quinn, who gave Gwen John sympathetic support and amassed a large collection of her work. He was also an important patron of her brother Augustus. A.G.

REFERENCES
M. G. Compton, 'Gwen John', *Leeds Art Calendar*, vol. 8, no. 29, p. 22
London, Arts Council, *Gwen John*, catalogue by M. Taubman, 1968, p. 17

Lamb, Henry 1883–1960

Born in Adelaide, Australia, Lamb attended John's and Orpen's Chelsea Art School until 1907. In 1908 he went to France and enrolled at the Ecole de la Palette; in 1908, 1910 and 1911 he worked in Brittany. He helped to form the Friday Club, showed with the NEAC and attended Fitzroy Street meetings. Lamb exhibited with the Camden Town Group and joined the London Group, but did not exhibit; he was also closely connected with the Bloomsbury Group. He was elected ARA in 1940 and RA in 1949.

314 *Breton Cowherd* 1910

sd on rev. Henry Lamb 1909 [?]
oil on panel 35.5 × 25.5 cm/14 × 10 ins
Lent by the Marquesa de Guadalmina

Lamb was very receptive to the different moods of Breton subjects. While *Death of a Peasant* (no. 315) expresses the overpowering bereavement of the mourning peasant, in *Breton Cowherd* he concentrated on translating the landscape into line and flat areas of colour. This use of line and colour was inspired by Augustus John's interpretation of Puvis de Chavannes in his small oil panels, for instance no. 311, executed in the south of France.

314

Breton Cowherd was one of the paintings by the Fitzroy Street Group which was badly hung in an inner room at the NEAC in 1910, a direct reason for the formation of the Camden Town Group. The painting was owned by Judge William Evans, a patron of the Fitzroy Street Group. A.G.

EXHIBITION
1910, autumn, London, NEAC (105)
REFERENCE
London, Fine Art Society, *Camden Town Recalled*, catalogue by W. Baron, 1976 (85)

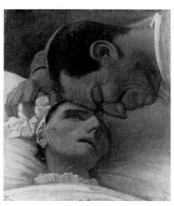

315

315 *Death of a Peasant* 1911

ns. 37 × 31.5 cm/14½ × 12½ ins
Lent by the Trustees of the Tate Gallery, London

In the stark contrast between the face of the dead woman and the face of the mourning man leaning over her, Lamb conveys the harshness of the life and death of a Breton peasant and the bitterness of bereavement (cf. Cottet, no. 53).

The painting was exhibited at Fitzroy Street and Frank Rutter reported that it made a considerable impact (*Art in My Time*). In his book *Evolution of Modern Art* Rutter wrote of it with great enthusiasm: 'His modern pietà *The Death of a Peasant* was the first great tragic picture England produced in the 20th century, and it heralded Britain's revolt from an impressionism it had never really known or understood.'

The painting was owned by Sir Michael Sadler. A painting of the same subject, shown at the NEAC in 1911, is now in Australia. A.G.

EXHIBITION
1911, London, Fitzroy Street
REFERENCES
F. Rutter, *Some Contemporary Artists*, 1922, p. 170
F. Rutter, *Evolution of Modern Art*, 1926, p. 132
F. Rutter, *Art in My Time*, 1933, p. 124
London, Tate Gallery, *Modern British Paintings, Drawings and Sculpture*, 1, 1964,
 pp. 366–7
London, Fine Art Society, *Camden Town Recalled*, catalogue by W. Baron, 1976 (89)

La Thangue, Henry Herbert 1859–1929

Born in Croydon, Surrey, La Thangue went to the RA Schools; in 1879 he won their gold medal travelling studentship which enabled him to go to Paris where he studied at the Ecole des Beaux-Arts under Gérôme. He painted in Brittany in 1881 and 1882 with Stanhope Forbes. La Thangue was a founder member of the NEAC in 1886, but withdrew his membership after the first exhibition and instigated a scheme to reform the Royal Academy. He was elected an ARA in 1898 and an RA in 1912.

316

317

316 *Return of the Reapers* 1886

> sbl. H. H. La Thangue; sd on rev. H. H. La T. 1886
> 118 × 68.5 cm/46.5 × 27 ins
> Lent by A. H. Grogan Esq.

The most interesting feature of this painting is its technique – the large, squarish brushstrokes which are particularly evident at the edge of the woman's skirt are a good example of the hallmark of what came to be known as the 'square brush school'. In an account of the artists who practised this technique, including La Thangue and Stanhope Forbes, it was described as '. . . a technical method which puts paint on canvas in a particular way with a square brush. . . . Those who practise it in its simplest form leave the brush-marks, and do not smooth away the evidence of method, thus some-times insisting on the way the picture is painted perhaps at the sacrifice of subtleties in the subject . . . there are infinite variations in this method . . . which was common in its extreme form at Paris when La Thangue was there' (Morley Roberts, 'A Colony of Artists', *Scottish Arts Review*, II, 1889, p. 73). The technique was used by Bastien-Lepage, which accounts for its widespread adoption in Britain. As a *premier coup* method it enabled La Thangue to cover large areas of canvas quickly, an important advantage since he insisted on painting *plein-air* and on adhering rigidly to the same timescales and weather conditions as the Impressionists, but without the aid of their smaller-sized canvases. *Return of the Reapers* is similar to La Thangue's *In the Dauphiné* (untraced), the technique of which caused a great furore at the NEAC when it was exhibited in 1886 as an unfinished sketch. By the end of the decade this style of painting was widespread and the general public recognized it 'as a kind of badge of the French School' (R. A. M. Stevenson, *The Studio*, I, 1893, p. 10). A.G.

REFERENCE
Oldham, Art Gallery, *A Painter's Harvest: H. H. La Thangue 1859–1929*, catalogue by K. McConkey, 1978, pp. 10, 21

Lavery, John 1856–1941

Born in Belfast, Lavery studied at the Haldane Academy, Glasgow, at Heatherley's in London, and at Julian's under Bouguereau. In 1883–4 he spent some time at Gretz and then decided to settle in Glasgow. He met Whistler, and exhibited at the RBA; in 1887 he became a member of the NEAC. Lavery was one of the forces behind the formation of the International Society, of which he was vice-president under Whistler. He was a member of the Secessions of Berlin, Munich and Vienna, and received a number of high honours. He made his reputation as a portrait painter. Lavery was elected ARA in 1911 and RA in 1921.

317 *The Tennis Party* 1885

> sdbl. J. Lavery 1885 77 × 183.5 cm/30¼ × 69½ ins
> Lent by Aberdeen Art Gallery

The Tennis Party, painted at Cathcart, Scotland, in summer 1885, was Lavery's first major work after deciding to settle in Scotland on seeing Guthrie's *To Pastures New* (Aberdeen Art Gallery) at the Glasgow Institute that spring. The experience of his sojourn in France can be seen in three different ways in *The Tennis Party*. First, the long narrow format of the canvas was used by William Stott for *The Ferry* and *Bathing*, two works which Lavery would have seen during the period he spent at Gretz in 1883 and 1884. Second, Stott's interpretation of Bastien's handling of space can be seen in *The Tennis Party*; and, third, Lavery acknowledged Bastien's direct influence: at their only meeting, in Paris, Bastien pointed to the people passing on the Pont des Arts and told Lavery: 'Always carry a sketchbook. Select a person – watch him – then put down as much as you remember. Never look twice. At first you will remember very little, but continue and you will soon get complete action' (Lavery p. 57). The feeling of motion which is conveyed is a result of the positioning of the figures on two separate planes and the abrupt change between them which is characteristic of Bastien.

Lavery's decision to paint a moment from 'modern' life was probably inspired by Manet, whose *Bar at the Folies-Bergère* (Courtauld Institute Galleries, London) had hung next in line to Lavery's *The Two Fishermen* (untraced) at the 1882 Salon. This is mentioned in his autobiography (Lavery p. 51), and probably also accounts for subsequent similarities in their painting technique.

There are several studies for *The Tennis Party*, and Alix MacBride, who posed for it with her sister and cousin, remembered that it went through many changes before it was completed (letter from Alix MacBride, Aberdeen Art Gallery). When it was exhibited at the Royal Academy it was criticized for its vulgar subject; however two years later at the Salon it received high praise from George Moore, writing in *The Hawk*: 'Two years ago I saw a picture of a game of lawn tennis in the Academy. I recognised this picture at once as a work of real talent . . . it passed unnoticed while foolish praise was lavished on Sir Frederick's [Leighton] silliness, Poynter's stupidity, and Tadema's dullness. To my surprise and sincere pleasure, I find this picture in the Salon. . . .' Two years later, at Munich, *The Tennis Party* did much to establish the reputation of the Scottish School in Germany. A.G.

EXHIBITIONS
1886, London, Royal Academy (740)
1887, Glasgow, Institute (299)
1888, Paris, Salon (1527)
1890, Munich, Glaspalast (737), bronze medal
1901, Munich, Secession, gold medal
REFERENCES
G. Moore, 'The Salon of 1888', *The Hawk*, 8 May 1888, p. 257
J. S. Little, 'A Cosmopolitan Painter: John Lavery', *The Studio*, vol. 27,
 October 1902, p. 11; November 1902, pp. 113–14
R. Muther, *Modern Painting*, III, 1896, p. 691
W. Shaw Sparrow, *John Lavery and His Work*, 1911, pp. 47–8, 67
J. Lavery, *The Life of a Painter*, 1940, pp. 57–8
G. Reynolds, *Painters of the Victorian Scene*, 1953, p. 104
W. Hardie, *Scottish Painting 1837–1939*, 1976, p. 78

318 *The Flower Show* c. 1888

> sbr. J. Lavery 27 × 27 cm/10½ × 10½ ins
> Lent by Kirkcaldy Museum and Art Gallery

Lavery joined Whistler's coterie at the RBA in spring 1887; this
association initiated various changes in Lavery's style, as can be
seen in the thin tonal washes and the softly defined outlines of the
figures in *The Flower Show*. Whistler's example probably encouraged
Lavery to experiment with oil-sketches and to use smaller canvases;
he also influenced Lavery's portrait style, with which he made a
considerable reputation in the 1890s. However, like most of
Whistler's followers, Lavery combined these ideas with his own
predilection for richer colour accents and a penchant for recording
contemporary events.

The Flower Show is probably one of the 50 or so works of scenes in
the grounds and pavilions of the Glasgow International Exhibition
which Lavery exhibited at the Craibe Angus Gallery, Glasgow, in
1888. These sketches secured him a commission to paint *The State
Visit of Queen Victoria, August 22, 1888* (Glasgow Art Gallery). A.G.

318

Leech, William 1881–1968

Born in Ireland, he studied under Osborne at the RHA Schools and at
the Metropolitan School of Art, Dublin. In 1901 he went to Paris and
enrolled at Julian's. He was influenced by Osborne, Orpen and later
by the Fauves. In 1910 he became an RHA.

319 *The Goose Girl* c. 1903

> s and insc. on paper on frame Quimperlé W.L.
> 72 × 91 cm/28¼ × 35¾ ins
> Lent by the National Gallery of Ireland, Dublin

When Leech arrived in 1903, Brittany was still drawing hundreds of
artists every year and its attractions had been made into something
of a commercial enterprise. For example, Madame Julia had trans-

319

formed the Villa Julia, where many artists stayed in the 1890s,
into the Académie de Mlle Julia. An advertising pamphlet offered
suitable chaperones (as well as art instruction) for women students.
It also pointed out that Brittany '. . . might be called an Artist's
Paradise for the beauty of the women, the delicate harmonies of the
landscapes, the indefinable charm – partly melancholy, wholly
poetical – of its traditions and associations which have attracted a
number of painters, musicians and writers' (H. A. Vachell, *Brittany,
Art Season at Pont-Aven: Académie of Mlle Julia*, c. 1900).

In *The Goose Girl*, Leech's training under Osborne can be seen
in the Bastien-influenced subject and composition. But it is also an
exercise in depicting reflected sunlight and bright, contrasting
colours of orange and violet. The decorative quality of the painting
anticipates the future direction of Leech's work. A.G.

Nevinson, Christopher 1889–1946

Born in London, he studied at St John's Wood Academy and the Slade
1908–12. In 1911 he first met Severini in Paris where he studied at
the Académie Julian and the Cercle Russe, mixing with Modigliani,
among others. He welcomed Marinetti to London in November
1913. In 1914 he joined the Rebel Art Centre and the same year
published, with Marinetti, *Futurist Manifesto, Vital English Art!*
In 1915 he exhibited at the Vorticist Exhibition as a Futurist,
but renounced Futurism in 1918. His war paintings were very
successful. He exhibited at the NEAC, the Friday Club and the
AAA, and was a founder member of the London Group.

320 *The Towpath, Camden Town, by Night* c. 1912

> ns. 76 × 56 cm/30 × 22 ins
> Lent by the Visitors of the Ashmolean Museum, Oxford

In his autobiography, Nevinson recalls that when he was a young
man he went to the Venice Biennale with his mother, a visit about
which he could remember nothing except seeing a painting by

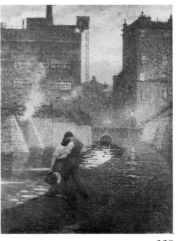

320

Signac (Nevinson, *Paint and Prejudice*, 1937, p. 13). The year must have been 1907, when Signac showed one picture, *Venice* (40). As a student in London Nevinson would have been able to see other Neo-Impressionist paintings, and his assimilation of Neo-Impressionist technique is evident in the separate strokes of colour in the blue-green range which he uses to build up the dense, pulsatingly intense paint surface of *The Towpath*. This intensity, emphasized by the sinister lovers standing in a grim urban environment, also shows how much his outlook and style shared with the Italian Futurists – the *Manifesto of the Futurist Painters* was published in *The Art News*, 15 August 1911, and Nevinson also met Severini in Paris that year.

In 1911–12 Nevinson painted a number of industrial landscapes, including *The Railway Bridge* (Manchester City Art Gallery), a prismatic London suburban landscape showing gasometers, exhibited at the AAA in 1911, and *La Villette*, depicting a man hauling a barge, which was shown at the NEAC in winter 1912. A painting entitled *Camden Town* was exhibited at the AAA in 1913 (302). A.G.

Nicholson, William 1872–1949

Born in Newark, Nicholson attended Herkomer's School of Art at Bushey in 1888. He then went to Paris and studied at the Académie Julian 1889–90. During 1894–6 he collaborated with James Pryde, and together they designed posters under the pseudonym of the Beggarstaff Brothers. From 1896 to 1900 he produced woodcuts for Heinemann, the publishers, and for W. E. Henley's *New Review* (1898). He exhibited at the NEAC in 1894 and at the International Society from 1898.

321 *Statuettes and Rodin Bronze* 1907

> sdtl. Nicholson 1907 57 × 52 cm/22½ × 20½ ins
> Lent by A. W. Bacon Esq. (on loan to Hevingham Hall, Suffolk)

The handling of blacks and creamy whites in *Statuettes and Rodin Bronze*, in which each surface reflects a different quantity of light, is the result of Nicholson's experiences in the 1890s. From the woodcut illustrations he made between 1896 and 1900 he acquired a knowledge of the patterns of dark and light. Like Rothenstein and Gilman, he was impressed by the idea that Velasquez's truth to tone was part of the English definition of Impressionism. His study of Velasquez was central to his painting, and because of this preoccupation he defined himself as a realist painter 'who had only white with which to give the equivalent in terms of his material of the brightest light . . . It means rendering all other colours so that your white will sing' (quoted Robert Nicholls, *William Nicholson*, 1948, p. 11).

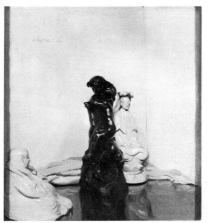

321

Rodin had special significance in England. He had been appreciated since W. E. Henley, editor of the *Magazine of Art*, introduced him in the 1880s, and in 1904 Rodin was elected president of the International Society, an exhibiting body to which Nicholson had contributed since its first show in 1898.

The painting was bought in 1908 by T. W. Bacon, an important patron. A.G.

EXHIBITION
1907, London, Goupil
REFERENCE
Lillian Browse, *William Nicholson*, 1956, p. 44, pl. 53

O'Conor, Roderic 1860–1940

Born in Ireland, O'Conor first studied in Antwerp and in 1883 went to Paris where he may have enrolled in Carolus-Duran's atelier. He never again left France except for short periods. In 1889 he started exhibiting at the Indépendants. O'Conor spent some time at Pont-Aven where he met Séguin, Forbes-Robertson, Filiger and Gauguin, who wanted him to return with him to Tahiti in 1895. O'Conor exhibited at Le Barc de Boutteville, Les XX, the Salon d'Automne and the AAA. In the 1900s his connections with the French art world made him an important figure in the Anglo-Saxon circle in Paris.

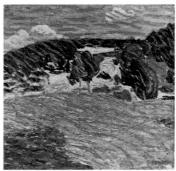

322

322 *Field of Corn, Pont-Aven* 1892

> sdbr. O'Conor 92 38 × 38 cm/15 × 15 ins
> Lent by the Ulster Museum, Belfast

O'Conor was probably introduced to Van Gogh's painting at the Indépendants in 1890 when each artist sent 10 works. The thickly encrusted paint, heavily applied in strong, diagonal strokes of pure, unmixed red, yellow and green, moving from right to left, resembles Van Gogh; however the areas of bare canvas between each brush-stroke create a different effect, reinforcing O'Conor's decorative treatment of the landscape. A.G.

REFERENCES
Ulster Museum Report, *Some Gallery Acquisitions of the Year*, 1963–4, p. 24
Connoisseur Year Book, 1964, p. 100
A. Crookshank and The Knight of Glin, *The Painters of Ireland*, 1978, repr. in colour p. 210

323 *Breton Peasant Woman Knitting* 1893

> sdtl. O'Conor 1893 oil on board 81.5 × 68 cm/32 × 26¾ ins
> Lent by a Private Collector, London

O'Conor painted Breton peasants on several occasions. In the treatment of *Breton Peasant Woman Knitting*, one of his boldest interpretations of this theme, he makes little differentiation between the

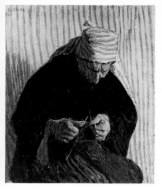

323

face and dress and the background, all of which fuse together to form a pattern of strong, expressive stripes in bright, pure colour. The image of an old woman knitting can be taken as a metaphor for time and death, which reflects the metaphysical preoccupations of the Pont-Aven School, and can be compared with Van Gogh's *La Berceuse*. A.G.

REFERENCE
A. Crookshank and The Knight of Glin, *The Painters of Ireland*, 1978, p. 262

234 *The Lezaver Farm, Finistère* 1894

La Ferme Lezaver, Finistère
[repr. in colour on p. 166]
sdbl. O'Conor 1894 72 × 93 cm/28½ × 36½ ins
Lent by the National Gallery of Ireland, Dublin

In 1894 O'Conor met Gauguin and the two artists appear to have formed quite a close friendship when Gauguin was staying at Pont-Aven; at one point O'Conor even intended to accompany him when he returned to Tahiti. They exchanged paintings and drawings until Gauguin's death, and the sensitive interpretation of the landscape in *The Lezaver Farm* was undoubtedly influenced by O'Conor's contact with Gauguin. The composition is divided into rhythmic bands which are similar to earlier Pont-Aven landscapes such as *Field of Corn, Pont-Aven* (no. 322), but his use of colour is quite different; by applying it in long, fine brushstrokes of his preferred reds and greens, O'Conor achieved a subtler and richer quality. He exhibited two landscapes at Le Barc de Boutteville in 1894, and a landscape entitled *Farm Near Pont-Aven* at the AAA (889) in 1908. A.G.

Orpen, William 1878–1931

Born in Ireland, Orpen studied at the Metropolitan School of Art, Dublin, and then at the Slade. From 1902 he ran the Chelsea Art School, a private teaching studio, with Augustus John. He was a member of the NEAC in 1900. In 1904 Orpen was elected ARHA, and RHA in 1908. He became a founder member of the National Portrait Society, was elected ARHA in 1904, RHA in 1908, ARA in 1919 and RA in 1921.

325 *Sunlight* c. 1912

sbr. Orpen oil on panel 50 × 61 cm/20 × 24 ins
Lent by the National Gallery of Ireland, Dublin

Orpen had the ability and skill to use whatever painting style was currently in fashion. His response to the Impressionist pictures in the Hugh Lane collection is recorded in several paintings, e.g. *Homage to Manet* (1909, Manchester City Art Gallery). In this respect the lemon

325

yellows outlined and contrasted with purple in *Sunlight* can be interpreted as Orpen's response to Post-Impressionism. *Sunlight* is one of several paintings executed in 1911 and 1912 which depict a nude model exposed to sunlight in an interior. The Monet on the wall behind, an Argenteuil subject (Wildenstein 330), was apparently owned by Orpen. It must have appealed to his sense of humour to use the same treatment for the Monet as for the rest of the painting. A.G.

REFERENCES
P. G. Konody and S. Dark, *Sir William Orpen, Artist and Man*, 1932, p. 217
A. Crookshank and The Knight of Glin, *The Painters of Ireland*, 1978, pp. 269, 271

Osborne, Walter 1859–1902

Born in Dublin, Osborne attended the Royal Hibernian Art Schools. In 1881–2 he studied at the Antwerp Academy after winning a scholarship, and in 1883 he painted in Brittany. During the 1880s he worked extensively in England; at Evesham (1884) and Andover with Edward Stott; at Walberswick, where he met Wilson Steer; at Rye and in Wiltshire. He exhibited at the RA and the NEAC. In 1886 he was elected to the Royal Hibernian Academy and as a member of the committee of the Dublin Art Club he introduced the work of NEAC members to Ireland. In the 1890s his landscapes became more highly coloured and he also made a reputation as a portrait painter.

326 *Apple Gathering, Quimperlé* 1883

sdbl and insc. Walter Osborne Quimperlé 1883
58 × 46 cm/23 × 18 ins
Lent by the National Gallery of Ireland, Dublin

Osborne probably went to Brittany from Antwerp at the end of 1882, and apparently stayed about a year, painting at Dinan, Pont-Aven and Quimperlé. Even in the winter months there were hundreds of artists in residence and the atmosphere was very cosmopolitan. The influence of Bastien-Lepage, evident in the handling of space, the

326

small, squarish brushstrokes and the pervasive grey light of *Apple Gathering, Quimperlé*, probably resulted from Osborne's exposure to this milieu where artists from many countries were emulating Bastien's style. Bastien painted at Concarneau in summer 1883, but there is no evidence that Osborne met him.

Quimperlé, which is about 12 miles from Pont-Aven, was a small, quiet agricultural town surrounded by orchard-covered hills. Henry Blackburn advised: 'A painter might well make Quimperlé a centre of operations, for its precincts are little known; the gardens shine with laden fruit trees; and the hills are rich in colour until late autumn . . .' (H. Blackburn, *Breton Folk*, 1880, p. 138). A.G.

EXHIBITIONS
1884, Dublin, Royal Hibernian Academy (90)
1884, Liverpool, Walker Art Gallery (888)
REFERENCES
J. Sheehy, *Walter Osborne*, 1974, p. 19
A. Crookshank and The Knight of Glin, *The Painters of Ireland*, 1978, p. 255

327 *An October Morning* 1885

sdbl. Walter Osborne 1885[?] 71 × 91.5 cm/28 × 36 ins
Lent by the Guildhall Art Gallery, London

The date on *An October Morning* is unclear; however a description of Osborne's *October by the Sea*, exhibited at the NEAC in 1887 (79), which talks of '. . . a wooden pier with figures among sand and pebbles – a careful study; the touches of pinks and purples rather strong' (*Weekly Dispatch*, 10 April 1887), suggests that this was *An October Morning*. Therefore 1885, not 1888, the other possible reading, is the most likely date. The pier is almost certainly that at Walberswick, a favourite motif for the many painters, including Steer, who went there to paint each autumn. Steer knew Osborne at this time, and he later recollected: 'I used to see a great deal of him when he came to England, both in London and in the country, in fact the first time I met him I think was at Walberswick in the eighties . . . ,' (letter to Sarah Purser, n.d., Sarah Purser papers, National Library of Ireland, in J. Sheehy, p. 22). Indeed, Osborne's treatment of the pebbles as individual brightly coloured dots (a practice probably derived from Edward Stott, with whom he painted in 1884), combined with his more naturalistic treatment of the children and the pier, painted with small, squared brushwork (derived from Bastien-Lepage), invites comparison with Steer's *Knucklebones* (no. 346). A.G.

EXHIBITIONS
1887, April, London, NEAC (79)
1888, Dublin, Royal Hibernian Academy (49)
1888, autumn, Liverpool, Walker Art Gallery (986)
1904, London, Guildhall (161)
1908, London, Franco-British Exhibition (314)
REFERENCES
J. Sheehy, *Walter Osborne*, 1974, p. 23
Anne Crookshank and The Knight of Glin, *The Painters of Ireland*, 1978, p. 255

327

Pringle, John Quinton 1864–1925

Born in Glasgow, Pringle attended evening classes at the Glasgow School of Art 1885–95 and 1899–1900. In 1891 he won the gold medal for life drawing. He regarded his painting as a private occupation, and to support himself he ran a watch repair shop.

328 *Poultry Yard, Gartcosh* 1906

ns. 62.5 × 75.5 cm/24½ × 29¼ ins
Lent by the Scottish National Gallery of Modern Art, Edinburgh

Pringle had an unusual ability to assimilate and develop painting styles, and was always searching for new means of expression. His involvement with the Glasgow School in the 1890s introduced him to the work of Bastien-Lepage and to the square brush technique, and his early works, executed in tonal ranges relieved by touches of much brighter colour, have a primitive, poetic quality. Since he may not have seen any Neo-Impressionist painting, it is possible that the broken colour technique in *Poultry Yard, Gartcosh* evolved from his square brush technique of the 1890s, and that the geometric construction of the landscape, although it has affinities with 'Post-Impressionist' landscapes, evolved out of tendencies that were already developing in his own work in the 1890s. It is also possible that Le Sidaner's paintings, which were shown at the Glasgow Institute from 1903, influenced his brushwork. A.G.

REFERENCES
Glasgow Herald, 17 April 1929
Scottish Art Review, vol. 9, no. 2, 1963
Glasgow, Art Museum, *John Pringle*, catalogue by James Meldrum, 1964, pp. 7, 23

328

Rothenstein, William 1872–1945

Born in Bradford, Rothenstein attended the Slade 1888–9, after which he left to join his friend Arthur Studd at the Académie Julian in Paris. There he met Besnard, Forain, Puvis de Chavannes and Toulouse-Lautrec, and in the company of Conder and Anquetin they visited Lautrec's favourite Parisian haunts. Rothenstein sent to the NEAC in 1893 and became a member in 1894, the year in which he settled in London. He also published volumes of lithographic portraits. In 1892 he formed a friendship with Degas, who influenced him greatly. He became a member of the Fitzroy Street Group in 1907. Between 1920 and 1935 he was principal of the Royal College of Art.

329 *Parting at Morning* 1891

sdbl and insc. Will Rothenstein to Arthur H. Studd
Paris – November 1891

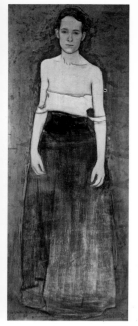

329

inscr br. Round the cliff on a sudden came the sea
 And the sun looked over the mountain's rim
 And straight was a path of gold for him
 And the need of a world of men for me
 Robert Browning

pastel, chalk and paint on paper on board
127 × 48 cm/50 × 19 ins
Lent by Sir John Rothenstein, CBE, KCSG

When *Parting at Morning* and other paintings by Rothenstein, together with works by Charles Conder, were exhibited in Paris, they attracted considerable attention in the press and brought Rothenstein to the attention of Camille Pissarro, to whom he was introduced at the exhibition by Camille's son, Lucien. Degas, who must have been intrigued by the unusual combination of chalk and gold paint as well as the rhythmic linearity of the draughtsmanship and the flat, simplified form of the figure, sent word that Rothenstein should call on him. It was Toulouse-Lautrec who persuaded the dealer Père Thomas to put on this show at 13 rue Malesherbes, which is an indication of the high regard in which these paintings were held. Thomas traded in Impressionist pictures and the work of the younger artists, and was, according to Emile Bernard, one of 'several dealers who were well disposed toward the revolutionaries' (quoted J. Rewald, *Post-Impressionism*, 1978, p. 64).

The greatest influence on *Parting at Morning* was Puvis de Chavannes. Puvis was already admired in England when Rothenstein left for Paris; Charles Ricketts, who knew Puvis, published a eulogistic article in the first issue of *The Dial* in 1889, which Rothenstein may have seen. He would also have encountered widespread enthusiasm for Puvis in Paris – an enthusiasm in which he shared, along with his friends Conder and Arthur Studd. At this time Studd purchased two sketches by Puvis, *Summer* and *Death and the Maidens*, which he bequeathed to the National Gallery, London. Rothenstein's interpretation of Puvis' pictorial methods anticipates that of both Picasso and Augustus John. The poem on the painting is misquoted from Robert Browning. A.G.

EXHIBITION
1892, March, Paris, Perè Thomas
REFERENCES
W. Rothenstein, *Men and Memories*, I, 1931, pp. 100–1
D. Sutton, in *Country Life*, May 1950, p. 1491
R. Speaight, *William Rothenstein*, 1962, p. 45

330 *The Browning Readers* 1900

ns. 76 × 96.5 cm/30½ × 38¼ ins
Lent by Bradford Art Galleries and Museums

Rothenstein returned from Paris to London in 1894 with the intention of renewing his English connections, and as a result his work executed in England reflects the prevalent trend of the 1890s – the desire to create a recognizable English school of painting. The title of this interior, *The Browning Readers*, confirms its intrinsic Englishness. However in one sense the mood of intimacy between Rothenstein's wife Alice and her sister Grace, the wife of William Orpen, is equivalent to the interior paintings of the Nabis, and the careful construction and the cool green colour echo yet another sort of painting – in England, Spanish painting had been considered as providing alternative techniques to those of French Impressionism, and Rothenstein drew from Velasquez and Goya to develop his approach. From Velasquez he learnt that light could be conveyed with a cool, clear palette, while Goya's example had 'brought back the old architectural sense and squareness of proportions and design' (W. Rothenstein, *Goya*, 1900, p. 12).

The Browning Readers was generally admired when it was exhibited at the NEAC and it prompted a succession of 'English' interiors by Orpen and others. It may have been one of the two interiors exhibited by Rothenstein at the Edward Schulte Gallery in Berlin in January 1902. A.G.

EXHIBITIONS
1900, autumn, London, NEAC (101)
1902, Wolverhampton, Industrial Exhibition
REFERENCES
H. Wellington, *William Rothenstein*, 1923, pp. 25–6
W. Rothenstein, *Men and Memories*, II, 1932, p. 2
F. Rutter, *Art in My Time*, 1933, p. 76

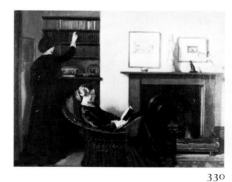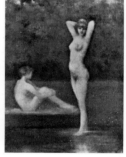

330 331

Roussel, Théodore 1847–1926

Born in Lorient, Brittany, Roussel settled *c.* 1874 in England where, except for short periods abroad, he remained for the rest of his life. He was self-taught until he came under Whistler's influence. He became a member of the RBA in 1887; was among the NEAC clique who exhibited as the London Impressionists; and was a founder member of the AAA. His first one-man show was at the Dowdeswell Gallery in 1894.

331 *The Bathers* 1887

ns. 39.5 × 29 cm/15½ × 11½ ins
Lent by Guy Roussel Esq.

When Whistler was introduced to Roussel in 1885, Roussel was pre-occupied with theoretical studies on painting and colour. Mortimer

Menpes recalled that Roussel ' . . . had designed a series of mathe-
matical instruments for matching the tones of nature . . . and
worked out a scheme for mixing perfectly pure pigment' (M. Menpes,
Whistler as I Knew Him, 1904, p. 20). Roussel's definition of
what he termed Positive Chromatic Analysis suggests that he must
have been reading Rood's *Modern Chromatics*. Positive Chromatic
Analysis, he said, was 'the means of discovering in any pigment of
the palette the prismatic rays it reflects . . . so that . . . you
can . . . analyse in a moment any of these pigments and with the
proper allowance for tonality extract from it one or more of its
chromatic components' (F. Rutter, *Théodore Roussel*, 1926,
p. 14). Roussel's insistence that scientific accuracy was necessary to
determine proper tonal relationships impressed Whistler: 'At last,'
he said, 'I have found a follower worthy of the Master' (*Whistler as I
Knew Him*, p. 19).

Paintings of the nude were a source of great provocation in
England in the 1880s. Whistler had deliberately set out to challenge
this attitude when he showed at the RBA in 1885–6 *Note in Violet
and Green*, a pastel study of a nude with a note reading: 'Horsley soit
qui mal y pense' (H. Taylor, *James McNeill Whistler*, 1978, p. 111),
a challenge to J. C. Horsley who had questioned whether the nude
should be studied at the Royal Academy.

The Bathers was the second nude painting by Roussel exhibited in
1887. His 5 ft square (150 cm square) *The Reading Girl* (Tate Gallery),
which depicted a naked woman lying in a deckchair reading a
newspaper, caused a sensation at the NEAC in May. Roussel was
possibly inspired to paint *The Bathers* out of doors after seeing
Alexander Harrison's *In Arcadia* (cf. no. 305), which was shown
with *The Reading Girl*. *The Bathers* can be compared to Steer's
A Summer's Evening (no. 345), which was painted about the
same time. A.G.

EXHIBITION
1887–8, London, RBA Winter Exhibition (207)

Russell, John Peter 1858–1930

Born in Sydney, Australia, Russell enrolled at the Slade in 1881.
Sometime in 1884–5 he went to Paris and enrolled at the Atelier
Cormon where he was befriended by Van Gogh; in Paris he also met
Rodin, Bernard and Anquetin. In 1886 he visited Belle-Isle in
Brittany, where he met Monet; he lived on the island from 1888 to
1908. Matisse met him there in 1897. Russell exhibited at the NEAC,
the Salon d'Automne and the AAA.

332 *The Red Sails* c. 1900

> *Voiles Rouges*
> str. J.R. 53 × 63.5 cm/20 × 25 ins
> Lent by the Musée Rodin, Paris

Russell's desire to leave Paris for a house and studio on Belle-Isle was
appreciated by Van Gogh, who wrote to him: 'I heartily hope that
you will be able to leave Paris for good soon, and no doubt leaving
Paris will do you a world of good in all respects' (Van Gogh, letter
477a). Van Gogh was anxious for Russell to make contact with
Gauguin at Pont-Aven. He also tried to persuade him to buy a
Gauguin painting but Russell apparently followed neither
suggestion. He was more interested in the Impressionists, who
had most impact on his style – he had met Monet at Belle-Isle in
1886. After seeing 10 of Monet's Antibes pictures in 1888, Russell
discarded his square brush technique and adopted long, narrow
brushwork and purer, broken colour. When he exhibited at the
NEAC in 1891 his work was compared with Monet's but his colour

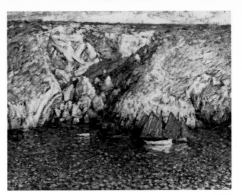

332

was considered more glaring. Russell was not interested in
emulating Monet's subtle atmospheric effects; instead, he generally
used high-keyed, brilliant colour. To ensure purity of colour, which
was his special obsession, he mixed his own pigments.

The Red Sails shows the herring boats returning to port in
Goulphar Creek, an inlet facing the Château d'Anglais, Russell's
house. The return of the fishing fleet was a popular Brittany subject,
often painted by Moret (cf. no. 149). A.G.

REFERENCES
London, Australia House, *The Lost Impressionist*, 1976 (16)
A. Galbally, *The Art of John Peter Russell*, 1977, pp. 63, 107

Sargent, John Singer 1856–1925

Born in Florence of American parents, Sargent studied in Carolus-
Duran's atelier 1874–9; he first exhibited at the Salon in 1877, and
in 1882 first showed in London. In 1885–6 he moved to England
where he lived for most of his life, but continued to exhibit in Paris.
During the later 1880s he knew Monet well. In 1890 he went to
America where he painted many portraits. He exhibited at the
NEAC, serving on the committee in 1887 and 1889. In 1894 he was
elected ARA and RA in 1897. From 1905 he spent most summers on
the Continent painting landscapes. He was an official war artist in
the First World War.

333 *A Boating Party* 1889

> ns. 88 × 92.5 cm/34½ × 36½ ins
> Lent by the Museum of Art, Rhode Island School of Design,
> Gift of Mrs Houghton P. Metcalf
> in memory of her husband, Houghton P. Metcalf

Painted at Fladbury, Worcestershire, where in 1889 Sargent rented
the rectory for the second summer running, this painting shows

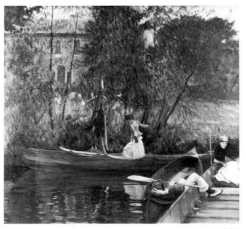

333

Paul Helleu and Sargent's sister Violet sprawled in boats in the foreground while Helleu's wife is helped into a canoe at the edge of the water. Sargent painted some of his most Impressionistic landscapes at Fladbury. The creamy lights and darks of the figures are reminiscent of Manet, but the atmospheric streaks of colour in the background and in the reflections on the water bring Sargent closest of all to Monet.

Sargent seems to have met Monet in his student days in the 1870s, and around 1885 they came to know each other better. Sargent visited Giverny several times from 1887, and he later confessed that 'Monet bowled me over' (Charteris p. 124). Sargent's personal knowledge of Monet must have been appreciated by the progressive faction at the NEAC, because they elected him to the hanging committee in 1889 and hung his two landscapes *A Morning Walk* and *St Martin's Summer* (both in Private Collections) in a place of honour. That both Sargent and Sickert owed their greatest debt to Monet was acknowledged by Sickert, and his remarks indicate the level of intelligent understanding present at the NEAC: 'To reproach either Mr Sargent or Mr Steer with having learnt from Monet, is to say foolishly that they are men of sense. . . . And to paint landscape in 1889 without knowing Monet by heart would be merely to betray a want of education, or worse affectation. . . . That they should be willing to learn from him, to seek with him, to place in the diadem of the sungod one row of added jewels is an honorable debt' (*New York Herald*, 19 April 1889). Sargent acknowledged their appreciation by lending his two Monets, *Early Spring* and *Orange and Lemon Trees* (Wildenstein 1126 and 867), to the NEAC autumn exhibition in 1891, and by continuing to send his Fladbury pictures to its exhibitions, thus indicating that he considered the club the only place where he could show his most Impressionistic work. A.G.

REFERENCES
W. Sickert, in *New York Herald*, 9 April 1889
Hon. E. Charteris, *John Sargent*, 1927, pp. 99–100, 124, 133
C. M. Mount, 'The English Sketches of J. S. Sargent', *Country Life*, April 1964, pp. 933–4
Leeds, City Art Galleries, *John Singer Sargent and the Edwardian Age*, catalogue by J. Lomax and R. Ormond, 1979, pp. 46–7

Sickert, Walter Richard 1860–1942

Born in Munich, Sickert came to England at the age of eight. He studied at the Slade 1881–2 and then became a pupil of Whistler. From 1885 Degas was an important friend and influence. Sickert exhibited at the RBA 1884–8 and became a member of the NEAC in 1888, taking an active part in its politics and serving on the committee. In 1889 he exhibited at, and wrote the catalogue for, the London Impressionists show. From 1885 he made regular visits to Dieppe and was based there 1898–1905. He first visited Venice in 1895. He founded the Fitzroy Street Group in 1907, was a founder member of the AAA in 1908, of the Camden Town Group in 1911, and of the London Group in 1913. In France he exhibited at the Indépendants and the Salon d'Automne. He was elected ARA in 1924 and RA in 1934.

ABBREVIATIONS
LB – L. Browse, *Sickert*, 1943
B – W. Baron, *Sickert*, 1973

334 *The Circus* c. 1885

sbr. Sickert oil on panel 21.5 × 35.6 cm/8½ × 14 ins
Lent by a Private Collector

The earliest of Sickert's theatrical subjects, *The Circus* was probably painted in Dieppe in summer 1885. Wendy Baron suggests that the

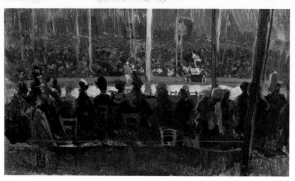

334

subject is Pinder's Circus, and that the picture was exhibited at the shows listed below. A description of the RBA picture as 'a rendering of a crowded circus . . . an even more noticeable treatment of a very paintable subject' (*The Artist*, 1 June 1888, p. 170), confirms this view.

Degas' precedent in painting circus subjects was followed by Tissot, Toulouse-Lautrec, Seurat and Bonnard as well as Sickert. In addition to the subject, the strong verticals and horizontals which monitor the spatial recession and the multiple figures of the crowd against the ringside also point to Degas. This contact with Degas provided a means of breaking away from Whistler's influence, and Sickert's enthusiasm was further encouraged when he met Degas for the third time in autumn 1885, after which he returned to London to describe Degas' methods to a group that included Steer, Starr and Roussel. A.G.

EXHIBITIONS
?1888, London, RBA (209)
?1895, London, Van Wisselingh's Dutch Gallery (39)
?1912, May, London, Carfax Gallery (19)
REFERENCES
W. Baron, 'Sickert's Links with French Painting', *Apollo*, March 1970, p. 189
B38, pp. 18, 22, 26, 33
London, Fine Art Society, *Sickert*, catalogue by W. Baron, 1973 (8)

335 *The P. S. Wings in the O. P. Mirror* 1888/9

ns. 61 × 51 cm/24½ × 20½ ins
Lent by the Musée des Beaux-Arts, Rouen

From 1887 onwards Sickert painted the English music hall, a subject to which he continually returned with new inventiveness. His reasons for choosing this theme are complex. There is an obvious precedent in Degas' café-concerts, a point of which Sickert would have been well aware, but although he considered Degas to be 'the greatest French painter, perhaps one of the greatest painters the world has seen' (stated in an interview in *The Artist*, October 1889, p. 275), he emphasized that the inspiration to paint music halls had come in London, and not in Paris.

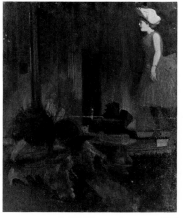

335

The search for intrinsically English subjects to paint is a reflection of Sickert's desire in 1889 to establish an independent, progressive English school that would not immediately be dismissed as French-influenced. By then the issue was rampant in the press. In addition, Sickert's choice of an urban subject can be interpreted as a reaction against the peasant subject matter of most French-trained English painters. Yet Sickert was well aware that London's music halls were unsavoury and disreputable places and that even the most enlightened critic would have difficulty knowing how to interpret them. A. L. Baldry typifies the critics' reaction in his review of the London Impressionists' exhibition: '[Sickert] gives us renderings of light and shade and colour effects that are so excellent in themselves that we do not for an instance deplore the fact that they have been studied amid the not too refined surroundings of London music halls' (The Artist, January 1890, p. 13). Even so, Degas' complex compositions, which Sickert knew well (cf. no. 60) were a key influence.

The composition of The P. S. Wings in the O. P. Mirror is extremely complicated, consisting of the heads of a real audience, with the reflected image of the Old Bedford Hall Singer (the abbreviations in the title stand for prompt side and opposite prompt). This combination of a real and a reflected image and the resulting psychological ambiguity instigated a lifelong fascination with mirror images. A.G.

EXHIBITION
1889, December, London, Goupil, London Impressionists (69)
REFERENCES
LB60
B45, pp. 29–31, 42, 97

336 The October Sun c. 1888

ns. oil on panel 26.5 × 35.5 cm/10½ × 14 ins
Lent by Norwich Castle Museum

Many of Whistler's followers shared his fascination with shop fronts and Sickert was no exception. The first, c. 1885, are very Whistlerian, but the later ones incorporate other elements.
In The October Sun the handling of the tonal values is Whistlerian, but the paint is thicker and more opaque while the geometrical organization, the articulated writing on the awning, the strong sunlight and the brilliant vermilion of the shop front give it more substance. This strong red in contrast to a dark, tonal background was a favourite combination for Sickert in 1887–9. He may have been prompted by Degas, who had first told him in 1885 'that the art of painting was to surround a patch of . . . Venetian red, that it appeared to be a patch of vermilion' (W. R. Sickert, 'Degas', Burlington Magazine, November 1917, p. 185). A.G.

EXHIBITION
1889, Paris, Exposition Universelle, British section (142)
REFERENCES
LB, p. 106
B30, pp. 17, 38
Hull, Arts Council, Sickert, catalogue by W. Baron, 1978, p. 8

336

337 The Sisters Lloyd c. 1889

sbr. Sickert 61 × 74 cm/24 × 29 ins
Lent by the Department of the Environment

By placing these two music hall entertainers against the painted backdrop of an interior Sickert was able to create a pattern of flattened decorative shapes. There is some physical resemblance between them and Steer's seaside children, and Wendy Baron has suggested that Steer may have influenced Sickert's choice of brighter colour and his freer brushwork; however Sickert has placed a greater emphasis on creating simplified forms which are part of the abstract pattern of paint. That the subject was a backdrop to a stage with no spatial depth seems to have eluded contemporary critics; the Pall Mall Gazette commented on 10 April 1894: 'If Mr Sickert were inventing the pattern of a carpet, he would deserve ungrudging praise. . . .' Another review which described the 'long corridor to the left, and a panelled room wall and red covered table with a candlestick on it' (Glasgow Herald, 7 April 1894) proves that this was the picture exhibited by Sickert at the NEAC in spring 1894. A date of c. 1889 seems feasible for The Sisters Lloyd, which reflects the general interest in decorative painting which was prevalent at the NEAC from about 1889. A.G.

EXHIBITIONS
1894, April, London, NEAC (54)
1911, Manchester, City Art Gallery, Contemporary Art Society (60)
REFERENCES
Glasgow Herald, 7 April 1894
Pall Mall Gazette, 10 April 1894
LB, p. 99
B47, pp. 31, 50

337

338 L'Hôtel Royal, Dieppe c. 1894

[repr. in colour on p. 167]
sbr. Sickert 50 × 61 cm/19¾ × 24 ins
Lent by a Private Collector

Dieppe fascinated Sickert throughout his life. The Hôtel Royal had a special appeal for him, and he painted it many times. He did not produce a series of paintings as he did of St Mark's in Venice; nevertheless, as he explained to Jacques Emile Blanche: 'The Hôtel Royal, Dieppe has left its mark on my talent, I am perhaps only a rectangular painter' (Portraits of a Lifetime). Blanche owned both this painting and The P. S. Wings in the O. P. Mirror (no. 335); he was a loyal friend to Sickert and did much to help his reputation in France (cf. no. 24). He later recollected Sickert painting this scene: 'One Fourteenth of July . . . in the gardens decorated for the National

Fête . . . after a broiling day, he was lingering before the old Hôtel Royal, grey green beneath a sky in which the moon was but a rose ring in the violet mist' (Emmons p. 88). This effect at twilight can be compared to Whistler's seascapes at Dieppe. In another version, shown at the NEAC in autumn 1893 (B67, untraced), this mood with its *fin de siècle* associations was accentuated by Sickert's inclusion of ladies wearing eighteenth-century dress strolling in the foreground.

It is uncertain whether this picture was exhibited at the NEAC in 1894, because both MacColl in his review, and Blanche when it was in his possession, describe a red figure in the background. It may be that the dark figure behind the mother and child was overpainted, because traces of red show in the dark paint. A.G.

EXHIBITIONS
?1894, November, London, NEAC (50)
?1895, London, Van Wisselingh's Dutch Gallery (1)
1909, Paris, Bernheim Jeune (65)
REFERENCES
J. E. Blanche, *Portraits of a Lifetime*, 1937, p. 48
R. Emmons, *The Life and Opinions of Walter Richard Sickert*, 1941, p. 88
LB, p. 40
B68, pp. 39, 57, 60
London, Fine Art Society, *Sickert*, catalogue by W. Baron, 1973 (20)

339

339 *Gaieté de Montparnasse, the Last Gallery to the Left* c. 1907

Gaieté de Montparnasse, dernière galerie de gauche
sbr. Sickert 59 × 48.5 cm/23¼ × 19 ins
Lent from the Collection of the late Morton H. Sands Esq.

Sickert marked his return to London in 1905 with a symbolic gesture – he painted the English music hall. This in turn inspired him, on his return to Paris in 1906, to paint a series of Parisian music halls, a subject he had not tackled before. The composition is unusual in all these paintings, which show new types of handling reflecting some of the current trends in French painting. Bonnard's composition and Rouault's expressive brushwork were two important influences.

The viewpoint that Sickert adopted to paint this picture is one of his most extreme. It brought the sweeping curve of the balcony against the strong vertical line of the wall behind. This un-compromising attitude is also seen in the blushes of pink and yellow against the sombre tonality of the rest of the painting. A.G.

REFERENCE
B237, p. 98

340

340 *Girl at a Window – Little Rachel* 1907

sbr. Sickert 51 × 40.5 cm/20 × 16 ins
Lent by a Private Collector

Sickert's return to England in 1907 coincided with a period of lack of confidence. In a letter to Nan Hudson he referred to '. . . the back-ward position I am in for my age, and my talent . . .' (B, p. 102). The founding of the Fitzroy Street Group in early spring 1907 was a tremendous morale-booster and a great encouragement to Sickert, who firmly insisted upon the value of the collective artistic experience. Sickert was particularly close to Gore, whose help he later acknowledged: 'He gave me a second youth and an example which renewed my courage and made me believe in my work again' (unpublished letter to Mrs S. Gore, 1914). Sickert looked afresh at his painting methods, following the examples of Gore and Lucien Pissarro; 'I have tried to recast my painting entirely and to observe colour in the shadows,' he wrote ('The Spirit of the Hive', *The New Age*, 26 May 1910).

Girl at a Window – Little Rachel is one of a series painted in 1907 which Sickert described in a letter to Nan Hudson as '. . . a set of Studies of illumination . . . a little Jewish girl of 13 or so with red hair and a nude alternate days' (quoted B, p. 113). These studies of the effect of natural light with their broken stippled touches of thick paint from a palette of purple, violet, green, blue and rust were a new departure for Sickert.

Hugh Hammersley, an early patron of Fitzroy Street, bought this painting from one of 'Mr Sickert's At Homes', which were held on Saturday afternoons at 19 Fitzroy Street. A.G.

REFERENCES
B, pp. 102, 104, 114, 347
London, Fine Art Society, *Sickert*, catalogue by W. Baron, 1973 (60)

341 *The Camden Town Affair* 1909

L'Affaire de Camden Town
sbr. Sickert 61 × 40.5 cm/24 × 16 ins
Lent by a Private Collector

Sickert, more than any other artist, was responsible for the vocabu-lary of Camden Town painting. He deliberately sought out the ordinary and the commonplace, yet his attitude to his subjects was still as ambivalent as it had been in the 1880s (cf. no. 335).

The title and subject of this painting shocked the prudish British public. Although Sickert did not recreate the scene accurately, it was based on a real event of September 1907, when a prostitute, Emily Dimmock, was found murdered in her lodgings. In spite of the brutal pose and the impropriety of showing a naked woman with a clothed man (the model was the man acquitted of Emily Dimmock's

341

murder), Sickert insisted that the picture was an exercise in pattern, texture and colour and the contrast between bare and clothed flesh. Two other versions – *What Shall We Do for the Rent?* (B269) and *Summer Afternoon* (B275) – were exhibited at the first Camden Town exhibition in June 1911 as *The Camden Town Murder Series Nos 1 and 2*. Public opinion was again outraged. *The Art News* suggested a justification that is strongly reminiscent of that offered for Sickert's music hall subjects back in the 1880s: 'To those who take exception to Mr Sickert's choice of subject it might be suggested that as Rembrandt found a fine problem of colour in a butcher's shop, so Mr Sickert finds in the sordid surroundings of a tawdry tragedy a fascinating problem of colour, design and suggestion of form' (*The Art News*, 15 July 1911). Paul Signac bought this painting from the Bernheim Jeune exhibition in 1909. A.G.

EXHIBITIONS
?1909, March–May, Paris, Indépendants (1466)
1909, June, Paris, Bernheim Jeune (15)
REFERENCES
B271, pp. 110, 112, 122, 184, 338, 347, 351
W. Baron, *The Camden Town Group*, 1979, no. 28

Spencer, Stanley 1891–1959

Born in Cookham in the Thames Valley, Spencer studied at the Slade under Tonks 1908–12. He contributed to the 2nd Post-Impressionist Exhibition in 1912. He was a member of the NEAC in 1919; in 1923 he re-enrolled at the Slade. Spencer was elected ARA in 1932, resigned in 1935 and rejoined in 1950.

342 *John Donne Arriving in Heaven* 1911

sd and insc on rev. S. Spencer 1911 Cookham
37 × 40.5 cm/14½ × 16 ins
Lent by a Private Collector

342

Henry Tonks, Professor of Drawing at the Slade, publicly denounced the first Post-Impressionist exhibition to his students and warned them not to attend, but it seems unlikely that anyone heeded his advice. On the evidence of Stanley Spencer's *John Donne Arriving in Heaven* the exhibition must have been very significant for him. He was, however, irritated when Tonks suggested this influence. In a letter to his brother Sydney he wrote: 'I took that painting and showed Tonks – "crit" as follows: ". . . it has no colour, and is influenced by a certain party exhibiting at the Grafton Gallery a little while ago [Post-Impressionists]" – the damn liar!' (18 May 1911, quoted Carline).
The painting was inspired by one of John Donne's sermons; Jacques and Gwen Raverat, who bought the painting, had given him a copy of Donne's *Sermons*. In a lecture given in Oxford in 1923 Spencer explained the painting, '. . . I seemed to see four people praying in different directions. I saw all their exact relative positions all in a moment. Heaven was Heaven everywhere, so, of course, they prayed in all directions' (Carline, p. 30). Perceiving Heaven in this way had been a visionary experience: '. . . walking along the road he turned his head and looked into heaven, in this case a part of Widbrook Common' (G. Spencer, p. 110).
When this painting was shown at the 2nd Post-Impressionist Exhibition it was suggested in *The Connoisseur* that Spencer 'would do better to discard the artificial conventions of Post-Impressionism; his *John Donne Arriving in Heaven* shows conviction, a fine sense of colour and a feeling for composition. It needs all these qualities, however, to prevent the spectator from feeling that the subject is a representation of some clumsily-modelled marionettes.' A.G.

EXHIBITION
1912–13, London, Grafton Galleries, 2nd Post-Impressionist Exhibition (149)
REFERENCES
The Connoisseur, November 1912, p. 192
R.H. Wilenski, *Stanley Spencer*, 1924, pp. 11, 15
C. Johnson, *English Painting from the Seventh Century to the Present-Day*, 1932, p. 328
G. Spencer, *Stanley Spencer by His Brother Gilbert*, 1961, p. 110
M. Collis, *Stanley Spencer*, 1962, p. 243
London, Arts Council, *Stanley Spencer*, 1976 (1)
R. Carline, *Stanley Spencer at War*, 1978, p. 30

Starr, Sidney 1857–1925

Born in Hull, Starr studied at the Slade under Poynter and Legros. In 1882 he met Whistler and became a 'follower'. At this time he was also a friend of Clausen. Around 1888 Whistler's influence was superseded by that of Degas, to whose work he had been introduced by Sickert. He exhibited at the RBA 1874–88, and was elected a member in 1886. He joined the NEAC and showed there until 1892 when a scandal forced him to leave for New York. He exhibited with the London Impressionists in 1889 and contributed to *The Whirlwind*.

343 *At the Café Royal* 1888

sbl. Starr pastel on canvas 60 × 50 cm/23½ × 19½ ins
Lent by a Private Collector

In the late 1880s there was a general revival of interest in pastel. Starr executed a number of works in this medium, and his large pastel *Paddington Station* (untraced) won a bronze medal at the Paris Exposition Universelle of 1889. Among his fellow artists who shared this enthusiasm were Whistler, Stott, Steer, Guthrie and Clausen, and in response the Grosvenor Gallery inaugurated annual pastel exhibitions in 1888. However, Starr refused to exhibit after the first show because he did not think that the contributors

343

understood the nature of the medium. 'Pastel', he wrote, 'as abundantly shown by the large predominance of ignorance on the point, making the exhibitions at the Grosvenor Gallery hopelessly vulgar, is not to be used to ape oil painting. It is in relation to oil painting what the dainty suggestiveness of the mandolin is to the illimitable power of an orchestra' ('Mr Guthrie's Pastels', *The Whirlwind*, 20 December 1890, p. 180). The treatment of the crowd in this literary and artistic meeting-place can be compared to that in Sickert's paintings of music halls (cf. no. 335). A.G.

EXHIBITIONS
1888, London, Grosvenor Gallery, 1st Pastel Exhibition (159)
?1911, Glasgow, Institute

344 *A City Atlas* 1888/9

sbr. Starr 61 × 51 cm/24 × 20 ins
Lent by the National Gallery of Canada, Ottawa

Referring to the band of English Impressionists who practised Degas' methods in London, the painter Mortimer Menpes recollected: 'There was another period when we used to travel all round London painting nature from the top of hansom cabs' (*Whistler as I Knew Him*, p. 19). A city atlas, a type of omnibus, is here depicted travelling through St John's Wood in north-west London – an instance of Sickert's dictum in the preface to the *London Impressionists* catalogue that their subjects were sought within a four-mile radius of London. 'For those who live in the most wonderful and complex city in the world,' he wrote, 'the most fruitful course of study lies in a persistent effort to render the magic and the poetry which they daily see around them' (London, Goupil Gallery, *London Impressionists*, 1889, 'Impressionism', preface by Sickert, p. 7). Also salient is the Degas-derived composition of the cut-off figure of a woman sitting on top of the cab, and the scratchy, diagonal lines of

colour which fill in the woman's dress and bonnet can be compared to Degas' pastel technique. Degas' influence was noticed in Starr's work at the NEAC from 1888, and yet Sickert insisted: 'Starr's French training again – I have it on the best authority – was acquired mostly on the boulevards of St John's Wood' (*New York Herald*, 19 April 1889); therefore, Starr may have learned about Degas through his friendship with Sickert. In addition there are echoes of Monet in the pink and blue sky, while the treatment of the street is Whistlerian. At the *London Impressionists* Starr also exhibited another London scene, *The Marble Arch* (untraced), executed from an unusual viewpoint. *The Illustrated London News* thought that it looked as though it had been painted from a balloon (7 December 1889). A.G.

EXHIBITION
1889, London, Goupil, *London Impressionists* (6)
REFERENCE
Ottawa, National Gallery of Canada, *Catalogue of Paintings and Sculpture*, 1959, p. 148

Steer, Philip Wilson 1860–1942

Born in Birkenhead, Steer studied at the Gloucester School of Art 1878–81, at Julian's under Bouguereau 1882–3, and at the Ecole des Beaux-Arts 1883–4. He exhibited at the RA, the Paris Salon, and the RBA 1885–7 under Whistler, whose influence is revealed in his early work. A founder member of the NEAC, he helped to establish the club as a focus for Impressionist-inspired artists between 1887 and 1894. He also showed with the London Impressionists in 1889, and at Les XX 1889–91. He taught painting at the Slade 1899–1930.

ABBREVIATIONS
MacColl – D. S. MacColl, *Life, Work and Setting of Philip Wilson Steer*, 1945
L – Bruce Laughton, *Philip Wilson Steer*, 1971

345 *A Summer's Evening* 1887/8

ns. 146 × 228.5 cm/57½ × 90 ins
Lent by a Private Collector

In *A Summer's Evening* Steer combined techniques derived from Monet and Renoir, using pure, bright, broken colour and a combination of brushstrokes. It is an experimental work and an important indication of Steer's level of understanding at that date, but it is not, as has been suggested, Steer's first painting using French Impressionist techniques. At the NEAC in 1887 he showed a painting of children sitting in a garden in France; entitled *Chatterboxes*, it was covered 'diagonally with long lines and spots of the brightest possible colours' (*The Spectator*, 16 April 1887). *Chatterboxes* appears to have been about 51 × 61 cm/20 × 24 ins in size, and was last heard of at the Paris Exposition Universelle of 1889, at which it was a lottery prize.

344

345

This information shows that, in *A Summer's Evening*, Steer was transferring his French Impressionist technique, already used on smaller paintings, on to a monumental canvas which would attract attention at the NEAC. The painting which had caused a stir at the NEAC in 1887 was Alexander Harrison's enormous *In Arcadia* (untraced; formerly Musée de Luxembourg, Paris), which showed a similar slim-hipped nude model standing in three poses of toilette in the open air. Steer may well have borrowed from Harrison's composition, probably for political reasons. The progressive clique at the NEAC, which included Sickert, Starr and Roussel, were anxious to give the NEAC a reputation for showing the most advanced painting of the time, rather than for being the place for Bastien-Lepage imitators, and to achieve this they needed a 'manifesto', to serve a function similar to that of Seurat's *Grande Jatte* (fig. 5) for the Neo-Impressionists in Paris in 1886. George Moore, who met Sickert and Steer in 1885, and was by this time part of their circle, may have suggested the idea – Moore had reviewed the last Impressionist exhibition, drawing attention to the *Grande Jatte* (*The Bat*, 25 May 1886).

The clique succeeded in their aims. Hung in the place of honour, *A Summer's Evening* attracted considerable attention. When sent to Les XX in 1889 it was compared to Seurat's *Les Poseuses* (cf. fig. 6) and described as *vibriste*. But technically it has little in common with Seurat's painting, though there is an obvious similarity between the figures in the two paintings, which is the source of the confusion. It seems very unlikely that Steer would have seen *Les Poseuses*, but he did see Harrison's picture. Furthermore it is likely that Seurat, too, saw Harrison's painting before executing *Les Poseuses*, for *In Arcadia* was at the 1886 Salon where it caused much comment. A.G.

EXHIBITIONS
1888, April–May, London, NEAC (78)
1889, Brussels, Les XX (Steer I)
?1891, Munich, Glaspalast
REFERENCES
B. Laughton, 'The British and American contribution to Les XX, 1884–9', *Apollo*, November 1967, p. 374
B. Laughton, 'Steer and French Painting', *Apollo*, March 1970, p. 212
L36, pp. 14–17
London, Royal Academy, *Impressionism*, catalogue by J. House, 1974 (132)

346 *Knucklebones* 1888/9

sbl. P. W. Steer 61 × 76 cm/24 × 30 ins
Lent by Ipswich Borough Council (Museums)

The application of colour as a series of coloured dots on the individual pebbles suggests that Steer may have been consciously using Neo-Impressionist techniques when he painted *Knucklebones*, but, equally, it may have been a natural response to the round shape of the pebbles, as in Osborne's *An October Morning* (no. 327). In the range of colour, the comma-like strokes used to depict the sea, and the freedom of the handling, the work is much closer to Monet, which provides further indication that Steer had a fairly advanced understanding of Monet's techniques by this time. Sickert, of course, would not have found this at all surprising (cf. no. 333). He made some interesting comments when an engraving of *Knucklebones*, from a drawing by him, was published in *The Whirlwind*. To him *Knucklebones* represented 'the best in modern impressionism'. He admired it because 'the children are natural and spontaneous in their grouping and their actions are studied with a keen insight into child nature'. What Sickert chose to emphasize was its similarities with the work of Degas, who in the 1880s executed a series of paintings of women engaged in intimate conversation. In addition, the high viewpoint and the sharply angled groups of children can be compared with Degas' compositions. A.G.

EXHIBITION
1889, London, Goupil, *London Impressionists* (35)
REFERENCES
W. R. Sickert, *The Whirlwind*, 12 July 1890
MacColl, p. 37
146, pp. 17–19, 20, 27, 38
London, Royal Academy, *Impressionism*, catalogue by J. House, 1974 (133)

347 *Boulogne Sands* 1888/94

[repr. in colour on p. 166]
sdbl. P. W. Steer 92 61 × 76 cm/24 × 30 ins
Lent by the Trustees of the Tate Gallery, London

The children in *Boulogne Sands* have the same impish and angular figures as those in *The Ermine Sea* (no. 349), and the same easy, relaxed poses as those in *Knucklebones* (no. 346). By intentionally making the figures appear badly drawn, Steer created a memorable image of naïveté, but at the time he was totally misunderstood. Even MacColl, his staunchest supporter, who delighted in 'the very music of the colour in its gayest and most singing', went on to say '. . . one of the little girls has awkward legs . . . and the painter ought to put them right before he allows the picture to leave his hands' (1892). Steer apparently took this advice, because when the painting was exhibited in 1894 the *Westminster Gazette* noted that he had 'attached the offending pair of legs to a new young lady who seems to be lying face down on the sand'.

Areas of *Boulogne Sands* are painted with small, separate strokes of colour which indicate that Steer knew about Neo-Impressionist techniques. His mastery of them was mentioned by Lucien Pissarro in a letter to his father in May 1891: 'He divides the tones as we do and is very intelligent; here is a real artist! . . . he tells me that he prefers your work to Monet's' (quoted *Apollo*, March 1970). Steer was possibly introduced to Neo-Impressionism through reviews of the Indépendants exhibitions which appeared in English periodicals in the 1880s (in 1887 Steer's untraced *Chatterboxes* was compared to the work of the Indépendants). Another possibility is that he was made aware of their style of painting by the critic George Moore, who, after reviewing the *Grande Jatte* in 1886, maintained his contacts with the *Revue indépendante* circle. Although Moore later became critical of the Neo-Impressionists, he visited their exhibitions and was familiar with their theory (G. Moore, 'The Division of the Tones', *The Speaker*, 10 September 1892).

By 1894 Steer's experiments with dividing his colours had ended. Also at the NEAC in 1892 was a figure study, *The Blue Dress* (198), which caused general delight because of its sound draughtsmanship and its very English quality reminiscent of Romney. This identification with the English School is an early instance of the direction Steer subsequently took.

Boulogne Sands was owned by Frederick Brown, a 'London Impressionist', Slade professor and Steer's lifelong friend. A.G.

EXHIBITIONS
1892, November–December, London, NEAC (8)
1894, London, Goupil (32)
REFERENCES
D. S. MacColl, *The Spectator*, 26 November 1892
G. Moore, *The Speaker*, 3 December 1892
Westminster Gazette, 24 February 1894
MacColl, pp. 45–6
J. Rothenstein, *Modern European Painters: Sickert to Smith*, 1952, pp. 65–6
London, Tate Gallery, *Modern British Paintings, Drawings and Sculpture*, II, 1964, pp. 688–9
B. Laughton, 'Steer and French Painting', *Apollo*, March 1970, pp. 213–14
L56, pp. 26–7

348

348 *Jonquils* 1889/90

sbl. Steer 91.5 × 91.5 cm/36 × 36 ins
Lent by a Private Collector

The model for *Jonquils* was Rosie Pettigrew, who met Steer *c.* 1888 and became a friend and companion, appearing in many of his pictures of this period. Steer has emphasized the formal components of the painting – the strong verticals, and the play of light and shadow caused by the gaslight. Through the window, the lamps in a passing carriage glow in the night, a subtle reference to London life. Studies by gaslight were a favourite theme of the progressive clique at the NEAC, and Sickert explained the aesthetic in his review of Steer's *The Sofa* (L47), also a study by gaslight: 'This picture is seen at its best by the artificial light by which it was painted. Considering the part that artificial light plays in the average existence of a London house, painters do well now and again, to give us a canvas which is seen in its full glory by gaslight' (*New York Herald*, 17 April 1889). *Jonquils* was praised at the NEAC and when it was sent to Les XX it was described as 'particularly graceful and English' (quoted *Apollo*, November 1967). It was purchased from Steer by Sir William Burrell, who was brought to Steer's studio by Lavery. A.G.

EXHIBITIONS
1890, April, London, NEAC (16)
1890, autumn, Liverpool, Walker Art Gallery (819)
1891, Brussels, Les XX (Steer 3)
1893, Glasgow, Institute (729)
1903, London, Whitechapel (205)
REFERENCES
MacColl, pp. 42–4, 46, 107
C. Bennett, 'Jonquils', *The Listener*, 8 April 1971
B. Laughton, in *Apollo*, November 1967, p. 375
L66, pp. 41–2

349 *The Ermine Sea* 1890

sdbl. P. W. Steer 90 61 × 76 cm/24 × 30 ins
Lent by Mrs Anthony Bamford

D. S. MacColl recollected that *The Ermine Sea* was 'painted from memory with a pencilled scrap of paper', (MacColl p. 115), and since MacColl did not meet Steer until 1890 it is reasonable to assume that it was painted in the year it is dated. This scrap of paper could have been a sketch of William Stott's *Venus Born of the Sea Foam* (Oldham Art Gallery), because the composition of the stylized waves breaking into criss-crossing pools on the shore, and reflecting the figures on their smooth surface, is similar to Stott's painting. Steer was obviously attracted by the flat, Japanese effect of the composition; however, the Monet-like atmospheric colour and the three fragile figures of the children posed in the twilight sea create a poetic quality which is personal to Steer. This evocative mood was of great interest to him at the time, as he explained in an address to the Art Workers' Guild in 1891: 'Two men paint the same model: one creates a poem, the other is satisfied with recording facts' (MacColl, p. 178).

 The Ermine Sea was formerly in the collection of Sir Augustus Daniel, an early patron who formed a large collection of Steers and also owned Sickert's *The Sisters Lloyd* (no. 337). A.G.

EXHIBITIONS
1891, November, London, NEAC (2)
1892, Glasgow, Institute (228)
1911, Manchester, City Art Gallery, Contemporary Art Society (117)
1912, Newcastle, Contemporary Art Society
REFERENCES
D. S. MacColl, *The Spectator*, 5 December 1891
MacColl, p. 115
L65, pp. 21, 27

Stott, Edward 1859–1918

Born in Rochdale, Stott attended Manchester School of Art. In 1880 he left for Paris and saw Bastien's *Joan of Arc* at the 1880 Salon. He attended Carolus-Duran's atelier and then studied at the Ecole des Beaux-Arts under Cabanel, 1882–3. On his return to England he painted with Walter Osborne on a number of occasions. He exhibited at the RA from 1883, was a founder member of the NEAC and also showed at the New Gallery. In 1906 he was elected ARA.

350 *Feeding the Ducks* 1885

sdbr. Edward Stott 85 48 × 39.5 cm/19 × 15½ ins
Lent by the City of Manchester Art Galleries

350

In Paris Stott met Bastien-Lepage, whose influence can be seen in the treatment of the figure, the handling of space and the squared signature in *Feeding the Ducks*. However, Stott was never interested in imitating Bastien's technical virtuosity. The detailed treatment of the landscape and farm buildings, and the paint surface which is built up with tentative blotches of light colour, indicate Stott's later preoccupations. *Feeding the Ducks* was painted *plein-air* at Evesham, Worcestershire, where Stott went with Walter Osborne in autumn 1884 after their return from Paris. By 1887 he had ceased to paint out of doors and Bastien's influence had diminished. He started working from memory and from sketches as he sought to convey the poetic quality of English rural life. In this respect he echoed the sentiments of many of his English contemporaries, whose contact with French naturalism inspired them to seek an English equivalent. A.G.

EXHIBITION
1885, London, Grosvenor Gallery, Summer Exhibition (373)

351 *The Year's Youth* *c.* 1898

sbl. Edward Stott 62 × 78.5 cm/24½ × 31 ins
Lent by Julian Iwaszkiewicz-Dowmunt Esq.

When starting a new painting Stott would take long walks in the morning and evening and make many preparatory studies from memory in pencil and pastel, which he would pin up on the walls of his studio. He did this because he thought that 'it is in the studio where he [might] best solve the difficulty of arriving at the best way of getting the most brilliant and lasting quality out of his pigments' (A. C. R. Carter, 'Edward Stott and His Work', *Art Journal*, 1899, p. 296). Although the light-toned colours and the broken brushwork of *The Year's Youth* are reminiscent of Monet, Stott's technique of beginning in monochrome and then adding the colours and values, working from light to dark, is quite different. To Stott, Impressionism '. . . has no relation whatever with any of the technicalities of painting', rather it meant '. . . a combined impression of the artist's

351

feeling – colour and form – . . . a recording of the impression of the painter's nature' (E. Stott, in *Art Journal*, 1893, p. 104). Around 1895 Stott started to give stronger definition to the natural forms in his painting, as can be seen in the stylized pattern of the over-hanging branches, and his brushwork became stronger and his colours purer. The way in which the blossoms are picked out to form a flat pattern against the more atmospheric space behind invites comparison with Conder's *Blossom at Dennemont* (no. 283). A.G.

EXHIBITION
1901, London, New Gallery (172)
REFERENCE
Magazine of Art, 1901, p. 403

Stott, William 1857–1900

Born in Oldham, and generally known as Stott of Oldham, Stott studied in Manchester before going to Paris in 1879, where he enrolled under Gérôme at the Ecole des Beaux-Arts. He spent his summers at Gretz where he vied for leadership of the American and British colony. In 1882 he enjoyed considerable success at the Salon and in 1889 had a one-man exhibition at Durand-Ruel's gallery. In 1885 he was elected a member of the RBA and enjoyed a close friend-ship with Whistler until 1887, when Stott's painting of Whistler's mistress depicted naked as *Venus Born of the Sea Foam* (Oldham Art Gallery) caused a rift in their relationship. In 1890 Stott was elected a member of the NEAC.

352

352 *Girl in a Meadow* 1880

sdbl. W. Stott 1880 72 × 57.5 cm/28¼ × 22¾ ins
Lent by the Trustees of the Tate Gallery, London

Girl in a Meadow was painted at Gretz-sur-Loing near Fontainebleau, a favourite colony of British and American artists in the 1880s. Soon after his arrival in France in 1879 Stott met R. A. M. Stevenson, who with his cousin R. L. Stevenson had discovered Gretz on a day trip from Barbizon in August 1875, and it was probably Stevenson who took him there. The Irish painter Frank O'Meara, already in residence, considerably influenced Stott's style.

In *Girl in a Meadow*, the handling of space and the inclusion of oversized weeds in the foreground are evidence of Stott's rather naïve response to Bastien-Lepage; however he soon assimilated

Bastien's technique and produced *The Ferry* (Private Collection; exhibited London, Fine Art Society, *William Stott of Oldham; Edward Stott*, catalogue by P. Skipwith, 1976 [3]) in 1881 and then *Bathing* (untraced), which secured his success at the Salon in 1882. *Bathing* showed the stone-covered bridge, a favourite motif of the Gretz painters, also seen in the background of *Girl in a Meadow*. A work entitled *The Bridge at Gretz* was exhibited in the William Stott Memorial Exhibition, Glasgow City Art Gallery, 1902 (59). A.G.

REFERENCE
London, Tate Gallery, *Modern British Paintings, Drawings and Sculpture*, II, 1964, p. 697

353

353 *The Two Sisters* 1882

> sdbl. William Stott of Oldham 1882 [William?] Stott 189[o?]
> 142 × 216 cm/56 × 85 ins
> Lent by Rochdale Art Gallery

The flat shapes of the children standing silent and melancholy in the vast space of sand, sea and sky were for Stott an expression in human form of the mood of twilight. 'To sum up, the figures, as figures, in Mr Stott's work are, to our thinking, debatable. As effects of nature of the same order as the skies and streams and flowers, they are equally marvellous with these in his rendering of them. And of the natural objects in his work we may be always sure. His pure landscape offers us one of the purest delights the soul can know' (A. Corkran, p. 325). In his later landscapes the figure is eliminated altogether. Stott's purpose was to seek the universal in landscape and he explained that: '. . . art like the others of music and poetry is the property of all the world, from the highest to the lowest' (address in the *Oldham Standard*, 21 February 1893).

The soft, pale colour and the decorative flatness of *The Two Sisters* can be attributed to the influence of Frank O'Meara, who made use of the lessons he learned from the two artists he admired the most, Puvis de Chavannes and Cazin (cf. no. 39), in his little-known landscapes. The thinly washed paint and Stott's desire to create a pictorial equivalent to the harmony of nature ally him to Whistler. In 1885 he became one of the first in Whistler's circle to exhibit at the RBA, becoming a member while still living in Paris. R. A. M. Stevenson commented that *The Two Sisters* influenced Alexander Harrison's seascapes painted the following year (cf. no. 305); however at this period, when the two artists were working closely together, it is uncertain which influenced the other. The second signature on *The Two Sisters* may indicate that it was reworked. A.G.

EXHIBITIONS
1884, Paris, Salon (2248)
1901, London, Royal Watercolour Society
1902, January, Manchester, City Art Gallery
1902, Glasgow, Museum and Art Galleries
1903, spring, Leeds, City Art Gallery (13)
1905, Newcastle-upon-Tyne, Laing Art Gallery (92)
1911, London, Van Wisselingh's Dutch Gallery (3)
1912, Manchester, City Art Gallery (105)
REFERENCES
A. Corkran, 'William Stott of Oldham', *Scottish Arts Review*, April 1889, p. 320
R. A. M. Stevenson, 'William Stott of Oldham', *The Studio*, October 1894, pp. 10–11
R. Muther, *Modern Painting*, II, 1896, p. 200

Whistler, James McNeill 1834–1903

Whistler, born in Massachusetts, attended West Point Military Academy and worked for the United States Coast Survey before going to France in 1855 to become an artist. In 1856 he studied at the Académie Gleyre. In 1858 he met Fantin-Latour and Courbet and became one of the realist circle. He moved to London in 1859, and spent most of his life there. In 1877 he exhibited at the opening exhibition of the Grosvenor Gallery, Ruskin, writing of *The Falling Rocket*, accused him of 'flinging a pot of paint in the public's face'; the lawsuit which Whistler brought against Ruskin in 1878 bankrupted him.

In September 1879 he visited Venice, returning to London in 1880. He acquired an international following during the 1880s. In 1884 he was elected a member of the Society of British Artists and was invited to exhibit at Les XX. He was elected president of the Society of British Artists 1886–8, and arranged for the society to receive a royal charter. His retrospective exhibition at the Goupil Gallery in 1892 made his reputation in England. In 1893 he was in Paris. He was elected president of the International Society in 1898. He also opened a school in Paris, later known as the Académie Carmen.

354 *Green and Violet, Dieppe* c. 1885

> sbr. with butterfly oil on panel 12 × 21.5 cm/5 × 8½ ins
> Lent by a Private Collector, Jersey

In the 1880s Whistler moved away from Thames subjects and began to concentrate on small oil panels of seascapes and beachscapes. Using one or two colours in a range of tones he applied thinned-down oil paint in broad horizontal bands to denote the sand, sea and sky. The panels were painted quickly and not reworked. They have a delicate, ephemeral quality which attracted the Symbolists; his Dieppe panels of 1885 belong to this sequence.

After a fallow period in the 1870s, Whistler was reintroduced to French artistic circles by Théodore Duret. Duret wrote an account of the Whistler–Ruskin trial in the *Gazette des Beaux-Arts* in 1879, and in 1881, in an article devoted to Whistler, he set a precedent for the interpretation of Whistler in French Symbolist circles. 'Mr Whistler', he wrote, 'in extracting the furthest consequences of the harmonic compositions of colours which had appeared instinctively in his first works, has arrived with his Nocturnes at the extreme limits of formulated painting. One step further and there would be nothing on the canvas but a uniform stain, incapable of saying anything to the eye or the mind. Whistler's Nocturnes make me think of those pieces of Wagnerian music where the harmonic sound, separated from any melodic scheme or accentuated cadence, remains a sort of abstraction offering nothing but an undefined musical impression' (Duret, in *Gazette des Beaux-Arts*, April 1881, p. 367).

354

Whistler's exhibitions of these small oils at Petit's at the end of the 1880s, and his friendship with Mallarmé, brought him close to the Symbolist circle. Huysmans published an essay on Whistler in *Certains* (1889). Duret made an analogy between Whistler and Verlaine's poetry, and suggested that Whistler was an influence on Debussy. 'In these circles, where the research of unusual form and of subtle expression was the base of aesthetics, they [Whistler's small oils] excited enthusiasm' (T. Duret, *Whistler*, 1907, p. 118).

J. E. Blanche also confirmed that Whistler was important in Symbolist circles: 'In Paris, the Whistler cult became entangled in men's minds with Symbolism, the Mallarmé and – should I say so – the Wagner cults' (*Portraits of a Lifetime*, 1937, p. 83). A.G.

EXHIBITIONS
?1887, Paris, Petit, *Exposition Internationale* (186)
1905, London, New Gallery, *Whistler Memorial Exhibition* (72)

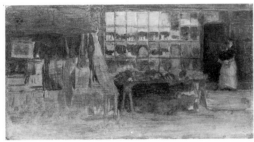

355

355 *The General Dealer* c. 1888

sbr and sbl. with butterflies oil on panel 12.5 × 22 cm/5 × 8¾ ins
Lent by the Museum of Art, Rhode Island School of Design

In the 1880s and 1890s, wherever he went, Whistler treated the subject of shopfronts and houses viewed directly from the front. The subject appealed to his inclination for geometrical compositions – the doors and windows emphasize the paintings' horizontals and verticals. The early renderings are more prosaic and specific, while the works of the late 1890s are more abstract. The atmospheric quality of *The General Dealer* makes a date in the late 1880s most likely. In 1901 Whistler noted on a list sent to him by J. J. Cowan that *The General Dealer* depicted a shop in Chelsea, Whistler's home territory in London. Mortimer Menpes, one of Whistler's pupils in the 1880s, described how Whistler and he set about painting these shopfronts: 'Then Whistler would get his little pochade box and together we would drift out into the open – on to the Embankment or down a side street in Chelsea – and he would make a little subject, sometimes in water, sometimes in oil colour. It might be a fish shop with eels for sale at so much a plate, and a few soiled children in the foreground – or perhaps a sweet stuff shop, and the children standing with their faces glued to the pane. There we

would stay and paint until luncheon time, sitting on rush-bottomed chairs borrowed from the nearest shop' (M. Menpes, *Whistler as I Knew Him*, 1904, pp. 3–4).

Whistler showed a number of these small studies at his one-man exhibitions at the Dowdeswell Gallery in 1884 and 1886, and also exhibited them at the RBA, where, especially after he was elected president in 1886, his avant-garde position in England was formally acknowledged, though only for a short time.

Whistler's decision to exhibit these panels had great significance for the younger British artists. All his followers, including Sickert, Starr and Lavery, adopted the practice of painting on small panels. This enabled them to use freer painting techniques and to treat simpler subjects. It is for this reason – as was pointed out at the time of his retrospective at the Goupil Gallery in 1892 – that Whistler's name was associated with Impressionism in England. The *Western Daily Mercury* named him 'the founder of Impressionism in England' (25 March 1892), and the *Daily Graphic* added that he 'had taught painters how to look at nature with their own eyes . . . to consider art of more importance than subjects'.

From 1884 Whistler was equally important to the young Belgian painters. In that year Octave Maus wrote to ask him if he would exhibit at Les XX. He knew Whistler only by name, but, as Maus explained: '. . . what man more than Whistler could personify the love of independence, the combativeness, the scorn of conventionality, the fervid glow of artistic feeling that fired these youthful souls.' Whistler reciprocated this admiration: 'I like and admire your rebellious spirit and without it progress is impossible. We will fight together for the victory of our ideal.'

The General Dealer was owned by Alexander Reid. A.G.

REFERENCES
O. Maus, 'Whistler in Belgium', *The Studio*, June 1904, pp. 7–12
E. R. and J. Pennell, *Life of James McNeill Whistler*, II, 1908, p. 16
London, Arts Council, *Whistler*, catalogue by A. McLaren Young, 1960 (53)

356 *Mrs Charles Whibley Reading* 1894

ns. oil on panel 21.5 × 21.5 cm/8½ × 5 ins
Lent by the Hunterian Art Gallery, University of Glasgow, Birnie Philip Bequest

The painting shows Ethel Philip, one of the sisters of Whistler's wife, in the drawing-room of the Whistlers' house at 110 rue du Bac in Paris. She acted as Whistler's secretary until her marriage to Charles Whibley in 1895. After his marriage to Beatrix Godwin (*née* Philip) in 1888 Whistler did a number of paintings and lithographs of

356

intimate interiors depicting his wife and sister-in-law. They have a similarity with the work of Vuillard and the Nabis, which is probably not coincidental. It is more than likely that Whistler met Vuillard at one of Mallarmé's Tuesday evenings in the rue de Rome – Mallarmé was a close friend and had translated his *Ten O'Clock* in 1888. Whistler revealed his admiration for the Nabis by including work by Vuillard, Vallotton, Bonnard and K.-X. Roussel in the first International Society exhibition in London in 1898. A.G.

EXHIBITIONS
1904, Edinburgh, Royal Scottish Academy (308)
1905, London, International Society (94)
REFERENCES
J. W. Lane, *Whistler*, 1942, p. 72
London, Arts Council, *Whistler*, catalogue by A. McLaren Young, 1960 (60)
D. Sutton, *Nocturne: The Art of James McNeill Whistler*, 1963, p. 129
London, B. and D. Colnaghi Ltd, *Glasgow University's Pictures*, 1973 (97)
Oberlin, USA, Allen Memorial Art Museum, *The Stamp of Whistler*,
 catalogue by R. H. Getscher, 1977, p. 31

Yeats, Jack B. 1871–1957

Born in London, Yeats lived with his maternal grandparents in Sligo, Ireland, from 1879 to 1887, when he attended South Kensington School of Art, Chiswick Art School and Westminster School of Art. In 1892–3 he worked as a poster artist in Manchester. Around 1902 he began to paint in oils, and in 1904 had an exhibition at the Clausen Gallery, New York. He settled permanently in Ireland in 1910. He exhibited at the AAA, the Salon des Indépendants and the Armory Show, and in over 160 other group shows in various countries. He wrote and illustrated many books. The poet W. B. Yeats was his brother.

357 *The Circus Dwarf* c. 1911

> sbr. Jack B. Yeats 91.5 × 61 cm/36 × 24 ins
> Lent by a Private Collector, Montreal

Yeats had been fascinated by the circus from an early age, and as a boy he had seen the travelling circus in Sligo each summer. Later he made drawings of circus subjects for illustrated magazines, and had a toy circus with which he gave performances. Many of his drawings of the circus were studies of circus people outside the ring, and reflect Yeats' general interest in itinerant Irish gypsies and horse-traders. The misfit was a frequent theme in his paintings, as it was in his brother W. B. Yeats' poetry. In this respect *The Circus*

357

Dwarf is a study of a tragic and miserable predicament.

Yeats' black-and-white illustrations, his poster designs, his admiration for Japanese prints, and the stencil patterns of the figures that he made from 1893 to 1909, account for the strong linear style and flattened effect of *The Circus Dwarf*. He did not begin painting in oils in earnest until 1910, and although he said that Goya and Sickert were the only two painters he admired, the work of the Fitzroy Street Group at the AAA, which he saw when he exhibited there from 1909, must have influenced the bright, strong colouring of *The Circus Dwarf*.

John Quinn, an early patron, encouraged Yeats to send *The Circus Dwarf* and four other oils to the Armory Show in New York in 1913. The Expressionistic quality in the painting formed the basis for Yeats' later painting style. A.G.

EXHIBITIONS
1912, London, Walker Gallery (3)
1913, New York, Armory Show (356)
1913, London, AAA (635)
REFERENCES
J. B. Yeats, *Life in the West of Ireland*, 1912, repr. p. 111
T. G. Rosenthal, *Yeats (The Masters*, 40), 1966, pp. 4–5
A. Pyle, *Jack B. Yeats*, 1970, p. 116
Dublin, National Gallery of Ireland, *Jack B. Yeats*, 1971, no. 32, p. 12

Italy

Divisionism: Its Origins, Its Aims and Its Relationship to French Post-Impressionist Painting

Sandra Berresford

Italy presents no homogeneous response to Post-Impressionism. In spite of several attempts to create an artistic centre in Post-Risorgimental Rome, regional schools continued to flourish up to and beyond the 1890s. Symbolism, Social Realism and Art Nouveau (termed *Stile Liberty* in Italy), three unifying elements in late nineteenth-century Italian painting, were nevertheless given different emphasis and interpretation in the various regions. Dominated primarily by English and German prototypes, *Liberty* produced some interesting and original examples in the decorative arts. Moreover, it provided a background of 'Modernism' in the north, in Milan and Turin in particular, and, as such, its influence was felt by the Divisionists. Apart from *Liberty*, Divisionism can justly claim to have been the leading avant-garde movement in Italy in the 1890s. Symbolist and Social Realist artists concentrated more on content than on technique and rarely developed radically new pictorial and compositional solutions. Divisionism, in which both Symbolism and socialism played an integral part, was an exception since its exponents sought and realized a new pictorial means of expression.

Not only did it dominate north-west Italy and later spread to Rome, but its influence was felt over almost three decades of Italian painting. In its most vital form, however, Divisionism belongs to the years between 1891 and 1907, the year of Pellizza's death: Segantini died in 1899 and other major protagonists – Vittore Grubicy, Morbelli, Nomellini and Previati – did not expand their Divisionist vocabulary beyond this date, although they painted up to and beyond the First World War. After 1907, a second generation of Divisionists was formed under the auspices of Alberto Grubicy's gallery in Milan (they contributed, for example, to exhibitions in Paris in 1907 and 1912), but these artists were generally eclectic and contribute little to a basic understanding of Division-ism. Of this group, Benvenuti (1881–1959), Cominetti (1882–1930) and Merello (1872–1926) developed the expressive and decorative possibilities of the technique in the early twentieth century. Innocenti's *The Visit* (fig. 12) is representative of a Roman-based group of Divisionists, which included Lionne (1865–1921) and Noci (1874–1953), whose extravagant female portraits, not a little influenced by the Spaniards Hermen Anglada and Ignacio Zuloaga, were shown at the Roman Secession from 1913.

In the context of the present exhibition it was considered more appropriate to represent the major Divisionists by two or three important or characteristic works rather than attempt an overall historical survey. For this and practical reasons, it was not possible to include works shown at the Brera Triennale of 1891 where Divisionist works first appeared in the north, or those presented at the Florentine Promotrici from 1890 to 1892. Secondary figures of the first generation such as Fornara (1871–1968), Longoni (1859–1932) and Sottocornola (1855–1917) produced one or two works of great artistic quality or historical impor-tance: Fornara's *Washerwomen* (1897, Private Collection, Domodossola), Longoni's *Orator of the Strike* (c. 1891, Private Collection, Pisa) and Sottocornola's *Workers' Dawn* of c. 1897), are cases in point. These, and other artists, have been sacrificed in order to outline the important historical links between the Divisionists and the early works of the Futurists – Balla and Boccioni in particular – all of whom evolved to some degree out of a Divisionist experience.

Divisionism is not a movement easily defined, like Impressionism, by joint exhibitions. The Brera exhibition of 1891 was not an organized assault on academic art: Previati's *Motherhood* (fig. 13) and Segantini's *The Two Mothers* (fig. 14) were hung in the same room, but works

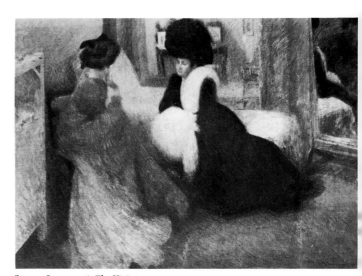

fig. 12 Innocenti *The Visit*
Galleria Nazionale d'Arte Moderna, Rome

fig. 13 Previati *Motherhood*
Banca Popolare, Novara

fig. 14 Segantini *The Two Mothers*
Civica Galleria d'Arte Moderna, Milan

by V. Grubicy, Longoni, Morbelli and Nomellini were scattered throughout the exhibition. At least three attempts were made, largely by Morbelli and Pellizza, to put on joint exhibitions but they all failed due to financial and organizational difficulties and the artists' strong sense of individuality. Works by the Divisionists did appear in the same northern exhibitions but, since the artists came from different regions, the regional organization of the rooms often precluded them from showing as a group. Many of them did not live in Milan: V. Grubicy and Segantini spent long periods in the Alps; Nomellini was based in Genoa; Morbelli spent his summers at Casale Monferrato and Pellizza was based in the tiny Alessandrian town of Volpedo. Nevertheless, Milan formed the group's artistic nucleus, since all but Nomellini had studied at the Brera and it was against the cultural background of the Scapigliatura that they first emerged. The term, meaning 'scruffy' or 'dishevelled', came from a novel of 1862 by C. Righetti, and refers to their bohemian way of life. Primarily a Romantic literary movement, it was at its height in Milan in the 1860s and 1870s. However, three artists, Carnovali (d. 1873), Cremona (d. 1878), and Ranzoni (d. 1889) were of great influence on the Divisionists, anticipating their search for light and atmosphere. The Grubicy Gallery, founded in Milan in 1879, supported first the Scapigliati and then the Divisionists; all the main Divisionists, except Pellizza and Morbelli who had independent means, came to have financial contacts with Vittore or Alberto Grubicy at some stage.

Each of the Divisionists arrived at the technique and adapted it in a different way but neither they nor their contemporary critics had any difficulty in distinguishing their common aims or in giving them some sort of group identity. Morbelli limited this group to 12 or 14 artists in 1897 and extended it to over 30 by 1903. Through an intricate network of friendships they were all reasonably aware of developments made by others in the group. Pellizza, who knew Nomellini by 1888 and who corresponded with Morbelli and Segantini from c. 1894, and Grubicy, who knew all the Divisionists well (though Nomellini somewhat later), were the two pivots around which these friendships revolved.

All the Divisionists were aware of the principle laid down by O. N. Rood in his *Modern Chromatics* of 1879,[1] namely that two colours juxtaposed (or 'divided'), rather than mixed on the palette, would fuse optically at a given distance, resulting in increased luminosity and a superior representation of natural light. Chevreul[2] had proved that complementary colours (red–green, yellow–violet, orange–blue etc.) were mutually intensified when juxtaposed, but Rood had suggested that still greater luminosity could be achieved by juxtaposing the complementaries of light which reacted differently from those of pigment – e.g. the complementary of green light is not red but violet. Gradations of a colour within its own hue by the addition of white or of colours in near proximity to it on Rood's Colour Circle would again increase luminosity. Optical fusion could be induced by placing small dots of paint alongside one another. This fusion does not, in fact, occur within the realm of normal perception and certainly not in Divisionist paintings where the brushstrokes tend to be rather large.[3] Dove's explanation, quoted by Rood and Fénéon,[4] of how the eye jumps from one coloured dot to the next perceiving them both separately and imagining their combination, is a more satisfactory explanation of the brilliant, vibrant effect of these paintings. The Divisionists were not, however, purely concerned with complementaries; they wanted to render all forms and effects of light as accurately as possible – pure sunlight, partially absorbed light, reflected light, irradiation and, in Balla's case, artificial light.

The 'point' was never, in fact, adopted by the Divisionists, although a stippled effect sometimes occurs in the works of Nomellini and Pellizza. According to Rood, in practice Mile had 'traced fine lines of colour parallel to each other, the tints being alternated' in order to achieve 'true mixtures of coloured light'.[5] Morbelli adopted precisely this technique, noting that the finer the lines he used, the closer he came to the vibrant effect of light. Pellizza favoured a mixture of brushstrokes: 'It should not all be in little dots, nor in little lines, nor all mixed, neither should it be uniformly smooth or rough, but varied as the appearance of objects in nature are varied so that forms and colours can obtain a meaningful harmony.'[6] Previati and Segantini used long, sweeping brushstrokes that were more often superimposed than juxtaposed, merging in an Impressionist fashion when the pigment was still wet. Segantini's technique is remarkably close to a passage from Ruskin's *Elements of Drawing*, 1857, in which he proposes that colours should be applied in 'rather vigorous small touches, like finely chopped straw', filling in the interstices created by this loose brushwork with other, gradated colours.[7] Ruskin's book had originally influenced

the Neo-Impressionists through Rood's quotations from it, but it had been translated into Italian as early as 1870; Previati quoted it widely and Morbelli described it as 'very important'.

Allied to the artists' belief that Divisionism could increase luminosity was the Positivist-inspired conviction that a combination of art and science could only benefit the 'progress' of art and that the depiction of light was an intrinsically modern subject for painting. Grubicy foresaw the emergence of a whole new aesthetic:

Research based on the scientific theory of colours, apart from furnishing the art of painting with a technique, a language of greater social breadth, can open up the channel towards a whole new aesthetic of its own, to the treatment, that is, of radically new subjects, to the expression of certain aspects of the beauty of Nature untackled up until now. . . . It is substantially an aesthetic which leads towards the study of another aspect of LIFE, since we all feel that LIGHT IS LIFE and if, as many rightly affirm, ART IS LIFE and light is a form of life, the Divisionist technique, which tends to increase the expression [of light] on the canvas compared with the past, can be the cradle of the aesthetic horizons of tomorrow, horizons which will . . . have their own physiognomy which will leave a characteristic mark of our times for those to come, as all the great arts of the past have left their mark on theirs.[8]

Pellizza's *Sun* (1903–4, Galleria Nazionale d'Arte Moderna, Rome), one of a series of works portraying the phenomenon of light, is an extreme example of such a belief.

The 'radically new' subjects predicted by Grubicy were primarily concerned with Symbolism and socialism – the latter inasmuch as it was, itself, an Idea or concept. The Brera Triennale of 1891 saw the emergence of both trends. On that occasion, Grubicy defined Symbolism as an art aiming to express Ideas but whose forms were still attached to Reality and drawn from Nature, as was the case of Segantini's *Two Mothers*. Previati's *Motherhood* was an example of the still higher 'Ideist' art (a term derived from A. Aurier's 'Le Symbolisme en peinture', *Mercure de France*, II, 1891), where Ideas were no longer subservient to Reality but were to be expressed by means of a special, indefinite language, in a

fig. 15 Segantini *The Punishment of Luxury* Walker Art Gallery, Liverpool

'fluctuating, synthetic, overall vision of forms and colours which barely let the Symbolism or musical, almost supernatural, Ideism peep through'.[9]

Pellizza's Symbolism and that of Segantini at his best was undoubtedly attached to Reality and was inspired by an empathetic, at times pantheist, attitude towards nature. Grubicy did not, as many critics have supposed, disapprove of Symbolism. Indeed, his own 'Ideist' concept of art, based on formal and abstract values, was probably closest to that of the less academic Symbolists in France, although the results were obviously profoundly different. He and Segantini agreed to go their separate ways *c.* 1890, not simply because Segantini had introduced Literary Symbolism to his work – first in the *Fruits of Love* (1889, Museum der Bildenden Kunst, Leipzig) and then in *The Punishment of Luxury* (fig. 15), but because he had combined it with a naturalist landscape.[10] Grubicy did not, for example, object to the Symbolism of Previati's huge, Pre-Raphaelite-inspired religious or mythological triptychs. Nomellini too got caught up in a wave of D'Annunzian epic Symbolism in the later 1890s, and only Morbelli consistently rejected overt Symbolist references in his art.

fig. 16 Pellizza *In the Hayloft*

With the possible exception of Previati, all the Divisionists were drawn towards socialism to some extent. Grubicy wrote in 1889 that it was inevitable that the artist, as a sensitive human being, should become involved in the 'ideas and aspirations influencing the disinherited classes'.[11] Pellizza too felt that the artist could not remain outside such 'vital questions' and that it was 'no longer time for Art for Art's sake, but for Art for Humanity'.[12] Much of their involvement depended on an idealistic, humanitarian concern inspired by authors such as Tolstoy, Dostoievsky, Morris and Ruskin. Ruskin's anti-machine aesthetic is reflected in the writings of Grubicy and Segantini. Pellizza's *In the Hayloft* (fig. 16) the story of a destitute and dying agricultural worker, for example, was intended to portray 'the eternal contrast between life and death'[13] on the ideal plane. Although workers and peasants figure widely in Divisionist works, images with specific political implications rarely occur; Pellizza's *The Fourth Estate* (no. 376) is a political image almost in spite of its Idealist conception. The artist authorized its publication by the socialist press and Segantini drew a copy of J. F. Millet's *The Sower* in 1897 for the Almanac of the Italian Socialist Party, but only Emilio Longoni, whose socialism was of a less humanitarian nature, regularly produced political images in his work. He was prosecuted for 'incitement to class hatred' when *Reflections of a Starving Man* (1893, Museo Civico, Biella) was published in a journal. In 1894, Nomellini was tried for his involvement with a group of Anarchists led by Luigi Galleani – the same year in which some of the Neo-Impressionists were involved in the trial of the Anarchist Emile Henry in France. The Divisionists' identification with the masses undoubtedly stems from the Romantic image of the artist as an outsider. According to Pellizza, it was the artist's duty to join with the masses and to ease their suffering by creating Beauty.[14] Both he and Segantini believed that long periods of solitude, away from society, were necessary for artistic creation, but it remains something of a paradox just how this and their literary or rather esoteric forms of Symbolism were to be reconciled with their egalitarian beliefs.

For many years, quite unjustly and with little historical foundation, Divisionism was considered an eclectic, belated and somewhat provincial reflection of Neo-Impressionism. This opinion was probably introduced to Italy in 1895 by Vittorio Pica, when, in the first major article written on the French movement, he clearly states French precedence in the technique without attempting to distinguish between French, Belgian and Italian versions of the style.[15] This same attitude was repeated in later writings and taken up by far less authoritative critics than Pica. In 1891, Grubicy had suggested that the origins of Divisionism could be found in Rood's colour theories and in the late works of the Scapigliati.[16] Morbelli and Pellizza also stressed the importance of their Lombard predecessors as well as earlier sources, probably in much the same way that the Neo-Impressionist sought 'respectable' antecedents such as in Murillo, Rubens and Delacroix. By 1896, however, Grubicy felt obliged to deny any influence from France:

To speak of precedence, of importation from this or that country is contrary to the truth. In fact, while the affirmation of the POINTILLISTS . . . dates back only fifteen years, without mentioning the great past masters, we had Daniele Ranzoni in Milan who, from 1870 and even earlier, painted portraits according to the most rigorous (if intuitive) POINTILLIST precepts, obtaining results of intense light, mobility and life.[17]

Divisionism could not have evolved from Ranzoni and Fontanesi alone – there is no 'scientific' juxtaposition of colours in their works – and Grubicy had, in any case, stated earlier that the Neo-Impressionists in Paris had applied Rood's colour theories when no one was yet interested in the subject in Italy.[18] Previati also stated that their 'starting point' had been 'knowledge of the artistic moment in which we are living, dominated that is by the movement begun in France by the LUMINISTS' (a common term in Belgium and Italy for the Impressionists).[19]

There are, however, few references to Neo-Impressionism in the Divisionists' writings and private correspondence and virtually no references to specific paintings. One must either believe in a chauvinist-inspired 'conspiracy of silence' or conclude that they knew very little of French precedents. Although anti-French feeling was strong in the 1890s, particularly under the governments of Crispi (which did little to facilitate the movement of avant-garde art between the two countries), the latter view is corroborated by the literary sources and by the visual evidence of the paintings. With the exception of Pellizza's *Washing in the Sun* (no. 377), Divisionist paintings bear no relation to Neo-Impressionist ones beyond that which could have resulted from their familiarity with the same optical texts. A comparison with the Belgian Neo-Impressionists who had direct experience of French Neo-Impressionist paintings is enlightening. Moreover, a basic knowledge of Impressionism is a prerequisite for an understanding of Neo-Impressionism and this was almost totally absent in Italy in the formative years of Divisionism.

The Divisionist technique came to Italy in three ways: by means of optical treatises,[20] through Vittore Grubicy and through long-standing connections between Florence and Paris. Of the treatises used by the Neo-Impressionists, Rood's *Modern Chromatics*, translated into Italian in the early 1880s, was the most important for the Divisionists. Many of them, and Previati in particular, stressed the importance of Mile in their conversion to Divisionism, but since Mile's rather inaccessible treatise was quoted by Rood, they may not have known the original work. Morbelli knew Chevreul's *De la Loi du contraste simultané des couleurs*, 1839, and his *Des Couleurs et de leurs applications aux arts industriels*, 1865. Grubicy knew the former through Calvi's commentary of 1842. Charles Blanc's *Grammaire des arts du dessin*, 1867, was known to Morbelli and possibly to Pellizza who may have derived some of his ideas on the expression of line and colour from it. The book was widely used as a text in arts and crafts schools in Italy. Works by Brücke and Helmholtz were known only to the two theorists of Divisionism, Morbelli and Previati. These were combined with some specifically Italian texts:

Leonardo's *Treatise on Painting* (probably also studied by Seurat), G. Bellotti's *Luce e Colori*, 1886, and L. Guaita's *La Scienza dei Colori*, 1893, are variously cited. Charles Henry's theories of the expressive qualities of line and colour, so important for Seurat, were known to Morbelli and may have influenced Pellizza who, by 1900, felt that he had established some laws about the lines, forms and colours in his work and the emotional effect he wished to arouse in the observer.[21] Unconvincing attempts have been made to suggest that Segantini used the Golden Section in his work as early as 1886. When A. P. Quinsac examined Pellizza's work in relation to the Golden Section and Henry's Aesthetic Protractor, she found no evidence that he applied mathematical formulae to his work.[22]

The Divisionists' interest in optical treatises varies from artist to artist. By 1892 Previati had translated Vibert's *The Science of Painting* of 1891, and he wrote a *Note on the Technique of Painting* in 1895–6 which remained unpublished. His chief work, *Principi scientifici del Divisionismo: La Tecnica della Pittura*, was published in 1906, well after the height of Divisionism, and was more important in the development of the young Futurists. Morbelli had begun experimenting in painting techniques before 1888 and was probably quite well read in optics by 1894 when he began corresponding with Pellizza on the subject. His bibliography of optical and aesthetic texts is impressive but, since it was compiled shortly before his death in 1919, it gives no useful indication as to when he read the texts concerned.[23] Segantini rarely made pronouncements on technical matters, though very vociferous as far as pictorial content was concerned. Pellizza read Rood's *Modern Chromatics* in January, 1895, three years after he began painting in the Divisionist technique. Only Grubicy seems to have known Fénéon's authoritative accounts of Neo-Impressionism, published in the Belgian periodical *L'Art moderne* in 1886 and 1887.[24]

Grubicy's importance in introducing the technique is confirmed by Longoni, Previati and Pellizza who, although not directly influenced by Grubicy himself, wrote to him in 1907, 'From Cremona to Segantini, Previati, Morbelli and myself, and generally to all those who have come into contact with you, all must have felt the influence of your persuasive force.'[25] In autumn 1886, Grubicy is said to have persuaded Segantini to paint a second version of his *Ave Maria a Trasbordo*, using 'divided' colours. In fact, Millet's pastel technique is probably more relevant (again introduced to Segantini by Grubicy), but there are some traces of complementary colours (red and green) superimposed in the strip of land in the background. Grubicy's habit of reworking his own canvases makes it virtually impossible to ascertain exactly when he began using the technique, but he did note that he lightened his palette and used purer colours on his return from Holland in 1885.

Grubicy's knowledge of Neo-Impressionism depends more on his contacts with the Low Countries than with France. From 1882 to 1885 he lived in Holland, moving to Antwerp in spring 1885 and returning there late that year or early in 1886 as Italian delegate for sales at the International Exhibition. He could, therefore, have seen the Les XX exhibitions in Brussels where many of his Dutch friends, such as Josef Maris, Isaac Israels and H. W. Mesdag, exhibited. Segantini exhibited there in 1890. There is no evidence, however, that Grubicy saw exhibitions at Les XX between 1887 and 1893 when Neo-Impressionist works were shown. He did follow events in Belgium: in 1898 he wrote to Octave Maus, secretary of the Libre Esthétique where Grubicy was to exhibit the following year, that he was 'exactly familiar with your aesthetic ideas, the work of Les XX, of Art Moderne and the Libre Esthétique'.[27] It was in *L'Art moderne* that Grubicy first encountered the term 'Neo-Impressionist' in Fénéon's 'Le Néo-Impressionnisme' of May 1887 and he used the term himself in an article in *La Riforma* in August that year.[28] Two earlier articles in *L'Art moderne* – 'L'Impressionnisme aux Tuileries' of September 1886 and 'La Grande Jatte' of February 1887 – combined to give an accurate account of Neo-Impressionist developments in France at that stage, although the periodical was not illustrated and Grubicy could not have benefited from the numerous references to specific Neo-Impressionist paintings.

Grubicy's knowledge of Impressionism was also largely dependent on *L'Art moderne*. His spring tours in Europe, from 1871 to 1882, included Paris and he estimated that he 'absorbed from 20–30 thousand contemporary works of art per year',[29] but he was primarily concerned with Salon painting and no specific references to Impressionist exhibitions or paintings occur in his writings. In 1896, he did refer to having seen a work by Sisley[30] and, since the first Sisley was exhibited in Italy in 1903, he must have seen it elsewhere, probably in Paris in 1889, rather than at Les XX where Sisleys were shown in 1890 and 1891. His definition of Sisley as 'one of the most acclaimed POINTILLISTS in Paris' is obviously inaccurate but, given the context – a comparison with a work by Fontanesi – the reference to Sisley is quite apposite and it seems unlikely that he confused Sisley and Seurat, as has been suggested.[31]

Grubicy was in Paris in May and June 1889 to cover the Exposition Universelle for *La Riforma*. He was too early to see Neo-Impressionist works at the exhibition of the Indépendants, but, at the end of May or in early June, the Groupe Impressionniste et Synthétiste opened at the Café Volpini in front of the press pavilion of the Champ de Mars. The fact that he listed Gauguin, then totally unheard of in Italy, alongside Puvis de Chavannes, E. J. Laurent, G. F. Watts and Léon Frédéric in his account of Ideist art in 1891,[32] is striking, but could have been derived from *L'Art moderne* for Gauguin exhibited at Les XX that year. The prompt adoption of the term 'Ideism' itself, and Grubicy's insistence that Previati should exhibit *Motherhood* at the Salon de la Rose + Croix in 1892, suggest that he tried to keep up with developments in France. Symbolist concepts are, however, more easily conveyed by literature then Neo-Impressionist ones, which require direct, pictorial experience; even black-and-white photographs, had they circulated, would not have proved very informative. Yet, in all his writings, the only Neo-Impressionist work specifically named by Grubicy is E. J. Laurent's *The Young Poet Watches His Youth Pass By*

(untraced), which he saw at the Villa Medici in Rome in 1891 and noted that it was done in 'divided colour'.[33] Laurent (1861–1929) had studied with Seurat and Aman-Jean at the Ecole de Beaux-Arts, but his own version of Neo-Impressionism was much closer to the work of Symbolists such as Henri Martin, Séon, Le Sidaner or Aman-Jean himself than to Seurat or Signac.

Florence was the only Italian city to possess any long-standing ties with Paris in the second half of the nineteenth century. The movement known as the Macchia flourished in Tuscany c. 1856–80. Artists used *macchie* (patches) of colour and strong tonal contrasts to capture light and atmosphere in their landscapes, studies for which were frequently executed *plein-air*. Many of the Macchiaioli travelled to Paris up to the late 1870s, but their appreciation of French painting was generally limited to J. F. Millet, Courbet and the Barbizon School.[34] Their enthusiasm was shared by the Scapigliati and later by the Divisionists themselves. Pellizza's attention was all for the Barbizon painters and Bastien-Lepage, for example, when he visited Paris in October 1889. The Impressionist works of Monet and Renoir came as a complete revelation to him on a second visit to Paris in 1900.[35] If Morbelli did visit Paris in the 1880s, his reaction would have been very much the same. When Diego Martelli, critic and friend of the Macchiaioli, travelled to Paris in 1878, he wrote that Zandomeneghi's Impressionist-inspired *Moulin de la Galette* (1878, Private Collection, Milan) belonged to 'a new kind of painting whose concept and aim those at home cannot comprehend'.[36] In fact, when Martelli persuaded Camille Pissarro to show two works in Florence in 1878 and Manet to show one in 1880, they were met with almost total incomprehension by his Macchiaioli friends who found them lacking in form and sentiment. Of the Impressionists themselves, only Degas possessed any real ties with Italy; he visited relatives in Florence in 1857, 1858 and 1875, where he met many of the Macchiaioli. He remained close to D. Martelli and to three artists who moved to Paris – G. De Nittis, Boldini and Zandomeneghi – and who were associated, in varying degrees, with the Impressionists. However, they rarely exhibited in Italy, and contacts with the Florentine ambiance ceased after Martelli's death in 1896.

When Pellizza wrote in 1892 that he wanted to go to Florence, 'now that the Impressionists exhibit principally in that town alone',[37] he was not referring to Pissarro or Manet but to a group of Tuscan 'Impressionists', mostly pupils of Giovanni Fattori, who exhibited at the Florentine Promotrici from 1890 to 1892. The role played by this group in the origins of Divisionism has yet to be precisely revealed, mainly because of the absence of dated works from the crucial 1890–2 period. From catalogues and contemporary accounts,[38] however, it is known to have consisted of Enrico Banti (1867–99); Leonetto Cappiello (1875–1942); Arturo Ghezzani (1865–92); Edoardo Gordigiani (1866–1961); Giorgio Kienerk (1869–1948); Giovanni Lessi (1852–1922); Alfredo Müller (1869–1940); Plinio Nomellini; Feruccio Pagni (1866–1936); Giacomo Salmonì; Angelo Torchi (1856–1915); Ulvi Liegi (1868–1939) and, later, Guglielmo Micheli (1868–1926) and Mario Puccini (1868–1920).

Fattori did not approve and warned his pupils that 'history will classify you as the servile followers of Pissarro, Manet, etc. and, finally of Sig. Müller'.[39]

Two other contemporaries, Mario Tinti and Anthony De Witt, testified to the importance of Müller's brief sojourn in Florence.[40] He had travelled to Paris in 1888 to study with François Flameng and Carolus-Duran; by the time he returned to Florence towards the end of 1890, he had come into contact with the Impressionists. According to Müller, these included Toulouse-Lautrec, Pissarro, Renoir, Degas, Cézanne and the dealer, Vollard.[41] He certainly knew Zandomeneghi by 1895, but some of these friendships must date from a second stay in Paris from around 1892 to 1914. None of the works shown by Müller at the Florentine Promotrici of 1890–1 and 1891–2 have been traced, but one, a *Light Interior*, demonstrated a 'profound research into light'[42] with particular attention to reflected shadows, confirming Fattori's opinion of Müller as the leading painter of 'blue shadows and orange-blossom light'.[43] Two other works showed Japanese influence, then all the rage in Paris. Referring to the 1891–2 exhibition, one critic noted an advance in their handling of light and now termed the group 'Vibrationists', perhaps deriving the name from Müller's *Vibrations in White, Yellow and Blue*, shown the year before. He noted that, while they expressed light and atmosphere in terms of colour rather than form, they now believed that 'it was not possible to reproduce the vibrations of colour by mixing them but rather by superimposing them'.[44] Virtually all these works have yet to emerge from private collections but Giorgio Kienerk's *On the Banks of the Arno*, dated 1891 (fig. 17), identifiable with the *Arno, Summer Morning* shown in Florence in 1890–1, demonstrates affinities with the flickering brushstroke of Pissarro or Sisley and pure colours are juxtaposed in an area to the left. Two other dated works, *Trees Overlooking the Sea*, 1891, and *San Martino d'Albaro*, 1892 (both Private Collection, Pisa), are executed in a Divisionist technique and are immediate responses to nature, without the composition, reflection and emphasis on content so typical of the northern Divisionists.

Kienerk is not known to have travelled to Paris at this time but others of the group did: Torchi was there c. 1890–1 and

fig. 17 Kienerk *On the Banks of the Arno*
Private Collection, Florence

fig. 18 Nomellini *The Gulf of Genoa*
A. Nomellini Collection, Milan

painted Divisionist works on his return; Ulvi Liegi was there
several times between 1889 and 1895; Gordigiani spent the
summers of 1886–93 there. Liegi and Gordigiani are said to
have established contacts with the Impressionists but the
latter specifically disclaimed any knowledge of Seurat's work
at the time.[45] The young dilettante, Egisto Fabbri Junior,
(1866–1933), travelled with Gordigiani and Müller to Paris in
the late 1880s when he began buying work by Cézanne and
eventually had 21 pieces in his collection. Gustavo Sforni,
a Florentine dealer and painter advised by Müller and
Gordigiani, also had two Cézannes in his collection at the
beginning of the twentieth century.[46]

Nomellini never mentioned having visited Paris, though
many critics have assumed it, but he did move to Genoa in
1890 where he painted with Kiernerk and another young
artist, possibly Müller. An early Divisionist work, *The Gulf of
Genoa* (fig. 18), demonstrates an empirical approach towards
the technique, comparable with that of Kienerk or Torchi,
and in no way implies direct experience of Neo-Impressionist
paintings. Pellizza visited Nomellini in Genoa late in 1890, in
May 1891 and late in 1892. Convinced by Nomellini of the
merits of Divisionism, Pellizza wrote to him in May 1891,
'I hold it to be a perfectly correct principle that pure colours
applied to the painting give greater luminosity and brilliance.
I have not noticed whether applied in little dots or fine lines
etc. I have proved it by experiment.'[47] Thus influence from
Florence travelled north.

The Vibrationists derived more from late Impressionism,
combined with an 'unscientific' awareness of the division of
colour, than from Neo-Impressionism. Deprived of the
presence of Müller and Nomellini it was short-lived, and
many of the artists drifted back into less radical developments
of the Macchiaiolo tradition. In Florence, they had been
sustained only by Silvestro Lega, Telemaco Signorini and
Diego Martelli, who did what he could to defend their 'yellow
risottos'.[48] Zandomeneghi (somewhat ironically, it is true),
had told Martelli of Neo-Impressionist developments in
France by 1888, so he was forewarned.[49] Pellizza was to
lament the critic's death in 1896 as the loss of an influential
potential supporter of the Divisionist cause.[50]

Martelli's conference on Impressionism,[51] published in
1880 but with a limited circulation, remained the most
reliable account of the group in Italian until Pica's *Gli
Impressionisti francesi* of 1908. Pica's *Impressionisti, divisionisti
e sintetisti* of 1895 was the first attempt in Italy to discuss Neo-
Impressionism and its protagonists in any great detail.
Influenced by his own predilection for Symbolism, he could
not resist criticizing their over-dependence on science and a
certain lack of 'finish'. His judgments on Van Gogh, Cézanne
and Gauguin were hardly of the most enlightened, but the
article remains an isolated yet admirable attempt to discuss
Post-Impressionist painting in Italy, especially since it was
included in a review of the Venice Biennale of 1895, where no
such works were exhibited. Pica's own knowledge of Neo-
Impressionism stemmed from some years spent in Paris. He
knew Morbelli, Pellizza and Segantini, but since their
acquaintance dates from the mid 1890s, he cannot be
regarded as a primary source of Divisionism. It was followed
in 1896 by E. A. Marescotti's article, 'Symbolism in Painting',
which touched upon Symbolist aspects of Neo-Impressionism
(placing Séon above Seurat).[52]

Pica had done an excellent job in introducing avant-garde
European graphics to Italy with his articles in *Emporium*
from 1896 to 1898, published as a book in 1904.[53] Easily
transported, adapted and reproduced, they penetrated Italy
far more rapidly than their equivalents in the fine arts. Major
graphic exhibitions were held in Venice in 1901 and in Rome
and Turin in 1902. Pica had little luck, however, in
persuading the Venice Biennale to exhibit Impressionist or
Post-Impressionist works: two Monets and a Renoir were
shown there in 1897; a few works by Monet, Pissarro, Renoir
and Sisley appeared in 1903 and 1905; a Renoir retro-
spective was held in 1910, but it was not until 1920 that a
major Post-Impressionist exhibition, including Neo-
Impressionist works by Angrand, Cross, Luce, Seurat and
Signac, was held. Only Symbolist Neo-Impressionist works by
Henri Martin and Le Sidaner had been seen in the early years
of the Biennale. Other exhibitions came far too late to have
influenced Divisionism: Ardengo Soffici organized an
Impressionist/Post-Impressionist exhibition at the Florentine
Lyceum in 1910; Impressionist and Post-Impressionist works
were shown in Rome at the International Exhibition of 1911,
and in 1913 when the Galerie Bernheim Jeune lent an
important collection to the Secession; this was followed in
1914 by exhibitions of Matisse and Cézanne and, in 1915, by
a selection of Post-Impressionist graphics from the Richter
collection in Dresden.

In its early years, the Biennale steered a conservative course
between Salon painting, a generic sort of Impressionism
(Scottish and Scandinavian painters being particularly
popular), and the Symbolist/Idealist currents which then
dominated Europe. Of the latter, Pre-Raphaelitism and
Aestheticism were initially the most important in Italy.
Giovanni Costa's Roman exhibiting society, In Arte Libertas,
founded in 1886, with which Grubicy, Morbelli and later
Pellizza had contacts, promoted Pre-Raphaelite art.
D'Annunzio led a parallel movement in literature. Although
very few Pre-Raphaelite works had been seen in Italy before

the first Biennale of 1895, the traditional cultural and political ties between England and Italy and the amount of space devoted to the Pre-Raphaelites in periodicals from the mid-1880s meant that they were the strongest single foreign influence on Italian art in the 1890s. The influence of Burne-Jones, Holman Hunt and G. F. Watts can be found in Divisionist painting although, again, only Grubicy had any direct experience of their work, having seen exhibitions at the New and Grosvenor Galleries in London in 1888. All professed sincere admiration for Quattrocento painters. All were profoundly influenced by Ruskin's moral and aesthetic ideas which were widely reported in Italian journals, such as *Emporium* or *Marzocco*, to which many Divisionists subscribed, and Ruskin may, in some cases, have influenced their technique. In turn, Segantini exhibited several times in England and the Divisionists were more widely reported in the English art press than any other Italian artists.

In the early years of the twentieth century, when French Post-Impressionist art was making unofficial inroads into Germany thanks to Meier-Graefe and Count Kessler, the influence of the German Secessions swept Italy. In 1916, Boccioni lamented that, 'In Italy, Lenbach was and is more famous than Manet. Hans Thoma more than Pissarro, Liebermann more than Renoir. Max Klinger more than Gauguin, Joseph Sattler more than Degas, etc., not to mention Cézanne; finally, the Austrian Klimt . . . was considered an aristocratic innovator of style.'[54] Segantini, on the other hand, was far more famous in Germany in those years than any of the French artists mentioned. Assisted by their contacts with Gerolamo Cairati, the Italian representative at Munich exhibitions, the Divisionists exhibited at the Glaspalast, at the Secession and throughout Germany, with great success. Segantini was particularly renowned; he had works in many German museums, received many gold medals, had collections of works in the Munich and Vienna Secessions respectively in 1896 and 1898, and became a member of the latter. He corresponded with Max Liebermann, Bruno and Paul Cassirer in Berlin and Klimt in Vienna.

If the climate in Italy was dominated in the early twentieth century by Jugendstil and Secession, it did not prevent several young artists from being drawn to Paris: Carrà and Balla in 1900; Soffici from 1900 to 1907; Boccioni, Severini, Lorenzo Viani and Modigliani in 1906; Gino Rossi and Arturo Martini in 1907, and many others. Some of these artists – like Boccioni, Carrà or Soffici – would be responsible not only for the critical appreciation of the Divisionists' contribution to modern art but also for a reassessment of Impressionist and Post-Impressionist art in Italy at the end of the first decade of this century.

NOTES

1. O. N. Rood, *Modern Chromatics*, 1879 (*Students' Textbook of Colour*, 1881).
2. M. E. Chevreul, *De la Loi du contraste simultané des couleurs et de l'assortiment des objets colorés*, 1839.
3. cf. J. Carson Webster, 'The Technique of Impressionism: a Reappraisal', *College Art Journal*, November 1944, pp. 3–22.
4. O. N. Rood, *op. cit.* (1881), p. 207, and F. Fénéon in 'Les Impressionnistes', *La Vogue*, reprinted in extract, 'La Grande Jatte', in *L'Art moderne*, 6 February 1887, pp. 43–4.
5. O. N. Rood, *op. cit.* (1881), pp. 139–40.
6. G. Pellizza, letter to A. Mucchi, 18 May 1898, in F. Bellonzi, T. Fiori, *Archivi del Divisionismo*, 2 vols, 1968 (henceforth AD), vol. I, p. 211.
7. J. Ruskin, *The Elements of Drawing*, 1857, p. 227.
8. V. Grubicy, 'Tecnica e Estetica divisionista', *La Triennale*, 1896, no. 14–15, pp. 110–12, in AD, vol. I, p. 91.
9. V. Grubicy, 'La Maternità di Gaetano Previati', *Cronaca d'Arte*, 17 May 1891, pp. 181–2, in AD, vol. I, p. 91.
10. cf. P. Levi, 'L'Ultimo Segantini', *La Rivista d'Italia*, December 1899, pp. 644–5.
11. V. Grubicy, 'Il Socialismo in Italia secondo le Osservazioni di un'Artista', *La Riforma*, 27 July 1889.
12. G. Pellizza, letter to Neera (1897), in AD, vol. I, p. 206, and G. Pellizza to A. Morbelli, 12 May 1895, in A. Scotti, *Catalogo dei Manoscritti di Giuseppe Pellizza da Volpedo*, 1974, p. 39.
13. G. Pellizza, notes on *Sul Fienile (In the Hayloft)*, dated 30 April 1896, in A. Scotti, *op. cit.*, p. 43.
14. G. Pellizza, notes on *Fiumana* (1896), in AD, vol. I, p. 198.
15. V. Pica, 'Impressionisti, divisionisti e sintetisti', in *L'Arte Europea a Venezia*, 1895, pp. 112–35; *L'Arte Mondiale a Venezia*, 1897, pp. 149–69; and in *Marzocco*, February 1897.
16. V. Grubicy, 'Polemichi d'Arte', *Cronaca d'Arte*, 21 June 1891, p. 217, in AD, vol. I, pp. 92–4.
17. V. Grubicy, 'Tecnica e Estetica divisionista', *op. cit.*
18. V. Grubicy, 'I Colori nell'Arte', *La Riforma*, 26 August 1887, in A. P. Quinsac, *La Peinture divisionniste italienne, origines et premiers développements*, 1972, pp. 254–5.
19. G. Previati to his brother Giuseppe, 18 March 1893, in AD, vol. I, p. 278.
20. Apart from the works already cited, by Rood and Chevreul, cf. J. Mile, 'Über die Empfindung, welche entsteht, wenn verschiedenfarbige Lichtstrahlen auf identische Netzhautstellen fallen', 1838, in A. P. Quinsac, *op. cit.*, pp. 274–7; M. E. Chevreul, *Des Couleurs et de leurs applications aux arts industriels, à l'aide des cercles chromatiques*, 1865; C. Blanc, *Grammaire des arts du dessin*, 1867; E. W. Von Brücke, *Des Couleurs du point de vue physiologique, artistique et industriel*, 1866; E. W. Von Brücke, *Principes scientifiques des Beaux-Arts*, 1879, 1891 (Helmholtz's *L'Optique de la peinture* is extensively quoted); G. Bellotti, *Luce e Colori*, 1886; L. Guaita, *La Scienza dei Colori*, 1893; C. Henry, 'Rapporteur esthétique', *Revue indépendante*, April 1888, and 'Cercle chromatique', *Revue indépendante*, May 1888. Henry's important work, 'Introduction à une esthétique scientifique', *Revue contemporaine*, August 1885, is not cited by the Divisionists.
21. G. Pellizza, letter to V. Pica, 1900, and letter to D. Tumiati, 1900, in A. Scotti, *op. cit.*, p. 72, p. 74.
22. A. P. Quinsac, *op. cit.*, p. 133.
23. The bibliography is published in A. P. Quinsac, *op. cit.*, pp. 269–74. Morbelli's *Via Crucis del Divisionismo*, a diary written between 1912 and 1919 (in AD, vol. I, pp. 142–63) also gives information regarding the artist's reading-matter and technique.
24. F. Fénéon, 'Correspondence particulière de l'Art moderne, L'Impressionnisme aux Tuileries', *L'Art moderne*, 19 September 1886, pp. 300–2; 'Le Néo-impressionnisme', 1 May 1887, pp. 138–40, and 'La Grande Jatte', 6 February 1887, pp. 43–4.
25. G. Pellizza to V. Grubicy, 1907, in A. Scotti, *op. cit.*, p. 137.
26. V. Grubicy to B. Benvenuti, 14 February 1910, AD, vol. I, pp. 107–8.
27. V. Grubicy to O. Maus, 18 September 1898, in A. P. Quinsac, *op. cit.*, p. 241.
28. V. Grubicy, 'I Colori nell'Arte', *op. cit.*
29. V. Grubicy to B. Benvenuti, *op. cit.*
30. V. Grubicy, 'Tecnica e Estetica divisionista', *op. cit.*
31. A. P. Quinsac, *op. cit.*, p. 137.
32. V. Grubicy, 'Pittura ideista', *Prima Esposizione Triennale di Brera (Tendenze evolutive delle Arti plastiche)*, 1891.
33. Ibid.

34. cf. R. Longhi, preface to J. Rewald, *Storia dell'Impressionismo*, 1949, pp. VII–XXIX.

35. cf. A. Scotti, 'G. Pellizza a Parigi nel 1889', *Rivista di Storia, Arte e Archeologia per le Provincie di Alessandria e Asti*, 1974–5, pp. 69–90.

36. D. Martelli to G. Fattori, 13 September 1878, in L. Vitali, *Lettere dei Macchiaioli*, 1953, p. 300, n. 5.

37. G. Pellizza, in A. Scotti, 1974, *op. cit.*, p. 30.

38. Catalogues are in the *Legato Martelli*, Biblioteca Marucelliana, Florence. Cf. also 'Fonseca' (E. De Fonseca), *Di Tutti i Colori. Chiacchiere squilibrate di Fonseca sulla Esposizione di Pittura in Firenze anno 1891*, 1891.

39. G. Fattori to P. Nomellini, 12 March 91, in L. Vitali, *op. cit.*, p. 67.

40. M. Tinti, 'Alfredo Müller', Florence, Società della BB.AA. di Firenze, *Fiorentina Primaverile*, April–July 1922, pp. 156–8, and A. De Witt, 'Edoardo Gordigiani', Florence, Palazzo Strozzi Unione Fiorentina. *XVIII Mostra internazionale d'Arte Premio del Fiorino*, pp. 57–63, p. 58.

41. 'Notiziario artistico, Mostra Müller', *La Nazione*, 12 March 1930, in Quinsac, *op. cit.*, p. 151, and M. Tinti, *op. cit.*, p. 157.

42. E. De Fonseca, *op. cit.*, p. 26.

43. G. Fattori to a group of pupils (January or February 1891), in L. Vitali, *op. cit.*, p. 65.

44. Coccetti, 'Le Belle Arti a Firenze', *La Riforma*, 25 February 1892, in A. P. Quinsac, *op. cit.*, pp. 239–40.

45. E. Gordigiani, in M. Campana, M. Portalupi, *Edoardo Gordigiani nel suo 90 Compleanno*, 1955, p. 20.

46. cf. R. Monti, introduction to *Pittori toscani del Novecento*, 1978, pp. 11–19, and N. Antinori, *Un Mercante Fiorentino da Ricordare: Egisto Paolo Fabbri, 1828–1894*, 1977, pp. 43–4.

47. G. Pellizza to P. Nomellini, in A. Scotti, 1974, *op. cit.*, p. 29.

48. cf. P. Nomellini to D. Martelli, 4 March 1890 (or 1891), in A. Del Soldato, V. Masini, *Diego Martelli e I Macchiaioli*, Florence, Biblioteca Marucelliana, December 1976–March 1977, and M. Giardelli, *Silvestro Lega*, 1965, pp. 78–82.

49. F. Zandomeneghi to D. Martelli, 14 March 1888 and 23–24 March 1888, in A. Marabottini, V. Quercioli, *D. Martelli. Corrispondenza inedita*, 1978, pp. 191–4.

50. G. Pellizza to A. Morbelli, 8 December 1896, in AD, vol. I, p. 195.

51. D. Martelli, *Gli Impressionisti*, 1880, repr. in *Diego Martelli, Scritti d'Arte* (ed. A. Boschetto), 1952, pp. 98–110.

52. Pica, 1895, cf. n. 15; Marescotti, 'Il Simbolismo nella Pittura', *Natura ed Arte*, 1895–6, XXI, pp. 761–4.

53. V. Pica, *Attraverso gli Albi e le Cartelle*, 1904; 2nd series, 1907.

54. U. Boccioni, 'Carlo Fornara', *Gli Avvenimenti*, 2–9 April 1916, in AD, vol. I, pp. 59–62, p. 60.

Balla, Giacomo 1871–1958

Born in Turin, Balla received little formal training and moved to Rome in 1895 where he befriended the artists D. Cambellotti and G. Prini, the author G. Cena and the educationalist A. Marcucci. He painted from life in the Roman Campagna and became a successful portrait painter, a career which he gradually renounced as, after 1897, his conviction in Divisionism grew. Although he signed the *Futurist Painting Manifesto* in 1910, he first exhibited with them in Paris in 1912, the year in which he produced his *Iridescent Interpenetrations*.

ABBREVIATIONS
AF – M. Drudi Gambillo, T. Fiori, *Archivi del Futurismo*, 2 vols, Rome, 1958, 1962
AD – F. Bellonzi, T. Fiori, *Archivi del Divisionismo*, 2 vols, Rome, 1968
Rome 71/72 – Rome, Galleria Nazionale d'Arte Moderna, *Giacomo Balla*, December 1971–February 1972

358

358 *Self-Portrait* 1902

Autoritratto
sbc. Balla; sdtr. Balla 1902 58 × 43.5 cm/23 × 17¼ ins
Lent by a Private Collector

Possibly exhibited as one of several portraits in Rome in 1902, this work is not recorded in contemporary criticism. Balla painted several self-portraits throughout his long career; he is seen here in half-figure against a background of two of his paintings. G. De Marchis has suggested that the painter Bertieri introduced Balla to Pellizza in Turin before 1895 (*G. Balla, L'Aura Futurista*, 1977, p. 5). Pellizza and Balla may have met in Rome in 1896 where Divisionist works by Pellizza and A. Morbelli had been shown in winter 1895–6. They certainly knew each other by 1902 (cf. A. Scotti, *Catalogo dei Manoscritti di G. Pellizza da Volpedo*, 1974, p. 98), and had probably met in Paris in the autumn of 1900 when Pellizza was the guest of Balla's friend, G. Cena. They met again in 1906 when Pellizza spent some months in Rome.

In 1897, Balla produced his first attempt at Divisionism, *March Sun* (Peruzzi, Rome), an 'unscientific' version, in which the generic Impressionism of the Piedmontese painter, Enrico Reycend, is also reflected. Balla's Divisionist work is sporadic until after his visit to Paris, lasting seven months from September 1900. However *Luna Park* (1900, Private Collection, Milan), the only work surviving from this period, shows no direct influence from the Neo-Impressionist or Divisionist works which Balla could have seen there. Nor in the *Self-Portrait* is the artist's expressive – if still somewhat arbitrary – application of the Divisionist technique

immediately identifiable with that of Pellizza and his northern counterparts. The figure is built up by the traditional method and long streaks of colour, predominantly blue, violet and greens, are superimposed on this structure, resulting in a criss-cross pattern, particularly on the face, which enlivens the picture surface. Undoubtedly Balla's own pastels, and possibly also those of Zandomeneghi, played their part in the development of this individual and sometimes 'graphic' Divisionist technique. s.b.

EXHIBITION
?1902, Rome, LXXII Esposizione della Società di Amatori e Cultori di BB. AA.
REFERENCES
AF, vol. 2, no. 2
AD, vol. 2, X.35/1706
Rome 71/72 (9)
Turin, Galleria Civica d'Arte Moderna, *Giacomo Balla*, April 1963 (9)
M. Calvesi, in *L'Arte Moderna*, v, 1967, pp. 16, 124
M. Fagiolo Dell'Arco, *Balla Pre-Futurista*, 1968, no. 22, p. 40 (also in *FuturBalla*, 1970)

359 *Portrait in the Open Air* 1902/3

Ritratto all'Aperto
sbr. Balla 154.4 × 113 cm/60¾ × 44¼ ins
Lent by the Galleria Nazionale d'Arte Moderna, Rome

The painting depicts Leonilde Imperatori on the balcony of her home overlooking the Piazza di Spagna, and was commissioned from the artist by her father (Rome 71/72, p. 147). In 1901 Balla had executed a similar, full-length portrait, the *Portrait of Signor Pisani* (G. Cosmelli, Rome), with a view of Rome behind the balustrade. In the portrait of Leonilde Imperatori, however, he has raised the viewpoint, creating a greater sense of depth as one looks on to the square below. A basic harmony of whites, creams and yellows is used to create an effect of brilliant sunlight. Greens, oranges, reds and blues then cover the picture surface but are applied in a variety of techniques, ranging from multi-coloured dabs of paint to the more graphic, long streaks of red and blue seen on the flower-box to the left of the figure. Balla was to push the abstract, decorative qualities of the Divisionist technique to their extreme in *The Deer Park, Villa Borghese* (1910, Galleria Nazionale d'Arte Moderna, Rome), and finally in the creation of his Futurist *Iridescent Interpenetrations*. s.b.

359

EXHIBITIONS
1903, Rome, LXXIII Esposizione della Società di Amatori e Cultori di BB. AA. (692)
1914, Rome, LXXXIII Esposizione della Società di Amatori e Cultori di BB. AA. (19)
AF, vol. 2, no. 11
AD, vol. 2. x.33/1701
Rome 71/72 (10)
REFERENCES
C. Tridenti, in *Rassegna Contemporanea*, 25 March 1914, p. 109
Turin, Galleria Civica d'Arte Moderna, *Giacomo Balla*, April 1963 (13), p. 111
M. Calvesi in *L'Arte Moderna*, v, 1967, p. 124
M. Fagiolo Dell'Arco, *Balla Pre-Futurista*, 1968, no. 25, p. 40 (also in *FuturBalla*, 1970)

G. Ballo, *Preistoria del Futurismo*, 1960, pp. 10, 74, pl. 15
Turin, Galleria Civica d'Arte Moderna, *Giacomo Balla*, April 1963 (22), pl. IV
M. Calvesi, in *L'Arte Moderna*, v, 1967, p. 125
A. Baricelli, *Balla*, 1967, p. 12
M. Fagiolo Dell'Arco, *Balla Pre-Futurista*, 1968, no. 47, p. 19
 (also in *FuturBalla*, 1970)
V. Dortch Dorazio, *Balla, An Album of his Life and Work*, 1969, no. 30
M. Martin, *Futurist Art and Theory 1909–1915*, 1969, p. 67
Milan, Palazzo Permanente, *Mostra del Divisionismo Italiano*, March–April 1970 (106)
G. De Marchis, *G. Balla, L'Aura Futurista*, 1977, p. 8

360 *The Worker's Day* or *They Work, Eat and Go Home* or *Bricklayers* 1904–7

La Giornata dell'Operaio or *Lavorano, Mangiano, Ritornano* or
I Muratori
right panel sdbl. Balla 1904 oil on paper
99 × 135 cm/39½ × 53 ins
Lent by a Private Collector

This picture, known as *The Workers' Day*, was exhibited under the
second and third titles given above in 1907 and 1914 respectively.
B. Sani has convincingly suggested that the date, 1904, refers to the
right-hand panel alone, that this was part of a series depicting
artificial light, and that it may be identifiable as the *Via Salaria*
exhibited in Rome that year (Rome 71/72, p. 152). The other panels
would have been incorporated shortly before its exhibition in 1907.
The paintings depict construction sites near Balla's studio in Via
Salaria (cf. V. Dortch Dorazio 1969, no. 29). As M. Fagiolo Dell'Arco
has noted, however (1968, p. 19), the real subject is not the worker
but the passage of light from mid-day (bottom left), to sunset (top
left), to night (right). B. Sani, on the other hand, suggests that only
two moments are shown (Rome 71/72, p. 152). Balla had first
depicted nocturnal light in *The Spare Draught Horse* (1898, un-
traced). His *Work/Lantern* of 1902 (Winston, Birmingham, USA),
has virtually no content other than its study of artificial light and,
although it predates *The Worker's Day*, is a more direct antecedent of
the famous *Arc Lamp* (1909–11, Museum of Modern Art, New York).
Triptych forms were common in Divisionist paintings but the
horizontal division and the witty painted frame are highly
original. S.B.

EXHIBITIONS
1907, Rome, XXVII Esposizione della Società di Amatori e Cultori de BB. AA. (97)
1914, Rome, LXXXIII Esposizione della Società di Amatori e Cultori di BB. AA. (15)
REFERENCES
AF, vol. 2, no. 10
AD, vol. 2. x.96/1741
Rome 71/72 (18)

361

360

361 *The Madwoman* 1905

La Pazza
sdbr. Balla 1905 ; sbr. Balla 175 × 115 cm/69 × 45¼ ins
Lent by a Private Collector

The *Madwoman* forms part of the *Polyptych of Living Beings*
(*Il Polittico dei Viventi*) and was exhibited in Rome in 1909 along-
side *The Beggar* (1902, Private Collection, Rome), *The Invalids*
(1901–3, Private Collection, Rome), and the *Peasant/Gardener* (1902,
Accademia di San Luca, Rome). M. Fagiolo Dell'Arco (1968, p. 22)
records that Balla intended to extend the polyptych to include at
least 15 more subjects. A photograph, taken in Balla's studio in
Via Parioli around 1908 (M. Fagiolo Dell'Arco 1968, p. 8), shows a
different, full-length version of *The Madwoman in Via Parioli*
(*c*. 1905, untraced). Balla had, in fact, painted the 'madwoman'
(identified as Mathilde Garbini, cf. Rome 71/72, p. 151), several
times, both in studies for these works and in a non-Divisionist
portrait executed *c*. 1905 (Cosmelli, Rome). The artist's interest
in the physiological expression of psychological disorders may
have begun in Turin where he attended Cesare Lombroso's
lectures at the University. One of his earliest friends in Rome was
Prof. Ghilarducci, a pioneer of electric shock therapy, in whose
studio *The Invalids* was painted.
 Contemporary critics found the title of the polyptych an
ambiguous remnant of Symbolism, although the works themselves

were praised as 'a strong, bold piece of modern painting' (L.Serra 1908–9, p. 264). V. Pica described the figures as 'five painful types of victims of existence' (1909, p. 253), which was probably closest to the artist's intention and to his humanitarian identification with society's outcasts. G. Gena's *Gli Ammonitori*, a novel first published in the *Nuova Antologia* of 1903, in which an artist, identifying with the oppressed classes, tries unsuccessfully to emerge from his Romantic, individualist isolation in order to serve the masses, may have influenced Balla (G. De Marchis 1977, p. 9). Cena, Balla and others attempted just such an aim with the foundation of the Scuole dell'Agro Romano in 1907.

Balla had first attempted the formula of a full-length, backlit figure in a pastel, *Elisa at the Door* (1904, Cosmelli, Rome). This contrast of light and shade is exaggerated still further in *The Madwoman*. While the sunlit background is painted in a myriad of dots and dashes of pure colour, the modelling of the figure is more closely related to Balla's pastel technique. The grey frame, painted with little red dots, pushes the figure back into the picture, and was undoubtedly inspired by Seurat's painted borders and frames. S.B.

EXHIBITIONS
1909, Rome, LXXIX Esposizione della Societá di Amatori e Cultori di BB.AA. (33, *Dei Viventi*)
1909, Paris, Salon d'Automne (21, *Des Vivants*), p. 8
REFERENCES
AF, vol. 2, no. 4
AD, vol. 2, X.120/1757
Rome 71/72 (17)
L. Serra, in *Natura ed Arte*, 1908–9, XVI, p. 264
V. Pica, in *Emporium*, April, 1909, p. 253
In *L'Art décoratif*, special number on Salon d'Automne 1909, p. 120
Turin, Galleria Civica d'Arte Moderna, *Giacomo Balla*, April 1963 (24)
M. Calvesi, in *L'Arte Moderna*, v, 1967, p. 124
A. Barricelli, *Balla*, 1967, pp. 14–15, pl. 19
M. Fagiolo Dell'Arco, *Balla Pre-Futurista*, 1968, no. 57, pp. 22–3, 43–4 (also in *FuturBalla*, 1970)
Milan, Palazzo Permanente, *Mostra del Divisionismo Italiano*, March–April 1970, pp. 121–2
G. De Marchis, *G. Balla, L'Aura Futurista*, 1977, pp. 9–11

Boccioni, Umberto 1882–1916

Born in Reggio Calabria, Boccioni officially studied at the Rome Academy 1900–6 and unofficially, with Gino Severini, frequented Balla's studio. When their Divisionist works were rejected from the Società di Amatori e Cultori di Belle Arti in 1905, he and Severini organized a 'Salon des Refusés'. He travelled to and worked in Paris, Russia and Venice. On his move to Milan in 1908 he met the Divisionists Previati, Longoni, Martelli and Camona as well as Romolo Romani, Arnoldo Bonzagni, Carlo Carrà and, in 1909, L. Russolo and F. T. Marinetti. Boccioni was largely responsible for the creation of the first *Futurist Painting Manifesto* of February 1910.

ABBREVIATIONS
AF – M. Drudi Gambillo, T. Fiori, *Archivi del Futurismo*, 2 vols, Rome, 1958, 1962
AD – F. Bellonzi, T. Fiori, *Archivi del Divisionismo*, 2 vols, Rome, 1968
AP/GB 1969 – A. Palazzeschi, G. Bruno, *L'Opera Completa di Boccioni*, Milan, 1969

362 *La Signora Virginia* 1905

sdbr and insc. U. Boccioni Roma giugno 1905
140 × 115.5 cm/55 × 45½ ins
Lent by the Civica Galleria d'Arte Moderna, Milan

On his return from Paris in 1901, Balla had introduced Boccioni and Severini to Divisionism although he had failed to teach them 'the fundamental and scientific rules of it' (G. Severini, *Tutta la Vita di un Pittore*, 1946, vol. 1, p. 21). By 1905 both pupils had progressed, 'instinctively and logically developing . . . Impressionist vision and

theory (in a daring and violent fashion). . . . Only Balla was capable of understanding this position' (*Tutta la Vita di un Pittore*, p. 30). Boccioni's debt to Balla in *La Signora Virginia* is clear: in the setting of the figure, in the contrast between the dark foreground and the distant light interior, and in the graphic-like Divisionist touch itself, handled with boldness. The size and impact of the image reflect Balla's *Mother* (Private Collection, Rome); this was executed in 1901 and so Boccioni could have seen it in Balla's studio.

In a letter to Severini from Milan late in 1907, Boccioni asked for his possessions to be forwarded and wrote that 'Sironi will do what he can with Signora Virginia' (in AD, vol. 1, p. 39). This has led some critics to believe that the work was done in Rome (G. Ballo 1964, p. 78). In the same letter, Boccioni wrote that he now rejected Balla's work as too attached to Reality and too far from the Ideal towards which he himself was striving. S.B.

REFERENCES
AF, vol. 2, no. 97
AD, vol. 2, XVIII.5/2207
AP/GB 1969, no. 4
G. Ballo, *Preistoria del Futurismo*, 1960, pp. 98–9
G. Ballo, *Boccioni. La Vita e L'Opera*, 1964, no. 4
L. Caramel, C. Pirovano, *Galleria d'Arte Moderna. Padiglione dell'Arte Moderna, Raccolta Grassi*, 1973, no. 15
Milan, Palazzo Reale, *Boccioni e il suo Tempo*, December 1973–February 1974 (18)

362

363 *Workshops at Porta Romana* 1908

Officine a Porta Romana
sdbr. U. Boccioni 1908 75 × 145 cm/29½ × 57 ins
Lent by the Banca Commerciale Italiana

Influenced by Balla's depiction of the industrial suburbs of Rome, Boccioni first attempted the subject as the background of his *Self-Portrait* in 1908 (Brera, Milan), a few months before the execution of *Workshops at Porta Romana*, in the suburbs of Milan. According to the work's original owner, Vico Baer, Boccioni intended it to form part of a series (M. Martin 1968, p. 67, n. 1). It is possible that *Morning* (1909, Mazzotta, Milan) and *Dusk* (1909, Galleria Gissi, Turin [in 1967]), depicting the same area at different times of the day, formed part of this series, although their dimensions bear no relation one to another.

363

In late 1907 and early 1908, influenced by the Central European and predominantly Symbolist culture of the Venice Biennales, Boccioni underwent a profound crisis and began to search both for new ideas and new forms of expression in his art. In March and April 1908 he visited Previati, who represented a bastion of the Ideal in Milan and whose *Principi scientifici del Divisionismo* of 1906 provided Boccioni with the scientific basis he had found lacking in Balla. According to Boccioni, Previati had created a new style, 'an impressionistic synthesis of form and colour. He has reduced classic form to luminous masses and volumes which deform atmosphere and bodies according to the artist's will'. Nevertheless, he fully recognized the essential dichotomy between Previati's modern style and his subject matter: 'His deformations, which are nearly always suggested by laws of rhythmic emotion, remain a kind of impressionistic dream of classical-Christian traditional form' (Boccioni, *G. Previati*, 1916, in AD, vol. I, p. 56). He therefore tried to adapt the expressive, dynamic qualities of Previati's technique to a modern subject – the city. If the unrestrained handling of the Divisionist technique in *Workshops at Porta Romana* is due in part to Previati, the vibrancy of Boccioni's palette, with its mainly pure colours, is not, and had been established before 1907 in a series of Venetian landscapes. Previati's influence was to remain with Boccioni throughout his early Futurist period: *The City Rises* (1910, Museum of Modern Art, New York), for example, is an attempt to fuse the city, Idealism and a new-found dynamism by means of what is still for the most part a Previati-influenced Divisionist technique. S.B.

EXHIBITION
Milan, Galleria Centrale d'Arte, *Grande Esposizione Boccioni*, December 1916–January 1917
REFERENCES
AF, vol. 2, no. 97
AD, vol. 2, XVIII.130/2332
AP/GB 1969, no. 63
G. Ballo, *Preistoria del Futurismo*, 1960, pp. 74, 76, 142
G. Ballo, *Boccioni, La Vita e L'Opera*, 1964, no. 120, pp. 74, 76, 154–5, pl. IV
M. Martin, *Futurist Art and Theory*, 1968, p. 67
G. Perocco, *Le Origini dell'Arte Moderna a Venezia, 1908–20*, 1972, p. 102
Milan, Palazzo Reale, *Boccioni e il Suo Tempo*, December 1973–February 1974 (26)
Milan, Palazzo Permanente, *Arte e Società dal Realismo al Simbolismo, 1865–1915*, May–September 1979

Boldini, Giovanni 1842–1931

Born in Ferrara, Boldini joined the Macchiaioli in Florence in 1862. On a visit to Paris in 1867 he met Caillebotte, Degas, Manet and Sisley. He painted fashionable society and genre scenes there and in Holland, Germany and Spain (with Degas). He returned to Florence a number of times and assisted his Macchiaioli friends with their contribution to the Exposition Universelle of 1889. His house in Paris was frequented by many celebrities: Puvis de Chavannes, Raffaëlli, Dumas *fils*, Sarah Bernhardt, Yvette Gilbert, Robert de Montesquiou and others. Boldini was close to his only rivals as a portraitist – Sargent, Helleu and Whistler.

364 *Portrait of Mme Max* 1896

Portrait de Mme Max
sdbl. Boldini 1896 200 × 100 cm/78¾ × 39½ ins
Lent by the Musée d'Orsay, Paris

Boldini had a high reputation in London and Paris as a painter of women; actresses and the aristocratic elite flocked to be painted by this artist whose very brush could create fame. Always fashionable, two of his larger female portraits made excellent backdrops to a fashion show at the Hôtel des Modes in 1908. He was often a little risqué, but never exceeded the conventional bounds of respectability. As A. R. Willard noted, Boldini never tried to compete with the camera but possessed 'an abnormally acute perception of what gives individuality to a face or figure' which bordered on caricature (*A History of Modern Italian Art*, 1898, p. 486). Only once, when offended by Marie de Montesquiou, did he cross the narrow line between portraiture and caricature.

Boldini had studied Romney, Gainsborough and Reynolds in London and Frans Hals in Holland. Hals' influence, combined with that of the Impressionists, is reflected in the rapidity of Boldini's brushwork, which is his 'signature' as much in his Paris street scenes or his exquisite flower-pieces as in his better-known large portraits. Velasquez's work, seen in Spain in 1889, influenced the range of blacks, whites and silvery greys which Boldini's fellow artists appreciated in his work, as they had in De Nittis before him. The *Portrait of Mme Max*, like the *Portrait of Robert de Montesquiou* (1897, Palais de Tokyo, Paris) is superbly handled within this limited range, enlivened here by the flesh tones and a bold splash of red on the lips. S.B.

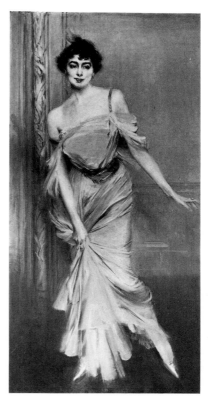

364

EXHIBITIONS
1896, Paris, Société Nationale (154)
REFERENCES
C. L. Ragghianti, E. Camesaca, *L'Opera Completa di G. Boldini*, 1970, no. 275, pl. XXXVII
Ferrara, Casa Romei, *Giovanni Boldini*, 1963 (30)
Paris, Musee Jacquemart André, *Boldini*, March–May 1963 (32)

Carrà, Carlo 1881–1966

Carra discovered Divisionism before visiting Paris in 1900 to work at the Exposition Universelle. He had seen the Segantini exhibition in Milan in 1899 and visited the Grubicy Gallery, and was friendly with F. Minozzi, an ardent follower of Segantini. Having seen Impressionist works in Paris in 1900, he spent some months among London Anarchist circles. He studied at the Brera in Milan under Cesare Tallone, 1906–8. Through frequenting the Famiglia Artistica Carrà met a number of other Divisionists. Having met Boccioni and L. Russolo and subsequently F. T. Marinetti around 1909, he signed the first *Futurist Painting Manifesto*.

365 *Milan Railway Station* *c.* 1909/10

> *La Stazione a Milano*
> ns. 80 × 90 cm/31½ × 35½ ins
> Lent by G. Trento, Milan

This little-known painting was, until quite recently, the property of the Co-operative of Painters and Decorators, founded in Milan in 1904, where Carrà was employed in 1904–6. He remained in touch with the Co-operative after he left, and it is possible that one of its directors, a Signor Gobbi, had a hand in commissioning the work. The painting, depicting workers at the old station in Milan at Piazza San Fedele, can probably be dated around 1910. The silhouettes of moving figures with their long shadows relate to a drawing, *The Workers*, dated 1910 and published in *L'Azione Cooperativa* in August 1911. The sense of rushing movement and the Divisionist touch itself are reminiscent of *Leaving the Theatre* (1909, E. Estorick, London) and relate to Boccioni's *The City Rises* of 1910 (Museum of Modern Art, New York). Influenced primarily by Previati in the development of his Divisionist technique, Carrà generally avoided the Decadent overtones of Previati's work. Here the train, bursting into the station in a blaze of light, is seen as a powerful modern image and, as such, is an immediate forerunner of the Futurist *Milan Railway Station* (Stuttgart, Staatsgalerie) of 1910–11. S.B.

REFERENCE
M. Carra, *Carlo Carra, Tutti gli Scritti*, 1978, p. 11

365

Grubicy de Dragon, Vittore 1851–1920

Born in Milan, from the early 1870s to *c.* 1889 Grubicy dealt in pictures, pioneering the work of the Scapigliati, of Segantini, E. Longoni and others. He introduced Segantini and others to the Divisionist technique and as an art critic defended it from 1886 to the mid-1890s. From 1884 he began to paint under the guidance of Anton Mauve. He became a well-known personality in Milanese artistic circles and encouraged the young Futurists, especially Romolo Romani and Carlo Carrà.

ABBREVIATIONS
AD – F. Bellonzi, T. Fiori, *Archivi del Divisionismo*, 2 vols, Rome, 1968
VV 1976 – M. Valsecchi, F. Vercelotti, *Vittore Grubicy de Dragon*, Milan, 1976

366

366 *At the Warm Spring* 1890/1901

> *Alla Sorgente Tiepida*
> sbr. V. Grubicy; sd and insc on rev. Vittore 1890,
> Novembre sopra Intra, Lago Maggiore
> 47 × 39.5 cm/18½ × 15½ ins
> Lent by the Civica Galleria d'Arte Moderna, Milan

The painting depicts a pool in the mountains below Miazzina with the Massone and the Eyehorn in the background (VV 1976, p. 42). Signed on the back, 'Vittore 1890, Novembre sopra Intra, Lago Maggiore', it was exhibited with this title in 1894. A label on the back in Grubicy's hand describes it as the 'X canto detached from the work Winter in the Mountains'. It formed the centre part of a triptych, *Winter in the Mountains*, shown in Venice in 1901 (V. Pica 1901, p. 50): *Snow/From the Window or Joyful Snow* (1896–1912, formerly Private Collection, Milan) was shown to its left and *Evening or Winter Sun* (1895–9, formerly Toscanini, Milan) on its right. *The Four Seasons* (*Spring*, 1897–1901, Civica Galleria d'Arte Moderna, Milan; *Summer*, 1897–1901, Galleria Nazionale d'Arte Moderna, Rome; *Autumn*, 1898, Galleria d'Arte Moderna, Venice; and *Winter*, 1898, Galleria d'Art Moderna, Venice) were exhibited directly beneath (Pica 1901, p. 50). In 1899 Grubicy wrote to Octave Maus, President of the Libre Esthétique where Grubicy showed part of the *Winter in the Mountains* polyptych that year, that the entire 'poem' consisted of about 20 paintings, subdivided into three or four groups, and that he dreamed one day to exhibit them all together (A. P. Quinsac, *La Peinture divisionniste italienne*, 1972, p. 241).

Although the painting was retouched before its exhibition in Venice, as a label on the back affirms, it remains typical of the artist's early period. The tiny flickers of paint are applied over a firm, chiaroscural preparation. The overall brownish tone and the subject matter itself recall the Barbizon School and J. F. Millet, whose influence Grubicy had first felt via his Dutch friends, Mauve in particular, and via the Lombard painter, Antonio Fontanesi.

Fontanesi had treated this same subject several times in the 1860s and 1870s, e.g. in *Woman at the Spring* (1865, Galleria Nazionale d'Arte Moderna, Rome). S.B.

EXHIBITIONS
1894, Milan, Esposizione Triennale di Brera (357)
1901, Venice, IV Esposizione Internazionale d'Arte (Room s20)
1902, Turin, 'Ars Nova', I Esposizione d'Arte Decorativa Moderna (20)
1913, Munich, XI Internationale Kunstausstellung (1135)
REFERENCES
AD, vol. 2, I.121/95
VV 1976, p. 42
V. Pica, *L'Arte a Venezia nel 1901*, 1901, p. 50
U. Bernasconi, in *Emporium*, April 1915, p. 245
Milan, Palazzo Permanente, *Mostra del Divisionismo Italiano*, March–April 1970 (24)
L. Caramel, C. Pirovano, *Galleria d'Arte Moderna. Opere dell'Ottocento*, II, 1975, no. 1199

367

367 *Winter in the Mountains, a Pantheist Poem: Morning* 1894/1911

Inverno in Montagna, Poema panteista: Mattino
sbr. V. Grubicy 75 × 56 cm/29½ × 22 ins
Lent by the Civica Galleria d'Arte Moderna, Milan

The painting depicts a view over Lake Maggiore in the direction of Ispra and Angera, with the town of Intra below, and the Lake of Comabbio seen as a blade of light in the distance (VV 1976, p. 36). Much the same view is seen in *Winter* (1898; Galleria d'Arte Moderna, Venice). First exhibited as part of a triptych, *Winter in the Mountains*, in 1899, *All Whiteness* (1894–1911; Civica Galleria d'Arte Moderna, Milan) was shown to its left and *The Wide Valley* (1894–1911, Civica Galleria d'Arte Moderna, Milan) on its right. A photograph attached to the back of the painting, inscribed 'Winter in the Mountains, a Pantheist poem in 8 paintings, 1894–1911', shows this upper triptych and five paintings below: from left to right, *Night* (1894–1911; Civica Galleria d'Arte Moderna, Milan); *El Crapp di Rogoritt* (1894–1911, Civica Galleria d'Arte Moderna, Milan); *The Spring* (1897, Private Collection, Milan) and *At Eventide* (1896, Civica Galleria d'Arte Moderna, Milan). On the back of *Morning*, Grubicy noted that it was the fifth in the series, that it had been started in 189? (the last figure is illegible), and that he had spent at least eight months on it.

In 1891 Grubicy had vigorously defended 'Ideist' art, in which Art's highest objective, the expression of Ideas, was to be accomplished by means of a special language: 'When the artist aims to express. . . . Ideas, objects which contribute to their expression should not be of value in themselves, but only as SIGNS, as letters of the alphabet: and these signs – however indispensable – are nothing in themselves: the Idea constitutes everything' (cf. V. Grubicy, *Tendenze evolutive delle Arti plastiche*, 1891, pp. 47–50). In Grubicy's later works, therefore, less emphasis is placed on particular motifs and more on mood, created by the 'orchestration' of colour controlled within a limited range of tone and line. Having observed, contemplated and annotated nature in formal and tonal harmonies, Grubicy could then continue the painting at a later date. The pastel *Morning* (c. 1894–1911, Museo Civico, Lodi) may be the preparatory, non-Divisionist 'annotation' for this painting.

Grubicy wrote that his almost religious contemplation of nature regularly led to synesthetic experiences: 'The colours and forms of a scene readily assume musical values, sometimes harmonizing in simple, gentle and melodic waves, sometimes becoming complicated in harmonic chords of close polyphony, so detailed as to suggest the sound of specific instruments and even to see numerous violin bows whilst I contemplate the white flashes of the silver birches, standing out against the blue sky and the dark green of the heather and gorse-covered mountains' (AD, vol. I, p. 111). The possibility of synesthesia had been discussed by the Scapigliati (Carlo Dossi, Giuseppe Rovani and others) in Milan, but Grubicy's concept of the musicality of a work of art also owes much to the French Symbolists. Whistler's 'Symphonies' and Signac's Opus numbers, reported in the Belgian review *L'Art moderne*, may have been known to him. S.B.

EXHIBITIONS
1899, Venice, III Esposizione Internazionale d'Arte (Room z18)
1909, Venice, VIII Esposizione Internazionale d'Arte (Room 32, 27)
?1909, Munich, X Internationale Kunstausstellung (570)
REFERENCES
AD, vol. 2, I.143/115
VV 1976, p. 36
V. Pica, *L'Arte Mondiale alla III Esposizione di Venezia*, 1901, p. 141
L. Caramel, C. Pirovano, *Galleria d'Arte Moderna, Opere dell'Ottocento*, II, 1975, no. 1207

368 Triptych: (left) *From the Window, Miazzina* (centre) *What Peace in Valganna!* (right) *Summer on Lake Como* c. 1894/1901

(left) *Dalla Finestra, Miazzina* (centre) *Che Pace in Valganna!*
(right) *Estate sul Lago di Como*
Lent by the Galleria Nazionale d'Arte Moderna, Rome

(left) *From the Window, Miazzina* 1898

s and insc br. Dalla finestra, Miazzina Grubicy
47.5 × 39 cm/18¾ × 15½ ins

REFERENCES
AD, vol. 2, I.111/88
VV 1976, p. 46
A. P. Quinsac, *La Peinture divisionniste italienne*, 1972, p. 194, pl. 7

(centre) *What Peace in Valganna!* c. 1894

sbr. V. Grubicy 36.5 × 62 cm/14¼ × 24½ ins

REFERENCES
AD, vol. 2, I.100/97
U. Bernasconi, in *Emporium*, April 1915, p. 252
C. Carra in *Il Primato artistico italiano*, August–September 1920 (in AD, vol. I, p. 69)
R. Boccardi, in *Eroica*, 1921, nos 73–6 (cf. VV 1976)

(right) *Summer on Lake Como* 1897/1901

sbl. V. Grubicy 48 × 40 cm/19 × 15¾ ins

EXHIBITION
1901, Venice, IV Esposizione Internazionale d'Arte (Room s. 16)
REFERENCE
AD, vol. 2, I.155/136

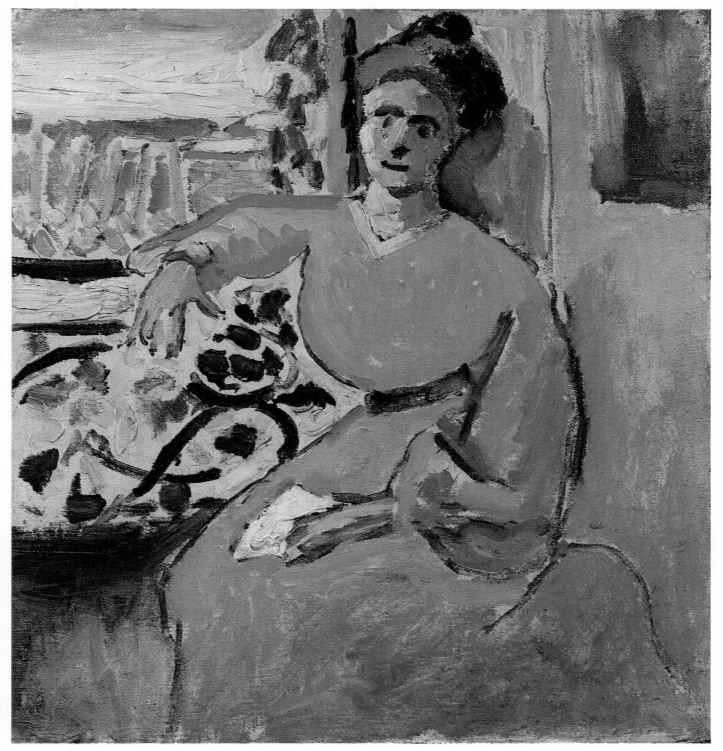

131 Matisse *Study for a Portrait* or *Woman in Front of a Window*

54 Cross *La Pointe de la Galère*

418 Toorop *The Shell Gatherer*

212 Signac *Presto (finale)* or *Breeze, Concarneau*

73 Derain *Fishermen at Collioure*

239 Vuillard *The Red Mantelpiece*

115 Le Sidaner *The Table – Autumn*

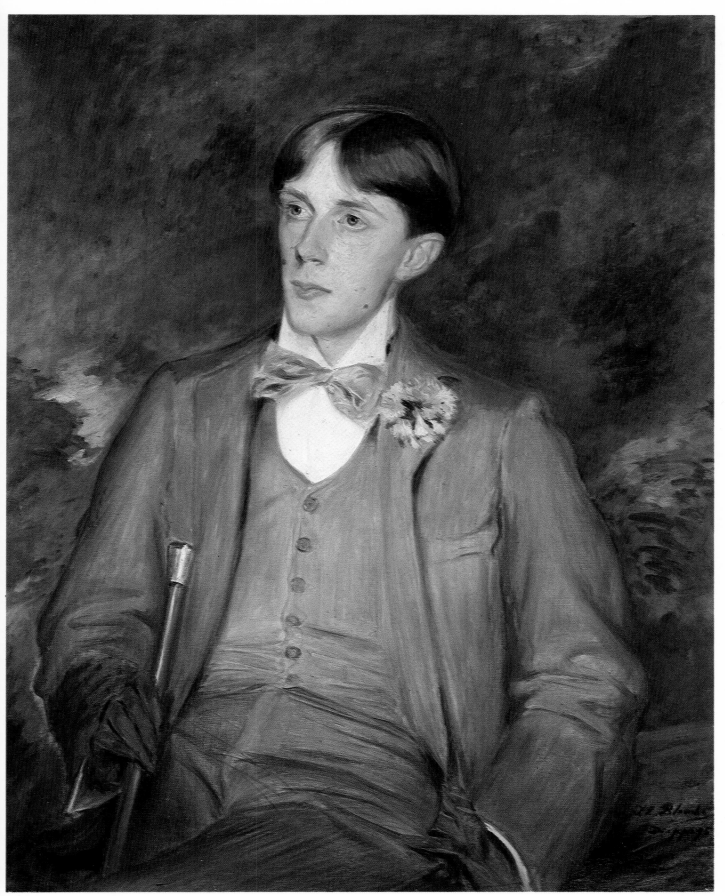

25 Blanche *Portrait of Aubrey Beardsley*

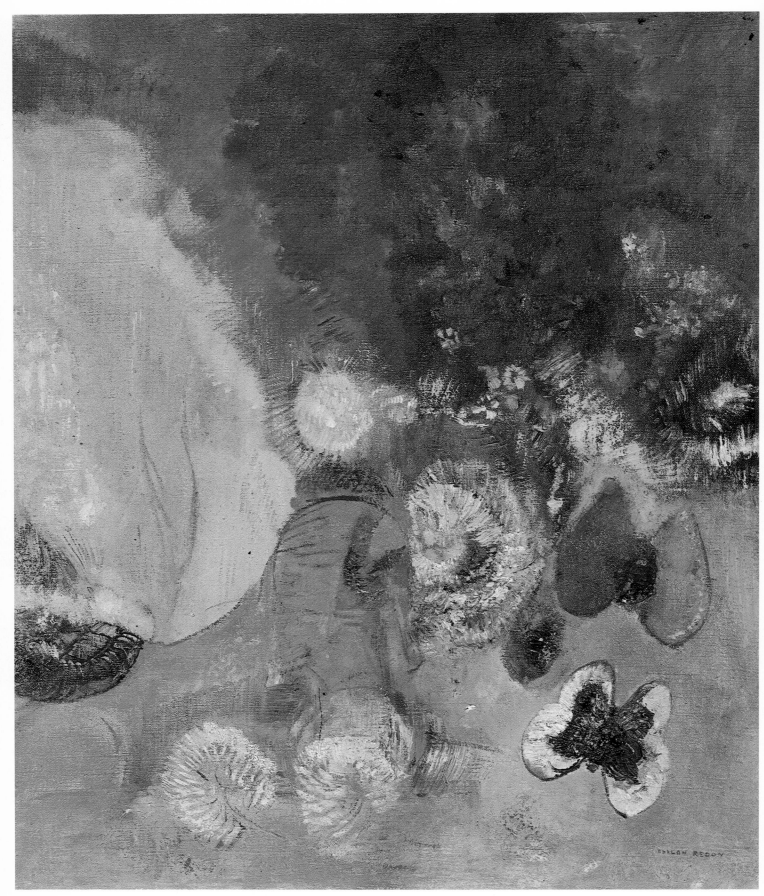

170 Redon *The Red Sphinx*

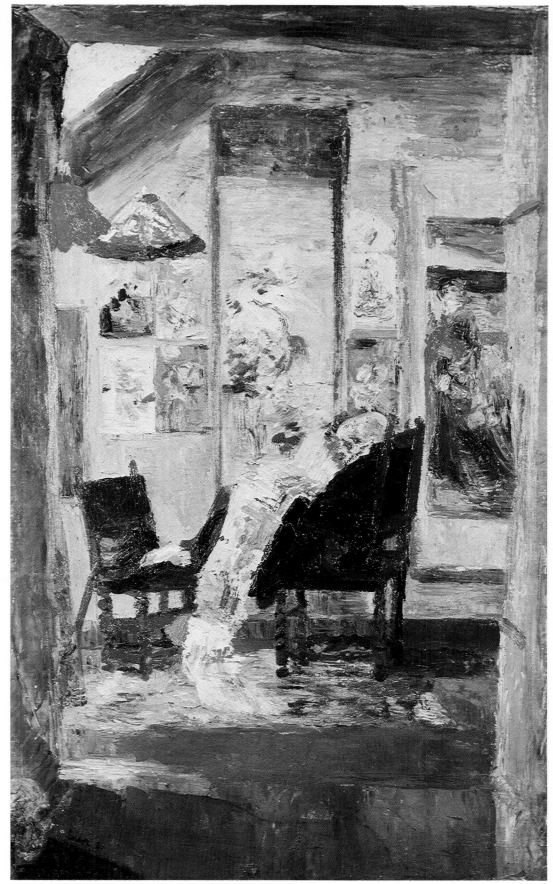

395 Ensor *Skeleton Studying Chinoiseries*

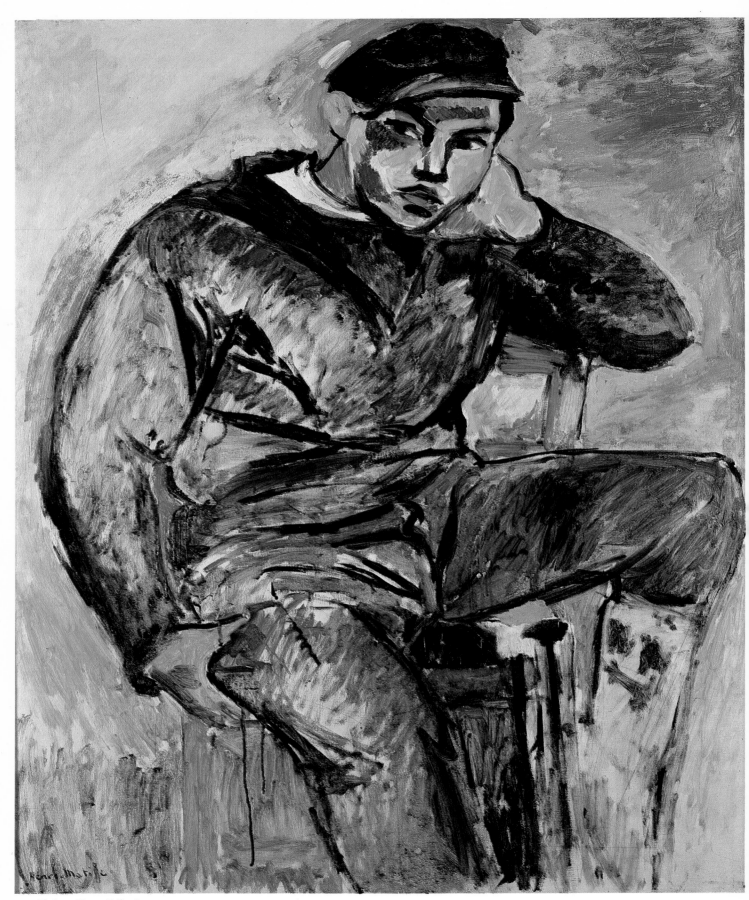

132 Matisse *Young Sailor I*

368

Although there is no evidence to suggest that Grubicy intended these particular works to be hung as a triptych (*Summer on Lake Como* in fact forms part of *The Four Seasons*, exhibited in Venice in 1901), their dimensions lend themselves to such an arrangement. One can, therefore, experience the type of religious effect which the artist sought in his two *Tenuous Trios*, executed *c.* 1907 (Florence, Galleria d'Arte Moderna and Turin, Galleria Civica d'Arte Moderna), and ultimately in the polyptych *Poem of Winter*.

From the Window, Miazzina depicts a view from Villa Pantaleoni looking towards the Eyehorn in the direction of Ossola (V V 1976, p. 46). Camillo and Arrigo Boito and the young Toscanini used to visit Grubicy there, when he was a guest over the winter months. The unusual composition undoubtedly reflects Japanese influence and is seen, to a lesser extent, in *Summer on Lake Como*. This may constitute further evidence of Grubicy's international culture, for Japanese art was very much the fashion in Paris; alternatively he may have been introduced to Japanese art still earlier by Fontanesi, who had taught in Japan during 1877–8. According to Primo Levi, by 1890 Grubicy had been studying Japanese art, religion and psychology (!) for over four years (P. Levi, in *La Rivista d'Italia*, 15 December 1899, p. 655).

What Peace in Valganna! was painted to commemorate his friend, the sculptor Giuseppe Grandi (1843–94), whose funeral in November at Ganna, a small lake situated between Lake Maggiore and Lake Lugano, inspired a number of works which occupied Grubicy for several years. With its simple lines and mirror-image, this painting best succeeds in creating the harmony and sense of peace which Grubicy sought to convey. S.B.

Morbelli, Alessandro 1853–1919

After studying at the Brera *c.* 1869–80, Morbelli turned to Divisionism before 1888 through his own experiments and after meeting Vittore Grubicy. His career began successfully and he won a number of major prizes. Morbelli was widely read in contemporary literature, aesthetics, social problems and the scientific and optical treatises behind Divisionism. Having resisted Albert Grubicy's attempts to sell an inferior version of Divisionism, he fell into relative obscurity after 1900. Morbelli remained firmly attached to a rigorous Divisionist technique, recording his theories and experiments in a diary, the *Via Crucis del Divisionismo*, 1912–19.

ABBREVIATIONS
AD – F. Bellonzi, T. Fiori, *Archivi del Divisionismo*, 2 vols, Rome, 1968
Tominetti 1971 – M. Poggialini Tominetti, *Angelo Morbelli*, Milan, 1971

369 *The First Letter* 1890

La Prima Lettera
sdbl. Morbelli 1890 104 × 78 cm/41 × 30¾ ins
Lent by O. Morbelli, Milan

In this painting Morbelli depicts his young wife, Maria Pagni, against the background of Rosignano Monferrato where the family had a country house. The subject of a woman reading a letter has precedents among both the Scapigliati and the Macchiaioli, but the setting of the figure and the attention paid to reflected light recall, in particular, Silvestro Lega's *Portrait of a Lady* (1883, Taragoni, Genoa). A. P. Quinsac suggests that the increased luminosity in Morbelli's work in the 1880s is explained by a visit to Paris and knowledge of Impressionism (*La Peinture divisionniste italienne*, 1972, pp. 123–4). It could, however, equally be the result of familiarity with works by the Macchiaioli, for Morbelli was in Florence at some time in the early 1880s (AD, vol. I, p. 127).

According to Grubicy, by 1888 Morbelli had, '. . . sometimes obtained the desired optical fusion of coloured lights without darkening them by mixing them on the palette or having recourse to the disagreeable and gaudy daubs of the pseudo-impressionists' (quoted Tominetti 1971, p. 30). Here, the artist's search for luminosity is achieved primarily by the traditional impasto technique. There are, however, traces of complementary colours (mostly reds and greens) in the cast shadow on the face and on the hands, applied in the fine, short brushstroke typical of Morbelli's Divisionist style. S.B.

369

REFERENCES
AD vol. 2, VI.39/1422
Tominetti 1971, p. 42.
Milan, Famiglia Artistica, *Mostra Commemorativa di Angelo Morbelli*, 1949 (3)
S. Pagni, *La Pittura Italiana della Scapigliatura*, Milan, 1955 p. 496
Milan, Palazzo Permanente, *Mostra del Divisionismo Italiano*, March–April 1970 (77)

370

370 *For Eighty Cents* 1895

Per Ottanta Centesimi
sdbr. Morbelli 1895 124 × 70 cm/48¾ × 27½ ins
Lent by the Civico Museo Antonio Borgogna, Vercelli

For Eighty Cents depicts peasants weeding rice-fields near Casale Monferrato. First exhibited in 1895, its title was extremely topical, for Italy had suffered a grave agricultural crisis in the early 1890s and wages dropped sharply. The work's social message was quickly recognized: P. Dini in 1895 noted that 'this terrible and deadly toil, rewarded with very little money, is well represented here,' while G. Martinelli referred in 1896 to the appalling conditions in which these women worked,' in the asphyxiating heat' and 'the stench of the waters of the rice-fields under the blaze of the June sun'. Morbelli makes no attempt to create pathos or genre, and the uncompromising, 'photographic' composition was much criticized at the time. A second work of c. 1896–1900 (recently rediscovered, AD, vol. 2, VI, 68/1442) presents a far happier compositional solution.

Morbelli worked on the painting throughout 1894, eliminating a figure at Grubicy's suggestion (AD, vol. 1, p. 123), exhibiting it in Venice in 1895 and retouching it before its exhibition in Turin in 1896 (AD, vol. 1, p. 125). In October 1894 he wrote to Pellizza of 'the impossibility of working from life, the changes in flora are such that, before finishing the work, there will be time to see the rice sown, weeded and harvested, with the painting still only half-done' (AD, vol. 1, p. 121). He resorted to photographs in the end, and Pellizza felt that the work suffered for it (cf. A. Scotti, *Catalogo dei Manoscritti di Giuseppe Pellizza da Volpedo*, 1974, pp. 48–9).

Other artists, including Favretto, Tommasi and Steffani, had been challenged by the extraordinary luminosity of the rice-fields in late nineteenth-century Italian painting. Steffani's *Rice-field* (c. 1864, Civica Galleria d'Arte Moderna, Milan) may have influenced Morbelli's row of figures (A. Scotti, *Il Quarto Stato*, 1976, p. 62). Guglielmo Ciardi's sharp and atmospheric paintings of the river Sile, dating from the 1870s, were also probably studied with care. Morbelli felt that the Divisionist technique, which enabled him to produce 'better results: atmosphere, light and the illusion of planes and tones' (V. Colombo 1895, pp. 78–9), was uniquely suited to the task. G. Martinelli in 1896 agreed, stating that, 'Morbelli has achieved perfection in the fusion of different colours and a

consequent transparency and luminosity which it would be hard to achieve better, either by this or any other hitherto unknown system.' Green predominates and, interestingly, is opposed by purple (its contrast in terms of light rays) rather than by its contrasting complementary colour (red). Colours are applied on a neutral ground with a specially devised, hard, three-pointed brush which makes the intricately woven brushstrokes run in parallel threes. S.B.

EXHIBITIONS
1895, Venice, I Esposizione Internazionale d'Arte (226)
1896, Turin, Promotrice, Esposizione Triennale, (211)
1899, Milan, Palazzo Permanente, Esposizione di Primavera (118)
REFERENCES
AD, vol. 1, pp. 121, 123, 125, 173, 175–6; vol. 2, VI. 58/1433
Tominetti 1971, pp. 69–72
P. Dini, in *Natura ed Arte*, 1894–5, XXIII, p. 888
V. Colombo, *Gli Artisti Lombardi a Venezia*, 1895, p. 77
V. Pica, *L'Arte Europea a Venezia*, 1895, p. 175
G. Martinelli, in *Emporium*, June 1896, pp. 451–2
Milan, Palazzo Permanente, *Mostra del Divisionismo Italiano*, March–April 1970 (78)
Milan, Palazzo Permanente, *Arte e Socialità in Italia dal Realismo al Simbolismo, 1865–1915*, May–September 1979

371 *The Christmas of Those Left Behind* 1903

Il Natale dei Rimasti
sdbr. A. Morbelli 1903 59 × 104 cm/23¼ × 41 ins
Lent by the Galleria d'Arte Moderna, Venice

The Pio Luogo Trivulzio, founded in Milan in 1776, housed by 1900 over 800 old men and women (A. Tedeschi, in *Illustrazione Italiana*, 26 August, 9 September and 16 September 1900). Morbelli first painted the old people's home in 1883 in his *Last Days* (Civica Galleria d'Arte Moderna, Milan). Over the next 20 years he produced over 20 oils, 15 pastels and many studies of the place (Tominetti 1971, p. 57); he set up a studio there c. 1902.

Morbelli's observation of life at Pio Luogo Trivulzio is sympathetic but dispassionate. Compared in his time to Hubert Herkomer, Morbelli may well have known Herkomer's pictures of the Chelsea Hospital and the Westminster Union, published in *The Graphic* from the 1870s. However, from the densely populated *Last Days* to the two small, distant figures of *Christmas at Pio Luogo Trivulzio* (1909, Museo Civico d'Arte Moderna, Turin), Morbelli's interest in the figures declines and the paintings become formal studies of light and atmosphere. Only in his drawings, many of them of extraordinary quality, does the artist maintain an interest in individual characters. The evolution of *The Christmas of Those Left Behind* from a pencil and conté study (V. M. Biganzoli Morbelli, Milan) to a pastel dated 1902 (A. Morbelli, Milan) to an oil sketch dated 1903 (Private Collection), in which he eliminates or changes the spacing of the figures, is typical of this formal game. A series of technical observations, relating either to this painting or to that of *Christmas at Pio Luogo Trivulzio*, demonstrate that Morbelli was primarily concerned with how the Divisionist technique could render different types of light:

371

reflected, shadows, full sunlight, the phenomenon of irradiation and atmospheric perspective (AD, vol. I, pp. 140–1).

The painting was among the first to be purchased from the Venice Biennale for the Galleria d'Arte Moderna in Venice. s.b.

EXHIBITIONS
1903, Venice, V Esposizione Internazionale d'Arte (35)
1905, Munich, IX Internationale Kunstausstellung (861)
REFERENCES
AD, vol. I, pp. 138, 241; vol. 2, VL79/1439
Tominetti 1971, pp. 56–8
V. Pica, L'Arte Mondiale alla V Esposizione di Venezia, 1903, pp. 151, 153
R. Pantini, in The Studio, October 1908, p. 66
Milan, Galleria Pesaro, Mostra Postuma di Angelo Morbelli,
 catalogue introduction by R. Calzini, 1929–30, pp. 27–8
R. Calzini, 'Angelo Morbelli, il Pittore dei "Vecchioni"' in Alexandria, 1936, no. 11,
 p. 289
S. Pagni, La Pittura Lombarda della Scapigliatura, 1955, p. 498

Nomellini, Plinio 1866–1943

Born in Livorno, Nomellini attended its School of Arts and Crafts 1878–84. He then studied in Florence under Giovanni Fattori, befriending Silvestro Lega, Telemaco Signorini, Diego Martelli and others of the Macchiaioli circle. Nomellini became an important figure in the Tuscan school of Impressionists. He associated with many famous figures of the day including Puccini, Mascagni, D'Annunzio, Eleonora Duse, Isadora Duncan and the artists Galileo Chini and Lorenzo Viani.

ABBREVIATION
AD – F. Bellonzi, T. Fiori, Archivi del Divisionismo, 2 vols, Rome, 1968

372

372 The Call to Work 1893

La Diana del Lavoro
sdbl. P° Nomellini 93 60 × 110 cm/23¾ × 43¼ ins
Lent by the Miniati Faucci Collection, Ancona

The painting depicts workers in the Sampierdarena shipyards near Genoa. The fact that it does not appear to have been exhibited after its completion may be the result of Nomellini's imprisonment for some months in 1894 during his trial for involvement in an Anarchist plot. Several artists, including Pellizza, Morbelli, Signorini and Fattori vouched for him at the trial. Probably influenced by T. Signorini, Nomellini showed an early interest in social themes; in 1889–90 he exhibited Strike (untraced) at the Florentine Promotrice, followed by Brick Makers (1889, Private Collection, Florence), part of a series depicting working men and women, in 1890–1.

Although the elongated format and some of the background figures recall the Macchiaioli, the daring, 'photographic' composition is without precedent in their work. The Divisionist touch is more assured than in the Gulf of Genoa (1891, fig. 18),

but is still tentative and, in its empirical Impressionism, is immediately distinguishable from its northern counterparts. Only the three foremost figures are Divisionist and then not systematically so: the hat, hair and coat of the principal figure, for example, are treated with the traditional impasto technique, as is the mass of figures behind. Smaller dashes of paint are applied directionally in the faces of the main figures, particularly that of the boy, and break up the overall surface, especially in the relatively empty foreground area which is enlivened by touches of pure colour – blue, Prussian blue, orange and occasional dashes of yellow, interspersed with a good deal of white. At a distance, the brushstrokes do not fuse entirely successfully but one can no longer distinguish the pure colours and the whole takes on a brownish, altogether more 'Ottocento' intonation.

Towards the turn of the century, Nomellini's work tended to lose its social relevance and to assume Idealist, D'Annunzian postures. Only in 1909 did he again depict a Shipyard (Galleria d'Arte Moderna Genova-Nervi, Genoa) – a colourful, dynamic work. It was exhibited that year at the Venice Biennale and may well have been of interest to the early Futurist painters. s.b.

REFERENCES
AD, vol. 2, IV.19/1047
F. Bellonzi, La Pittura Italiana, Il'900, 1963, pp. 51–2
F. Bellonzi, in Notiziario d'Arte, July–August 1966, p. 15
F. Bellonzi, in La Nuova Antologia, September 1966, p. 60
F. Bellonzi, in Civiltà delle Macchine, September–October 1966, pp. 50, 56
A. M. Damigellia, L'Impressionismo Fuori di Francia, 1967, pp. 20–1
Milan, Palazzo Permanente, Mostra del Divisionismo Italiano, March–April 1970 (154)
Milan, Palazzo Permanente, Arte e Socialità in Italia dal Realismo al Simbolismo,
 1865–1915, May–September 1979

373 The First Reading Lesson c. 1905

Prime Letture
sbr. Plinio Nomellini 167 × 167 cm/65¾ × 65¾ ins
Lent by the Civica Galleria d'Arte Moderna, Milan

After 1899 and the exhibition of Moonlight Symphony (1899, Galleria d'Arte Moderna, Venice) Nomellini used the Venice Biennale to promote his nationalist, mythological and Garibaldian epics, (concocted from a mixture of Stuck, Böcklin, D'Annunzio, Liberty etc.), which later generations rejected because of their content, but which often prove pictorially rich in colour and movement. At the

373

same time he executed a number of unpretentious *plein-air* portraits of his wife and children, in which the Symbolism of *The Son* (1908–9, Galleria d'Arte Moderna Giannoni, Novara) is the exception rather than the rule. *The First Reading Lesson* is the first of this series and was exhibited with the *Giovane Etruria* in Milan in 1906. In what was in some respects a rejection of the restrictions of Divisionist technique and a return to Impressionism, patches of sunlight filtering through the trees (a distant recollection of Silvestro Lega?) and coloured reflections are used to create a rich, decorative surface. S.B.

EXHIBITION
1906, Milan, Esposizione di Milano (Room XVI, 15)
REFERENCES
AD, vol. 2, IV.72/1060
L. Lucilio, in *Natura ed Arte*, 1905–6, XVII, p. 328: XVIII, p. 372
U. Ojetti, *L'Arte all'Esposizione di Milano. Note e Impressioni*, 1906, pp. 50–1
E. Moschino, in *Il Secolo XX*, June 1907, p. 457
V. Pica, in *Emporium*, December 1913
Livorno, Villa Fabbricotti, Florence, Palazzo Strozzi, *Mostra di Plinio Nomellini*, 1966 (25)
L. Caramel, C. Pirovano, *Galleria d'Arte Moderna, Opere dell'Ottocento*, 1975, III, no. 1920

Pellizza da Volpedo, Giuseppe 1868–1907

Pellizza studied at the Brera 1883–7 and with G. Puricelli and Pio Sanquirico; subsequently he attended the Accademia di San Luca and the Académie de France in Rome. Probably introduced to Divisionism by Nomellini, he first painted in this technique *c.* 1892. From 1894 he was in correspondence with A. Morbelli and G. Segantini, and with many literary figures of the day, e.g. G. Cena, Neera (Anna Radius Zuccari), U. Ojetti, A. Orvieto, V. Pica, G. Stiavelli and D. Tumiati. Pellizza spent time in Rome, Paris and Switzerland. He joined *Tendances Nouvelles*, directed by Paul Adam and Auguste Rodin, in 1905, and in June 1907 committed suicide.

ABBREVIATIONS
AD – F. Bellonzi, T. Fiori, *Archivi del Divisionismo*, 2 vols, Rome, 1968
MSS 1974 – A. Scotti, *Catalogo dei Manoscritti di Giuseppe Pellizza da Volpedo*, Tortona, 1974
A. Scotti 1976 – A. Scotti, *Giuseppe Pellizza da Volpedo. Il Quarto Stato*, Cultura e Classe 13, Milan, 1976

374 *The Procession* 1892/6

La Processione
scr. [on stone by river] Pellizza 86 × 158 cm/34 × 73 ins
Lent by the Museo Nazionale della Scienza e Tecnica, Milan

Pellizza began *The Procession* in 1892 (MSS 1974, p. 36) and completed it over 1894–5. He painted from life at Volpedo (A. Scotti 1976, p. 123) and had difficulty in finding the landscape exactly as he wished; he was therefore only able to work on it for a few months each year (MSS 1974, p. 51). Exhibited in Venice in 1895, Pellizza

retouched it before its exhibition in Turin in 1896, trying to eliminate the bluish tone which he had found unsatisfactory in another early Divisionist work, *In the Hayloft* (1892–4, fig. 16). He again retouched it and varnished it in November 1896, before sending it to Florence where it was probably not shown, having been previously exhibited elsewhere (AD, vol. 1, p. 193). The work was well received in Venice and Turin on account of its luminous and poetic qualities.

Originally entitled *Mysticism*, *The Procession* was intended to evoke a religious sense of peace. Pellizza believed that a work could be inspired by an idea and that the artist would then have to find suitable forms in nature to express it, or that nature itself could inspire Ideas: 'It was the avenue, shaded by poplars, which inspired in me the idea of *The Procession* because, in fact, it seemed to me that no other subject could have been more suited to that place at that time: the lines of the landscape themselves . . . are nearly all slightly curved [the 'tone' is given by the curved line which defines the upper part of the painting], and seemed to me to be strictly related to the gentle religious feeling, moving upwards, which predominates in the souls of the believers who advance, praying and singing, and the prayer and song rise up as one with that offered by the whole of illuminated Nature' (MSS 1974, p. 51).

Pellizza later regretted the figure of a woman leaning towards her child as 'a remnant of the academy' and out of harmony with the Ideal sentiment of the work (MSS 1974, p. 51). He probably suppressed the figure of a woman washing at the river, seen in a study of 1893 (A. Gatti, Turin) and still partially visible here, for the same reason. An oil-study of 1893 (Private Collection, Turin) probably shows the original proportions of the work, for a strip of canvas was later added to the left of the final painting. Pellizza was to treat the processional theme again in the *Dead Child* (Palais de Tokyo, Paris), between 1896 and 1902.

In *The Procession*, the gold border serves not only to increase luminosity but as a reminder of Quattrocento religious painting. The Secessionist frame was added after the artist's death. S.B.

EXHIBITIONS
1895, Venice, I Esposizione Internazionale d'Arte (Room C, 264)
1896, Turin, I Esposizione Triennale (226)
1897, Brussels, Exposition Internationale de Bruxelles (19)
1901, Vienna, Secession
1902, Berlin, Internationale Ausstellung
1903, Munich, Internationale Kunstausstellung (Room 46, 870)
1904, St Louis, Universal Exposition (Gallery, 126)
1905, Angers, Union International
1906, Rome, LXXVI Esposizione della Società di Amatori e Cultori di BB. AA. (44)
REFERENCES
AD, vol. 1, pp. 173–4, 176–8, 185, 193, 195–6, 205, 225, 228, 241; vol. 2, V.113/1261
MSS 1974, pp. 35–9, 51, 100, 111, 115, 125, 132
A. Scotti 1976, pp. 122–4
P. Dini, in *Natura ed Arte* 1894–5, XXIII, pp. 888–90
G. Martinelli in *Arte Illustrata*, June and July 1895
V. Pica, *L'Arte Europea a Venezia*, 1895, p. 175
G. Martinelli, in *Emporium*, June 1896, p. 452
D. Tumiat, in *Marzocco*, February 1896
G. Cena, in *Nuova Antologia*, October 1902
P. L. Occhini, in *Vita d'Arte*, April 1909, p. 191
M. Bernardi, in *Nuova Antologia*, 1939, vol. 1504, p. 239
Alessandria, Pinacoteca Civica, *Mostra del Pittore G. Pellizza da Volpedo*, 1954 (47)
Milan, Palazzo Permanente, *Mostra del Divisionismo Italiano*, March–April 1970 (54)

375 *The Mirror of Life (That Which the First One Does, the Others Follow)* 1895/8

Lo Specchio della Vita (E ciò che fa la prima, e l'altre fanno)
sdbc. [on painted frame] Pellizza 1895–98
centre panel 87 × 200 cm/34¼ × 78¾ ins;
total 132 × 291 cm/52 × 114¾ ins
Lent by the Civica Galleria d'Arte Moderna, Turin

374

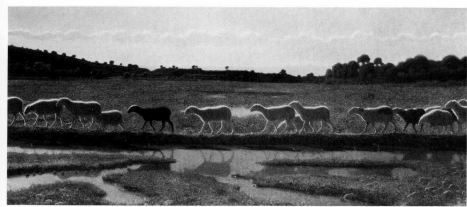

375

An oil-sketch, (Opera Card. Ferrari, Milan), dated Volpedo, 1 June 1894, is probably the first idea for this work. By February 1895 the painting was sketched out and Pellizza had given it a subtitle from Dante's *Divine Comedy* (Purgatory, Canto III): 'And that which the first one does, the others follow' (MSS 1974, p. 37). Exhibited with both titles in Turin in 1898, it was well received there, and subsequently also in Munich and Vienna. In 1906 it was purchased by the king of Italy.

Pellizza described the painting variously as 'Naturalist' (AD, vol. 1, p. 214) or 'Symbolist' (MSS 1974, p. 59) and he intended it to mark a new period of 'more refined technique' and 'balanced vision' (MSS 1974, p. 62). Pellizza painted the picture from life, and its Symbolism sprang from particular features of nature whose secrets the artist 'reveals' in a way comparable to G. Pascoli's contemporary poetry. The mood is similar to that of Segantini, who in fact advised him on the painting of the sheep, for which many studies survive (AD, vol. 1, p. 368), while technically it is unusually close to A. Morbelli, with whom Pellizza was in close contact during the execution of this work. Interested in the Pre-Raphaelites and Ruskin (MSS 1974, p. 54), he may have found a prototype in the theme and extraordinary luminosity of Holman Hunt's *Our English Coasts* (1852, Tate Gallery, London).

The unusual painted frame, intended as 'a means towards greater expression' (MSS 1974, p. 62) was later regretted by the artist, who found that its brown tone clashed with the landscape (MSS 1974, p. 90). S.B.

EXHIBITIONS
1898, Turin, Esposizione Nazionale di BB.AA. (561)
1900, Paris, Exposition Universelle, Italian section (79)
1901, Munich, Internationale Kunstausstellung
1901, Vienna, Secession
1902, Berlin, Internationale Ausstellung
1904, London, Earl's Court, Italian Exhibition
1905, Angers, Union International
1906, Rome, LXXVI Esposizione della Società di Amatori e Cultori di BB.AA.
REFERENCES
AD, vol. 1, pp. 135, 204–5, 207–9, 212, 214, 223, 225, 227, 230, 235, 368; vol. 2, VI41/1278
MSS 1974, pp. 37, 53–4, 56, 58–9, 62–3, 66, 89–90, 114, 116, 125, 129, 132–3
A. Scotti 1976, pp. 125, 133
P. Viazzi, in *L'Arte all'Esposizione del 1898*, 1898
E. Thovez, in *Emporium*, July 1898, p. 75
W. Ritter, in *Emporium*, July 1901, p. 62
R. Pantini, in *The Studio*, October 1908, pp. 67–8
P. L. Occhini, in *Vita d'Arte*, April 1909, p. 181
M. Bernardi, *Ventiquattro Opere della Galleria d'Arte Moderna a Torino*, n.d., p. 54
Alessandria, Pinacoteca Civica, *Mostra del Pittore G. Pellizza da Volpedo*, 1954 (40)
R. Barilli, in *L'Arte Moderna*, VI, 1967, pp. 307, 309
Turin, Civica Galleria d'Arte Moderna, *Il Sacro e Il Profano nell'Arte dei Simbolisti*, 1969 (303)

376 *The Fourth Estate* 1901

Il Quarto Stato
sdcr. [on top of wall] P. di Volpedo 1901
283 × 550 cm/111¾ × 206¾ ins
Lent by the Civica Galleria d'Arte Moderna, Milan

Pelliza intended *The Fourth Estate* to be his political and artistic manifesto. Begun in November 1898, the same year as the Bava Beccaris massacre of workers in Milan, it was to demonstrate the inevitable progress of the working class: '. . . true force lies in the intelligent and good workers who, with the tenacity of their ideals, oblige other men to follow them or to clear the way because retrograde power cannot stop them,' (MSS 1974, p. 60). The title, first adopted in February 1902 (MSS 1974, p. 95), may have been derived from Jaurès' *History of the French Revolution* which Pellizza had read *c.* 1900 (A. Scotti 1976, pp. 193–4).

The technical and ideological evolution of the painting occurred over a 10-year period (*c.* 1891–1902), and was closely connected with Pellizza's increasing adherence to socialism (cf. A. Scotti 1976, pls 1–50 and *passim*). His first sketches of striking agricultural workers date from *c.* 1890–1 (A. Scotti 1976, pls 1–4), around the same time as his association with the politically aware Nomellini in Florence and Genoa. A shared programme of socialist literature and theory to which Pellizza and Morbelli subscribed from 1894 onwards reinforced their humanitarian socialist beliefs. Pellizza joined the Peasants' and Workers' Mutual Aid Society in Volpedo *c.* 1890, becoming its vice-president in 1895. He sympathized with the problems faced by agricultural workers for, although Volpedo did not suffer the violent and often equally violently suppressed strikes in neighbouring areas, the agricultural crisis which affected the whole of Italy in the 1890s was reflected in that area by a high emigration rate (*Pellizza per il Quarto Stato*, 1977, pp. 16–17). Pellizza used the peasants of Volpedo as his models throughout, and the setting of the picture was established there as early as 1891 (A. Scotti 1976, pls 5, 6 and 9).

The first version of the work, executed *c.* 1892, was entitled *The Ambassadors of Hunger* (Private Collection, Biella), and depicts three male spokesmen for a distant crowd of striking agricultural workers; their poses are already those of the principal figures of *The Fourth Estate*. By July 1895 Pellizza had sketched out a new version of the work, entitled *Fiumana* (*The Living Torrent*, Ferraris, Biella), and then began a large Divisionist work (Private Collection, Turin). measuring 225 × 435 cm/88½ × 167¾ ins, on which he worked throughout 1896 and 1897. A woman and child now replace the right-hand 'ambassador' and the crowd becomes more compact and closer to the principal figures, as in the final version. The figures are

376

elongated and idealized, in keeping with the picture's new literary title. Pellizza wrote in August 1895 that it was 'an attempt . . . to raise myself above the vulgarity of subjects which do not conform to a strong idea. I am attempting Social painting . . . a crowd of people, workers of the soil, who are intelligent, strong, robust, united, advance like a torrent, overthrowing every obstacle in its path, thirsty for justice' (MSS 1974, p. 40). Following Max Nordau, Pellizza believed that 'Art must give the people a portrait of themselves, but embellished' (MSS 1974, p. 46), and this Idealism is also reflected in *The Fourth Estate*. In December 1896, finding *Fiumana* too dark, he retouched it and eventually abandoned this large canvas altogether. By May 1898 he had begun another work, *The Worker's Progress* (Private Collection, Alba), the immediate predecessor of *The Fourth Estate*, which initially bore this title (cf. MSS 1974, p. 124).

From November 1898 Pellizza worked up the main figures in almost life-size cartoons and transfered them on to the huge final canvas. Not only do his laborious methods recall those of Renaissance workshops, but the composition, the principal female figures and the significance of hand gestures all recall Raphael's *Stanze* in the Vatican (cf. G. Cena 1902, p. 741). Having modelled the figures in a light base on a white ground, Pellizza then superimposed a fine network of Divisionist brushstrokes (AD, vol. I, p. 220). By using pinks, rose madders, reds, oranges and browns, he succeeded in creating a warm, flesh-coloured, golden light. The range of colours is vast, from the brilliant violet sky (reds and blues juxtaposed) to the predominantly white foreground over which a myriad of pale greens, pale yellows, ochre, orange, rose and grey are applied. Dark blues, crimsons and violet are used in shadows. The picture surface is constructed from a variety of Divisionist brushstrokes, ranging from the long, vigorous horizontal lines of the immediate foreground, through the tiny, multi-directional strokes on faces and hands, to the green dabs of paint on the shirt of the principal figure to the left. Forced back into the distance by the enormous size of the painting, in places the observer no longer finds

the brushstrokes individually perceptible. Occasionally, however, as in the long streak of white down the nose of the left-hand leader or in the folds of the woman's dress, Pellizza abandoned Divisionism.

Pellizza intended to exhibit the work in Paris in 1900 and in Venice in 1901, but it was completed only in time for Turin in 1902, where he was bitterly disappointed at its reception. It did not win the Artists' Prize and even normally sympathetic critics, like V. Pica, remained reticent. Many critics found the work's expressive qualities stifled by the laborious, static, Divisionist technique, by what they considered its monotonous colouring and by its overt Symbolism:' [they] advance . . . in a calm and orderly manner, like a crowd of puppets moved by mechanical force; . . . with faces that say nothing; . . . they leave the spectator cold, as they will leave the capitalist or the authority towards whom this collective demonstration is directed, indifferent' (P. De Luca 1901–2, pp. 513–14). The critics, used to gruesomely realistic or pathetically sentimental depictions of the working classes, found this idealized version hard to accept; only socialist critics, such as G. Cena or E. Nicolello, appreciated its message (A. Scotti 1976, pp. 54–5).

The political content and size of the work made it hard to exhibit and it was not until 1907 that it next appeared in Rome, where it was ignored by most critics. The socialist popular press, however, made good use of the image between 1903 and 1906 (A. Scotti 1976, p. 55–6).

After 1902 Pellizza began to work on a series of *Glorifications* and *Idylls* of Symbolist and Pantheist inspiration, believing that such 'eternal subjects' would endure while specific political subjects would not survive the passage of time (MSS 1974, pp. 104–5). Later paintings with socialist themes, such as the *Bridge* (1904, formerly Fogliato Gallery, Turin) and *The Family of Emigrants* (c. 1906, Private Collection, Genoa), are not specifically political and are disguised or tempered by an idyllic mood. S.B.

EXHIBITIONS
1902, Turin, Esposizione Quadriennale (300)
1907, Rome, LXXVII Esposizione della Società di Amatori e Cultori di BB.AA. (391)

REFERENCES

AD, vol. 1, pp. 185, 187, 193, 195, 198, 216–17, 219–20, 225, 228–9, 232;
 vol. 2, v.169/1291
MSS 1974, pp. 39–40, 44, 46–9, 52–3, 60, 66, 68, 72, 76, 78–9, 81–2, 86–8, 91, 95, 97,
 99–100, 111, 114, 116, 118, 122, 124, 127, 131, 133, 137
A. Scotti 1976, p. 29 and passim
P. De Luca, in Natura ed Arte, 1901–2, XX, pp. 513–14
In La Quadriennale, Rivista dell'Esposizione, nos 1–12, passim, 1902
E. Ajtelli, in Emporium, October 1902, pp. 263–4
G. Cena, in Nuova Antologia, 16 October 1902, pp. 740–1
Comba (D. Mobac), in Il Supplemento del Caffaro, 3 November 1902
E. Nicolello, in Gazzetta del Popolo, 13 November 1902
R. Pantini, in Nuova Antologia, 1 November 1903, p. 134
Leonardo (M. Olivero), in Tendances Nouvelles, n.d., 1904, pp. 41–2
G. Stiavelli, in Avanti!, 4 March 1907
R. Pantini, in The Studio, October 1908, pp. 65, 68
P. L. Occhini, in Vita d'Arte, April 1909, p. 193
Alessandria, Pinacoteca Civica, Mostra del Pittore G. Pellizza da Volpedo,
 1954 (74), pp. 19–20
C. Maltese, Storia dell'Arte Italiana, 1785–1943, 1960, pp. 268–9
Milan, Palazzo Permanente, Mostra del Divisionismo Italiano, March–April 1970 (56)
L. Caramel, C. Pirovano, Galleria d'Arte Moderna: Opere dell'Ottocento, III, 1975, no. 2014
Turin, Foyer del Piccolo Regio, Pellizza per il Quarto Stato, March–April 1977 (5)
Milan, Palazzo Permanente, Arte e Società in Italia dal Realismo
 al Simbolismo, 1865–1915, May–September 1979 (128)

377 *Washing in the Sun* 1905

Panni al Sole
[repr. in colour on p. 163]
sdbr. G. Pellizza 1905 87 × 131 cm/34¼ × 51¾ ins
Lent by a Private Collector

Pellizza's silence about this work suggests that it was probably a study (A. Scotti 1976, p. 6). In his use of pure colour and synthetic outline he approaches the Neo-Impressionists, to whose influence, it has been suggested, Pellizza may have been exposed during a possible third visit to Paris (A. Scotti, *Mostra del Divisionismo Italiano*, 1970, p. 101), although there is no evidence to corroborate this. Pellizza was, however, in Paris in October and November 1900, where he noted Seurat's *The Harbour at Grandcamp* (1885, Rockefeller Collection, New York) at the Exposition Universelle (A. Scotti, in *Storia, Arte e Archeologia per le Provincie di Alessandria e Asti*, 1974–5, p. 72). He was more struck here by the work of Henri Martin and by the Impressionists – Monet in particular. Around 1903 he turned towards landscape painting and noted that his Divisionist technique was 'becoming quicker and easier, as is suitable for the depiction of the fleeting effects of nature, seen in the open air' (AD, vol. 1, p. 231) and that, as such, it was approaching a kind of Impressionism (MSS 1974, p. 107). S.B.

REFERENCES

AD, vol. 2, v.248/1369
A. Scotti 1976, pp. 48–9
E. Somaré, Pittori Italiani dell'Ottocento, 1949, pp. 41–2
Alessandria, Pinacoteca Civica, Mostra del Pittore G. Pellizza da Volpedo, 1954 (83)
New York, Guggenheim Museum, Neo-Impressionism, 1968 (164)
Milan, Palazzo Permanente, Mostra del Divisionismo Italiano,
 March–April 1970, pl. IV, p. 101

Previati, Gaetano 1852–1920

Born in Ferrara, Previati studied in Florence and at the Brera in Milan. His early works depict historical, patriotic or Romantic themes and, from the early 1880s, the religious works which culminated in the *Via Crucis* (1901–2, P. Benni, Milan) and in grandiose, Symbolist triptychs after 1900. Towards the end of the 1880s his palette lightened and his brushstrokes became freer, and by 1890 Grubicy had orientated him towards Divisionism. Previati published three treatises on Divisionism and painting technique, which were known to the Futurists, who initially held his work in high esteem.

ABBREVIATION

AD – F. Bellonzi, T. Fiori, Archivi del Divisionismo, 2 vols, Rome, 1968

378 *The Madonna of the Lilies* 1893/4

La Madonna dei Gigli
sbr. Previati 181 × 220 cm/71¼ × 86¾ ins
Lent by the Civica Galleria d'Arte Moderna, Milan

In January 1893 Previati wrote to his brother that he had sketched out 'A Madonna and child and a field of lilies . . . the effect depends on the proportion . . . tone – on the light [and] on "a certain something" which in vain is found in religious subjects of the past and which stems from the same sources' (AD, vol. 1, p. 278). An admirer of Botticelli and other Quattrocento artists, Previati wrote later that year that he was trying to capture an effect, 'finished like that of a fifteenth-century artist' (AD, vol. 1, p. 283). By January 1894 he had enlarged the canvas and sketched out the figure, still with no traces of divided colour, which was superimposed later on this structure (AD, vol. 1, p. 288). By February he was thinking of calling the work 'Light': 'If I manage to achieve the pictorial effect I am seeking it would be the most suitable title, nor would it be unfitting in the allegorical sense' (AD, vol. 1, p. 290).

Both here, and in the immediate antecedent of this painting, *Motherhood* (1890–1, Banca Popolare, Novara; fig. 13), Previati used the Divisionist technique to create light, which in his mind was associated with religious mysticism and with the Idealism which was to mark 'the milestone in the necessary transformation of present-day art' (AD, vol. 1, p. 272). Convinced that 'the new element essential to the art of painting, after the very important choice of subject, can only be based on the greater illusion of light produced by the painting' (AD, vol. 1, p. 280) and that it was impossible to convey new emotions by old pictorial methods, Previati considered Divisionism an intrinsic and inseparable part of the new Idealist art (AD, vol. 1, p. 281).

Like *Motherhood*, *The Madonna of the Lilies* was attacked both for its technique and for its new, Symbolist content. Rejected by the jury at the Brera in 1894, he was subsequently allowed to exhibit it 'at his own risk' (N. Barbantini 1919, p. 119). It was not generally well received (cf. L. Fortis 1895, pp. 90–1), but Pellizza saw it there and liked it (A. Scotti, *Catalogo dei Manoscritti di G. Pellizza da Volpedo*, 1974, p. 34). As E. Corradini noted in 1906, although the Madonna is lit from behind (and should, therefore, appear dark), she appears to be the light source, since the work was executed according to 'a spiritual truth of vision' and not according to reality. Only the lilies

378

were painted from life; the figures were done from memory
(N. Barbantini 1919, p. 101).

The painting, carried out in much the same colours and style as
Motherhood, consists of small dots in the background and long,
sweeping brushstrokes, typical of Previati's expressive style, in the
foreground. Greens, blues and yellows predominate but, although
Previati was one of the most rigorous theorists of Divisionism, his
colours are rarely applied pure on to the canvas and complementary
contrasts, according to Chevreul's chromatic circle, occur
sporadically in his work. Instead, colour was explored, as here,
within its own tones or closely related colours (cf. U. Boccioni,
'Gaetano Previati', 1916, repr. in AD vol. I, p. 57). S.B.

EXHIBITIONS
1894, Milan, Esposizioni Riunite
1901, Venice, IV Esposizione Internazionale d'Arte (Room R, 2)
1904, Milan, Galleria Grubicy
1906, Milan, Galleria Grubicy, *Mostre Collettive Segantini-Previati* Room D, 4)
1910, Brussels, Exposition Universelle Internationale
1910, Milan, Palazzo della Società per BB.AA., *Mostra Personale di G. Previati* (108)
REFERENCES
AD, vol. I, pp. 79, 278, 288–90; vol. 2, III.405/817
L. Fortis, *L'Arte alle Esposizioni Riunite di Milano*, 1895, pp. 89–91
E. Moschino, in *Natura ed Arte*, 1900–1, XX, pp. 766–7
S. Benelli, *La IV Esposizione d'Arte a Venezia*, 1901, p. 19
S. D. Paoletti, *L'Arte alla IV Esposizione di Venezia*, 1901, pp. 81–3
D. Tumiati, in *Emporium*, January 1901, pp. 9, 17
A. Locatelli-Milesi, *L'Opera di Gaetano Previati*, 1906, p. 20
E. Corradini, in *Nuova Antologia*, December 1906
V. Grubicy, in *Il Secolo*, January 1910
N. Barbantini, *Gaetano Previati*, 1919, pp. 101, 119, 131–2
Ferrara, Palazzo dei Diamanti, *Gaetano Previati, Mostra Antologica*,
 July–October 1969 (25)
A. P. Quinsac, *La Peinture divisionniste italienne*, 1972, p. 128
L. Caramel. C. Pirovano, *Galleria d'Arte Moderna, Opere dell'Ottocento*, III, 1975, no. 2111

Rossi, Gino 1884–1937

Little is known of Rossi's early artistic training. By 1907 he was in
Paris with the sculptor Arturo Martini where they met Modigliani
and Medardo Rosso. Fascinated by the work of Van Gogh, Gauguin
and the Nabis, Rossi visited Brittany, and on his return to Italy he
painted Brittany-inspired landscapes. He lived at Burano near
Venice 1911–15, where he was joined by E. Moggioli. L. Scoponich
and Pio Semeghini, all of whom exhibited at the Ca' Pesaro. Rossi
returned several times to France, where, after the First World War,
he 'discovered' Cézanne. He eventually went insane and spent the
last 20 years of his life in a mental asylum.

379

379 *Spring in Brittany* c. 1908

Primavera in Bretagna
ns. 27.5 × 36 cm/10¾ × 14½ ins
Lent by the Museo Civico, Comune di Treviso

Rossi's small, Brittany-inspired landscapes are rarely dated; *Spring in
Brittany* may have been executed from memory on his return to
Italy in 1908 (L. Menegazzi 1974, pp. 12, 14). Benno Geiger, who
knew both Rossi and Emile Bernard well, excludes the possibility of a
meeting when Bernard was in Venice in 1900 (1949, p. 18). Rossi
was, in fact, originally drawn to Paris to study with Hermen
Anglada, and his discovery of Gauguin, Van Gogh and the Nabis
seems to have been fortuitous. Though he adopted the synthetist
outline and palette (here somewhat subdued), Rossi avoided the
esoteric Symbolism of the Nabis and depicted simple landscapes,
seascapes and peasant life. In his portraits, however, he used Van
Gogh's and Gauguin's icon-like poses in works such as *The Girl with
the Flower* (1909, Private Collection, Treviso), adapting Van Gogh's
peasant types very successfully to the fishermen of Burano in *Man
with a Canary* (c. 1912, Private Collection, Milan) and *Fisherman in a
Green Beret* (c. 1913, Barnabò, Johannesburg). S.B.

REFERENCES
G. Marchiori, 'Gino Rossi', *Emporium*, May 1935, p. 281
B. Geiger, *Gino Rossi, Pittore*, 1949, p. 18
Rome, Galleria Nazionale d'Arte Moderna, *Gino Rossi*, 1956, pp. 52–6
Venice, Sala Napoleonica, *Primi Espositori di Ca' Pesaro, 1908–1919*,
 1958 (2), pp. 55, 168
Paris, Musée National d'Art Moderne, *Les Sources du XXe Siècle*, 1960–1, (602)
Milan, Galleria Gian Ferrari, *Gino Rossi, Pittore*, 1964 (2)
G. Perocco, *Le Origini di Arte Moderna a Venezia, 1908–1920*, 1972, p. 123
Treviso, Casa da Noal, *Gino Rossi*, catalogue by L. Menegazzi,
 September–October 1974 (15), pp. 12–14, 27, 29

Segantini, Giovanni 1858–99

After a difficult and later much romanticized childhood, Segantini
studied at the Brera c. 1875–9. He met Grubicy around 1878, signed
an exclusive contract with him in 1881, and was introduced by him
to Divisionism in 1886. His career divides into three main periods as
he moved higher up the Swiss Alps to paint: 1881–6, Brianza;
1886–94, Savognin (Grisons); and 1894–9, Maloja (Engadine).
Internationally the most famous Divisionist, he exhibited in Paris,
England and widely throughout Germany and Austria, becoming a
member of the Vienna Secession in 1898. His untimely death, while
working on the *Triptych of Nature* on the Schafberg, greatly
encouraged the Romantic myth associated with his name.

ABBREVIATIONS
Servaes 1902 – F. Servaes, *Giovanni Segantini, sein Leben und seine Werke*, Vienna, 1902
AD – F. Bellonzi, T. Fiori, *Archivi del Divisionismo*, Rome, 1968, 2 vols
Gozzoli 1973 – F. Arcangeli, M. C. Gozzoli, *L'Opera completa di G. Segantini*, Milan, 1973

380 *Idyll* 1882/5

Idillio
sbl. G. Segantini 56.5 × 84.5 cm/22 × 32 ins
Lent by Aberdeen Art Gallery

Segantini recalled this work as one of many pastorals executed in
the Brianza in which he attempted to 'reproduce [his] feelings,
especially in the evening, after sundown, when [his] soul was given
to sweet melancholy' (AD, vol. I, p. 375). The painting may be the
Idyll criticized by Grubicy in 1883 for its 'inconsequential tonal
contrasts' (AD, vol. I, p. 84, and Gozzoli no. 131), but Grubicy's words
could refer to any number of Idylls and, stylistically, it seems dateable
to the end of the Brianza period when the influence of J. F. Millet was
strong. The bright reds and greens suggest that it may even have
been altered later, at Savognin. The curious placing of the figures
and the suggestion of a wheel beneath the boy's legs also imply a
radical change of composition at some point; the almond blossom is
probably a later addition. In a coloured chalk drawing (pre-1894,

380

EXHIBITIONS
1889, Paris, Exposition Mondiale (156)
1899, Milan, Palazzo Permanente, *Esposizione di alcune Opere di G. Segantini* (34)
1900, Paris, Exposition Internationale Universelle (group II, class 7, 98)
1906, Milan, Galleria Grubicy, *Mostre Collettive Segantini-Previati* (Room B, ?9)
1907, Paris, Salon des Peintres Divisionnistes Italiens (289)
REFERENCES
Servaes 1902, no. 87
AD, vol. 1, p. 108; vol. 2, II.233/288
Gozzoli 1973, no. 289, pl. XXVII
St Gallen, Kunstmuseum, *Giovanni Segantini*, July–September 1956 (74)
Milan, Palazzo Permanente, *Mostra del Divisionismo Italiano*, March–April 1970 (4)
Hyogo (Japan), Museum of Modern Art, *Giovanni Segantini*,
 Travelling Exhibition, April–May 1978 (T33)
Milan, Palazzo Permanente, *Segantini*, December 1978–January 1979

Kröller-Müller Museum, Otterlo), executed some time after the painting, as was Segantini's custom, he lowered the viewpoint and rationalized the composition. S.B.

EXHIBITIONS
1906, Milan, Galleria Grubicy, *Mostre Collettive Segantini-Previati* (Room D, ?4)
1907, Paris, Salon des Peintres Divisionnistes Italiens (294)
1908, St Moritz, Ausstellung Pro Museum Segantini
1909, Paris, Salon Pro Musée Segantini
REFERENCES
Servaes 1902, no. 40
AD, vol. 1, pp. 84, 376; vol. 2, II.102/215
Gozzoli 1973, no. 131, pl. III
St Gallen, Kunstmuseum, *Giovanni Segantini*, July–September 1956 (33)
Milan, Palazzo Permanente, *Mostra del Divisionismo Italiano*, March–April 1970 (1)
Hyogo (Japan), Museum of Modern Art, *Giovanni Segantini*,
 Travelling Exhibition, April–May 1978 (T10)
Milan, Palazzo Permanente, *Segantini*, December 1978–January 1979

381 *The Return to the Sheepfold* 1888

Ritorno all'Ovile
sdr. [on fence] G. Segantini MDCCCLXXXVIII; monogram
br. 80 × 133 cm/31½ × 52½ ins
Lent by a Private Collector

This painting depicts Barbara Uffer ('Baba'), a local girl from Savognin whom Segantini often used as a model. It was the last of a series of Millet-inspired works by this title which he had begun in Brianza. However in comparison to the *Return from the Sheepfold* of 1882 (Private Collection, Galliate), this work shows a considerable increase in luminosity, although white and pale yellow, rather than pure colours, are used to create a moonlight effect. Complementaries are confined, as in the majority of Segantini's works, to reds and greens. The paint is applied in long, filamented brushstrokes in heavy, superimposed layers on the ground, where it creates a straw-like effect, and on the sheep, where it is used directionally to create form. The painting of the figures and farm buildings is more traditional, but there is a general tendency towards the simplification of outline which was to become typical of later Savognin works. S.B.

382 *Rest in the Shade* 1892

Riposo all'ombra
[repr. in colour on p. 162]
sdbr. G. Segantini 92 44 × 68 cm/17½ × 26¾ ins
Lent by the Gesellschaft Kruppsche Gemäldesammlung, Essen
(Villa Hügel)

A superb rendering of the crystalline mountain atmosphere of Savognin, over 1200 metres (about 3700 ft) above sea-level, the painting depicts 'Baba' in the garden of Segantini's home – or so Pellizza identified the spot, when in July 1906 he made a pilgrimage to the locations painted by Segantini in the Alps (cf. A. Scotti, *Catalogo dei Manoscritti di Giuseppe Pellizza da Volpedo*, 1974, p. 136). The same farm buildings appear in the background of *Cow in a Yard*, (1890, Private Collection, Zürich). Segantini had earlier experimented the daring contrast of a wide foreground area in shadow and a background bathed in sunlight in *Contrast of Light* (1887, Musées Royaux des Beaux-Arts, Brussels). The composition, with an almost horizontal fence and a figure placed at an angle to it, creating depth, can also be found earlier, in *Girl Knitting* (1888, Kunsthaus, Zürich).

In a letter of 1896, Segantini described his painting technique: he prepared the canvas with oil and gesso and then applied a ground of 'quite fluid, earth-coloured red' because he could not 'tolerate the white canvas before [his] eyes'. Having outlined his composition, using a long, fine brush he 'tempest[ed] the canvas with sharp, fine brushstrokes, laden with pigment, always leaving space between one brushstroke and the next, an interstice which [he filled] with complementary colours, if possible when the base colour [was] still wet, so that the painting fuses better'. His palette was a simple one, consisting of two whites, four reds, two yellows, two blues, two greens and two browns. This Divisionist technique resulted in 'light, atmosphere and truth' (AD vol. 1, p. 365).

Rest in the Shade closely corresponds to this description. Although the leaves to the left and parts of the figure are treated in a more painterly, traditional fashion, a fine Divisionist touch is applied over the vast majority of the canvas and is used directionally to define form; note, for instance, the contrasts of horizontal and vertical brushstrokes in the fence and farm buildings. In the foreground, the red base emerges between the thickly interwoven filaments of green, blue and yellow. Greens and steely blue-greys predominate, with touches of yellow, ochre, white and orange in the sunlit background. A brilliant dash of vermilion in the headscarf of the woman at the window immediately enlivens this area and is diametrically opposed to the signature. Very little black indeed is used, being primarily substituted by dark blue. Forms are simplified, as seen for example, in the 'blocked-in' shadows on the farm buildings, a tendency which was to culminate in the cloisonnist effect of *Hay-Gathering* (1891–8, Segantini Museum, St Moritz). S.B.

381

EXHIBITIONS
1894, Milan, Castello Sforzesco, *Esposizioni Riunite. Esposizione Segantini* (59)
1900, Budapest
REFERENCES
Servaes 1902 (99)
AD vol. I, p. 376; vol. 2, II.285/314
Gozzoli 1973 (326)
Hyogo (Japan), Museum of Modern Art, *Giovanni Segantini*, Travelling Exhibition, April–May 1978 (T36)
Milan, Palazzo Permanente, *Segantini*, December 1978–January 1979

383

383 *Love at the Source of Life* or *The Fountain of Youth* 1896

Amore alla Fonte della Vita or *La Fontana della Giovinezza*
sdbr. G. Segantini Maloja 1896 75 × 100 cm/29½ × 39½ ins
Lent by the Civica Galleria d'Arte Moderna, Milan

Segantini had painted many Naturalist versions of couples at a fountain during his Brianza period, and in 1896, at Maloja, he returned to the theme in full Symbolist vein. In a letter of October 1896 he described to Domenico Tumiati the somewhat abstruse concept behind the work: 'It represents the gay, carefree love of the female and the pensive love of the male, united by the natural impulse of youth and Spring. The path which they walk down is lined with flowering rhododendrons, they are dressed in white [pictorial representation of lilies]. "Eternal love" say the red rhododendrons; "eternal hope" reply the "evergreen pines". An angel, a mystic guardian angel, unfolds a great wing over the mysterious source of life. Living water springs from the living rock, both symbols of eternity. The scene is bathed in sunlight, the sky is blue; my eye used to delight in the sweet, harmonic cadences of white, green and red: I want to communicate this especially in the greens' (AD, vol. I, p. 363). Servaes and others have seen a moral counterpart in the *Source of Evil* or *Vanity* (1897, Private Collection, Milan).

Though the background was painted from nature, the figures are symbolic and the influence of the Pre-Raphaelites, Burne-Jones in particular, was one which contemporary critics quickly recognized (R. de la Sizeranne 1898, p. 374). The Quattrocento may have inspired Segantini's use of gold in the foliage on the right and in the angel's wings; he had adopted it when he first turned to Symbolist painting c. 1890, and it can be found in *The Punishment of Luxury* (1891. fig. 15) and in the hair of *The Goddess of Life* (1894–7, Civica Galleria d'Arte Moderna, Milan). Dissatisfied with the composition, the artist executed a variant in sanguine (G. Schäffer, Schweinfurt) the following year (cf. B. Segantini, *G. Segantini, Scritti e Lettere*, 1910, p. 133). Two years later, he executed a fan (Civica Galleria d'Arte Moderna, Milan) with a schematized, decorative version of the same scene in which the influence of Japanese art, introduced to

Segantini by Vittore Grubicy (P. Levi 1899, p. 655), is even more apparent. S.B.

EXHIBITIONS
1896–7, Florence, Festa dell'Arte e dei Fiori (566)
1897, Dresden, Internationale Kunstausstellung (2869)
REFERENCES
Servaes 1902, no. 54
AD, vol. I, pp. 362–3, 377; vol. 2, II, 338/414
Gozzoli 1973, no. 370
V. Pica, in *Marzocco*, 18 April 1897
B. Bibb, in *The Studio*, August 1897, pp. 144, 155
R. de la Sizeranne, in *Revue des deux mondes*, 15 March 1898, p. 374
D. Tumiati, in *L'Arte*, no. 6–7, p. 311
P. Levi, in *Rivista d'Italia*, 15 December 1899, pp. 663–4
Milan, Palazzo Permanente, *Mostra del Divisionismo Italiano*, March–April 1970 (12)
L. Caramel, C. Pirovano, *Galleria d'Arte Moderna. Opere dell'Ottocento*, III, 1975, no. 2315
Paris, Grand Palais, *Le Symbolisme en Europe*, March–July 1976 (214)

384 *The Representation of Spring* 1897

La Raffigurazione della Primavera
sdbl. G. Segantini 1897 116 × 227 cm/45½ × 89½ ins
Lent by the Fine Arts Museums of San Francisco,
Jacob Stern Permanent Loan Collection

The Representation of Spring was the last major work Segantini executed at Soglio during 1896–7, before undertaking the huge *Triptych of Nature* (1896–9, Segantini Museum, St Moritz). It was commissioned by the painter Rosenthal for a private gallery in America (probably the Stern Gallery, at which it had arrived by 1899; cf. B. Segantini 1910, p. 137). It was exhibited at the Munich Secession and retouched before being sent to America (AD, vol. I, p. 369). The artist himself described it as an example of 'naturalist Symbolism' (in AD, vol. I, p. 369), while his friend Tumiati defined this as a Symbolism 'drawn from the elements which the landscape itself offers, without the intrusion of abstract figures' (D. Tumiati 1898, p. 314).

In *Grief Comforted by Faith* (1896, Kunsthalle, Hamburg), Segantini had resolved the problem of combining his literary and naturalist Symbolism by raising the former to the 'Ideal' realm of the lunette and by treating the latter in the 'Real' world beneath. He was to adopt this solution in the *Triptych of Nature*. At the same time, he evolved a number of purely naturalist works, such as this or the *Return to the Native Land* (1895, Staatliche Museen, Berlin) which were Symbolist only in the sense that they were expressions of his intrinsic Pantheism; he believed that art should be 'a cult, emanating from the spirit. . . with its roots in nature, mother of life, and in contact with the invisible life of nature and of the universe' (AD, vol. I, p. 380). S.B.

EXHIBITION
1897, Munich, Secession (1535a)

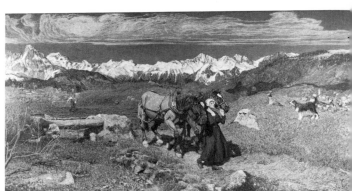

REFERENCES
Servaes 1902, no. 120
AD, vol. 1, p. 369; vol. 2, 11.341/383
Gozzoli 1973, no. 376
D. Tumiati, in *L'Arte*, no. 6–7, pp. 311, 314
P. Levi, in *Rivista d'Italia*, 15 December 1899, p. 673
B. Segantini, *G. Segantini, Scritte e Lettere*, 1910, pp. 99, 137
New York, Cultural Center, *Ottocento (Nineteenth Century Italian) Painting in American Collections*, Travelling Exhibition, November–December 1972 (52)

REFERENCES
AD, vol. 2, XXX.18/2745
P. Pacini, *Severini*, 1966, pp. 8, 25
F. Roche, 'Severini et l'héritage néo-impressionniste, 1906–1912', *L'Information de l'Histoire de l'Art*, no. 1, 1967, pp. 18–19
Paris, Musée National d'Art Moderne, *Gino Severini* 1967 (1)
Milan, Palazzo Permanente, *Mostra del Divisionismo Italiano*, March–April 1970, (145)
P. Pacini, 'Percorso Prefuturista di Gino Severini', 4, *Critica d'Arte*, March–April 1975, p. 47

Severini, Gino 1883–1966

Pointed by Balla in the direction of Divisionism, Severini associated with Boccioni and later, in 1906, met Pellizza in Rome. He then moved to Paris where Suzanne Valadon took him to two famous meeting-places for artists, the Mère Adèle and the Lapin Agile; there he met Utrillo, Utter and, later, Max Jacob, Juan Gris, Braque and Picasso. Although he signed the *Futurist Painting Manifesto* in 1910, he remained more attached to artistic developments in Paris than to those in Italy.

ABBREVIATION
AD – F. Bellonzi, T. Fiori, *Archivi del Divisionismo*, 2 vols, Rome 1968

385 *The Wafer Vendor* or *Avenue Trudaine* 1908

Le Marchand d'oublies
sdbl. G. Severini MCMVIII 59 × 72 cm/23¼ × 28½ ins
Lent by a Private Collector

Although Severini later recalled that he had been drawn to Paris by Seurat (*Tutta la Vita di un Pittore*, 1946, p. 117), his early work denotes no such influence and remains profoundly attached to Balla's teaching. He appreciated Impressionist work in the Musée du Luxembourg and at Durand-Ruel's gallery, but it was not until 1908 and the Seurat retrospective at Bernheim Jeune that he became familiar with Seurat's art. Lugné-Poë introduced him to Félix Fénéon around this time. The first fruit of Neo-Impressionist influence is to be found in *The Wafer Vendor*, in which the technique – pure colour, applied in dashes rather than small dots – is more reminiscent of Signac (whose works Severini could have seen at the Indépendants) than of Seurat. This is even more true of *Spring in Montmartre* (Private Collection, Milan), executed early in 1909, in which he reveals himself entirely free of the Italian Divisionist tradition. Severini later recalled staying in a hotel in the rue des Martyrs (running into the avenue Trudaine) which was frequented by the travelling salesmen of the Parisian boulevards. Severini would make a little money on commission by pretending to purchase goods, thus encouraging genuine potential buyers (*Tutta la Vita di un Pittore*, 1946, p. 74). S.B.

385

Zandomeneghi, Federico 1841–1917

Born in Venice, Zandomeneghi associated with the Macchiaioli in Florence 1862–74, after which he moved to Paris. In the late 1870s he frequented the Café de la Nouvelle-Athènes, meeting Degas and Camille Pissarro. His conversion to Impressionism came gradually and, largely at Degas' insistence, he exhibited with them in 1879, 1880, 1881 and 1886. In the 1880s he lived in rue Tourlaque near Renoir, Suzanne Valadon and Toulouse-Lautrec. 'Launched' by Durand-Ruel in the early 1890s, his reputation in France was overshadowed by Degas and Renoir, while fame in Italy came only after his death.

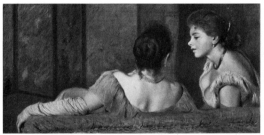

386

386 *Conversation* c. 1892

Conversation or *Causerie* or *Sul Divano*
sbr. Zandomeneghi 47 × 90 cm/18½ × 35½ ins
Lent by the Maria Grazia Piceni-Testi Collection

Zandomeneghi excelled in the portrayal of the *petites bourgeoises* of Paris, and a masculine presence is rarely felt in his work. *Conversation* is one of the finest of a series of similar subjects – women reading, chattering, listening to music – executed in the 1890s alongside more intimate boudoir scenes. His Titian-haired beauties with their porcelain complexions betray the influence of Renoir, and that of Degas is reflected in the unusual composition. The back view and partially turned profile are motifs found in many of Zandomeneghi's works, and the colouring, a delicate harmony of pinks and greens, is uniquely his own. Although painted in oil, the technique is directly related to that of pastel, his favourite medium from the 1890s. Relations between Degas and *'Le Venétien'* became strained in the 1890s when Durand-Ruel encouraged Zandomeneghi to create more bizarre compositions, imitating Degas, to sell in America. Signac, who had no taste for Zandomeneghi's work – 'glossiness, pomades, cold-cream and little women' – nevertheless remarked astutely that he never 'succeeded' in making them ugly (*Journal*, in *Gazette des Beaux-Arts*, April 1952, p. 278). S.B.

REFERENCES
E. Piceni, *Zandomeneghi, Catalogo Generale dell'Opera*, 1967, no. 143, pl. XV
V. Pica, *Mostra Postuma di F. Zandomeneghi*, Milan, Galleria Pesaro, 1922 (4)
M. Cinotti, *Zandomeneghi*, 1960, pp. 46–7, pls 36–8 and XIII
Paris, Durand-Ruel, *Zandomeneghi*, 1967, pl. 11

The Low Countries

Belgian Art: Les XX and the Libre Esthétique

MaryAnne Stevens

The jury at the official exhibiting Salon in Brussels in 1883 was particularly severe. A large number of paintings were rejected with, tacked on the back of each stretcher, an ignominious note addressed to the luckless artists: 'They should exhibit on their own.' Response to this advice was swift. On 28 October 1883, at the Taverne Guillaume on the Place du Musée, Brussels, 20 of the rejected artists and one lawyer from the Cour d'Appel, Octave Maus, met to draw up plans for the establishment of a new exhibiting body. Appropriately calling themselves 'The Twenty', or 'Les XX', they elected Maus as their secretary and agreed to hold annual spring exhibitions outside the confines of the Salon. Furthermore, they laid down the principles which were to assure this exhibiting body a place in the forefront of the European avant-garde. They allowed each member to exhibit six works; generally selected by each artist, these were hung as a group along a single hanging line, rather than being ranked up the walls as was the pattern within the Salon. Second, they voted to invite notable Belgian and foreign artists to exhibit with them at each annual exhibition. Third, they ensured flex-ibility and responsiveness to change within their group by establishing no aesthetic criteria and no fixed membership. And finally, they agreed to hold lectures, concerts, poetry- and play-readings in the galleries during each annual exhibition.[1]

This programme met with immediate enthusiasm from other artists. Félicien Rops, for example, wrote to Maus on 29 December 1883: 'What pleases me enormously about 'Les XX' is their disdain for a specific policy. A policy is already a rule. Rules represent order. And order and doctrine are stultifying!'[2] On 4 January 1884 an official charter was drawn up and signed by the 20 artists, with Maus empowered to invite Belgian and foreign artists in their name. The establishment of the group was announced to the public in a new review, *L'Art moderne*, and Les XX's first exhibition opened at the Palais des Beaux-Arts on 2 February 1884. The character of this first exhibition was governed by some of the members' concern to avoid excessive antagonism of the art establishment. Thus, a careful balance was maintained between landscape and figure paintings by Artan, Stobbaerts and Lambreaux which represented a continuation of the Belgian nineteenth-century colourist tradition, and those works of the new *plein-air* school represented by Ensor (no. 392), Van Rysselberghe

and Vogels (no. 427), who were beginning to experiment with a radical extension of the loose paint technique and bolder palette inherited from the French Barbizon School.

The exhibition's reception in the press was mixed. The more traditional critics, rightly recognizing it as a direct challenge to the monopoly of the Brussels Salon, castigated it for being, in the words of the *Courrier belge*, 'an exhibition of practical jokers, who only have contempt for the public, art, good taste and good manners'. Equally predictably, Les XX gained immediate support from the younger generation of Belgian writers such as Emile Verhaeren and Camille Lemmonier as well as from the newly established Belgian reviews, *L'Art moderne*, *La Wallonie* and *La Jeune Belgique*.

Les XX held annual exhibitions until 1893, when it was voluntarily disbanded and reformed, again under the guiding hand of Maus, into another annual exhibition body calling itself 'La Libre Esthetique'. A notable feature of both organizations was the speed with which they responded to changes taking place in Belgian and foreign art. Les XX rapidly accommodated the growing interest in the decorative arts *c.* 1890 by specifically slanting its invitation policy towards artists working within that field. The Libre Esthétique likewise absorbed the new *luminariste* group, Vie et Lumière, founded in 1904 by such Belgian artists as Anna Boch, Ensor, Claus and Heymans, by according it a central place within the 1905 exhibition devoted to 'L'Evolution externe de l'Impressionnisme'.[3] However, in order to understand fully the directions taken by these two exhibiting bodies and their impact upon Belgian and European art up to 1905, the emergence of Les XX should be seen against the background of political, social and cultural events in Belgium *c.* 1880.

In 1880, Belgium celebrated 50 years of independent statehood. The occasion was not altogether joyful. The economy was burdened with a costly colonial programme directed by the personal whim of the monarch, the socialist 'threat' loomed large, and the culture of the country was controlled by Paris. The standards of Parisian academic art were imposed upon both the Salon and the Académie Royale des Beaux-Arts, French literature was published freely through the absence of Belgian copyright laws and, to the horror of *L'Art moderne*, the Parisian theatre, especially the plays of Dumas *fils* was 'corrupting the taste of the Brussels theatre-going public'. It was primarily this domination

by Paris which was to affect the policies of Les XX.

The desire of Les XX to defy the Brussels Salon had been preceded by two other independent exhibiting bodies, La Chrysalide and L'Essor, the latter founded in 1882. While these two bodies were shorter-lived than Les XX, all three groups wanted to be seen not only as expressions of disgust with the traditional Salon but also as manifestos for Belgian art, a casting aside of Parisian cultural domination. This call to reassert Belgian national culture was also reflected in the establishment at the beginning of the 1880s of a number of periodicals: *La Jeune Belgique*, founded in 1880, and *L'Art moderne* and *La Wallonie*, both founded in 1881. Yet, despite their desire to promote true Belgian literature, these periodicals were also concerned to preserve the purity of the French language. Although superficially contradictory in intention, this latter concern reflects the fact that, despite Belgium being a country of two distinct linguistic groups, Flemish and French, French was the language of the educated elite. Thus, although Maeterlinck, Rodenbach and Verhaeren were Flemish by birth, they made their contributions in French to the Renaissance of Belgian literature in the 1880s. On the other hand, this concern to preserve the French language also had important consequences for the alliances established with France by these Belgian periodicals. Dismissal of the world of Dumas *fils* implied as hearty a dislike for the official school of French literature as Les XX's defiance of the Paris-dominated Salon. Thus, the literary reviews saw the fight against French domination of Belgian literature as an invitation to fraternize with the French literary avant-garde. Albert Mockel, the founder of *La Wallonie*, contributed to Paris avant-garde reviews such as *L'Ermitage* and *La Revue blanche*, while Verhaeren figured in *Ecrits pour l'Art* and *La Revue indépendante*. Likewise, French writers were published in the Belgian reviews. *La Wallonie* carried articles by Stuart Merrill and René Ghil as well as publishing Jacques Daurelle's interviews with Anquetin, Bernard, Denis, Bonnard and Toulouse-Lautrec, first published in *L'Echo de Paris*.[4] Similarly *L'Art moderne*, Edmond Picard's review, ran articles on Parisian avant-garde art by writers such as Félix Fénéon.[5]

The literary contacts established by the Belgian avant-garde reviews which had supported the first Les XX exhibition in 1884 are reflected in the pattern of the group's exhibitions. This can be seen in four areas: the balance between tradition and innovation, the geographic distribution of artists within each exhibition, the balance between the fine and the decorative arts, and the concept of the *Gesamtkunstwerk*.[6]

It was in the third Les XX exhibition, in 1886, that evidence of a significant shift towards progressive artists is first found. Les XX had now lost four of its more conservative members and replaced them with more innovative ones, Toorop, Anna Boch and Rops. Furthermore, in this year the French contingent included for the first time Monet, Renoir and Redon. By 1888 the shift was consolidated. Following the shock of Seurat's *Grande Jatte* (fig. 5), which had been exhibited at the 1887 Les XX, the group pursued an active policy of inviting artists in the forefront of French painting and established a bias towards Neo-Impressionism. Advocated by Maus in the preface to the 1888 catalogue,[7] this tendency towards Neo-Impressionism was expressed in the invitations extended to all the leading Parisian Neo-Impressionists and in the election of Signac as the second French member of Les XX in 1891. In 1892, through Signac, Les XX mounted a Seurat retrospective of 18 paintings, including no. 204 and several of his other major works. Furthermore, prominent Les XX members such as Finch, Lemmen, Van de Velde and Van Rysselberghe were converted to Neo-Impressionism.

The shift to Neo-Impressionism was not greeted with unanimous approval. An anonymous reviewer in *La Wallonie* summarized the anxiety over the trend when he wrote that:

> . . . the interests of the Les XX Salon [of 1888] certainly confirm the collapse of all previous formulae and their replacement by new interests and new theories. For some time now, light has increasingly preoccupied artists, and little by little, the brown tones and smudgy forms which haunted the canvases of the art of bygone days have disappeared. It would indeed be hard to better the glories of pure colour present in so much of the contemporary work – although, who knows? But on a more serious level, this only represents a change of theory and technique and the majority of the works exhibited at Les XX merely entertain the *eye* by their wonderful tonalities; there is a disturbing feeling which persists, namely, that some of these artists demonstrate complete ignorance of, or lack of concern for, the Idea.[8]

However, despite the reviewer's fears, painters of the Idea still made their presence felt in the subsequent Les XX exhibitions. Symbolism in Belgium was represented by Khnopff (cf. no. 403), Mellery (cf. no. 405) and Ensor (cf. no. 396), and in France by invitations to Anquetin, Gauguin, Redon, Bernard and Denis.

The geographic distribution of artists invited to exhibit at Les XX reflects its members' friendships and artistic links. The annual distribution between countries during the 10 years of exhibitions was uneven. Italy, for example, was represented only in 1885, 1886 and 1890, and by only three artists – Mancini, Michetti and Segantini (cf. nos 380–4). Germany and Switzerland fared even less well. The former was only represented in 1885 and 1889, although in both cases by distinguished artists (Von Uhde and Klinger), while Switzerland appeared only once, in 1885. However, Holland, England and France did far better, with Holland represented in all but three exhibitions, and England and France appearing in all.

In the case of Holland, the main connection came through Jan Toorop, elected to membership of Les XX late in 1884. Through him, invitations were extended in the early years to the established leaders of the Hague School such as Mesdag, Mauve and J. Israels, and later to such avant-garde artists as Breitner (cf. no. 388) and Thorn Prikker (cf. no. 413). Furthermore, it was through the enthusiasm of Toorop, aided by Van de Velde, that exhibitions organized by Les XX were held in Amsterdam in 1889 and in The Hague in 1892, the latter exhibition 'introducing' to the Dutch Seurat, Signac, Camille Pissarro, posters by Toulouse-Lautrec and the graphic works of Redon.

For England, the position was more complicated.[9] The invitees were divided between fine artists, Whistler (cf. no. 355), Sickert (cf. nos 355–7), William Stott (cf. no. 353) and Steer (cf. no. 345), and, from 1891, decorative artists – Walter Crane, Herbert Horne and Selwyn Image. The fine artists were invited either through associations with Paris, as in the case of Stott, Sargent (cf. no. 333) and Whistler, or through direct contacts with England. Both Toorop and Finch had English relatives. They both visited England during the 1880s, exhibited with the Society of British Artists and at the Grosvenor Galleries, and were thus well placed to spot potential invitees. Finch, for example, recommended both Rosa Montalba and Sickert to Maus, and Toorop may have discovered Steer. The invitations to the decorative artists came through Lemmen and Van de Velde. Lemmen owned a large collection of books illustrated by Walter Crane and could have suggested his name to Maus. Van de Velde knew Crane's political writings as well as the works of William Morris, both of which he used in preparing a series of lectures in 1889 entitled 'Le Reveil des métiers d'art et de l'artisanât en Angleterre et ailleurs'. It was primarily through him that 'an element which marked a certain antagonism to what was called "Impressionism" '[10] was brought into Les XX by 1891.

The presence of France at Les XX was firmly established in 1886 when the number of French invitees rose from five out of 18 in 1885 to nine out of 20; by 1888 the number stood at 13 out of 16 and the proportion thereafter never dropped below half. The contacts between Brussels and Paris, apart from those of the literary reviews, were also consolidated by frequent visits to Paris by members of Les XX, especially Van Rysselberghe, and participation by Les XX members in Paris exhibitions such as the Indépendants and the Salon de Rose + Croix.

A further aspect of Les XX, incorporated in 1894 as a dominant feature of the Libre Esthétique, was the shift from exclusive exposure of the fine arts to one which included the decorative arts. These had made their first tentative appearance at Les XX in 1888, but, fired by the presence in 1891 of illustrations by Walter Crane and of two vases, a statuette and two sculpted wood panels, *Soyez amoureuses* and *Soyez mystérieuses*, by Gauguin, the final Les XX exhibition of 1893 displayed a total commitment to the decorative arts. Not only was this clear in the work exhibited by three members, Anna Boch, Van de Velde and Finch, but also in the work of two of the 16 invitees – Bernard exhibited a screen and Besnard cartoons for eight stained glass windows.

The stage was now set for Les XX, followed by the Libre Esthétique, to take full advantage of Brussels' position at the cross-roads between England and France. Put very simply, Brussels imported the Arts and Crafts tradition through Crane and Morris and blended it with the non-naturalist, decorative tradition of Paris, represented in the work of Gauguin, Lautrec and Van Gogh, to produce an early formulation of Art Nouveau. While the Libre Esthétique pursued a rigorous policy of exhibiting the decorative arts until its demise in 1914, issuing invitations to designers such as Gallé, Daum et Frères, and Morris, the enthusiasm for the decorative arts already present within Les XX by 1891 encouraged similar developments in Paris.

The fourth area in which Les XX distinguished itself, and which was perpetuated in the Libre Esthétique, was a belief in the equality of the arts. Derived from Richard Wagner's theory of the *Gesamtkunstwerk* or 'total art work', which he had proclaimed in his music dramas and essays, Les XX asserted this theory at their first exhibition by inviting Catulle Mendès to lecture on Wagner, by including lectures by writers such as Picard and Rodenbach, and by organizing two concerts. All the events took place within the galleries of the exhibition. From then on, almost every Les XX and Libre Esthétique exhibition contained programmes of lectures, poetry-readings and concerts. Lectures were given by such stars of the literary avant-garde as Mallarmé (1890), Gustave Kahn (1891), Verlaine (1893) and Edouard Schuré (1899), on subjects which ranged from contemporary poetry, theatre, art and society to the work of fifteenth-century Belgian artists. Concerts consisted primarily of works by living Belgian and French composers, Franck, d'Indy, Ravel and Fauré – exceptions being made for Beethoven, Schumann and Bach – and often included the first performance of new compositions, such as Debussy's *Quartet in G Minor* (Op. 10), given on 1 March 1894 by the famous Ysaÿe Quartet.

Many of the artists' names which appear in the catalogues of the Libre Esthétique are little known today. Yet Marquet and Matisse (cf. no. 131) were invited to exhibit in 1906, and Vlaminck (cf. no. 228) the following year. Indeed, for Octave Maus, the driving force behind both this group and Les XX, the principles of no rules and continual response to the new in art remained constant throughout the course of the organizations. Maus reiterated the importance of freedom from rules on the demise of Les XX in 1893,[11] and he proclaimed the latter principle to illustrate the contribution that Brussels could make to European art in the manifesto of the Libre Esthétique: 'Enlightened art lovers, the members of the new society have one ambition alone: to support all manifestations of the new in art, be they Belgian or foreign, in all their manifold guises.'[12]

NOTES

1. M. O. Maus, *Trente années de lutte pour l'art, 1884–1914*, 1926, pp. 16–18.
2. M. O. Maus, *op. cit.*, p. 24, n. 1.
3. cf. O. Maus, preface to catalogue of 'La Libre Esthétique: la douzième exposition', 1905.
4. J. Daurelle, 'Chez les jeunes peintres', *L'Echo de Paris*, 28 December 1891, in *La Wallonie*, January 1892, pp. 73–7.
5. e.g. 'L'Impressionnisme aux Tuileries', *L'Art moderne*, September 1886.
6. For further information see individual catalogues to each Les XX exhibition, 1884–93, and M. O. Maus, *op. cit.*

7. O. Maus, 'La Recherche de la lumière dans la peinture', 1888.
8. 'Chronique des Arts–Salon des XX' (signed P. M. O.), *La Wallonie*, March 1888, p. 132.
9. cf. B. Laughton, 'The British and American Contribution to Les XX, 1884–1893', *Apollo*, November 1967, pp. 372 ff.
10. O. Maus, Fonds Octave Maus, Bibliothèque Royale, Brussels.
11. Statement made to Les XX, quoted M. O. Maus, *op. cit.*, p. 146
12. 'Manifeste de la Libre Esthétique', *L'Art moderne*, October 1893.

Painting in Holland

Joop Joostens

To understand the innovations in Dutch painting between 1880 and 1910 – the trends that set in after the Hague School (the Dutch equivalent of Impressionism in France) – it is necessary to distinguish between developments in The Hague in the wake of the Hague School and what was going on in Amsterdam. Without a knowledge of the background it is impossible to understand the disparity in the events that affected the evolution of art in Holland in those years, with its fundamental difference in outlook between the young generation of artists in The Hague and those in Amsterdam. The former group painted in an emotional and intuitive manner, entirely in the spirit of their famous predecessors, the Masters of the Hague School; the Amsterdam painters, on the other hand, followed a rational approach which they owed partly to their training at the Rijksakademie[1] and perhaps even more to the spiritual climate of the city, which was by tradition inclined towards rationalism and intellectualism.

The difference in starting-points between the Hague and Amsterdam artists, therefore, determined the roles they were to play in subsequent events. Contact between older and younger artists in The Hague was close, mainly because young artists still completed their training with a period in the studio of a more experienced painter;[2] as a result innovations were assimilated only gradually in The Hague – a logical consequence of the aims that the Masters of the Hague School had set themselves–and matured in the 1890s.

The young artists in Amsterdam, however, were trained at a new 'institute of higher education', and in their direct surroundings were confronted not with a dominant older generation of artists but with a cultural and social situation that was suddenly and rapidly developing after a lengthy period of stagnation. Just as the Masters of the Hague School were deeply respected by the next generation, the Amsterdam artists who were young in the 1880s (the 'Eighties Generation') were admired well into the twentieth century.

A final important consideration is the blossoming of art training in Amsterdam – an applied arts school by the name of Quellinus, orientated towards practical experience, was founded in 1879, followed in 1881 by the Rijksnormaalschool voor Tekenonderwijzers (State College for Drawing Teachers) and the Rijksschool voor Kunstnijverheid (State School for Arts and Crafts), where more attention was paid to theory and pure draughtsmanship. All three institutions were connected with the building of the Rijksmuseum. Combined with the reorganized Rijksakademie and a number of private art schools, the educational facilities of Amsterdam attracted talented artists, young and old, from all over the country, who came to Amsterdam and in turn contributed to the successive stages of innovation. The new appeal of Amsterdam was fatal to the developments taking place in The Hague, however promising they had been.

The National Salon held in The Hague in 1884 highlighted several developments in the work of advanced painters, both in that of the Masters of the Hague School, and in that of the younger generation. The paintings of the Masters, notably Jacob and Willem Maris, Anton Mauve, P. J. C. Gabriel, Willem Roelofs and J. M. Weissenbruch, were remarkable for the return of colour – during the 1870s they had used a predominantly grey palette. The work of the younger painters attracted attention either because of a 'criminal indifference to line and form' for the sake of 'harmony in colour, tone and movement', or because of a preference for the human figure. The former criticism applied to the work of the two young Hague artists, Breitner and Van der Maarel, the latter to that of a number of Amsterdam artists including Van Looy, Van Rappard, Van der Valk and Voerman, and to that of the young Hague artist Isaac Israels, son of the great figure-painter among the Masters of the Hague School, Jozef Israels. The tendencies revealed at this exhibition were to remain for some time.

The situation in The Hague in the early 1880s is characterized in a letter of July 1883 from Vincent Van Gogh to his brother Théo, telling him about the paintings he had seen in Breitner's studio:

Seen at a distance, they are patches of faded colour on a bleached, dusty, and mouldy wallpaper, and in this respect it has some qualities, which for me, however, are absolutely unsatisfactory. I cannot understand how it is possible for a man to make such a thing. It is like things one sees in fever, or impossible and absurd, like the most fantastic dream. I really think that Breitner has not quite recovered, and actually made these things while he was feverish.[3]

Apparently Van Gogh did not realize that artists like Breitner were already exploring the possibilities of colour to express the physical sensation of the world around them. Breitner was more interested in times and places where that world presented itself almost exclusively in terms of colour-planes, for instance the parade grounds of the brightly-uniformed cavalry stationed in The Hague, than in searching out situations dominated by human attitudes – the kind of scene that captivated Van Gogh. The sensation of colour, form and movement that artists such as Breitner sought to portray is directly linked with the portrayal of light which preoccupied the painters of the Hague School as well as the French Impressionists. Besides Breitner, the Hague colourists included Van der Maarel (1857–1921), Robertson 1857–1922), de Zwart (1862–1931), Tholen (1860–1931) and Bauer (1864–1932), and two painters who lived in Leiden: Verster (1861–1931) and M. Kamerlingh Onnes (1860–1925).

Of particular importance to the young members of the Eighties Generation was the emergence *c.* 1880 of a keen

interest among the art collectors of The Hague in the French art of the Barbizon School, in naturalists such as Courbet and the still-life painters Vollon, Philippe Rousseau and Ribot. This trend was bound up with the growing popularity of the young Masters of the Hague School, who were at that time becoming known as the leading innovators of art, and who professed an affinity with the French Barbizon School. The Barbizon School came to be known in Holland at that time as the modern French school of painting, and enjoyed that status for many years.

A prominent role in arousing this interest in French artists was played by the Hague art dealer H. J. Van Wisselingh (1816–84) and his son E. J. Van Wisselingh (1848–1912), who was then working in Paris. Also influential was the Hague subsidiary of the French art dealers Goupil (Boussod & Valadon). Two of the collections formed in those years still exist: that of the marine painter Mesdag in the Hague Rijksmuseum H. W. Mesdag, and that of Baron Van Lynden, bequeathed to the Amsterdam Rijksmuseum in 1900.

In June–July 1882 Mesdag and three other collectors in The Hague displayed their recently acquired 'modern' French paintings at the Hague Art Academy. Corot, Daubigny, Diaz, Dupré, T. Rousseau and Troyon were numerically among the best represented artists. Remarkably, there was not a single work by Millet, although considerable interest had already been shown in him by all the more advanced painters in The Hague and Amsterdam. His work did not reach Holland for several years. At the end of the decade E. J. Van Wisselingh, who had taken over his father's business in The Hague in 1884, introduced Monticelli into Holland. His glowing colours pleased the young Dutch artists and collectors. By organising exhibitions in Amsterdam, E. J. Van Wisselingh soon drew the attention of young collectors in Amsterdam to the Barbizon School, and their interest lasted longer than that of their colleagues in The Hague. This was largely due to the influence of the subsidiary firm set up by Van Wisselingh in Amsterdam in 1890.[4]

The cool, clear palette of the French Impressionists was considered too intellectual, too cold, and not expressive enough. This is perfectly illustrated by an experience described by Vincent Van Gogh. In summer 1888 Vincent, through his brother Théo, attempted to interest his fellow countrymen, especially E. J. Van Wisselingh, in recent French art, notably Impressionism and the work of Gauguin and his circle.[5] The canvases by these artists that Théo sent to the Hague branch of Boussod & Valadon were returned after some months. As far as we can tell no interest in them whatsoever was shown in Holland. Perhaps it was the Monticelli-like myriad colours that persuaded Baron Van Lynden to buy Monet's *The Corniche, Monaco* (1884) – for many years the only painting by a French Impressionist in a Dutch collection.

In October 1880 a group of students at the Amsterdam Rijksakademie founded the Sint Lucas Society. The founding member, Anton Derkinderen (1859–1925), and the other early members of the board – Eduard Karsen (1860–1941), J. Van Looy (1855–1930), M. Van der Valk (1857–1935), Jan Veth (1864–1925) and Willem Witsen (1860–1923)–were

to become known as the Innovators. The members' aim was to stimulate each other's interests in the fine arts, literature, drama and music, by organizing lectures and discussions. Its aim, therefore, was not only attuned to the nature of academic training at the time on both theoretical and practical levels, but also saw in it a challenge.

The foundation of this society underlines the difference in training and outlook between young painters in Amsterdam and those in The Hague. Apart from lessons in draughtsmanship and free painting the Hague artists had received an exclusively practical training, and in view of the small number of artists there the need for a society like Sint Lucas was never felt. Several of the young artists in Amsterdam, such as Van Looy (who was to make a name for himself as a writer), Veth and Witsen, soon came into contact with those contemporary poets and writers who were to become known as the 'Eighties Generation'. In 1885 they started publishing a new literary and cultural journal, *De Nieuwe Gide* (*The New Guide*), and asked their artist friends for contributions. Veth revealed himself in the journal as the mouthpiece of a generation in search of innovation, and was soon invited to produce work on a permanent basis by other progressive publications. He particularly admired the Masters of the Hague School, who owe their title of 'Master' to Veth's love of their work. His frequent reference to the art of Barbizon and everything Van Wisselingh brought to Holland, and his lack of enthusiasm for French Impressionism and Neo-Impressionism, helped to shape the opinions of Dutch artists and collectors about contemporary French art.

It is thanks to the Amsterdam artists, and to Veth in particular, that De Nederlandsche Etsclub (The Dutch Etching Society) was founded early in 1885. The society published portfolios and put on exhibitions to interest the public in the neglected art of engraving. The shows soon expanded to include drawings as well as prints, and by inviting foreign artists to participate the society developed in a similar way to the Belgian group, Les XX. Moreover, its founders did not concentrate exclusively on their fellow Amsterdam artists, but from the outset were in close contact with young artists in The Hague. This resulted in a fruitful period of collaboration in the arts. The society lasted for ten years, and organized eight exhibitions.

In winter 1886 Breitner moved from The Hague to Amsterdam; he may have felt the need for a more thorough academic training, or perhaps he was attracted by Amsterdam's cosmopolitan atmosphere or by its blossoming cultural life. Early in 1887 Isaac Israels (1865–1934) also left The Hague for Amsterdam. Until then he had had little contact with the artists of his generation, but once in Amsterdam he soon became one of its leading members.

The impact of Amsterdam on Breitner and Israels was considerable, but the mark they left on the city was no less great. The young Amsterdam painters, who, it seems, had until then concentrated on realistic figure painting, came under the spell of the art of *sensation* in the later 1880s. In this new trend realistic forms became subservient to the orchestration of full-bodied, contrasting colours, or merged into symphonies in virtual monochrome – representations of

studio interiors, street views, canals and landscapes bathed in evening light or seen in misty weather. Among the leading Amsterdam exponents of *sensation* art were Karsen, Van Looy, Jan Voerman (1857–1941) and Witsen. Veth, being a portrait painter, remained faithful to realistic forms. Derkinderen took a quite separate position, tending towards a monumental idealism in the style of Puvis de Chavannes, whose work he greatly admired.

Impressions, *sensations*, visions, orgies, symphonies of colour – all these terms recur in the review of exhibitions held between 1887 and 1893, and especially of those shows which focussed on the work of the younger artists such as the exhibition held in Leiden to celebrate the opening of the extension to the Museum in 1890, and the exhibitions held in the following years in Utrecht and Amsterdam for the five-yearly university celebrations. These three shows allowed them to display their common ideals and their affinity with the Hague School, and their conviction that Dutch art was regaining its old strength and vitality.

Also highly appreciated, alongside the work of Monticelli, was the late work of Matthijs Maris, and his aloofness as an artist held a strong appeal for the Eighties Generation. Here, too, Van Wisselingh provided the link.

In April 1890 Jan Toorop (1858–1928) returned to Holland for good after spending nearly eight years in Brussels. He had studied at the Amsterdam Rijksakademie from 1880 to 1882, and had been a member of Sint Lucas, becoming friendly with Veth, Van Looy and Derkinderen; he did not neglect these contacts when he moved to Brussels. In fact, he seized every opportunity of bringing his Dutch and Belgian friends and their work together. He became a well-known figure, and acquired a great reputation, especially in Holland. He did not disappoint his public.

Surprisingly, Toorop did not settle in Amsterdam or in The Hague, but in an isolated fishing village to the north of The Hague, Katwijk aan Zee. He became obsessed with the harsh, insecure existence of the fishermen and their families. Evidently the cosmopolitan city of Brussels, where he was regarded by the most progressive circles, notably Les XX, as a gifted and original artist, did not allow his innermost feelings to crystallize into the dominant theme of his work: the realization that the experience of living means a constant battle between life and death. His Impressionist work is remarkable for his preoccupation with expressing the inner emotions of the people he portrayed. His paintings suggest that he must have been particularly interested in the way human beings unite in the face of disaster and death, and he probably hoped to find that human solidarity and struggle in its purest form in the fishing community of Katwijk, which he no doubt considered representative of a natural society unaffected by the modern world. He aimed in his Katwijk paintings to give visual form to this consciousness, and they reveal his perseverance in a search for adequate, expressive forms. To achieve this, he explored the potential of all the innovations he had encountered in Brussels – the Divisionism of Seurat and Signac, the Cloisonnism of Gauguin and his followers, the expressive handling of Van Gogh, and Japanese prints and enamels, which were then considered highly

modern. All these influences produced a highly personal style based on strong colour contrasts and a succinct, expressive, linear treatment.

When Toorop exhibited the results of a year's painting in Holland in a series of exhibitions in summer 1891, he was instantly recognized as the most important innovator of the day. On the surface his work was in line with current Dutch colourism, but its content was very different.

During 1892 Toorop's art underwent several profound changes. Colour was almost totally suppressed in favour of line and contour, the brush was replaced by the pencil, and representations of reality ceded to allegorical and symbolic themes – in other words, the personal element made way for a more collective underlying concept. Similar changes in form and content soon appeared in the work of Toorop's contemporary Derkinderen, and in that of numerous other, mostly younger, artists, notably Thorn Prikker and Roland Holst (1868–1938). These four artists became the leading exponents of Dutch Symbolism. Whereas art had been almost synonymous with colour in 1891, less than two years later the treatment of line had become all-important. A new generation had appeared on the scene.

Toorop's influence extended beyond his art. In winter 1891 he joined the board of a new artists' society, the Haagsche Kunstkring (the Hague Art Circle), which embraced all artistic disciplines in accordance with the Wagnerian notion of *Gesamtkunst*. He set to work at once with enthusiasm to end the isolation of Dutch art. In May 1892 he organized, on behalf of the Kunstkring, the first major Van Gogh exhibition, and in July–August he assisted Les XX in presenting the work of the leading French and Belgian Divisionists Seurat, Signac, Pissarro, Van Rysselberghe, Van de Velde, Lemmen and Finch, as well as posters by Toulouse-Lautrec, and, at his special insistence, drawings by Redon. The response to this Les XX exhibition was considerably more gratifying than it had been for the one he had mounted in Amsterdam in 1889.

Particularly important was the visit Henri Van de Velde paid to the exhibition in The Hague and the relationships he established with Dutch artists. In October–November 1893 the Haagsche Kunstkring included works by Monet, Renoir, Sisley and C. Pissarro at one of its regular showings of members' work. Great though the response to these shows may have been, however, it was wholly concentrated in The Hague. That city consequently acquired a strongly international orientation, looking particularly towards Brussels and Paris. Toorop, who had moved from Katwijk to The Hague in 1892, was to play a decisive role in subsequent developments.

These events are echoed in the work of several younger artists who had mastered the principles of Divisionism: Aarts in The Hague, and Bremmer and J. Vijlbrief (1868–95) in Leiden. Aarts, who was to become famous especially for his graphic work, soon abandoned Divisionism. Bremmer adhered to it, even though he gave up his career as an artist in favour of teaching and writing. Through his lessons and publications he encouraged artists and art collectors to adopt a more international critical attitude, and to value the light, clear palette so rarely used in Holland then. Many of his ideas

are reflected in the collection of the Rijksmuseum Kröller-Müller at Otterlo, which owes its existence to the advice Bremmer gave to one of his most eminent pupils, Mrs H. Kröller-Müller.

Toorop returned to Divisionist painting in 1897, but a convincing explanation for this return has yet to be found. Whereas his work of 1889–91 was more Pointillist than Divisionist in style, he now kept strictly to the formal ideas upon which Divisionism was based. After several years of Symbolism, complex in form and content, he must have felt the need to reflect on problems of a purely painterly order. He went back to Katwijk, but this time he was interested solely in the subtle light-changes above the sea and the dunes. Although he exhibited his work regularly, from then on he had few followers.

Thorn Prikker, who had abandoned 'fine' art in 1895 to devote himself to design, also surprised the public in 1901 with a series of Pointillist pastels of landscapes painted in summer 1900 in the vicinity of Visé near Liège, Belgium; during the following four summers he was similarly occupied. Like his Symbolist works, these drawings are more abstract and intuitive, and less intellectually conceived than Toorop's Divisionist paintings and drawings.

In 1901 Toorop and Thorn Prikker, together with two other artists from The Hague and the young physician and art collector W. Lauring, organized the 'First International Exhibition', with works by the Frenchmen Cross, Denis, Luce, Maufra, C. Pissarro, Redon, Signac, Steinlen and Vuillard, and the Belgians Claus, Degouve de Nuncques, Ensor, Morren and Van Rysselberghe. Remarkable in this display of the work of living artists was the inclusion of three paintings by Van Gogh and four by Cézanne, all lent by the Hague collector M. Hoogendijk.

It was typical of the situation in Holland at the time that this 'First International Exhibition' failed to influence what artists were doing at home. The Hague had forfeited its leadership of the art world, and was accused of betraying the Dutch cause to foreign whims. The country's creative minds were now drawn towards Amsterdam, where there was so much novelty and mutual inspiration that there was no need for a more international orientation. In the end even Toorop could not resist the attraction of Amsterdam. His first major exhibition there was held in 1904, and he even moved to Amsterdam. In the meantime he had started painting with a broader brushstroke, as Signac and Van Rysselberghe had been doing for some years. As in his earlier Neo-Impressionist period, he tended towards the more expressive brushstroke, but now colour was his point of departure.

Little or nothing of the developments in The Hague during the 1890s left its mark on Amsterdam. After the excitement of the 1880s, artists in Amsterdam apparently felt the need for a period of reflection. Their work shows increasing concern for tightly structured compositions based on a grid of horizontal and vertical elements, for firmly defined forms and carefully matched colours. However, dark shades still predominate. Even Breitner, who quickly won his fellow artist's respect with his emotional paintings, preferred, after 1893, peaceful, balanced, clearly defined forms and harmonious colours. The

Barbizon School and the late Hague School still continued to provide them with examples, and the flower and fruit still-lives of Fantin-Latour, with their balanced composition and harmonious colouring, were also a significant influence. Interest in these two schools was also shown by the art dealers of Amsterdam, among whom the firms of Buffa and Preyer, besides E. J. Van Wisselingh, had now risen to prominence.

The Amsterdam Stedelijk Museum for modern art was opened in September 1895, to accommodate the steadily expanding National Salon which was held every three years, and to house the collection of a society which had been formed in 1874, mainly by Amsterdam art collectors, to provide the city with a collection of modern art. By the time it moved into its new premises the society was run by a younger generation of members, whose admiration for the French art of Barbizon and the late Hague School was more outspoken than that of their predecessors. Thanks in part to the extended loans from two of these members, Amsterdam soon boasted a notable collection of paintings of those schools.

However, interest in more recent international developments remained slight, as was shown by the cool reception given to several exhibitions – a small show of works by Monet, Pissarro, Renoir, Sisley, d'Espagnat, Maufra and Moret, held in the Amsterdam artists' society Arti et Amicitiae early in 1900; the large retrospective of Toorop in the Buffa Gallery in February 1904; and the Van Gogh retrospective in summer 1905 organized by Théo Van Gogh's widow in the Stedelijk Museum.

In this fairly self-centred artistic climate Piet Mondrian (1872–1944) received his academic training between 1892 and 1896. Until c. 1906 his paintings display all the characteristics of the work of the late Amsterdam Impressionists, although he showed more concern with the principles of ordering – a concern revealed more fully in his work after 1900.

In December 1900 a second show was organized in Amsterdam of the works that Jan Sluyters (1881–1957) had executed for the Prix de Rome. Besides the usual copies after old masters he exhibited some provocative sketches of Spanish dancers and scenes of Paris by night. It was not what the jury had expected; worse still, its members felt that the artist was entering a domain 'that did not lie within the sphere of the Fine Arts'.

For Sluyters it must have been a gradual process. His search for a new, personal art form led him from Rome to Spain, and from there, in autumn 1906, to Paris, where he became acquainted with the latest developments in art at the Salon d'Automne, and with cosmopolitan life. It is possible that he was more attracted by Parisian life than by Parisian art. His Paris paintings show that he understood that the new developments in art were indissolubly linked with life in a modern metropolis, so much more intense and exciting than life in Amsterdam, and that a superficial rendering could not do justice to that intensity and excitement; it became necessary—more even than in the days of Symbolism—to use colour and line for their *expressive* value, even if that meant a break with tradition.

It is hardly surprising, then, that Sluyters' Paris paintings were not appreciated at home. In April 1907 the board of the Sint Lucas Society refused to include his work in its annual spring exhibition, and in September the jury of the National Salon turned down his paintings. Forty years after the Salon des Refusés in Paris, Holland too had its *refusé*, complete with vehement reactions for and against him in the press and in the art world.

One of Sluyters' defenders was the young critic Conrad Kikkert (1882–1865). His articles were written with as much warmth and intensity as Sluyters painted, and he undoubtedly helped to open the eyes of Sluyters' contemporaries to the implications of the style of painting Sluyters had evolved in Paris. However, it was some time before this new insight had a wide influence, and Kikkert seems to be exaggerating when he describes the Spring 1908 Sint Lucas exhibition as giving evidence of 'a new striving after a different light, *plein-air*, and more characterizations of moods, after a freer, more exuberant, passionate, light manner of rendering, technically with the dissection of colour, a swift, direct brushstroke, strong lines . . . a new shoot on the branch of Modern French light-impressionism . . . quite different from Van Gogh'.

It is no coincidence that the same exhibition included 17 works by Toorop, at least 11 of them in the late Divisionist, sometimes pre-Fauve manner. Thus the significance of Toorop's work as representative of progressive French developments was recognized at last in Amsterdam. In January 1909 Toorop, now 50, was represented at a group exhibition of the other, much older and more conservative, Amsterdam artists' society – Arti et Amicitiae. The following month Amsterdam's new art gallery, De Larense Kunsthandel, held a retrospective of his work. Toorop's position in the Amsterdam art world was firmly established. In 1908 Van Gogh, too, at last obtained recognition in Amsterdam; in September the art dealer C. M. Van Gogh organized a fairly large exhibition of Vincent's work, with special emphasis on the paintings executed in France. Amsterdam was reassured. The new movement, in a direction that 'did not lie within the sphere of Fine Art', was, after all, a movement of true art and artists.

In January 1909 Mondrian, Sluyters and their friend the portrait painter C. Spoor were given the chance to hold a joint exhibition of their work in the Stedelijk Museum. At this show it became evident that Sluyters had found a convert in Mondrian, who was already quite well known. Indeed it must have been under the influence of Sluyters that Mondrian eventually broke away from late Amsterdam Impressionism. Kikkert maintained that Toorop had originally been meant to participate in this show, but had thought better of it. Mondrian and Toorop must have met during the previous summer in the seaside resort of Domburg in Zeeland. Toorop had been there every summer for about 10 years, both for his health and for the exceptional light, and over the years many artists had joined him there. It was Mondrian's first visit to Domburg; it is not known whether he and Toorop had already met before the Sint Lucas exhibition of 1908. In the long run Mondrian's contact with Toorop must have been more important than his association with Sluyters.

A third convinced 'Luminist' (the name given to the followers of French Neo-Impressionism), Leo Gestel (1881–1941), presented himself at the Sint Lucas spring exhibition in 1909. With their Luminist paintings Sluyters, Mondrian and Gestel were thought to have established at last a link with the international development of art – with Impressionism and Neo-Impressionism, known as 'French light-Impressionism', from which the term 'Luminism' was derived. However, as opposed to the work of the French artists, the work of the Luminists is characterized by the use of unnatural colours and colour contrasts. The Luminists were thus moving in the same direction as the French Fauves and the Expressionists in Germany, whose work was still unknown in Holland. In their use of unnatural colour the Luminists, like the Fauves and the Expressionists, achieved a much more direct representation of the world around them than did the Impressionists and Neo-Impressionists. The Luminists' view of reality was essentially different from that of the Impressionists and Neo-Impressionists. In the eyes of Sluyters and his generation reality was a combination of separate elements. Thanks to the Neo-Impressionist system of colour analysis, artists had learned to distinguish between the naturalness of colour and its expressive value. By this new, abstract and expressive use of 'unnatural' colour, artists could visualize the individuality of the things around them.

What Sluyters did more or less intuitively, Mondrian did much more deliberately. He knew of the Theosophic colour theories of Annie Besant and C. W. Leadbetter, which had been published in a Dutch translation in 1903. Going a step further than the Symbolists, Impressionists and Neo-Impressionists, he used abstract, pure colour to portray the deeper spiritual significance that he sensed in the things around him.

NOTES

1. The Amsterdam Rijksakademie, or Fine Arts Academy, had been reorganized in 1870 to become an institute of academic status which soon blossomed under the leadership of its new director, August Allebé (1838–1972), a painter of realistic genre pictures.
2. Breitner spent some time with H. W. Mesdag and Willem Maris; Willem de Zwart with Jacob Maris, etc.
3. Letter 299. Van Gogh had met Breitner in March 1882 at the beginning of Van Gogh's Hague period. For some time the two artists had gone 'out drawing', and 'often made sketches together in the soup kitchen or in the waiting-room etc.', (letter 174). 'Last night I went out with him [Breitner] to look for types among the people in the streets, so as to study them afterwards at home with a model' (letter 178). Van Gogh was disappointed when their brief collaboration came to an end, and regretted that Breitner and the other progressive young Hague painters were 'afraid to take models regularly', (letter 185).
4. Two years later, when Van Wisselingh himself had moved from The Hague to London, the subsidiary became the more independent firm of E. J. Van Wisselingh & Co., still in business today.
5. cf. letters 465, 480, w4.

Aarts, Johan Joseph 1871–1934

Born in The Hague, Aarts trained at the Hague Academy, and took a teaching post there in 1895. On moving to Amsterdam in 1911 he taught at the Amsterdam Academy. From 1895 his small output of paintings was executed in a Neo-Impressionist technique. He was better known for his graphic work.

387 *Path Among the Dunes* 1895

Bosweg, Duinlandscap
ns. 32 × 47.5 cm/12¾ × 18¾ ins
Lent by the Gemeentemuseum, The Hague

The Hague Kunstkring's summer 1892 exhibition of French and Belgian Neo-Impressionists (cf. no. 390), and the return of Toorop to Holland in 1890 (cf. no. 419), precipitated the creation of a small group of Dutch Neo-Impressionists. These included Bremmer, Aarts, Toorop (to a limited extent), and a friend of Bremmer's, Vijlbrief (1868–95).

 The impact of the 1892 exhibition on Aarts was delayed since he seems only to have adopted the Neo-Impressionist technique in 1895. Despite being one of his earliest exercises in the new technique, this painting reflects an independence of style. Aarts, like Bremmer (cf. no. 390), has adopted Toorop's small, well-spaced dot technique, but in this painting, unlike Toorop and Bremmer, he is concerned less with creating a patterned surface than with conveying a reasonably realistic image of a path which recedes past the dunes on the right-hand side. M A. S.

387

Breitner, Georg-Hendrik 1857–1923

Born in Rotterdam, Breitner trained at the Hague Academy and in the studios of Maris and Mesdag. Exhibiting with Arti et Amicitiae in Amsterdam in 1878, he subsequently met the younger generation of the Hague School – Isaac Israels, Suze Robertson and Verster. In 1882 he met Van Gogh, and travelled with him in 1883 around the Drente province. Breitner studied in Paris at the Atelier Cormon in 1884, where he met Toulouse-Lautrec, Anquetin and Bernard. He was invited to exhibit for the first time with Les XX in Brussels in 1886, and again in 1889. He also participated in the Hague Les XX exhibition of 1892, organized by Toorop. His travels included London, Berlin and Norway.

388 *Factory Girls* c. 1890

Fabriekmeisjes
sbr. G. H. Breitner 74 × 49 cm/29¾ × 19¼ ins
Lent by the Rijksmuseum Kröller-Müller, Otterlo

388

Although this painting was executed some four years after Breitner's move to Amsterdam, the concern with colour and paint-texture at the expense of precision of outline relates it to his formative years in The Hague and Paris. As an apprentice to Mesdag and W. Maris in 1880, Breitner would have been brought into contact with developments within the Hague circle of artists c. 1880. First, there was a general trend among the older generation of Hague School artists such as Mesdag and Mauve to reject the grey palette of the 1870s and to adopt a brighter one. Second, and not unrelated, a taste for French painting was developing among artists and collectors. Introduced through the energetic activities of the dealers H. J. and E. J. Van Wisselingh and by a subsidiary of the Paris-based dealers, Goupil, Boussod & Valadon, it was not Impressionism that was imported but work by Courbet and the Barbizon School. Breitner's adoption of the loose, heavy-impasto technique of the French painters and the more highly coloured palettes of the indigenous artists drew criticism from Vincent Van Gogh in March 1882 (letter 178) for neglecting to study from the model, and provoked hostile comment from critics for 'a criminal indifference to line and form'. Breitner's period of study in Paris under Cormon would have reinforced this interest in colour and loose handling. Although Cormon had the contemporary reputation of a history and costume-piece painter on a monumental scale (e.g. *The Age of Stone*, Salon of 1884), it was his earlier work as a colourist, perpetuated in the intermittent production of flower-pieces during the 1880s, which attracted the younger artists to his studio.

 The subject matter of *Factory Girls* seems to reflect the paintings of urban and rural labourers by members of the Hague School, Jozef Israels and Mauve, as well as by Breitner's contemporary, Isaac Israels (e.g. *Transport of Colonial Soldiers*, 1883–4, Rijksmuseum Kröller-Müller, Otterlo). However, this painting may also record Breitner's own interest in the Naturalist school of French literature. By 1881 he was reading the novels of Flaubert, the Goncourt brothers and Zola, and the affinity between these writers and Breitner's own work was frequently commented upon; he even became known as 'the Zola of Amsterdam'. M A. S.

REFERENCES
Otterlo, Rijksmuseum Kröller-Müller, *Catalogue of Paintings*, 1969, no. 43
Bonn, Rheinisches Landesmuseum, *Georg Hendrik Breitner: Gemälde, Zeichnungen, Fotografien*, 1978 (II)

389 *Lauriergracht, Amsterdam* c. 1895

[repr. in colour on p. 167]
sbr. G. H. Breitner 76 × 116cm/30 × 45¾ ins
Lent by the Stedelijk Museum, Amsterdam, Gift of the Vereeniging tot het vormen van een Openbare Verzameling van Hedendaagse Kunst, 1949

This painting is one of a series of large-scale views along the canals and streets of Amsterdam, including *The Dam in Amsterdam*, 1893–4, and *The Wharf, Prinseneiland*, 1902 (both Stedelijk Museum, Amsterdam). Breitner's move from The Hague to Amsterdam in 1886 had distanced him from his contact with the intense colour which dominated the work of his generation of Hague School artists and, after executing a series of figure subjects in his studio, e.g. *Reclining Nude* (1889, Boymans-Van Beuningen Museum, Rotterdam) and *The Red Kimono* (1893, Gemeentemuseum, The Hague), he turned to views of the city in a much subdued palette. The interest in the relationship between colour-planes, which he had pursued in The Hague (e.g. *The Wooden Shoes*, c. 1885, Rijksmuseum, Amsterdam), is retained in this painting by emphasis on a rigorous, grid-like composition. However, rather than adapting the intense colours of his paintings of the 1880s to convey the interest in light and shadow in this painting, Breitner has adopted an almost anti-Impressionist technique in which these concerns are recorded through the positive and negative qualities of a mono-chrome palette. In this way, Breitner not only reflects the more sombre palettes of members of the Amsterdam School, such as Witsen (cf. no. 428), but also integrates into his painting his interest in photography. M A.S.

EXHIBITIONS
1895, Amsterdam, *Kunstwerken van Levende Meesters*
1901–2, Amsterdam, Arti et Amicitiae, *G. H. Breitner*
REFERENCE
Bonn, Rheinisches Landesmuseum, *Georg Hendrik Breitner: Gemälde, Zeichnungen, Fotografien*, 1978 (15)

Bremmer, Hendrik Pieter 1871–1956

Born in Leiden, Bremmer studied at the Hague Academy. His first Neo-Impressionist paintings date from 1893. He also lectured, wrote and taught, and edited *Moderne Kunstwerken* (1903–10) and *Beelende Kunst* (1914–38). He was teacher and advisor to Mme Kroller–Muller, and was largely responsible after 1909 for building up her important collection, now known as the Rijksmuseum Kröller–Müller and housed in Otterlo.

390 *Still-Life* 1896

sdbl. H.P.B. Jan 1896 41 × 55 cm/16¼ × 21¼ ins
Lent by the Rijksmuseum Kröller–Müller, Otterlo

French and Belgian Neo-Impressionism had been brought to Holland by Toorop almost single-handed. He exhibited his recent work at five exhibitions throughout Holland in 1891, one of which was held at the invitation of the Hague Kunstkring. This body also invited Toorop to join their board in 1891, and in that capacity he organized, with the co-operation of Les XX in Brussels, a large

390

exhibition of French and Belgian Neo-Impressionists. This took place in July and August 1892 and included works by Seurat, Signac, Pissarro, Van Rysselberghe, Van de Velde, Lemmen and Finch. Despite the interest in bold, non-naturalistic colour, for which The Hague was renowned in the 1880s (cf. no. 426), this exhibition was greeted with enthusiasm. Bremmer, a recent graduate of the Academy, adopted the new technique, producing his first Neo-Impressionist paintings in the winter of 1892 (e.g. *Still-Life with Lantern*, January 1893, Rijksmuseum Kröller–Müller, Otterlo, no. 46). Although the 1892 exhibition did give an initial impetus to the adoption of Neo-Impressionism by Bremmer, the carefully spaced dots and the emphasis upon the creation of an abstract pattern on the surface of the painting suggest that Bremmer was also much influenced by Toorop's personal variant of the style. M A.S.

REFERENCE
Otterlo, Rijksmuseum Kröller–Müller, *Catalogue of Paintings*, 1969, no. 47

Claus, Emile 1849–1924

Trained at the Académie des Beaux-Arts, Antwerp, Claus first painted in the Belgian realist tradition. However three winters in Paris in close contact with Le Sidaner converted him to Impressionism. He first exhibited paintings in this technique at the Libre Esthétique of 1894. In 1904 he was a founder member, with Anna Boch, Heymans, Morren, Degouve de Nuncques and Ensor, of the Vie et Lumière Impressionist group associated with the Libre Esthétique. In 1883 Claus had settled in Flanders and thereafter most of his subject matter was taken from the Flemish countryside.

391

391 *A Sunny Day* 1899

Zonnige dag
sbl. Emile Claus; d. on rev. 1899 92.5 × 73 cm/36½ × 28¾ ins
Lent by the Museum voor Schone Kunsten, Ghent

The radiant light falling on the sparkling courtyard underlines this painting's affinity with French Impressionism. The scale of the dominant woman in the foreground, the peasant subject matter and the technique of short, criss-cross brushstrokes of bright, juxtaposed colours indicate a more specific debt to the work of Camille Pissarro. Having established his reputation as a realist artist when he exhibited *The Cockfight* (untraced) at the Antwerp Cercle Artistique in 1882, it was only at the end of the 1880s that Claus was converted to Impressionism.

Impressionism arrived rather late in Belgium, and, like Neo-

Impressionism, received a particularly Belgian interpretation. There were two points of contact with the French movement – through the annual exhibitions of Les XX and through travel to Paris. It was only in the third exhibition of Les XX in 1886 that the dominant influence of the Barbizon School was broken when invitations were extended to Monet and Renoir. From then until 1891, despite the numerical superiority of the Neo-Impressionist group, French Impressionism was regularly represented in the work of Guillaumin and Caillebotte in 1888, Monet in 1889, Renoir in 1890 and Sisley in 1891, and the exhibiting group's interest in the principles of Impressionism was expressed in Octave Maus' preface to the catalogue to the fifth exhibition in 1888: 'To express the iridescent light of day, the caresses of the atmosphere, the fleeting shafts of light which envelops all objects, this desire fills the heart of artists with an unsettling sense of anxiety. Tentatively embarked upon, then followed with dedication by a few artists, this search for light has now become the dominating principle of our era' ('La Recherche de la lumière en peinture', n.p.).

This contact with French painting at Les XX was very important for Claus. However, as with his future fellow founders of the Belgian Impressionist group Vie et Lumierè, established in 1904, he was equally influenced by his first visit to Paris. Encouraged by the Belgian critic, Camille Lemmonier, Claus spent the winters of 1889–91 in Paris, working closely with the French artist Le Sidaner (cf. no. 115), who was himself adopting a modified form of Impressionism during these years. At the Libre Esthétique exhibition of 1894, Claus showed the fruits of his conversion to Impressionism in the form of five paintings (nos 98–102 in that exhibition).

Although a parallel can be made between *A Sunny Day* and the work of Pissarro, the bright colours and the rather open network of brushwork comprise a distinctive modification of the French model. This intensification of colour is even more clearly stated in a large painting executed at the same time as *A Sunny Day – Cows Crossing the Lys* (1899, Museum voor Schone Kunsten, Ghent) – as well as in the work of other Belgian Impressionists such as Anna Boch and Georges Morren. Similarly, although the peasant subject matter makes a reference to a dominant theme in Pissarro's work (cf. nos 152, 155), Claus was also working within a well-established Belgian tradition, as was pointed out by Henri Van de Velde in his lecture 'Le Paysan en peinture', delivered during the 1891 exhibition of Les XX. M A.S.

EXHIBITION
1900, Brussels, Libre Esthétique (31)
REFERENCE
Ghent, Musée des Beaux-Arts, *Catalogue – II, Maîtres Modernes*, 1930, p. 38, no. 1904 – X

Ensor, James 1860–1949

Ensor, born in Ostend, attended the Académie Royale des Beaux-Arts in Brussels 1877–80, where he befriended Mellery and Finch and came into contact with a radical literary and political circle. In 1880 he returned to Ostend where, apart from brief visits to Brussels, London and Paris, he spent the rest of his life. His exhibiting career during the 1880s was stormy. Rejected by the Antwerp Salon in 1882 but accepted in the same year by the Salon in Paris, he contributed works to La Chrysalide and L'Essor in Brussels, both fore-runners of Les XX, of which he was a founder member, though his relations with them became strained later. From 1893 he exhibited regularly at the Libre Esthétique and his reputation spread abroad.

ABBREVIATIONS
Haesaerts – P. Haesaerts, *James Ensor*, 1957
Ensor 1976 – New York, Guggenheim Museum, *Ensor*, 1976

392 *Russian Music* 1881

La Musique russe
sdbl. James Ensor 81 133 × 110 cm/52½ × 43¼ ins
Lent by the Musées Royaux des Beaux-Arts de Belgique, Brussels

This canvas belongs to a group of pictures, including *Le Salon bourgeois*, 1880 and *Afternoon, Ostend*, 1881 (both Koninklijk Museum voor Schone Kunsten, Antwerp), set in the home of Ensor's parents at Ostend. Populated by his relations and close friends, they record the timeless ritual of domestic life. The models in *Russian Music* are Ensor's younger sister, Mariette, nicknamed Mitche, and Ensor's fellow student at the Académie Royale in Brussels, Willy Finch (cf. no. 401).

The disregard for conventional space, the rough, sketchy technique and the knitted texture of bright and sombre colours indicate that, even in the early 1880s, Ensor was making a gesture of defiance against his academic training. Accused of 'iconoclastic ideas' (M.W., 'Chronique d'art, l'Essor, l'Exposition le noir et blanc', *La Jeune Belgique*, 1882–3, p. 354), Ensor resolutely turned for his artistic prototypes to the previous generation of less conventional Belgian artists, such as Hippolyte Boulenger, Henri de Braekeleer and Vogels (cf. no. 427), who had derived their own inspiration from the traditional Flemish school of colourists, going back to Rubens, and from the coarse technique of the French members of the Barbizon School such as Rousseau, Diaz and Daubigny.

As suggested by its title, the picture conveys a mood of musicality, a theme already treated by Baudelaire in the 1860s and revived in connection with the growing enthusiasm for Wagner of the 1880s. It was this evocation of music in Ensor's painting which Khnopff adapted for his *Listening to Schumann* (cf. no. 403). The reference to Russian music relates to the general interest in Russian culture during the 1880s, when it was interpreted as an alternative to the reigning Naturalist and Decadent schools of art and to the more specific interest in the music of that country which Les XX introduced into their annual concerts in 1891. M A.S.

EXHIBITIONS
1881, Brussels, Exposition Générale des Beaux-Arts
1886, Brussels, Les XX (Ensor 13)
1905, Brussels, Libre Esthétique (175)
1909, Brussels, Musée d'Art Moderne, XVI Salon du Sillon (30)
1913, Ghent, Exposition Universelle et Internationale (190)
REFERENCES
E. Verhaeren, *James Ensor*, 1908, pp. 28–9, 31, 32, 103, 107
P. Colin, *James Ensor*, 1921, pp. 25, 40, 46
G. le Roy, *James Ensor*, 1922, pp. 25, 35, 100, 120
P. Feirens, *James Ensor*, 1929, p. 4
Haesaerts, pp. 53, 56
J. Ensor, *Lettres à Franz Hellens – Eugène Demolder*, 1969, p. 9
F. Legrand, 'Les Lettres de James Ensor à Octave Maus', *Bulletin des Musées Royaux des Beaux-Arts de Belgique*, 1966, no. 1–2, p. 24, n. i

392

393

393 *Still-Life* c. 1882

Nature morte
sbr. Ensor 80 × 100 cm/31½ × 39¼ ins
Lent by the Musée des Beaux-Arts, Liège

The most striking features of this still-life are the boldness of technique and the intensity with which light beams across the objects to define and animate them. As in his interior scenes, started some two years previously (cf. no. 392), Ensor is experimenting with brush and palette knife to lay on wedges of thick impasto. Rather than delineating the individual forms, he coaxes them out of the surrounding texture, building them up through overlapping layers of often rich colour. Despite the effect of intense luminosity in this picture, Ensor is still using a dark ground, a practice he continued until the mid-1880s.

The choice of a still-life subject is significant. Although in this picture Ensor is certainly beginning to investigate the properties of rich colour rather than the accurate depiction of objects, the subject matter does reveal aspects of two formative influences on him as an artist. First, despite his anarchic disregard for academies and tradition, Ensor is still working within the tradition of realism which marked Belgian art throughout the nineteenth century. Second, his interest in the observation of particular objects, with a view to identifying their individual characteristics, may have been encouraged through his friendship with Ernest Rousseau, rector of the Université Libre of Brussels, and his wife Mariette. Introduced to the Rousseaus by a fellow Ostender, Hannon, at the Académie Royale des Beaux-Arts in Brussels, Ensor appreciated the lively and often subversive political and philosophical debates which took place at their home, and also met, through Mme Rousseau, a varied circle of natural scientists who opened his eyes to 'the infinitely great, the infinitely small, the invisible, the sub-conscious creating new fields of experience' (in F. Legrand, *Ensor, cet inconnu*, 1971, pp. 18–19). M A.S.

REFERENCE
Ensor 1976 (11), repr. in colour

394 *Rooftops of Ostend* 1885

Les Toits d'Ostende
sdbr. Ensor 1885 109 × 133.5 cm/43 × 52½ ins
Lent by Louis Franck, Chalet Arno, Gstaad

Ensor had left the Académie Royale des Beaux-Arts in Brussels in a mood of defiance: 'I walked out of that establishment for the near-blind without further ado. I have never been able to understand why my teachers were so upset by my restless explorations. I was guided by a secret instinct, a feeling for the atmosphere of the sea coast, which I had imbibed with the breeze, inhaled with the pearly mists, soaked up in the waves, heard in the wind' (quoted F. Edebau, 'James Ensor and Ostend', *Ensor* 1976, p. 10).

When Ensor returned to Ostend in 1880 it was to his parents' house, where he set up his studio in the attic, from where he could observe the 'atmosphere of the sea coast'. The physical location of Ensor's studio offered him new subject matter in the form of plunging views into streets, such as *Rue de Flandre, Winter* (1880, Collection Louis Franck, Gstaad), and wide, panoramic views across the rooftops, as in this painting. Although the urban landscape never superseded Ensor's early interest in seascapes, the broad, loose brushwork and misty tones which he employed in his seascapes to convey the 'pearly mists' of the coastal town were carried over into his urban views. The new subject matter and viewpoints were also called upon in his large figure paintings of the later 1880s such as *Christ's Entry into Brussels* (1888, Collection Louis Franck, Gstaad). M A.S.

REFERENCE
Ensor 1976 (20), repr. in colour

394

395 *Skeleton Studying Chinoiseries* 1885

Squelette regardant les chinoiseries
[repr. in colour on p. 239]
sdbl. Ensor 85 99.5 × 64.5 cm/39¾ × 25½ ins
Lent by Julian J. Aberbach

The magic, non-natural world of fantasy inhabited by Ensor in his attic studio in Ostend is summarized in this painting. Under the eaves a skeleton is glimpsed through an open door, as it sits inspecting what appears to be an album of Japanese prints. The sense of spatial dislocation is heightened by the scrolls and groups of brightly coloured prints tacked to the plaster walls. In terms of subject matter the skeleton and the oriental prints allude to the world of artificiality revealed to Ensor by the objects sold in his mother's curio shop downstairs. Unlike his compatriot Alfred Stevens (1823–1906), Ensor's interest in oriental objects was not confined to their literal transcription. Rather, he evokes the atmosphere of distant exoticism through the handling of colour and space in the picture, so that it becomes a web of interlocking colour-planes, the most extreme instance of its time of a move towards non-naturalism in painting. M A.S.

REFERENCES
Haesaerts, pp. 14, 36
Ensor 1976 (21), repr. in colour

396 *The Ray* 1892

La Raie
sdbl. Ensor 92; sbr. Ensor 80 × 100 cm/31½ × 39¼ ins
Lent by the Musées Royaux des Beaux-Arts de Belgique, Brussels

Ensor had been painting still-lives throughout the 1880s, pictures in which he used intense shafts of light to animate the objects. However, towards the end of the 1880s, he began to move from the traditional method of recording light by dabs of brilliant paint towards the adoption of near-white grounds for his canvases. It is this latter technique which imbues the composition of *The Ray* with an inner luminosity. Ensor's preoccupation with the multiple possibilities of light was recognized by the writer Demolder, who published the first monograph on Ensor in the year that *The Ray* was painted. In this small volume Demolder noted that Ensor used light not only to 'devour objects' but also to enrich them, 'for it multiplies, like a treasure trove, the reflection of a reflection and the nuance of a nuance' (E. Demolder, *James Ensor*, 1892, pp. 6–7).

In comparison with Ensor's *Still-Life* of c. 1882 (no. 393), this painting shows a much greater concern for the clear delineation of forms through the use of an almost graphic outline. While this feature of his style began to emerge in works of c. 1890 and was to remain an important element of his work in the 1890s, it may also reflect Ensor's increasing mastery of graphic media, especially etchings, which he had started to execute in 1886. Ensor's concern to sharpen the edges of his images with more prominent outlines went some way towards answering the criticism of 'sketchiness', which had been levelled at him as early as 1881. 'Among new arrivals, James Ensor seems full of promise and has attracted attention. His sketches reveal an attentive observation to the effects of light and air, a finesse in producing certain tonalities, and an extraordinary lack of banality for a beginner. There are the makings of a painter here, but there is also a scorn for drawing, modelling, and perspective. M. Ensor should not fool himself: Talent is not complete without the science of form' (J. F. Portaels, in *L'Art moderne*, June 1881, p. 107). Despite this sign of 'improvement', Ensor was still, in 1892, open to great hostility from the critics as well as suffering a sense of increasing isolation from the rest of the Brussels avant-garde. His relations with Les XX had never been wholly peaceful. He had voted against the inclusion of Whistler in the 1886 exhibition, and from 1888 he had to suffer the humiliation of seeing his paintings rejected by the group of which he was a founder member. Ensor's work had become increasingly remote from this now dominantly Neo-Impressionist exhibition, yet so dependent was he on Les XX as his sole exhibition outlet that, despite these rebuffs, he was the only member to veto its dissolution in 1893. M.A.S.

REFERENCES
E. Verhaeren, *James Ensor*, 1908, repr. opp. p. 88
P. Fierens, *James Ensor*, 1929, pp. 4, 5, 8
A. de Ridder, *James Ensor*, 1930, pp. 16, 42, pl. 33
Haesaerts, p. 16
T. Kiefer, *James Ensor*, 1976, p. 55, repr. p. 63
Ensor 1976 (38), repr. in colour

397

397 *Pierrot and Skeleton in Yellow* 1893

Pierrot et squelette en jaune
sdbl. Ensor 1893 38 × 48 cm/15 × 19 ins
Lent by Mr and Mrs Jeff de Lange

The skeleton dressed in sharp yellow, the carnival masks on the wall, the grotesque face poking out from behind the door on the left, and the whitened, tragi-comic figure of the pierrot contribute to the creation of an atmosphere of ghoulish mystery which the presence of the calm blue and white still-life does little to alleviate. Ensor had introduced masks and skeletons into his paintings as early as 1883 (e.g. *Les Masques scandalisés*, Musées Royaux des Beaux-Arts de Belgique, Brussels), and they remained a prominent iconographic feature in his work. The source for this imagery, however, lies in Ensor's childhood experiences. His mother owned a curio shop full of trinkets, seaside souvenirs and all the paraphernalia necessary for the annual Ostend carnival celebrations. Much of the stock was stored in the attic and Ensor recalled that 'I was even more fascinated by our dark and frightening attic, full of horrible spiders, curios, seashells, plants and animals from distant seas, beautiful chinaware, rust and blood-coloured effects, red and white coral, monkeys, turtles, dried mermaids and stuffed Chinamen' (quoted F. P. Edebau, 'James Ensor and Ostend', *Ensor* 1976, p. 9).

The symbolism of these masks, skeletons and pierrots in Ensor's work not only conveys the traditional meanings of dissimulation, death and despair; rather, Ensor seems to have populated his works with these images as an expression for his own feelings of outrage against his hostile critics and an uncomprehending public. M.A.S.

REFERENCE
Ensor 1976 (39), repr. in colour

398 *Masks and Death* 1897

Les Masques et la mort
sdbr. J. Ensor 97 79 × 100 cm/31 × 39¾ ins
Lent by the Musée des Beaux-Arts, Liège

The iconography of this painting relates it to both *Pierrot and Skeleton in Yellow* of 1893 (no. 397) and to the extensive sequence of

396

398

often grotesque and cruel paintings of masks and death upon which Ensor had embarked in 1883 (e.g. *Skeletons Quarrelling Over a Hanged Man*, 1891, Koninklijk Museum voor Schone Kunsten, Antwerp). However, the bald, slab-like handling of the paint and the rather crisp outline of the forms makes this stylistically a transitional work, incorporating the luminosity and graphic outline introduced by the early 1890s (cf. no. 396) and also looking forward to the increasingly facile, less inventive work executed after 1900. This development appears to have been partly the result of Ensor's changing position within the artistic circles of Brussels. After years of critical abuse and financial insolvency, he had his first one-man show in Brussels in 1896, organized by Demolder. In the same year he sold his first painting to the State. Two years later, his position as a leading avant-garde artist was assured in Paris through the exhibition of his work at the offices of *La Plume*. By 1905 he had been decorated by the king, met his future patroness, Emma Lambotte, and been accorded a major exhibition by the Kunst van Heden in Antwerp. After being the outcast and then the *enfant terrible* of the art world, Ensor had become a 'grand old master'. M A.S.

REFERENCES
Haesaerts, pl. 120
Ensor 1976 (42), repr. in colour

Evenepoel, Henri 1872–99

Evenepoel first studied at the Académie Royale des Beaux-Arts in Brussels. In October 1892 he went to Paris to attend the Ecole des Beaux-Arts, studying initially under Galland and then in Moreau's atelier, where he met Matisse, Simon Bussy and Rouault. Highly receptive to the variety of art available in Paris, Evenepoel changed his style swiftly from sombre-toned history paintings to genre pictures and portraits executed in an increasingly heightened colour-range and flattened space. Ill-health forced him to spend some months in Algeria. In his short life he exhibited with several groups, including the Société des Artistes Français from 1894 and the Ghent Salon in 1899, and was invited to contribute to both the Cercle Artistique de Bruxelles and to the 1900 Libre Esthétique.

ABBREVIATIONS
Lettres choisies – F. E. Hyslop (ed.), H. Evenepoel, *Lettres choisies, 1892–1899*, 1972
Hyslop – F. E. Hyslop, *Henri Evenepoel, Belgian Painter in Paris, 1892–1899*, 1975

399 *The White Hat* 1897

Le Chapeau blanc
sdlc. h. Evenepoel 97 57 × 46 cm/23½ × 19½ ins
Lent by Louis Franck, Chalet Arno, Gstaad

The placing of the sitter against a single-toned, sombre background emphasizing the arabesques of the hat and the sleeves, the absence of any concession to three-dimensionality in the pattern of the dress, and the harmonious concentration on blue and grey tones, relate this painting to a group of highly flattened, 'decorative' pictures which Evenepoel was executing between 1896 and 1898 (e.g. *La Loge*, 1896, and *The Poultry Seller*, 1897, both Koninklijk Museum voor Schone Kunsten, Antwerp). They contribute to making this portrait one of Evenepoel's most Nabi-inspired paintings.

During Evenepoel's period in Paris between 1892 and 1899, he actively sought out the vast range of art on exhibition there. Encouraged no doubt by Moreau's liberal teaching methods, he happily absorbed and discarded these examples. Among the artists whom he greeted with enthusiasm were those admired also by the Nabis. In a letter of 16 May 1894 to Charles Didsheim he spoke

399

rapturously of the 'spirit, distinction of tone and sheer physical beauty . . . the simplicity' of the 40 paintings by Manet exhibited at Durand-Ruel's in 1894 (*Lettres choisies*, p. 106). He also found similar qualities in the work of Puvis de Chavannes (*Lettres choisies*, 19 November 1893, pp. 39–40) and Degas (*Lettres choisies*, 17 January 1895, p. 109). He frequently expressed his admiration for the work of the Nabis, which he saw during his frequent visits to the smaller galleries, especially Le Barc de Boutteville, and to the Société Nationale. However, he seems to have had little personal contact with the Nabis. Evenepoel did visit Toulouse-Lautrec's studio early in January 1895 (*Lettres choisies*, 21 January 1895, p. 11). Although he seems to have known about a focal point of Nabi activity, Lugné-Poë's Théâtre de l'Oeuvre (cf. Vuillard, no. 234), he never seems to have become friendly with any of the Nabis during his stay in Paris, and he was never invited to participate in their group activities.

Nevertheless, Evenepoel executed several lithographs that closely resemble Nabi graphics, especially the work of Bonnard (e.g. *In the Square*, colour lithograph, 1897, published in *L'Estampe moderne*), and the present painting, *The White Hat*, has its counterpart in the work of Denis (e.g. *Martha in a White Veil*, 1894, Private Collection, St Germain-en-Laye) and Maillol in the early 1890s. M A.S.

REFERENCE
Hyslop, p. 56

400 *Fête at the Invalides* 1898

Fête aux Invalides
sdbl h. Evenepoel 98 80 × 120 cm/31½ × 47¼ ins
Lent by the Musées Royaux des Beaux-Arts de Belgique, Brussels

This painting was the first that Evenepoel completed after returning to Europe in May 1898 after six months' convalescence in Algeria. His correspondence shows that the subject had been noted a year earlier. In a letter to his father, dated 2 June 1897, he describes his view from the fourth floor of a building giving on to the parade ground in front of Les Invalides in Paris: 'The Sunday crowd of Parisians stroll in the road and amongst the stalls: women in pale-coloured dresses, children carried in the arms of men, the red trousers of the infantrymen who fill this part of town' (quoted Brussels, Musées Royaux, *Evenepoel*, 1972, p. 41). The reconstruction of this scene, one year later, was aided by at least two sketches executed early in June 1897 and possibly also by photographs taken with his pocket Kodak, which he had bought after selling a picture at the 1896 Salon.

It has been suggested by Hyslop that this contemporary Parisian scene, captured with such gentle humour, owes much to Pieter Breughel's seventeenth-century scenes of festivity. More immediately, however, the painting's subject matter seems to fall into the category of popular genre scenes executed during the mid-1890s in France by several artists, including Adler (cf. no. 1),

400

Bonnard (cf. no. 32) and Steinlen. When the painting was exhibited at the Salon des Artistes Français in 1899, the light-hearted, festive mood captured by Evenepoel seems to have been interpreted with much indignation by the critic of *Le Progrès militaire* as nothing better than 'a schoolboy's taunt at the military profession' (*Lettres choisies*, p. 191).

In contrast to that of *The White Hat* (no. 399), his palette in this painting has become much more highly coloured. It reveals not only the continued impact on his work of his teacher, Moreau, but also the effects of his response to the intense colours of Algeria, recorded in paintings such as *The Orange Market, Blidah* (1898, Musées Royaux des Beaux-Arts de Belgique, Brussels), and his admiration for the palette of his fellow student at Moreau's atelier, Matisse (*Lettres choisies*, October 1896, p. 140). M.A.S.

EXHIBITIONS
1899, Paris, Salon des Artistes Français (543)
1899, Ghent, Exposition de la Ville de Gand, XXXVIII Salon (223)
1900, Brussels, Libre Esthétique (98)
1905, Brussels, Libre Esthétique, *L'Evolution externe de l'Impressionnisme*, retrospective section (16)
REFERENCES
L. and P. Haesaerts, *Henri Evenepoel*, 1932, pl. 24
Brussels, Musées Royaux, *Hommage à Henri Evenepoel 1872–1899, Oeuvres des collections publiques de Belgique*, catalogue by M. J. Chartrain-Hebbelinck, 1972, pp. 41–2, repr. in colour pp. 32–3
Lettres choisies, pp. 190–1
Hyslop, p. 90, pl. 32

Finch, Alfred William (Willy) 1854–1930

Of English parentage, he trained from 1878 to 1880 at the Brussels Academy, where he met Ensor. A founder member of Les XX, he met Whistler in England and was responsible for inviting him to exhibit at their first exhibition, in 1884. Whistler invited Finch to show at the RBA in 1887 and 1888. Finch adopted Neo-Impressionism in winter 1887. He began to exhibit with the Indépendants in Paris in 1889. After 1891 he became a ceramicist. In 1897 he moved to Finland, where he introduced French Impressionist and Post-Impressionist art.

401 *The Haystacks* 1889

Les Meules
sdbl. A. W. Finch 89; s on rev. A. W. Finch 32 × 50 cm/12½ × 19½ ins
Lent by the Musée d'Ixelles

Executed in the company of Finch's friend and fellow Neo-Impressionist, Georges Lemmen (1865–1916), this painting of a subject more commonly treated by the Impressionists records the impact made upon Finch by the exhibition of paintings by Seurat and Camille Pissarro at Les XX in 1887. Yet, as in the work of Van Rysselberghe, Van de Velde and Toorop, Finch has modified the

technique of the *Grande Jatte* to meet his personal requirements. The majority of subjects in Finch's Neo-Impressionist oeuvre were painted along the Channel coast. The damp atmosphere, which diffuses the brilliance of colour to create a grey overall tone, is conveyed by rather widely spaced dots in related colour values. This technique and colour effect sets Finch's painting slightly apart from the mainstream of French Neo-Impressionism, illustrating Finch's concern, expressed in a letter to Octave Maus (January 1888), that he did not want his work to resemble that of 'our friends in Paris' (quoted New York, Guggenheim Museum, 1968, p. 162).

However, Finch does seem to have been susceptible to certain important developments within French Neo-Impressionism. He adopted Seurat's colour-related, painted borders in *The Cliffs on the South Foreland* (1891–2, Art Gallery of Ateneum, Helsinki, repr. Guggenheim Museum, 1968, no. 124), and, like Toorop (cf. no. 418), he was conscious of the stylized organization of elements within the landscape found in Signac's paintings (e.g. *Portrieux–The Jetty*, 1888, Rijksmuseum Kröller–Müller, Otterlo; exhibited at Les XX in 1890), which he adopted in paintings such as *Breaking Waves at Heyst* (1891, Mrs Johanna Weckman Collection, Helsinki). The several aspects of French neo-Impressionism which feature in Finch's work enabled Felix Fénéon to group Finch with French artists such as Angrand, Luce and Schuffenecker, as members of the second generation of Neo-Impressionists ('Treize toiles et quatre dessins de M. Albert Dubois-Pillet', *Revue indépendante*, October 1888, in *Oeuvres plus que complètes*, I, 1970, p. 117). M.A.S.

EXHIBITIONS
1890, Brussels, Lex XX (Finch 2)
1892, Paris, Indépendants (355)
REFERENCES
M. O. Maus, *Trente années de lutte pour l'art (1884–1924)*, 1926, p. 81
1962, Brussels and Otterlo, *Le Groupe des XX et son temps* (38)
1968, New York, Guggenheim Museum, *Neo-Impressionism* (120)
J. Rewald, *Post-Impressionism*, 1978, pp. 91, 102, 387, 396, 430–1

401

Khnopff, Fernand 1858–1921

Brought up in Bruges, Khnopff was impressed by the silent, medieval character of that city. He intended to study law, but rejected it in favour of painting, and trained at the Bruges Académie des Beaux-Arts where he was taught by Mellery. In 1877 he went to Paris and studied the work of Moreau and Delacroix. Back in Brussels, he exhibited first with L'Essor and then with Les XX, of which he was a founding member. A friend of Symbolist writers, he was also an anglophile, responding warmly to the Pre-Raphaelites, especially the art of Rossetti and Burne-Jones, and after 1894 contributing regularly to the avant-garde English review *The Studio*. Support for his work from the poet and critic Verhaeren brought Khnopff renown in France and led to acclaim from Sâr Péladan; he exhibited at the first Salon de la Rose + Croix in 1892 and illustrated several of Péladan's books. He lived in Bruges after 1900, becoming increasingly isolated.

402 *Portrait of Jeanne de Bauer* 1890

Portrait de Jeanne de Bauer
sbl. Fernand Khnopff 51 × 33 cm/19¾ × 13 ins
Lent by a Private Collector

The wistful look on the sitter's face, the low-keyed colours and the timeless setting of this portrait relate it to other portraits in Khnopff's oeuvre such as *Portrait of the Artist's Sister* (1887, Collection Bernard Thibaut de Maisière, Brussels) and *Portrait of Madame Rothmaler* (1889, Galleria d'Arte Moderna, Venice). The insistence upon an almost monochromatic colour range and the absence of space in the portrait suggests that Khnopff had absorbed certain features of Whistler's portrait style displayed in such pictures as *Arrangement in Black No. III (Lady Archibald Campbell)* (1884, Philadelphia Museum of Art), exhibited at Les XX in 1888 (Whistler 1). However, the studied distancing of the sitter from the spectator underlines the meditative, hermetically-sealed image frequently found in Khnopff's work (e.g. *A Blue Wing*, 1894, Collection Anne-Marie Gillion-Crowet, Brussels, and *Silence*, 1890, Musées Royaux des Beaux-Arts, Brussels). Here he expressed his debt to the unattainable women of Rossetti and Burne-Jones and perhaps also reflects the Symbolist literary atmosphere of his friends such as Gregoire Le Roy and Emile Verhaeren. M.A.S.

EXHIBITIONS
1891, London, New Gallery, Summer Exhibition (53)
1897, Brussels, Exposition Internationale (232)
1905, Brussels, Musée d'Art Moderne, *Peinture et sculpture de l'enfant* (80)
1910, Brussels, Musée d'Art Moderne, *Le Portrait belge au XIX siècle* (56)
REFERENCE
L. Dumònt-Wilden, *Fernand Khnopff*, 1907, p. 70

402 403

403 *Portrait of Madame Van Ryckevorsel* 1888

Portrait de Madame Van Ryckevorsel
sbl. Fernand Khnopff oil on panel 47 × 36 cm/18½ × 14¼ ins
Lent by a Private Collector

As a founding member of Les XX in Brussels, Khnopff had close relations with other members of the group such as Ensor and Toorop. The musical reference in this portrait reflects Khnopff's own painting of 1883, *Listening to Schumann* (Musées Royaux des Beaux-Arts, Brussels) and looks back to Ensor's musical painting, *Russian Music*, 1881 (no. 392). Both artists were interested in the theory of equality between art and music initially propounded in France by Baudelaire in his 1861 defence of Wagner ('Tannhäuser à Paris', *Revue européenne*, April 1861). Les XX consolidated this belief by

holding concerts of works by composers such as D'Indy, Fauré, Franck, Chausson and Schumann at their annual exhibitions and by inviting Catulle Mendès to lecture on Wagner at the opening exhibition in 1884.

The use of the screen behind the sitter as a flattening device, together with the illogical organization of space, is also found in the work of Toorop and Ensor during the 1880s (cf. nos 415, 395). This handling of space underlines the fact that the painting is more than a mere recording of the physical likeness of his sitter; rather it is a picture which captures the mood of musical reverie. M.A.S.

404

404 *Roses and Japanese Fan* c. 1885

Roses et éventail japonais
sbr. Fernand Khnopff 50 × 25 cm/19¾ × 9¾ ins
Lent by Marcel Mabille, Brussels

The rather loose handling of paint and the overt reference to the Japanese vogue relate this still-life to Ensor's paintings of the mid-1880s such as no. 395. However, unlike Ensor's work, where retreat from naturalism was expressed through such artificial means as a living skeleton, Khnopff has relied entirely upon formal devices to achieve the same end. This still-life is transformed into an exercise in decorative surfaces by careful organization of colour into horizontal bands up the picture surface; by the echoes of the colour range of the painting in the colours of the Japanese fan; and, despite the slight hint of a shadow cast by the vase, by the absence of any logical representation of three-dimensional space. This reference to the decorative properties of painting emphasizes Khnopff's general interest in the decorative arts, especially polychrome sculpture panels, decorative screens and theatre designs. M.A.S.

Mellery, Xavier 1845–1921

Mellery studied under Portaels at the Académie de Bruxelles 1860–7. In 1870, he won the Prix de Rome and travelled to Italy and Holland. He lived on the island of Marken in Zeeland 1878–9, then moved to an isolated house outside Brussels where he spent the rest of his life. His ambitions to become a monumental decorative artist were never realized and his output mainly comprised small-scale monochrome works which captured the silence and inner life of his secluded world. He exerted a profound influence on one of his pupils. Fernand Khnopff. Although never a member of Les XX, he exhibited as an invited artist in 1885, 1888, 1890 and 1892 and became a regular exhibitor with the Libre Esthétique from 1894.

405 *After Evening Prayers* c. 1890

Après la prière du soir
sbr. X. Mellery drawing and watercolour on paper
100 × 70 cm/39½ × 27½ ins
Lent by the Musée d'Ixelles

Whether looking through a doorway (e.g. *The Kitchen*, Koninklijk Museum voor Schone Kunsten, Antwerp), glimpsing nuns at prayer (e.g. *Beguines at Prayer*, Musée Royaux des Beaux-Arts de Belgique, Brussels) or watching, as in this picture, a silent procession of nuns ascending the stairs after Vespers, Mellery, by emphasizing line, and light and shade, transforms the events and surroundings of everyday life into statements about the interior life of things, the *âme des choses*. C. Lemmonier noted the way in which Mellery had used light as the medium through which the artist's own thoughts could be expressed: 'You have created a light which is the negation of that which envelops our immediate visual experience of things: it is rather the interior light of your mind, capable of revealing the mystery of your thoughts; for the mystery, the unsettling effect of shadows, the deep meditation and the silence are the true expressions of your thoughts' (letter to Mellery, 8 January 1899). The object therefore becomes transformed by this inner light into the symbol through which thoughts are expressed. Whatever the image, it must be 'silenced' and divested of movement so that the spectator's attention cannot be distracted from its external meaning: 'It was this interior life, this life of the mind which I saw in everything, in my mind, everywhere and which I firmly believed could be captured in concrete form. . . . I have followed nature in all her peculiar and multiple guises, noting them all so that I may discover that quality which resists these temporary changes' (Mellery to C. Lemmonier, Lacken, 5 November 1905, quoted Paris, Grand Palais, *Peintres de l'imaginaire*, 1972, p. 31).

Mellery's interest in capturing the meditative silence of interior scenes is paralleled in Khnopff's work, while his use of light for symbolic ends brings him close to Bonnard and Vuillard (cf. no. 237). MA.S.

405

Mondrian, Piet 1872–1944

Born in Amersfoort, Mondrian qualified as a state school drawing teacher in 1892, and then entered the Amsterdam Academy. Until his move to Paris in 1912 he was active in artistic circles in Amsterdam, joining Arti et Amicitiae in 1892 and the Sint Lucas Society by 1898. He founded the Moderne Kunstkring with Toorop and Sluyters in 1910 and organized the first exhibition of work by Picasso and Braque at this group's first show in 1911. Returning to

406

Holland during the First World War, Mondrian founded the De Stijl group in 1916 with J. J. P. Oud. After 1918, he spent most of his time abroad.

ABBREVIATIONS
Seuphor – M. Seuphor, *Piet Mondrian, Life and Work*, 1956
w-o – L. Wijsenbeck and J. Oud, *Mondrian*, 1962
Mondrian – The Hague, Gemeentemuseum, *Mondrian in de Collectie net Haags Gemeentemuseum*, ed. Blok, 1968 edn

406 *Evening* c. 1907

Avond
sbl. Piet Mondriaan 66 × 76 cm/26 × 30 ins
Lent by the Gemeentemuseum, The Hague

This painting was executed towards the end of what R. Welsh has called Mondrian's 'Naturalist Period' (Toronto, Art Gallery, *Piet Mondrian*, 1966). The sombre tones, free brushwork and rather thin paint surface contrast with the colourful canvases of Hague School artists such as Verster (cf. no. 426) and early Breitner (cf. no. 388). Although Mondrian trained with his uncle, Fritz Mondriaan, a member of the Hague School, Piet's time at the Academy of Fine Arts in Amsterdam encouraged him to adopt the 'crepuscular' style of, e.g. Witsen (cf. no. 428).

Before his contact with Toorop (cf. no. 421) and Sluyters (1881–1957), whose work reflected recent developments in French painting, Mondrian remained wedded to the Dutch tradition of quiet, accurately recorded landscapes. While this conservatism is represented here, the use of evening light suggests that even at this date Mondrian was beginning to reduce specific detail in order to reveal the emotions which a landscape can evoke. To this extent, the painting not only relates to such monumental crepuscular pictures as *Mill by Moonlight* (1905–6, Gemeentemuseum, The Hague), but points forward to Mondrian's search for a non-objective vocabulary, towards which his Domburg experiences of 1908–9 were to be an important contribution (cf. no. 407). MA.S.

407 *Sea After Sunset* 1909

Zee na Zonsondergang
sbl. P. Mondriaan oil on board 41 × 76 cm/16 × 30 ins
Lent by the Gemeentemuseum, The Hague

This seascape was executed during Mondrian's second visit to Domburg, a seaside village on the island of Walcheren, Zeeland. It belongs to a series of oil studies on board, such as *Dunes I–III* (1909–10, Gemeentemuseum, The Hague), which capture the desolate outlines of sea, dunes and sky of this region.

Technically, the painting is a transitional work. The long, swept brushstrokes recall the loose handling of paint in many of Mondrian's landscapes of the previous 10 years (cf. no. 406). However, the slab-like dabs of paint and the rather bold colours

407

reflect his recent contacts with more progressive schools of painting. It has been suggested that this adaptation of a pointillist technique results from his contact with Toorop during the former's first visit to Domburg in September 1908 (cf. no. 421). However, R. Welsh (Toronto, Art Gallery, *Piet Mondrian*, 1966, p. 104) argues that the period during which the artists could have seen each other in 1908 was too short to enable Mondrian fully to integrate the older artist's decorative application of pointillism. Rather, Mondrian probably picked up the technique from exhibitions of Toorop's recent work. Likewise, the semi-Fauvist colour probably represents Mondrian's response to the highly coloured work of the Dutch artist Sluyters, again available to Mondrian through exhibitions in Amsterdam.

This picture is also important for an understanding of Mondrian's relationship to nature. Although retaining a naturalistic title, Mondrian has used long brushstrokes, decorative pointillism and bold colour to create an abstract pattern. According to his friend A. P. Van de Briel, Mondrian had early expressed a concern to replace the objective recording of nature by landscape which represented the artist's emotions. After 1900, Mondrian explored this further, assisted by a growing interest in Theosophy. By c. 1902, he had become interested in the writings of the founder of the Theosophical Society, Mme Blavatsky; by 1909, he had also read the summaries of Rudolf Steiner's lectures given in Holland in March 1908 and published as *Mystiek en Ethiek*. On 25 May 1909, attracted by the Theosophists' essentially anti-Symbolist doctrine, Mondrian joined the Amsterdam Theosophical Society. The Theosophists believed that objects should not be particularized to act as the specific representative, or symbol, of general ideas, but that they should be distorted and generalized to reveal higher levels of meaning, the spiritual states of being. Mondrian declared that the use of a non-naturalistic red for his image of a praying young girl in *Devotion* (1908, Gemeentemuseum, The Hague) was intended to turn the spectator's attention away from the material image of a girl praying and towards the idea of 'devotion' (R. Welsh and J. Joostens, *The Mondrian Sketchbooks, 1912–1914*, 1969, p. 10; cf. also R. Welsh in New York, Guggenheim Museum, *Piet Mondrian*, 1971, p. 42). Similarly, in *Sea After Sunset* the divisions between dune, sea, sky and setting sun are forced into generalized, semi-abstract patterns. This move towards the 'abandonment of all residual attachment to particular instances of natural beauty' (Welsh 1971, p. 42) was to lead Mondrian to the formulation in 1916 of a pure abstract art proclaimed in the formation of De Stijl.

A group of these decorative, semi-pointillist paintings was exhibited at the 1910 Sint Lucas Society exhibition in Amsterdam. Here, after some 20 years of activity within the tradition of nineteenth-century Dutch landscape painting, Mondrian was hailed as one of the most modern artists in the city. M A.S.

REFERENCES
Seuphor, p. 270
w-o, pl. 47
Mondrian, no. 75 (repr.)

Van Rysselberghe, Théo 1862–1926

Born in Ghent, he studied at the Ghent Académie des Beaux-Arts and at the Académie in Brussels. Exhibiting in the Brussels Salon for the first time in 1881, he won a travelling scholarship to Spain; his travels of the next two decades took him to Morocco, much of Europe, the Near East and North Africa. A founding member of Les XX in November 1883, he became Octave Maus' second-in-command at Les XX and, after 1893, at the Libre Esthétique, exploiting his links with Paris and England, as well as his adoption after 1887 of Neo-Impressionism, to influence the pattern of each annual exhibition. His circle of friends included writers such as Maeterlinck, Verhaeren, Gide and Fénéon. Despite moving to Paris in 1897, he maintained close contact with Brussels and was responsible, from 1906 onwards, for inducing the Fauves to exhibit at the Libre Esthétique.

408 *Portrait of Alice Sèthe* 1888

Portrait d'Alice Sèthe
sdbl. v.r. 1888 194 × 97 cm/76½ × 38 ins
Lent by the Musée du Prieuré, St Germain-en-Laye

The three beautiful and gifted Sèthe sisters, Alice, Maria and Irma, all sat for Van Rysselberghe. The portrait of Alice, the future Mme Paul Du Bois, was the first to be executed, followed in 1891 by Maria (soon to marry Henri Van de Velde) seated at the piano (Koninklijk Museum voor Schone Kunsten, Antwerp), and concluded in 1894 by Irma, playing the violin (Petit Palais, Geneva).

Portrait of Alice Sèthe was painted in the year of Van Rysselberghe's conversion to Neo-Impressionism. He had seen Seurat's paintings at Les XX in 1887 and those of Signac in 1888. He had also been to Paris where he could have continued his study of the new technique. However, there are three features of this painting which set it apart from the mainstream of contemporary French Neo-Impressionism. The full-length, monumental format of the portrait is an elaboration of his *Portrait of Octave Maus* of 1885, in which the artist expressed a debt to the portrait style of Whistler. Second, the presence of the mirror, rather than serving as a record for greater realism, fulfils the same essentially decorative purpose in this portrait as the mirror in the Maus portrait. Finally, Van Rysselberghe uses colour more to enhance his subject than to apply strictly the theory of colour mix. Thus the orange-brown table acts

408

as an effective foil to the remarkable and striking blue dress worn by the sitter. Following this portrait, Van Rysselberghe's understanding of Neo-Impressionism developed rapidly. By the time he came to execute the portrait of Maria at the piano in 1891, he had adopted further aspects of Neo-Impressionist techniques such as Seurat's painted borders and picture frames, as well as a colour mix of blue-orange and red-green.

Portrait of Alice Sèthe was exhibited in Paris at the Indépendants in 1890 when it was noted by Maurice Denis: 'It was in 1890 . . . that I first saw the works of Théo van Rysselberghe and, amongst these, a large portrait, that of Mme Paul Du Bois, light in tone, pointilliste, well-constructed, thoughtful, fastidious,' (introduction to the catalogue of the *Exposition d'Ensemble Théo van Rysselberghe*, Galerie Giroux, Brussels, 1927). Van Rysselberghe's friend Cross probably saw this portrait at the Indépendants and echoed its format in his own monumental portrait of his wife, painted in 1891 (Palais de Tokyo, Paris). M.A.S.

EXHIBITIONS
1889, Brussels, Les XX (Van Rysselberghe: Portraits: II)
1890, Paris, Indépendants (783)
1910, Brussels, *Le Portrait belge au XIXe siècle*
1913, Ghent, Exposition Universelle et Internationale (517)
REFERENCES
P. FERENS, *Théo van Rysselberghe*, 1937, pp. 17–18
Ghent, Musée des Beaux-Arts, *Rétrospective Théo van Rysselberghe*, 1962 (46)

409 *La Pointe de Per Kiridec (Near Roscoff, Brittany)* 1889

La Pointe de Per Kiridec (près de Roscoff, Bretagne)
sdbr. 18 TVR 89 68 × 106 cm/26¾ × 41¾ ins
Lent by the Rijksmuseum Kröller-Müller, Otterlo

Van Rysselberghe spent much of the summer of 1889 in Paris, partly talent-spotting for the 1890 Les XX exhibition. He then travelled to Brittany in October. He was not the first Neo-Impressionist to visit Brittany; Signac had gone there for the first time in 1885.

Despite its Breton location, there is little about this painting to suggest that Van Rysselberghe was seeking to convey the distinctive flavour of the region. The technique, with its dominant tones of blue and orange, reveals a much fuller acceptance of the principles of contemporary French Neo-Impressionism than is found in the pictures of the previous year, such as *Portrait of Alice Sèthe* (no. 408). The composition, with its prominent, anti-picturesque rock on the right-hand side, shows Van Rysselberghe imposing on to the Breton coastline compositional devices derived from Japanese prints, Monet (e.g. no. 137) and Seurat (e.g. *Le Bec du Hoc*, Tate Gallery, London), rather than responding directly to the distinctive character of the coastline itself.

Herbert has emphasized that, despite the parallels with Signac and Seurat, this painting also demonstrates Van Rysselberghe's individual use of the Neo-Impressionist technique. As in the *Portrait of Alice Sèthe* (no. 408), he concentrates on recording the physicality of the objects themselves, rather than seeing them as mere supports for the investigation of light broken into colour. M.A.S.

EXHIBITIONS
1890, Brussels, Les XX (Van Rysselberghe 5 or 6)
1891, Brussels, Les XX (Van Rysselberghe 1)
1891, Paris, Indépendants (1214)
1898, Krefeld, *Ausstellung Flämischer Künstler* (118)
REFERENCES
M.-J. Chartrain-Hebbelinck, 'Les lettres de Van Rysselberghe à Octave Maus', *Bulletin des Musées Royaux des Beaux-Arts de Belgique*, 1966, 1–2, pp. 70–3
New York, Guggenheim Museum, *Neo-Impressionism*, catalogue by R. L. Herbert, 1968, (134)
Otterlo, Rijksmuseum Kröller-Müller, *Catalogue of Paintings*, 1969, no. 595

410 *Family in Orchard* 1890

Famille dans le verger
[repr. in colour on p. 163]
sdbl. 18 VR 90 115.5 × 163.5 cm/45½ × 64½ ins
Lent by the Rijksmuseum Kröller-Müller, Otterlo

This picture is set in the manor house on the estate of the ancient Abbaye d'Aulnes, which was rented by Van Rysselberghe's mother-in-law, seen on the left with her back to the spectator; the woman with her face half-turned to the viewer on the right is Marie Sèthe, the future Madame Henri Van de Velde.

In a sense, this painting belongs to Van Rysselberghe's series of Neo-Impressionist portraits, a genre to which he devoted more energy than any other Divisionist artist. However, this painting is more notable for its green-violet colour mix, as opposed to the red-green or blue-orange colours of French Neo-Impressionism. Van Rysselberghe has here adopted the spectral theory in preference to the pigmental division of colour, which Van de Velde had already used in *Bathing Huts on the Beach at Blankenberghe* (1888, no. 423). Given the date of *Family in Orchard* it is curious to find Van Rysselberghe reverting to a colour technique which had not only been rejected by Seurat and Signac in favour of the more conventional system of pigment complementaries, but had also been set on one side by Van Rysselberghe himself in 1889 in *La Pointe de Per Kiridec* (no. 409). Despite this reversion to the scientific representation of light transformed into colour, the green-violet colour mix in this painting endows it with an evocative, poetic mood which is even more pronounced in its companion painting, *The Tennis Match* (Collection Pierre Faure, Toulouse). The use of colour to convey mood rather than scientific information about the theory of spectral colour becomes increasingly pronounced in Van Rysselberghe's work during the 1890s (cf. no. 411). M.A.S.

EXHIBITION
?1891, Brussels, Les XX (Van Rysselberghe 4, as *En juillet—avant-midi*)
REFERENCES
Ghent, Musée des Beaux-Arts, *Rétrospective Théo Van Rysselberghe*, 1962 (55)
M.-J. Chartrain-Hebbelinck, 'Les Lettres de Van Rysselberghe à Octave Maus', *Bulletin des Musées Royaux des Beaux-Arts de Belgique*, 1966, 1–2, p. 73
Otterlo, Rijksmuseum Kröller-Müller, *Catalogue of Paintings*, 1969, no. 596

411 *The Canal in Flanders* 1894

Le Canal en Flandre
sdbl. 18 TVR 94 55 × 75 cm/31½ × 23½ ins
Lent by a Private Collector

Writing in *L'Art moderne* in 1898, the Belgian Symbolist writer and close friend of Van Rysselberghe, Emile Verhaeren, described this painting as 'nuances of greys and greens which transport the sad impression of heavy sky and rainy weather to the very edge of the horizon, to infinity. No violent oppositions, the nuances of the two basic colours counterbalance each other. They stretch across the composition, each occupying an equal and balanced space within the picture. And these lines forever driving, forever plunging towards the horizon . . . they add to the bleak, cold idea, to the feeling of dampness, to the elongated spleen of the painting'

411

(13 March 1898, quoted New York, Guggenheim Museum, 1968 [138]).

This description of *The Canal in Flanders* omits any reference to the scientific principles of Neo-Impressionism, underlining instead the evocative or poetic use to which Van Rysselberghe has put Divisionist technique. It also emphasizes the more general trend among Neo-Impressionists during the 1890s to seek formal pattern within a landscape through which light is transformed into areas of coloured pigment. The decorative or formal qualities of the landscape have been increased by Van Rysselberghe's arrangement of broader, looser dabs of paint across the canvas surface in place of the small, separate dots of pure colour common to early Neo-Impressionism.

Soon after its execution this painting was exhibited in Dresden and Vienna. R. L. Herbert has suggested that the growing popularity in Germany and Austria of Van Rysselberghe's work of the 1890s may have been due to its proto-Expressionist qualities which can be seen in the composition and mood of this painting.

The Canal in Flanders was exhibited with a frame designed by Van Rysselberghe. Adopting this technique from Whistler, he had developed a modified form of 'Whistler' frame for his paintings by 1890. The attention to frames reflects Van Rysselberghe's more general interest in the applied arts. During the 1890s he designed furniture, book illustrations and posters and was responsible for installations at both Les XX and Libre Esthétique exhibitions. M A.S.

EXHIBITIONS
1897, Dresden, Internationale Kunstausstellung
1898, Brussels, Libre Esthétique (384)
1898, Vienna, Secession (not in catalogue)
REFERENCES
E. Verhaeren, in *Ver Sacrum*, 1898, p. 9
E. Verhaeren, in *L'Art moderne*, 13 March, 1898
M. O. Maus, *Trente années de lutte pour l'art (1884–1914)*, 1927, p. 228
Ghent, Musée des Beaux-Arts, *Rétrospective Théo Van Rysselberghe* (62)
New York, Guggenheim Museum, *Neo-Impressionism*,
 catalogue by R. L. Herbert, 1968 (138)

412 *Bathers at Cavalière* 1905

Les Baigneuses à Cavalière
sdbl. TVR 05 81 × 100 cm/32 × 39½ ins
Lent from the Collection of the late Mrs Barnett Shine

412

Along with many of the other Neo-Impressionists, Van Rysselberghe adopted looser brushwork and brighter colour c. 1900. He remained close to his French Neo-Impressionist colleagues, particularly to Cross; he and Cross both turned c. 1900 to timeless Bather scenes situated on the Mediterranean coasts (cf. no. 55), of which *Bathers at Cavalière* is a fine and typical example. These paintings express an ideal of living which has none of the political relevance of Signac's idyll of 1895, *In the Time of Harmony* (fig. 2, cf. no. 214). Denis and Roussel were treating similar themes at the time (cf. nos 71 and 183), as was Matisse in *Luxe, calme et volupté* of 1904–5 (fig. 3). J.H.

Thorn Prikker, Johannes 1868–1932

Trained at the Hague Academy 1883–7, Thorn Prikker's early painting was realist in style, influenced by the Hague School of painters and by Breitner. However, contact with Toorop and a growing interest in the work of Flemish artists of the fifteenth and early sixteenth centuries helped to steer him towards a linear, non-naturalist style and religious subject matter. A member of the small group of Dutch Symbolist painters, he decided in 1895 to devote his art to the service of the people. He collaborated with Van de Velde in the decorative arts, and in 1904 was appointed professor at the Krefeld Kunstgewerbeschule. He exhibited in Amsterdam. The Hague and Brussels, being invited to Les XX in 1893 and to the Libre Esthétique in 1898.

413 *The Descent from the Cross* 1892

sbl. J. Thorn Prikker 88 × 147 cm/34¾ × 57¾ ins
Lent by the Rijksmuseum Kröller-Müller, Otterlo

Thorn Prikker executed c. 1892 a number of paintings and drawings of religious subjects. This painting is related in its technique to such contemporary paintings as *The Madonna of the Tulips* or *At the Foot of the Cross* (1892, Rijksmuseum Kröller-Müller, Otterlo) and in subject matter to pencil and chalk drawings such as *The Holy Women at the Foot of the Cross* (1891–2) and *Christ on the Cross, with Mary* (1891–2; both in Rijksmuseum Kröller-Müller, Otterlo). The strong graphic character of this painting, its colour firmly contained by the bounding contours of the forms, relates the picture to a similar development within the oeuvre of Toorop about one year earlier. As in Toorop's *Oh Grave, Where Is Thy Victory?* (1892, Rijksmuseum Kröller-Müller, Otterlo), much use is made of details, such as the flowing robes of St John and St Mary at the foot of the cross, to create an essentially decorative, rather than literal, transcription of the scene. Thorn Prikker has also adopted for this purpose the decorative possibilities of the Neo-Impressionist technique which Toorop had already been investigating in his painting *The Shell Gatherer* of 1891 (no. 418).

Despite the strongly two-dimensional character of this painting, the ensuing distortion of recognizable reality does not imply a personal interpretation of the biblical scene by the artist. Indeed, the simplicity of the image not only reflects Thorn Prikker's admiration for the directness of religious imagery in fifteenth- and early sixteenth-century Flemish paintings but also illustrates the artist's own, rather unspecific, Symbolist programme, as defined in a letter to Henri Borel. Referring to the imagery of the paintings executed between 1892 and 1896, Thorn Prikker explained that he wished to capture not the visual impression of things but their essence, such as the sentiment of love or hatred, and mystical reality (quoted Paris, Grand Palais, *Le Symbolisme en Europe*, 1976, p. 224). M A.S.

413

EXHIBITIONS
1892, Haarlem, *Kunst zij ons Doel*
1892, Amsterdam, Arti et Amicitiae (121)
1892, The Hague, Kunstkring (14)
1902, The Hague, *Die Hague* (14)
REFERENCES
T. Van Doesburg, *Drie Voordrachten over de Nieuwe Beeldende Kunst*, 1919, pl. 17
B. H. Polak, *Het Fin-de-Siècle in de Nederlandse Schilderkunst*, 1955, no. 138, p. 59
B. M. Spaanstra-Polak, 'Jugendstil in de Nederlandse Schilderkunst en Grafiek',
 Forum, January 1959, p. 354
L. Gans, *Nieuwe Kunst. De Nederlandse Bijdrage tot de Art Nouveau*, 1960, p. 61
Otterlo, Rijksmuseum Kröller-Müller, *Catalogue of Paintings*, 1969, no. 654

414 *Cornfield* 1900/4

sdbr. J.T.P.04 pastel on paper
45.5 × 56 cm/18 × 22 ins
Lent by the Gemeentemuseum, The Hague

Having virtually abandoned painting in favour of the decorative arts
some five years earlier, in 1901 Thorn Prikker exhibited a little
group of pastel drawings on horizontally ribbed paper. Executed in
the area of Vise, near Liège in Belgium, during the previous summer,
they show a Neo-Impressionist technique. During the next three
summers Thorn Prikker added to this group, producing drawings of
haystacks, cornfields and more extensive landscape views.

 To define this picture as Neo-Impressionist is not strictly correct.
It does conform to the principles of colour advocated in the theory of
Divisionism and to the use of the broken colour-stroke. However, as
in the later work of other Neo-Impressionist artists such as Toorop
(cf. no. 421), Van Rysselberghe (cf. no. 412), Signac (cf. no. 216) and
Cross (cf. no. 57), Thorn Prikker has here modified the technique to
create a decorative, rhythmic pattern across the surface of the paper,
rather than a scientific representation of spectral light falling upon
objects within a landscape. To this extent, as in Toorop's *Dunes at
Zoutelande* of 1907 (no. 421), this picture anticipates Mondrian's
similar adaptation of Neo-Impressionism by *c.* 1909
(cf. no. 407). M A.S.

REFERENCE
Düsseldorf, Städtische Kunsthalle, *Vom Licht zur Farbe*, 1977 (116)

414

Toorop, Jan 1858–1928

Toorop, born in Java, came to Holland in 1872. He studied at the
Amsterdam Academy and the Académie des Beaux-Arts, Brussels.
He became a close friend of Ensor, exhibited with L'Essor in 1883
and with Les XX 1885–93. After travels in France and England he
became a board member of the Hague Kunstkring after 1890,
organized exhibitions of works by Van Gogh and Les XX, and had
many one-man shows throughout Holland. His international
reputation was acquired through exhibiting at the Indépendants
and the first Salon de la Rose + Croix, in Berlin, Copenhagen,
England, Dresden, Vienna and Munich. He adopted Neo-
Impressionism *c.* 1887, and a Symbolist style in the 1890s. After his
conversion to Catholicism in 1905 he restricted himself almost
exclusively to religious subject matter.

415

415 *Annie Hall at Lissadell, Kenley* 1885

Annie Hall in Lissadell, Kenley or *Annie Hall
à Lissadell, Kenley*
sdbr. Jan Toorop 28.6.85 99 × 73 cm/39 × 28¾ ins
Lent by the stedelijk Museum, Amsterdam

The woman seated at the open window is Annie Hall, the English art
student whom Toorop had met at the Brussels Académie des Beaux-
Arts in 1884 and whom he was to marry in 1886. This picture dates
from Toorop's second journey to England in 1885, during which he
visited Lissadell, Annie's parents' home in Surrey.

 The dense network of brushstrokes and palette-knife touches
which build up an overlapping rhythm of brilliant colours and
sombre tones, together with the curious disregard for the logical
arrangement of space, relate this painting to Ensor's work of the
early 1880s, such as no. 392 and *The Artist's Parents* (1881, Musées
Royaux des Beaux-Arts, Brussels). Toorop had met Ensor soon after
his arrival in Brussels in 1882. Together they visited Paris, probably
in 1884, to study French painting, especially the work of Manet.
Ensor's influence can also be seen in the subject of Toorop's
painting. The silent abstracted atmosphere of this middle-class
domestic interior had already been captured in Ensor's paintings,
e.g. *Afternoon at Ostend* (Koninklijk Museum voor Schone Kunsten,
Antwerp) and no. 392.

 The striking feature of this painting is the prominent white dress.
Toorop produced a number of paintings between *c.* 1885 and 1887

in which white is used as a positive and dominant tone, e.g. *The White Lady* (1885, Musée des Beaux-Arts, Ghent), *Le Trio fleuri* (1885–6, Gemeente museum, The Hague) and *Young Girl at the Piano* (1887, Jan Cunen Museum, Oss). White had been used in a similar way much earlier by Whistler, in paintings such as *Symphony in White No. 111 (Two Little White Girls*; 1867, Barber Institute, Birmingham), one of the four paintings which he had exhibited at Les XX in 1884. Close study of *Symphony in White No. 111*, together with a visit to Whistler during one of his two trips to England in 1884 or 1885, were most probably the source of Toorop's elevation of white into a colour in its own right. MA.S.

EXHIBITIONS
1893, Munich, Jahresausstellung von Kunstwerken
1894, Leiden, The Hague, Arnhem, *Jan Toorop*
REFERENCES
R. Siebelhoff, *The Early Development of Jan Toorop, 1879–1892*,
 University of Toronto (thesis), 1973, no. P.85.19 'La Dame Blanche'
Paris, Institut Néerlandais, *Jan Toorop*, 1977 (31)
Otterlo, Rijksmuseum Kröller-Müller, *Jan Toorop*, 1978–9 (10)

416 *After the Strike* c. 1888

Na de Werkstaking or *Après la grève*
sbr. Toorop 65 × 76 cm/25½ × 30 ins
Lent by the Rijksmuseum Kröller-Müller, Otterlo

The subject of this painting may derive from the prolonged strikes which occurred in the Charleroi industrial area during 1886. Toorop executed a number of pictures on the theme of poverty. In the paintings of 1884 and 1885, such as *Flower Market in London* (1885 ; Rijksmuseum Kröller-Müller, Otterlo), his approach is essentially dispassionate ; he observes the passing scene rather than imbuing it with moral connotations. In *After the Strike*, however, together with its pendant *Before the Strike* (Art Gallery of Ontario, Toronto) and a related painting, *Alcoholism*, (Private Collection, The Hague), Toorop has reduced the number of figures in the composition and brought them forward to the picture-plane, which forces the sad plight of the group on to the attention of the spectator.

By the mid-1880s socialism had become an important movement in Brussels, involving writers and artists such as Van de Velde, Meunier, Van Rysselberghe and Verhaeren. Socialism and artistic reform were also the concerns of many members of the Les XX group, as demonstrated in Henri Van de Velde's proselytizing zeal and the welcome given by the group to the ideas of William Morris and Walter Crane. Toorup shared this political concern, as is revealed in *After the Strike*.

The date of this painting is problematic. Although the subject may date from 1886, the intrusion of areas of Neo-Impressionist technique into a painting still predominantly handled in the broad brushstroke technique of *Annie Hall at Lissadell, Kenley* (no. 415)

suggests that it could not have been executed before Toorop had seen the works by Seurat exhibited in February 1887 at Les XX. Toorop often dated his paintings many years after their execution. Another painting, *In de Nes (Nachtleren)* (Gemeentemuseum, The Hague), stylistically close to *After the Strike*, carries the date 1889, but at this time Toorop was already working in the much fuller, Neo-Impressionist style of such works as *On the Bend of the River* (Museum, Dordrecht), and so 1888 seems a more appropriate dating for *After the Strike*. MA.S.

EXHIBITIONS
1894, Leiden, De Lakenhal Museum, *Jan Toorop*
1898, Rotterdam, Galerie Oldenzeel, *Jan Toorop*
1904, Amsterdam, Galerie Buffs, *Jan Toorop*
1909, Amsterdam, Larensche Kunsthandel, *Jan Toorop*
B. Polak, *Het Fin-de-Siècle in de Nederlandse Schilderkunst*, The Hague, 1955, p. 343
Otterlo, Rijksmuseum Kröller-Müller, *Catalogue of Paintings*, 1969, no. 691
Otterlo, Rijksmuseum Kröller-Müller, *Jan Toorop*, 1978–9 (17)

417 *Autumn Landscape in Surrey* c. 1890

Oude Eiken in Surrey or *Vieux chênes dans le Surrey*
sbr. J Th. Toorop 63 × 76 cm/24¾ × 30 ins
Lent by the Stedelijk Museum, Amsterdam, Gift of the Vereeniging tot het vormen van een Openbare Verzameling van Hedendaagse Kunst, 1949

The bold outlines, the inconsistent arrangement of space, and the areas of both rather flat and of 'stringy' handling of colour, in contrast to the more characteristic Neo-Impressionism of this period in his career, suggests that Toorop is reacting in this painting to the works of Van Gogh and Segantini shown at Les XX in 1890.

Although this picture is not as explicitly Symbolist as paintings of the following three years (e.g. no. 420), the poetic tones, the flattened composition and the decorative effect created by texture and outline express a growing interest in this type of art. Toorop was a member of Les XX, where, despite the predominance after 1887 of the Neo-Impressionist group, Symbolist artists such as Gauguin, Anquetin and Redon were also invited to exhibit. Les XX complemented each exhibition with concerts and lectures in the galleries ; the lecturers included leaders of the Symbolist Movement in literature, for instance Picard, Mallarmé, Kahn, Rodenbach and Verhaeren, the last two of whom were close friends of Toorop.

The sinuous outline of this painting is also a feature of Toorop's graphic work of the 1890s (e.g. *The Return unto Oneself*, Rijksmuseum Kröller-Müller, Otterlo), and of his fully fledged Art Nouveau posters such as *Delftsche Slaolie* (1894). His continued admiration for Van Gogh was expressed when he organized the first Dutch exhibition of his paintings and drawings at the Hague Kunstkring in 1892. MA.S.

416

417

EXHIBITIONS
1904, Amsterdam, Galerie Buffa, *Jan Toorop*
REFERENCES
J. B. Knipping, *Jan Toorop*, n.d., pp. 19–20
B. Polak, *Het Fin-de-Siècle in de Nederlandse Schilderkunst*, 1955, pp. 94, 346
R. Siebelhoff, *The Early Development of Jan Toorop, 1879–1892*,
 University of Toronto (thesis), 1973, no. P.90.07
Paris, Institut Néerlandais, *Jan Toorop* (68)
Otterlo, Rijksmuseum Kröller-Müller, *Jan Toorop*, 1978–9 (28)

419

418 *The Shell Gatherer* 1891

Schelpenvrissers op het strand or *Le Pêcheur de coquillages*
[repr. in colour on p. 234]
sdbl. J Th Toorop 1891 61.5 × 66 cm/24¼ × 26 ins
Lent by the Rijksmuseum Kröller-Müller, Otterlo

After the Strike (no. 416) and his other pointillist paintings demonstrate the powerful impact on Toorop of Seurat's seven paintings shown at the 1887 Les XX. Deeply moved by the news of the French artist's death in March 1891, Toorop executed this rather forlorn painting of a fisherman at Katwijk in homage to him.

Nevertheless, the technique of this painting reveals closer affinities to the work of Signac and Van de Velde. The patterning of water and sky into bands of coloured dots is also found in Signac's *Sunset at Herblay* (no. 210) exhibited at Les XX (Signac 7) in 1891. The wide-spaced dots over thinly painted flat areas of colour are analogous to the technique used by Van de Velde at first tentatively in no. 423, and then with more assurance in *The Beach at Blankenberghe* (1889, Kunsthalle, Bremen).

This painting also reveals features which illustrate the emergence in the early 1890s of a dual style in Toorop's work. Beneath the surface of dots lie carefully executed lines delimiting the main colour areas of the composition. These lines, together with the undulating bands of colour-dots, indicate a greater concern with the decorative than with the representational interpretation of Neo-Impressionism. This decorative treatment has two aspects in Toorop's subsequent work. Surface pattern, created through different-coloured areas of dots, is found in *In the Shelter of the Dunes* (1898, Rijksmuseum Kröller-Müller, Otterlo) and as the back-drop for several portraits (e.g. *Portrait of Mme J. de Lange*, 1900, Private Collection). The decorative power of line emerges in drawings of 1891 (e.g. *Shellfish Gatherers*, Rijksmuseum Kröller-Müller, Otterlo), in Symbolist works such as *The Three Brides* (1893; Rijksmuseum Kröller-Müller, Otterlo) and in his Art Nouveau graphic work (e.g. *Dolce*, 1897) and posters (e.g. *Het Hooge Land*, Beekbergen, 1896). M A. S.

EXHIBITIONS
1898, Rotterdam, Galerie Oldenzeel, *Jan Toorop*
REFERENCES
New York, Guggenheim, *Neo-Impressionism*, 1968 (147)
Otterlo, Rijksmuseum Kröller-Müller, *Catalogue of Paintings*, 1969, no. 694
Paris, Institut Néerlandais, *Jan Toorop*, 1977 (58)
Otterlo, Rijksmuseum Kröller-Müller, *Jan Toorop*, 1978–9 (33)

419 *Fishing Boat on the Beach at Katwijk* 1891

Vissersboot op het strand, Katwijk
sbl and insc. Katwijk/zee J. Th. Toorop 72 × 97 cm/28½ × 38 ins
Lent by the Stedelijk Museum, Amsterdam

On returning to Holland after his prolonged stay in Brussels, Toorop settled in an isolated fishing village to the north of The Hague, called Katwijk am Zee. At the time he executed this painting Toorop had already expressed the silent desolation of this seaside region in *The Shell Gatherer* (no. 418). In *Fishing Boat on the Beach at Katwijk* he concentrates instead upon the inhabitants of this lonely environment, their inexorable involvement with the sea and their struggle to survive. Toorop had depicted the poor during the 1880s (cf. no. 416), but at Katwijk, perhaps under the influence both of representations of peasants by Millet and the Hague School and of contemporary interpretations of Brittany, he came to appreciate the peasants' noble persistence in seeking a living from the sea and the land.

The careful symmetry of the composition and the broad, banded brushstrokes relate this painting to the decorative elements in both *The Shell Gatherer* and *The Dunes and Sea at Zoutelande* (no. 421). However the rich, sombre colours expressing the nobility and melancholy of the subject are symbolic of Katwijk, since they recur in successive images of the region executed during the 1890s. Although not clearly stated in this painting, the religious faith of the peasants is included by Toorop as one of the characteristics of the region in other paintings. e.g. *Toil and Affliction* (1891, Rijksmuseum Kröller-Müller, Otterlo) and *The Calvinists of Katwijk* (1892, Centraalmuseum der Gemeente, Utrecht). M A.S.

EXHIBITIONS
1894, Arnhem, Artibus Sacrum, *Jan Toorop*
1899, Dresden, Kunstsalon Arno Wolfframm, *Jan Toorop*

420 *The Young Generation* 1892

La Jeune génération
sdbl. Jan Toorop 1892 96.5 × 110 cm/38 × 43¼ ins
Lent by the Boymans-Van Beuningen Museum, Rotterdam

Despite the elaboration of its densely patterned surfaces, this picture and its near contemporaries *The Prowlers* (1891, Rijksmuseum Kröller-Müller, Otterlo) and *Venus of the Sea* (c. 1890, Private Collection), uses such literal and conventional imagery that it is as much an allegorical painting as a symbolic one. The baby in the highchair, Toorop's daughter Charley, surrounded by the newly-sprung shrubs, represents the new age. The woman on the left, with

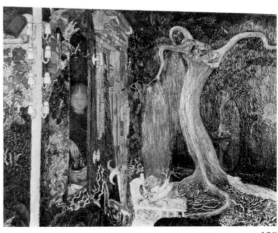

420

a faded lily in her hand, the gnarled trees and the crumbling brick doorway illustrate the old age. The railway tracks and the telegraph pole refer to the rapid passage of time, which ushers in the new age, and the attributes of the new age, Faith, Beauty and Life, are revealed in the Bird of Purity chasing out the Bird of Ugliness from the Wood of Beauty, in the figure of Buddha, the emblem of Clarity of Thought, and in the colours pink, green, yellow and turquoise.

This painting was exhibited at the first Salon de la Rose + Croix in 1892. Several of its features conform closely to the programme of this Salon as laid down by Sâr Péladan in *Salon de la Rose + Croix: Règle et monitoire*, published in 1891. The use of readily identifiable emblems meets Péladan's demand for allegorical painting in his Salons: 'Allegory, be it expressive of "Modesty and Vanity" or decorative as in the works of Puvis de Chavannes' (Rule VI, no. 3), Second, although it includes a Buddha, this can be seen as a reference to an eastern theogony, acceptable as subject matter to Péladan without being one confined exclusively to 'the yellow races', which Péladan abhorred (Rule VI, no. 2). Finally, although produced by a foreign artist, the picture gained admittance to the Salon because Péladan firmly believed that 'For the Order of the Rose + Croix the word "foreign" has no meaning. This Salon assumes an international character of the most elevated type' (Rule XV). M A.S.

EXHIBITIONS
1892, Brussels, Les XX (Toorop 3)
1892, Paris, Salon de la Rose + Croix (176)
1892, Antwerp, L'Association pour l'Art
1892, Amsterdam, Arti et Amicitiae
1893, Munich, Jahresausstellung von Kunstwerken aller Nation
1904, Amsterdam, Galerie Buffa, *Jan Toorop*
REFERENCE
Paris, Institut Néerlandais, *Jan Toorop*, 1977 (43)

421 *The Dunes and Sea at Zoutelande* 1907

sdbl. J. Th. Toorop 1907 oil on board 47.5 × 61.5 cm/18¾ × 24¼ ins
Lent by the Gemeentemuseum, The Hague

Although Toorop has used similar broad brushwork in this painting to that in certain areas of *Fishing Boat on The Beach at Katwijk* (no. 419), his palette has lightened in keeping with the more optimistic character of this summer scene. Furthermore, this picture illustrates his appreciation of the way in which brushstrokes, when isolated from each other by small areas of unpainted board, create a 'mosaic' effect on the surface of the painting. In this respect Toorop has developed Neo-Impressionism in a similar direction to that taken later by Signac (cf. no. 216), Matisse and Derain (cf. no. 73). This technique was also an influence on Mondrian's approach to colour (cf. no. 407).

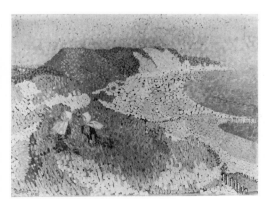

421

The Dunes and Sea at Zoutelande belongs to the final group of important Neo-Impressionist paintings by Toorop. Conversion to Catholicism in 1905, and the move to Nijmegen in 1909, turned his attention to religious painting, in a style reminiscent of stained glass windows, to which he devoted himself for the rest of his life. M A.S.

REFERENCES
Düsseldorf, Städtische Kunsthalle, *Vom Licht zur Farbe*, 1977 (128)
Paris, Institut Néerlandais, *Jan Toorop*, 1977 (65)

Van de Velde, Henri 1863–1957

Born into an influential Antwerp family, Van de Velde entered the Antwerp Academy in 1880, and in 1884 went to Paris to study under Carolus-Duran. On his return to Belgium, he associated himself with the Belgian 'Barbizon' group of Claus, Heymans, Crabeels and Roseels who were working around Wechel der Zande. Deeply impressed by Seurat's *Grande Jatte*, he adopted Neo-Impressionism in 1888, the year in which he was elected to Les XX. By *c.* 1891, however, his interest in the decorative arts began to emerge, and after renewed contact with William Morris in 1894 he committed himself totally to this sphere. In 1895 he built his own house, the Villa Bloemenwerf at Uccle, which led to the development of an extensive international architectural practice whose designs included the Kunstgewerbeschule at Weimar (1904–6) and the building for the Rijksmuseum Kröller-Müller at Otterlo (1921–8).

ABBREVIATIONS
Leben – H. Van de Velde, *Geschichte meines Lebens*, 1962
Hammacher–Billiter–A. M. Hammacher, *Le Monde de Henri van de Velde*, Antwerp, 1967 (incorporating a catalogue raisonné of paintings by E. Billiter)

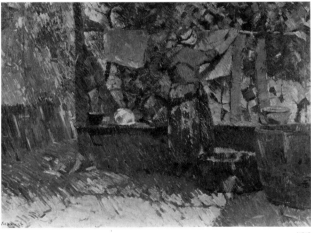

422

422 *Washerwoman* 1887

De Wasvrouw
sdbl. Velde 87 116 × 150 cm/45½ × 59 ins
Lent by the Koninklijk Museum voor Schone Kunsten, Antwerp

The sparkle of light and shadow in this painting reflects Van de Velde's early concern with *plein-air* painting. On his arrival in Paris in 1884 he had first intended to study under 'the young leader of the *plein-air* school of painters', Bastien-Lepage (*Leben*, p. 25). Since Bastien was dying, Van de Velde moved to the painter of picturesque Breton scenes, Feyen-Perrin, and then to the fashionable portraitist Carolus-Duran. However, his chief discoveries while in Paris were Millet and the Barbizon School, and the Impressionists, first seen at Durand-Ruel's.

The warmth of the colour in this painting indicates that it dates from the summer of 1887. It must therefore have been painted while Van de Velde was staying at the village of Wechel der Zande. The monumentality of the washerwoman and the integration of her figure into the surrounding area suggest parallels with Millet's treatment of peasants. Indeed, the affinity was also intellectual, since Van de Velde, influenced by socialist tracts and Zola's novels, saw his washerwoman as a symbol of peasant acceptance of the inevitability of toil. The technique of this painting suggests links with the Impressionists. The rather loose brushwork, typical of his work of this date, is used to capture the glitter of light and shadow, the directional brushstrokes hint at Cézanne, while the narrow stripes of green, red and yellow paint on the washerwoman's clothing are features also found in a tighter form in Pissarro's work of the early 1880s (cf. no. 152).

Despite the ease of execution apparent in this painting, Van de Velde was not entirely happy with Impressionism. In his autobiography (Leben, pp. 39–40) he declared that while Impressionism was still the most significant technique for him in the summer of 1887, he realized that it did not fully complement his 'vibrant and highly receptive personality' (Leben, p. 40). This dissatisfaction with the technique was one of the factors which persuaded him to explore the possibilities of Neo-Impressionism in Bathing Huts on the Beach at Blankenberghe (no. 423). M.A.S.

REFERENCES
Hammacher–Billiter, no. 11
Antwerp, Catalogus schilderijen 19de en 20ste eeuw, Koninklijk Museum
 voor Schone Kunsten, 1977, no. 2549

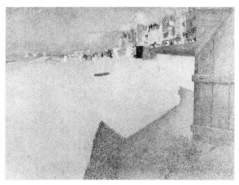

423

423 Bathing Huts on the Beach at Blankenberghe 1888

Plage de Blankenberghe avec cabines
ns. 71 × 100 cm/28 × 39½ ins
Lent by the Kunsthaus, Zürich

Van de Velde came to the fashionable seaside resort of Blankenberghe to spend the summer of 1888 in his brother's house. He was in a state of personal, professional and ideological crisis; the technical experimentation and the spatial tensions in this painting stand witness both to this crisis and to its resolution.

Van de Velde's personal life had been shattered by the recent death of his mother and he had come to Blankenberghe primarily to assuage his grief. The tension between the flat shadow area of the foreground and the deep recession of the sunlit but virtually deserted beach capture in some degree his own emotional desolation.

From a professional point of view, Van de Velde was faced with the need to resolve the stylistic turmoils of the previous year. By

1887 he had evolved the modified forms of Impressionism found in *The Washerwoman* (no. 422). In that spring he had also been confronted with Seurat's Neo-Impressionist paintings at the fourth Les XX exhibition. The effect was traumatic: 'Seurat's *Sunday on la Grande Jatte* shook me to the core. I felt myself caught up in an irresistible urge to adopt as quickly and as thoroughly as possible the theories of the new technique' (Leben, p. 40). Since Van de Velde apparently only met Seurat in 1889, his study of the new technique was limited to the period of the 1887 exhibition and to Signac's submissions to the 1888 Les XX. The result, as Herbert has pointed out (Neo-Impressionism, 1968), is this rather unusual opposition of greens and purples as opposed to the reds and greens preferred by Seurat and Signac. Herbert suggests that this deviation from the French prototypes may be due to the fact that Van de Velde had taken the theory of colour-light literally. Green and purple are true opposites in the spectrum but, since Seurat and Signac had already concluded that pigments could not work like spectral colours because the eye picks up from the canvas reflected light, not original light, they had reverted to the colour opposition of red and green.

Van de Velde's adoption of so scientifically-based a theory as Neo-Impressionism would at first sight seem to run counter to his own disgust with the scientific, materialistic world of the 1880s. By 1888 he had become deeply involved in the theories of socialism, and during this summer at Blankenberghe, when not at his easel, he spent his time reading and in endless debate about the socialist state and art's role within it. The fact that Seurat, Signac and especially Luce were Anarchists who expressed hatred for their era through an 'outrageous' new technique and images of social outcasts (cf. Luce, no. 117) or scenes of the society of the future (e.g. Seurat's *Une Baignade, Asnières*, fig. 4), could have persuaded Van de Velde that Neo-Impressionism was an appropriate style for the art of the new socialist order. M.A.S.

REFERENCES
Leben, pl. 10
Hammacher–Billiter, no. 18
New York, Guggenheim Museum, *Neo-Impressionism*,
 catalogue by R. Herbert, 1968 (140)

424 Woman at a Window c. 1889

Vrouw hij het raam
ns. 111 × 125 cm/43¾ × 49¼ ins
Lent by the Koninklijk Museum voor Schone Kunsten, Antwerp

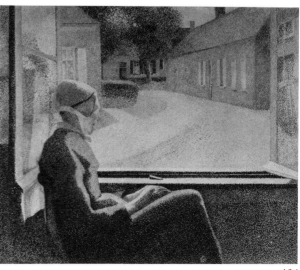

424

The subject of this picture is one commonly found in Low Countries' painting. The monumentality of the seated peasant woman reflects Van de Velde's earlier enthusiasm for the peasant paintings of Millet and Pissarro (cf. no. 152), about which he was to lecture two years later at Les XX ('Le Paysan en peinture'). However, it is from the technical point of view that this painting is important. In comparison with no. 423 the density of dots is generally much greater, with only slight thinning at the edges of the canvas. To this extent Van de Velde is working in a similar style to Van Rysselberghe at this date (cf. no. 410). The range of colours has increased. When depicting the woman's right arm catching the fall of the sunlight, Van de Velde has used deep yellow and orange against mauve, green and blue within a very small area of canvas. This extension of colour range has occurred, Herbert suggests (*Neo-Impressionism*, 1968) because Van de Velde has adopted Seurat and Signac's opposing pigments of red and green, instead of the spectral opposites, green and purple. In fact, Van de Velde has given the painting a dominant tonality of pink and blue, not red and green, which achieves a softer overall effect. Here, Van de Velde remains faithful to the Belgian modifications to Neo-Impressionism as practised by Van Rysselberghe and Toorop. M A.S.

EXHIBITIONS
1890, Brussels, Les XX (Van de Velde 1)
1890, Paris, Indépendants (816)
1891, Antwerp, 'Als ik kan', (261)
1893, Munich, Münchener Jahresausstellung vom Kunstwerk aller Nation (1584)

REFERENCES
Hammacher–Billiter, no. 20
New York, Guggenheim Museum, *Neo-Impressionism*,
 catalogue by R. Herbert, 1968 (142)
Antwerp, Koninklijk Museum voor Schone Kunsten, *Catalogus schilderijen*
 19de een 20ste eeuw, 1977, no. 2589

425 *The Garden at Calmpthout* c. 1891

Le Jardin à Calmpthout
ns. 70 × 94.5 cm/27½ × 37¼ ins
Lent by the Bayerische Staatsgemäldesammlungen, Munich

The Villa Vogelenzang at Calmpthout was owned by Van de Velde's sister, Jeanne, and from 1889 the artist visited her for long periods during the summer months.

The technique of this painting is transitional. Van de Velde has retained both the Impressionists' interest in the luminosity of the scene and the Neo-Impressionists' characteristic of allowing the colour to spill over from the picture to the frame. The Pointillism in *Woman at a Window* (no. 424) has here melted into an intricate pattern of sinuous lines that snake across the surface of the painting. Two factors help to explain this modification of style. The first was the interest aroused by the influx after 1888 of the two-dimensional, overtly decorative, non-naturalistic paintings from Paris into the Les XX exhibitions. Anquetin exhibited in 1888 (cf. no. 7), Gauguin in 1889 and 1891, Van Gogh in 1890 and 1891, and Toulouse-Lautrec in 1890. Second, there was Van de Velde's own attraction to the decorative arts. By the mid-1880s he had become aware of the English Arts and Crafts Movement, and his enthusiasm was fanned within the circle of Les XX. The first decorative objects were exhibited at Les XX in 1880; by 1891 Walter Crane had been invited to exhibit and Gauguin sent to that exhibition two vases and a statue and two sculpted wood panels, *Soyez Amoureuses* and *Soyez Mystérieuses*.

The emphasis on the decorative line in *The Garden at Calmpthout* was further explored in Van de Velde's drawings and pastels of the same period (e.g. *Woman Reading*, pastel, c. 1892 and *Decorative Panel with Fruit*, pastel, c. 1892, both Rijksmuseum Kröller-Müller,

425

Otterlo), and in his printed work such as posters and book illustrations for Max Elscamp's *Dominical* (1892). The flat, decorative surface in this picture points forward to a greater two-dimensionality in later paintings (e.g. *Woman Reaping*, 1893, Petit Palais, Geneva) and to his eventual rejection of paintings in favour of wallpaper and decorative panels (e.g. *The Angels' Vigil*, 1892–3, appliqué-embroidered wall panel. Kunstgewerbemuseum, Zürich). Van de Velde's move into the decorative arts reflects the general situation in Belgian art at the beginning of the 1890s. Situated at the meeting-point of the Arts and Crafts Movement from England and the decorative, Japanese-inspired art of Paris, Brussels was ideally placed to produce that fusion between the two styles which formed Art Nouveau. Van de Velde's debt to both these sources established him as a central figure within the new style. M A.S.

REFERENCES
Hammacher–Billiter, no. 29
Leben, repr. pl. 22

Verster, Floris-Hendrik 1861–1927

Born in Leiden, Verster studied under Breitner in 1878–9 and then attended the Academy of Fine Arts in The Hague. He spent a brief period in Brussels, studying in the atelier of Banson, and then returned to Leiden where he settled. He established himself as a painter of flower-pieces and as a watercolourist. His intense still-lives reflect his admiration for Vermeer, while his fluent handling of paint expresses his debt to Breitner.

426 *Cinerarias* 1891

sdbl Floris Verster '91 74.5 × 57 cm/29¼ × 22½ ins
Lent by the Stedelijk Museum, Amsterdam
Gift of the Vereeniging tot het vormen van een Openbare
Verzameling van Hedendaagse Kunst, 1949

Verster's work encompasses two styles that seem diametrically opposed. On the one hand there are still-lives executed in a dry, meticulous, almost 'primitive' style, and on the other are his flower-pieces and landscapes painted with the conscious neglect of detail found here. The boldness of colour and looseness of execution, which allow the shape of the object to emerge from the background, mark this painting as the work of a member of the 1880s' generation of young Hague artists. Like Breitner before c. 1890, Verster had been deeply impressed in his formative years by the example of the loose technique and strong colouring of the older members of the Hague School such as Mesdag and Jozef Israels, and by contact with works by artists of the French Barbizon School of landscape painters. These paintings had been made available in The Hague through

426

commercial galleries such as H. J. and E. J. Van Wisselingh, which was responsible for introducing the heavily loaded, brilliantly coloured flower-pieces of the French artist Monticelli (cf. no. 144). Although much more open in his technique, it was perhaps to Monticelli that Verster was referring in this painting of cinerarias. M A.S.

EXHIBITION
1891, Rotterdam, *Kunstwerken van Levende Meesters*
REFERENCE
W. Scherjon, *Floris Verster*, 1892, no. 70

Vogels, Guillaume 1836–96

Largely self-taught, Vogels became a professional artist late in life, possibly encouraged by his close friend and fellow member of Les XX, Pericles Pantazis. Vogels confined himself largely to landscapes and scenes of the Brussels suburbs. He adopted the technique of two other landscapists, Artan and Boulenger, who were themselves influenced by the Barbizon painters. He exhibited at the Ghent Triennale in 1874 and with the La Chrysalide circle in 1878. He was a founder member of Les XX in 1883 and influenced the stylistic development of its younger members such as Ensor, Khnopff, Toorop and Van Rysselberghe.

427 *Winter Landscape* 1880/5

> *Paysage d'hiver*
> sbl. G. Vogels 52 × 60 cm/20½ × 23½ ins
> Lent by the Musée d'Ixelles

By autumn 1883, when Octave Maus was considering which Belgian artists should be invited to participate in the proposed exhibiting group, Les XX, the name of Guillaume Vogels figured high on the list. Although he had hardly been noticed in the previous

427

decade, his prominent exhibiting career and bold painting technique made him an obvious candidate. In 1881 one of his paintings, *Canal in Holland*, had been accepted at the Paris Salon; in 1883 he was exhibiting with L'Essor in Brussels, and in Amsterdam and Nice.

Although he had derived his technique from Belgian landscape artists such as Boulenger and Artan, in the early 1880s he began to use bolder colours handled in broad, loose brushstrokes applied to landscapes under snow, rain or stormy sunsets, as well as to still-lives. This more dramatic technique met a mixed reception from the critics. Some saw his new style as proof of the fact that 'he cannot progress beyond a rough sketch' ('L'Exposition du cercle artistique à Bruxelles', *L'Art moderne*, 1882, p. 139), while staunch supporters of Les XX such as Emile Verhaeren, when reviewing the inaugural exhibition of this group in 1884, considered Vogels to be 'a master' ('Le Salon des XX', *La Jeune Belgique*, February 1884, p. 197). It was this new boldness of technique, combined with Vogels' influential position within Les XX, which seems to have attracted the admiration of younger artists such as Ensor (cf. no. 392), Toorop (cf. no. 415) and Van Rysselberghe. So pronounced was Ensor's debt to Vogels in the early 1880s that the names of these two artists were frequently linked by critics reviewing exhibitions in which both participated (e.g. 'Au cercle artistique: Exposition Vogels–Ensor–Storm de Gravesande', *L'Art moderne*, 1884, pp. 86–7). M A.S.

REFERENCE
Charleroi, Palais des Beaux-Arts, and Ixelles, Musée des Beaux-Arts,
 Rétrospective Vogels, 1968

Witsen, Willem 1860–1923

A painter and an etcher, Witsen received his artistic training under d'Allebé at the Amsterdam Rijksadademie. By the 1890s he had become a prominent figure in Amsterdam painting. He exhibited in Paris, where his work was praised.

428

428 *The Oude Schans* c. 1889

> *De Oude Schans*
> sbr. Witsen 100 × 129 cm/39½ × 50¾ ins
> Lent by the Stedelijk Museum, Amsterdam, Gift of the Vereeniging
> tot het vormen van een Openbare Verzameling
> van Hedendaagse Kunst, 1949

The subject matter, composition and tonality of this painting at first suggest a close resemblance to Breitner's painting of the same date, *Lauriergracht, Amsterdam* (no. 389), but there are certain differences. Witsen seems uninterested in developing the pattern of overlapping colour-planes formed with bold brushstrokes, such as can be seen in Breitner's painting, and adopts, instead, a rather smooth, tight brushstroke technique, which emphasizes the detail of the houses and their reflections in the canal below. In addition, the sombre tonality of Witsen's painting is not the result of a rejection of bright colour and an interest in photography but rather the consequence of the relative isolation of Amsterdam during the 1880s and 1890s from the artistic innovations found elsewhere in Europe. Unlike Brussels and The Hague, Amsterdam had no equivalent to Les XX or the Hague Kunstkring, with their pioneering policies of inviting foreign artists to exhibit, especially those from the Paris avant-garde. Artistic apathy was at such a pitch in Amsterdam that a small show of Impressionists in 1900, a Toorop show in 1904 and a Van Gogh exhibition in 1905 passed almost unnoticed. It was in this independent, 'crepuscular' school of painting that Piet Mondrian was trained (cf. no. 406). M A.S.

Chronology

In the French and British chronologies, all exhibitions take place in Paris or London, unless otherwise stated. Exhibitions in other cities in these countries, and all exhibitions in the remaining countries' chronologies, are listed in alphabetical order of cities. Only skeletal chronologies are given for Germany and Italy during the earlier 1880s, before the beginning of the

France

JOHN HOUSE WITH MARYANNE STEVENS

1880

Foundation of French socialist party.
Huysmans, *Croquis parisiens*, publ.
Burty, *Grave imprudence*, publ.
Zola, 'Le Naturalisme au Salon', *Le Voltaire*, 18, 19, 22 June.
Durand-Ruel resumes buying paintings from Sisley and Pissarro.

EXHIBITIONS
April 5th Impressionist group exh., inc: Cassatt, Degas, Forain, Gauguin, Guillaumin, C. Pissarro, Raffaëlli, Zandomeneghi.
April *La Vie moderne* offices, *Manet*.
May onwards Salon, inc: Aman-Jean, Bastien-Lepage, Béraud, Besnard,

Boldini, Carrière, Cazin, Dagnan-Bouveret, Fantin-Latour, Guillou, Harrison, La Touche, Liebermann, Maignan, Manet, Martin, Monet, Moreau, Moret, Renoir, Roll, Sargent, Schuffenecker.
June *La Vie moderne* offices, *Monet*.

1881

Bourget, *Essais sur la psychologie française*, publ.
Sensier, *La Vie et l'oeuvre de J. F. Millet*, publ.
Ogden Rood, *Modern Chromatics*, French edn.
Duret, 'James Whistler', *Gazette des Beaux-Arts*, April.
Péladan, 'Le Matérialisme dans l'art'

(his first writing on art), *Le Foyer, Journal de famille*, 31 Aug
Durand-Ruel resumes buying paintings from Renoir and Monet.

EXHIBITIONS
April 6th Impressionist group exh., inc: Cassatt, Degas, Forain, Gauguin, Guillaumin, C. Pissarro, Raffaëlli, Zandomeneghi.

May onwards Salon (newly reorganized, under the control of the artists), inc: Bastien-Lepage, Béraud, Besnard, Boldini, Cazin, Fantin-Latour, Guillou, Harrison, Hodler, La Thangue, La Touche, Liebermann, Maignan, Manet (2nd class medal), Martin, Moret, Puvis de Chavannes, Renoir, Sargent, W. Stott.
La Vie moderne offices, *Sisley*.
Le Vie moderne offices, *Redon*.

1882

Loti, *Le Mariage de Loti*, publ.
Redon, *A Edgar Poe*, lithographs, publ.

EXHIBITIONS
March 7th Impressionist group exh., organized by Durand-Ruel, inc: Gauguin, Guillaumin, Monet, C. Pissarro, Renoir, Sisley.
May onwards Salon, inc: Aman-Jean, Bastien-Lepage, Béraud, Besnard, Blanche, Carrière, Cézanne, Claus, Dagnan-Bouveret, Fantin-Latour,

Guillou, Harrison, Helleu, Klinger, La Touche, Liebermann, Maignan, Manet, Martin, Maurin, Puvis de Chavannes, Renoir, Roll, Sargent, W. Stott, Whistler.
Spring G. Petit, 1st Exposition Internationale, inc: Alma-Tadema, Baudry, Dupré, Gérôme, Israels, Menzel, Millais, de Nittis, A. Stevens
May onwards Ecole des Beaux-Arts, *Courbet*.
Le Gaulois offices, *Redon*.
?Oct. 1st Exposition des Arts Incohérents.

1883

Feb. death of Wagner in Venice.
April death of Manet.
Huysmans, *L'Art moderne* (art criticism), publ.
Gonse, *L'Art japonais*, publ.
Redon, *Les Origines*, lithographs, publ.
Verlaine, 'Les Poètes Maudits', publ. in *La Lutèce*.

EXHIBITIONS
Durand-Ruel, series of one-man shows: *Boudin* (Feb.), *Monet* (March), *Renoir* (April), *C. Pissarro* (May).
April G. Petit, *Exposition rétrospective de l'art japonais*.

May onwards Salon, inc: Aman-Jean, Bastien-Lepage, Béraud, Besnard, Carrière, Cazin, Cross, Fantin-Latour, Guillou, La Touche, Liebermann, Maignan, Martin, Maurin, Moret, Puvis de Chavannes, Renoir, Roll, Sargent, Seurat (drawing), E. Stott, W. Stott, Vogels, Whistler.
May–June G. Petit, 2nd Exposition Internationale, inc: Cabanel, Leibl, de Nittis, A. Stevens, Watts, Whistler.
Sept. onwards Exposition Nationale des Beaux-Arts (Artistes Vivants), inc:

Bastien-Lepage, Béraud, Besnard, Cazin, Dagnan-Bouveret, Fantin-Latour, Guillou, Liebermann, Maignan, Martin, Maurin, Puvis de Chavannes, Roll.
Oct.–Nov. Exposition des Arts Incohérents, inc: Allais.
Palais de l'Industrie, *Tissot*.
Dec. 2nd exh. of Société des Jeunes Artistes, inc: Angrand.
Dec.–Jan. 1884 G. Petit, *L'Art du dix-huitième siècle* (from the Goncourt Collection).

1884

Trades unions legalized.
Death of Bastien-Lepage.
Huysmans, *A Rebours*, publ.
Revue indépendante founded by Fénéon.
Revue wagnérienne founded in Munich by Houston Chamberlain, Dujardin and de Wyzéwa (1st issue, Paris, 1885).

EXHIBITIONS
Jan. Ecole des Beaux-Arts, *Manet* (retrospective).
4–5 Feb. Manet studio sale.
April–May G. Petit, 3rd Exposition Internationale, inc: Bastien-Lepage, Béraud, Carolus-Duran, Cazin, Liebermann, Roll, A. Stevens.

May onwards Salon, inc: Bastien-Lepage, Béraud, Besnard, Blanche, Carrière, Claus, Dagnan-Bouveret, Fantin-Latour, Forain, Guillou, Harrison, Herkomer, Khnopff, La Touche, Liebermann, Martin, Maurin, Puvis de Chavannes, Roll, Sargent, Segantini, E. Stott, W. Stott, Whistler.
May–July Salon des Artistes Indépendants, inc: Angrand, Cross, Dubois-Pillet, Redon, Schuffenecker, Seurat, Signac (the only exh. of the Salon des Indépendants, to be succeeded by the Société des Artistes Indépendants in Dec. 1884).

Ave de l'Opéra, *Raffaëlli* (independently organized one-man show).
Cercle des Arts Libéraux, inc: Seurat.
Oct.–Nov. Exposition des Arts Incohérents, inc: Allais, Angrand.
Dec. Société des Artistes Indépendants, 1st exh., inc: Angrand, Cross, Dubois-Pillet, Guillaumin, Redon, Schuffenecker, Seurat, Signac (no exh. 1885, annual shows from 1886, hereafter referred to as Indépendants).

Germany

GILLIAN PERRY

1883

EXHIBITIONS
Berlin Fritz Gurlitt, Impressionist exh.

principal developments charted in the present exhibition. The French chronology lists only the most significant exhibitions after 1908, the approximate end date of the French section in this exhibition; the Low Countries chronology ends in 1910. Where no month or season is indicated for an exhibition, its exact dates are uncertain. Artists included in the present exhibition are listed whenever their work appeared, other artists only when their appearance is particularly interesting. Exhibition titles often appear in abbreviated form.

Great Britain and Ireland

ANNA GRUETZNER

1880

Nov., Whistler returns from Venice.

EXHIBITIONS
May–July Grosvenor Gallery, inc: Bastien-Lepage, Clausen.
May onwards RA, inc: Bastien-Lepage, Fantin-Latour, Forbes, La Thangue.

Dec. Fine Art Society, *Whistler* (12 Venice etchings).
Glasgow, Feb.–April Glasgow Institute of Fine Arts, inc: Fantin-Latour, Guthrie, La Thangue, Lavery, Tissot.
Liverpool, Oct. Walker Art Gallery, exh. inc: Clausen, La Thangue.

1881

EXHIBITIONS
Jan. Fine Art Society, *Whistler* (Venice pastels).
May onwards RA, inc: Besnard, Clausen, Fantin-Latour, Tissot.
May–July Grosvenor Gallery, inc: Whistler.
Autumn Hanover Gallery, inc: Besnard.

Dec.–Jan. 1882 Grosvenor Gallery, inc: Clausen.
Glasgow, Feb.–April Institute, inc: Clausen, Fantin-Latour, La Thangue, Lavery, Starr, Tissot.
Liverpool, autumn Walker AG, inc: Fantin-Latour, Osborne.

1882

EXHIBITIONS
Jan. French Gallery, inc: Bastien-Lepage, Tissot.
May onwards RA, inc: Besnard, Clausen, Fantin-Latour, Forbes, Guthrie, Rodin, Sargent, Starr, W. Stott.
May United Arts Gallery, inc: Bastien-Lepage, Liebermann, Vernier.
July Grosvenor Gallery, inc: Clausen, La Thangue, Sargent, Whistler.

July 13 King Street, St James's, small exh. of French Impressionists organized by Durand-Ruel, inc: Degas, Monet, Renoir.
July Fine Art Society, *British and American Artists from the Paris Salon*, inc: Harrison, Sargent, W. Stott.
Glasgow, Feb.–May Institute, inc: Guthrie, Henry, Lavery.
Liverpool, autumn Walker AG, inc: Fantin-Latour, Forbes, La Thangue, Lavery, Osborne, Starr, W. Stott.

1883

F. Wedmore, 'The Impressionists', *Fortnightly Review*, Jan.
April, Sickert takes Whistler's *Mother* to Salon and visits Manet and Degas.
G. Moore, *A Modern Lover*, publ.

EXHIBITIONS
Feb. Fine Art Society, *Whistler* (etchings).
April Dowdeswell, *Paintings, Drawings and Pastels by Members of La Société des Impressionnistes*, inc: Cassatt, Degas, Manet, Monet, Pissarro, Renoir, Sisley.

May–July Grosvenor Gallery, inc: Clausen, Forbes, La Thangue, Whistler.
May–July Dudley Gallery, inc: Besnard, Cazin, Roll, Rodin.
May onwards RA, inc: Fantin-Latour, Forbes, Guthrie, Starr, Steer, E. Stott.
Winter 1883–4 Grosvenor Gallery, *Sir Joshua Reynolds*.
Glasgow, Feb.–April Institute, inc: Bastien-Lepage, Guthrie, La Thangue, Lavery, W. Stott.
Liverpool, autumn Walker AG, inc: Clausen, Fantin-Latour, Forbes, La Thangue, Lavery, W. Stott.

1884

E. Chesneau, *The English School of Painting*, publ.

EXHIBITIONS
April McLean, inc: Bastien-Lepage.
May onwards RA, inc: Clausen, Dagnan-Bouveret, Fantin-Latour, Forbes, Rodin, Sargent, Starr, Steer, E. Stott.
May–July Grosvenor Gallery, inc: Forbes, La Thangue, Sargent, W. Stott, Whistler.
May Dowdeswell, *Whistler*.
June Dudley Gallery, inc: Besnard, Roll.
Oct. Hanover Gallery, inc: Bastien-Lepage, Cazin, Fantin-Latour, Raffaëlli, Tissot.

Winter 1884–5 Society of British Artists, inc: Sickert, Steer, Whistler.
Winter 1884–5 Grosvenor Gallery, *Thomas Gainsborough*.
Dublin, Nov. Dublin Sketching Club, inc: Whistler.
Edinburgh, Oct. exh. of portraits, inc: Whistler's *Carlyle*.
Glasgow, Feb.–April Institute, inc: Clausen, Fantin-Latour, Forbes, Guthrie, Henry, La Thangue, Lavery, W. Stott.
Liverpool, autumn Walker AG, inc: Clausen, Fantin-Latour, Forbes, Lavery, Osborne.

Italy

SANDRA BERRESFORD

1880

EXHIBITIONS
Florence, Sept.–March 1881 Società Donatello, 1 Esposizione di Quadri Moderni, inc: Corot, Daubigny, Delacroix, Diaz, Dupré, Fantin-Latour, Eva Gonzales, Ingres, Jongkind, Manet, Millet.

1882

A. Costa founds Partito dei Lavoratori in Milan.

1884

Martelli, article on Manet in *Fieramosca*, March.

The Low Countries

MARYANNE STEVENS

1880

Oct., Sint Lucas Society founded in Amsterdam.

1881

La Jeune Belgique founded in Brussels by M. Waller.
L'Art moderne founded in Brussels by E. Picard.

EXHIBITIONS
Brussels La Chrysalide, inc: Ensor.

1882

La Revue moderne founded in Brussels.

EXHIBITIONS
Brussels Cercle Artistique, exh. inc: Ensor.
The Hague, June–July Art Academy, *French 19th-Century Artists*, inc: Corot, Daubigny, Diaz, Dupré, T. Rousseau, Troyon.

1883

Oct., Als Ik Kan group founded in Antwerp.
Oct., Les XX founded in Brussels by O. Maus and 20 Belgian artists.
Maeterlinck, 'Les Joncs' (1st poem), *La Jeune Belgique*.

EXHIBITIONS
Amsterdam Universal Exhibition, inc: Segantini.
Brussels L'Essor, inc: Ensor, Khnopff, Toorop.

1884

Government falls, resulting in universal suffrage and establishment of Partie Ouvrier Belge.
Lectures at Les XX by E. Picard, G. Rodenbach, C. Mendès.
Two concerts at Les XX.
La Basoche founded in Brussels.

EXHIBITIONS
Brussels, Feb.–March 1st Les XX, inc. (members): Ensor, Finch, Khnopff, Van Rysselberghe; (invitees): Chase, Gervex, Heymans, J. Israels, Maris, Mauve, Rodin, Rops, Sargent, W. Stott, Whistler.
Brussels Exposition Générale des Beaux-Arts, inc: Toorop.

France

1885

Death of Victor Hugo.
Duret, *Critique d'avant-garde* (art criticism), publ.
'Adoré Floupette', *Les Déliquescences*, publ.
Redon, *Hommage à Goya*, lithographs, publ.
Kropotkin, *Paroles d'un révolté* (selected essays of 1879–82), publ.
Mallarmé, 'Richard Wagner – rêverie d'un poète français', *Revue wagnérienne*, Aug.
Kropotkin's Anarchist review *Le Révolté*, ed. Jean Grave, transferred from Geneva to Paris.
Aristide Bruant founds Le Mirliton in Montmartre.

EXHIBITIONS
March–April Ecole des Beaux-Arts, *Delacroix*.
March–April Ecole des Beaux-Arts, *Bastien-Lepage*.
April–May Galerie Sedelmeyer, *Tissot*.
May onwards Salon, inc: Aman-Jean, Béraud, Besnard, Blanche, Carrière, Claus, Cross, Dagnan-Bouveret, Fantin-Latour, Guillou, Harrison, Herkomer, La Touche, Maignan, Martin, Puvis de Chavannes, Raffaëlli, Roll, Sargent, Simon, W. Stott, Vallotton, Whistler.
May–June G. Petit, 4th Exposition Internationale, inc: Béraud, Besnard, Bonnat, Cazin, Gervex, Liebermann, Monet, Raffaëlli, Sargent, A. Stevens.

1886

March, Van Gogh arrives in Paris
Gauguin visits Brittany for first time.
Death of Monticelli.
First Neo-Impressionist paintings shown at 8th and last Impressionist exh.
Zola, *L'Oeuvre*, publ.
Fénéon, *Les Impressionistes en 1886*, publ.
Loti, *Pêcheur d'Islande*, publ.
A. Jullian, *Richard Wagner*, with lithographs by Fantin-Latour, publ.
Redon, *La Nuit*, lithographs, publ.
Kropotkin, 'La Conquête du pain', *Le Révolté* (publ. as book, 1892).
Moréas, 'Manifeste du symbolisme'.

Figaro littéraire, 18 Sept.
Kahn, 'Réponse des symbolistes, *L'Evénement*, 28 Sept.
Le Symboliste founded by Kahn, Adam and Moréas.

EXHIBITIONS
March–April Bernheim Jeune, *Moreau Watercolours*.
May onwards Salon, inc: Aman-Jean, Béraud, Besnard, Blanche, Carrière, Claus, Dagnan-Bouveret, Fantin-Latour, Guillou, Harrison, La Touche, Legrand, Maignan, Maurin, Moret, Puvis de Chavannes, Raffaëlli, Roll, Sargent, Simon, W. Stott, Vallotton.

May–June 8th Impressionist group exh., inc: Cassatt, Degas, Forain, Gauguin, Guillaumin, C. Pissarro, L. Pissarro, Redon, Schuffenecker, Seurat, Signac, Zandomeneghi.
June–July 5th Exposition Internationale, inc: Besnard, Blanche, Boldini, Cazin, Gervex, Liebermann, Monet, Raffaëlli, Renoir, Rodin.
Aug.–Sept. Indépendants, inc: Angrand, Cross, Dubois-Pillet, L. Pissarro, Redon, Henri Rousseau, Seurat, Signac.
Oct.–Dec. Exposition des Arts Incohérents.
Dec.–Jan. 1887 Martinet, exh. inc: C. Pissarro, Seurat, Signac.
Dec.–Jan. 1887 G. Petit, *Whistler*.

1887

Death of Laforgue.
Gauguin in Martinique.
Revue indépendante refounded by Dujardin.
Grave's Anarchist review *Le Révolté* replaced by *La Révolte* (1887–94).
Théâtre Libre founded by Antoine.
Théâtre des Ombres Chinoises founded by Salis at Le Chat Noir.
First Paris performance of Wagner, *Lohengrin*.

EXHIBITIONS
Feb.–March Le Tambourin café, *Japanese Prints*, organized by Vincent Van Gogh.
March *chez* Paulin, C. Pissarro.

March–May Indépendants, inc: Angrand, Cross, Dubois-Pillet, Luce, Maurin, L. Pissarro, Redon, Henri Rousseau, Seurat, Signac.
May onwards Salon, inc: Aman-Jean, Béraud, Besnard, Blanche, Carrière, Claus, Dagnan-Bouveret, Fantin-Latour, Guillou, Harrison, La Touche, Le Sidaner, Liebermann, Maignan, Martin, Maurin, Puvis de Chavannes, Raffaëlli, Roll, Simon, Vallotton.
May–June Ecole des Beaux-Arts, *Millet*.
May–June G. Petit, 6th Exposition Internationale, inc: Besnard, Cazin, Harrison, Leibl, Liebermann, Monet, C. Pissarro, Raffaëlli, Renoir, Sisley, Whistler.

?Spring Le Tambourin café, exh. inc: Anquetin, Bernard, Van Gogh. Toulouse-Lautrec, organized by Vincent Van Gogh.
?Autumn Restaurant La Fourche, exh. inc: Anquetin, Bernard, Van Gogh, organized by Vincent Van Gogh.
Oct. onwards Union Centrale des Arts Décoratifs, *Japanese Art*.
Nov.–Dec. Durand-Ruel, *Puvis de Chavannes*.
Dec. Boussod & Valadon (blvd Montmartre branch, organized by Théo Van Gogh), exh. inc: Gauguin, Guillaumin, C. Pissarro.
Dec.–Jan. 1888 *Revue indépendante* offices, exh. inc: Anquetin, Manet, C. Pissarro, L. Pissarro, Raffaëlli, Seurat, Signac.

1888

Eiffel Tower begun.
Van Gogh leaves Paris for Arles.
Gauguin joined by Bernard at Pont-Aven in Brittany.
Oct., Gauguin joins Van Gogh in Arles.
Sérusier's *The Talisman*, painted under Gauguin's instruction in Oct., leads to foundation of Nabi group in winter 1888–9, by Sérusier, Denis, Bonnard, Ranson, joined 1889 by Vuillard and Roussel.
Mallarmé meets Whistler through Monet, and translates Whistler's *Ten O'Clock* lecture into French.
C. Henry, *Cercle chromatique*, publ.
Loti, *Madame Chrysanthème*, publ.
Redon, *Tentation de Saint-Antoine*, lithographs (1st series), publ.
Petit Théâtre des Marionnettes founded by Signoret (taken over by Buchor, 1889).

EXHIBITIONS
Jan. G. Petit, Exposition de Peinture et de Sculpture par 33 Artistes Français et Etrangers, inc: Angrand, Blanche, Khnopff, Redon.
Jan. Boussod & Valadon (Théo Van Gogh), exh. inc: Degas, Gauguin.
Jan. Durand-Ruel, exh. inc: Degas.
Jan. *Revue indépendante* offices, exh. inc: Seurat.
Feb. *Revue indépendante* offices, exh. inc: Angrand, Besnard, Seurat.
March–May Indépendants, inc: Angrand, Anquetin, Cross, Dubois-Pillet, Van Gogh, Luce, Maurin, L. Pissarro, Rousseau, Seurat, Signac.
April Boussod & Valadon (Théo Van Gogh), exh. inc: Gauguin, Schuffenecker, Zandomeneghi.
May onwards Salon, inc: Aman-Jean, Blanche, Carrière, Cazin, Claus, Dagnan-

Bouveret, Fantin-Latour, Guillou, Harrison, Herkomer, La Touche, Lavery, Legrand, Le Sidaner, Liebermann, Maignan, Martin, O'Conor, Raffaëlli, Roll, Sargent, Sérusier, Simon.
May–June *Revue indépendante* offices, *Guillaumin*.
May–June Durand-Ruel, exh. inc: C. Pissarro, Renoir, Whistler.
June–July Boussod & Valadon (Théo Van Gogh), *Monet* (views of Antibes).
June–July Galerie Bing, *Exposition historique de l'art de la gravure au Japon*.
July *Revue indépendante* offices, *Luce*.
Sept. Boussod & Valadon (Théo Van Gogh), exh. inc: Manet, C. Pissarro, Zandomeneghi.
Sept.–Oct. *Revue indépendante* offices, *Dubois-Pillet*.
Sept.–Oct. *chez* G. Seguin, blvd Saint-Michel, *L'Affiche de M. Paul Signac*.

Germany

1885

Ibsen comes to Munich.
Nietzsche completes *Also Sprach Zarathustra*.
Munch visits Paris.

EXHIBITIONS
Geneva Cercle des Beaux-Arts, *Hodler* (1st one-man exh.).

1886

Nietzsche, *Jenseits von Gut und Böse*, publ.

EXHIBITIONS
Berlin Jubiläums Ausstellung, inc: Corinth, Liebermann.

1887

Ibsen's *Ghosts* performed in Berlin.

1888

Nietzsche writes *Der Antichrist*.

Great Britain and Ireland

1885

G. Moore meets Sickert who introduces him to Steer.
Oct., Sickert returns from Degas in Paris to teach Whistler's followers Impressionist techniques.

EXHIBITIONS
May onwards RA inc: Clausen, Fantin-Latour, Forbes, Sargent, Sickert, Starr, Steer, E. Stott.
May Grosvenor Gallery, inc: Clausen, Fantin-Latour, Forbes, Sargent, Steer, E. Stott.
June Hanover Gallery, inc: Cazin, Moreau, Raffaëlli, Tissot.

Summer Society of British Artists, inc: Sickert, Starr, Whistler.
Salon Parisien, inc: Bastien-Lepage, Claus, Knhopff, W. Stott.
Winter 1885-6 Society of British Artists, inc: Sickert, Starr, Steer, W. Stott, Whistler,
Winter 1885-6 Grosvenor Gallery, inc: *Millais*.
Glasgow, Feb.-April Institute, inc: Clausen, Fantin-Latour, Forbes, Guthrie, Henry, Lavery, Segantini, Steer, W. Stott.
Liverpool, autumn Walker AG, inc: Clausen, Fantin-Latour, Harrison, Lavery, Starr, Steer, E. Stott.

1886

G. Moore, 'Half a Dozen Enthusiasts', *The Bat*, 25 May (anon. review of last Impressionist exh.)
June, Whistler elected President of Society of British Artists.

EXHIBITIONS
Jan. Dowdeswell, *Sickert*.
April New English Art Club, 1st exh., inc: Clausen, Forbes, La Thangue, Sargent, Starr, Steer, E. Stott.
May onwards RA, inc: Fantin-Latour, Forbes, Lavery, Osborne, Sargent, Starr.
May Dowdeswell, *Whistler*.
Summer Grosvenor Gallery, inc: Clausen, Fantin-Latour, Forbes, Sargent, E. Stott.

Summer Society of British Artists, inc: Starr, W. Stott, Whistler.
Salon Parisien, inc: La Touche.
Nov. Goupil, *Moreau* (watercolours for La Fontaine's *Fables*).
Winter 1886-7 Society of British Artists, inc: T. Roussel, Sickert, Starr, Steer, W. Stott, Whistler.
Winter 1886-7 Hanover Gallery, inc: Bastien-Lepage, Cazin, Tissot.
Winter 1886-7 Grosvenor Gallery, *Sir Anthony Van Dyck*.
Glasgow, Feb.-April Institute, inc: Bastien-Lepage, Clausen, Guthrie, Henry, Hornel, La Thangue, Lavery.

1887

Monet visits London for opening of RBA exh.

EXHIBITIONS
Feb.-March Goupil, inc: Dagnan-Bouveret.
April NEAC, inc: Blanche, Clausen, Forbes, Harrison, Henry, Lavery, Osborne, T. Roussel, Sargent, Steer, E. Stott.
May RA, inc: Fantin-Latour, Forbes, Lavery, Osborne, Sargent.

May-July Grosvenor Gallery, inc: La Thangue, Osborne, Steer, E. Stott.
Summer Royal Society of British Artists, inc: Lavery, T. Roussel, Sickert, Starr, Steer, W. Stott, Whistler.
Summer Continental Gallery, inc: Claus.
Dec. Goupil, inc: Bastien-Lepage.
Winter 1887-8 Royal Society of British Artists, inc: Lavery, Monet, T. Roussel, Sickert, Starr, Steer, W. Stott, Whistler.
Glasgow, Feb.-April Institute, inc: Guthrie, Henry, Hornel, Lavery, Tissot.

1888

Constable sketches enter Victoria and Albert Museum.
G. Moore, *Confessions of the Artist as a Young Man*, publ.
April, 'Impressionist clique' gains control of NEAC.
May, Whistler forced to resign as President of RBA.
Whistler, 'Ten O'Clock', *Fortnightly Review*, June.
E. M. Rashdall, 'Claude Monet', *The Artist*, 2 July.

EXHIBITIONS
Jan. Dowdeswell, *Monticelli*.
April NEAC, inc: Blanche, Clausen, Degas, Forbes, Harrison. Maitland, Osborne, T. Roussel, Sickert, Starr, Steer, E. Stott, Whistler.
Spring Earl's Court, *Italian Exhibition*, inc: Morbelli, Segantini.
Spring Royal Society of British Artists, inc: Sickert, Starr, W. Stott.

May onwards RA, inc: Fantin-Latour, Forbes, Harrison, Sargent.
May-July Grosvenor Gallery, inc: Clausen, Fantin-Latour, Forbes, T. Roussel.
June-July Goupil, *The Maris brothers*.
July Continental Gallery, inc: Claus.
Oct.-Dec. Grosvenor Gallery, 1st *Pastel Exhibition*, inc: Besnard, Blanche, Clausen, Fantin-Latour, Helleu, Roll, T. Roussel, Starr, Steer, W. Stott.
Winter 1888-9 Hanover Gallery, inc: Cazin.
Winter 1888-9 Grosvenor Gallery, *A Century of British Art 1737-1837*.
Glasgow, Feb. Institute, inc: Guthrie, Henry, Hornel, Lavery.
Glasgow, April Institute, inc: Guthrie, Lavery.
Glasgow, spring *Lavery*.
Liverpool, autumn Walker AG, inc: Fantin-Latour, Forbes, Harrison, La Thangue, Lavery, Osborne, T. Roussel, Sickert, W. Stott.

Italy

1885

1886

Partito Operaio disbanded in Milan, and its leaders arrested.
D'Annunzio, *Isaotta Guttadauro* (Pre-Raphaelite-inspired poems), publ.
G. Costa founds exhibition society In Arte Libertas in Rome; annual exhibitions until 1902.

1887

Previati begins to illustrate Edgar Allan Poe's *Tales* (until 1890).

EXHIBITIONS
Venice Esposizione Nazionale di BB.AA., inc: Previati, Segantini.

1888

Venturi founds *Archivio Storico dell'Arte* (periodical) in Rome, devoted to Italian cultural heritage, especially Quattrocento.

EXHIBITIONS
Bologna Esposizione Nazionale di BB.AA., inc: Previati, Segantini.

The Low Countries

1885

De Nederlandse Etsclub founded in Amsterdam.
Lectures at Les XX, inc: Raffaëlli, 'Le Laid dans l'art'.
De Nieuwe Gids founded in Amsterdam.
Chronique des Beaux-Arts et de la littérature founded in Antwerp.
Oct., Maeterlinck travels to Paris.
Rodenbach lectures on Schopenhauer in Brussels.

EXHIBITIONS
Brussels, Feb.-March Les XX, inc. (members): Ensor, Finch, Khnopff, Van Rysselberghe, Toorop, Vogels; (invitees): Cazin, Fantin-Latour, Mellery, Mesdag, Raffaëlli, Uhde.

1886

Redon executes illustrations to E. Picard, *Le Juré*.
L'Art libre founded in Brussels.
La Pléiade founded by Mikhael, Quillard, St-Pôl-Roux.
La Wallonie founded in Liège by A. Mockel: commissions contributors to Paris review, *Ecrits pour l'art*.

EXHIBITIONS
Amsterdam Universal Exhibition, inc: Segantini.
Brussels, Feb.-March 3rd Les XX, inc. (members): Ensor, Finch, Khnopff, Van Rysselberghe, Vogels; (invitees): Besnard, Breitner, Degas (but refused to send), Monet, Monticelli, Redon, Renoir, Whistler, Zandomeneghi.
The Hague *Works by Living Artists*, inc: Toorop.

1887

Redon executes frontispiece for Verhaeren, *L'Idole*.
Lectures at Les XX, inc: E. Picard. 'Lecture du *Juré*'.

EXHIBITIONS
Antwerp 1st Salon de l'Art Indépendant, inc: Van de Velde.
Brussels, Feb.-March 4th Les XX, inc. (members): Ensor, Finch, Khnopff, Van Rysselberghe, Toorop, Vogels; (invitees): Cazin, C. Pissarro, Raffaëlli, Rodin, Seurat, Sickert.

1888

Redon executes frontispiece for Verhaeren, *Les Débâcles, Les Soirs*.
Lecturers at Les XX, inc: Villiers de l'Isle Adam, O. Maus.
Concerts at Les XX, inc: Bach, Fauré, Franck, d'Indy, Scarlatti, Schumann, Spanish works.

EXHIBITIONS
Brussel, Feb.-March 5th Les XX, inc: (members): Ensor, Finch, Khnopff, Van Rysselberghe, Toorop, Vogels; (invitees): Anquetin, Blanche, Burne-Jones (but refused to send), Degas (but refused to send), Dubois-Pillet, Forain, Guillaumin, Helleu, Mellery, Signac, Whistler.
The Hague Pulchri Studio, exh. inc: Toorop.

France

1889

Exposition Universelle held in France (for which Eiffel Tower built 1888–9).
Huysmans, *Certains* (art criticism), publ.
Schuré, *Les Grands initiés*, publ.
Bergson, *Les Données immédiates de la conscience*, publ.
Moréas, *Les Premières années du symbolisme*, publ.
Morice, *La Littérature de toute à l'heure*, publ.
Vanor, *L'Art symboliste*, preface by Adam, publ.
Redon, *A Gustave Flaubert*, lithographs (*Tentation de Saint-Antoine*, 2nd series), publ.
La Plume founded.
Le Moderniste illustré founded by Aurier, inc. articles by Gauguin, Bernard.
Moulin Rouge opened in Montmartre.

EXHIBITIONS
Jan. G. Petit, Exposition de la Société des 33 (2nd and last year), inc: Angrand, Blanche, Carrière, Khnopff.

Jan.–Feb. Durand-Ruel, Exposition des Peintres-Graveurs (1st year), inc. paintings by: C. Pissarro, L. Pissarro, Redon.
Feb.–March Durand-Ruel, *William Stott of Oldham*.
Feb.–March Boussod & Valadon (Théo Van Gogh), *Monet*.
May onwards Salon, inc: Adler, Aman-Jean, Béraud, Besnard, Blanche, Carrière, Claus, Cottet, Dagnan-Bouveret, Fantin-Latour, Guillou, Guthrie, Harrison, La Touche, Le Sidaner, Martin, Maurin, O'Conor, Raffaëlli, Roll, Simon, Vallotton.
May onwards Exposition Universelle. French section, inc: Aman-Jean, Béraud, Besnard, Carrière, Cazin, Dagnan-Bouveret, Fantin-Latour, Guillou, La Touche, Maignan, Martin, Maurin, Puvis de Chavannes, Raffaëlli, Roll, Tissot. American section, inc: Harrison, Sargent. British section, inc: Clausen, Forbes, Lavery, Sickert, Starr, Steer, W. Stott, Whistler. German section, inc:

Kalckreuth, Leibl, Liebermann. Italian section, inc: Boldini, Morbelli, Nomellini, Previati, Segantini, Zandomeneghi. Norwegian section, inc: Munch. Swiss section, inc: Hodler, Vallotton.
Exposition centennale de l'art français, inc: Bastien-Lepage, Béraud, Cazin, Cézanne, Fantin-Latour, Manet, Monet, C. Pissarro, Puvis de Chavannes, Raffaëlli, Roll, Tissot.
Summer Café Volpini, *Groupe impressionniste et synthétiste*, inc: Anquetin, Bernard, Gauguin, Laval, Schuffenecker.
June Cercle Artistique et Littéraire Volney, exh. inc: Toulouse-Lautrec.
June–July G. Petit, *Monet-Rodin* (retrospective).
Sept.–Oct. Indépendants, inc: Anquetin, Dubois-Pillet, Filiger, Van Gogh, Hayet, Luce, O'Conor, L. Pissarro, Rousseau, Seurat, Signac, Toulouse-Lautrec.

1890

Death of Vincent Van Gogh.
Redon, illustration to Baudelaire's *Les Fleurs du mal*, publ.
Denis, 'Définition du néo-traditionnisme', *Art et Critique*, Aug.
Biographies of C. Pissarro, Seurat, Dubois-Pillet, Luce, Cézanne, Schuffenecker, Van Gogh, publ. in *Les Hommes d'aujourd'hui*.
Mercure de France founded by Valette.
L'Art dans les deux mondes founded by Durand-Ruel (ends 1891).
Théâtre d'Art founded by Fort, with Lugné-Poë as assistant. ·

EXHIBITIONS
Feb.–March Boussod & Valadon (Théo Van Gogh), *C. Pissarro*.
March Durand-Ruel, Peintres-Graveurs, inc. paintings by: Luce, C. Pissarro.

March–April Indépendants, inc: Angrand, Anquetin, Anna Boch, Cross, Dubois-Pillet, Filiger, Finch, Van Gogh, Guillaumin, Luce, O'Conor, L. Pissarro, Rousseau, Van Rysselberghe, Seurat, Signac, Toulouse-Lautrec, Van de Velde.
April–May Ecole des Beaux-Arts, *La gravure japonaise*.
May onwards Salon des Artistes Français (continuing exhibitions of the body founded in 1881, often known as the Salon des Champs-Elysées, to distinguish it from the exhibitions of the Société Nationale), inc: Adler, Aman-Jean, Chabas, Claus, Corinth, Fantin-Latour, Guillou, Guthrie, Legrand, Le Sidaner, Maignan, Maillol, Martin, Maurin, Renoir, Simon, W. Stott, Vallotton.

May onwards 1st exh. of the Société Nationale des Beaux-Arts (founded as an alternative to the Salon des Artistes Français, with Meissonier as President, Puvis de Chavannes as Vice-President; often known as the Salon du Champ de Mars), inc: Anquetin, Béraud, Besnard, Blanche, Boldini, Carrière, Cazin, Cottet, Cross, Dagnan-Bouveret, Forain, Harrison, La Touche, Liebermann, Puvis de Chavannes, Roll. T. Roussel, Sargent.
Dec. G. Petit, Exposition Internationale (1st of a new series of exhibitions), inc: Blanche, Forain, Sisley, A. Stevens, Zorn.
Dec.–Jan. 1891 Durand-Ruel, *Un groupe d'artistes*, inc: Besnard, Blanche, Carrière, Fantin-Latour, La Touche, Zandomeneghi, Zorn.

1891

Deaths of Théo Van Gogh, Rimbaud and Seurat.
Gauguin leaves for Tahiti.
Péladan, *Salon de la Rose + Croix, règle et monitoire*, publ.
Huysmans, *Là-Bas*, publ.
Huret, *Enquête sur l'évolution littéraire*, publ.
Redon, *Songes*, lithographs, publ.
Daurelle, 'Chez les jeunes peintres', *Echo de Paris*, 28 Dec.
Revue blanche founded by Natanson brothers (ends 1903).
Moréas founds L'Ecole Romane.

EXHIBITIONS
Feb. Cercle Artistique et Littéraire Volney, inc: Toulouse-Lautrec.
March–April Indépendants, inc: Angrand, Anquetin, Bernard, Anna Boch, Bonnard, Cross, Denis, Dubois-Pillet (retrospective), Van Gogh, Guillaumin, Luce, L. Pissarro, Rousseau, Van Rysselberghe, Seurat, Signac, Toulouse-Lautrec, Vallotton.

April Durand-Ruel, Peintres-Graveurs, inc. paintings by: Carrière, La Touche, Redon.
April Durand-Ruel, *Cassatt* (mainly graphic work).
April Durand-Ruel, *C. Pissarro* (watercolour, pastels, prints only).
April–May Boussod & Valadon, *Carrière*.
May onwards Salon des Artistes Français, inc: Adler, Aman-Jean, Brangwyn, Chabas, Corinth, Fantin-Latour, Guillou, Guthrie, Legrand, Le Sidaner, Maignan, Martin, Simon, Tuke.
May onwards Société Nationale, inc: Béraud, Besnard, Blanche, Boldini, Carrière, Cazin, Claus, Cottet, Cross, Dagnan-Bouveret, Harrison, Hodler, La Touche, Liebermann, Puvis de Chavannes, Raffaëlli, Roll, Sargent, Whistler.
May Durand-Ruel, *Monet* (inc. *Haystacks* series).

Société des Pastellistes, inc: Béraud, Besnard, Blanche, Boldini, Dagnan-Bouveret.
Ecole des Beaux-Arts, *La Lithographie*.
Palais des Arts Libéraux, Salon des Refusés, inc: Anquetin, Toulouse-Lautrec.
Revue blanche offices, *Vuillard*.
Dec. G. Petit, Exposition Internationale, inc: Forain, Sisley.
Dec. Le Barc de Boutteville, 1st Exposition des Peintres Impressionnistes et Symbolistes, inc: Anquetin, Bernard, Bonnard, Cross, Denis, Filiger, Gauguin, Van Gogh, Luce, Manet, Ranson, Roussel, Sérusier, Signac, Toulouse-Lautrec, Vuillard.
Saint-Germain-en-Laye,
Aug.–Sept. Château, 1st Nabi group exh., inc: Bonnard, Denis, Ranson, Roussel, Vuillard.

1892

Death of Aurier.
Nabis establish marionette theatre at the Coulins' house.
Aurier, 'Les Peintres symbolistes', *Revue encyclopédique*, April.
Lecomte, *L'Art impressionniste*, publ.
Gide, *Le Traité de Narcisse, Théorie du symbole*, publ.

EXHIBITIONS
Feb. Durand-Ruel, *C. Pissarro*.
Feb.–March Durand-Ruel, *Monet* (*Poplars* series).
March Père Thomas, *Conder and Rothenstein*.
March–April Durand-Ruel, 1st Salon de la Rose + Croix, organized by Péladan, with opening fanfare by Satie, inc:

Aman-Jean, Bernard, Filiger, Hodler, Khnopff, Martin, Maurin, Osbert, Point, Previati, Schwabe, Séon, Toorop, Vallotton.
March–April Indépendants, inc: Angrand, Anquetin, Bernard, Anna Boch, Bonnard, Cross, Denis, Luce, Moret, O'Conor, L. Pissarro, Ranson, Rousseau, Van Rysselberghe, Seurat (retrospective), Signac, Toorop, Toulouse-Lautrec.
[continued on page 286]

Germany

1889

Worpswede artists' colony started by Mackensen, Modersohn and H. am Ende. Munch holds 1st one-man exh. in Oslo.

EXHIBITIONS
Munich Glaspalast, 1st Jahresausstellung, inc: Corinth, J. Israels, Liebermann, Von Stuck, Trübner, Uhde.

1890

Kaiser Wilhelm I dismisses Bismarck.
Langbehn, *Rembrandt als Erzieher* (*Rembrandt as Educator*), publ.

EXHIBITIONS
Munich Glaspalast, Jahresausstellung, inc: Boldini, Carrière, Corinth, Daubigny, Dupré, Gauld, Guthrie, C. Herrmann, Hornel, Khnopff, Lavery, Liebermann, Roll.

1891

Ibsen's *Hedda Gabler* performed in Munich.

EXHIBITIONS
Berlin, summer Internationale Kunstausstellung, inc: Dill, Dupré, Heine, C. Herrmann, Khnopff, Liebermann, Segantini.
Munich Glaspalast, Jahresausstellung, inc: Bastien-Lepage, Besnard, Böcklin, Boldini, Bonnat, Breitner, Clausen, Corot, Dagnan-Bouveret, Daubigny, Diaz, Dill, Dupré, Heine, C. Herrmann, Hofmann, Lavery, Leibl, Liebermann, Manet, Millais, Millet, Monet, Munch, Nomellini, Roussel, Segantini, Sickert, W. Stott, Von Stuck, Thoma, Tissot, Uhde.

1892

Munich Secession founded.
Gruppe XI founded in Berlin in protest at Munch's treatment at Verein Berliner Künstler; later forms nucleus of Berlin Secession.

EXHIBITIONS
Berlin Verein Berliner Künstler, inc: Munch.
Munich, ?summer Secession, inc: Bocklin, Corinth, Corot, Courbet, J. Israels, Millet, Piglhein, Segantini, Von Stuck, Trübner, Uhde.

Great Britain and Ireland

1889

Moore becomes art critic of *The Hawk*.
Sickert becomes art critic of *The New York Herald*.
Dec., *London Impressionists*, catalogue preface by W. Sickert.
The Dial founded (ends 1897).

EXHIBITIONS
April Goupil, *Monet* (20 paintings).
April–May Dowdeswell, *French and Dutch Romanticists*, inc: Barbizon and Hague School masters, Monticelli.
April NEAC, inc: Blanche, Clausen, Degas (photos of his work), Forbes, Guthrie, Lavery, Maitland, Manet (photos of his work), T. Roussel, Sargent, Sickert, Starr, Steer, E. Stott, Whistler.
May onwards RA, inc: Fantin-Latour, Forbes, Osborne, Sargent.
May–July Grosvenor Gallery, inc: Clausen, Fantin-Latour, Starr.

May 29 Queen Sq., Bloomsbury, *Whistler* (organized by Sickert).
May New Gallery, inc: La Thangue, Sargent, E. Stott.
June Gainsborough Gallery, *Manet*.
Oct.–Dec. Grosvenor Gallery, pastel exh., inc: Blanche, Clausen, Forbes-Robertson, Guthrie, Osborne, W. Stott.
Nov. Dowdeswell, inc: Breitner, Segantini.
Dec. Goupil, *London Impressionists*: Francis Bate, Fred Brown, Francis James, Maitland, B. Sickert, W. Sickert, Starr, Steer, George Thomson.
Winter 1889–90 Hanover Gallery, inc: Claus, Raffaëlli.
Glasgow, March Institute, pastel exh., inc: Clausen, Fantin-Latour, Henry, Lavery, Sickert, Starr, W. Stott.
Liverpool, autumn Walker AG, inc: Clausen, Fantin-Latour, La Thangue, Osborne, E. Stott.

1890

May, Sickert and Steer rejected at RA.
28 June, *The Whirlwind*, organ of the London Impressionists, 1st issue (last issue 27 Dec.).
June, Whistler, *The Gentle Art of Making Enemies*, publ.
G. Moore, 'Degas: The Painter of Modern Life', *The Magazine of Art*, Sept.
D. S. MacColl becomes art critic of *The Spectator*.

EXHIBITIONS
Feb.–March Goupil, *Daubigny*.
March–April Dowdeswell, inc: Monticelli, Segantini.
March–May NEAC, inc: Blanche, Clausen, Guthrie, Lavery, T. Roussel, Sickert, Starr, Steer, E. Stott, W. Stott.
April–May Goupil, *Mauve*.
May onwards RA, inc: Fantin-Latour, Forbes, Forbes-Robertson, Osborne, Sargent, E. Stott.
May New Gallery, inc: Clausen, La Thangue, Sargent, E. Stott.

May–July Grosvenor Gallery, inc: Clausen, Fantin-Latour, Guthrie, Hornel, Lavery, W. Stott.
Summer Hanover Gallery, inc: Cazin, Khnopff, Raffaëlli.
Oct. New Gallery, 1st exh. of Arts and Crafts Exhibition Society, inc: Clausen.
Oct. Grosvenor Gallery, pastel exh., inc: Blanche, Clausen, Forbes-Robertson, Guthrie, Khnopff, Raffaëlli, Steer, W. Stott, Toorop.
French Gallery, inc: Claus, Liebermann.
Glasgow, Feb.–April Institute, inc: Guthrie, Henry, Hornel, Lavery, Monticelli, Sickert, Starr, W. Stott.
Glasgow, Dec.–March 1891 Institute, inc: Forbes-Robertson, Guthrie, Henry, Hornel, Lavery, Monticelli, T. Roussel, Steer, W. Stott.
Liverpool, autumn Walker AG, inc: Fantin-Latour, Forbes, La Thangue, Osborne, Steer, E. Stott, W. Stott.

1891

G. Moore becomes art critic of *The Speaker*.

EXHIBITIONS
May onwards RA, inc: Clausen, Fantin-Latour, Forbes, Forbes-Robertson, La Thangue, Lavery, Osborne, Sargent.
May New Gallery, inc: Khnopff, Osborne, E. Stott, W. Stott.
May–June NEAC, inc: Blanche, Clausen, Henry, Hornel, O'Conor, T. Roussel, Russell, Sickert, Starr, Steer, E. Stott.
June Goupil, *Lavery*.
June–July Dowdeswell, *Early English Masters* (18th- and early 19th-century painting).
Summer Hanover Gallery, inc: Cazin, Clausen, Courbet, Raffaëlli.

Summer Hanover Gallery, *Dutch Watercolours*, inc: Thorn Prikker, Verster.
Nov. NEAC, inc: Blanche, Clausen, Degas, Fry, Guthrie, Harrison, Henry, Maitland, Monet, T. Roussel, Sargent, Sickert, Starr, Steer, E. Stott.
Earl's Court, *German Exhibition*, inc: Kalckreuth, Liebermann, Putz.
Dec. Société des Beaux-Arts, Mr Collier's Rooms, Old Bond Street, inc: Degas, Monet, Monticelli, Pissarro, Sisley.
Winter 1891–2 New Gallery, *The Victorian Exhibition 1837–1887*.
Liverpool, autumn Walker AG, inc: Fantin-Latour, Forbes, La Thangue, Osborne, Steer, E. Stott, W. Stott, Whistler.

1892

C. A. Theuriet, *Jules Bastien-Lepage and His Art*, publ. (inc. chapters by Clausen and Sickert).

EXHIBITIONS
March–April Goupil, *Whistler* (retrospective).
March Barbizon Gallery, inc: Béraud, Cazin, Monticelli.
Spring McLean, inc: Barbizon School, Monticelli.
Spring French Gallery, inc: Bastien-Lepage, Cazin.

April NEAC, inc: Clausen, Guthrie, Maitland, T. Roussel, Sickert, Starr, Steer, E. Stott.
May onwards RA, inc: Clausen, Fantin-Latour, Forbes, La Thangue, Lavery, E. Stott.
May New Gallery, inc: Forbes, Khnopff, La Thangue, E. Stott.
July Barbizon Gallery, inc: Manet.
Summer Continental Gallery, inc: Guthrie, Harrison.
[continued on page 287]

Italy

1889

D'Annunzio, *L'Isotteo e la Chimera* and *Il Piacere*, publ.

1890

EXHIBITIONS
Florence, winter–spring 1891 XLV Esposizione Annuale della Società per BB.AA, inc: Kienerk, Müller, Nomellini.
Livorno, c. 1890 Bagni Pancaldi, exh. organized by Müller of *c.* 10 Impressionist-influenced paintings.
Milan, Jan. Società Permanente, *Ranzoni* (retrospective).
Rome, Feb.–March Palazzo delle Esposizioni, In Arte Libertas, inc: Grubicy, Moreau, Puvis de Chavannes, Segantini.

1891

Pope Leo XIII issues *Rerum Novarum*, on need for social reform.
F. Turati founds Socialist journal, *Critica Sociale*, in Milan.
Segantini, 'Così Penso e Sento la Pittura', *Cronaca d'Arte*, Feb.
Pascoli, *Myricae*, publ.
Natura ed Arte (periodical), founded in Milan (also publ. in Rome); ends 1913.
Arte Italiana Decorativa e Industriale (periodical) founded in Milan, directed by C. Boito; ends 1911.
Previati starts to illustrate Manzoni's *I Promessi Sposi*; finishes 1896, publ. 1900.

EXHIBITIONS
Florence, winter–spring 1892 XLVI Esposizione Annuale della Società per BB.AA., inc: Kienerk, Müller, Nomellini and Vibrationist works.
Milan, late spring R. Accademia di Belle Arti di Brera, I Esposizione Triennale, inc: Grubicy, Longoni, Morbelli, Nomellini, Previati, Pusterla, Segantini, Sottocornola.
Milan, winter–spring 1892 Grubicy, *Segantini*.
Rome Villa Medici, exh. inc: Laurent (Symbolist Neo-Impressionist work).

1892

Italian Socialist Party founded, with *Lotta di Classe* as official organ.
Vibert, *La Scienza della Pittura*, Italian edn (translated by Previati).
V. Grubicy, *Art and the State in Italy*, publ.

EXHIBITIONS
Genoa Esposizione Italo-Colombiana, inc. Pellizza, Segantini.
Milan Società per le BB.AA, ed Esposizione Permanente, inc: Previati.
[continued on page 287]

The Low Countries

1889

Redon executes frontispiece for J. Destrée, *Les Chimères*.
Lectures at Les XX, inc: de Wyzéwa, 'Les Origines littéraires de la littérature décadente (Verlaine, Laforgue, Mallarmé)'.
Concerts at Les XX.
Maeterlinck, *Les Serres chaudes*, and 1st play, *La Princesse Maleine*, publ.

EXHIBITIONS
Amsterdam Les XX, inc: Breitner, Toorop, Whistler.
Brussels, Feb.–March 6th Les XX, inc. (members): Ensor, Finch, Khnopff, Lemmen, Rodin, Van Rysselberghe, Toorop, Van de Velde; (invitees): Besnard, Cross, Gauguin, Klinger, Luce, Monet, C. Pissarro, Signac, Steer, W. Stott.
Brussels *Japanese Art*.

1890

Redon executes frontispiece for I. Gilkin, *La Damnation de l'artiste* and *Les Ténèbres*.
Lectures at Les XX, inc: Mallarmé, 'Villiers de l'Isle Adam', E. Picard, 'Trois poètes belges d'exception: Maeterlinck, van Lerberghe, Verhaeren'.
Three concerts at Les XX.

EXHIBITIONS
Brussels 7th Les XX, inc. (members): Ensor, Finch, Khnopff, Rodin, Van Rysselberghe, Toorop, Van de Velde, Vogels; (invitees): Cézanne, Dubois-Pillet, Van Gogh, Hayet, Mellery, L. Pissarro, Redon, Renoir, Segantini, Signac, Sisley, Toulouse-Lautrec.

1891

Lectures at Les XX, inc: G. Kahn, 'Le Vers libre', E. Picard, 'Jules Laforgue et la femme', Van de Velde, 'Le Paysan en peinture'.
Three concerts at Les XX, inc: Russian music.

EXHIBITIONS
Brussels, Feb.–March 8th Les XX, inc. (members): Ensor, Finch, Khnopff, Rodin, Van Rysselberghe, Toorop, Van de Velde; (invitees): Angrand, Chéret, Crane, Filiger, Gauguin, Van Gogh, Guillaumin, C. Pissarro, Seurat, Steer, Verster.
The Hague Kunstkring, exh. inc: Toorop.
Rotterdam Galerie Oldenzeel, *Toorop*.
Utrecht *Works by Living Artists*, inc: Toorop.

1892

Redon executes frontispiece for Verhaeren, *Les Flambeaux noirs*.
Pour l'Art founded in Brussels.
Lectures at Lex XX.
Concerts at Les XX.
G. Rodenbach, *Bruges-la-Morte*, publ.
Le Reveil founded in Brussels.

EXHIBITIONS
Amsterdam Arti et Amicitiae, *Keuze-Tentoonstelling von hedendaagsche Kunst*, inc: Thorn Prikker, Toorop.
Antwerp Association pour l'Art, inc: Toorop.
Brussels, Feb.–March 9th Les XX, inc. (members): Ensor, Finch, Khnopff, Rodin, Van Rysselberghe, Signac, Toorop, Van de Velde, Vogels; (invitees): Besnard, Cassatt, Denis, Horne, Image, Luce, Mellery, L. Pissarro, Seurat, Toulouse-Lautrec.
[continued on page 287]

France

Germany

1892 (continued)

April Le Barc de Boutteville, *Van Gogh*, organized by Bernard.
April Durand-Ruel, Peintres-Graveurs, inc: Redon pastels.
April Cercle Artistique et Littéraire Volney, inc: Toulouse-Lautrec.
May Durand-Ruel, *Renoir*.
May Le Barc de Boutteville, 2nd Exposition des Peintres Impressionnistes et Symbolistes, inc: Bernard, Bonnard, Cross, Denis, Luce, C. Pissarro, Sérusier, Signac, Toulouse-Lautrec.
May onwards Salon des Artistes Français, inc: Adler, Brangwyn, Chabas, Fantin-Latour, Guillou, Legrand, Le Sidaner, Maignan, Martin, Simon.

May onwards Société Nationale, inc: Aman-Jean, Béraud, Besnard, Blanche, Boldini, Carrière, Cazin, Claus, Conder, Cottet, Cross, Dagnan-Bouveret, Guthrie, Harrison, Helleu, Hodler, La Touche, Lhermitte, Liebermann, Puvis de Chavannes, Raffaëlli, Sargent, Whistler.
Revue blanche offices, *Seurat*.
Oct. Durand-Ruel, *Degas* (pastel and monotype landscapes).
Nov. Le Barc de Boutteville, 3rd Exposition des Peintres Impressionnistes et Symbolistes, inc: Cross, Denis, Gauguin, C. Pissarro, Roussel, Sérusier, Toulouse-Lautrec.

?Nov.–Dec. G. Petit, Exposition Internationale.
Dec. Pavilion de la Ville de Paris, *Maîtres hollandais*, inc: Breitner, J. Israels, Mauve, Mesdag.
Dec.–Jan. 1893 Hôtel Brébant, *Peintres Néo-Impressionnistes*, inc: Cross, Luce, L. Pissarro, Van Rysselberghe, Seurat, Signac.
Saint-Germain-en-Laye,
summer Château, Nabi group exh.

1893

Death of Père Tanguy.
Vollard opens gallery in rue Laffitte.
Delacroix, *Journal*, I and II, publ.
A. Samain, *Au Jardin de l'Infante*, publ.
Théâtre de l'Oeuvre founded by Lugné-Poë, with Vuillard as a co-director.
Marty, *L'Estampe originale*, 1st vol., publ.

EXHIBITIONS
Jan.–Feb. Durand-Ruel, *Utamaro and Hiroshige* (preface by Bing).
Feb. Boussod & Valadon, *Maurin and Toulouse-Lautrec*.
March Durand-Ruel, *C. Pissarro*.
March–April 2nd Salon de la Rose + Croix, inc: Aman-Jean, Delville, Khnopff, Osbert, Point, Séon.
March–April Indépendants, inc: Amiet, Angrand, Anquetin, Bonnard, Cross, Denis, Luce, Moret, O'Conor, L. Pissarro, Ranson, Rousseau, Van Rysselberghe, Signac, Steinlen, Toulouse-Lautrec, Vallotton, Valtat.
April Durand-Ruel, Peintres-Graveurs, inc: Redon (painting and pastel).

May onwards Salon des Artistes Français, inc: Adler, Brangwyn, Chabas, Fantin-Latour, Guillou, Legrand, Le Sidaner, Martin.
May onwards Société Nationale, inc: Aman-Jean, Blanche, Carrière, Claus, Conder, Cottet, Dagnan-Bouveret, Guthrie, Harrison, Helleu, Hodler, La Touche, Lavery, Liebermann, Puvis de Chavannes, Raffaëlli, Roll, Rothenstein, Simon, Tissot.
May Durand-Ruel, *Zandomeneghi*.
?May Le Barc de Boutteville, 4th Exposition des Peintres Impressionnistes et Symbolistes, inc: Angrand, Anquetin, Bonnard, Cottet, Denis, Filiger, Guillaumin, C. Pissarro, Ranson, Roussel, Sérusier, Signac, Toulouse-Lautrec, Vallotton, Vuillard.
Palais de l'Industrie, *Exposition d'art musulman*.
Galerie Laffitte, beginning of series of small shows of Neo-Impressionists, of single artists and group.

Oct. *La Plume* offices, organized by Le Barc de Boutteville, *Les Portraits du prochain siècle*, inc: Angrand, Anquetin, Bernard, Cézanne, Filiger, Gauguin, Van Gogh, Luce, Raffaëlli, Vallotton, Vuillard.
Nov. Durand-Ruel, *Gauguin* (Tahitian paintings).
Nov.–Dec. G. Petit, Exposition Internationale, inc: Aman-Jean, Anquetin, La Touche.
Nov.–Dec. Durand-Ruel, *Cassatt*.
Dec. Le Barc de Boutteville, 5th Exposition des Peintres Impressionnistes et Symbolistes, inc: Angrand, Anquetin, Bonnard, Chéret, Conder, Cottet, Denis, Gauguin, Guillaumin, Lacombe, Luce, Moret, Ranson, Roussel, Sérusier, Toulouse-Lautrec, Vuillard.
Dec.–Jan. 1894 Galerie Laffitte, *Peintres Néo-Impressionnistes*, inc: Cross, Luce, L. Pissarro, Van Rysselberghe, Seurat, Signac.

1893

Munch comes to Berlin.

EXHIBITIONS
Berlin, May–Sept. Grosse Kunstausstellung, inc: Carrière, Corinth, Dagnan-Bouveret, Dill, Dupré, Lavery, Mackensen, Von Stuck, Uhde.
Berlin, Dec. Unter den Linden, *Munch*.
Munich Glaspalast, Jahresausstellung, inc: Böcklin, Corot, Courbet, Daubigny, Steer, Toorop.
Munich, summer Secession, inc: Breitner, Clausen, Cottet, Corinth, Courbet, Dagnan-Bouveret, Dupré, Heine, Hofmann, Liebermann, Slevogt, W. Stott, Von Stuck, Uhde.

1894

Death of Caillebotte: leads to controversy over his bequest of Impressionist paintings to the nation.
Procès des trente; Fénéon and Luce imprisoned.
L'Ymagier founded by Jarry and de Gourmont.
First performance of Debussy's *L'Après-midi d'un faune*, inspired by Mallarmé's poem.

EXHIBITIONS
Jan. Père Thomas, exh. inc: Bernard, Bonnard, Schuffenecker, Toulouse-Lautrec, Valtat.
Jan.–Feb. Durand-Ruel, *Guillaumin*.
March Durand-Ruel, *C. Pissarro*.
March Le Barc de Boutteville, 6th Exposition des Peintres Impressionnistes et Symbolistes, inc: Anquetin, Bonnard, Conder, Cottet, Denis, Filiger, Gauguin, Guillaumin, Hayet, Lacombe, O'Conor, Ranson, Seguin, Sérusier, Vuillard.
March–April Durand-Ruel, *Redon* (inc. paintings and pastels).

April–May Indépendants, inc: Amiet, Angrand, Cross, Denis, Luce, Moret, L. Pissarro, Rousseau, Signac, Toulouse-Lautrec, Valtat.
April–May 3rd Salon de la Rose + Croix, inc: Delville, Khnopff, Osbert, Point.
April onwards Société Nationale, inc: Aman-Jean, Béraud, Besnard, Blanche, Carrière, Cazin, Claus, Conder, Cottet, Dagnan-Bouveret, Dauchez, Guthrie, Harrison, Helleu, Hodler, La Touche, Lavery, Le Sidaner, Liebermann, Puvis de Chavannes, Roll, Sargent, Simon, W. Stott, Tissot, Whistler.
May onwards Salon des Artistes Français, inc: Adler, Brangwyn, Chabas, Evenepoel, Fantin-Latour, Forbes, Guillou, Legrand, Martin.
May Durand-Ruel, *Toulouse-Lautrec* (lithographs).
May Durand-Ruel, *Manet*.
June Durand-Ruel, *Caillebotte* (retrospective).
July Le Barc de Boutteville, 7th Exposition des Peintres Impressionnistes

et Symbolistes, inc: Angrand, Anquetin, Bernard, Bonnard, Chéret, Conder, Denis, Guillaumin, Hayet, Moret, O'Conor, Toulouse-Lautrec.
G. Petit, Exposition Internationale.
Palais du Champ de Mars, *Tissot* (New Testament illustrations).
La Plume offices, 1st Salon des Cent, inc: Séon.
Durand-Ruel, *Puvis de Chavannes*.
Galerie Laffitte (becomes Galerie Moline during 1894), series of Neo-Impressionist exhibitions continues.
Nov. Le Barc de Boutteville, 8th Exposition des Peintres Impressionnistes et Symbolistes, inc: Angrand, Anquetin, Bonnard, Chéret, Cottet, Denis, Filiger, Forbes-Robertson, Guillaumin, Hayet, Lacombe, Maurin, Moret, O'Conor, Séguin, Sérusier, Toulouse-Lautrec.
Toulouse, *Dépêche de Toulouse* offices, inc: Anquetin, Bonnard, Denis, Ibels, Roussel, Toulouse-Lautrec, Vuillard.

1894

Meier-Graefe, *Munch*, publ.
Pan founded in Berlin.

EXHIBITIONS
Bremen, winter Kunsthalle, Worpswede artists' 1st group show, inc: Mackensen, Modersohn.
Munich Glaspalast, Jahresausstellung, inc: Cottet, Liebermann, Roussel.
Munich, summer Secession, inc: Dill, Guthrie, Hofmann, Khnopff, Lavery.

1895

Jan., banquet in honour of Puvis de Chavannes; guests inc: Aman-Jean, Bourdelle, Cazin, Chabas, Fantin-Latour, Gauguin, Monet, Rodin.
Huysmans, *En route*, publ.
Delacroix, *Journal*, III, publ.

EXHIBITIONS
Feb.–March Le Barc de Boutteville, *Séguin* (preface by Gauguin).
Feb.–March Galerie Laffitte (Moline), exh. inc: Seurat.
March–April G. Petit, Exposition Internationale, inc: Aman-Jean, Cottet, Harrison, Le Sidaner, Whistler.

April–May Indépendants, inc: Angrand, Cross, Forbes-Robertson, Lacombe, Luce, Moret, Rousseau, Van Rysselberghe, Sérusier, Signac, Toulouse-Lautrec.
April–May 4th Salon de la Rose + Croix, inc: Delville, Maurin, Osbert, Point, Séon.
April–May Le Barc de Boutteville, 9th Exposition des Peintres Impressionnistes et Symbolistes, inc: Anquetin, Denis, Forbes-Robertson, Hayet, Moret, Ranson, Sérusier.

April onwards Société Nationale, inc: Aman-Jean, Besnard, Blanche, Carrière, Cazin, Claus, Cottet, Dauchez, Denis, Evenepoel, Guthrie, Harrison, Helleu, Hodler, La Touche, Lavery, Liebermann, Puvis de Chavannes, Roll, Simon, W. Stott.
April–May Galerie Laffitte (Moline), exh. inc: Bernard, Filiger, Rousseau.
May onwards Salon des Artistes Français, inc: Adler, Brangwyn, Chabas, Fantin-Latour, Guillou, Herkomer, Legrand, Maignan, Martin, Rouault.
[continued on page 288]

1895

Nietzsche, *Der Antichrist*, publ.
Legislation censoring art exhibitions repealed.

EXHIBITIONS
Berlin, March Ugo Barroccio, *Munch* (*Love* series).
Munich Glaspalast, Jahresausstellung, inc: Clausen, Corinth, Forbes, Liebermann, Mackensen, Manet, Modersohn, Roussel, Steer, W. Stott.
Munich, summer Secession, inc: Böcklin, Corot, Cottet, Hofmann, Khnopff, Lavery, Raffaëlli, Slevogt, Von Stuck, Toulouse-Lautrec, Whistler.

Great Britain and Ireland

1892 (continued)

Summer Continental Gallery, inc: Besnard, Boldini, Degas, Roll.
Nov. NEAC, inc: Blanche, Breitner, Degas, Fry, Henry, Nicholson, Sargent, Sickert, Steer.
Dec. Dowdeswell, *Early British Painters.*
Winter 1892–3 New Gallery, *Burne-Jones.*

Glasgow, Feb.–April Institute, inc: Degas, Fantin-Latour, Guthrie, Henry, Hornel, Lavery, Raffaëlli, T. Roussel, Sickert, Steer, W. Stott, Whistler.
Liverpool, autumn Walker AG, inc: Clausen, Fantin-Latour, Forbes, Guthrie, Henry, Hornel, Khnopff, Osborne, Sickert, Steer, E. Stott, W. Stott.

1893

G. Moore, *Modern Painting* (art criticism from *The Speaker*), publ.

EXHIBITIONS
Feb. Grafton Galleries, inaugural exh., inc: Besnard, Blanche, Carrière, Claus, Degas (inc. *L'Absinthe*), Fantin-Latour, Gauld, Guthrie, Henry, Hornel, Khnopff, Lavery, Liebermann, Raffaëlli, T. Roussel, Van Rysselberghe, Segantini, W. Stott, Whistler.
April NEAC, inc: Conder, Degas, Fry, Monet, Osborne, Rothenstein, Sargent, Sickert, Steer, E. Stott.
May onwards RA, inc: Clausen, Fantin-Latour, Forbes, Lavery, La Thangue, Osborne, Sargent, W. Stott.
May New Gallery, inc: Khnopff, La Thangue, Sargent, E. Stott.

June–July Dowdeswell, *Early British Masters.*
Summer Continental Gallery, inc: Besnard, La Touche, Roll.
Nov. New Gallery, Arts and Crafts Exhibition Society, inc: L. Pissarro.
Nov.–Dec. NEAC, inc: Blanche, Conder, Fry, Henry, Rothenstein, Sickert, Steer.
Nov.–Dec. Grafton Galleries, *L'Art Décoratif Français*, inc: L. Pissarro (woodcuts).
Glasgow, Feb.–May Institute, inc: Boldini, Hornel, Lavery, Raffaëlli, T. Roussel, Steer, W. Stott.
Liverpool, autumn Walker AG, inc: Besnard, Conder, Hornel, La Thangue, Manet, Monet, Osborne, Segantini, Sickert, E. Stott, W. Stott.

1894

April, *The Yellow Book* (periodical), founded (ends April 1897).

EXHIBITIONS
Dutch Gallery, inc: Fantin-Latour, Monticelli, Whistler.
Jan.–Feb. Goupil, *Japanese Prints* (from Duret's collection).
Jan.–March Grafton Galleries, inc: Blanche, Breitner, Claus, Fantin-Latour, Guthrie, Lavery, Raffaëlli, Renoir, Rodin, Roll, T. Roussel, W. Stott, Von Stuck, Whistler.
Feb. Goupil, *Steer.*
April–May NEAC, inc: Fry, Henry, Nicholson, Rothenstein, Sickert, Steer, E. Stott.
May onwards RA, inc: Clausen, Fantin-Latour, Forbes, Lavery, La Thangue, Osborne, Sargent, W. Stott.

May New Gallery, inc: Fantin-Latour, Forbes, Khnopff, La Thangue, E. Stott.
May Grafton Galleries, inc: Breitner, Lavery, T. Roussel, W. Stott.
Summer Continental Gallery, inc: Besnard, Cottet.
July Dowdeswell, *T. Roussel.*
Oct.–Nov. Goupil, *Mauve.*
Nov.–Dec. Goupil, *Utamaro.*
Nov.–Dec. NEAC, inc: Blanche, Conder, Fry, Henry, Rothenstein, Sargent, Sickert, Steer.
Glasgow, Feb.–March Institute, inc: Claus, Fantin-Latour, Guthrie, Henry, La Thangue, Lavery, T. Roussel, Steer.
Liverpool, autumn Walker AG, inc: Clausen, Fantin-Latour, Forbes, Fry, La Thangue, Osborne, T. Roussel, Sargent, Segantini, Steer, E. Stott, W. Stott.

1895

R. A. M. Stevenson, *Velasquez*, publ.
April, Oscar Wilde trial. Wilde seen carrying a book with a yellow cover. Consequently Beardsley ceases to be art editor of *The Yellow Book.*

EXHIBITIONS
Jan. Dutch Gallery, *Walter and Bernhard Sickert.*
April–May NEAC, inc: Conder, Fry, Rothenstein, Sickert, Steer, E. Stott.
May onwards RA, inc: Clausen, Fantin-Latour, Forbes, La Thangue, Lavery, Osborne, Sargent, W. Stott.

May New Gallery, inc: Clausen, Khnopff, La Thangue, Sargent, E. Stott.
Rembrandt Head Gallery, *Helleu* (drypoints and pastels).
Continental Gallery, inc: Claus, Cottet.
Nov.–Dec. NEAC, inc: Conder, Fry, Rothenstein, Sickert, Steer, W. Stott.
Winter 1895–6 New Gallery, *Exhibition of Spanish Art.*
Glasgow, Feb.–May Institute, inc: Claus, Fantin-Latour, Guthrie, Henry, Hornel, La Thangue, Lavery, Monet, Monticelli, T. Roussel, Steer, W. Stott, Whistler.
Liverpool, autumn Walker AG, inc: Forbes, La Thangue, Sargent, E. Stott, W. Stott.

Italy

1892 (continued)

Rome, Jan.–Feb. Palazzo delle Esposizioni, In Arte Libertas, inc: Segantini.
Turin Esposizione Internazionale di BB.AA., inc: Morbelli, Segantini.

1893

Italian workers killed in French riots, resulting in strong anti-French feeling. In Sicily, grave unrest and beginning of trades unions.
La Battaglia per l'Arte founded in Milan. Previati, Conconi and Pusterla plan mobile pavilion illustrating Dante's *Inferno*; plans frustrated through lack of funds.

EXHIBITIONS
Florence, winter–spring 1894 XLVIII Esposizione Annuale della Società per BB.AA., inc: Kienerk, Morbelli, Nomellini, Pellizza.

1894

Government represses working-class movements.
Socialist Party outlawed and leaders arrested.
May–June, trial of Anarchists, including Nomellini, in Genoa.
Pica, *The Art of the Far East*, publ.
D'Annunzio, *Il Trionfo della Morte*, publ.

EXHIBITIONS
Florence, winter–spring 1895 XLIX Esposizione Annuale della Società per BB.AA., inc: Kienerk, Morbelli, Nomellini, Pellizza.
Milan, May–Oct. Esposizioni Riunite del 1894 in Milano, inc: Grubicy, Morbelli, Pellizza, Previati, Segantini.

1895

Emporium (periodical) founded in Bergamo.
Il Convito founded in Rome by A. de Bosis and D'Annunzio (ends 1898).
Venice Biennale founded.
V. Pica, 'Impressionisti, divisionisti e sintetisti', in his *L'Arte europea a Venezia.*
Previati writes *Memoria sulla Tecnica della Pittura* (unpubl.).

EXHIBITIONS
Rome, Sept.–Feb. 1896 LXVI Esposizione della Società di Amatori e Cultori di BB.AA., inc: Morbelli, Nomellini, Pellizza.
Venice, April–Oct. I Esposizione Internazionale d'Arte della Città di Venezia, inc: Besnard, Boldini, Cazin, Dagnan-Bouveret, Forain, Grubicy, Liebermann, Morbelli, Pellizza, Previati, Puvis de Chavannes, Redon, Roll, Segantini, Von Stuck, Whistler, Witsen.

The Low Countries

1892 (continued)

The Hague, May Kunstkring, *Van Gogh.*
The Hague, July–Aug. Kunstkring, *Societé des XX*, inc: Breitner, Finch, C. Pissarro, Redon, Van Rysselberghe, Seurat, Signac, Van de Velde.
The Hague Kunstkring, exh. inc: Thorn Prikker, Toorop, Verster.

1893

Les XX dissolved; O. Maus reconstitutes group as La Libre Esthétique.
Lectures at Les XX, inc: Verlaine, 'La Poésie contemporaine'.
Concerts at Les XX, inc: three by Ysayë Quartet.
Lugné-Poë and Théâtre d'Art perform Maeterlinck's *Pelléas et Mélisande* in Brussels, then tour Holland.
Van Nu en Straks founded in Brussels; Van de Velde designs covers.

EXHIBITIONS
Antwerp Association pour l'Art, exh. inc: Thorn Prikker.
Brussels, Feb.–March 10th Les XX, inc. (members): Ensor, Finch, Khnopff, Rodin, Van Rysselberghe, Signac, Toorop, Van de Velde; (invitees): Bernard, Besnard, Cross, Madox Brown, Steer, Thorn Prikker, Toulouse-Lautrec.

1894

Lectures at Libre Esthétique, inc: Van de Velde, 'L'Art futur'.
Concerts at Libre Esthétique, inc: four by Ysayë Quartet.

EXHIBITIONS
Arnhem Artibus Sacrum, *Toorop.*
Brussels, spring 1st Libre Esthétique, inc: C. R. Ashbee, Beardsley, Besnard, Carrière, Chéret, Claus, Denis, Ensor, Gauguin, Image, Khnopff, Lerolle, Maillol, Mellery, Morisot, W. Morris, C. Pissarro, G. Pissarro, L. Pissarro, Puvis de Chavannes, Ranson, Redon, Renoir, Van Rysselberghe, Signac, Sisley, Thaulow, Toorop, Toulouse-Lautrec, Vogels, G. F. Watts; decorative arts strongly represented, and continued so in all subsequent Libre Esthétique exhs.
The Hague Kunstkring, *Toorop.*
Leyden Lakenhal Museum, *Toorop.*

1895

Van de Velde establishes La Société van de Velde SA, based on William Morris and Co.
Sept., Stedelijk Museum opened in Amsterdam.
Lectures at Libre Esthétique, inc: Lugné-Poë, 'Pour être un acteur d'aujourd'hui', E. Picard, 'La Socialisation de l'art'.
Four concerts at Libre Esthétique.
De Kroniek founded in Amsterdam.

EXHIBITIONS
Brussels 2nd Libre Esthétique, inc: Beardsley, Besnard, Chéret, Claus, Cross, Denis, Ensor, Guillaumin, Holman Hunt, Khnopff, Klinger, Lavery, Luce, Mellery, C. Pissarro, L. Pissarro, Ranson, Redon, Signac, Toulouse-Lautrec, Vallotton, Vogels.
Brussels La Ligne Artistique, inc: Ensor (major group).
The Hague Kunstkring, inc: Toorop.

France

1895 (continued)

May Durand-Ruel, *Monet* (including *Rouen Cathedral* series).
Salon des Cent, Galerie La Plume, inc: Denis, Toulouse-Lautrec.
Sept. Le Barc de Boutteville, 10th Exposition des Peintres Impressionnistes et Symbolistes, inc: Angrand, Anquetin, Forbes-Robertson, Hayet, Maillol, O'Conor, Séguin.

Nov.–Dec. Vollard, *Cézanne.*
Dec.–Jan. 1896 Bing, Salon de l'Art Nouveau, inc: Aman-Jean, Angrand, Anquetin, Beardsley, Besnard, Blanche, Bonnard, Brangwyn, Carrière, Cassatt, Conder, Cottet, Cross, Denis, Guillaumin, Khnopff, Lacombe, Liebermann, Luce,

Martin, C. Pissarro, Raffaëlli, Ranson, Roussel, Van Rysselberghe, Sérusier, Signac, Simon, Thorn Prikker, Toulouse-Lautrec, Van de Velde, Verster, Vuillard, Whistler.
Saint-Germain-en-Laye, summer Château, Nabi group exh.

1896

Death of Verlaine.
Mellério, *Le Mouvement idéaliste en peinture,* publ.
Redon, *Tentation de Saint-Antoine* (3rd series), and *La Maison hantée,* lithographs, publ.
Théâtre des Pantins, marionette theatre, established by Nabis; performs Jarry's *Ubu roi.*
Vollard, 1st *Album des peintres-graveurs,* publ.

EXHIBITIONS
Jan. Manzi-Joyant, *Toulouse-Lautrec.*
Jan. Durand-Ruel, *Bonnard.*
Feb. Durand-Ruel, *Guillaumin.*
Feb.–March Bing, *Meunier.*
March Durand-Ruel, *Morisot* (retrospective).

c. March Le Barc de Boutteville, 11th Exposition des Peintres Impressionnistes et Symbolistes, inc: Denis, Lacombe, Maillol, Sérusier.
March–April 5th Salon de la Rose + Croix, inc: Osbert, Point, Séon.
April–May Indépendants, inc: Cross, Luce, Munch, Rousseau, Signac, Valtat.
April–May Durand-Ruel, *C. Pissarro.*
April–May Bing, *Carrière.*
April onwards Société Nationale, inc: Aman-Jean, Béraud, Blanche, Boldini, Cazin, Claus, Cottet, Dagnan-Bouveret, Dauchez, Denis, Evenepoel, Guthrie, Harrison, La Touche, Lavery, Le Sidaner, Liebermann, Matisse, Puvis de Chavannes, Raffaëlli, Roll, Sargent, Simon, W. Stott.

May onwards Salon des Artistes Français, inc: Adler, Chabas, Fantin-Latour, Guillou, Herkomer, Legrand, Lévy-Dhurmer, Maignan, Martin, Rouault.
May–June Durand-Ruel, *Renoir.*
Summer Le Barc de Boutteville, 12th Exposition des Peintres Impressionnistes et Symbolistes, inc: Denis, Guillaumin, Roussel.
Galerie de la Bodinière, 1st Salon des Peintres de l'Ame, inc: Chabas, Lévy-Dhurmer, Osbert, Point, Séon.
G. Petit, *Lévy-Dhurmer.*
Sept. Durand-Ruel, *Puvis de Chavannes.*
Nov. Le Barc de Boutteville, 13th Exposition des Peintres Impressionnistes et Symbolistes, inc: Roussel.

1897

Feb., part of Caillebotte bequest displayed in Musée du Luxembourg.
Death of Le Barc de Boutteville.
Gauguin, 'Noa-Noa', *Revue blanche.*

EXHIBITIONS
March 6th Salon de la Rose + Croix, inc: Khnopff, Maurin, Mellery, Osbert, Séon, Rouault.
April–May Indépendants, inc: Cross, Luce, Munch, Rousseau, Signac, Toulouse-Lautrec, Valtat.

April onwards Salon des Artistes Français, inc: Adler, Chabas, Fantin-Latour, Guillou, Legrand, Lévy-Dhurmer, Martin, Séon, Tuke.
April onwards Société Nationale, inc: Aman-Jean, Besnard, Blanche, Boldini, Carrière, Cazin, Claus, Cottet, Dagnan-Bouveret, Dauchez, Denis, Evenepoel, Guthrie, Harrison, Helleu, Hodler, La Touche, Lavery, Le Sidaner, Matisse, Raffaëlli, Roll, Simon, W. Stott, Whistler.

June–July Le Barc de Boutteville (organized by Charles Dosburg), 14th Exposition des Peintres Impressionnistes et Symbolistes.
Dec. Le Barc de Boutteville (organized by Charles Dosburg), 15th and last Exposition des Peintres Impressionnistes et Symbolistes, inc: Toulouse-Lautrec.
?Dec.–?Jan. 1898 Vollard, exh. inc: Bonnard, Lacombe, Ranson, Roussel, Sérusier, Vallotton, Vuillard.

1898

Death of Mallarmé.
Huysmans, *La Cathédrale,* publ.
Signac, 'D'Eugène Delacroix au néo-impressionnisme', serialized in *Revue blanche,* May–July.

EXHIBITIONS
Feb.–March Durand-Ruel, *Zandomeneghi.*

April Durand-Ruel, *Guillaumin.*
April–June Indépendants, inc: Cross, Luce, Rousseau, Signac.
May onwards Salon des Artistes Français, inc: Adler, Chabas, Fantin-Latour, Guillou, Legrand, Martin.
May onwards Société Nationale, inc: Aman-Jean, Anquetin, Besnard, Blanche, Carrière, Cazin, Claus, Conder, Cottet, Dagnan-Bouveret, Dauchez,

Denis, Evenepoel, La Touche, Le Sidaner, Lévy-Dhurmer, Puvis de Chavannes, Raffaëlli, Sargent, Simon.
May Durand-Ruel, *Monet.*
June Durand-Ruel, *C. Pissarro.*
June G. Petit, *Monet.*
Vollard, *Redon.*
Revue blanche offices, *Vallotton.*
Dec. Vollard, *Gauguin.*

1899

Signac, *D'Eugène Delacroix au néo-impressionnisme,* publ. in book form.
Redon, *Apocalypse de Saint-Jean,* last set of lithographs, publ.
Vollard publ. albums of colour lithographs by Denis, Bonnard, Vuillard.

EXHIBITIONS
Feb.–March G. Petit, *Besnard, Cazin, Monet, Sisley, Thaulow,* and pottery by Chaplet.
March Durand-Ruel, mixed exh. organized by Antoine de la Rochefoucauld, inc. (in the following groupings): Bonnard, Denis, Lacombe, Ranson, Roussel, Sérusier, Vallotton, Vuillard; Redon; Angrand, Cross, Luce, Van Rysselberghe, Signac; Valtat; Bernard, Filiger.
April Durand-Ruel, *Monet, C. Pissarro, Renoir, Sisley.*

May onwards Salon des Artistes Français, inc: Adler, Chabas, Fantin-Latour, Guillou, Legrand, Martin, Rouault.
May onwards Société Nationale, inc: Béraud, Besnard, Blanche, Carrière, Cazin, Claus, Cottet, Dagnan-Bouveret, Dauchez, Denis, Evenepoel, Guthrie, La Touche, Le Sidaner, Matisse, Puvis de Chavannes, Raffaëlli, Roll, Simon, W. Stott.
May–June Durand-Ruel, *Jongkind* (retrospective).
June Musée National du Luxembourg, *Fantin-Latour* lithographs.
June–July Durand-Ruel, *Puvis de Chavannes* (retrospective).
Oct.–Nov. Durand-Ruel, *Luce.*
Oct.–Nov. Indépendants, inc: Cézanne, Cross, Luce, Signac.

Germany

1896

Von Tschudi becomes Director of Berlin Nationalgalerie and encourages acquisition of French works.
Jugend and *Simplicissimus* founded in Munich.
Kandinsky comes to Munich.

EXHIBITIONS
Berlin, ? summer Internationale Kunstausstellung, inc: Boldini, Corinth, Evenepoel, Guthrie, Innocenti, Khnopff, Lavery, Liebermann, Raffaëlli, Segantini.
Munich Glaspalast, Jahresausstellung, inc: Corinth, Ensor, Mackensen, Modersohn, Rops.
Munich, summer Secession, inc: Cottet, Evenepoel, Guthrie, Khnopff, Lavery, Liebermann, Raffaëlli, Segantini.

1897

Berlin Nationalgalerie buys first Cézanne, *Mill on the Couleuvre at Pontoise.*
Dekorative Kunst founded.

EXHIBITIONS
Berlin, ? summer Grosse Kunstausstellung, inc: Fantin-Latour, C. Herrmann, Liebermann, Modersohn.
Munich Glaspalast, Jahresausstellung, inc: Amiet, Böcklin, Corot, Courbet, Daubigny, Hodler, Hofmann, Hornel, Khnopff, Liebermann, Monet, Slevogt, Von Stuck.

1898

Signac, 'D'Eugène Delacroix au Néo-impressionnisme', *Pan* (shortened version).

EXHIBITIONS
Berlin Cassirer, *Liebermann, Meunier and Degas.*
Munich Glaspalast, Jahresausstellung, inc: Corinth.
Munich, summer Secession, inc: Cottet, Courbet, Dill, Evenepoel, Hofmann, Segantini.

1899

Liebermann becomes president of the newly formed Berlin Secession.
Die Insel founded in Munich.

EXHIBITIONS
Berlin, spring Secession 1, inc: Böcklin, Corinth, Dill, C. Herrmann, Hodler, Hofmann, Leibl, Liebermann, Mackensen, Modersohn, Slevogt, Von Stuck, Uhde.
Bremen, winter Kunsthalle, exh. by Worpswede artists, inc: Mackensen, Modersohn, Modersohn-Becker.
Dresden Deutsche Kunstausstellung, inc: Liebermann, Mackensen, Modersohn, Von Stuck.
Munich Glaspalast, Jahresausstellung, inc: 1st joint exh. of Munich group Die Scholle.
Munich, summer Secession, inc: Böcklin, Cottet, Dill, Hornel, Liebermann, Monet, Slevogt, Uhde.

Great Britain and Ireland

1896

Jan.–Dec., *The Savoy* (periodical).

EXHIBITIONS
April–May NEAC, inc: Fry, Rothenstein, Sickert, Steer, E. Stott.
April–May Goupil, *W. Stott*.
May onwards RA, inc: Clausen, Fantin-Latour, Forbes, Harrison, Lavery, La Thangue, Osborne, Sargent, E. Stott, W. Stott.
May New Gallery, inc: Clausen, Khnopff, La Thangue, Sargent, E. Stott.
June–July Goupil, *A Pre-Raphaelite Collection*.
Summer Continental Gallery, inc: La Touche.
Dutch Gallery, inc: Manet, Monticelli, Whistler.

New Gallery, Arts and Crafts Exhibition Society, inc: Boldini, Conder, Gauld, Osborne, L. Pissarro.
Nov.–Dec. Goupil, *Dagnan-Bouveret (The Lord's Supper)*.
Nov.–Dec. NEAC, inc: Conder, Fry, Rothenstein, Sickert, Steer.
Winter 1896–7 New Gallery, *G. F. Watts*.
Glasgow, Feb.–May Institute, inc: Blanche, Fantin-Latour, Guthrie, Henry, Hornel, Lavery, T. Roussel, W. Stott, Whistler.
Liverpool, autumn Walker AG, inc: Segantini.

1897

D. Martin, *The Glasgow School of Painting*, publ.

EXHIBITIONS
April–May NEAC, inc: Fry, Renoir, Sickert, Steer.
May onwards RA, inc: Clausen, Fantin-Latour, Forbes, La Thangue, Osborne, Sargent, E. Stott.
May New Gallery, inc: Conder, Khnopff, La Thangue, Sargent, E. Stott.
Dutch Gallery, *The Maris Brothers*.

Continental Gallery, inc: Cottet, Evenepoel, Lévy-Dhurmer.
Nov.–Dec. NEAC, inc: Conder, Fry, Sickert, Steer.
Glasgow, Feb.–May Institute, inc: Dagnan-Bouveret, Fergusson, Guthrie, Henry, Hornel, Khnopff, La Thangue, Lavery, Monet, Monticelli, Rothenstein, W. Stott, Whistler.
Liverpool, autumn Walker AG, inc: Bastien-Lepage, Forbes, Fantin-Latour, Hornel, Khnopff, Lavery, Sargent, W. Stott.

1898

EXHIBITIONS
Jan. South London Art Gallery, inc: Clausen, Manet, Monet.
March Goupil, inc: Cazin, Clausen, Whistler.
April–May NEAC, inc: Conder, Degas, Fry, Rothenstein, Sickert, Steer.
Spring Continental Gallery, inc: Cottet, Evenepoel, Martin.
Spring Dutch Gallery, inc: Fantin-Latour, Monticelli, E. Stott.
May onwards RA, inc: Clausen, Fantin-Latour, Forbes, La Thangue, Osborne, Sargent, Sickert, E. Stott, W. Stott.
May Goupil, *Toulouse-Lautrec*.
May Continental Gallery, *Carrière*.
May New Gallery, inc: Khnopff, Sargent, E. Stott.
May International Society of Sculptors, Painters and Carvers, 1st exh. (Whistler president, Lavery vice-president), inc: Aman-Jean, Besnard, Blanche, Bonnard, Carrière, Cézanne, Clausen, Conder, Cross, Degas, Denis, Fantin-Latour, Forain, Guillaumin, Guthrie, Henry, Hornel, Khnopff, Klimt, Klinger, Lavery, Liebermann, Manet, Monet, Nicholson,

Puvis de Chavannes, Redon, Renoir, Rodin, Rothenstein, K.-X. Roussel, Van Rysselberghe, Segantini, Toorop, Toulouse-Lautrec, Vallotton, Vuillard, Whistler.
June Guildhall, inc: Bastien-Lepage, Cazin, Degas, Dagnan-Bouveret, Fantin-Latour, Monet, Moreau, C. Pissarro, Puvis de Chavannes, Renoir, Tissot.
June Continental Gallery, inc: Evenepoel.
July Goupil, *Raffaëlli* (polychrome etchings).
Oct. New Gallery, inc: Cottet.
Nov.–Dec. NEAC, inc: Conder, Fry, Rothenstein, Sickert, Steer.
Dec. Goupil, *Japanese Prints*.
Winter 1898–9 New Gallery, *Burne-Jones*.
Aberdeen Artists' Society, inc: Segantini.
Glasgow, Feb.–May Institute, inc: Clausen, Guthrie, Hornel, Lavery, T. Roussel, W. Stott, Whistler.
Liverpool, autumn Walker AG, inc: Blanche, Clausen, Forbes, Hornel, La Thangue, Lavery, Osborne, W. Stott.

1899

EXHIBITIONS
Jan. Pastel Society, 1st exh., inc: Besnard, Carrière, Clausen, Guthrie, Helleu, Khnopff, Lévy-Dhurmer, Rothenstein, Segantini, W. Stott, Whistler.
April–May NEAC, inc: Fry, A. John, Orpen, Osborne, Rothenstein, Sickert, Steer.
Spring Goupil, inc: Clausen, Henry, Hornel, Whistler.
May onwards RA, inc: Clausen, Fantin-Latour, Forbes, La Thangue, Osborne, E. Stott, W. Stott.
May New Gallery, inc: Sargent.
May International Society, inc: Blanche, Bonnard, Cottet, Fantin-Latour, Gauld, Guthrie, Henry, Hornel, Klimt, Lavery, Monet, Nicholson, C. Pissarro, Renoir, Rodin, Rops, Rothenstein, Von Stuck, Simon, Vallotton, Vuillard, Whistler.
June–July Goupil, *T. Roussel*.
May–July Grafton Galleries, *L'Art Nouveau* (organized by S. Bing), inc: Besnard, Carrière, Conder, Cottet,

Fantin-Latour, Manet, Monet, C. Pissarro, Renoir, Rodin, Sisley, plus Bing's collection of Japanese prints.
Summer Carfax Gallery, inc: Conder, A. John, Rodin, Rothenstein, Steer.
Dutch Gallery, inc: Fantin-Latour, Monticelli, E. Stott.
Rembrandt Gallery, *Helleu* (drypoints and pastels).
New Gallery, Arts and Crafts Exhibition Society, inc: L. Pissarro.
Guildhall, *Turner*.
Oct.–Dec. Grafton Galleries, *Modern French Art*, inc: Besnard, Carrière, Conder, Cottet, Fantin-Latour, La Touche, Le Sidaner, Puvis de Chavannes, Raffaëlli.
Nov.–Dec. NEAC, inc: Conder, Fry, A. John, Orpen, Osborne, Sickert, Steer.
Glasgow, Feb.–May Institute, inc: Clausen, Forbes, Guthrie, Hornel, La Thangue, Lavery, Monticelli, T. Roussel, W. Stott, Von Stuck, Whistler.
Liverpool, autumn Walker AG, inc: Blanche, Forbes, Hornel, La Thangue, Lavery, Osborne.

Italy

1896

Grubicy, 'La Tecnica ed Estetica Divisionista', *La Triennale* (nos 14–15). Morbelli and Pellizza plan joint Divisionist exh. at Turin Triennale, but fail.
E. A. Marescotti, 'Il Simbolismo nella Pittura', *Natura ed Arte*, after Aug. *Marzocco* (journal) founded in Florence by Orvieto, Occhini, D'Annunzio, Tumiati *et al.*

EXHIBITIONS
Florence, winter–spring 1897 Festa dell'Arte e dei Fiori, inc: Besnard, Carrière, Dagnan-Bouveret, Grubicy, Khnopff, Kienerk, La Thangue, Liebermann, Longoni, Monet, Morbelli, Müller, Nomellini, Pellizza, Pusterla, Puvis de Chavannes, Roll, Segantini, Von Stuck.
Turin Esposizione Triennale della Società Promotrice di BB.AA., inc: Morbelli, Nomellini, Pellizza, Previati, Segantini.

1897

Pellizza, 'Il Pittore e la Solitudine', *Marzocco*, Jan.
Corporation of Italian Artists founded. Segantini works on illustrations for the Amsterdam Bible (until 1899).

EXHIBITIONS
Milan R. Accademia di BB.AA. di Brera: III Esposizione Triennale, inc: Longoni, Sottocornola.
Venice, April–Oct. II Esposizione Internazionale della Città di Venezia, inc: Besnard, Blanche, Carrière, Cazin, Corinth, Cottet, Dagnan-Bouveret, Grubicy, Harrison, Hofmann, Khnopff, Lavery, Liebermann, Lionne, Monet, Morbelli, Previati, Puvis de Chavannes, Raffaëlli, Redon, Renoir, Rodin, Roll, Sargent, Segantini, W. Stott, Von Stuck, Tissot, Whistler, Witsen, plus exh. of Japanese art.

1898

Rioting in Milan ends in a massacre. Severe repression of Socialists and Socialist press.

EXHIBITIONS
Genoa Esposizione della Società Promotrice per BB.AA., inc: Nomellini.
Turin Esposizione Nazionale di BB.AA., inc: Nomellini, Pellizza, Previati.

1899

Segantini, 'Che Cos'è l'Arte', *Ver Sacrum* (no. 5).
Death of Segantini.
Italian Association of Painters and Sculptors founded.

EXHIBITIONS
Milan, spring Palazzo Permanente, Mostra di Primavera, inc: Morbelli.
Milan Società per le BB.AA. ed Esposizione Permanente, *Segantini*.
Venice, April–Oct. III Esposizione Internazionale della Città di Venezia, inc: Besnard, Blanche, Claus, Cottet, Dagnan-Bouveret, Evenepoel, Fornara, Grubicy, Harrison, Hodler, Khnopff, Kienerk, Klimt, La Touche, Lavery, Le Sidaner, Liebermann, Lionne, Nomellini, Pellizza, Raffaëlli, Roll, Whistler.

The Low Countries

1896

Lectures at Libre Esthétique, inc: L'Abbé Charbonnel, 'Art réligieux, art ecclésiastique', P. Gérardy, 'L'Ame allemande d'aujourd'hui'.
Four concerts at Libre Esthétique.

EXHIBITIONS
Brussels, spring 3rd Libre Esthétique, inc: Besnard, Bonnard (invited, but works arrived too late), Carrière, Claus, Cottet, Denis, Ensor, Finch, Guillaumin, Khnopff, Martin, Maurin, Monet, Moret, L. Pissarro, Renoir, Rops, Signac, Thorn Prikker, Toulouse-Lautrec, Van de Velde, Vogels, Vuillard (invited, but works arrived too late), Zandomeneghi.
Brussels *Ensor* (1st one-man exh.).
Groningen Museum voor Oudheden, *Toorop*.
Groningen Museum voor Oudheden, exh. inc: Thorn Prikker.
Rotterdam Galerie Oldenzeel, exh. inc: Toorop.

1897

No lectures at Libre Esthétique; instead, 'Séance Verlaine' to raise money for statue of poet in Paris.
Two concerts at Libre Esthétique, inc: French 17th-century music, German 17th- and 18th-century music.

EXHIBITIONS
Brussels, spring 4th Libre Esthétique, inc: Besnard, Blanche, Bonnard, Claus, Cottet, Cross, Ensor, Finch, Gauguin, Helleu, Khnopff, Luce, Maurin, Monet, Munch, Toorop, Toulouse-Lautrec.
Brussels Exposition Internationale, exh. inc: Pellizza.

1898

Lectures at Libre Esthétique, inc: C. Morice, 'Au Temps des Van Eyck', G. Mourey, 'Dante Gabriel Rossetti', J. Destrée, 'Benozzo Gozzoli'.
No concerts at Libre Esthétique.

EXHIBITIONS
Brussels, spring 5th Libre Esthétique, inc: Cazin, Claus, Denis, Ensor, Le Sidaner, Liebermann, Maillol, O'Conor, Ranson, Van Rysselberghe, Simon, Thorn Prikker.
The Hague *Arts and Crafts*, inc: Van de Velde.
Rotterdam Galerie Oldenzeel, *Toorop*.

1899

Lectures at Libre Esthétique, inc: C. Morice, 'Le Christ de Carrière', E. Schuré, 'Le Theâtre de Rêve'.
No concerts at Libre Esthétique.

EXHIBITIONS
Brussels, spring 6th Libre Esthétique, inc: Anquetin, Carrière, Cottet, Finch, Grubicy, Mellery, Raffaëlli, Rops (retrospective).
Brussels Société des Beaux-Arts, inc: Segantini.
Brussels, Oct. Cercle Artistique, inc: Evenepoel.

France

1900

Exposition Universelle.
Death of Oscar Wilde in Paris.
Picasso first visits Paris.

EXHIBITIONS
Jan.–Feb. Bernheim Jeune, *Renoir*.
March G. Petit, Société Nouvelle de Peintres et de Sculpteurs (1st exh.), inc: Aman-Jean, Brangwyn, Claus, Cottet, Dauchez, La Touche, Le Sidaner, Martin, Simon.
March–April *Revue blanche* offices, *Seurat*.
April Bernheim Jeune, *Bonnard, Denis, Maillol, Ranson, Roussel, Sérusier, Vallotton, Vuillard*.
April Durand-Ruel, *Redon* (inc. paintings and pastels).
April onwards Salon des Artistes Français, inc: Adler, Chabas, Friesz, Guillou, Lavery, Legrand, Martin, Rouault.

April–Oct. Exposition Universelle.
Exposition centennale de l'art français, 1800–1889, inc: Bastien-Lepage, Béraud, Besnard, Boudin, Carrière, Cazin, Cézanne, Degas, Fantin-Latour, Gauguin, Guillaumin, Maignan, Manet, Maurin, Monet, Monticelli, Moreau, Morisot, C. Pissarro, Puvis de Chavannes, Raffaëlli, Renoir, Roll, Seurat, Sisley, Vallotton. *Exposition décennale des Beaux-Arts, 1889–1900*, inc: Adler, Aman-Jean, Béraud, Besnard, Blanche, Carrière, Cazin, Chabas, Chéret, Cottet, Dagnan-Bouveret, Dauchez, Raffaëlli, Renoir, Roll, Le Sidaner, Lévy-Dhurmer, Maignan, Martin, Raffaëlli, Roll, Simon. German section, inc: Kalckreuth, Liebermann, Slevogt, Von Stuck. Austrian section, inc: Klimt, Kupka. Belgian section, inc: Claus, Ensor,

Evenepoel, Khnopff, Vogels. Dutch section, inc: Toorop. American section, inc: Harrison, Sargent, Whistler. British section, inc: Clausen, Stanhope Forbes, La Thangue, Lavery, Melville, Osborne, Rothenstein, E. Stott. Italian section, inc: Boldini, Morbelli, Pellizza, Segantini. Swiss section, inc: Amiet, Hodler. Place de l'Alma, *Rodin* (independently organized one-man show).
Nov.–Dec. Durand-Ruel, *Monet* (*Bassin aux nymphéas* series).
Dec. Indépendants, inc: Luce, Puy, Schuffenecker, Signac.
Dec. Durand-Ruel, *Sickert*.
Dec. Projects for the Decoration of the Mairie d'Asnières, inc: Rousseau, Signac.

1901

Death of Toulouse-Lautrec.
Camoin visits Cézanne at Aix.

EXHIBITIONS
Jan.–Feb. Durand-Ruel, *C. Pissarro*.
March Bernheim Jeune, *Vincent Van Gogh* (71 items).
March G. Petit, Société Nouvelle, inc: Aman-Jean, Claus, Cottet, Dauchez, La Touche, Le Sidaner, Martin, Simon.
April Durand-Ruel, exh. inc: Valtat.
April Bernheim Jeune, *Carrière*.
April Palais des Champs Elysées, *Tissot*.

April–May Indépendants, inc: Angrand, Anna Boch, Bonnard, Cézanne, Cross, Denis, Ensor, Lacombe, Luce, Matisse, Ranson, Rousseau, Roussel, Van Rysselberghe, Schuffenecker, Sérusier, Signac, Vallotton, Valtat, Vuillard.
April–June Société Nationale, inc: Aman-Jean, Anquetin, Béraud, Bernard, Blanche, Carrière, Cazin, Claus, Cottet, Dagnan-Bouveret, Dauchez, Denis, La Touche, Lavery, Le Sidaner, Raffaëlli, Simon.

May onwards Salon des Artistes Français, inc: Adler, Chabas, Guillou, Legrand, Martin, Picabia, Rouault.
May Ecole des Beaux-Arts, *Daumier*.
May Durand-Ruel, *Moret*.
June Vollard, *Bernard*.
June–July Vollard, exh. inc: Picasso.
Vollard, *Redon*.

1902

First performance of Debussy, *Pelléas et Mélisande*, libretto by Maeterlinck.

EXHIBITIONS
Feb. B. Weill, exh. inc: Matisse.
March G. Petit, Société Nouvelle.
March–May Indépendants, inc: Bernard, Bonnard, Cézanne, Cross, Denis, Luce, Marquet, Matisse, Rousseau, Roussel, Van Rysselberghe, Signac, Toulouse-Lautrec (retrospective), Vallotton, Valtat, Vuillard.

April B. Weill, exh. inc: Picasso.
April–June Société Nationale, inc: Aman-Jean, Anquetin, Bernard, Besnard, Blanche, Carrière, Claus, Cottet, Dagnan-Bouveret, Dauchez, Harrison, Hodler, La Touche, Lavery, Le Sidaner, Roll, Sargent, Sickert, Simon, Whistler.
May onwards Salon des Artistes Français, inc: Adler, Chabas, Guillou, Legrand, Maignan, Martin, Picabia.

May Durand-Ruel, *Toulouse-Lautrec* (retrospective).
June Galerie de l'Art Nouveau, *Signac*.
June Durand-Ruel, *Renoir*.
Durand-Ruel, *Roussel*.
Vollard, *Maillol*.
Maison des Artistes, *Van Rysselberghe*.
Nov.–Dec. B. Weill, exh. inc: Picasso.

1903

Death of Gauguin in Marquesas Islands, and of Camille Pissarro.

EXHIBITIONS
Jan. Hôtel Drouot, Vente *Roussel*.
Feb.–March G. Petit, Société Nouvelle, inc: Blanche, Claus, Cottet, Dauchez, Martin, Sickert, Simon.
March Durand-Ruel, *Redon*.
March Vollard, *Gauguin* (inc. 50 paintings).
March–April Indépendants, inc: Angrand, Bonnard, Camoin, Cross, Denis, Dufy, Forain, Friesz, Luce, Marquet, Matisse, Munch, O'Conor, Ranson, Rousseau, Roussel, Van Rysselberghe, Schuffenecker, Sickert, Signac, Vallotton, Vuillard.

April Bernheim Jeune, *Oeuvres de l'ecole impressionniste*, inc: Cassatt, Cézanne, Degas, Guillaumin, Manet, Monet, C. Pissarro, Renoir, Sisley.
April–June Société Nationale, inc: Aman-Jean, Anquetin, Béraud, Bernard, Besnard, Blanche, Boldini, Bonnard, Claus, Cottet, Dagnan-Bouveret, Dauchez, Denis, Harrison, La Touche, Lavery, Le Sidaner, Maillol, Raffaëlli, Roll, Sargent, Sickert, Simon, Vallotton.
April–May Bernheim Jeune, *Vallotton and Vuillard*.
May onwards Salon des Artistes Français, inc: Adler, Chabas, Friesz, Guillou, Legrand, Maignan, Martin, Picabia.

May B. Weill, exh. inc: Marquet, Matisse.
Bernheim Jeune, *Carrière*.
Bernheim Jeune, *Vuillard*.
Oct.–Dec. Salon d'Automne (1st exh.), inc: Adler, Aman-Jean, Besnard, Blanche, Bonnard, Carrière, Gauguin, Guillaumin, Harrison, Marquet, Matisse, Moret, O'Conor, Rouault, Von Stuck, Vallotton, Vuillard.
Nov. Durand-Ruel, *Zandomeneghi*.
Nov.–Dec. Druet, exh. inc: Bonnard, Cross, Denis, Roussel, Van Rysselberghe, Sérusier, Signac, Vuillard.
Dec.–Jan. 1904 B. Weill, exh. inc: Kupka, Vallotton.

Germany

1900

Death of Nietzsche.
Rilke visits Worpswede.

EXHIBITIONS
Berlin, spring Secession II, inc: Böcklin, Corinth, Cottet, Dill, C. Herrmann, Hodler, Hofmann, Lavery, Liebermann, Pissarro, Raffaëlli, Renoir, Roll, Segantini, Slevogt, Von Stuck, Uhde, Vuillard, Whistler.
Munich Glaspalast, Jahresausstellung, inc: artists' groups in Germany, e.g. Die Scholle (Munich), Der Cronberger Künstlerbund (Frankfurt), Die Freie Vereinigung (Düsseldorf).
Munich, summer Secession, inc: Böcklin, Degas, Hofmann, Liebermann, Monet, Monticelli, Munch, Renoir, Van Rysselberghe, Segantini, Slevogt, Von Stuck, Uhde.

1901

Corinth and Slevogt settle in Berlin.

EXHIBITIONS
Berlin, spring Secession III, inc: Böcklin, Corinth, Van Gogh, Heine, C. Herrmann, Hofmann, Lavery, Liebermann, Monet, Pissarro, Raffaëlli, Renoir, Rohlfs, Segantini, Simon, Von Stuck, Toulouse-Lautrec, Uhde, Whistler.
Berlin, winter Secession IV, *Graphics*, inc: Corinth, Heine, C. Herrmann, Hofmann, Liebermann.
Munich, autumn Phalanx School (1st exh.) presided over by Kandinsky.

1902

Meier-Graefe, *Manet und Impressionismus*, publ.
Opening of Folkwang Museum, Hagen, designed by Van de Velde.

EXHIBITIONS
Berlin, spring Secession V, inc: Böcklin, Corinth, Heine, C. Herrmann, Hodler, Hofmann, Kandinsky, Lavery, Manet, Munch, Simon, Slevogt, Whistler.
Berlin, winter Secession VI, *Graphics*, inc: Carrière, Corinth, Feininger, Hofmann, Kandinsky, Liebermann, Manet, Nolde, Redon, Renoir, Rodin, Toulouse-Lautrec, Vallotton, Vuillard, Whistler.
Munich, summer Secession, inc: Clausen, Cottet, Hofmann, Lavery, Von Stuck, Uhde.

1903

Rilke, *Worpswede*, publ.
Meier-Graefe, *Entwicklungsgeschichte der modernen Kunst*, publ.

EXHIBITIONS
Berlin, spring Secession VII, inc: Bonnard, Cézanne, Corinth, Forain, Gauguin, Van Gogh, Hofmann, Hodler, Liebermann, Manet, Modersohn, Monet, Nolde, Pissarro, Slevogt, Toulouse-Lautrec, Vallotton, Vuillard.
Berlin, winter Secession VIII, *Graphics*, inc: Beardsley, Corinth, Feininger, Hofmann, Israels, Liebermann, Munch, Nolde, Previati, Rodin, Slevogt, Toulouse-Lautrec, Whistler.
Munich Glaspalast, Jahresausstellung, inc: Heine, Nomellini, Rohlfs.
Munich, spring Secession, inc: Van Gogh, Munch, Putz, Toorop.
Munich, summer Secession, inc: Dill, Hodler, Jawlensky, Roll, Segantini, Sickert, Von Stuck, Uhde.

Great Britain and Ireland

1900

W. Rothenstein, *Goya*, publ.

EXHIBITIONS
Jan. Pastel Society, inc: Clausen, E. Stott.
April Carfax Gallery, *Conder*.
April–May NEAC, inc: Conder, Fry, A. John, G. John, Orpen, Rothenstein, Sickert, Steer.
April–May Goupil, *Monticelli*.
May onwards RA, inc: Clausen, Fantin-Latour, Forbes, La Thangue, Osborne, Sargent, E. Stott.
May New Gallery, inc: Khnopff, Sargent.
Summer Grafton Galleries, *Romney*.
July Continental Gallery, *Guillou*.
Guildhall, *Living British Artists*, inc: Clausen, Forbes, Guthrie, Henry, La Thangue, Lavery, Sargent, Stott.

Nov. Forbes Paterson, *Monticelli*.
Nov. 'The Company of the Butterfly', Manchester Sq. (Whistler's company), *Nicholson*.
Nov.–Dec. NEAC, inc: Conder, Fry, A. John, G. John, Orpen, Rothenstein, Sickert, Steer.
Dec. Carfax Gallery, *Conder and Rothenstein*.
Glasgow, Feb.–May Institute, inc: Clausen, Guthrie, Henry, Hornel, Liebermann, Monticelli, Sargent, W. Stott.
Liverpool, autumn Walker AG, inc: Clausen, Forbes, Lavery, Osborne, Sargent, E. Stott.

1901

EXHIBITIONS
March Goupil, inc: Clausen, Monet, Monticelli, Whistler.
April–May NEAC, inc: Conder, Fry, Henry, Orpen, Rothenstein, Sickert, Steer.
May onwards RA, inc: Clausen, Forbes, La Thangue, Osborne, Sargent, E. Stott.
May Carfax Gallery, *Conder*
June Pastel Society, inc: Claus, Clausen, Lévy-Dhurmer, E. Stott.
Guildhall, *Spanish Painters*, inc: Goya, Velasquez.
Oct. Goupil, inc: Bastien-Lepage, Clausen, Henry.
Oct.–Dec. International Society, inc: Boldini, Conder, Cottet, Forain, Gauld, Henry, Hornel, Khnopff, Lavery, Liebermann, Le Sidaner, Monet, Nicholson, Osborne, C. Pissarro, Renoir, Segantini, Von Stuck, Whistler.
Nov. Carfax Gallery, *Orpen*.

Nov.–Dec. NEAC, inc: Conder, Fry, Henry, Orpen, Osborne, Rothenstein, Sickert, Steer.
Dec. Carfax Gallery, *Conder*.
Hanover Gallery, *French Impressionists*, inc: Monet, Moret, C. Pissarro, Renoir, Sisley, Zandomeneghi.
Winter 1901–2 Whitechapel Art Gallery, inc: Clausen, Fergusson, Gauld, Guthrie, Lavery, Whistler.
Glasgow, Feb.–April Institute, inc: Cottet, Fergusson, Guthrie, Henry, La Thangue. Lavery, Sargent.
Glasgow International Exhibition, inc: Clausen, Fantin-Latour, Forbes, Gauld, Lavery, Manet, Monet, Monticelli, Raffaëlli, Renoir, Rothenstein, T. Roussel, Steer, E. Stott, W. Stott, Tissot, Whistler.
Liverpool, autumn Walker AG, inc: Clausen, Forbes, Hornel, La Thangue, Sargent, E. Stott.

1902

EXHIBITIONS
April–May NEAC, inc: Conder, Fry, Henry, Orpen, Osborne, Sickert, Steer.
May onwards RA, inc: Clausen, Forbes, La Thangue, Osborne, Sargent, E. Stott.
May Carfax Gallery, *Conder*.
May New Gallery, inc: Henry, Khnopff, Lavery, Sargent, E. Stott.
Spring Hanover Gallery, inc: Besnard, Cazin, Le Sidaner, Monet, C. Pissarro, Raffaëlli.
June Pastel Society, inc: Aman-Jean, Clausen, Lévy-Dhurmer, E. Stott.
June Goupil, inc: Cazin, Fantin-Latour, Gauld, Henry.
June Carfax Gallery, *Steer*.
Guildhall, *French and English Painters of the 18th Century*.

Dutch Gallery, inc: Fantin-Latour, Rodin, Steer, E. Stott.
French Gallery, inc: Cazin, Monticelli.
Nov. Goupil, *Clausen*.
Nov. Carfax Gallery, *Rothenstein Pastels*.
Nov.–Dec. NEAC, inc: Conder, Fry, Henry, A. John, G. John, Orpen, Osborne, Rothenstein, Steer.
Dec. Carfax Gallery, *Conder*.
Glasgow, Feb.–May Institute, inc: Clausen, Fergusson, Henry, Hornel, Lavery, Khnopff, Nicholson, Renoir, Sargent, E. Stott.
Liverpool, autumn Walker AG, inc: Clausen, Forbes, La Thangue, Osborne, Sargent, E. Stott.

1903

EXHIBITIONS
March Carfax Gallery, *A. and G. John*.
March Goupil, inc: Clausen, Degas, Fantin-Latour, Henry, Le Sidaner, C. Pissarro, Raffaëlli.
April–May NEAC, inc: Henry, Orpen, Rothenstein, Steer.
April–May Carfax Gallery, *Fry*.
May onwards RA, inc: Clausen, Forbes, La Thangue, Osborne, Sargent, E. Stott.
May New Gallery, inc: Boldini, Khnopff, Lavery, E. Stott.
May–June Carfax Gallery, *Sargent*.
May–July Grafton Galleries, *French Masters*, inc: Cazin, Cottet, Moret, Puvis de Chavannes, Renoir, Roll.
Spring Dutch Gallery, inc: Conder, Fantin-Latour, Whistler.
June Stafford Gallery, *Nicholson*.
June Pastel Society, inc: Besnard, Claus, Clausen, Cottet, Guthrie, La Touche,

Le Sidaner, Lévy-Dhurmer, K.-X. Roussel.
Aug. Continental Gallery, inc: Harrison.
Grafton Galleries, *J. S. Forbes Collection*, inc: Bastien-Lepage, Fantin-Latour, Monet, Monticelli
Oct. Obach & Co., *Whistler etchings*.
Nov.–Dec. NEAC, inc: Fry, Henry, A. John, Orpen, Rothenstein, Steer.
Nov.–Dec. Dutch Gallery, *Conder*.
Dec. Goupil, inc: Besnard, Clausen, Fantin-Latour, Fry, La Touche, Le Sidaner, Rothenstein, Whistler.
Edinburgh Society of Scottish Artists, inc: Segantini.
Glasgow, Feb.–May Institute, inc: Clausen, Forbes, Guthrie, Henry, Le Sidaner, Raffaëlli, Segantini.
Liverpool, autumn Walker AG, inc: Clausen, Cottet, Forbes, La Thangue, Lavery, Sargent, E. Stott.

Italy

1900

King Umberto I assassinated by Anarchist, Bresci.
Italia Ride founded in Bologna; Kienerk and Soffici contribute.

EXHIBITIONS
Milan R. Accademia di BB.AA. di Brera, IV Esposizione Triennale, inc: Fornara, Segantini.
Milan *La Pittura Lombarda nel Secolo XIX*, inc: Grubicy, Longoni, Morbelli, Segantini.

1901

Novissima (monthly magazine) founded by De Fonseca; Fonara, Innocenti, Kienerk, Nomellini and Previati contribute (ends 1910).

EXHIBITIONS
Lodi Esposizione Sacra, inc: Previati.
Venice, April–Oct. IV Esposizione Internazionale d'Arte della Città di Venezia, inc: Besnard, Blanche, Carrière, Cazin, Claus, Clausen, Cottet, Ensor, Fontanesi (retrospective), Fornara, Grubicy, Khnopff, Kienerk, La Touche, Lavery, Martin, Monticelli, Morbelli, Noci, Nomellini, Previati (separate room), Raffaëlli, Rodin (separate show), Van Rysselberghe, Sargent, Segantini, Von Stuck, plus *Scuola di Trenta* (Barbizon School retrospective).

1902

Arte Decorative Moderna (magazine on decorative arts) founded in Turin.

EXHIBITIONS
Milan, winter–spring 1903 Esposizione Collettiva al Palazzo delle BB.AA., inc: Fornara, Grubicy, Previati.
Rome LXXIII Esposizione della Società di Amatori e Cultori di BB.AA., inc: Balla, Lionne, Noci, plus major international graphics exh.: Esposizione Internazionale di Bianco e Nero.
Turin, April–Nov. Esposizione Internazionale d'Arte Decorativa Moderna.
Turin Società Promotrice di BB.AA, inc: Fornara, Innocenti, Kienerk, Nomellini, Pellizza, Previati.

1903

Galleria d'Arte Moderna opened in Milan.
Galleria d'Arte Moderna in Venice receives funds to purchase Italian and foreign works direct from Venice Biennale.

EXHIBITIONS
Rome LXXIII Esposizione della Società di Amatori e Cultori di BB.AA., inc: Balla, Innocenti, Noci.
Venice, April–Oct. V Esposizione Internazionale della Città di Venezia, inc: Balla, Besnard, Blanche, Boldini, Carrière, Claus, Cottet, Dagnan-Bouveret, Ensor, Forain, Grubicy, Harrison, Innocenti, Khnopff, Kienerk, La Thangue, La Touche, Lavery, Lévy-Dhurmer, Liebermann, Lionne, Longoni, Martin, Monet, Morbelli, Noci, Nomellini, Pellizza, C. Pissarro, Previati, Raffaëlli, Renoir, Rodin, Roll, Sargent, Sickert, Sisley, Von Stuck, Whistler.

The Low Countries

1900

Lectures at Libre Esthétique, inc: F. Jammes, 'Les Poètes contre la littérature', Gide, 'De l'Influence en littérature', Klingsor, 'Les poètes mis en musique', with musical examples of settings of poetry to music.

EXHIBITIONS
Amsterdam Arti et Amicitiae, inc: Monet, Moret, C. Pissarro, Renoir, Sisley.
Brussels 7th Libre Esthétique, inc: Claus, Ensor, Evenepoel, Luce, Roussel, Signac, Toorop, Valtat, Van de Velde.
Rotterdam Kunstkring, *Toorop*.

1901

Lectures at Libre Esthétique, inc: M. Beaubourg, 'Du Grotesque et du tragique dans notre époque'.
Two concerts at Libre Esthétique.

EXHIBITIONS
Amsterdam, winter–spring 1902 Arti et Amicitiae, *Breitner*.
Brussels 8th Libre Esthétique, inc: Cézanne, Claus, Cross, Denis, Grubicy, Guillaumin, Hodler, Monet, C. Pissarro, Renoir, Van Rysselberghe, Sérusier, Vuillard.
The Hague 1st International Exhibition, inc: Cézanne, Claus, Cross, Denis, Ensor, Van Gogh, Luce, Van Rysselberghe.

1902

Lectures at Libre Esthétique, inc: Jarry, 'Les Marionnettes'.
Concerts at Libre Esthétique.

EXHIBITIONS
Brussels, spring 9th Libre Esthétique, inc: Conder, Khnopff, Le Sidaner, Rodin, K.-X. Roussel, Toorop, Toulouse-Lautrec, Vallotton (retrospective).
Delft *Toorop*.
The Hague Binnenhuis, *Thorn Prikker*.

1903

Lectures at Libre Esthétique, inc: G. de Voisins, 'Les Jardins, la Faune et le Poète', O. Maus, 'L'Humeur en musique'.
Four concerts at Libre Esthétique.

EXHIBITIONS
Brussels 10th Libre Esthétique, inc: Besnard, Blanche, Denis, Martin, Van Rysselberghe.

France

1904

Bernard visits Cézanne at Aix.

EXHIBITIONS
Feb. Bernheim Jeune, *Bernard*.
Feb.–March L. Soulié, exh. inc: Van Gogh.
Feb.–March Durand-Ruel, *Moret*.
Feb.–March Indépendants, inc: Bonnard, Camoin, Cross, Delaunay, Denis, Van Dongen, Dufy, Friesz, Luce, Marquet, Matisse, Munch, O'Conor, Ranson, Rousseau, Roussel, Van Rysselberghe, Schuffenecker, Sérusier, Signac, Vallotton, Valtat, Vuillard.
March B. Weill, exh. inc: Toulouse-Lautrec.
March Druet, *Luce*.
March–April G. Petit, Société Nouvelle, inc: Blanche, Claus, Conder, Cottet, Dauchez, La Touche, Le Sidaner, Martin, Simon.

April B. Weill, exh. inc: Camoin, Marquet, Matisse.
April Bernheim Jeune, exh. inc: Bonnard, Denis, Maillol, Roussel, Vallotton, Vuillard.
April Durand-Ruel, *C. Pissarro* (retrospective).
April–June Société Nationale, inc: Aman-Jean, Bakst, Béraud, Besnard, Blanche, Boldini, Carrière, Claus, Conder, Cottet, Dagnan-Bouveret, Dauchez, Denis, Harrison, La Touche, Lavery, Le Sidaner, Raffaëlli, Roll, Rouault, Sargent, Simon, Whistler.
April–July Pavilion de Marsan, *Les Primitifs français*.
May onwards Salon des Artistes Français, inc: Adler, Chabas, Guillou, Legrand, Martin, Picabia.
May–June Durand-Ruel, *Monet* (*Thames* series).

June Bernheim Jeune, *Sickert*.
June Vollard, *Matisse*.
Oct.–Nov. Salon d'Automne, inc: Adler, Bonnard, Camoin, Carrière, Cézanne (separate room), Delaunay, Denis, Guillaumin, Kandinsky, Lavery, Liebermann, Maillol, Marquet, Matisse, Moret, O'Conor, Puvis de Chavannes (separate room), Redon (separate room), Renoir (separate room), Rouault, Roussel, Toulouse-Lautrec (separate room), Vuillard, Zandomeneghi.
Oct.–Nov. B. Weill, exh. inc: Dufy, Picasso.
Nov. Vollard, *Van Dongen*.
Nov.–Dec. Druet, *Denis* (preface by Gide).
Dec. Druet, *Signac*.

1905

So-called *cage des fauves* at Salon d'Automne leads to christening of Fauve group.
Morice, 'Enquête sur les tendances actuelles des arts plastiques', *Mercure de France*, Aug. and Sept.

EXHIBITIONS
Jan. Templaere, *L'Atelier de Fantin-Latour*.
Jan.–Feb. Henry Graves, *Henri Martin and Ernest Laurent*.
Feb. Henry Graves, *Intimistes* (1st exh.), inc: Bonnard, Matisse, Vuillard.
Feb.–March Galerie Serrurier, exh. inc: Picasso.
Feb.–March B. Weill, exh. inc: Toulouse-Lautrec.
March–April G. Petit, Société Nouvelle, inc: Blanche, Brangwyn, Claus, Conder, Cottet, Dauchez, La Touche, Le Sidaner, Martin, Simon.
March–April Druet, *Cross*.
March–April Indépendants, inc: Angrand, Bernard, Bonnard, Camoin,

Cross, Delaunay, Denis, Derain, Van Dongen, Dufy, Friesz, Van Gogh (retrospective), Herrmann, Kollwitz, Lacombe, Luce, Marquet, Matisse, Munch, O'Conor, Rouault, Rousseau, Roussel, Van Rysselberghe, Sérusier, Seurat (retrospective), Sickert, Signac, Vallotton, Valtat, Vlaminck, Vuillard.
April Barbazanges, *William Nicholson*.
April B. Weill, exh. inc: Camoin, Matisse.
April onwards Société Nationale, inc: Aman-Jean, Anquetin, Béraud, Besnard, Boldini, Carrière, Claus, Cottet, Dagnan-Bouveret, Dauchez, Denis, Guthrie, Harrison, Henry, La Touche, Lavery, Le Sidaner, Raffaëlli, Roll, Sargent, Simon.
May onwards Salon des Artistes Français, inc: Adler, Chabas, Guillou, Legrand, Maignan, Martin, Picabia.
May Ecole des Beaux-Arts, *Whistler* (retrospective).
May–June B. Weill, exh. inc: Friesz, Ranson.

June Bernheim Jeune, *Forain*.
June–July G. Petit, *Besnard*.
June–July Druet, *Cross and Signac*.
Oct.–Nov. Salon d'Automne, inc: Bonnard, Camoin, Carrière, Cézanne, Derain, Van Dongen, Duchamp-Villon, Friesz, Guillaumin, Ingres (retrospective), Jawlensky, Kandinsky, Lavery, Maillol, Manet (retrospective), Marquet, Matisse, Moret, O'Conor, Picabia, L. Pissarro, Raffaëlli, Redon, Renoir, Rouault, Rousseau, Roussel, Sickert, Vallotton, Valtat, Vlaminck, Vuillard.
Oct.–Nov. Druet, *Van Dongen*.
Oct.–Nov. B. Weill, exh. inc: Camoin, Derain, Dufy, Marquet, Matisse, Vlaminck.
Nov.–Dec. Druet, *Van Rysselberghe*.
Dec. Galerie E. Prath and P. Maynier, exh. inc: Bourdelle, Braque, Camoin, Derain, Van Dongen, Friesz, Marquet, Matisse, Vlaminck.

1906

Denis and Roussel visit Cézanne at Aix.
Osthaus visits Cézanne at Aix.
Deaths of Cézanne and Carrière.

EXHIBITIONS
Feb. Druet, *Ranson*.
Feb.–March Henry Graves, *Intimistes*, inc: Bonnard, Vuillard.
Feb.–March Durand-Ruel, *Redon*.
March Durand-Ruel, *Manet* (from Faure collection).
March Durand-Ruel, *Monet* (from Faure collection).
March G. Petit, Exposition de Peintres et de Sculpteurs, under presidency of Rodin, inc: Aman-Jean, Besnard, Blanche, Carrière, Claus, Conder, Cottet, Dauchez, La Touche, Le Sidaner, Maillol, Martin, Rodin, Simon.
March–April Druet, *Matisse*.

March–April Indépendants, inc: Angrand, Bernard, Bonnard, Braque, Camoin, Cross, Delaunay, Denis, Derain, Van Dongen. Dufy, Friesz, Herrmann, Lacombe, Léger, Luce, Marquet, Matisse, Munch, O'Conor, Ranson, Rouault, Rousseau, Roussel, Van Rysselberghe, Schuffenecker, Sérusier, Vallotton, Valtat, Vlaminck, Vuillard.
April Bernheim Jeune, *Guillaumin*.
April–May Druet, *Luce*.
April onwards Société Nationale, inc: Aman-Jean, Béraud, Bernard, Besnard, Blanche, Boldini, Carrière, Claus, Cottet, Dagnan-Bouveret, Dauchez, Denis, Harrison, La Touche, Lavery, Le Sidaner, Roll, Simon.
May onwards Salon des Artistes Français, inc: Adler, Chabas, Guillou, Legrand, Maignan, Martin, Picabia.
May Bernheim Jeune, *Vallotton*.
May Ecole des Beaux-Arts, *Fantin-Latour*.

May–June Bernheim Jeune, *Vuillard*.
June *chez* Pierrefort, exh. inc: Luce, Matisse, Schuffenecker.
G. Petit, *Moreau*.
Cercle de l'Union Artistique, inc: Béraud, Blanche, Chabas, Dagnan-Bouveret, Harrison, Roll.
Oct.–Nov. Salon d'Automne, inc: Bonnard, Brancusi, Camoin, Carrière (retrospective), Cézanne, Delaunay, Derain, Van Dongen, Dufy, Friesz, Gauguin (retrospective), Guillaumin, Kandinsky, Kupka, Lavery, Marquet, Matisse, Moret, O'Conor, Redon, Renoir, Rossi, Rouault, Rousseau, Roussel, Sickert, Vallotton, Valtat, Vlaminck, Vuillard; plus exh. of Russian art, organized by Diaghilev.
Oct.–Nov. Bernheim Jeune, *Roussel*.
Nov. Bernheim Jeune, *Bonnard*.
Dec.–Jan. 1907 *chez* Rivaud, 6th Exposition Intime, inc: Cottet, Dauchez, Simon.

1907

Death of Jarry.
Picasso paints *Les Demoiselles d'Avignon*.

EXHIBITIONS
Jan. Bernheim Jeune, *Sickert*.
Jan.–Feb. Bernheim Jeune, *Signac*.
Feb. Druet, *Marquet*.
Feb. Bernheim Jeune, *Luce*.
Feb. Galeries Shirleys, *Beardsley* (drawings).

March Druet, *Guillaumin*.
March Hôtel Drouot, Vente *Odilon Redon*.
March–April Indépendants, inc: Amiet, Angrand, Braque, Camoin, Cross, Delaunay, Derain, Dufy, Gilman, Gore, Herrmann, Kandinsky, Luce, Matisse, O'Conor, Ranson, Rousseau, Russell, Schuffenecker, Sérusier, Signac, Vallotton, Vuillard.

?March G. Petit, Exposition de Peintres et de Sculpteurs, under presidency of Rodin, inc: Aman-Jean, Besnard, Blanche, Claus, Conder, Cottet, Dauchez, La Touche, Le Sidaner, Martin, Rodin, Sargent, Simon.
April Durand-Ruel, *Moret*.
April Bernheim Jeune, *Denis*.
April–May Bernheim Jeune, *Cross* (preface by Denis).
[continued on page 294]

Germany

1904

EXHIBITIONS
Berlin, spring Secession IX, inc: Amiet, Carrière, Corinth, Cottet, C. Herrmann, Hodler, Hofmann, Jawlensky, Kandinsky, Lavery, Liebermann, Mackensen, Modersohn, Simon, Slevogt, Von Stuck, Uhde, Vallotton, Whistler.
Berlin, ? Oct. Cassirer, exh. inc: Corinth, Degas, Manet, Monet, Rodin.
Berlin, ? Dec. Cassirer, exh. inc: Munch, Renoir.
Berlin, winter Secession X, *Graphics*, inc: Corinth, Van Gogh, Liebermann, Maillol, Slevogt, Von Stuck.
Munich, Jan. 9th Phalanx exh., inc: Kubin, Kandinsky.
Munich, spring 10th Phalanx exh., inc: Van Rysselberghe, Signac, Toulouse-Lautrec, Vallotton.
Munich, summer Secession, inc: Corinth, Klimt, Liebermann, Slevogt, Von Stuck, Uhde.

1905

Die Brücke formed in Dresden by Kirchner *et al.*

EXHIBITIONS
Berlin, spring Secession XI, inc: Jawlensky, Kandinsky, Munch, Nolde.
Berlin Zweite Ausstellung des Deutschen Künstlerbundes, inc: Hodler, Hofmann, Kandinsky, Klimt, Liebermann, Slevogt, Von Stuck, Uhde.
Dresden Galerie Arnold, *Van Gogh*.
Munich Glaspalast, Jahresausstellung, inc: Balla, Morbelli, Von Stuck, Toorop.
Munich, summer Secession, inc: Putz, Rohlfs.
Prague, Feb.–March Manès, *Munch*.

1906

EXHIBITIONS
Berlin, Feb.–March Cassirer, exh. inc: Cézanne, Corinth, Courbet, Moll.
Berlin, spring Secession XI, inc: Amiet, Bonnard, Corinth, Cross, Denis, Dill, Evenepoel, Gauguin, Hofmann, Jawlensky, Kandinsky, Liebermann, Mackensen, Manet, Modersohn, Munch, Nolde, Rodin, Van Rysselberghe, Signac, Slevogt, Von Stuck, Valtat, Vuillard.
Berlin, summer Fritz Gurlitt, *Nolde*.
Berlin *Die Deutsche Jahrhundert Ausstellung 1775–1875*, inc: Böcklin, Leibl, Liebermann.
Berlin, Oct.–Nov. Galerie Wertheim, *Kandinsky*.
Berlin, winter Eduard Schulte, *Russian Art*, inc: Vrubel.
Berlin, winter Secession XII, *Graphics*, inc: Corinth, Van Gogh, Hofmann, Kandinsky, Schmidt-Rottluff, Slevogt, Von Stuck.
Bremen, Feb.–March Kunstverein, Internationale Ausstellung, inc: Cézanne, Corinth, Van Gogh, Hodler, Hofmann, Jawlensky, Munch, Nolde, Slevogt.
Bremen, winter Kunsthalle, *Ausstellung Worpswede Künstler*, inc: Mackensen, Modersohn, Modersohn-Becker.
Cologne, May–Nov. Deutsche Kunstausstellung, inc: Holzel, Nolde.
Dresden, Jan. Galerie Arnold, *Nolde*.
Dresden, summer Galerie Arnold, *English Graphics*, inc: A. John, Rothenstein.
Dresden, autumn Seifert's lighting factory, 1st Die Brücke exh., inc: Bleyl, Heckel, Kirchner, Nolde, Pechstein, Schmidt-Rottluff.
Dresden, winter 2nd Die Brücke exh. (graphics), inc: Amiet, Bleyl, Heckel, Kandinsky, Kirchner, Nolde, Pechstein, Schmidt-Rottluff.
Munich, summer Secession, inc: Besnard, Carrière, Clausen, Cottet, Dill, Hodler, Lavery, Von Stuck, Uhde.

Great Britain and Ireland

1904

W. Dewhurst, *Impressionist Painting – Its Genesis and Development*, publ.

EXHIBITIONS
Jan.–March International Society, inc: Anquetin, Blanche, Carrière, Cottet, Fantin-Latour, Guthrie, Hornel, Lavery, Le Sidaner, Liebermann, Monet, Nicholson, L. Pissarro, Raffaëlli, Rodin, T. Roussel, Toulouse-Lautrec, Whistler.
Jan. Pastel Society, inc: Cottet, Degas, Le Sidaner, Roll, K.-X. Roussel.
Jan. Goupil, inc: Besnard, Clausen, Rothenstein.
April–May NEAC, inc: Blanche, Fry, Gilman, Henry, A. John, Orpen, Rothenstein, Sargent, Steer.
May onwards RA, inc: Clausen, Forbes, Henry, La Thangue, Orpen, Sargent, E. Stott.
Dutch Gallery, inc: Conder, Fantin-Latour, Monticelli.

Guildhall, *Irish Painters*, inc: Henry, Lavery, O'Conor, Osborne, Orpen, Yeats.
Earl's Court, *Italian Exhibition*, inc: Pellizza, Previati, Segantini.
Oct. Leicester Galleries, *Conder, Rothenstein and C. H. Shannon*.
Nov. Leicester Galleries, *Lavery*.
Nov.–Dec. Goupil, *Clausen*.
Nov.–Dec. NEAC, inc: Blanche, Fry, Henry, A. John, Orpen, L. Pissarro, Rothenstein, Sickert, Steer.
Dublin, Nov. *Modern French Art*, organized by Hugh Lane.
Glasgow, March–May Institute, inc: Clausen, Fergusson, Forbes, Guthrie, Hornel, Le Sidaner, Sargent, Segantini, E. Stott, Von Stuck.
Liverpool, autumn Walker AG, inc: Clausen, Forbes, Hornel, Lavery, Orpen, Raffaëlli, Sargent.

1905

Hugh Lane starts to buy Impressionist paintings.
As a result of Grafton Galleries' Impressionist exh. Frank Rutter starts fund to buy an Impressionist painting for National Gallery. He wanted a Monet Vétheuil subject but had to settle for Boudin's *The Harbour at Trouville*.

EXHIBITIONS
Jan.–Feb. Grafton Galleries, exh. organized by Durand-Ruel, of: Boudin, Cézanne, Degas, Manet, Monet, Morisot, C. Pissarro, Renoir, Sisley.
Feb.–March Obach, *Fantin-Latour*.
March Baillie Gallery, *Bevan*.
April Carfax Gallery, *Sargent Watercolours*.
April–May NEAC, inc: Conder, Fry, Henry, A. John, Orpen, L. Pissarro, Rothenstein, Sargent, Steer.
May onwards RA, inc: Clausen, Forbes, Henry, La Thangue, Sargent, E. Stott.
May Grafton Galleries, *J. S. Forbes Collection*, inc: Bastien-Lepage, Fantin-Latour, Monet, Monticelli.

May–June Baillie Gallery, *Fergusson*.
June Pastel Society, inc: Conder, La Touche, Le Sidaner, Lévy-Dhurmer, Roll, Goupil, inc: Le Sidaner.
International Society, inc: Aman-Jean, Blanche, Carrière, Conder, Cottet, Ensor, Hornel, La Touche, Lavery, Nicholson, Raffaëlli, Rodin, K.-X. Roussel, Sickert, Simon, Vuillard.
Oct.–Nov. NEAC, inc: Blanche, Conder, Fry, Henry, A. John, Orpen, L. Pissarro, Rothenstein, Sargent, Steer.
Nov. Friday Club, 1st exh., organized by V. Bell, inc:
Dec.–Jan. 1906 Leicester Galleries, *Conder*.
Dec.–Jan. 1906 Leicester Galleries, *Blanche*.
Glasgow, Feb.–May Institute, inc: Le Sidaner, Raffaëlli, Whistler.
Liverpool, autumn Walker AG, inc: Aman-Jean, Clausen, Forbes, Guillou, Henry, La Thangue, Lavery, Monticelli, Rodin, Rothenstein, Sargent, Steer, E. Stott.

1906

EXHIBITIONS
Jan.–Feb. International Society, inc: Aman-Jean, Besnard, Boldini, Carrière, Cézanne, Claus, Conder, Cottet, Degas, Fergusson, Forain, Guillaumin, Guthrie, Hornel, La Touche, Lavery, Manet, Monet, Nicholson, C. Pissarro, Raffaëlli, Renoir, Rodin, Segantini, Simon, Vuillard.
Feb. Lafayette Gallery, *Pictures from the 1905 Salon d'Automne*, inc: O'Conor.
Feb.–March Agnew, *Independent Art of Today*, inc: Conder, Fry, Henry, Lavery, Nicholson, Orpen, Rothenstein, Sickert, Steer.
May onwards RA, inc: Blanche, Clausen, Forbes, La Thangue, Sargent, E. Stott.
June Pastel Society, inc: Clausen, Conder, Le Sidaner, Lévy-Dhurmer, Roll.

June–July NEAC, inc: Blanche, Conder, Fry, Gore, Henry, A. John, Orpen, L. Pissarro, Rothenstein, Sargent, Sickert, Steer.
Grafton Galleries, *Munich Fine Art Exhibition*, inc: Hofmann, Putz, Von Stuck.
Nov. Colnaghi, *T. Roussel*.
Nov.–Dec. William B. Paterson, *Nicholson*.
Nov.–Dec. NEAC, inc: Blanche, Conder, Fry, Gore, A. John, Orpen, L. Pissarro, Rothenstein, Sickert, Steer.
Glasgow, Feb.–May Institute, inc: Fergusson, Forbes, La Thangue, Le Sidaner, Monticelli, Sargent, E. Stott.
Liverpool, autumn Walker AG, inc: Clausen, Conder, Forbes, Hornel, A. John, Khnopff, La Thangue, Lavery, Le Sidaner, Monticelli, Raffaëlli, Rodin, Sargent, Von Stuck, Whistler.

1907

Spring, Fitzroy Street Group founded by Sickert, Gore, Gilman *et al*.

EXHIBITIONS
Jan.–March International Society, inc: Aman-Jean, Besnard, Blanche, Boldini, Conder, Cottet, A. John, Lavery, Le Sidaner, Maillol, Nicholson, Orpen, Puvis de Chavannes, Rodin, Segantini, Von Stuck, Whistler.

Spring Whitechapel AG, inc: Claus, Clausen, Conder, Cottet, Forbes, Henry, Hornel, A. John, La Thangue, Lavery, Orpen, L. Pissarro, Rothenstein, Steer, E. Stott, W. Stott.
May onwards RA, inc: Blanche, Clausen, Forbes, Henry, Hornel, La Thangue, Russell, Sargent, E. Stott.
May New Gallery, inc: Blanche, Sargent.
[continued on page 295]

Italy

1904

EXHIBITIONS
Milan Grubicy, inc: Fornara, Previati, Segantini.
Rome LXXIV Esposizione della Società di Amatori e Cultori di BB.AA., inc: Innocenti.

1905

Previati, *La Tecnica della Pittura*, publ.
Poesia founded by F. T. Marinetti.

EXHIBITIONS
Florence Mostra d'Arte Sacra, inc: Previati.
Rome Teatro Costanzi, Esposizione di Rifiutati, inc: Boccioni, Severini.
Venice, April–Oct. VI Esposizione Internazionale della Città di Venezia, inc: Aarts, Aman-Jean, Besnard, Blanche, Boldini, Carrière, Claus, Clausen, Cottet, Fantin-Latour, Forbes, Fornara, Grubicy, Innocenti, Kienerk, La Thangue, La Touche, Lavery, Lionne, Longoni, Martin, Modersohn, Monet, Morbelli, Noci, Nomellini, Pellizza, C. Pissarro, Previati, Raffaëlli, Renoir, Rodin, Roll, Romani, Sisley, Sottocornola, E. Stott, Von Stuck, Toorop, Vallotton, Vuillard, Whistler.

1906

Previati, *Principi scientifici del Divisionismo: La Tecnica della Pittura*, publ.

EXHIBITIONS
Milan, April–Nov. Inaugurazione del Nuovo Valico del Sempione. Esposizione di Milano. Mostra Nazionale di BB.AA., inc: Innocenti, Longoni, Morbelli, Nomellini.
Rome LXXVI Esposizione della Società di Amatori e Cultori di BB.AA., inc: Balla, Innocenti, Longoni, Morbelli, Noci, Nomellini, Pellizza, Severini.

1907

Pellizza commits suicide.
Commission for Segantini Museum founded.
V. Pica, article on Monet in *Emporium* (XXVI).

EXHIBITIONS
Rome LXXVII Esposizione della Società di Amatori e Cultori di BB.AA., inc: Balla, Innocenti, Lionne, Morbelli, Noci, Nomellini, Pellizza, Severini.
[continued on page 295]

The Low Countries

1904

Vie et Lumière circle founded in Brussels by Belgian 'Impressionists'.
Lectures at Libre Esthétique, inc: Mellério, 'L'Evolution de l'art impressionniste', Dufour, 'Jules Laforgue et l'impressionnisme', Laloy, 'L'Ecole contemporaine de musique française', Gide, 'L'Evolution du théâtre'.
Concerts at Libre Esthétique provide musical parallel to Impressionism.

EXHIBITIONS
Amsterdam Galerie Buffa, *Toorop*.
Brussels, spring 11th Libre Esthétique, *Exposition des peintres impressionnistes*, catalogue preface by O. Maus; exh. inc: Bonnard, Cassatt, Cézanne, Cross, Denis, Degas, Gauguin, Van Gogh, Guillaumin, Luce, Manet, Monet, C. Pissarro, Renoir, Roussel, Van Rysselberghe, Seurat, Signac, Toulouse-Lautrec, Vuillard.
Rotterdam Kunstkring, *Verster*.

1905

No lectures at Libre Esthétique.
Five concerts at Libre Esthétique.
Kunst van Heden founded in Antwerp by F. Franck.

EXHIBITIONS
Amsterdam Stedelijk Museum, *Van Gogh*.
Antwerp Kunst van Heden, exh. inc: Ensor.
Brussels 12th Libre Esthétique, *L'Evolution externe de l'Impressionnisme*, catalogue preface by O. Maus; exh. inc: Claus, Clausen, Ensor, Evenepoel (retrospective), Herrmann, Nolde, O'Conor, Toorop, Vogels (retrospective).

1906

No lectures at Libre Esthétique.
Concerts at Libre Esthétique.

EXHIBITIONS
Brussels, spring 13th Libre Esthétique, *Révolution*, catalogue preface by O. Maus; exh. inc: Camoin, Maillol, Manguin, Marquet, Matisse.
Rotterdam Galerie Reckers, *Toorop*.
Utrecht Voor de Kunst, *Toorop*.

1907

Lectures and concert at Libre Esthétique.

EXHIBITIONS
Brussels, spring 14th Libre Esthétique, *Souvenirs et espoirs, Eugène Carrière*, catalogue preface by O. Maus; exh. inc: Carrière (retrospective), Claus, Finch, Lacombe, Vlaminck.
The Hague Galerie Krüger, *Toorop*.

France

1907 (continued)

April–June Société Nationale, inc:
Aman-Jean, Anquetin, Béraud, Besnard,
Blanche, Claus, Dagnan-Bouveret,
Dauchez, Denis, Harrison, La Touche,
Lavery, Le Sidaner, Raffaëlli, Roll,
Simon.
May onwards Salon des Artistes
Français, inc: Adler, Chabas, Guillou,
Legrand, Maignan, Martin, Picabia.
May–June Ecole des Beaux-Arts,
Carrière.
May–June E. Blot, *C. Pissarro*.
May–Oct. Musée des Arts Decoratifs,
Objets d'art russes anciens (from Tenichev
collection).
June Bernheim Jeune, exh. inc:
Bonnard, Denis, Lacombe, Maillol,
Ranson, Roussel, Sérusier, Vallotton,
Vuillard.
June Bernheim Jeune, *Cézanne
watercolours*.
Summer Bernheim Jeune, *Rodin
drawings*.

Sept.–Oct. Serre de l'Alma, *Salon des
peintres divisionnistes italiens*, organized
by A. Grubicy gallery, inc: Fornara,
Previati, Segantini.
Oct.–Nov. Salon d'Automne, inc: Bakst,
Bonnard, Braque, Camoin, Cézanne
(retrospective), Delaunay, Derain, Dufy,
Fergusson, Friesz, Guillaumin,
Kandinsky, Kupka, Lavery, Léger,
Marquet, Matisse, Modigliani, Moret,
Redon, Rouault, Rousseau, Sickert,
Vallotton, Valtat, Vlaminck; plus
Belgian exh, inc: Claus, Ensor,
Evenepoel, Finch, Khnopff, Mellery,
Rops, Van Rysselberghe.
Nov. Druet, *Friesz*.
Nov. Bernheim Jeune, *Fleurs et natures
mortes*, inc: Bonnard, Cézanne, Fantin-
Latour, Gauguin, Van Gogh, Matisse,
Manet, Monet, Monticelli, C. Pissarro,
Redon, Renoir, Roussel, Van
Rysselberghe. Seurat, Sisley, Vuillard.

Nov.–Dec. Durand-Ruel, *C. Pissarro*
(graphics).
Dec. Bernheim Jeune, *L'Atelier de Sisley*.
Dec.–Jan. 1908 Bernheim Jeune,
Portraits d'hommes, inc: Anquetin,
Béraud, Besnard, Blanche, Bonnard,
Camoin, Carrière, Cézanne, Degas,
Van Dongen, Fantin-Latour, Forain,
Gauguin, Van Gogh, Guillaumin, Luce,
Manet, Marquet, Matisse, Monet,
Monticelli, C. Pissarro, Redon, Renoir,
Rodin, Rouault, Rousseau,
Van Rysselberghe, Sargent, Seurat,
Signac, Sickert, Toulouse-Lautrec,
Vallotton, Valtat, Vuillard.
Dec. E. Blot, exh. inc: Bonnard, Carrière,
Cézanne, Denis, Van Gogh, Manet,
Matisse, Picasso, Renoir, Roussel,
Signac.

1908

Vauxcelles' review of Braque's exh. in
Nov. leads to christening of his style as
'Cubism'.
Banquet in honour of 'Douanier'
Rousseau organized by Picasso *et al*.
Matisse, 'Notes d'un peintre', *Grande
revue*.

EXHIBITIONS
Jan. Bernheim Jeune, *Van Gogh* (100
items).
Jan. Druet, *Van Gogh* (35 items).
Jan. Druet, *Sérusier*.
Feb. Bernheim Jeune, *Vuillard*.
?March G. Petit, *Exposition de Peintres
et de Sculpteurs*, under presidency of
Rodin, inc: Aman-Jean, Besnard,
Blanche, Cottet, Dauchez, La Touche, Le
Sidaner, Martin, Rodin, Sargent, Simon.
March–May Indépendants, inc: Amiet,
Angrand, Braque, Camoin, Cross,
Derain, Finch, Gilman, Gore, Kandinsky,
Luce, Munch, O'Conor, Rousseau,
Russell, Schuffenecker, Sérusier,
Severini, Sickert, Signac, Vallotton,
Vlaminck.

April–May Bernheim Jeune,
Van Rysselberghe.
April–June Société Nationale, inc:
Aman-Jean, Anquetin, Béraud, Bernard,
Blanche, Claus, Cottet, Dauchez, Denis,
Fergusson, Harrison, La Touche, Lavery,
Le Sidaner, Raffaëlli, Roll, Simon.
May onwards Salon des Artistes
Français, inc: Adler, Chabas, Guillou,
Legrand, Maignan, Martin.
May–June Durand-Ruel, *Natures
mortes*, inc: Renoir.
July Druet, exh. inc: Camoin, Redon,
Roussel, Sérusier, Vallotton.
Oct–Nov. Salon d'Automne, inc: Bakst,
Bonnard, Camoin, Denis, Derain,
Van Dongen, Duchamp, Fergusson, Friesz,
El Greco (retrospective), Kandinsky,
Lavery, Léger, Marquet, Matisse,
Monticelli (retrospective), Moret,
O'Conor, Ranson, Rouault, Sickert,
Vallotton, Valtat, Vuillard, Vlaminck.
Oct. Bernheim Jeune, *Toulouse-Lautrec*.
Nov. Druet, *Redon*.

Nov. Kahnweiler, *Braque* (inc. L'Estaque
landscapes).
Nov. Bernheim Jeune, *Vuillard*.
Nov.–Dec. Druet, *Denis*.
Nov.–Dec. Bernheim Jeune,
Van Dongen.
Dec. B. Weill, exh. inc: Matisse.
Dec.–Jan. 1909 Bernheim Jeune,
Seurat.
Dec.–Jan. 1909 Druet, exh. inc:
Bonnard, Cézanne, Cross, Denis,
Gauguin, Van Gogh, Maillol, Redon,
Roussel, Seurat, Signac, Vallotton.
Dec.–Jan. 1909 Galerie Notre-Dame-
des-Champs, exh. inc: Braque, Derain,
Picasso.

1909

EXHIBITIONS
May Durand-Ruel, *Monet, Nymphéas,
paysages d'eau*.
Nov. Druet, *Van Gogh*.

1910

EXHIBITIONS
Feb. Bernheim Jeune, *Matisse*.
Oct.–Nov. Bernheim Jeune, *Cross*
(retrospective).

Germany

1906 (continued)

Weimar, summer Deutsche
Künstlerbund III, inc: Corinth, Hodler,
Hofmann, Kandinsky, Liebermann,
Nolde, Von Stuck, Uhde.

1907

Deutsche Werkbund formed under
Hermann Muthesius.

EXHIBITIONS
Berlin, spring Secession XIII, inc:
Corinth, Van Gogh, C. Herrmann,
Liebermann, Munch, Nolde, Rodin,
Slevogt.
Berlin, winter Secession XIV, *Graphics*,
inc: Corinth, Van Gogh, Heckel,
Kandinsky, Klimt, Liebermann, Maillol,
Matisse, Munch, Nolde, Van
Rysselberghe, Schmidt-Rottluff, Slevogt.
Düsseldorf, May–Sept. Deutsch-
Nationale Kunstausstellung, inc:
Corinth, Hofmann, Liebermann, Nolde,
Slevogt, Von Stuck, Uhde.
Munich, summer Secession, inc:
Corinth, Dill, Raffaëlli, Slevogt, Stuck.

1908

Von Tschudi dismissed from directorship
of Berlin Nationalgalerie for his policy of
acquiring French works.
Worringer, *Abstraktion und Einfühlung*,
publ.

EXHIBITIONS
Berlin, spring Secession XV, inc:
Bonnard, Cézanne, Corinth, Denis,
Van Gogh, C. Herrmann, Liebermann,
Maillol, Munch, Rodin, Roussel, Slevogt,
Von Stuck, Vuillard.
Berlin, Oct.–Nov. Kurfürstendamm,
Belgische Kunst, inc: Ensor, Evenepoel,
Khnopff, Van Rysselberghe.
Berlin, winter Seccession XVI, *Graphics*,
inc: Heckel, Hofmann, Kandinsky,
Kirchner, Liebermann, Matisse, Munch,
Nolde, Pechstein, Schmidt-Rottluff,
Slevogt.
Bremen, Feb.–April Kunsthalle,
Vereinigung Nordwestdeutscher
Künstler, inc: Modersohn-Becker, Nolde,
Slevogt.
Munich, summer Secession, inc: Aman-
Jean, Corinth, Lavery, Raffaëlli, Rodin,
Von Stuck, Uhde.
Munich, Dec. Moderne Kunsthandlung,
Munch.

1909

Von Tschudi appointed director of
Bayerische Staatsgemäldesammlungen,
Munich.
Matisse, *Notes d'un peintre*, German edn.

EXHIBITIONS
Berlin, spring Secession XVIII, inc:
Bonnard, Cézanne, Corinth, Van Gogh,
Hodler, Hofmann, Jawlensky, Klimt,
Liebermann, Slevogt, Uhde, Vuillard.
Berlin, winter Secession XIX, *Graphics*,
inc: Corinth, Feininger, Gauguin,
Van Gogh, Hodler, Kirchner,
Liebermann, Manet, Munch, Pechstein,
Puvis de Chavannes, Renoir, Rodin,
Schmidt-Rottluff, Signac, Slevogt,
Toorop, Toulouse-Lautrec.
Berlin, Nov.–Dec. Cassirer, *Cézanne*.
Düsseldorf, May–Oct. Grosse
Kunstausstellung, inc: Klimt,
Liebermann, Slevogt.
Düsseldorf, May–Oct. *Ausstellung für
Christliche Kunst*, inc: Bernard, Böcklin,
Carrière, Corinth, Denis, Puvis de
Chavannes, Redon, Sérusier, Slevogt,
Thorn Prikker, Toorop, Uhde.
Munich, Dec. Neue Künstler-
vereinigung (1st exh.), inc: Jawlensky,
Kandinsky.

Great Britain and Ireland

Italy

The Low Countries

1907 (continued)

May–June NEAC, inc: Fry, Gore, Henry, Innes, A. John, L. Pissarro, Rothenstein, Sargent, Sickert, Steer.
June Pastel Society, inc: Le Sidaner, Sargent.
June Goupil, inc: Besnard, Degas, Monet, L. Pissarro.
Grafton Galleries, United Arts Club, inc: Grant.
Autumn NEAC, inc: Henry, Innes, A. John, Orpen, L. Pissarro, Sargent, Sickert, Steer.

Nov. Carfax Gallery, *A. John Drawings*.
Dublin Irish International Exhibition, inc: Segantini.
Glasgow, Feb.–June Institute, inc: Forbes, Henry, Hornel.
Liverpool, autumn Walker AG, inc: Aman-Jean, Clausen, Conder, Cottet, Fantin-Latour, Forbes, Hornel, La Thangue, Le Sidaner, Raffaëlli, Rodin, Sargent, E. Stott.

1907 (continued)

Venice, April–Oct. VII Esposizione Internazionale della Città di Venezia, inc: Adler, Bakst, Besnard, Blanche, Breitner, Cázin, Conder, Cottet, Dauchez, Denis, Ensor, Evenepoel, Fantin-Latour, Grubicy, Innocenti, Khnopff, Kienerk, La Touche, Lavery, Le Sidaner, Lionne, Longoni, Morbelli, Noci, Nomellini, Previati, Raffaëlli, Rodin, Roll, Van Rysselberghe, Sargent, Signac, Von Stuck, Verster, Vrubel, Vuillard, Witsen.

1908

Fry writes in defence of Cézanne to *Burlington Magazine*.

EXHIBITIONS
Feb. Walker's Gallery, *Yeats*.
Feb. Baillie Gallery, *Bevan*.
Spring NEAC, inc: Gore, A. John, G. John, Nicholson, Orpen, L. Pissarro, Rothenstein, Sargent, Sickert, Steer.
May onwards RA, inc: Clausen, Dagnan-Bouveret, Forbes, Hornel, La Thangue, Orpen, Sargent, E. Stott.
June Goupil, *Lavery*.
June–July Baillie Gallery, Friday Club, inc: Bell.
June Pastel Society, inc: Besnard, Le Sidaner.
July Allied Artists Association, 1st exh. inc: Bell, Bevan, Fergusson, Gilman, Ginner, Gore, Harrison, Innes, Lamb, Lavery, O'Conor, L. Pissarro, Raffaëlli, T. Roussel, Russel, Sickert, Steer.
International Society, inc: Anquetin, Blanche, Bonnard, Carrière, Cézanne, Claus, Cottet, Cross, Degas, Denis, Forain, Gauguin, Van Gogh, Lavery, Le Sidaner, Matisse, Monet, Nicholson,

Orpen, Renoir, Rodin, K.-X. Roussel, Signac, Simon, Vallotton, Vuillard.
Franco-British Exhibition, British Section, inc: Clausen, Fergusson, Forbes, Guthrie, Henry, Hornel, La Thangue, Lavery, Orpen, Osborne, Rothenstein, Sargent, Steer, E. Stott; French Section, inc: Adler, Aman-Jean, Bastien-Lepage, Béraud, Besnard, Blanche, Carrière, Cazin, Chabas, Cottet, Dagnan-Bouveret, Denis, Fantin-Latour, La Touche, Le Sidaner, Maignan, Manet, Martin, Monet, Moreau, C. Pissarro, Puvis de Chavannes, Raffaëlli, Renoir, Roll, Simon.
Oct. Baillie Gallery, inc: Conder, Fergusson, Gilman, Hornel, Monticelli, L. Pissarro, Sickert.
Glasgow, Feb.–May Institute, inc: Guthrie, E. Stott.
Liverpool, autumn Walker, AG, inc: Blanche, Guthrie, Helleu, Hornel, La Thangue, Lavery, Le Sidaner, Rodin, Rothenstein, Sargent, Steer, E. Stott.

1908

Soffici, article on Cézanne in *La Voce*, June.
Pica, *Gli Impressionisti francesi*, publ.
The Duchess Bevilacqua La Masa leaves the Ca' Pesaro in Venice for exhibitions by 'youths, students and the poor who are normally excluded from the official exhibitions'. First exh. July–Sept.

EXHIBITIONS
Faenza 1 Biennale Romagnola d'Arte, inc: Nomellini, Previati.
Rome, Feb.–June LXXVII Esposizione della Società di Amatori e Cultori di BB.AA., inc: Balla, Grubicy, Lionne, Morbelli, Noci, Previati.
Graphics inc: Besnard, Carrière, Cassatt, Cottet, Denis, Ensor, Fantin-Latour, Helleu, Khnopff, Liebermann, Munch, Raffaëlli, Renoir, Van Rysselberghe, Toulouse-Lautrec, Whistler.

1908

Concerts at Libre Esthétique, inc: *Festival Vincent d'Indy*.

EXHIBITIONS
Amsterdam C. M. Van Gogh, *Van Gogh*.
Brussels, spring 15th Libre Esthétique, *Salon jubilaire*, catalogue preface by O. Maus; exh. inc: Besnard, Bonnard, Cassatt, Claus, Cross, Degas, Denis, Ensor, Finch, Guillaumin, Khnopff, Luce, Mellery, Monet, Raffaëlli, Renoir, Rodin, Roussel, Sérusier, Signac, Toorop, Vallotton, Van de Velde, Van Rysselberghe, Vuillard.

1909

21 Oct., 1st issue of *The Art News* (ends 9 April 1912), official organ of Allied Artists Association (AAA).

EXHIBITIONS
April Carfax Gallery, *Fry*.
April–May Grafton Galleries, inc: A. John, Lavery, Nicholson, Orpen.
April–May Goupil, *Steer*.
May onwards RA, inc: Clausen, Forbes, Henry, La Thangue, Sargent, E. Stott.
May–June Leicester Galleries, *Clausen*.
June NEAC, inc: Bell, Gore, A. John, Lamb, Nicholson, Orpen, L. Pissarro, Rothenstein, Sargent, Sickert, Steer.
July AAA, inc: Bevan, Fergusson, Gilman, Gore, A. John, Kandinsky, Nicholson, Orpen, T. Roussel, Russell, Sickert, Yeats.
International Society, inc: Anquetin, Blanche, Conder, Cottet, Denis, Forain, Van Gogh, Hornel, A. John, Lavery,

Le Sidaner, Maillol, Manet, Monet, Nicholson, Orpen, Rodin, Rothenstein, Segantini, Yeats.
Winter NEAC, inc: Blanche, Gilman, Gore, Grant, A. John, G. John, Lamb, Nicholson, Orpen, L. Pissarro, Sargent, Sickert, Steer.
Winter RA, McCulloch Collection, inc: Bastien-Lepage, Clausen, Dagnan-Bouveret, Forbes, Hornel, La Thangue, Lavery, Orpen, Osborne, Rodin, Sargent, E. Stott, Whistler.
Glasgow, Feb.–May Institute, inc: Guthrie, Monticelli, Nicholson.
Liverpool, autumn Walker AG, inc: Blanche, Clausen, Forbes, Guthrie, Henry, Hornel, Khnopff, Lavery, Le Sidaner, Orpen, Raffaëlli, Rodin, Rothenstein, Roussel, Sargent, Sickert, E. Stott.

1909

F. T. Marinetti, 'The Founding and Manifesto of Futurism', *Le Figaro*, Feb.
Soffici, 'L'Impressionismo e la Pittura italiana', *La Voce*, March.

EXHIBITIONS
Rome LXXIX Esposizione della Società di Amatori e Cultori di BB.AA., inc: Balla, Lionne, Morbelli, Nomellini, Previati.
Venice, April–Oct. VIII Esposizione Internazionale della Città di Venezia, inc: Besnard, Claus, Dauchez, Ensor, Fergusson, Grubicy, Guthrie, Helleu, Henry, Innocenti (separate show), Khnopff, Lavery, Liebermann, Lionne, Longoni, Nicholson, Noci, Nomellini, Pellizza (separate show), Previati, Raffaëlli, Rodin, Rothenstein, Sargent, Von Stuck, Tuke, Whistler.

1909

Four concerts at Libre Esthétique, inc: R. Strauss.

EXHIBITIONS
Amsterdam Larensche Kunsthandel, *Toorop*.
Brussels, spring 16th Libre Esthétique, *Portraits et figures*, catalogue preface by O. Maus; exh. inc: Bonnard, Cazin, Claus, Cross, Denis, Helleu, Khnopff, Redon, Renoir, Van Rysselberghe, Signac, Vuillard.

1910

Four concerts at Libre Esthétique.

EXHIBITIONS
Brussels, spring 17th Libre Esthétique, *L'Evolution du paysage*, catalogue preface by O. Maus; exh. inc: Camoin, Cazin, Claus, Corot, Courbet, Cross, Daubigny, Diaz, Dupré, Finch, Gauguin, Van Gogh, Guillaumin, Jongkind, Khnopff, Marquet, Matisse, Monet, C. Pissarro, Renoir, Rodin, Roussel, Van Rysselberghe, Seurat, Signac, Sisley, Vogels, Vuillard.
Rotterdam Kunstkring, *Breitner*.

1910

M. Denis, 'Cézanne', *Burlington Magazine*, Jan.–Feb., (Fry's translation of Denis article originally publ. in *L'Occident*, Sept. 1907).
T. Duret, *Manet and the French Impressionists*, English edn.
Nov., F. Rutter, *Revolution in Modern Art*, publ.

Nov., R. Mayer Reifstahl, 'Vincent Van Gogh', *Burlington Magazine*.

EXHIBITIONS
Jan. Carfax Gallery, *Conder*.
Jan. Arts and Crafts Exhibition Society, inc: L. Pissarro.
[continued on page 297]

1910

Manifesto of the Futurist Painters, signed by Balla, Boccioni, Carrà, Russolo, Severini, *et al.*, publ. Feb.
'The Technical Manifesto of Futurist Painting' (signed by Balla, Boccioni, Carrà, Russolo, Severini, *et al.*), *Poesia*, April.
[continued on page 297]

France

Germany

1910

Herwarth Walden founds *Der Sturm* (review) in Berlin.
Berlin Secession jury rejects work by 27 artists, inc. Die Brücke; New Secession founded in protest.

EXHIBITIONS
Berlin, spring Secession XX, inc: Cézanne, Corinth, Feininger, Van Gogh, Hodler, Hofmann, Liebermann, Maillol, Manet, Matisse, Monet, Munch, Renoir, Slevogt, Uhde.
Berlin, winter Secession XXI, *Graphics*, inc: Bonnard, Corinth, Degas, Feininger, Hodler, Klimt, Liebermann, Manet, Munch, Renoir, Slevogt.
Berlin, Oct.–Nov. Cassirer, *Van Gogh.*

Düsseldorf, July–Oct. *Sonderbund Westdeutscher Künstler*, inc: Bonnard, Braque, Camoin, Cross, Denis, Derain, Jawlensky, Kandinsky, Kirchner, Liebermann, Maillol, Matisse, Nolde, Pechstein, Picasso, Roussel, Schmidt-Rottluff, Signac, Van de Velde, Vuillard.
Leipzig, Oct.–Nov. *Ausstellung Französischer Kunst des 18, 19 und 20 Jahrhunderts*, inc: Bonnard, Carrière, Cézanne, Courbet, Denis, Gauguin, Manet, Matisse, Monet, Monticelli, Puvis de Chavannes, H. Rousseau, Signac.
Munich, summer Secession, inc: Corinth, Modersohn, Von Stuck.
Munich, Sept. Neue Künstlervereinigung II, inc: Braque, Derain, Jawlensky, Kandinsky, Picasso.

1911

Der Blaue Reiter formed as a breakaway group from the Neue Künstlervereinigung.

EXHIBITIONS
Berlin, Jan.–Feb. Cassirer, exh. inc: Braque, Derain, Jawlensky, Kandinsky, Picasso.
Berlin, March Cassirer, exh. inc: Cézanne, Courbet, Degas, Hodler, Uhde.
Berlin, spring Secession XXII, inc: Braque, Corinth, Derain, Feininger, Hodler, Liebermann, Picasso, Van Rysselberghe, Slevogt, Uhde.
Berlin, Oct.–Nov. Cassirer, *Hodler.*

Berlin, winter Secession XXIII, *Graphics*, inc: Cézanne, Corinth, Derain, Feininger, Gauguin, Hofmann, Liebermann, Redon, Renoir, Rodin, Signac, Slevogt, Uhde.
Cologne, Oct. Wallraf Richartz Museum, *Kunst Unserer Zeit*, inc: Amiet, Böcklin, Degas, Derain, Gauguin, Hodler, Kandinsky, Liebermann, Maillol, Rodin, Sérusier, Slevogt, Von Stuck, Toorop, Uhde.
Munich, winter Thannhäuser Gallery, 1st Blaue Reiter exh., inc: Kandinsky, Rousseau.

1912

EXHIBITIONS
Feb. Bernheim Jeune, *Peintres futuristes italiens*, inc: Balla, Boccioni, Carrà, Russolo, Severini.
May Barbazanges, *Quelques artistes indépendants anglais*, organized by Roger Fry, inc: V. Bell, Etchells, Fry, Ginner, Gore, Grant, Lewis.

1912

EXHIBITIONS
Berlin, March–April Der Sturm Gallery, exh. inc: Braque, Derain, Kandinsky, Kirchner, Pechstein, Rousseau.
Berlin, spring Secession XXIV, inc: Corinth, Van Gogh, Hodler, Liebermann, Pechstein, Picasso, Rousseau, Van Rysselberghe, Toorop, Valtat.
Berlin, April Cassirer, *Cézanne.*
Berlin, April–May Der Sturm Gallery, exh. inc: Boccioni, Carrà, Russolo, Severini.
Cologne, May–Sept. Sonderbund Internationale Kunstausstellung, inc: Amiet, Bonnard, Braque, Camoin, Cézanne, Cross, Denis, Derain, Gauguin, Van Gogh, Heckel, Hodler, Jawlensky, Kandinsky, Kirchner, Maillol, Matisse, Modersohn-Becker, Mondrian, Munch, Nolde, Pechstein, Picasso, Schmidt-Rottluff, Vuillard.

Frankfurt, July–Sept. *Die Klassische Malerei Frankreichs im 19 Jahrhunderts*, inc: Cézanne, Courbet, Cross, Degas, Gauguin, Van Gogh, Manet, Monet, Monticelli, Puvis de Chavannes, Renoir, Rodin, K.-X. Roussel, Seurat, Toulouse-Lautrec, Vuillard.
Hagen, ?July Folkwang Museum, *Moderne Kunst*, inc: Bernard, Böcklin, Bonnard, Carrière, Cézanne, Corinth, Courbet, Cross, Degas, Denis, Gauguin, Van Gogh, Heckel, Hodler, Hofmann, Jawlensky, Kandinsky, Kirchner, Liebermann, Maillol, Manet, Matisse, Munch, Nolde, Renoir, Rodin, Van Rysselberghe, Schmidt-Rottluff, Seurat, Signac, Thorn Prikker, Toorop, Toulouse-Lautrec, Vallotton, Van de Velde, Vuillard.
Munich, Feb. Thannhäuser Gallery, *Munch.*

Great Britain and Ireland

1910 (continued)

April–May International Society, inc: Aman-Jean, Besnard, Blanche, Cottet, Denis, Fantin-Latour, Forain, Hornel, Lavery, Le Sidaner, Manet, Maillol, Monet, Nicholson, Orpen, L. Pissarro, Rodin, Sargent, Simon, Vallotton, Vuillard.
May onwards RA, inc: Clausen, Forbes, Henry, La Thangue, Leech, Orpen, Sargent, E. Stott.
May Goupil, *Rothenstein*.
May–June Whitechapel AG, *Twenty Years of British Art*, inc: Clausen, Conder, Forbes, Fry, Gauld, Guthrie, Hornel, A. John, G. John, Lavery, La Thangue, Nicholson, Orpen, T. Roussel, Sargent, Steer, E. Stott; plus Johannesburg Collection, inc: Boldini, Le Sidaner, Monet, Monticelli, C. Pissarro, Puvis de Chavannes, Rodin.
June Alpine Club Gallery, Friday Club, inc: Bell, Grant.

June–July Chenil Gallery, *Nicholson*.
Summer NEAC, inc: Bell, Bevan, Fry, Gilman, Gore, Innes, G. John, Leech, Nicholson, Orpen, L. Pissarro, Sargent, Steer.
July AAA, inc: Bevan, Fergusson, Gilman, Ginner, Gore, Kandinsky, Sickert, Yeats.
Nov. Chenil Galleries, *A. John*.
Winter NEAC, inc: Bevan, Fry, Gilman, Gore, Grant, Innes, Lamb, Nicholson, Orpen, L. Pissarro, Rothenstein, Sargent, Sickert, Steer.
Nov.–Jan. 1911 Grafton Galleries, *Manet and the Post-Impressionists*, organized by Fry, inc: Cézanne, Denis, Derain, Van Gogh, Maignan, Maillol, Manet, Marquet, Matisse, Picasso, Redon, Rouault, Sérusier, Seurat, Signac, Vallotton, Valtat, Vlaminck.

Brighton, June–Aug. Public Art Galleries, *Modern French Artists*, inc: Bastien-Lepage, Bernard, Besnard, Boldini, Bonnard, Carrière, Cézanne, Cottet, Cross, Degas, Denis, Derain, Gauguin, Guillaumin, La Touche, Luce, Martin, Matisse, Monet, Monticelli, Moret, C. Pissarro, Puvis de Chavannes, Redon, Raffaëlli, Renoir, Sérusier, Signac, Simon, Tissot, Vallotton, Valtat, Vlaminck.
Glasgow, Feb.–May Institute, inc: Nicholson, Sargent.
Liverpool Walker AG, inc: Blanche, Guthrie, Hornel, La Touche, Lavery, Le Sidaner, Raffaëlli, Sargent, Simon, E. Stott.

1911

Jan., *The Letters of a Post-Impressionist* (Van Gogh's letters), English edn. C. L. Hind, *Post Impressionists*, publ.
Summer, *Rhythm*, quarterly journal on arts launched by Middleton Murry and Katherine Mansfield. J. D. Fergusson was art editor. *Rhythm* reproduced drawings by Picasso, Cézanne, Derain, Larionov, *et al.* Last issue spring 1913.
'Manifesto of Futurist Painters', *The Art News*, 15 Aug. (signed by Boccioni, Carrà, Russolo, Balla, Severini).

EXHIBITIONS
Jan. Carfax Gallery, *Sickert*.
Jan. Chenil Gallery, *Innes*.
Jan. Baillie Gallery, *Leech*.
Feb. Alpine Club Gallery, Friday Club, inc: Bell, Grant.
March Chenil Gallery, *Gore*.
March Stafford Gallery, *Courbet*.
April–May International Society, inc: Anquetin, Blanche, Bonnard, Cottet, Degas, Denis, Forain, Lavery, Monet, Nicholson, Orpen, X. Pissarro, Rodin, K.-X. Roussel, Vuillard, Yeats.

May onwards RA, inc: Clausen, Dagnan-Bouveret, Forbes, Henry, Lavery, La Thangue, Orpen, Sargent, E. Stott.
June Stafford Gallery, *Sickert*.
June Carfax Gallery, Camden Town Group, 1st exh. inc: Bevan, Gilman, Ginner, Gore, A. John, Lamb, L. Pissarro, Sickert.
July AAA, inc: Bevan, Fergusson, Forbes-Robertson, Gilman, Ginner, Gore, Kandinsky, Lavery, Nevinson, Sickert, Yeats.
July Goupil, *Esperantist Vagabond Club*, inc: Bevan, Fergusson, Ginner, Gilman, Gore.
Chenil Gallery, *A. John*.
Dutch Gallery, *W. Stott*.
Oct. Stafford Gallery, *C. Pissarro*.
Nov. Stafford Gallery, *Cézanne and Gauguin*.
Dec. Carfax Gallery, Camden Town Group, inc: Bevan, Gilman, Ginner, Gore, Grant, Innes, Lamb, L. Pissarro, Sickert.

Winter NEAC, inc: Bevan, Gore, A. John, G. John, Lamb, Orpen, L. Pissarro, Sargent, Sickert, Steer.
Glasgow, Feb.–May Institute, inc: Forbes, Monticelli, Nicholson.
Manchester, winter loan exh. inc: Bevan, Clausen, Conder, Etchells, Fergusson, Fry, Gauguin, Gilman, Ginner, Gore, Hornel, Innes, A. John, G. John, Nicholson, Orpen, Picasso, L. Pissarro, Rodin, Rothenstein, Sargent, Sickert, Steer.
Liverpool, autumn Walker AG, inc: Clausen, Forbes, Hornel, La Touche, Lavery, Le Sidaner, Monticelli, L. Pissarro, Sargent, Steer, E. Stott.

1912

EXHIBITIONS
Jan. Goupil, inc: Denis, Sérusier.
Feb. Alpine Club Gallery, Friday Club, inc: Bell, Grant.
March Stafford Gallery, *Fergusson*.
March Goupil, *Orpen*.
March Sackville Gallery, *Italian Futurist Painters*, inc: Boccioni, Carrà, Russolo, Severini.
April Stafford Gallery, *Picasso*.
April–May International Society, inc: Aman-Jean, Anquetin, Bonnard, Carrière, Cottet, Denis, Forain, Gauguin, Van Gogh, Lavery, Maillol, Manet, Monet, Nicholson, C. Pissarro, Renoir, Rodin, Sargent, Vuillard.

May onwards RA.
May Carfax Gallery, *Sickert*.
Summer NEAC, inc: Nicholson, Orpen, L. Pissarro, Rothenstein, Sargent, Sickert, Steer.
Summer Goupil, inc: Clausen, Conder, A. John, Le Sidaner, Nicholson, Orpen, Steer.
July AAA, inc: Bell, Bevan, Dismorr, Fergusson, Forbes-Robertston, Fry, Gilman, Ginner, Gore, Kandinsky, Leech, L. Pissarro, Yeats.
July–Oct. Tate Gallery, *Whistler*.
Autumn Grosvenor Gallery, Arts and Crafts Exhibition, inc: L. Pissarro.
Great White City, *The Latin British Exhibition*, inc: Morbelli, Previati, Segantini.

Oct. Stafford Gallery, inc: Dismorr, Fergusson.
Oct.–Nov. Leicester Galleries, *Clausen*.
Oct.–Jan. 1913 Grafton Galleries, *2nd Post-Impressionist Exhibition*, inc: Bell, Bonnard, Braque, Cézanne, Derain, Etchells, Fry, Gore, Grant, Lamb, Matisse, Picasso, Spencer, Vlaminck.
Winter NEAC, inc: Blanche, Innes, A. John, Orpen, L. Pissarro, Rothenstein, Sickert, Steer.
Dec. Carfax Gallery, Camden Town Group, inc: Bevan, Gilman, Ginner, Gore, Lamb, L. Pissarro, Sickert.
Liverpool, autumn Walker AG, inc: Lavery, Orpen.

Italy

1910 (continued)

Marinetti, *Marfarka Il Futurista*, publ. Segantini, *Scritti e Lettere*, publ. in German and Italian edns.

EXHIBITIONS
Florence Lyceum, exh. inc: Cézanne, Degas, Gauguin, Van Gogh, Monet, C. Pissarro, Renoir.
Milan, Jan.–Feb. Palazzo della Società per le BB.AA., *Previati*.
Venice, spring Ca' Pesaro, IV Esposizione, *Rossi*.
Venice, summer Ca' Pesaro, *Boccioni*.
Venice, summer IX Esposizione Internazionale d'Arte della Città di Venezia, inc: Corinth, Cottet, Courbet (separate show), Ensor, Grubicy, Innocenti, Klimt, Liebermann, Lionne, Morbelli, Noci, Nolde, Nomellini, Raffaëlli, Renoir (separate show), Roll, Sargent, E. Stott, Von Stuck, Vogeler.

1911

Segantini Museum opened at St Moritz, with donations from A. Grubicy and Gottfried Keller Trust.

EXHIBITIONS
Milan, April–May Sale Ricordi, Esposizione d'Arte Libera, inc: Boccioni, Carrà, Russolo.
Rome Palazzo delle BB.AA., Esposizione Internazionale di BB.AA., inc: Adler, Amiet, Bakst, Balla, Béraud, Besnard, Blanche, Bonnard, Breitner, Cassatt, Cazin, Chabas, Claus, Clausen, Conder, Corinth, Cottet, Dagnan-Bouveret, Dauchez, Ensor, Forbes, Fry, Grabar, Guthrie, Harrison, Helleu, Henry, Hodler, Hofmann, Ibels, A. John, Klimt, La Thangue, La Touche, Laurent, Lavery, Le Sidaner, Liebermann, Lionne, Mackensen, Malyavin, Monet, Morbelli, Nicholson, Nomellini, Orpen, Osbert, Renoir, Rodin, Roll, Rothenstein, Sargent, Serov, Signac, Von Stuck, Vallotton, Vernier, Vogeler, Vuillard.
Venice, spring Ca' Pesaro, VI Esposizione, *Rossi*.

1912

Boccioni, 'The Technical Manifesto of Futurist Sculpture', *Poesia*, April.

EXHIBITIONS
Venice, April–Oct. X Esposizione Internazionale della Città di Venezia, inc: Blanche, Boldini, Claus, Fergusson, Fry, Innocenti, Khnopff, Kiernerk, La Thangue, La Touche, Leech, Lionne, Longoni, Morbelli, Noci, Nomellini, Previati, Rodin, Sickert, Van Rysselberghe.

Select Bibliography

*with comprehensive bibliography

GENERAL

Bénédite, L., *Great Painters of the XIXth Century and their Paintings*, London 1910

Čelebonović, A., *The Heyday of Salon Painting*, London 1974

Chicago, Art Institute, *Art Nouveau, France, Belgium*, 1976

Gordon, D. L., *Modern Art Exhibitions*, Munich 1974

Hamilton, G. H., *Painting and Sculpture in Europe, 1880–1940*, London 1967

Herbert, E. W., *The Artist and Social Reform, France and Belgium, 1885–1898*, New Haven 1961

Hoffmann, W., *The Earthly Paradise, Art in the 19th Century*, London 1961

Hofstätter, H. H., *Symbolismus and die Kunst der Jahrhundertende*, Cologne 1965

London, Royal Academy of Arts, *Impressionism, its Masters, its Precursors and its Influence in Britain*, catalogue by J. House, 1974

Madsen, S. T., *Sources of Art Nouveau*, Oslo 1956

Meier-Graefe, J., *Modern Art*, London 1908

Munich, Haus der Kunst, *Weltkulturen und moderne Kunst*, 1974

Muther, R., *The History of Modern Painting*, London 1896 and new edn 1907

New York, Guggenheim Museum, *Neo-Impressionism*, catalogue by R. L. Herbert, 1968

*Paris, Grand Palais, *Le Symbolisme en Europe*, 1976

Philadelphia, Museum of Art, *From Realism to Symbolism, Whistler and his World*, 1971

Rosenblum, R., *Modern Painting and the Northern Romantic Tradition*, London 1975

FRANCE

*Barr, A. H., *Matisse, His Art and His Public*, New York 1951, and reprinted

Blanche, J. E., *Les Arts plastiques, La IIIe République, de 1870 à nos jours*, Paris 1931

Cézanne, P., *Correspondance*, Paris 1978

*Cleveland, Museum of Art, etc., *Japonisme, Japanese Influence on French Art, 1854–1910*, 1975

Delouche, D., *Peintres de la Bretagne, Découverte d'une province*, Rennes 1977

Denis, M., *Journal*, Paris 1957–9

—, *Théories, Du Symbolisme au classicisme*, Paris 1964

Doran, P. M., *Conversations avec Cézanne*, Paris 1978

*Duthuit, G., *The Fauvist Painters*, New York 1950

Duval, E. L., *Téodor de Wyzéwa, a Critic without a Country*, Geneva and Paris 1961

*Elderfield, J., *The 'Wild Beasts', Fauvism and Its Affinities*, New York 1976

Fénéon, F., *Oeuvres plus que complètes*, Paris 1970

Francastel, P., *L'Impressionnisme*, Paris 1937, and reprinted 1974

Gauguin, P., *Lettres à sa femme et à ses amis*, Paris 1946

—, *Oviri, Ecrits d'un sauvage*, Paris 1974

Van Gogh, *The Complete Letters of Vincent Van Gogh*, London 1958

*Jaworska, W., *Gauguin et l'école de Pont-Aven*, Paris 1971, English translation 1972

Lehmann, A. G., *The Symbolist Aesthetic in France, 1885–1895*, Oxford 1968

*London, Hayward Gallery, *French Symbolist Painters*, 1972

London, Tate Gallery, *Gauguin and the Pont-Aven Group*, 1966

Lovgren, S., *The Genesis of Modernism*, Stockholm 1959

Matisse, H., *Ecrits et propos sur l'art*, Paris 1972

*Mauner, G., *The Nabis, Their History and Their Art, 1888–1896*, New York and London 1978

*Pincus-Witten, R., *Occult Symbolism in France, Josephin Péladan and the Salons de la Rose + Croix*, New York and London 1976

Pissarro, C., *Lettres à son fils Lucien*, Paris 1950

Redon, O., *Lettres d'Odilon Redon*, Brussels and Paris 1923

—, *A soi-même*, Paris 1961

*Rewald, J., *The History of Impressionism*, London and New York 1973

*—, *Post-Impressionism*, New York and London 1978

Rey, R., *La Renaissance du sentiment classique*, Paris 1931

Rookmaaker, H. R., *Gauguin and 19th Century Art Theory*, Amsterdam 1972

Roskill, M., *Van Gogh, Gauguin and the Impressionist Circle*, London 1970

Rubin, W., *Cézanne, The Late Work*, New York and London 1978

*Shattuck, R., *The Banquet Years*, London 1959

Signac, P., *D'Eugène Delacroix au néo-impressionnisme*, Paris 1899, and reprinted 1964

—, 'Extraits du journal inédit', *Gazette des Beaux-Arts*, 36 (1949), 39 (1952), 42 (1953)

Sutter, J., *The Neo-Impressionists*, London 1970

Venturi, L., *Les Archives de l'Impressionnisme*, Paris 1939

Vollard, A., *Souvenirs d'un marchand de tableaux*, Paris 1937

Webster, J. C., 'The Technique of Impressionism', *College Art Journal*, November 1944

Woolley, G., *Richard Wagner et le symbolisme français*, Paris 1931

GERMANY, NORWAY AND SWITZERLAND

*Berend-Corinth, C., *Die Gemälde von Lovis Corinth, Werkcatalog*, Munich 1958

Burger, F., *Cézanne und Hodler*, Munich 1913

Cologne, Wallraf Richartz Museum, *Lovis Corinth: Gemälde, Aquarelle, Zeichnungen und druckgraphische Zyklen*, 1976

Darmstadt, *Ein Dokument Deutscher Kunst 1901–76: Akademie, Sezession, Avant-garde*, 1976

Dresdner, A., *Der Weg der Kunst*, Jena and Leipzig 1904

*Finke, U., *German Painting from Romanticism to Expressionism*, London 1974

Hamann, R., and J. Hermand, *Naturalismus*, Berlin 1968

—, *Stilkunst bis 1900*, Berlin 1968

Langaard, I., *Edvard Munch, modningsär*, Oslo 1960

Perry, G., *Paula Modersohn-Becker: Her Life and Work*, London 1979

Rilke, R. M., *Worpswede Monographie*, Bielefeld and Leipzig 1903

*Selz, P., *Ferdinand Hodler*, Berkeley, University Art Museum 1972

*—, *German Expressionist Painting*, Berkeley 1957

Stuttmann, F., *Max Liebermann*, Hanover 1961

*Voss, H., *Franz von Stuck 1863–1928, Werkcatalog der Gemälde*, Munich 1973

*Washington, National Gallery, *Edvard Munch: Symbolic Images*, 1978 (including essays by R. Rosenblum and A. Eggum)

GREAT BRITAIN AND IRELAND

*Arts Council of Great Britain, *James McNeill Whistler*, catalogue by A. McLaren Young, 1960

—, *Decade 1910–1920*, catalogue by A. Bowness, 1965

—, *Decade 1890–1900*, catalogue by A. Bowness and B. Laughton, 1967

—, *Stanley Spencer 1891–1959*, catalogue by D. Robinson *et al.*, 1976

*Baron, W., *Sickert*, London 1973

*—, *The Camden Town Group*, London 1979

Bradford, Art Gallery, *Sir William Rothenstein 1872–1945: a centenary exhibition*, 1972

Cooper, D., *The Courtauld Collection*, London 1954

*Cork, R., *Vorticism and Abstract Art in the First Machine Age: 1. Origins and Development*, 1975; *2. Synthesis and Decline*, 1976

*Farr, D., *English Art 1870–1940*, Oxford 1979

*Irwin, D. and F., *Scottish Painters at Home and Abroad 1700–1900*, London 1975

*Laughton, B., *Philip Wilson Steer*, Oxford 1971

—, 'The British and American Contribution to Les XX 1884–1893', *Apollo*, November 1967, pp. 186–97

Leeds, Art Galleries, *John Singer Sargent and the Edwardian Age*, catalogue by J. Lomax and R. Ormond, 1979

London, Fine Art Society, *Sickert*, catalogue by W. Baron, 1973

—, *J. D. Fergusson 1874–1961*, catalogue by R. Billcliffe, 1974

London, Tate Gallery, *Modern British Paintings, Drawings and Sculpture*, 2 vols, catalogue by M. Chamot, D. Farr and M. Butlin, 1964

National Museum of Wales, *Augustus John Studies*

for Compositions, catalogue by A. D. Fraser
 Jenkins, 1978
Nicolson, B., 'Post Impressionism and Roger
 Fry', The Burlington Magazine, January 1951,
 pp. 11–15
Ormond, R., John Singer Sargent: Paintings,
 Drawings, Watercolours, London 1970
Rothenstein, J., Modern English Painters, 2 vols,
 London 1976
Rothenstein, W., Men and Memories, London
 1931–2 (revised edn, ed. M. Lago, 1978)
Scottish Arts Council, The Glasgow Boys –
 1880–1900, 2 parts, 1968
*Shone, R., Bloomsbury Portraits: Vanessa Bell,
 Duncan Grant and their Circle, London 1976
—, 'The Friday Club', The Burlington Magazine,
 May 1975, pp. 279–84
Spalding, F., Roger Fry: Art and Life, London 1980
Sutton, D., Nocturne – The Art of James McNeill
 Whistler, London 1963

ITALY
Baldini, U., et al., Pittori Toscani del Novecento,
 Florence 1978
Ballo, G., Preistoria del Futurismo, Milan 1964
*Barocchi, P., Testimonianze e Polemiche figurative
 in Italia dal Divisionismo al Novecento, Messina
 and Florence 1974
Bellonzi, F., Il Divisionismo nella Pittura italiana,
 Milan 1967
—, Architettura, Pittura, Scultura, dal
 Neoclassicismo al Liberty, Rome 1978
*Bellonzi, F., and T. Fiori, Archivi del Divisionismo,
 2 vols, Rome 1968, henceforth AD; an
 appendix which will update and add material
 to these volumes is in preparation. It already
 includes an extensive bibliography.
Caramel, L., and C. Pirovano, Musei e Gallerie di
 Milano. Galleria d'Arte Moderna. Padiglione
 dell'Arte Contemporanea. Raccolta Grassi,
 Milan 1973
*—, Musei e Gallerie di Milano. Galleria d'Arte
 Moderna. Opere dell'Ottocento, Milan 1975
Comanducci, A. M., Dizionario illustrato dei Pittori,
 Disegnatori e Incisori italiani, 5 vols, Milan
 1970
Drudi Gambillo, M., and T. Fiori, Archivi del
 Futurismo, Rome 1958 (vol. 1), 1962 (vol. 2)
Ferrara, Palazzo dei Diamanti, Gaetano Previati.
 Mostra Antologica, catalogue by P. Bucarelli,
 F. Bellonzi, M. Calvesi and R. Barilli, 1969
Grubicy, V., 'Tecnica e Estetica divisionista', La
 Triennale, no. 14–15, 1896 reprinted AD,
 vol. 1, pp. 98–100
—, Tendenze evolutive delle Arti plastiche, Milan
 1891
Hyogo (Japan), Museum of Modern Art, Giovanni
 Segantini, 1978 and subsequently to Milan,
 Palazzo Permanente
Livorno, Villa Fabbricotti, and Florence, Palazzo

Strozzi, Mostra di Plinio Nomellini, catalogue
 by C. L. Ragghianti et al., 1966
Longhi, R., preface to J. Rewald's Storia
 dell'Impressionismo, Florence 1949,
 pp. VII–XXIX
*Maltese, C., Storia dell'Arte italiana 1785–1943,
 Turin 1960
Martinelli, G., 'La Critica a Venezia', Arte
 Illustrata, June 1895
—, 'All'Esposizione di Torino', Emporium, June
 1896, pp. 445–60
*Milan, Palazzo Permanente, Mostra del
 Divisionismo italiano, catalogue by E. Bairati
 et al., 1970
—, Arte e Società in Italia dal Realismo al
 Simbolismo 1865–1915, 1979
Milan, Palazzo Reale, Boccioni e il Suo Tempo,
 catalogue by G. Ballo, F. Russoli and
 L. De Maria, 1973
*Monteverdi, M., Storia della Pittura italiana
 dell'Ottocento, 3 vols, Milan 1975
Mucchi, A. M., 'Il Divisionismo', L'Arte
 all'Esposizione del 1898, Turin 1898,
 pp. 171–4
Pagani, S., La Pittura lombarda della Scapigliatura,
 Milan 1955
Paoletti, S. D., 'Nota sul Divisionismo', La IV
 Esposizione Internazionale a Venezia, 1901,
 Trento 1901 (publ. as extract from L'Alto
 Adige, Trento)
Perocco, G., Le Origini dell'Arte Moderna a Venezia
 1908–1920, Treviso 1972 (first publ. as
 Artisti del Primo Novecento italiano, Turin
 1965)
Pica, V., L'Arte europea a Venezia, Naples 1895
—, 'L'Arte europea a Firenze. G. Segantini e i
 Pittori lombardi', Marzocco, 18 April 1897
*Piceni, E., and M. Monteverdi, La Pittura
 Lombarda dell'Ottocento, Milan 1969
Previati, G., Principi scientifici del Divisionismo. La
 Tecnica della Pittura, Turin 1906
Quinsac, A. P., 'Le Divisionnisme en Italie: un
 Mouvement difficile à cerner', L'Information
 de l'Histoire de l'Art, no. 2, 1969
*—, La Peinture divisionniste italienne: origines et
 premiers développements, 1880–1895, Paris
 1972
*—, Giovanni Segantini. Catalogue Raisonné.
 Publication is planned by the
 Schweizerisches Institut für
 Kunstwissenschaft by July 1980
Rome, Galleria Nazionale d'Arte Moderna,
 Giacomo Balla, 1971
Soffici, A., 'L'Impressionismo e la Pittura italiana',
 La Voce, March 1909, reprinted in P. Barocchi
 1974, pp. 207–15
Tumiati, D., 'Divisionismo. Tre Artisti. Segantini,
 Pellizza da Volpedo, Morbelli', Marzocco,
 February 1896
Venice, XXVI Esposizione internazionale d'Arte,

Il Divisionismo italiano, introduction by
 M. Valsecchi, 1952
Venice, Sala Napoleonica, Primi Espositori di Ca'
 Pesaro, catalogue by G. Perocco, 1958

THE LOW COUNTRIES
Braet, H., L'Accueil fait au Symbolisme en Belgique,
 1885–1900, Brussels 1967
Brussels, Musées Royaux des Beaux-Arts de
 Belgique, Le Groupe des XX et son temps, 1962
—, Les Jeux de la lumière dans la peinture belge: de
 Boulenger à Rik Wouters 1965
—, Peintres belges: Lumière française, 1969
Colmjon, G., De Haagse School, Leiden 1950
Gans, L., Nieuwe Kunst. De Nederlandse bijdrage tot
 de Art Nouveau, Utrecht 1966
*Ghent, Museum voor Schone Kunsten,
 Rétrospective Théo van Rysselberghe 1962
The Hague, Gemeentemuseum, Licht door Kleur:
 Nederlandse Luministen, 1976
—, Kunstenaren der Idee. Symbolistische Tendensen
 in Nederland, c. 1880–1930, 1978
Hammacher, A. M., Amsterdamsche
 Impressionisten en hun kring, Amsterdam
 1941
Hyslop, F. E. (ed.), Henri Evenepoel à Paris: Lettres
 choisies, Brussels 1972
Hyslop, F. E., Henri Evenepoel: Belgian Painter in
 Paris, 1892–1899, University Park,
 Pennsylvania 1975
James, M. S., 'Mondrian and the Dutch
 Symbolists', Art Journal, No. XXIII, 1963–4
Joostens, J., 'Henry van de Velde en Nederland,
 1892–1902, Belgische Art Nouveau en
 Nederlandse Nieuwe Kunst', Cahiers Henry
 van de Velde, nos 12–13, 1974
Laughton, B., 'The British and American
 Contribution to Les XX, 1884–1893', Apollo,
 November 1967
*Legrand, F.-C., Symbolism in Belgium, Brussels
 1972
Loojes-Terpstra, A. B., Moderne Kunst in Nederland
 1900–1914, Utrecht 1959
Mathews, A. J., 'La Wallonie', 1886–1892: The
 Symbolist Movement in Belgium, New York
 1947
Maus, M.-O., Trente années de lutte pour l'art:
 1884–1914, Brussels 1926
Maus, O., Fonds Octave Maus, Bibliothèque
 Royale, Brussels
Otten, M., Albert Mockel: Esthétique du Symbolisme,
 Brussels 1962
*Paris, Institut Néerlandais, Jan Toorop,
 1858–1928: Impressionniste, Symboliste,
 Pointilliste, 1977 (revised, Otterlo,
 Rijksmuseum Kröller-Müller, J. Th. Toorop.
 De Jaren 1885 tot 1910, 1978–9)
*Pollak, B., Het Fin de Siècle in de Nederlandse
 Schilderkunst. De Symbolistische beweging.
 1890–1900, Utrecht 1955

Acknowledgments

The Selection Committee for the exhibition would like to thank
the following individuals, in addition to the lenders, who contributed
in many different ways to the organization of the exhibition
and the preparation of the catalogue.

William R. Acquavella
Mme Hélène Adhémar
Dott.ssa Alberici
Ronald Alley
Clément Altarriba
Mlle F. Amanieux
F. X. Amprimoz
Julian Andrews
Mlle M. E. Anquetil
Colin Anson
Jan Askeland
Colette Audibert
Dr Gunter Aust
Richard Auty

Mlle R. Bacou
Signorine Elisa and
 Luce Balla
Dr Wendy Baron
Ilse Bartlett
Timothy Bathurst
Dr F. Baumann
Dr W. A. L. Beeren
Dr W. Bell
Prof. F. Bellonzi
Knut Berg
F. Bergot
Dr T. Berlage
John G. Bernasconi
Miss Valerie Beston
Mrs Robert Bevan
Signora
 M. V. Biganzoli Morbelli
Dr Erica Billeter
Mlle Irène Bizot
Eileen Black
Mme Blatas
Alf Bøe
M. Boisgirard
Luc Boissonas
Dr Gerhard Bott
Richard J. Boyle
Jurgen Brasche
Hugh Brigstocke
J. Carter Brown
Dr David Brown
Miss Lillian Browse
Dr G. Busch

Mme A. Cacan de Bissy
Mme Françoise Cachin
Jean K. Cadogan
Anthea Callen
Julian Campbell
Arch. L. Cambellotti
Dr Peter Cannon-Brookes
Avv. G. Caponetto
André Cariou
Dott. M. Carrà
Bernard Ceysson
Lawrence Chalmers
Bruce W. Chambers
Mme
 M.-J. Chartrain-Hebbelinck
Francis W. Cheetham
Dott.ssa M. Cinotti
Timothy Clifford
Miss Angela Coles
B. Collingwood Stevenson
Mlle Isabelle Compin

Frank Constantine
Avv. F. Conti
Lynne Cooke
Jean Coquelet
Nigel Corbally-Stourton
Desmond Corcoran
Signora and
 Ing. F. Cosmelli
Denis Coutagne
Verv. Lili Couvée
Dr Frederick J. Cummings
Ing. Curti
Caroline Cuthbert

William Darby
Carlos Baptista da Silva
Richard Day
Mlle Catherine de Croës
Prof. Giorgio de Marchis
Dominique Denis
Mlle Claire Denis
Gerald Deslandes
Dott. R. de Tieri
Jean Devoisins
E. de Wilde
Anthony d'Offay
Miss Anne Donald
Douglas Druick
Charles Durand-Ruel

Paul Eeckhout
Christoph Eggenberger
John Elderfield
Dr Lindsay Errington

Prof. M. Fagiolo dell'Arco
Everett Fahy
Dennis Farr
Signora and
 Prof. D. Faucci
Dr Walter Feilchenfeldt
Mlle Catherine Ferbos
Avv. F. Ferraris
Wolfgang Fischer
Mme Jacqueline Fontseré
Jean Forneris
Signora
 G. Franchini Severini
A. D. Fraser Jenkins
Dr Heinz Fuchs

Signora Gandini
Dr Kenneth Garlick
Pierre Gaudibert
Dr Gilberte Gepts
Gerhard Gerkens
Oscar Ghez
Miss Teresa Gleadowe
Dr John Golding
Prof
 Lawrence Gowing, ARA
M. and Mme
 Pierre Granville
Dr Lucius Grisebach
Dr Hans Werner Grohn
Gilbert Gruet
E. M. Gruetzner
Mme S. Guillaume
S. Guillouet

Douglas Hall
Michael Hasenclever
A. G. Hatton
Dr John Hayes
Christoph Heilmann
Prof Robert Herbert
Dr J. Heusinger von Waldegg
E. V. Hickey
Norman Hirschl
Prof Dr Werner Hofman
Dr Dieter Honisch
John Hoole
Martin Hopkinson
Jill House

Prof Michael Jaffé
Esther Jagger
Dr B. Jansen
C. M. J. Joachimides
Flemming Johansen
Mrs Diana L. Johnson
Phillip Johnston
Joop Joostens
Ellen Joostens
Samuel Josefowitz
Dr Mariette Josephus Jitta
Claudie Judrin

Andrea Kerr
Wolfgang Ketterer
Dott.ssa V. Kienerk
Dr Christian Klemm
Dr Rudolf Koella
Dr Peter Krieger

Mme Geneviève Lacambre
Jean Lacambre
Michel Laclotte
Miss Cecily Langdale
Prof. Peter Lasko
P. W. G. Lawson
Thomas P. Lee
Mme
 Francine-Claire Legrand
Mme Nadine Lehni
Guido Lenzi
Dr Helmut Leppien
Michael Levey
Dr Simon Levie
W. Liebermann
Marco Livingstone
Gilbert Lloyd
Dr T. Locher
Guy Loudmer
John Lumley

Jeremy Maas
Yves Mabin
Hugh Macandrew
Mrs Margaret MacDonald
Magne Malmanger
Dott. P. Mantura
Jean-Patrice Marandel
Raffaelle Massarotto
François Mathey
Kenneth McConkey
Ian McKenzie Smith
James McLaughlin
Margaret McLeod
James Meldrum

Prof. L. Menegazzi
Rodney Merrington
Dr Franz Meyer
Henry Meyrick-Hughes
Prof. Hamish Miles
Charles Moffatt
John Morgan
Richard Morphet
Dr Dewey F. Mosby
Alain Mousseigne
John Myerscough

Roald Nasgaard
Friedrich Netzel
Dott. A. Nomellini
Signora F. Nomellini
Hans Edvard
 Nørregard-Nielsen
Dott.ssa C. Nuzzi

Elizabeth Ogborn
Avv. Prof.
 Francesco Ogliari
D. Ojalvo
Richard Ormond
Hervé Oursel
Dr R. Oxenaar
Dott. P. Pacini
Jean Paladilhe
Andrew McIntosh Patrick
C. J. Pearson
Dr Jose de Azeredo Perdigão
Prof Guido Perocco
Dr Hans Albert Peters
Prof. E. Piceni
Godfrey Pilkington
F. Pomarède
Sir John Pope-Hennessy
C. N. P. Powell
Dott.ssa
 M. Precerutti-Garberi
Dott. Lucio Puttin
Dr E. H. Puvogel

Pierre Quarré

Patrick Ramade
Dr Robert Ratcliffe
Prof Stephen Rees-Jones
Sir Norman Reid
Prof. John Rewald
Dr Rickmanm
Joseph Rishel
Miss Antonia Roberts
Philippe Roberts-Jones
Alexander Robertson
Duncan Robinson
David Robson
Dott. G. Romano
Signora M. Romualdi
Mlle Anne Roquebert
Robert Rowe
Angelica Rudenstine
William Rubin
Mr Karl Ruhrberg

Dott. E. Sacerdoti
Françoise Safin-Crahay
Antoine Salomon
Dr. A. Scheidegger

Prof. Dr Ludwig Schreiner
Dott.ssa A. Scotti
Dott.ssa R. Maggio Serra
Brian Sewell
Miss Hsio-Yen Shih
Richard Shone
Dr R. Siebelhof
Peyton Skipwith
David Somerset
Claude Souviron
Dr Frances Spalding
Prof.
 Dr Erich Steingraber
Timothy Stevens
Hugh Stevenson
Quentin Stevenson
Miss Jacqueline Stewart
Michel Strauss
Dr Roy Strong
Dr Charles Stuckey
Martin Summers
Jean Sutherland Boggs
Dr George Szabo

John Tancock
The staff of the
 Tate Gallery Library
Charles Terrasse
W. N. Terry
Eugene V. Thaw
Colin Thompson
Godfrey Thompson
Richard Thomson
Lynne Thornton
Dott.ssa M. Tomea
Nicholas Tooth
Julian Treuherz
Philip Troutman

Dr M. Urban

Dr J. van der Wolk
Auke van der Woud
Dr T. van Velzen
Dott. F. Vercelotti
Marian Verstraeten
Mme Verwimp
Germain Viatte
Jacques Villan
Mlle Vincent
Prof. Dr Paul Vogt
Claudia von Schilling

Leslie Waddington
Victor Waddington
Dr Hugo Wagner
Miss Ethna Waldron
Robert Walker
John Walsh
Geoffrey Watson
Colin Webb
Miss Angela Weight
Claude Whistler
James White
Daniel Wildenstein
Prof. Frank Willett
Arnold Wilson
The staff of the Witt Library

Dr Armin Zweite

Photographic Acknowledgments

The exhibition organizers would like to thank
the following individuals and agencies who
kindly made photographs available. All other photographs
were provided by the owners of the paintings.

ACL, Brussels 392, 396, 400
Arts Council of Great Britain 301
Bulloz 53, 71, 126, 145, 146, 147
A. C. Cooper 202, 224
Cooper-Bridgeman Library 93
Courtauld Institute of Art 235, 321
Prudence Cumming Associates 212, 280
The Fine Art Society Ltd 292, 294, 296,
 316, 345
Giraudon fig. 2, fig. 6, fig. 7, fig. 11, 39,
 51, 66, 75, 186, 187, 220
G. Howald, Berne 34, 91, 167, 170
Mittetfoto, Oslo 266
Harold Morris 298
Photo d'Art Speltdoorn 403
Photo Service T. A. P. Daniel, Liège 393
Rheinisches Bildarchiv 268
Roger-Viollet 127
Service de Documentation
 Photographique de la Réunion des
 Musées Nationaux, Paris 3, 129, 178,
 364

The following artists' works are
copyright © SPADEM 1979:
Adler, Aman-Jean, Anquetin, Béraud,
Bernard, Blanche, Boldini, Bonnard,
Carrà, Claus, Dagnan-Bouveret,
Dauchez, Denis, Ensor, Forain, Heine,
Helleu, Le Sidaner, Luce, Maillol, Martin,
Matisse, Mellery, Picasso, K.-X. Roussel,
Van Rysselberghe, Sérusier, Signac,
Vlaminck, Vuillard.

The following artists' works are
copyright © ADAGP 1979:
Besnard, Bonnard, Braque, Camoin,
Derain, Hayet, Schuffenecker, Severini,
Simon, Valtat.

Index of Artists

The numbers are the page numbers of catalogue entries

The Friends of the Royal Academy

Patron: HRH The Duke of Edinburgh, KG, KT

FRIENDS

Until 31 December 1979

£10 annually or
£7 annually for museum staff,
teachers, pensioners, and young
friends (16–25)

From 1 January 1980

£12.50 annually, or
£10 annually for museum staff
and teachers, or £7 annually
for pensioners and young
friends (16–25)

Gain free and immediate admission to all Royal Academy
Exhibitions with a guest or husband/wife and children under 16.

Obtain catalogues at a reduced price.

Enjoy the privacy of the Friends' Room in Burlington House.

Receive private view invitations to various exhibitions including the
Summer Exhibition.

Have access to the library and historical archives.

Benefit from other special arrangements, such as lectures and tours.

ARTIST SUBSCRIBERS

Until 31 December 1979

£17.50 annually

From 1 January 1980

£22.50 annually

Receive all the privileges shown above.

Receive free submission forms for the Summer Exhibition.

Obtain art materials at a reduced price.

Obtain constructive help where the experience of the Royal
Academy could be of assistance.

SPONSORS

£500 (corporate)
£100 (individual)
annually

Receive all the privileges offered to Friends.

Enjoy the particular privileges of reserving the Royal Academy's
private rooms when appropriate and similarly of arranging evening
viewings of certain exhibitions.

Receive acknowledgement through the inclusion of the Sponsor's
name on official documents.

BENEFACTORS

£1,000 or more

An involvement with the Royal Academy which will be honoured in
every way.

Further information is available from The Secretary, The Friends of
the Royal Academy.

BENEFACTORS

Mrs Hilda Benham
Mrs Keith Bromley
The John S. Cohen Foundation
The Colby Trust
The Lady Gibson
Mrs Mary Graves
Sir Antony Hornby
The Landmark Trust
The Trustees of the Leach Fourteenth
 Trust
Hugh Leggatt, Esq.
Sir Jack Lyons, CBE
The Manor Charitable Trustees
The Lord Moyne
Mrs Sylvia Mulcahy
G. R. Nicholas, Esq.
Lieutenant-Colonel Vincent Paravicini
Mrs Vincent Paravicini
Phillips Fine Art Auctioneers
Mrs Basil Samuel
The Revd Prebendary E. F. Shotter
Keith Showering, Esq.
Dr Francis Singer
Lady Daphne Straight
Harry Teacher, Esq.
Henry Vyner Charitable Trust
Charles Wollaston, Esq.

CORPORATE SPONSORS

Barclays Bank International Limited
The British Petroleum Company Limited
Christie Manson and Woods Limited
Courage Limited
Courtaulds Limited
Debenhams Limited
The Delta Metal Company Limited
Ford of Europe Incorporated
The Worshipful Company of Goldsmiths
The Granada Group
Arthur Guinness Son and Company
 (Park Royal) Limited
Guinness Peat Group
House of Fraser Limited
Alexander Howden Underwriting
 Limited
IBM United Kingdom Limited
Imperial Chemical Industries Limited
Marks and Spencer Limited
Mars Limited
The Worshipful Company of Mercers
Midland Bank Limited
Monsanto Limited
Moore Business Forms Limited
The Nestlé Charitable Trust
Philips Electronic and Associated
 Industries Limited
The Rio Tinto-Zinc Corporation Limited
Rowe and Pitman, Hurst-Brown
The Royal Bank of Scotland Limited
J. Henry Schroder Wagg and Company
 Limited
Seascope Limited
Shell UK Limited
Thames Television Limited
J. Walter Thompson Company Limited
Ultramar Company Limited
United Biscuits (UK) Limited
Waddington Galleries Limited
Watney Mann and Truman Brewers
 Limited

SPONSORS

Mrs Ambrose-Ann Appelbe
Miss Margaret Louise Band
A. Chester Beatty, Esq.
Peter Bowring, Esq.
Lady Brinton
Simon Cawkwell, Esq.
W. J. Chapman, Esq.
Henry M. Cohen, Esq.
Mrs Elizabeth Corob
Raphael Djanogly, Esq., JP
Thomas B. Dwyer, Esq.
Brian Eldridge, Esq.
Mrs Myrtle Franklin
Victor Gauntlett, Esq.
Jack Goldhill, Esq.
Peter George Goulandris, Esq.
J. Home Dickson, Esq.
Mrs Patricia D. Howard
J. P. Jacobs, Esq.
Alan Jeavons, Esq.
Roland Lay, Esq.
Miss B. A. Le Blanc
Owen Luder, Esq.
A. Lyall Lush, Esq.
Jeremy Maas, Esq.
Lieutenant-Colonel L. S. Michael, OBE
David A. Newton, Esq.
S. H. Picker, Esq.
Dr Malcolm Quantrill
Cyril Ray, Esq.
Lady Horsley Robinson
The Rt. Hon. Lord Rootes
The Hon. Sir Steven Runciman
Peter Saabor, Esq.
Sir Robert Sainsbury
Mrs Pamela Sheridan
R. J. Simia, Esq.
Steven H. Smith, Esq.
Cyril Stein, Esq.
Ronald Sturdy, Esq.
P. A. Taverner, Esq.
K. A. C. Thorogood, Esq.
Sidney S. Wayne, Esq.
Humphrey Whitbread, Esq.